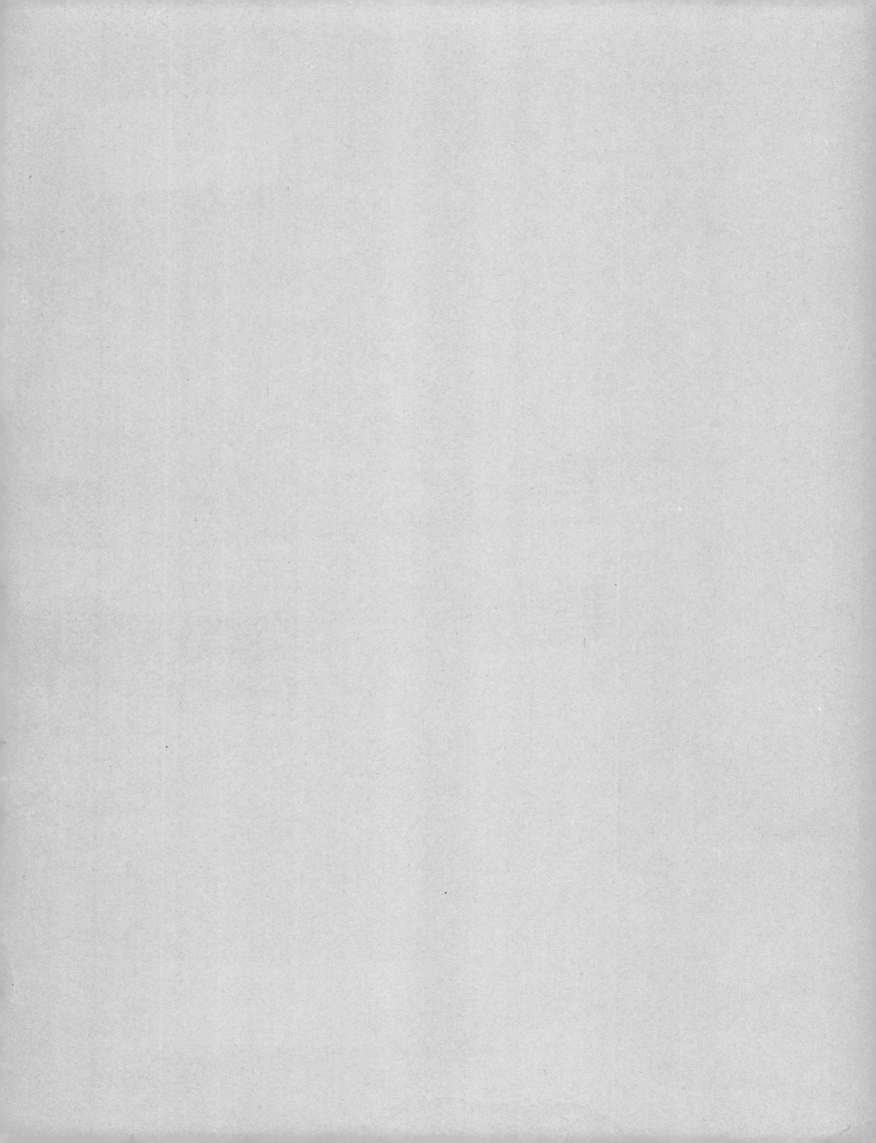

LEONARDO DA VINCI
Engineer and Architect

LEONARDO DA VINCI

Engineer and Architect

The Montreal Museum of Fine Arts

This catalogue has been published for the exhibition

Leonardo da Vinci
Engineer and Architect

presented at the Montreal Museum of Fine Arts
from May 22 to November 8, 1987

Legal Deposit – 2nd trimester 1987
Bibliothèque nationale du Québec
National Library of Canada
ISBN: 2-89192-084-8

This exhibition,
organized by the Montreal Museum of Fine Arts
in collaboration with the Engineering Centennial Board,
is being presented with the financial support of the
Government of Canada, Ministry of Communications,
and of the Conseil des Arts de la Communauté urbaine de Montréal.

The Museum wishes to acknowledge
the outstanding contributions of Pratt & Whitney Canada
and of the following sponsor corporations:
Air Canada
Alcan
Hydro-Québec
National Bank of Canada
Ultramar
Xerox Canada Inc.

Insurance for this exhibition
has been provided by the Government of Canada
through the Insurance Programme for Travelling Exhibitions.
The exhibition has received the promotional assistance
of the daily newspaper *La Presse*,
Radio Cité FM 107,3 and Télé-Métropole.

The exhibition *Leonardo da Vinci, Engineer and Architect*
has been organised by Mr. Pierre Théberge,
Director of The Montreal Museum of Fine Arts.

This catalogue has been edited by Professor Paolo Galluzzi,
Guest Curator of the exhibition and Director of
the Istituto e Museo di Storia della Scienza, in Florence.

Contents

Acknowledgements

It was in 1983, when I was Chief Curator of the Museum, that I undertook to organize this exhibition at the suggestion of Bernard Lamarre, President of the Museum and also Chairman of the Board of the Canadian Engineering Centennial, which is being celebrated this year.

The exhibition forms part of the Engineering Centennial celebrations and has been made possible through the support of the Centennial's Board of Directors and in collaboration with many of its members under the direction of Léopold Nadeau, the General Coordinator, and of Léo Rosshandler, Chairman of the Art Exhibition Committee.

I entrusted the technical direction of the exhibition, together with the choice of themes and works, to Paolo Galluzzi, Director of the Istituto e Museo di Storia della Scienza in Florence, and Jean Guillaume, Director of the Department of Art History at the Centre for Renaissance Studies at the François-Rabelais University at Tours. Mr. Galluzzi is responsible for the section entitled "Leonardo Engineer", and Mr. Guillaume for the "Leonardo Architect" section. The design of the exhibition has been undertaken by Provencher Roy Architects; the models constructed especially for the event are the work of Muséo Techni, of Montreal, Design Jessart International of Saint-Adolphe d'Howard, and the S.A.R.I., Mariani and Frullini workshops, in Florence. Mr. Galluzzi also took on the task of selecting the scholars to write this catalogue and has supervised every stage of its production in Florence, in close collaboration with the designer, Jean-Pierre Rosier, with Francine Lavoie, Head of Publications at the Museum, and with the Museum's translators, André Bernier and Judith Terry.

The Museum has been fortunate in having received, at every stage of the project, invaluable advice from the distinguished specialist on Leonardo da Vinci, Carlo Pedretti, Armand Hammer Professor of Leonardo Studies at the University of California, Los Angeles. We have also had a considerable amount of help from the International Council for Leonardo Studies, of which Mr. Pedretti is director, including Alessandro Vezzosi's valuable work on Leonardo's biography and Murtha Baca's careful reading of the English catalogue texts. In Montreal, William Shea, Professor of the History and Philosophy of Science at McGill University, has been responsible for the reading of the French texts.

A number of other eminent specialists in Leonardo studies have collaborated with Messrs.

IX

Pedretti, Galluzzi and Guillaume on the writing of this catalogue, sharing with us the results of their lengthy researches into the great architect-engineer's ideas and achievements. We are deeply grateful to André Chastel, Salvatore Di Pasquale, Luigi Firpo, Martin Kemp, Pietro C. Marani, Augusto Marinoni and Gustina Scaglia: I feel sure that Leonardo, who was so passionately interested in learning about the latest scientific and technological discoveries of his time, would have approved of this symposium of scholars — a true "accademia vinciana".

The Museum has also received wholehearted support from the federal, provincial and municipal governments throughout the preparations for the exhibition. Our thanks are due to the Right Honourable Brian Mulroney, Prime Minister of Canada, and to the Honourable Robert Bourassa, Premier Ministre du Québec, for their personal help and that of their respective governments.

Numerous government ministers have made our task easier: at the federal level, the Right Honourable Joe Clark, Secretary of State for External Affairs; the Honourable Marcel Masse, Minister of Energy, Mines and Resources; the Honourable Flora MacDonald, Minister of Communications; and at the provincial level, Lise Bacon, Vice-première ministre et Ministre des Affaires culturelles; Gil Rémillard, Ministre des Relations internationales et Ministre délégue aux Affaires intergouverne-mentales canadiennes du Québec; and Yvon Picotte, Ministre du Loisir, de la Chasse et de la Pêche du Québec et Ministre du Tourism. They have all been of inestimable assistance in carrying out this project. The new Mayor of Montreal, Jean Doré, volunteered his support immediately upon taking office. Clément Richard, in his previous capacity as Ministre des Affaires culturelles au gouvernement du Québec, was also extremely helpful at the start of this venture. Without the aid of all these individuals and of the governments they represent, nothing would have been possible.

The international scope of this exhibition has enabled us to benefit from the good offices of the Canadian ambassadors in several European capitals, notably in Paris, Madrid, Rome, the Vatican, Moscow and Warsaw, who have frequently rendered us valuable service.

Leonardo's works are both rare and fragile, and we owe an immense debt of gratitude to the following directors and curators of museums, libraries and foundations who demonstated their faith in the undertaking by loaning us their treasures: the Librarian of the Royal Library at Windsor Castle, Oliver Everett; the Keeper of Manuscripts at the British Library, D.P. Waley and his colleagues, P.J. Porter and Ann Payne; the Curator of Pictures at the Picture Gallery, Christ Church, Oxford, David Pears, and his colleague, Catherine Whistler; the Assistant Keeper of Special Collections of the National Art Library of the Victoria and Albert Museum, Rowan Watson; the President of the Musées de France, Hubert Landais, and his colleague the Curator in Chief of the Department of Graphic Arts, Musée du Louvre, Roselyne Bacou; the Permanent Secretary of the Académie Française and President of the Commission des Bibliothèques, Maurice Druon; the Chancellor of the Institut de France, Édouard Bonnefous, and the Chief Librarian of the Institut de France, Françoise Dumas; the Director of the Library of the University of Basle, Freddy Grobli, and his colleague the Curator of Manuscripts, Martin Steinmann; the Director of the Staatliche Graphische Sammlung in Munich, Dieter Kurhmann, and his colleague the Curator of Italian Prints and Drawings, Richard Harprath; the Director General of Books and Libraries for the Spanish Ministry of Culture in Madrid, Juan Manuel Velasco Rami, his colleague the Executive Assistant to the Minister of Culture, Carmen Giménez, and the Director of the Biblioteca Nacional of Spain, Juan Pablo Fusi Aizpúra; the Director of the Biblioteca Nazionale Centrale in Florence, Anna Lenzuni; the Director of the Department of Prints and Drawings in the Uffizi Gallery, Florence, Anna Maria Petrioli Tofani; the Director of the

Acknowledgements

Biblioteca Reale in Turin, Giovanna Giacobello Bernard; the Director of the Biblioteca Comunale degli Intronati of Siena, Curzio Bastianoni; Elena Bartolini Salimbeni of Florence; the Mayor of Vinci, Rossella Pettinati; the Director of the Pierpont Morgan Library in New York, Charles A. Ryskamp, and his colleague the Curator of Drawings and Prints, Cara D. Denison; Armand Hammer, President of the Armand Hammer Foundation of Los Angeles, and also the Director of the Foundation, Dennis Gould, the Assistant Director, Quinton Hallett, and Kristin West, Administrator of the Artistic Programme of the Foundation. Louise d'Argencourt has also given us much useful advice.

Leonardo, whose most ambitious projects were carried out under the auspices of the greatest art patrons of his time, was well aware of the fundamental importance of such benefactors in the cultural development of a society. In our own day the situation is no different, and an exhibition of this magnitude could never have been attempted without the help of numerous patrons from both the public and private sectors. The Canada Council, the Ministère des Affaires culturelles du Québec, and the Conseil des Arts de la Communauté urbaine de Montréal under the presidency of the Honourable Jean-Pierre Goyer, have been most generous, as have many of our great commercial and financial institutions, whose administrators realize how essential it is for our society to come into contact with major works from the world's artistic heritage. The beneficence of Pratt & Whitney Canada, Air Canada, Alcan, the National Bank of Canada, Hydro-Québec, Ultramar, Xerox Canada Inc., *La Presse*, Radio Cité FM and Télé-Métropole in regard to this venture is unparalleled in the history of the Museum, and we cannot thank them sufficiently.

All the members of the Museum staff have been involved in the organization of this project and share a pride in being able to contribute towards its success. I am much indebted to them for their unfailing support.

At a time when our Museum is about to construct a new wing which will double the gallery space devoted to the display of the permanent collection and travelling exhibitions, let us hope that this presentation of works by the artist who was, for François I, "the King's foremost painter, engineer and architect" will bring home to us all the heights of grandeur and excellence to which engineering and architecture can aspire.

Pierre Théberge
Director of the Montreal Museum of Fine Arts

Preface

As the final proofs of this catalogue go to press, it is our wish to offer a few words of explanation and thanks.

First of all, some remarks on the general approach adopted during the preparation of the exhibition: we have sought to present an image of Leonardo as engineer and architect that takes full account of the latest historiographical research and does not succumb to the temptation of a long-standing celebratory tradition. Our first move toward achieving this aim was to obtain the collaboration of the foremost international specialists on Leonardo's work. Moreover, we have striven systematically to re-situate Leonardo within the context of his times by emphasizing the numerous, highly profitable exchanges and contacts that occurred between him and his contemporaries and the masters of preceding generations.

In our reconstruction through drawings and models of Leonardo's projects, we have respected his indications and have been careful to provide reconstructions of a plausible scale, using, wherever possible, the appropriate construction techniques and materials. Finally, we have concentrated (particularly in the section devoted to Leonardo as engineer) on the chronological development of his career which, far from being linear, was punctuated by fundamental changes.

From this approach arises a new picture, richer and more convincing than those somewhat theatrical presentations that depict Leonardo as a genius working in complete isolation. What this new image throws dramatically into relief are Leonardo's desperate efforts to transcend the objective limits that bound the technology and the construction methods of his period. We are able to perceive the progressive emergence of his plan to reduce to a few unifying principles — the very ones governing the creations of nature — the sum of all human activities and disciplines: science, technology, painting and architecture.

Of course, the exhibition can provide only a general survey, although quite a broad one, of Leonardo's engineering and architectural activities. It highlights certain aspects of his training (for example, his crucially important apprenticeship in the Florence of Brunelleschi) and the most innovative facets of his work as an engineer and architect (the "theoretical" foundation of technology, during the fifteenth and sixteenth centuries, and his studies of the tiburio and the centrally-planned

church). The exhibition also emphasizes the continuing dialogue that took place between Leonardo and his most influential contemporaries, and describes the complex relationships between the Master and his various patrons.

We feel certain that the spectacular graphic reconstructions, the working models, the extraordinary number of original documents, the wealth of information and the countless opportunities for reflection offered by the exhibition will be of enormous interest to visitors.

The "debut" of Leonardo da Vinci in Canada could hardly be taking place in a more sensational fashion. Not a single Leonardo document has ever been on public exhibition in this vast country until now. Today, on view for all to see, are hundreds and hundreds of autograph pages bearing the most magnificent drawings: the largest grouping of Leonardo sheets since his death at Amboise in 1519 and the subsequent tragic dispersal of his manuscripts. Never before has North America seen the simultaneous exhibition of eight manuscripts by Leonardo, totalling over twelve hundred pages, and dozens of outstanding loose sheets, along with manuscripts, drawings and documents by other architect-engineers of the period (including Taccola, Francesco di Giorgio and Giuliano da Sangallo).

The catalogue, edited by Paolo Galluzzi, will undoubtedly enhance the visitor's appreciation of this remarkable ensemble, both aesthetically and historically. It will be of invaluable aid to the non-specialist in grasping the role played by these manuscripts, machines and architectural studies within the context of the development of Western civilization.

Richly illustrated, and accompanied by a comprehensive bibliography, as well as lists of the lenders, the original works and the models loaned or constructed especially for the exhibition, the catalogue contains, apart from our own texts, eight contributions by leading world scholars in the fields of Leonardo's technology and architecture. Clearly, the function and utility of this publication go far beyond the present exhibition.

<p style="text-align:center">★</p>

For an event of such importance, the list of acknowledgements is inevitably a long one. We wish, first of all, to thank the Montreal Museum of Fine Arts for having enabled us to realize such an ambitious project. Our warmest thanks, also, to the authors of the catalogue, for their outstanding collaboration. Our particular gratitude goes to Carlo Pedretti, author of numerous brilliant studies on Leonardo and Director of the International Council for Leonardo Studies at the University of California, Los Angeles, which lent its patronage to this exhibition. Mr. Pedretti's advice has been invaluable and we have benefited greatly from his work in our research and reconstructions.

For their most fruitful collaboration, we thank Giunti Barbèra, in Florence, who have produced all the recent editions of Leonardo's manuscripts and who have put together this extremely high-quality catalogue in record time; the contribution of their Artistic Director, Franco Bulletti, has been particularly indispensable. We are also grateful to Jean-Pierre Rosier who is responsible for the graphic design, and to Judith Terry and André Bernier of the Montreal Museum of Fine Arts, for their translations and their meticulous revision of the texts.

All our gratitude and admiration go to the craftsmen who created the models for the exhibition — especially Romano Orlandini, who so expertly oversaw the woodwork executed by the S.A.R.I.

workshop, of Florence: it is work that proves that the artisan skills so common at Leonardo's time still survive in Florence today.

We also wish to thank Franca Principe of the Istituto e Museo di Storia della Scienza in Florence, who so competently coordinated the gathering of the photographic documentation for the exhibition catalogue.

For the section of the exhibition devoted to Leonardo as engineer, Paolo Galluzzi is especially grateful to Salvatore Di Pasquale, Director of the Dipartimento di scienza delle costruzioni of the University of Florence; his aid was particularly valuable in reconstructing Leonardo's extremely important contact with the construction site of Brunelleschi's dome. Paolo Galluzzi also wishes to thank Murtha Baca, of the International Council for Leonardo Studies at the University of California, Los Angeles, for her English translation of his text and her careful reading of the remaining English texts, and Marie-Claude Trémouille of Florence, for her French translations. His gratitude also goes to Lynne Otten and Elisabetta Palazzi Masserelli for their steadfast and efficient assistance, and to his friend and colleague William Shea, of McGill University in Montreal, for his valuable advice.

For the architecture section, Jean Guillaume warmly thanks the Getty Foundation, where he found ideal working conditions; he is also grateful to Christoph Luitpold Frommel and Howard Burns, who examined with him the problems posed by the creation of a large-scale model. He also owes a great debt of gratitude to his closest collaborators: Krista De Jonge, who drew the plans for the church model, and Sabine Kühbacher, who is responsible for most of the graphic reconstructions included in the architecture section.

Paolo Galluzzi
Director of the Istituto e Museo di Storia
della Scienza, Florence

Jean Guillaume
Director of the Department of Art History
at the Centre for Renaissance Studies
at the François-Rabelais University at Tours

Introduction

by
Carlo Pedretti

Body born of the perspective of Leonardo da Vinci,
disciple of experience.
(CA, f. 520 r/191 r-a, *c.* 1490)

There is hardly a country in the world where Leonardo da Vinci is not known above all as an inventor. Much admired as his paintings and drawings are by everyone, what appeals most to the popular imagination is the evidence provided by his notebooks that he had envisioned technological innovations which place him ahead of his time. Generalization has become unavoidable. He is the father of the airplane, the helicopter, the parachute, the submarine, the automobile, and now even of the bicycle. Drawing is the language with which he commits his ideas to paper. The way he presents the structural and operational aspects of a machine, as in an assembly line, lends itself to the making of a model, thus anticipating even the concept of the prototype.

The best example of Leonardo's use of a model is provided by his plans for the helicopter in Paris MS. B, f. 83 v, *c.* 1487-90 (Fig. 1). The screw-like device is described as having a diameter of eight *braccia*, that is about four metres, and as being made of reeds covered with taffeta. "A small model can

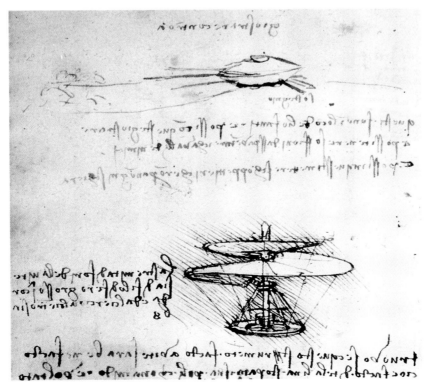

Fig. 1. Paris MS. B, f. 83 v (detail).

Fig. 2. Paris MS. D, f. 3 v (detail). The model of the eye.

be made of paper", he concludes, "with a spring-like metal shaft that once released after having been twisted, causes the screw to spin up into the air".

And so the widespread fascination with the models of Leonardo's machines finds its ultimate justification in Leonardo himself. He too must have been keen about translating his designs into models. On many occasions he would have a model built to test a scientific theory: he describes how to simulate the function of the eye by means of a glass device (Fig. 2) with which the principle of the contact lens is formulated; the flow of blood through the valves of the heart which come to be shut intermittently by its reflex motion, is illustrated by a series of notes and diagrammatic drawings again with the suggestion to test the proposed interpretation with a glass model. Models are also used for experiments of aerodynamics and hydrodynamics. Thus water currents are best investigated as dyes or minute millet seeds make them visible through the glass panes of a tank. The action of surface water as produced by wind causing a contrary motion at the bottom is ascertained again by such a model. This time the proposed experiment is related to a specific location: "Test at your pit... But see to it that you have a terracotta tile... Have it made here by the potter" (Codex Hammer, f. 9 v). He even went so far as to envisage a scale model of the countries around the Mediterranean to illustrate the theory of the action of rivers in removing and depositing soil. This is found on a late sheet of the Codex Atlanticus, f. 227 v/84 v-a, *c.* 1513-14 (Pedretti, 1977, note to § 1092), but the experiment seems to have been set earlier, as suggested by a note in the Codex Hammer, f. 15 r, *c.* 1508: "The beds of each river mouth will be known once a small-scale experiment is carried out with sand". And yet an implied warning · against the validity of such small-scale experiments is found on f. 17 v of the same manuscript: "How the percussions of the great waves of the sea are not in proportion with, nor are they similar in any effect to, the percussions of the small waves". For the same reason one can always tell whether the naval battle in a film is real or simulated with small-scale ships in a pool.

Leonardo had an unshakeable faith in models. A statement such as the one found in Arundel MS., f. 191 r, *c.* 1504 (Fig. 3): "Every instrument should be made by experience", may sound like a

philosophical pronouncement, but what it really means is that an instrument must be born out of a model. With a model, in fact, a theory is checked at once in the course of a technological conception. Hence the function of the prototype in the making of a machine. The folio on which this is written is one sheet with folio 190, and was originally folded in half longitudinally so as to form two long, narrow pages to be appropriately filled with lists of memoranda written in columns. The same statement, worded differently, is found on the same sheet (f. 191 r), but on what was originally the facing page: "Every instrument in itself must be made on the basis of the experience out of which it is born".

One of the entries in the list of memoranda on the very same page is: "an apprentice for the models". Another version of the same memorandum is in CA, f. 331 r/120 r-d, *c.* 1504, with a modified entry that clarifies Leonardo's intentions: "an apprentice to make the model for me". The entry "the cost of the taffeta for the wings" in the same list of memoranda (Arundel MS., f. 191 r) may hint at the model Leonardo has in mind—a flying machine. On the other hand, the rest of the sheet, both recto and verso, is filled with notes and calculations about the making of a ship log based on the belief that the velocity of the ship can be determined by the degree of inclination of the falling dust or mercury inside a container that resembles an hourglass.

It is puzzling that Leonardo should not have realized at once that this would never have worked, simply because the dust or mercury falling within the instrument is protected by the glass and cannot possibly record the degree of resistance offered by the air as the ship moves. The same device is described in all seriousness by Luca Pacioli in his unpublished *De viribus quantitatis*, ff. 196 r to 199 r, but a later hand appropriately adds: "*Res haec est dubia et incerta si perpendiculo imprimibus motus navis*" (This question is doubtful and uncertain if the movement given to the ship is perpendicular). All construction details and expected performance are carefully reviewed by Leonardo up to a final remark about the fall of the mercury: "Let us establish the scale in the prototype on the basis of the fall of the mercury". The prototype, of course, could not have met his expectations. Hence the lesson learned

Fig. 3. Arundel MS., f. 191 r.

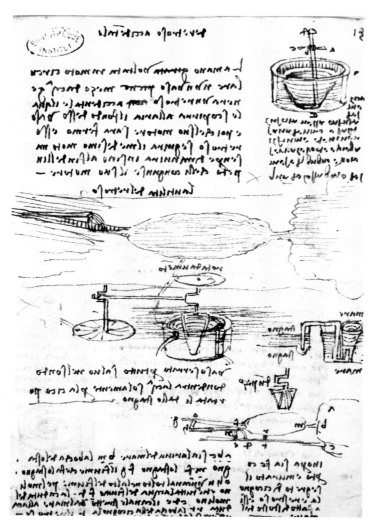

Fig. 4. Paris MS. F, f. 13 r. Study for a centrifugal pump.

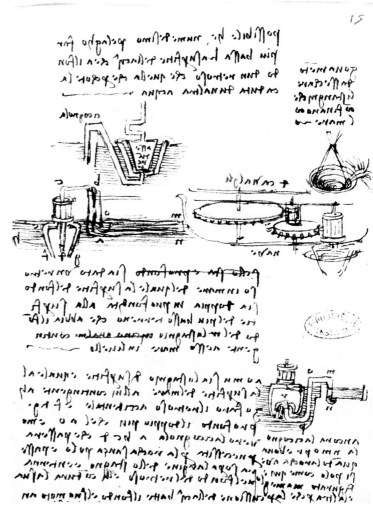

Fig. 5. Paris MS. F, f. 15 r. Study for a centrifugal pump.

about having an instrument or machine planned on the basis of an experiment. But the lesson is soon forgotten. The same ship log, modified but still based on the same wrong theoretical premise, reappears about 1508 in the Codex Hammer and in Paris MS. F. And as late as 1515, in Paris MS. G, Leonardo claimed he had succeeded where Vitruvius and Alberti had failed. Somehow, the performance of a prototype must have been affected by his faith in it. It may in fact be worthwhile, sometimes, to try to sort out Leonardo's aberrations in this matter. Quite pertinent, in this respect, is his discussion of Vitruvius' concluding remarks (*De architectura*, X, 16.5) about the performance of models. This in a text in Paris MS. L, ff. 53 v and r, *c.* 1502, in which Vitruvius is quoted as saying what he really does not say and is contradicted with a demonstration that proves him right! The *punctus dolens* about the use of models is thus faced with an act of faith: "Vitruvius says that small models are not confirmed in any operation by the effect of large ones. I intend to show here below that this conclusion is false".[1]*

A beautiful example of how an instrument must be born out of experience, that is, out of a model, is provided by one of Leonardo's most brilliant inventions, the centrifugal pump for draining marshes described in Paris MS. F, ff. 13 r to 16 v (Figs 4-7), and in Arundel MS., f. 63 v, *c.* 1508. The idea is

* Note on p. 317.

4

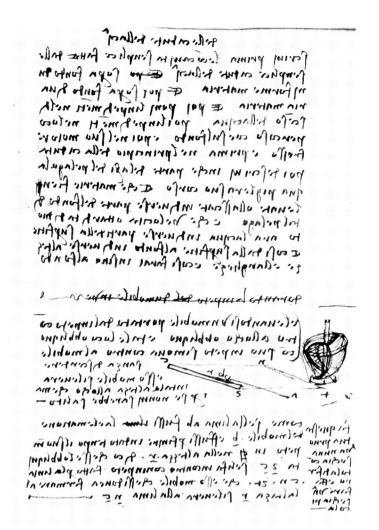

Fig. 6. Paris MS. F, f. 15 v. Study for a centrifugal pump.

Fig. 7. Paris MS. F, f. 16 r. Study for a centrifugal pump.

triggered by observing how water stirred by the revolving movement of a hand in a bucket generates a whirlpool or vortex in the form of an inverted cone. If such a vortex is artifically sustained by mechanical means, it is possible to siphon water from swamps bordering on the sea. The machine can be placed near the dividing shore or mounted on a ship. Here one can follow the steps of Leonardo's technological invention: the hand stirring the water in a bucket (as also recorded in the Codex Hammer, f. 27 r) is the observation which is turned into an experiment, i.e. a model. See Paris MS. F, f. 15 v: "Have this experiment of yours made in a bucket with an iron stick and let the bucket be made small". As the hand in the bucket becomes a metal stick in a "small bucket", the small–scale model is born. The final test will be with the prototype concealed to insure the secrecy of the invention (Paris MS. F, f. 13 r). The device is designated either as a mill or a siphon, and in fact whenever these terms appear in Leonardo's canalization studies of a later period, he refers to this invention. Thus the four mills in the Romorantin project (Arundel MS., f. 271 v) are devices for raising water as already mentioned in the plans for the villa of Charles d'Amboise in Milan of *c.* 1508 (see Pedretti, 1972[2], p. 324, note 40).

Among the fragmentary annotations on a sheet of Leonardo's early studies for a submarine (CA, f. 881 r/320 v-b: Fig. 8) is a caption of which only the first word is legible: "*modello*". Leonardo seems to be studying a decompression system that needs to be tested with a model. There must have

been elaborate plans for such an invention, which later Leonardo himself stated he had deliberately avoided making public because of "the evil nature of men" who would use it to bring death and destruction at sea.

It is also possible that in the case of the submarine Leonardo was referring to a model as a prototype. This is certainly the case with a flying machine which about 1493 he intended to test on the roof of his residence in Milan, the Corte Vecchia next to the Cathedral. He writes (CA, f. 1006 v/ 361 v-b: Fig. 9): "Board up the upper room and make the model large and high". This time a small sketch illustrates his intentions: the machine with bird-like wings hangs from a beam and is set on the circular platform of a removable stepladder. The memorandum continues: "And this may be placed on the roof above, which would be more suitable than any other place in Italy". And then a warning: "And if you stay on the roof at the side of the tower, the men at work on the tiburio will not see you". It appears therefore that Leonardo's studio was next to the tower of San Gottardo and that he was planning to use the roof of the vast building as a launching pad for a flight in the direction of the piazza of the Cathedral. It might well be that one such attempt made in Milan in the 1490s was the one which Gerolamo Cardano was to record some fifty years later (*De subtilitate*, 1550, p. 318): "*Vincius tentativit et frustra: hic pictor fuit egregius*"—a "*pictor*", in fact, who had just completed the *Last Supper*.

It was in his studio in the Corte Vecchia, to which he himself referred as "*la mia fabrica*", that Leonardo made the actual-size model of the colossal horse for the Sforza Monument, a model which, packed for transport as it appears in a well-known drawing in CA, f. 577 v/216 v-a (Fig. 10) had to be taken to a site suitable for casting, and there is good reason to believe that this was on the outskirts of town. Much information has been added recently about Leonardo's casting procedures, but practically nothing is known yet of the location where the complex operation was planned to take place. One can only surmise that this was somewhere in the area of Santa Maria delle Grazie outside Porta Vercellina, possibly on the property which Lodovico Sforza was to donate to Leonardo in 1498 and which is

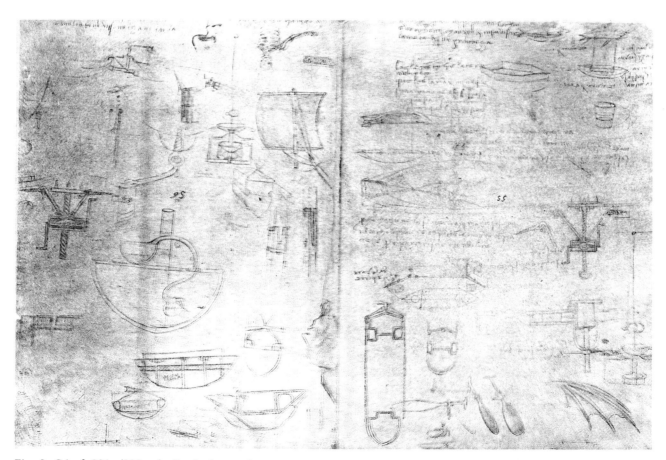

Fig. 8. CA, f. 881 r/320 v-b. Study for a submarine.

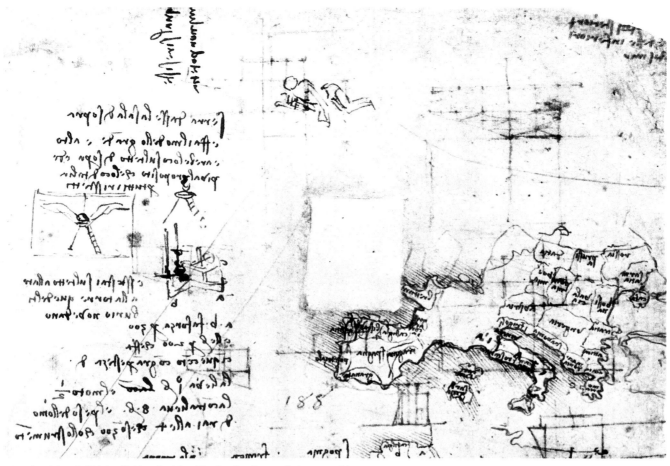

Fig. 9. CA, f. 1006 v/361 v–b (detail). Study for a flying machine.

Fig. 10. CA, f. 577 v/216 v–a. The packing for the transportation of the Sforza horse.

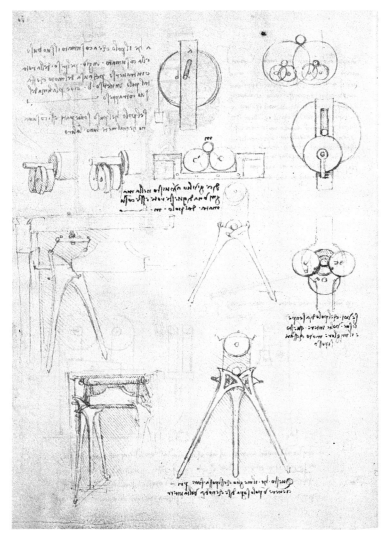

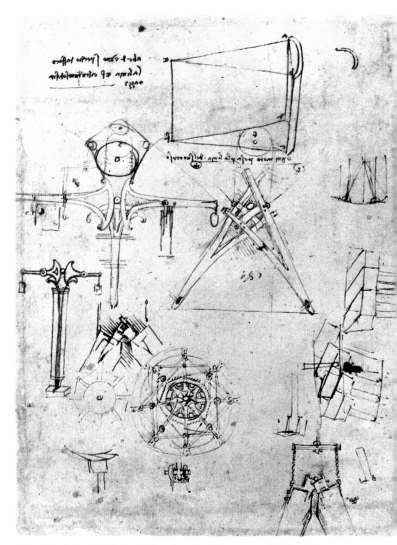

Fig. 11. Madrid MS. I, f. 12 v. Antifriction roller-bearings. Fig. 12. CA, f. 1086 r/392 r-b. Antifriction roller-bearings.

designated in the documents as a vineyard. This was next door to the monastery of San Gerolamo degli Ingesuati, which is mentioned in a memorandum of *c.* 1499-1500 together with a reference to a book of Phalaris' letters (CA, f. 638 r/234 r-b: "*ingesuati / pistole dj fallari*"). The monks of this order were traditionally versed in the preparation of colours for paintings, and they could also have supplied Leonardo with chemical ingredients needed for the casting operation. By December 1493 the moulds were ready and the foundry set up with its large pit for the colossal horse. The following year, the bronze set aside for the casting was sent to the Duke of Ferrara to be made into cannon. The model of Leonardo's horse may have been left there in the open, possibly protected by just an awning, certainly well visible from the road across that stretch of open fields. This would explain why it could have become an all-too-easy target for the invading French troops who entered Milan in 1499 precisely through Porta Vercellina. No French officer would have allowed its destruction had it been where it used to be in Leonardo's studio in the Corte Vecchia, out of the way of a military operation.

The 1490s were years of intense activity for Leonardo. Not only did he perform as a painter, a sculptor and an architect, but he was above all an engineer, very keen about the theoretical and practical aspects of the profession. This is eloquently shown by the extraordinary amount of devices and elements of machines collected in Madrid MS. I. His studio included not only painters but

technicians as well. Two of them, a Maestro Tommaso and a German, known as Giulio Tedesco, are recorded in 1493 and 1494 for work done around the studio, such as making candlesticks, springs, and locks. A note added on a page of Madrid MS. I (f. 12 v: Fig. 11) records technological information conveyed by Giulio: "Giulio says he has seen in Germany one of these wheels worn down at the axle *m*". The page contains details of an ingenious roller-bearing device for a bell-holding shaft, which Ladislao Reti has shown to have been reproduced, identical, some two hundred years later in Jacob Leupold's *Theatrum Machinarum Generale* of 1724. In 1845 the same device appears again in the *Traité de mécanique industrielle* by the French engineer J.V. Poncelet, who related it to the celebrated *Mutte* bell of the Cathedral of Metz. The striking resemblance suggests that a Leonardo idea had migrated to Germany, but it is also possible that the idea had been brought to him by his German assistant.

Be that as it may, this is precisely the kind of device that Leonardo was likely to have made into a model, that is, a prototype, thus realizing how roller bearings are indeed "the marvel of mechanical genius". It is a device on which he apparently kept working for several years at the turn of the century, as shown by a number of drawings of water pumps, one of which is inscribed "pumps from

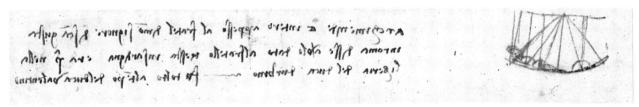

Fig. 13. CA, f. 968 Br/349 v-b.

Imola", thus hinting, possibly in retrospect, at the time of Leonardo's activity in the service of Cesare Borgia. One of these drawings of pumps overlaps the small sketch of a piece of monumental architecture which prefigures the kind of High Renaissance palace design that was to be carried out by Bramante and Raphael in Rome some ten years later.

Another sheet of the same series of studies for the roller-bearing device (CA, f. 1086 r/392 r-b: Fig. 12) from *c.* 1500 or possibly later, contains a diagram of the caustic of reflection that is surprisingly similar to the one on f. 968 Br /349 v-f (Fig. 13), the fragment with the record of a manuscript of Archimedes' works and with a reference to Cesare Borgia's pillage of the Urbino library in 1502. This sheet contains what Reti considers to be the final solution of the roller-bearing device and in fact the model that Reti had built is based on a design on this sheet.

Most of Leonardo's technological innovations in the 1490s are applied to machines for the production of textiles. On one occasion (CA, f. 985 r/356 r-a, *c.* 1495: Fig. 14) he was prompted to state: "This is second to the letterpress machine and no less useful, and as practiced by men it is of more profit and is a more useful and subtle invention". He was even thinking of automation, as is the case with a programme for the production of needles, or with a technological complex of "*battiloro*" machines for the production of *bizantini* i.e. sequins for ladies' dresses (Fig. 15).

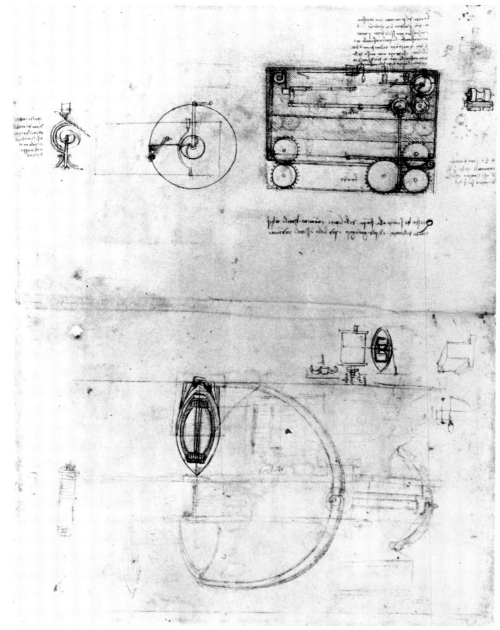

Fig. 14. CA, f. 985 r/365 r-a. The automatic weaving machine.

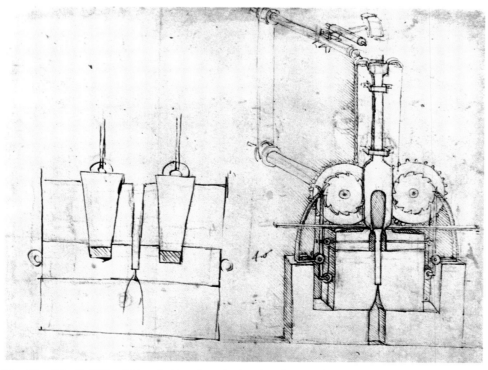

Fig. 15. CA, f. 1091 r/391 r-d. Puncher device for the production of sequins.

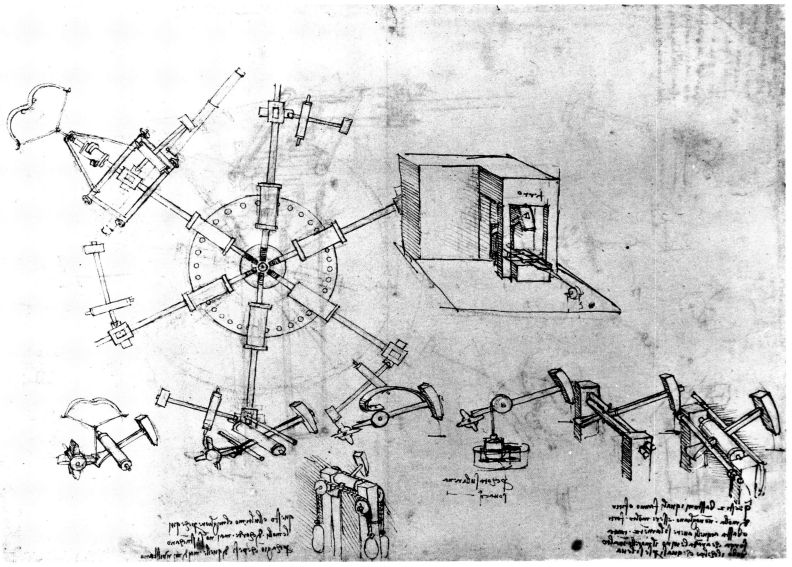

Fig. 16. CA, f. 67 Ar/21 r-a. Machine for the production of golden sequins.

Some of Leonardo's plans for "*battiloro*" machines, which have survived in fragments now in Munich, were known in the sixteenth century as recorded in a large sheet of copies in the Uffizi, which also preserves a record of Leonardo's intention of producing a prototype "movement of the actual model", and with an expedient to protect the invention: "All this wheel and the other mechanisms will be placed underneath the floor so as to keep them secret and not intelligible".

The automation plan for this machine as drawn schematically on CA, f. 67 Ar/21 r-a (Fig. 16 and Pl. VIII) includes the detail of an elevation of its architectural enclosure which shows only the hammering device. It is here that Leonardo introduces a principle of design which will appear time and again in his later anatomical studies. This is the way details are shown overlapping in his drawings, so that the flat surface of the sheet acquires several levels of depth which may correspond to different phases in the unfolding of a technological conception, and which, in any case, contribute to the rhythm of form in space and to the compositional balance of the presentation.

The concept of the prototype reappears in the representation of a shearing machine (CA. f. 1105 r/ 397 r-a, *c.* 1495: Fig. 17) again with a detail of the protective cover "to hide the secret". And the caption shows that Leonardo is having a reduced-scale model built: "Let *a b c* be the model. Remember

11

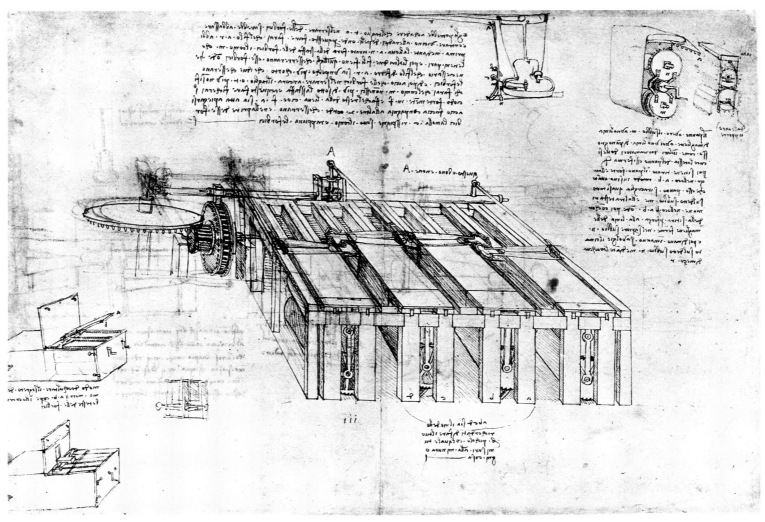

Fig. 17. CA, f. 1105 r/397 r–a. The shearing machine.

to make your *braccio* small, with which you roughly measure everything". The cryptic reminder can only be taken to mean that the measuring stick, a *braccio*, should be reduced in the same proportion as the model, so that it could be used for measuring every part of the model in the same way as the scale in a map is used.

The final evidence of Leonardo's practice of having prototypes built comes from his own notes of a later period. When in Rome as a guest of Giuliano de' Medici in the Vatican Belvedere from after 1514, Leonardo was given a workshop and the assistance of two German mirror makers for the purpose of carrying out the project of some machinery for the construction of parabolic mirrors with which to utilize solar energy for industrial purposes, namely for the function of large boilers in dyeing factories. (The Medici must have been very keen about developing a textile industry in Rome following the election of one of them to the Holy See.) Very little can be understood of the details and scattered notes pertaining to the Roman project in Paris MS. G and in related sheets of the Codex Atlanticus dating about 1515. But a series of drafts of a letter to Giuliano de' Medici complaining about the behaviour of the German assistants, reveals glimpses of Leonardo's working methods and procedures. Of particular interest to us is a paragraph in the draft in CA, f. 671 r/247 v–b (Richter, § 1351):

> Afterwards he wanted to have the models made in wood, just as they were to be in iron, and wished to take them away to his own country. But this I refused him, telling him that I would give him, in drawing, the breadth, length, height, and form of what he had to do; and so we remained in ill will.

12

Leonardo knew well that with a prototype an invention could no longer be protected, while a drawing could always omit or conceal a key feature.

The model as a prototype may have been taken to designate a "pilot project" in the layout of a new district as part of a programme of urban planning. This is the case with the district indicated in the plan of enlargement of the city of Milan, CA, f. 184 v/65 v-b. A sketch of the same district is also found in Forster MS. III (f. 23 v, *c.* 1493) and the same notebook (f. 68 r) contains a note that may well address the shareholders mentioned in the notes on the Codex Atlanticus sheet: "Does it please you to see a model which will prove useful to you and to me, and will also be of use to those who will be the cause of our usefulness?"

The traditional use of wooden models in architectural planning could well be replaced by drawing, like those of centralized churches in Leonardo's early Paris MS. B, which provide both technical information and volumetric effect. And yet Leonardo himself must have mastered the long-established practice of architectural model making, evidence of this being provided by the model for the tiburio of Milan Cathedral which he submitted in 1488. And when in 1500 the Marquis Francesco Malatesta wanted to build in Mantua a replica of the Villa Tovaglia on the outskirts of Florence, Leonardo made a drawing for him and was reported to have offered to make a coloured drawing or a model: "...the aforementioned Leonardo offered to do it in painting as well a model" (Beltrami, 1919, no. 105).

Sculpture too requires models. And Leonardo had good reason to use them. The complex casting apparatus for the Sforza Horse had to be tested in a small-scale model along with a model of the colossal horse. This is explained in a note in Madrid MS. II, f. 144 r, *c.* 1493: "To handle the form. In this case, it will be convenient to make a small model of the form, and have it in a small room with its own furnaces to test how the parts of the mould should be arranged". Some of the Renaissance bronzettes which are often associated with Leonardo's ideas for the Sforza Horse may very well stem from one such model.

A comparable practice in painting is known to have been introduced by Leonardo to test his innovative colour technique for the *Battle of Anghiari*. A trial panel of the central part of the composition is recorded by the Anonimo Gaddiano and is reproduced in a print by Zaccaria Zacchia of 1558. Both the special plaster and the oil colours could dry well by exposing the panel to intense heat, but not so the vast surface of the actual painting. One may wonder whether this was the first warning to Leonardo about the outcome of small-scale models not corresponding to that of full-size works. One of the Anghiari studies at Windsor (RL 12328 r: Fig. 18) includes a sketch of a galloping horse with the note: "Have a small one made of wax a finger long". Again a model. This time its purpose is explained by Cellini when he speaks of the use of wax models as a means of studying the composition of a painting — a method he says was introduced by Masaccio and adopted by Leonardo in "several beautiful things in Milan and Florence" — the *Last Supper* and the *Battle of Anghiari* obviously being implied. This may also be taken to explain the character of some of the composition studies for the *Battle of Anghiari*, particularly when an emphatic bird's-eye view shows the position of colliding horses being tested with figures added and attitudes changed every time the motif is repeated, thus betraying the arrangement of a battlefield simulated on a table, with small-scale models of the figures. Here the painter is like a general studying a plan of attack.

It was in the wake of his Anghiari studies that Leonardo's interest in anatomy revived. His early anatomical studies, particularly the skull series of 1489, are unsurpassed in accuracy, precision, and

effectiveness of visual demonstration — the domical cavity of the skull being presented in different kinds of sections as if to suggest that it could be disassembled like an architectural model. Form is related to the linear framework of a system of proportions, its volumetric entity being enhanced by the presence of axes which set the three-dimensional conditions for defining its centre of gravity at a point in which the *sensus comunis* was believed to reside.

The skull is the "house of the intellect" with which Nature begins the composition of the human body. It is therefore appropriate that it should come first in Leonardo's anatomical studies, and this at the time of his architectural studies for the tiburio of Milan Cathedral and for the new cathedral at Pavia. It was in the summer of 1490 that he and Francesco di Giorgio were invited to Pavia to advise on the construction of the new cathedral, and it was probably on that occasion that Leonardo was given a manuscript copy of Francesco di Giorgio's treatise on architecture (the present Codex Ashburnham 361 in the Laurentian Library: Fig. 19), to which he added a few marginal notes at the time of the *Battle of Anghiari*, *c.* 1506, when the new phase of his anatomical studies shows a shift of interest from structure to function.

And function is determined by muscular action, as best illustrated by a model with a system of wires corresponding to the lines of force of each muscle. A model, then, as an aid to drawing, and therefore as a didactic tool as well, possibly one of the *"instrumenti"* which Leonardo had in his studio at the time of his death in France in 1519 and which are recorded in his testament as "appertaining to his art and calling as a painter" to be left to his pupil Francesco Melzi.

And there is some evidence that Leonardo had also thought of a robot, just as he is known to have made a mechanical lion for festivals in France late in his life. One of the marginal notes in the codex of Francesco di Giorgio is a memorandum about what we may call *anathomia artificialis*: "The model should be made with a wax bust".

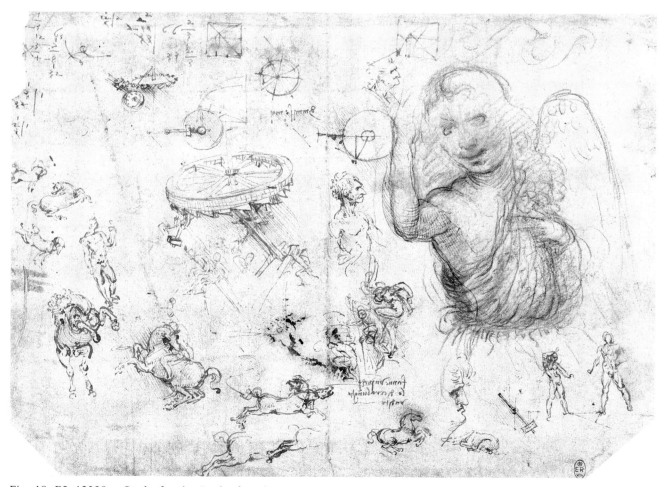

Fig. 18. RL 12328 r. Study for the *Battle of Anghiari*.

Fig. 19. Ashburnham MS. 361, f. 25 r. A page by Francesco di Giorgio annotated at the top by Leonardo.

Francesco di Giorgio died in 1501, but it is doubtful that the character and style of his architectural and technological drawings would have evolved in any way had he lived longer. His drawings, like those of Giuliano da Sangallo, who died in 1516, perpetuate an archaic convention which characterizes the illustrations of Mariano Taccola of some seventy years earlier, and the matrix of which may be traced back to mediaeval handbooks for architects, with machines shown in a stereotyped encasement so that they could be designated as edifices, e.g. "*edifici d'acque*". Perhaps it was not a coincidence that such an approach to technological illustration should reflect that shown in the

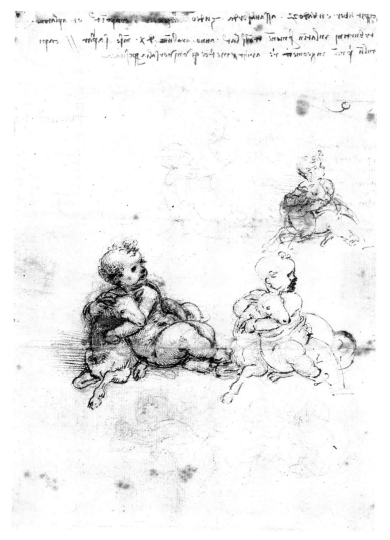

Fig. 20. The Weimar sheet (recto), Getty Museum, Malibu.

bas-reliefs of classical antiquity as in Trajan's Column, nor is it a coincidence that Francesco di Giorgio's bas-reliefs of war machines at Urbino should deliberately relate to the ancient examples in the same way as the illustrations of Valturius' *De re militari* of 1482 do.

A different trend of technological and scientific illustration, which originated in twelfth-century manuscripts of Greek and Arab texts, consists of nearly incomprehensible diagrams, and these can be shown to have survived in the scientific encyclopaedia of Giorgio Valla, a book published in 1501 and known to have been in Leonardo's possession at the time of the *Battle of Anghiari*. Occasionally these archaic trends merge, as in anatomical illustrations before Leonardo. Again, one can pick up a book of 1501, Magnus Hundt's *Anthropologium, de hominis dignitate*, to show their persistence at a time when Leonardo had already developed a new visual language. This was the time of his return to Florence after eighteen years of activity in Lombardy.

This turning point in Leonardo's career, when he was about to turn fifty, is best represented by a single sheet of studies, the whereabouts of which had long been unknown since it had disappeared from the Granducal collection at Weimar in the late 1920s (Figs 20–21).

The recto contains three sketches of a child with a lamb, and another such sketch, in black chalk,

16

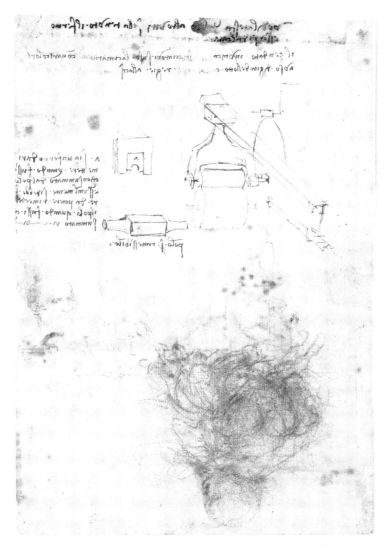

Fig. 21. The Weimar sheet (verso), Getty Museum, Malibu.

is on the verso. They may appear at first to be studies for the St. Anne cartoon which Leonardo is known to have made in 1501. A child in a similar posture is sketched in black chalk on a sheet at Windsor (RL 12540) which contains a figure study apparently inspired by the classical motif of the Diomedes as shown in Donatello's roundel for the Medici Palace. But the child's action is not that which is known to have been intended for the St. Anne cartoon. He is not playfully and eagerly reaching for the lamb. He has seized it and turns back with the peremptory look of one who is determined not to give it up. This is enough to reveal Leonardo's intentions. He is studying a detail of a composition known only in school copies, the *Madonna with the Children at Play*. Christ's playmate, as in the *Virgin of the Rocks*, is the infant St. John the Baptist, his cousin. The lamb as a sacrificial symbol belongs to John, the prophet, who predicts Christ's Passion with it. The play is in fact one of symbols. The Christ Child has snatched the lamb from his playmate, who is approaching him with a goldfinch in an attempt to lure him into returning the lamb in exchange for the bird, which is the symbol of Christ's divinity. And of course to no avail.

The motif must have gone through a long gestation in Leonardo's mind. In fact, it may be traced back to the Nativity scenes on which the *Virgin of the Rocks* is based (e.g. RL 12650). A related sheet in

17

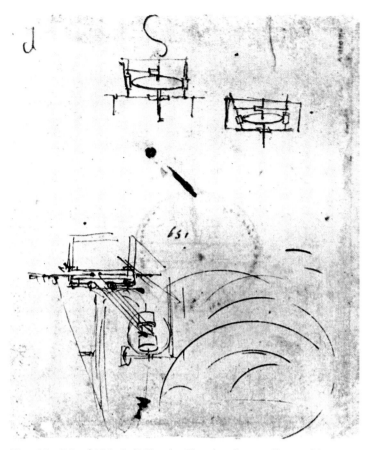

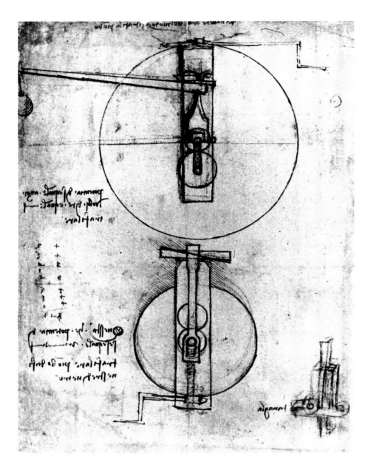

Fig. 22. CA, f. 718 Ar/265 v-b. Sketch of a textile machine.

Fig. 23. CA, f. 1035 r/370 v-b. Sketch of a rolling mill for the production of lead strips for windows.

the Metropolitan Museum is likely to have been a study for the same subject, unless the inking in is later, from the time of the first studies for the *Madonna with the Children at Play*, *c.* 1497.

At the top of the Weimar sheet is a note written with the same pen and ink as used for the studies of the child with the lamb. It gives the title of a book of geometry by Savasorda, thus hinting at Leonardo being back in Florence with his friend Luca Pacioli, the mathematician, who could have informed him of one such manuscript in the library of San Marco. A note on the verso, showing the same ductus and ink, refers to a "head of Altoviti", possibly a sculpture portrait of a member of the well-known Florentine family to which Raphael's and Michelangelo's friend Bindo belonged.

All of this seems to suggest that Leonardo was back in Florence, and therefore indicates a date after April 1500. And yet the verso of the sheet contains notes showing a different ductus and referring to technological studies that can be dated during Leonardo's last two or three years in Milan. They can be shown to relate to a metal roller device which occupied him at the turn of the century, like the roller-bearing device on which he was still working in 1502-3. These light, almost filiform drawings are not careless sketches. It is more appropriate to view them as a form of stenographic notation, all parts being present even if only hinted at.

A comparable type of stenographic drawing can be seen on a sheet of the Codex Atlanticus, (f. 718 Ar/265 v-b: Fig. 22), which dates from about the same time, *c.* 1497-99. It presents the technological conception of a textile machine that was to be elaborated in a detailed drawing now lost, but certainly of the same category as those found in Madrid MS. I, ff. 65 v, 66 r and 68 v. The stenographic notation of the Weimar sheet must have undergone the same process. It omits the enclosing frame to show the essential elements of the machine. A further stage in the elaboration

18

process can be seen in a drawing in CA, f. 1035 r/370 v-b (Fig. 23), which presents the same machine in a way comparable to a blueprint. There must have been a final phase of a perspective view comparable to the sketches which illustrate a related note in Paris MS. I, f. 48 v, *c.* 1497-99 (Fig. 24):

> Methods of making a tin plate thin and even. These [rolls] should be of the metal of which bells are made, in that they will be harder; and they will have a square core made of iron, so that they will not twist. Thus, as they roll one against the other, they will flatten out a tin plate about half a *braccio* wide.

A detail of the square core and its removable axle ("*polo rimessibile*") is shown on the Weimar sheet. Leonardo's preoccupation, as in the case of the roller-bearing device of about the same time, is with friction-caused wearing. Here he copes with the problem by suggesting a way of making the axle replaceable.

A note on the verso of the Weimar sheet about treating sendal fabric ("*zendado*") to make it waterproof is only indirectly related to technology, and yet significantly so. It belongs to the earlier set of notes, *c.* 1497-99, and reads as follows: "*il zendato invernjca [to e] stacciatovi. suso la cimatura conuarj colori / a uvso. dj gianbellotto. e altre opere regie allacq^a*" (Sendal coated with varnish over which has been sifted cloth polling of various colours so as to resemble the surface of camel's hair and other fabrics, is water resistant).

Emil Möller, who was the first to publish (1929) the verso of this sheet, took this as a reference to the silk material that Leonardo had planned to use for his flying machine, but Möller was misled by the reading of the last words and interpreted them as an obscure reference to *opere regie*, that is, works for the King of France, and therefore as a reflection of Leonardo's activity in Milan about 1508. According to the correct reading as clarified in translation, Leonardo is explaining a way of manufacturing a waterproof sendal fabric with decorative patterns in colour simulating camelcloth or velvet. This may be related to a note in Paris MS. I^2, f. 49 v, *c.* 1497 (Richter, § 704), about the making of a carnival costume consisting of a beautiful garment of fine cloth coated with varnish for the application of a decorative knot motif made of millet seeds applied to it through a stencil.

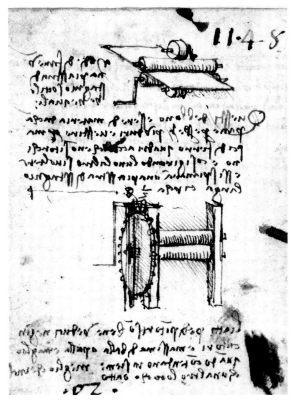

Fig. 24. Paris MS. I, f. 48 v. Machine for making tin plates.

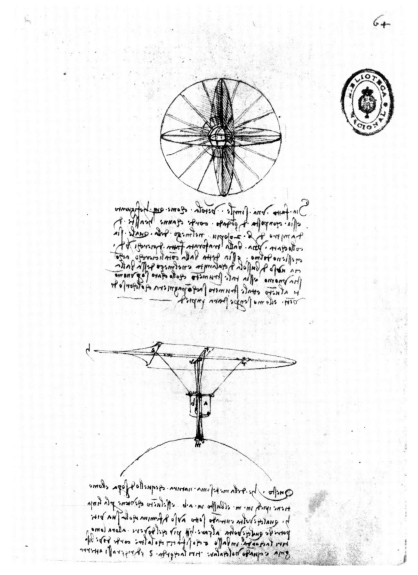

Fig. 25. Madrid MS. I, f. 64 r. Study of a glider which can be controlled by a pilot.

There is no reason to believe that Leonardo was thinking of a colourful, waterproof fabric for the wings of a flying machine, unless the flying device was intended for a performance on some festive occasion, as is traditional with the elaborate, colourful Chinese kites. Extravagant as this may seem, there is now evidence that such devices were known or reinvented by Leonardo, and in fact they are admirably illustrated and described in Madrid MS. I, f. 64 r (Fig. 25) *c.* 1497. With reference to the device shown at the top of the sheet, Leonardo specifies that it is made of sendal fabric, ropes, canes, and shafts, and that it has a diameter of twenty *braccia* or more, approximately ten metres. He then gives instructions to have a perforated ball made from hoops of green elm in the middle, arranged so as to act like the box of a compass, namely a Cardan joint, with a man inside; placed at the top of a hill, this will be lifted and carried away by the wind, the man always remaining upright.

The other illustration shows a glider the flight of which can be controlled by its pilot. The way it is drawn and described leaves little doubt that Leonardo had this device constructed and tested. A reconstruction of it would be more meaningful than that of any other of Leonardo's flying machines. And it would certainly work.

The stenographic drawing technique exemplified by the Weimar sheet is the same as the one described in a note on CA, f. 534 v/199 v–a, *c.* 1508 (Richter, § 490) about representing human figures in action: "...and pay attention to them in the streets and *piazze* and fields, and note them down with a brief indication of the forms; thus for a head make an O, and for an arm a straight or bent line, and the same for the legs and the body, and when you return home work out these notes in a complete form".

In Madrid MS. I, f. 82 r, *c.* 1497, Leonardo gives similar advice about the schematic representation of the essential elements of a machine: "All such instruments will generally be presented without their armatures or other structures that might hinder the view of those who will study them. These same armatures shall then be described with the aid of lines...".

And so Leonardo can go back to man. A note on the sheet of his Anatomical MS. B of *c.* 1508 (RL 12035 r; K/P 77 r) explains how his technological language can be applied to the study of the human figure:

> Remember never to change the outlines of any limb because of some muscle which you may have lifted off in order to expose another. And if indeed you remove muscles, the borders of one of which form the contour of one part of a limb from which you have detached it, then you must mark with frequent dots the boundary of that limb removed through the separation of any muscle whatever. And this you will do so that the shape of that limb which you are describing may not be left a monstrous thing through having its parts taken away. Besides this, one gets a greater knowledge of the whole because having lifted off the part you can see the true shape of the whole from which the part was removed.

For the first time, with this exhibition, the models of Leonardo's inventions are presented according to his principles of design.

I
LEONARDO ENGINEER

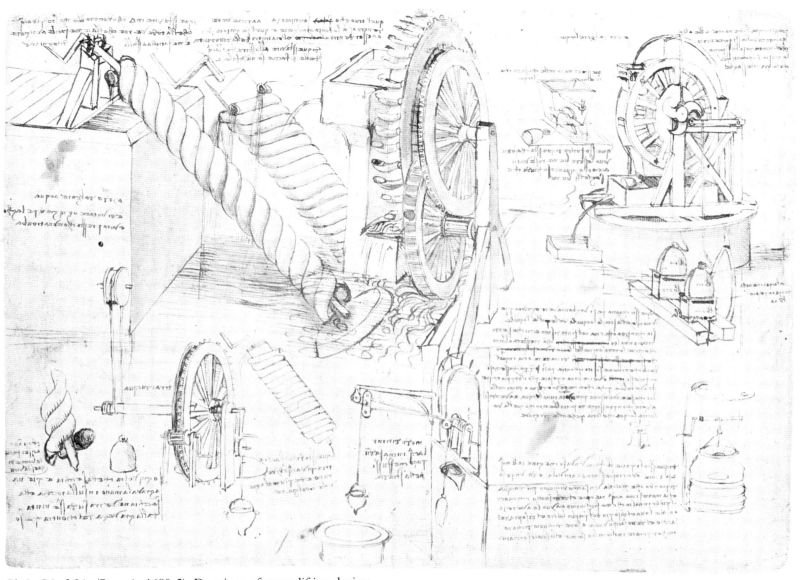

Pl. I. CA, f. 26 v/7 v-a (*c.* 1480-2). Drawings of water lifting devices.

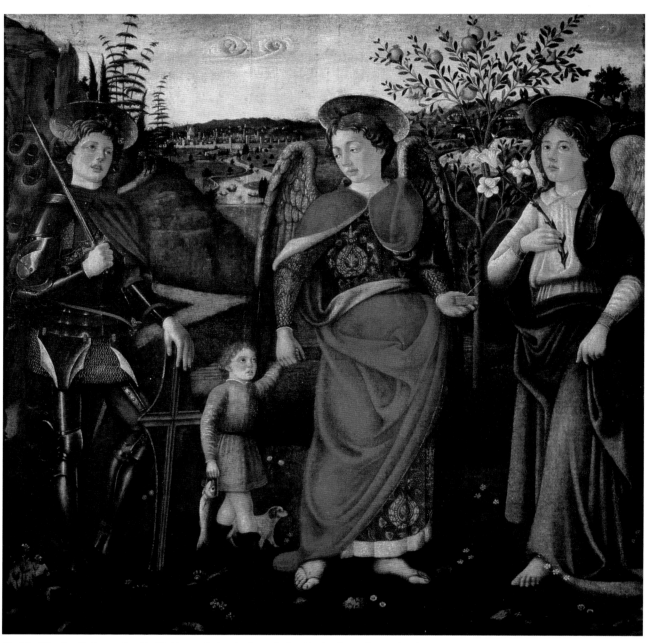

Pl. II. Biagio di Antonio (?). *Tobias and the Archangels* (*c.* 1470). Bartolini Salimbeni Collection, Florence. The painting shows a view of Florence at the time of Leonardo's arrival.

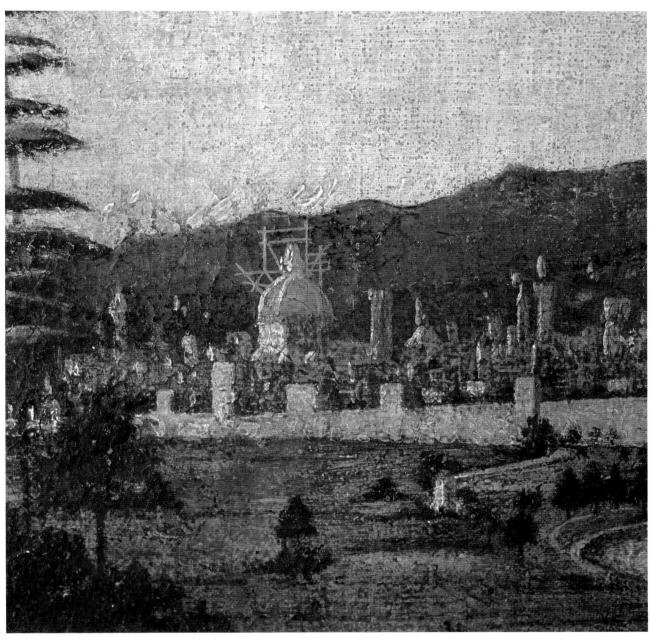

Pl. III. Detail of Pl. II showing the scaffolding around the lantern of Florence Cathedral. The work appears to have been completed except for the installation of the huge copper sphere on the top. This job was undertaken by Verrocchio's workshop where Leonardo served his apprenticeship.

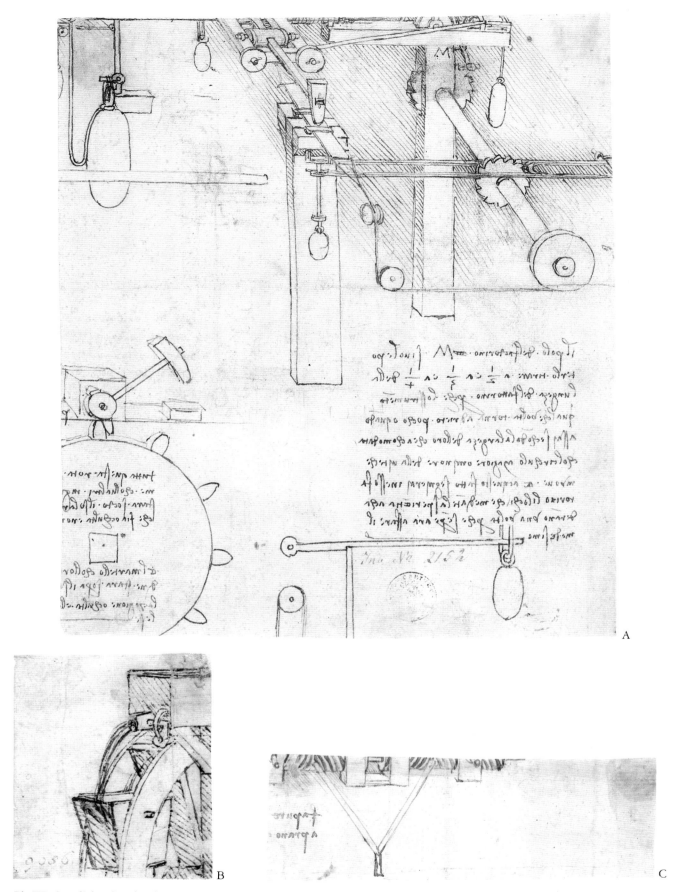

Pl. IV. Staatliche Graphische Sammlung, Munich, inv. nos 2152 r, 2152 A and 2152 B. Fragments of drawings and machines (A: 1490-5; B: 1480; C: 1482-5). The fragments present a "*battiloro*" (gold-beating) machine, a bucket-wheel and an inversed screw.

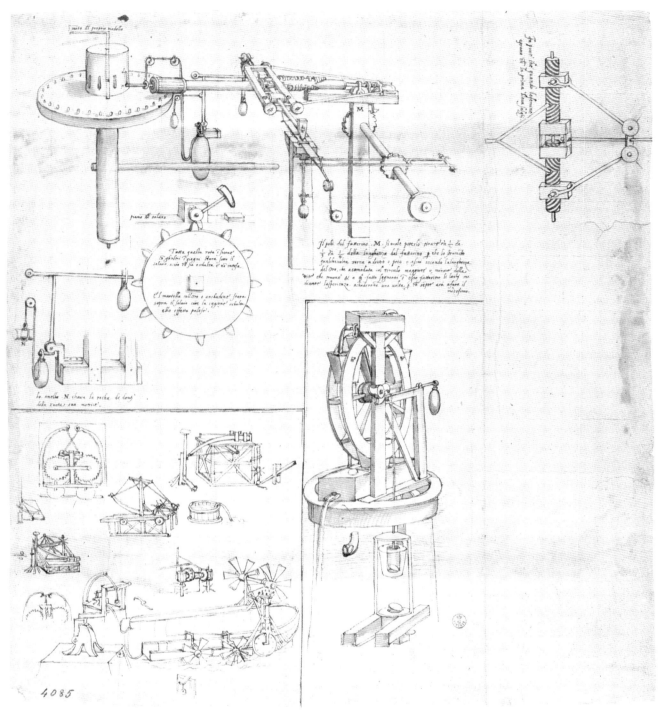

Pl. V. Anonymous Engineer. Copy of Leonardo's drawings (16th century). Gabinetto Disegni e Stampe, Uffizi, Florence, no. 4085 A. This copy includes certain fragments now in Munich (see Pl. IV). It provides evidence that Leonardo's technological studies were not unknown during the sixteenth century.

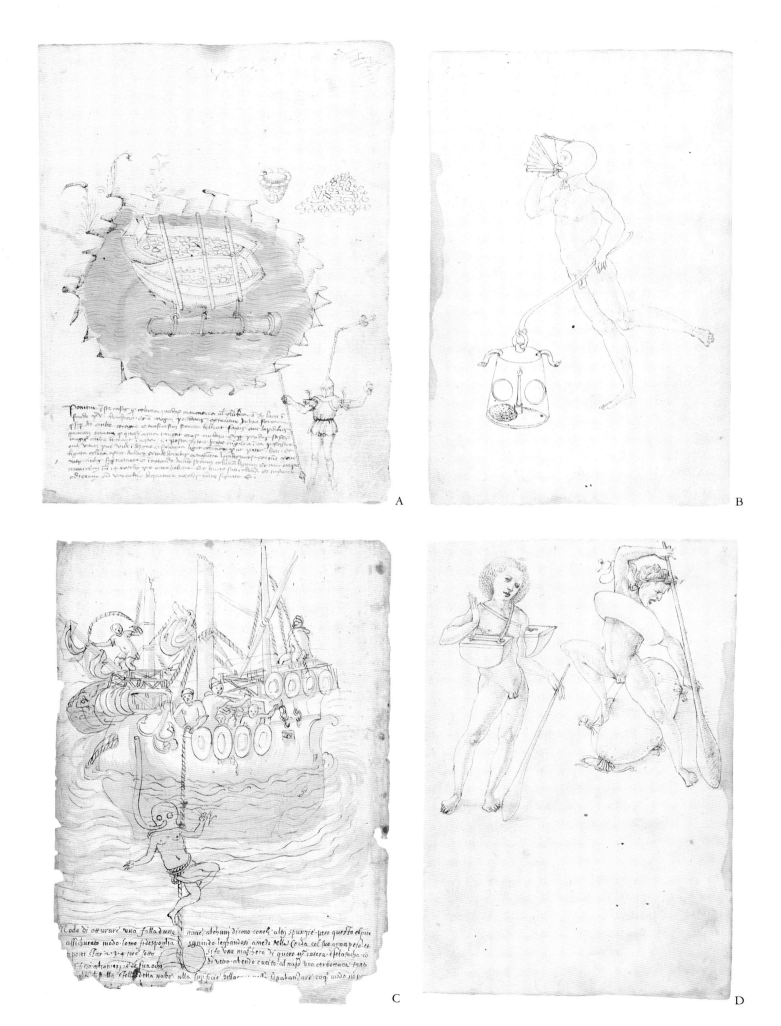

Pl. VI. A. Jacopo Mariano, called Taccola. MS. Palatino 766 (15th century). Biblioteca Nazionale, Florence, f. 18 r.
Man with underwater breathing mask. B. Anonymous Engineer. MS. Palatino 767 (15th century). Biblioteca Nazionale,
Florence, f. 9 v. Man with underwater breathing mask. C. Anonymous Engineer. MS. Palatino E.B.16.5 II
(16th century). Biblioteca Nazionale, Florence, f. 1 r. Man with underwater breathing mask. D. Anonymous Engineer.
MS. Palatino 767 (15th century). Biblioteca Nazionale, Florence, f. 10 r. Instruments to keep a man afloat.

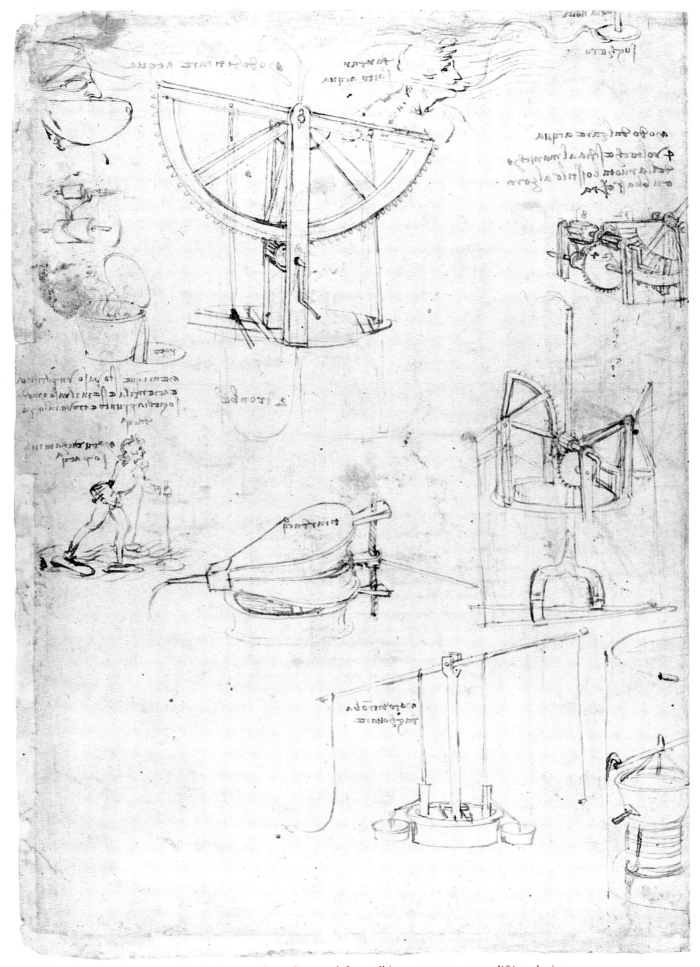

Pl. VII. CA, f. 26 r/7 r–a (*c.* 1480-2). Devices for a diver and for walking on water; water lifting devices.

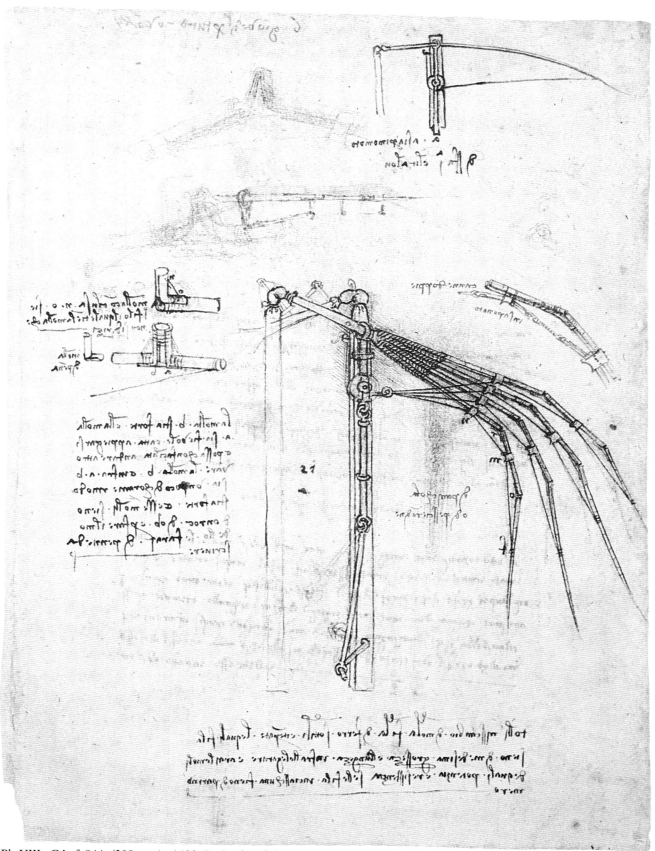

Pl. VIII. CA, f. 844 r/308 r-a (*c.* 1493-5). Study of the wing mechanism of a flying machine.

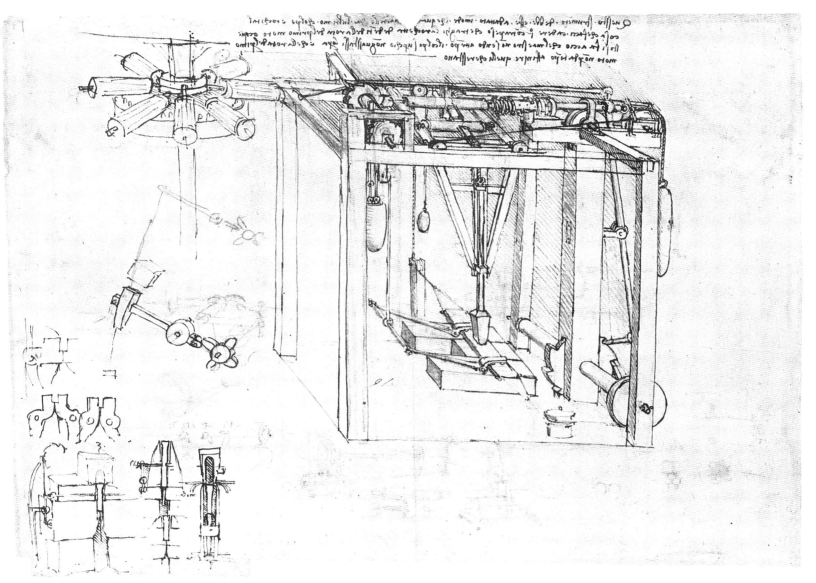

Pl. IX. CA, f. 29 r/8 r–a (c. 1493–5). Machine for the production of sequins.

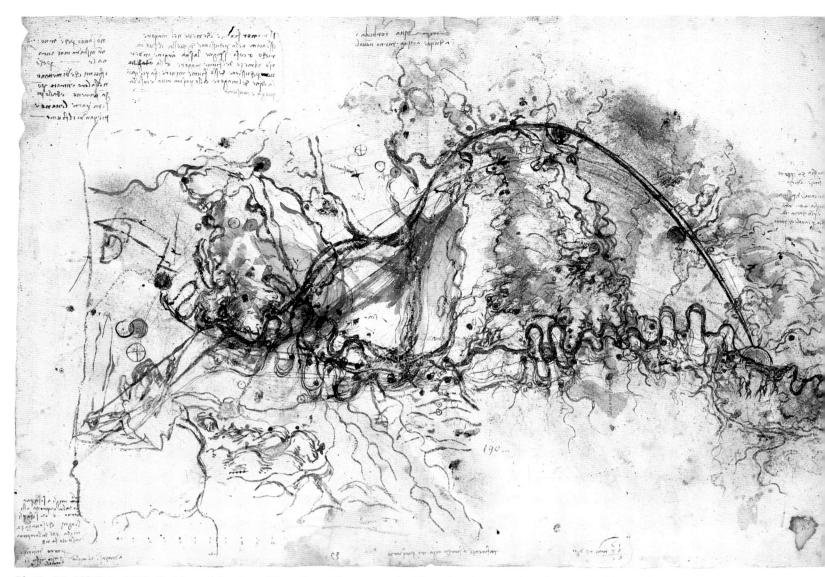

Pl. X. RL 12279 (*c.* 1503–4). Map of the Arno River from Florence to the West showing a project for a navigable canal.

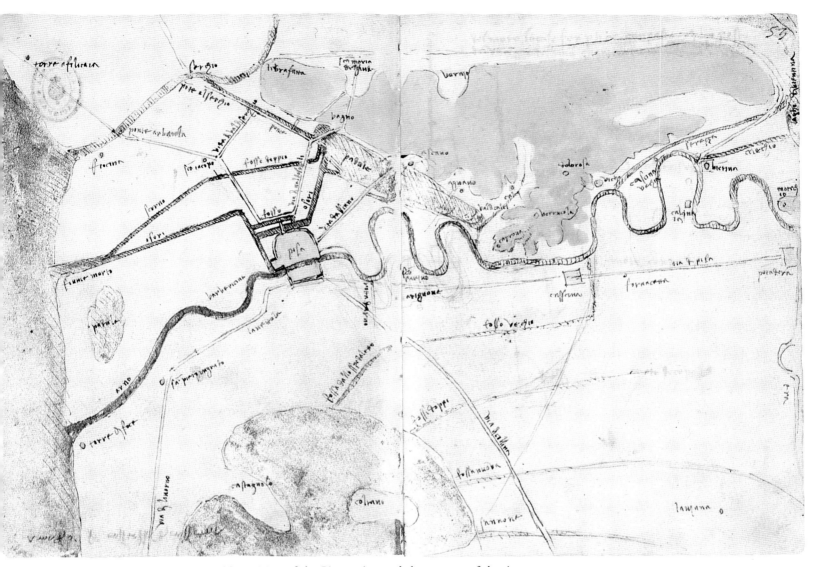

Pl. XI. Madrid MS. II, ff. 52 v–53 r (*c.* 1503–4). Map of the Pisa region and the estuary of the Arno.

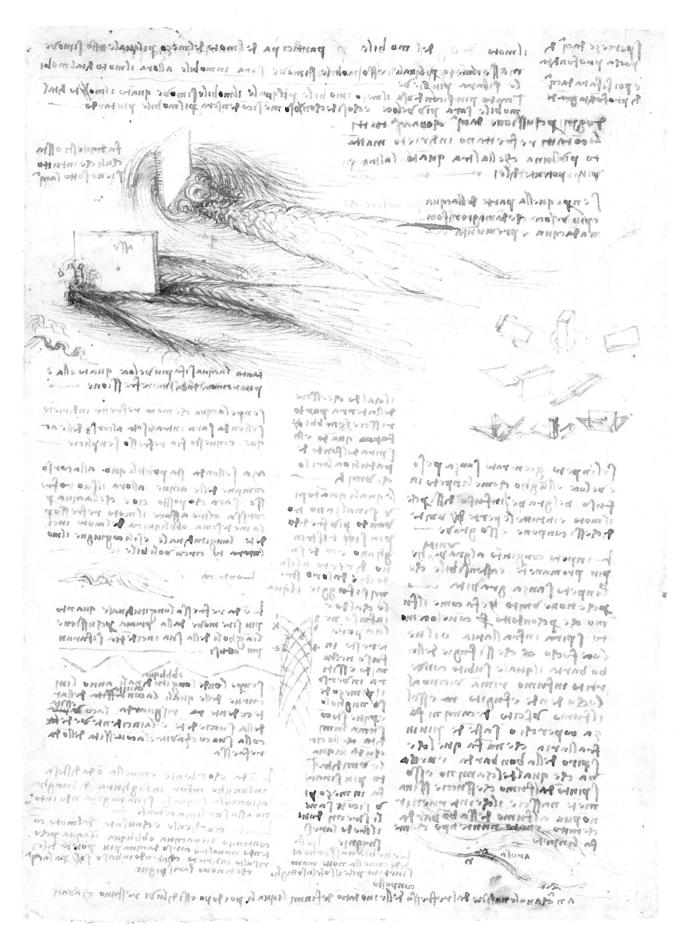

Pl. XII. RL 12660 r (*c.* 1507–9). Studies of water impeded by an obstacle.

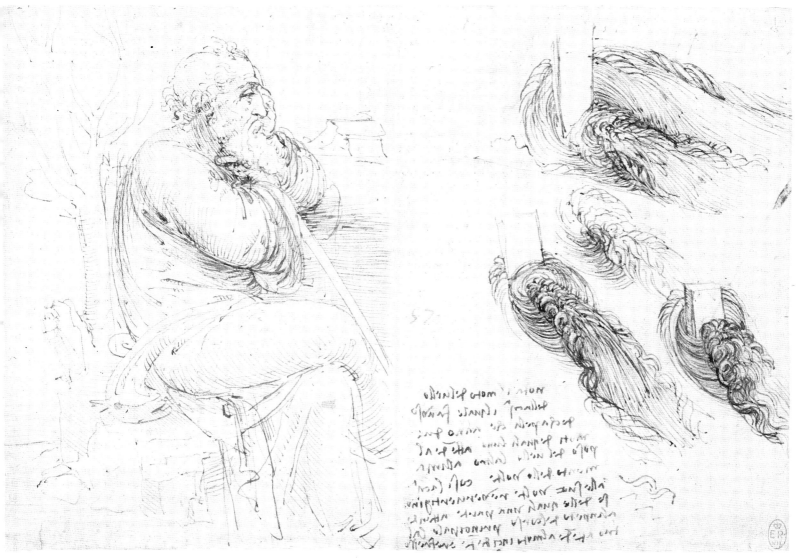

Pl. XIII. RL 12579 r (*c.* 1513). Water studies and an old man in profile.

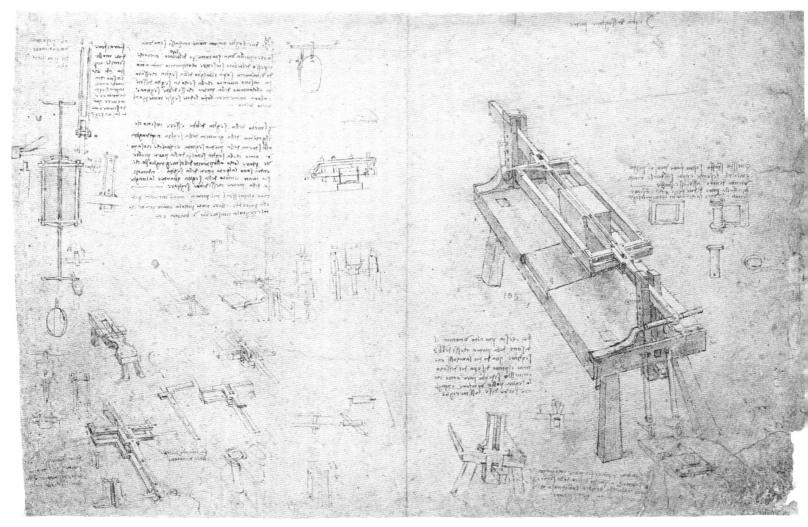

Pl. XIV. CA, f. 2/1 r-c (c. 1513). Late technological study: machine for cutting stones with a detail of its parts.

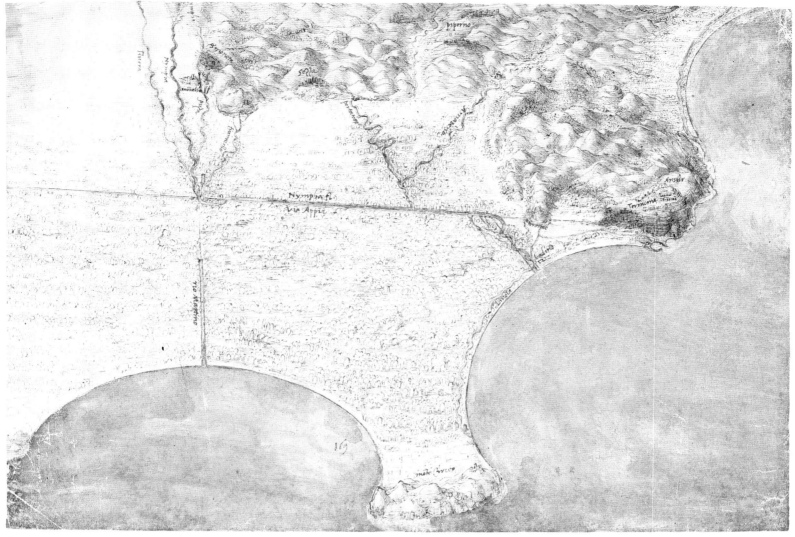

Pl. XV. RL 12684 (*c.* 1514–5). Bird's-eye view of the Tirreno coast from Terracina northwards. This study must be related to Leonardo's involvement in Giuliano dei Medici's project for draining the Pontine marshes.

I.1

The Career of a Technologist

by
Paolo Galluzzi

From myth to historical reconstruction

The enormous body of literature on Leonardo still betrays a striking hesitancy to present a precise definition of his personality: artist, architect, inventor, philosopher, scientist. For a long time, the vastness of Leonardo's interests led to the view of him as the very incarnation of genius, a genius who ignored the boundaries of the various disciplines and roamed freely through the immense realms of knowledge. Since the end of the last century, when Leonardo studies began to follow the hard and fast guidelines of historical and documentary rigour, it has not often happened that scholars have seriously focused their attention on Leonardo's activity as an engineer. They have preferred to linger over his extraordinary talents as a painter and architect, or to insist upon his impressive gifts as a scientist. And yet careful study of the highly revealing body of the Leonardo papers and manuscripts that have come down to us makes it difficult to escape the impression that, in fact, most of his energy was devoted to activities of a technological nature.

The story of Leonardo's eventful life, which still contains many uncertainties, clearly indicates that the money which Leonardo, who had no independent income, was able to earn (and which enabled him to have a fairly comfortable lifestyle) came largely from his work as an engineer in the service of various patrons. Indeed, the money he earned from his activity as a painter was merely an additional source of income to his practically constant earnings as an engineer.[1]*

Leonardo was an engineer in the sense that the expression had in his day: an inventor and builder of *ingegni* (complex machines as well as simple mechanical devices) of every sort and for every type of operation. The figure of the engineer, along with that of the *condottiere* or military leader, typifies Renaissance court life. It was within the context of the court that the engineer carried out his many duties, first and foremost of a military nature. He was expected to furnish technical solutions for making offensive weapons more effective and systems of defence more solid, to provide an army on

*The notes of chapter I.1 are on page 317.

the move with transportation on functional wheels or temporary bridges for crossing water courses that would be both sturdy and rapidly constructable. He was required moreover to modify the course of rivers in order to isolate an enemy under siege or, perhaps, to flood cities or fortifications. But Renaissance lords, particularly the great ones, had other needs besides military ones. They had agricultural and industrial interests and their profits could be greatly increased by the introduction of the mechanization of methods of irrigation or production. The Renaissance lord beautified cities not only with magnificent buildings which reflected the image of his own power, but also with large-scale public works, especially of a hydraulic nature (acqueducts, canalization projects, etc.) for the benefit of the general public. Finally, he maintained a sumptuous court, which often provided the setting for festivals and performances intended to create a sensation in keeping with his reputation. And it was not by chance that the organization of such performances — but also the invention of mechanical marvels for parks and gardens — offered the great engineers of the Renaissance extraordinary opportunities to display their talent.[2]

This is the vast horizon that characterized the activity of the Renaissance architect-engineer, at least at the beginning of the fifteenth century and, above all, on the Italian scene. The professional profile of this group of individuals was substantially homogeneous. From Taccola[3] to Brunelleschi,[4] from Francesco di Giorgio[5] to Leonardo, the tasks and functions of the court engineer were essentially the same. The backgrounds of these architect-engineers also have strikingly similar characteristics. They were all men of humble origin who had learned their profession in that great school of practical applications that was the Renaissance workshop. None of them had pursued a regular curriculum of studies, nor did any of them spend his entire career in the service of a single patron. They preferred the Italian language to Latin; they wrote little or not at all (Brunelleschi) and, with the partial exception of Francesco di Giorgio who attempted to write a comprehensive treatise,[6] their writings were of a fragmentary nature, essentially collections of drawings accompanied by brief captions in which they frequently made use of cryptographic systems to protect an invention from indiscreet eyes. In addition to their technical duties, especially on a military level and in the field of hydraulics, they were all practising architects, and some of them were successful painters and sculptors (Francesco di Giorgio). Their scientific background was as limited as their readings were modest. They all toiled to decipher Vitruvius, turning to various humanists for assistance.[7] They were familiar with a few principles of mediaeval statics[8] (but stripped of the quantitative analysis that characterizes those texts), practical arithmetic and, in the best cases, some rudiments of Euclid. The basic nucleus of their expertise was the fruit of jealously guarded methods learned either by experience or in the workshops of the masters to whom they had been apprenticed. These engineer-architects were greatly in demand, and not only by the Italian lords. Taccola served King Sigismund; Brunelleschi received important commissions from the Florentine authorities; Francesco di Giorgio offered his services to many Italian lords, finding his chief patron in Federico da Montefeltro of Urbino. Well paid, respected, admitted directly into the presence of princes, during the Quattrocento the most qualified of these engineers enjoyed a fine reputation. At a time of great change, of continual wars which saw the emergence of an entirely new military technology (firearms), of technically daring, immense buildings (Florence Cathedral), of rapid development in commerce and production (particularly in the fields of metallurgy and textiles), the services of these men were of fundamental importance.[9]

During those decades of great change and expansion, faith in the extraordinary possibilities of increasing wealth and well-being and of improving the quality of life through the use of new

technologies grew continually until it became a veritable utopia to which not even the engineers who were to make it a reality were immune. Hence it is not surprising that in this atmosphere their role in society became increasingly important.

Until a few decades ago, no one would have been willing to approach the problem of Leonardo as an engineer in terms of a career that developed within a professional tradition which others before him had inaugurated, a tradition based on specific knowledge and procedures. Today, fortunately, the traditional tendency to isolate Leonardo from the context in which he operated is dying out, and scholars are redoubling their efforts to place him within the framework of his time. Thus it is becoming evident that Leonardo's activity as an engineer followed the pattern and code of behaviour of a profession which was already firmly established. It is also obvious that one cannot properly or profitably talk about Leonardo as an engineer without taking into account the activity of the illustrious colleagues he imitated and whose abilities he sincerely admired. This does not mean that Leonardo's contributions in this field should be re-assessed, nor that he should be seen as simply having repeated techniques that had been conceived and put into practice by those who had preceded him. To take into consideration the network of relationships, of exchanges of professional experiences and knowledge that linked Leonardo to engineers of his own time and of earlier generations, does not make his activity in this field any less fascinating or original. Indeed, some recent scholarship, reacting against the long tradition of exaggerated celebration of Leonardo as a solitary genius, has tended to relegate his activity as an engineer to a sometimes clumsy imitation of his less famous colleagues. This is clearly an unacceptable conclusion.[10]. This complete reversal of historical perspective — from Leonardo seen in total isolation to his dissolution in his historical context — is probably an inevitable reaction. Like its exact opposite, this new historical perspective precludes the possibility of correctly assessing the significance of Leonardo's activity in this field.

<p style="text-align:center">*</p>

To arrive at a balanced evaluation of the significance of Leonardo's technological studies it is first necessary to deal with a fundamental and arduous critical problem. In essence, it is a question of finding the proper way of orienting oneself within the enormous, chaotic bulk of Leonardo's surviving papers. The slightly less than six thousand pages in Leonardo's hand that have come down to us correspond to about one third of the papers that Leonardo left as a legacy to his faithful pupil Francesco Melzi at the moment of his death at Amboise in 1519.[11] In spite of this heavy mutilation, these papers constitute the most extensive, detailed, and revealing documentation that we possess of the technology of the Renaissance. Without them, our knowledge would be drastically impoverished, not only with regard to technology during the fifteenth and sixteenth centuries in Italy (Florence, Milan, central Italy, and Rome, the centres where technology had advanced the most), but also with regard to other European countries, especially France and the already technologically advanced German-speaking nations.

Leonardo's manuscripts, in fact, do not contain precious information solely on his activities and his experiments. His manuscripts also present a confused but extremely rich picture of the entire panorama of the technology of his time. How then, in this tangle of notes and drawings, can we distinguish Leonardo's personal contributions from the ideas of others which had particularly struck him?

In rejecting the excesses of the celebratory type of scholarship that saw Leonardo as the sensational anticipator of every important modern device or machine (from the automobile to the airplane, from the steam engine to the submarine), several scholars called attention, in the last decades, to the fact that there are illustrations of several of Leonardo's sensational "inventions" in manuscripts and iconographical sources that unquestionably date from before him (see Pls VI-VII); thus the gradual reassessment of the long list of Leonardo's discoveries began. At the same time, criteria were devised for reading Leonardo's technological notes and drawings in a less "condescending" way than the one given since the early 1900s by those who began the popular practice of making working models based on Leonardo's drawings of machines and mechanisms. Using as their point of departure largely incomplete sketches of doubtful interpretation (the automobile and airplane are the most telling examples of this), these scholars did not hesitate to produce working models by integrating into Leonardo's drawings basic construction details which were not indicated by him.[12]

Fortunately, today a different attitude is gaining ground. Leonardo's drawings, and the captions where they occur, are accepted in the degree of completeness they actually possess. Thus the temptation to correct or complete them with the justification that this or that decisive detail had been intentionally omitted by Leonardo to protect his discovery is resisted. This more recent attitude toward Leonardo's technical studies has led to the discovery that a significant number of his designs (the case of his many studies for a flying machine is particularly illuminating) are not technically plausible, or are sometimes impossible. Thus a whole section of Leonardo's technological research is coming to be seen not so much as actual projects for devices that were to be immediately constructed, but rather as a sort of technological "dream", the product of a highly fertile imagination. Leonardo's manuscripts — but also those of other Renaissance engineers — are full of technological "dreams" of this kind, often described in minute detail. And yet it is difficult to imagine that Leonardo could have deluded himself that such devices were feasible. Leonardo's technological "dreams" are of a greater interest. They attest, in a man who was particularly versed in engineering, to a faith in the development — through technology — of unheard-of powers in man (to fly like a bird; to live underwater like a fish). Leonardo thus gave voice to the enthusiasm and quest for innovation of an entire age marked by sensational discoveries (suffice it to mention the invention of the printing press) and by the continual expansion of geographical horizons. It is not by chance that Leonardo's technological "dreams" often have a prophetic tone or are accompanied by reflections on human nature, as in some of his studies of flight or in the famous note in which he states that he wishes to keep secret his invention of a way to breathe underwater to prevent it from being used as an instrument of death.[13] Leonardo grasped that technology, along with its obvious potential benefits, could also bring considerable risks to humanity, thus anticipating the dramatic debate on the relationship between the advancement of technology and the degeneration of human nature which has raged throughout the history of modern culture and is more lively than ever today.

It should also be stressed that a considerable part of Leonardo's technological studies records the intense activity of an engineer who for the entire span of his long life was in the service of powerful patrons from whom he constantly received requests and specific commissions in exchange for a special fee or a regular salary. Leonardo designed, on his own initiative, technical solutions which he knew would be useful to his influential patrons, hoping to receive special rewards from their realization. This category includes practically the entire series of Leonardo's studies of military technology, the most noteworthy group of his investigations in the field of applied hydraulics, several large artistic

projects involving complicated technical problems (such as the equestrian monuments for Francesco Sforza and Gian Giacomo Trivulzio,[14] with their extremely delicate casting problems), his spectacular designs for festivals and theatrical performances at court,[15] not to mention his numerous studies of particular technical problems that were often quite down-to-earth (such as the mechanism for providing hot water for the bath of the Duchess Isabella of Aragon[16]), which he was requested to solve by his powerful patrons. Also belonging to this group are many of Leonardo's technical studies aimed at the most efficient use of energy sources and the mechanization of certain systems of production which it is difficult to imagine Leonardo undertaking without being requested to do so by an interested patron.

This same group includes the largest part of Leonardo's technological studies, which are consistently characterized by an empirical approach similar in style and method to that of the engineers of his time. These specific studies never reveal an attempt to derive the technical solution adopted from general laws and principles. In order to single out the many studies that belong to this category, it is necessary to take into account the information provided by the reconstruction of Leonardo's intellectual and material life. The identity and requirements of his various patrons help us in tracing the origin of a growing number of Leonardo's projects. In fact, many aspects of his technological activity appear to be not so much the fruit of an autonomous, highly fertile inventive capacity, as the direct consequence of his presence at a certain time in a certain place, in the service of this or that lord.

Another considerable group of Leonardo's technological studies is of a different nature. These studies, which cannot be directly related to specific commissions from patrons, are a record of the evolution of an autonomous process of professional "retraining" for which, at a certain point, Leonardo felt the need. These are more comprehensive, less fragmentary studies and reflect Leonardo's attempt, increasingly intense after 1490, to establish a connection between general principles and specific applications, thus rooting technology in science. For Leonardo, studies such as these not only enriched and perfected the possibilities of technological projects, but also tended to confer a new significance upon the profession of the artist-engineer. To repeat the expression used by Leonardo himself, they tended to transform him into a perfect imitator of Nature. For Leonardo, in the field of technology as in painting, the imitation of Nature presupposed the full capacity to grasp the ironclad laws that govern every natural process; hence for him to invent meant nothing other than knowing how to reproduce. Leonardo's studies of this kind display a progressive attempt to compile a new encyclopaedia of knowledge. The confused fragments that remain are sufficient to illustrate the effort made by Leonardo as well as the boundless dimensions of his ambitions. It was an arduous undertaking for someone like Leonardo, who had never had a regular education and never fully overcame his uncertainties in Latin and geometry. He attempted to unravel the secrets of movement. His attention lingered, fascinated, over the element of water, "*vetturale di natura*" (Nature's carrier). He carefully observed the flight of birds, realizing the necessity of broadening his research to include the element of air and the nature of the winds. He devoted himself to extensive research in mechanics, recognizing movement, weight, force, and percussion as the four "powers" of Nature. He immersed himself in the study of physical geography and anatomy. Along with Leonardo's interest in problems of a general nature, and in the constant laws governing various phenomena, we continually find in these studies his concern with a new, ambitious approach to useful applications ("*giovamenti*"). As the historian of science, Alexandre Koyré, put it, in these studies Leonardo seems to be transformed from a "technician" into a "technologist".[17]

The schematic division of Leonardo's technological studies into the three categories outlined above (technological "dreams", specific commissions, and attempts at deriving applications from general laws) omits a certain number — not precisely definable, but certainly quite consistent — of technical projects belonging to a fourth distinct group. These studies include drawings and notes on machines and mechanical devices derived from the experiences of others. Included in this group are "quotations" from contemporary and earlier authors (including the "classics"), the recording of technical solutions which Leonardo had witnessed in the course of his many travels, and memoranda regarding operational methods or devices of which he had learned from technicians of his acquaintance or who worked under him. The "quotations" can be identified (although not always, nor easily), and today we possess a long list of texts which Leonardo used as precious sources (Vitruvius, Valturius, Francesco di Giorgio, and so on).[18] The identification of the studies which record solutions or devices that had particularly struck Leonardo or which had inspired him — as was often the case — to improve them, is considerably more difficult. In a few cases identification is made possible by a note written by Leonardo himself, but in general one can only make cautious conjectures in the hope that further studies on the culture and technical practices of his time and of the places in which he lived will provide us with more precise guidelines.

<p style="text-align:center">★</p>

The objective of introducing criteria of distinction into the mass of Leonardo's studies requires not only an intense, systematic effort of contextualization, i.e. of precise references to his sources, his assignments and his environment. It also presupposes an attempt to establish, at least roughly, a chronological sequence for his drawings and notes on technology. This requirement, indispensable in all areas of Leonardo studies, is of unique importance for understanding Leonardo the engineer and scientist.

In the bulk of Leonardo's surviving writings, in fact, the documentary nucleus of greatest size and importance is constituted by the monumental Codex Atlanticus. Inaccurately called a "codex", suggesting a coherence of which it is totally devoid, the Atlanticus consists of a collection of more than a thousand pages of various sizes in which contents of a technological and scientific nature clearly predominate. This "album" was put together at the end of the sixteenth century by the sculptor Pompeo Leoni,[19] who took apart the many Leonardo notebooks in his possession with the intent of distinguishing the documents of a technical-scientific nature from those that represented studies of an artistic nature (including anatomical studies). The latter were included by Leoni in a second compilation, corresponding to the present-day corpus of Leonardo's drawings at Windsor Castle.[20] The Codex Atlanticus groups together sheets dating from the entire span of Leonardo's career. These sheets come from original notebooks which are impossible to reconstruct and are arranged with no apparent thematic or chronological criterion. Leoni's attempt to organize Leonardo's papers was truly a disaster, to a great degree an irreversible one, and it has made the historian's task of critical reconstruction extremely arduous.

In spite of these difficulties, the necessity of attempting a reconstruction, if not of Leonardo's original dismembered notebooks then at least of the chronological sequence of the sheets contained in the Codex Atlanticus, has gradually come to assume a growing intensity in modern Leonardo studies. A landmark in this effort was Gerolamo Calvi's masterly volume,[21] published more than sixty years

ago. Calvi, who had already published a model edition of the Codex Leicester (today Codex Hammer),[22] not only pointed out the need for a precise chronological ordering of Leonardo's works, but himself offered several masterly examples of this, establishing the chronological boundaries of the then known Leonardo manuscripts in terms which are still substantially accepted today. Naturally Calvi devoted special attention to the Codex Atlanticus. In fact, he provided an extremely useful series of indications which made it possible to assign fairly precise dates to a significant number of Leonardo's papers in the collection of the Ambrosiana Library. Calvi's work, which is still an unsurpassed model of Leonardo studies, was fortunately followed and imitated by other scholars, whose investigations of individual sheets or groups of sheets from the Codex Atlanticus have provided valuable chronological indications. In the last few decades, great progress has been made, due particularly to the comprehensive work initiated by Carlo Pedretti,[23] who also availed himself of the opportunity to conduct an orderly and systematic investigation of the Codex Atlanticus and the Windsor drawings.[24]

After his promising early work of thirty years ago,[25] in 1979 Pedretti published a complete catalogue of the Codex Atlanticus.[26] In this catalogue, sheet by sheet, he provides — on the basis of paleographic considerations, style of drawing and handwriting, as well as relationships with other datable sheets or known episodes in Leonardo's life — justifiable indications for the chronological situating of documents, to which he not infrequently assigns a specific date. Although presented by Pedretti himself as an attempt which further studies can only perfect and enrich, this catalogue provides historians of Leonardo's science and technology with important information from the vast documentation of the Codex Atlanticus, incorporating and relating it with the facts recorded in the Leonardo notebooks that have survived intact, which are often less chaotic and always easier to date.

Thus the goal of following Leonardo's evolution as an engineer and scientist is no longer an unrealizable dream.

Half a century of activity

The following pages are intended to give a general view of Leonardo's career as an engineer on the basis of biographical, documentary, and chronological evidence. We will attempt to reconstruct the commissions that Leonardo received from various institutions and patrons and to specify, date, and characterize the emergence of new interests and working methods, emphasizing the care with which he sought to absorb the experiences of colleagues who had come before him or who were still active during his time. By relating many of Leonardo's technological studies to specific stimuli and occasions, or to the emergence at certain times of an independent need on his part to further his own knowledge, we shall reduce the impression of fragmentariness left by those studies. Leonardo himself will no longer appear as the haughty, aloof genius he has traditionally been presented to be, but rather as a man who was subject to the same needs, expectations, and problems that characterized many other engineers of his day.

The Early Years in Florence (1469-1482)

Leonardo's professional debut as an artist and engineer dates, as is well known, from the time he moved to Florence, almost certainly at the end of the 1460s. Of the few facts we know concerning his early career, one of the most salient — even though it has been unjustifiably questioned — is his apprenticeship in Verrocchio's workshop which, along with that of Pollaiuolo, was the most productive and important in Florence during those decades.[27] The artist's workshop of the Renaissance was characterized by a vast multiplicity of activities. This was particularly true of the workshop of Verrocchio, who was remarkably versatile himself. The Renaissance workshop dealt with architecture, sculpture (including the technical aspects of casting), and painting, not to mention actual works of engineering. There are no specific documents relating to Leonardo's studies and technical activities during the years of his apprenticeship. There remains the testimony of Vasari, who speaks of the emergence, during the years of Leonardo's apprenticeship, of a strong interest in technological questions:

> And he practiced not one branch of art only, but all those in which drawing plays a part; and having an intellect so divine and marvelous... he not only worked in sculpture... but in architecture also... and he was the first, although but young, who suggested reducing the River Arno to a navigable canal from Pisa to Florence. He made designs of flour mills, fulling mills, and engines which might be driven by the force of water: and he wished his profession should be painting.[28]

Vasari's account should be treated with caution, since he might have been thinking of Leonardo's later career and have emphasized in the young Leonardo interests that would be largely present in his mature years. And yet precise elements suggest that Vasari's account is substantially accurate. The Leonardo manuscripts that have survived in their entirety all date from his Milanese years or later, so that they cannot shed light on his earliest activities as an engineer. The only trace of Leonardo's activity in this field during the years of his apprenticeship is recorded in several loose sheets and especially in numerous drawings and notes in the Codex Atlanticus. As early as 1925, Calvi had suggested the possibility of singling out a relevant group of sheets in the Ambrosiana that could be dated to Leonardo's first Florentine period.[29] Subsequently, other important studies enlarged the list of sheets from the Codex Atlanticus which contain notes and drawings from this period.

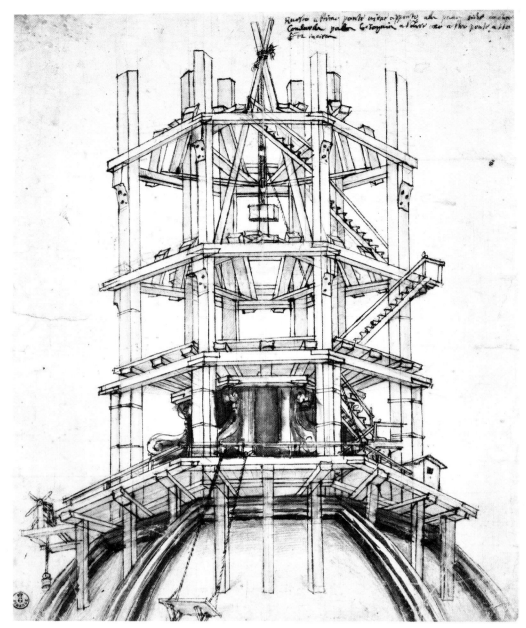

Fig. 26. Gherardo Mechini (*c.* 1601), Uffizi Gallery, Florence, Gabinetto dei Disegni e delle Stampe, no. 248 A. Drawing of the scaffolding for repairs to the lantern damaged by lightning.

The boldest, most imposing architectural project realized during the fifteenth century in Florence was unquestionably the construction of Brunelleschi's cupola on Florence Cathedral. The undertaking involved great innovations, for the most part conceived and put into practice by Brunelleschi himself. These innovations included not only the masonry courses, which were built without the usual centering, but also the use of several devices that made possible the continual up-and-down movement of workers and materials — materials which were often enormously heavy and had to be lifted to great heights (the upper eye of the cupola is about ninety metres from the ground). Begun in 1420, the work, including the placement of the lantern, was completed by 1461, that is, a few years before Leonardo arrived in Florence.[30] The only operation still to be carried out was placing the large, extremely heavy sphere of gilded copper atop the lantern. We can surmise that when Leonardo entered Verrocchio's workshop at the end of the 1460s, the construction site, a large portion of the machinery, and the scaffolding were still in place (Fig. 26 and Pl. III). And in fact it was to Verrocchio's workshop

49

Fig. 27. CA, f. 847 r/309 r–b (detail).

that the preparation of the gilded sphere was entrusted, along with the task of fixing it securely on top of the building, about one hundred metres from the ground.[31] This difficult work was carried out between 1468 and 1472. Proof of any direct participation by Leonardo in this project is lacking, but we have an autobiographical note from a much later time (after 1510) in Paris MS. G: "Keep in mind how the ball of Santa Maria del Fiore was soldered together".[32]

At any rate, it is certain that this achievement of the workshop where he was apprenticed gave Leonardo the opportunity to come into direct contact with the most advanced building technology of the entire Renaissance. Many sheets of the Codex Atlanticus record evident traces of the great impression that Brunelleschi's worksite made on the young Leonardo.[33] He was attracted by the extraordinary ingeniousness of the hoisting machines, of many of which he made careful drawings, as did many of his contemporaries (Francesco di Giorgio,[34] Buonaccorso Ghiberti,[35] Giuliano da Sangallo[36]). On folio 847 r/309 r–b of the Codex Atlanticus, for example, Leonardo drew rapid but

Fig. 28. CA, f. 1083 v/391 v–b.

Figs 29 A and B. Buonaccorso Ghiberti, *Zibaldone*, ff. 102 r and 103 v.

very effective sketches of one of Brunelleschi's hoists and two of his cranes (Fig. 27); next to one of the cranes, which is moving a large weight, is the following annotation in the flourishing handwriting characteristic of the young Leonardo: *"viticcio di Lanterna"* ("tendril" of the lantern) to indicate the use of a crane to position the tendril-shaped stones of the buttresses of the lantern. On folio 1083 v/ 391 v-b of the Codex Atlanticus (Fig. 28), Leonardo drew a more precise sketch of another hoist, a comparison of which with similar drawings by Buonaccorso Ghiberti[37] (Fig. 29) and Giuliano da Sangallo[38] (Fig. 30) suggests the large central *"colla"* (hoist) designed by Brunelleschi. This hoist, securely anchored to the ground beneath the cupola and equipped with three speeds (i.e. three different powers) served to lift the heaviest materials and was operated by animal power. In this drawing, which has no accompanying note, Leonardo introduced a technique that would later become habitual for him: he combined a general view of the machinery with a series of drawings of the most important construction details. Here he concentrated on the rotating cogs of the wheel (Brunelleschi's *palei* or pivoted gear teeth) and on the screw mechanism which changed the operation from lifting to lowering by inverting the direction of the rotation of the beams. This ingenious solution avoided the considerable nuisance of having to unhitch the animals and hitch them again in the opposite direction.

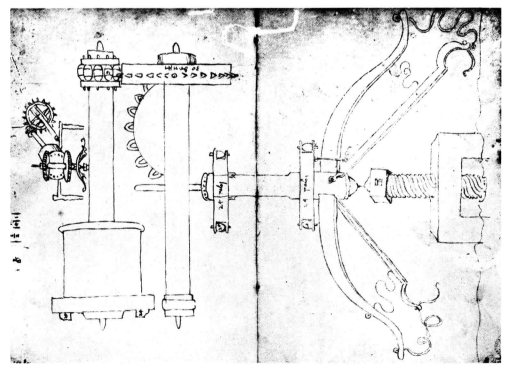

Fig. 30. Giuliano da Sangallo, *Taccuino Senese*, ff. 47 v-48 r.

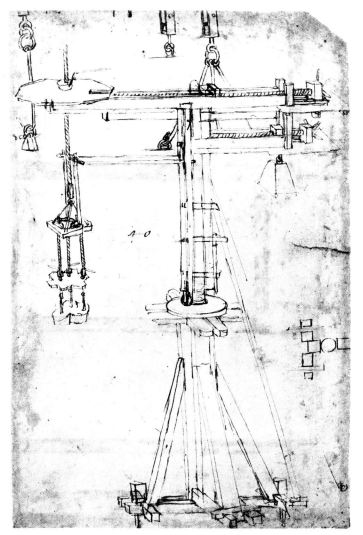

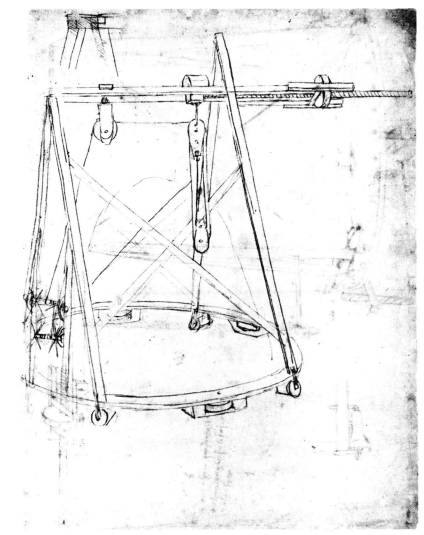

Fig. 31. CA, f. 965 r/349 r-a.

Fig. 32. CA, f. 808 r/295 r-b.

Finally, Leonardo emphasized the positioning of the ratchet wheel, a safety device designed to prevent the overturning of the load in the event of the cogs breaking or of an animal collapsing during the operation of the hoist.

Leonardo's attention was caught by another Brunelleschi machine, the revolving crane placed on the sturdy scaffold erected in the centre of the cupola to carefully position the materials lifted to a certain height by the central hoist; he drew it (CA, f. 965 r/349 r-a: Fig. 31) using the same technique of combining an effective general view with a study of several construction details. He also did careful drawings (CA, ff. 808 r and v/295 r-b and v-b: Fig. 32) of the revolving annular platform crane that can be progressively raised by turning four screws, a device designed by Brunelleschi and used in the construction of the lantern of Florence Cathedral. Other Leonardo drawings (CA, f. 105 Bv/37 v-b: Fig. 33; and f. 138 r/49 v-a: Fig. 34) that can be dated around the same time on the basis of style and handwriting, record his recollection of other machines from Brunelleschi's worksite (the light hoist, the carriage-mounted crane, and a screw-operated hoist). They indicate the attention with which he studied the form and operation of single and multiple turnbuckles and lewises (CA, f. 1078 Bv/389 v-b and 926 v/339 v-a), ingenious construction accessories widely used by Brunelleschi. This group of drawings, which Gustina Scaglia[39] and Ladislao Reti[40] identified, does not appear to be a matter of Leonardo simply copying the drawings of the same devices from the notebooks of contemporary

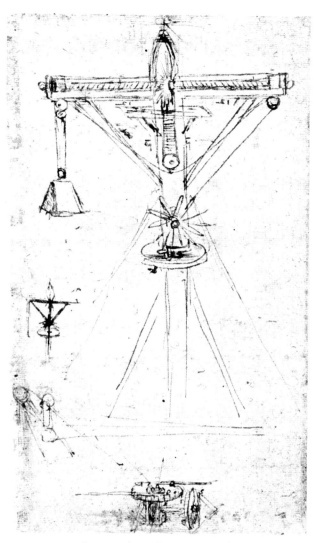

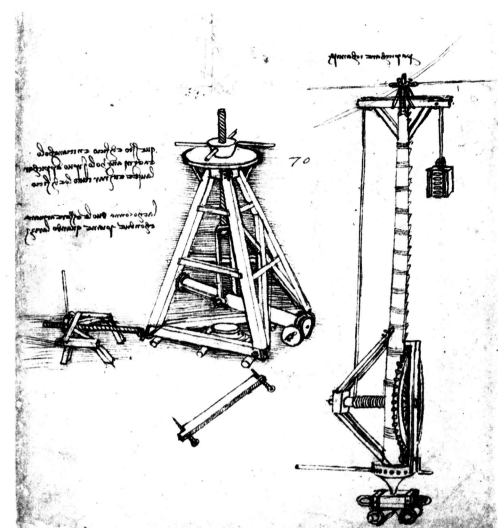

Fig. 33. CA, f. 105 Bv/37 v-b. Brunelleschi's elevator and light hoist (bottom).

Fig. 34. CA, f. 138 r/49 v-a. Carriage-mounted crane.

engineers, such as the *Zibaldone* of Buonaccorso Ghiberti (Fig. 35) or Giuliano da Sangallo's *Taccuino Senese*. Richer in details and made from different points of view, Leonardo's drawings appear to derive from a direct experience of the actual machines. As we have said, it is highly likely that Brunelleschi's technological monuments were still in operation or, in view of their extremely high cost, had been kept for future use in the warehouses of the Opera del Duomo, to which it would not have been difficult to gain access for a member of the workshop commissioned to carry out the final work on the cathedral.

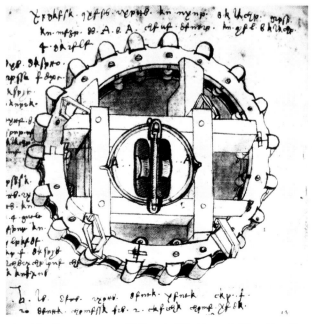

Fig. 35. Buonaccorso Ghiberti, *Zibaldone*, f. 98 v (detail). The horizontal wheel of the light hoist.

Reti did not attempt to date this group of studies, although he did place them during Leonardo's first Florentine period. Pedretti, on the basis of the ductus of the handwriting and the style of the drawings, dates them 1478-80.[41] I believe that their dating could even be moved back a few years to the time (1468-72) that the gilded copper ball for the top of the lantern was being prepared in Verrocchio's workshop.

The proposed earlier dating of this particular group of drawings emphasizes the extraordinary importance of Brunelleschi for the early years of Leonardo the engineer. Brunelleschi must surely have been a model for the inexperienced young Leonardo. And indeed, other documents from these years unequivocally indicate Leonardo's interest in Brunelleschi and the pains he took to familiarize himself with his works.

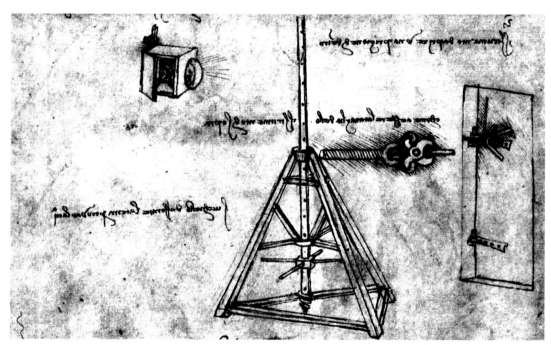

Fig. 36. CA, f. 34 r/9 v–b (detail).

On a sheet of the Codex Atlanticus that can be dated 1480 (f. 34 r/9 v–b: Fig. 36), Leonardo illustrated a screw device for "opening a prison from inside". Another sheet from about the same time shows an instrument for removing the heavy bars of a window. This is a screw jack, which is almost identical, except for its transversal arrangement, to the "Brunelleschian" screw hoist of which Leonardo made a drawing during the same years on folio 138 r/49 v–a of the Codex Atlanticus. These are specific examples of Leonardo's immersion in Brunelleschi's technology and of his early attempts to use it in different fields and for new solutions. He was particularly attracted by the device of the screw, with its extraordinary manoeuvrability and enormous power. For Leonardo, the graceful movement of the coils of this device seemed to reproduce the living forces of Nature itself, the force of whirlwinds and winds, of the water vortexes which Alberti had compared to a "liquid drill".[42] As in Brunelleschi's machines, the screw seemed to Leonardo to promise an endless multiplication of power.

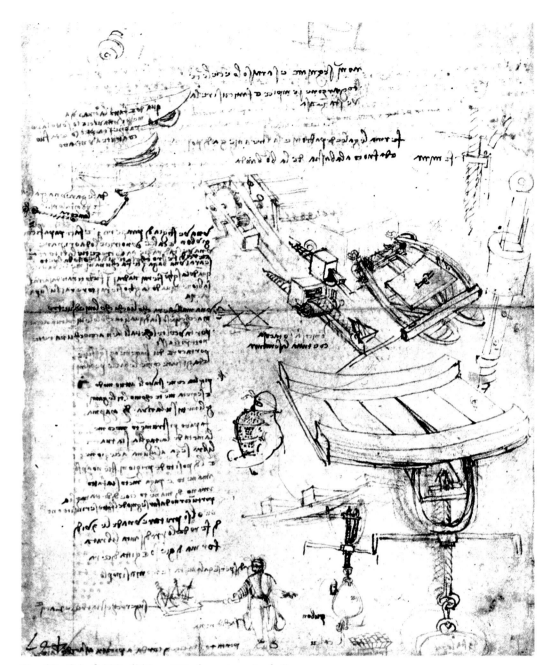

Fig. 37. CA, f. 909 v/333 v. "Underwater attacks".

And its uses were universal. On a famous sheet of the Codex Atlanticus (f. 909 v/333 v: Fig. 37), traditionally linked to Leonardo's visit to Venice in 1500 but actually belonging to the early years of his first Milanese period, there are drawings and notes on "underwater attacks" and devices for breathing underwater. Leonardo refers here to an invention from which he expected to derive considerable financial gain. The text and drawings are deliberately obscure (Leonardo is protecting his secret) and it is not easy to understand whether he is thinking of frogmen or of a submarine vessel that would allow men to go unseen beneath the keel of enemy ships and sink them with a drill-like instrument of which there are several sketches on the sheet. Leonardo writes: "You need to take an impression of one of the three iron screws of the Opera of Santa Liberata". Santa Liberata is, of course, Santa Maria del Fiore (Florence Cathedral), and the reference, as confirmed by the drawing, is to Brunelleschi's turnbuckles (intended primarily to maintain the tension of ropes and cables) which

Leonardo had already sketched on another sheet.[43] Thus we have here an original use of the screw and another eloquent reference to the influence of Brunelleschi. We can perhaps trace another echo of this in a Leonardo project from these years which is mentioned by Vasari:

> And among these models and designs there was one which he often demonstrated to many ingenious citizens who were then governing Florence, how he proposed to raise the Temple of San Giovanni in Florence, and place steps under it without damaging the building...[44]

Pedretti considers Vasari's account to be reliable. He has analyzed this problem with his usual acuteness and documentary thoroughness, attempting to imagine the procedure devised by Leonardo to raise a monument the size of the Baptistery. According to Pedretti, we can presume that Leonardo intended carefully digging until the foundations of the building were exposed and then constructing underneath it a firmly attached platform, to be raised with "the use of huge screws placed perpendicularly under that platform and activated simultaneously".[45] Here again we have a project that is Brunelleschian in spirit in which the technology of the screw plays a decisive role. To again

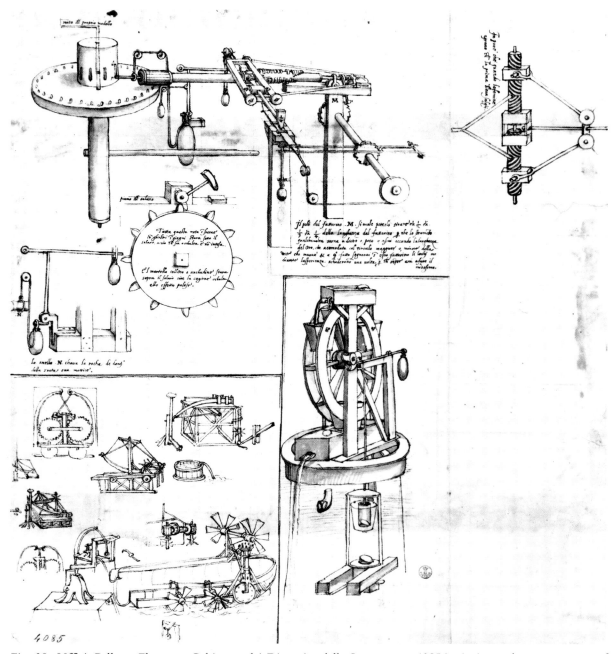

Fig. 38. Uffizi Gallery, Florence, Gabinetto dei Disegni e delle Stampe, no. 4085A. A sixteenth-century copy of drawings by Leonardo.

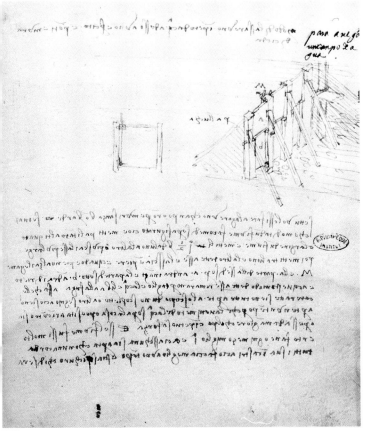

Fig. 39. Paris MS. B, f. 64 r.

Fig. 40. CA, f. 90 v/33 v-a.

quote Vasari: "...and by means of levers, windlasses and screws he showed the way to raise and draw great weights".[46]

It is Vasari, as we have already said, who informs us of the young Leonardo's projects regarding the Arno River, both to make it navigable from Florence to Pisa, and to use it as a source of energy for industrial purposes. No studies by Leonardo from this period dealing with the problem of the canalization of the Arno have come down to us, although Pedretti has recently drawn attention to a sheet of sixteenth-century copies of Leonardo drawings (Fig. 38 and Pls IV-V) which include a paddle-wheel boat that might preserve a memory of the *badalone*, the riverboat designed by Brunelleschi.[47] Another, more specific echo of Brunelleschi, this time related to problems of river canalization, is in Paris MS. B (f. 64 r: Fig. 39), which contains studies from the early years of Leonardo's first Milanese period (1485-90). In the context of a series of drawings and annotations of military technology and strategy (in particular the way to deviate the natural course of a river in order to flood an enemy city or encampment), Leonardo inserted a reference, that has only recently been deciphered, to a hydraulic engineering project of Filippo Brunelleschi: the ill-fated attempt to deviate the Serchio River in order to flood the city of Lucca and force it to surrender, a project put into operation by Brunelleschi in 1428 during the war between Florence and Lucca.[48] Another study that can be related to canalization problems is the sketch of a cataract on folio 90 v/33 v-a of the Codex Atlanticus (Fig. 40) which can be dated 1480-2.

57

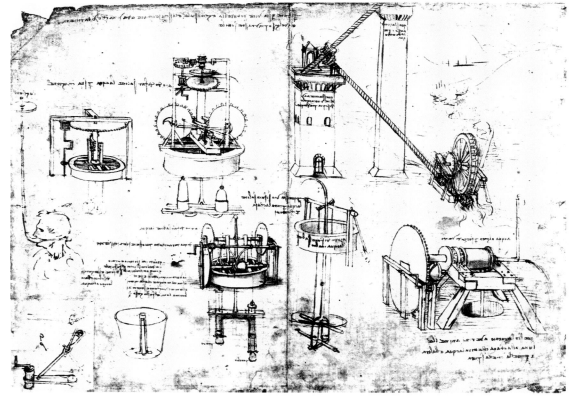

Fig. 41. CA, f. 1069 r/386 r-b.

There is further evidence of Leonardo's early interest in hydraulics. In a famous memorandum (CA, f. 888 r/324 r), probably written in 1482, shortly before he moved to Milan, Leonardo listed the works that he intended to leave in Florence and the ones he was taking with him to Milan.[49] The list, along with numerous references to drawings and paintings he had done in Florence, also mentions "certain instruments for ships" and "certain water instruments". The "instruments for ships" can be related to the studies of underwater attacks mentioned above. But many sheets of the Codex Atlanticus dating from Leonardo's first Florentine period attest to the attention he gave to "water instruments" from the very beginning of his career. The entire sheet (CA, f. 1069 r and v/386 r-b and v-b) contains a remarkable number of hydraulic devices (Figs 41–42 and Pl. I). There are various types of pump and an illustration of the combined use of two Archimedes screws, activated by a wheel

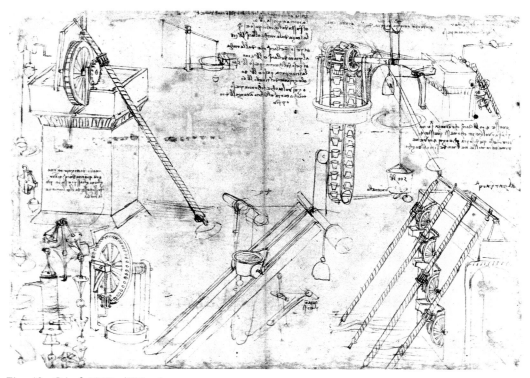

Fig. 42. CA, f. 1069 v/386 v-b.

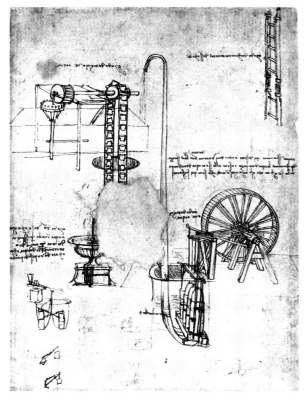

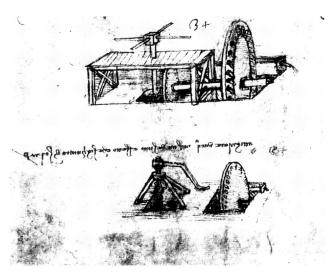

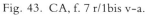

Fig. 43. CA, f. 7 r/1bis v–a. Fig. 44. CA, f. 34 r/9 v–b (detail).

turned by a river, which raise the water to the tops of two towers. The problem studied by Leonardo here is that of raising water from wells or water courses in order to then use its fall as a source of energy. These drawings, which still reflect Leonardo's immature style, reveal that he was beginning to experiment with new solutions: he shows, as in an X-ray, the underground mechanisms of the double-action pump, and renders with great precision complex wheelworks in which we can recognize an attempt to transform a constant circular thrust into an alternating motion. On the sheet in question we also find a drawing of a siphon, a sketch illustrating a method for breathing underwater, and, on a separate fragment, a diagram of a mechanism for a flying machine. Another sheet from the same time (CA, f. 7 r/1 bis v–a) reflects the same interests (Fig. 43): a siphon, a double-action pump activated by a large paddle wheel which can raise water to a great height, and a machine for raising the

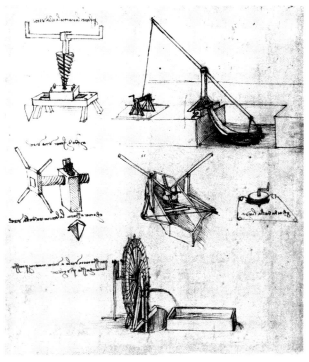

Fig. 45. CA, f. 156 r/56 r–b.

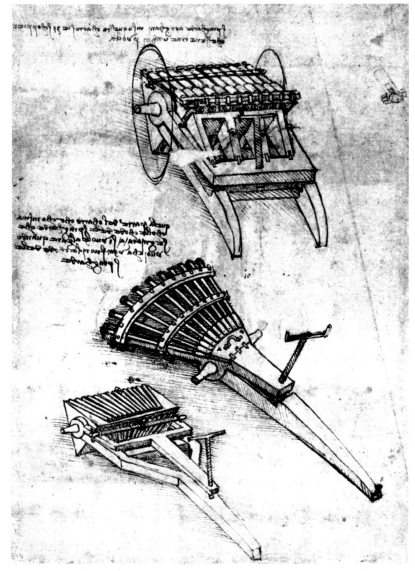

Fig. 46. CA, f. 157 r/56 v–a.

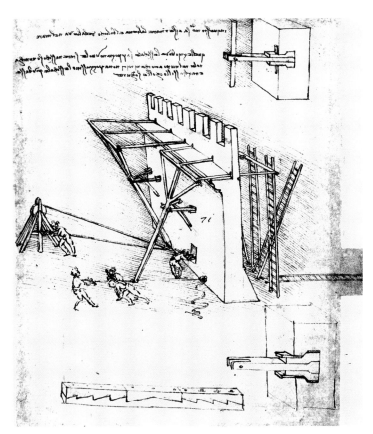

Fig. 47. CA, f. 139 r/49 v–b.

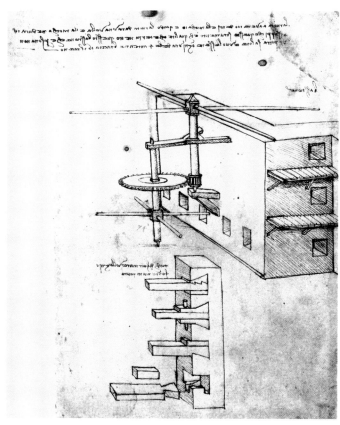

Fig. 48. CA, f. 89 r/32 v–a.

water from a pond by means of the continual movement of a conveyor belt with buckets that are filled by immersion in the well and emptied into a reservoir placed above. This sheet is obviously related to the one mentioned above (CA, f. 34 r/9 v-b: Fig. 44) on which there are sketches of other paddle wheels with buckets, as are other sheets of the Codex Atlanticus (for example f. 156 r/56 r-b: Fig. 45).

Another set of interests which clearly emerges from Leonardo's early sheets is related to military technology. Although, as Pietro Marani has shown,[50] Leonardo's interest in military architecture increased when he went to Milan, he had begun to focus on military technology while still in Florence. From this period we have studies of mortars and small bombards (*scoppietti*) of various types (CA, f. 157 r/56 v-a: Fig. 46; f. 167 r/59 r-c). These constitute specific evidence of Leonardo's effort to perfect himself in one of the most important areas of activity of the Renaissance engineer, which guaranteed steady work opportunities and high pay. Leonardo studied not only systems of attack, but also the use of mechanical devices for defence. To this category belong two progressively elaborated studies, which can be dated to about 1480, of techniques for defending a fortress in the event of the enemy scaling its walls. Leonardo constructs an almost cinematic sequence here. First he illustrates how to push away the enemy ladders by means of a movable protective outer railing (CA, f. 139 r/49 v-b: Fig. 47). Then, in the event that the enemy soldiers succeed in overcoming this first obstacle, he indicates, again with careful precision (CA, ff. 1039 r/372 v-b, and 94 r/34 v-a), an easy, spectacular method of sweeping them off the walls by rapidly rotating horizontal poles (CA, f. 89 r/32 v-a: Fig. 48). As in so many other cases, the novelty here consists in the use of well-known devices for a new purpose; in fact, Leonardo's solution depends upon a mechanical structure that is identical to that of a mill.

This specific evidence shows how in Leonardo's famous, much-discussed letter to Lodovico Sforza of 1482, in which he lists the various services he is able to offer, the references to his abilities as

Fig. 49. CA, f. 1082 r/391 r-a.

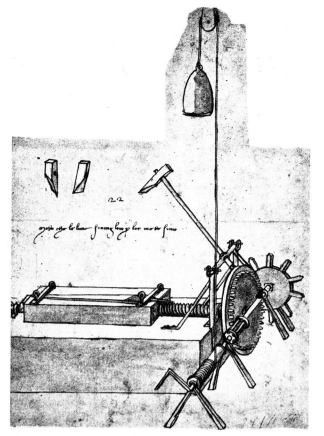

Fig. 50. CA, f. 24 r/6 r-b.

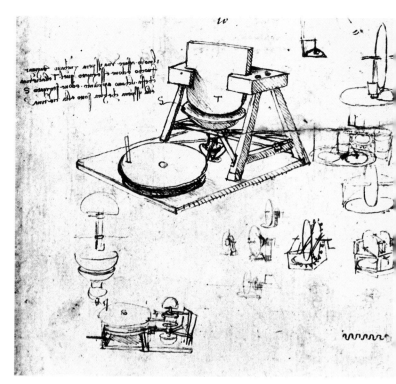

Fig. 52. CA, f. 17 v/4 v-a (detail).

a military engineer, albeit deliberately exaggerated, were not merely idle boasting. Although he was still lacking in practical experience, Leonardo had indeed reflected upon "new types of chariots", "covered ways and ladders and other instruments", the way to "take the water out of trenches", "bombards, mortars, and light ordnance of fine and useful forms, out of the common type" (CA, f. 1082 r/391 r-a: Fig. 49). Thus it was with some justification that Leonardo offered his services as an advisor to an aggressive, bellicose lord, not only for works of peace but also in time of war.[51]

Other studies in the Codex Atlanticus dating from Leonardo's early years in Florence show that he was studying various industrial machines. Suffice it to mention the machine for the production of files, on a sheet from about 1480 (CA, f. 24 r/6 r-b: Fig. 50). We have no proof that this was an invention of Leonardo's, but at any rate it is evidence of his interest in the mechanization of production methods that had formerly been carried out manually (see also Leonardo's later drawing for the mechanical filing of screws in Madrid MS. I, f. 15 r: Fig. 51). There are other studies, that can be dated 1478-80 (CA, ff. 17 v/4 v-a: Fig. 52; 1057 v/380 v-b), of machines for producing concave

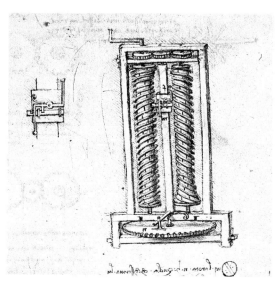

Fig. 51. Madrid MS. I, f. 15 r (detail).

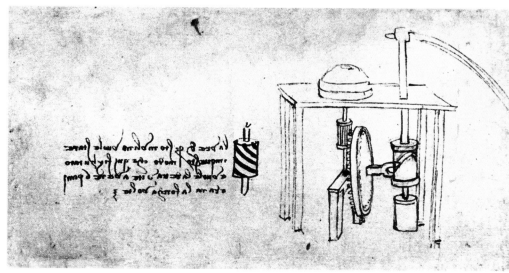

Fig. 53. CA, f. 1084 v/391 r-b (detail).

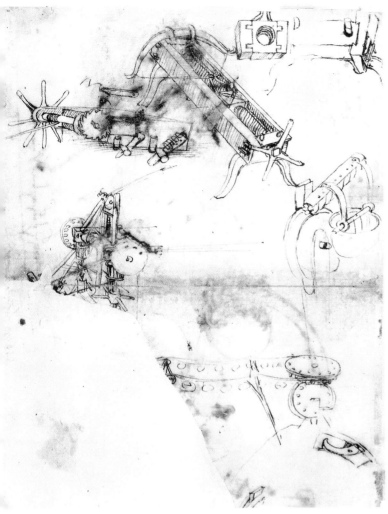

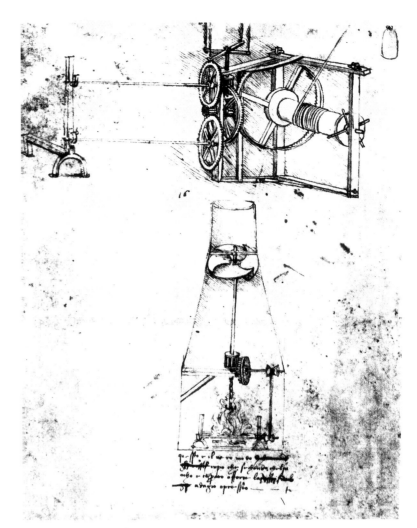

g. 54. Uffizi Gallery, Florence, Gabinetto dei Disegni e
lle Stampe, no. 446 Ev [f. 7 v].

Fig. 55. CA, f. 21 r/5 v-a.

mirrors, perhaps to be used as burning mirrors for soldering. Also worthy of attention are Leonardo's drawings of mills (CA, f. 1084 v/391 r-b: Fig. 53), of hoists, and of the screw mechanism for bending a catapult on the verso of an Uffizi sheet that can be dated 1478 (Fig. 54), and, finally, the drawing of two spits, one activated by a weight and the other by hot air, on folio 21 r/5 v-a of the Codex Atlanticus (Fig. 55). These spits, which were not invented by Leonardo, show how his attention was attracted by complex rotary systems that could adapt any source of energy (water, weight, air) to any imaginable use.

Leonardo's technological studies from this time do not have any particular coherence or continuity. They appear to be a series of "cases" analyzed in a practical fashion. Nor is there any surviving evidence that Leonardo attempted to relate these practical studies to general principles. Like his colleagues from the fascinating but limited world of the Renaissance workshop, Leonardo learned by experience to use natural and animal power; but the typical Renaissance engineer did not attempt to understand the nature of that power, nor to establish its use on a quantitative basis. Not even the great Brunelleschi had broken out of this mould, in spite of the fact that on more than one occasion he had felt the need to utilize the knowledge and mastery of geometry of a learned humanist like Paolo del Pozzo Toscanelli, one of the protagonists of the fifteenth-century Archimedean revival.[52] Toscanelli is also remembered in a note that can be dated 1480 (CA, f. 42 v/12 v-a) — "*Maestro Pagholo Medico*" (Master Paolo the Physician) — which probably preserves the evidence of Leonardo's intense effort to come into contact with the aged physician and mathematician. This is further confirmation of the influence of Brunelleschi, an influence that dominated the years of Leonardo's technical apprenticeship.

Leonardo in Milan (1482-1499): Continuity and Renewal

The letter to Lodovico Sforza mentioned above presents the "curriculum" of an engineer who was naturally concerned with emphasizing his most attractive capabilities for the patron he wished to serve. This explains why the accent of the letter is primarily on architecture and military technology, which were essential for furthering Lodovico's plans for expansion. In fact, in this letter civil technology is relegated to a secondary level; Leonardo mentions it only once, to emphasize his ability to direct water from one place to another. Finally, he states that he is a qualified sculptor and founder, in response to a specific desire of the duke — to erect a gigantic equestrian monument in memory of Francesco Sforza — a desire concerning which Leonardo was apparently well informed.

Whatever the reasons that led Leonardo to leave Florence, in 1482 he entered the service of the largest, most active and powerful court on the Italian peninsula, led by an ambitious lord who governed a territory full of natural resources and industrial activity, at the centre of which was the city of Milan, a real metropolis (it had a population of approximately 200,000, more than twice that of Florence). The Duchy of Milan could thus offer an ambitious, eclectic young man like Leonardo the opportunity to display his brilliance in a number of areas.

After arriving in Milan as an artist with a good reputation but not yet famous, Leonardo soon succeeded in making his extraordinary qualities known. He was given duties and specific commissions by the duke both as an artist and as an engineer. We do not know the amount of the regular salary he received until 1500, nor the exact contractual terms binding him to Lodovico. In documents of the time he is mentioned as "*ingeniarius ducalis*" and "*ingeniarius camerarius*". It is also certain that he was permitted to accept commissions from private parties, and in fact he took on several, both of an artistic and of a technical nature.[53]

Year by year the reconstruction of Leonardo's activity becomes less difficult. The available documentation increases and, in addition to the Codex Atlanticus, we have other precisely datable manuscripts which present a greater coherence of interests. This is the case of Paris MS. B and the Codex Trivulzianus,[54] both compiled during the second half of the 1480s in Milan. These two manuscripts are also similar in terms of their main thematic nuclei. In Paris MS. B and the Codex Trivulzianus, in fact, there is particular emphasis on architectural studies and studies of military technology, confirming that Leonardo took very seriously his duties as technical-military advisor, which fundamentally was the capacity in which he had offered his services to Lodovico. These are famous studies, which have been the object of much analysis even in recent times, analysis that presents Leonardo as a great but not very innovative military engineer.[55] Here Leonardo's drawing style is more mature; at the same time, his recourse to classical sources and contemporary texts such as Valturius' treatise on the art of war, published in 1482[56] and used as a source of information on ancient war machines as well as on a vast range of technical terms (in the Codex Trivulzianus), becomes increasingly evident. The drawings of military engineering dating from Leonardo's first decade in Milan constitute a precise, eloquent illustration of his letter to Lodovico Sforza. The reference in that letter to "extremely light, strong bridges" is echoed in the sketches of bridges on several sheets of Paris MS. B (see, for example, f. 23 r: Fig. 56) and of the Codex Atlanticus (see f. 855 r/312 r-a: Fig. 57, which shows a strongly cambered movable bridge, easy to set up and very sturdy). In addition, we find a considerable number of studies of weapons and instruments of attack recorded in Paris MS. B and in the Codex Atlanticus on sheets dating from these years, some of which (crossbows

Fig. 56. Paris MS. B, f. 23 r.

Fig. 57. CA, f. 855 r/312 r–a.

and catapults) were derived from Valturius ("I will make bombards," — Leonardo had written to Lodovico — "mortars, and light ordnance of fine and useful forms, out of the common type"). These studies are of interest not for their innovativeness, which is limited, but for the attempt they reveal to increase the firing rhythm, to facilitate the loading process even to the point of introducing automatic fuse ignition (Madrid MS. I, f. 18 v: Fig. 58), to lessen recoil, and to improve methods of rapid aiming. Leonardo's gifts as an engineer often come into play in the mechanization of operations. This is evident above all in the spectacular studies for the huge wheel operated by manpower (CA, f. 1070 r/ 387 r–a: Fig. 59) that permits the repeated discharging of the four powerful crossbows with which it is

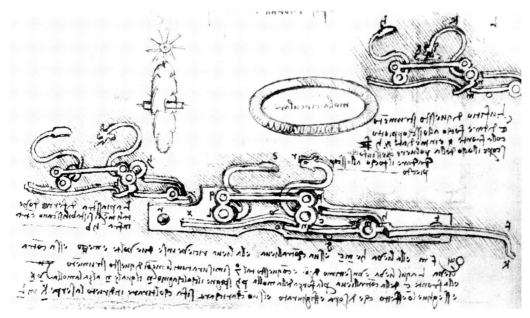

Fig. 58. Madrid MS. I, f. 18 v detail.

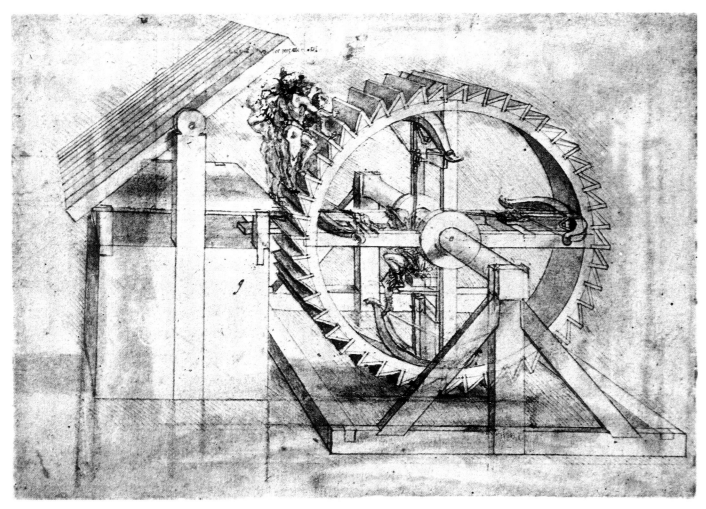

Fig. 59. CA, f. 1070 r/387 r–a.

Fig. 61. Paris MS. B, f. 33 r.

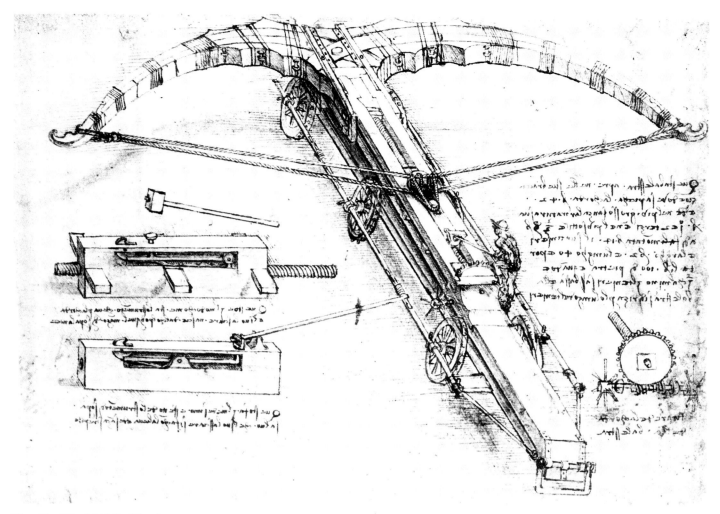

Fig. 60. CA, f. 149 Br/53 v-b.

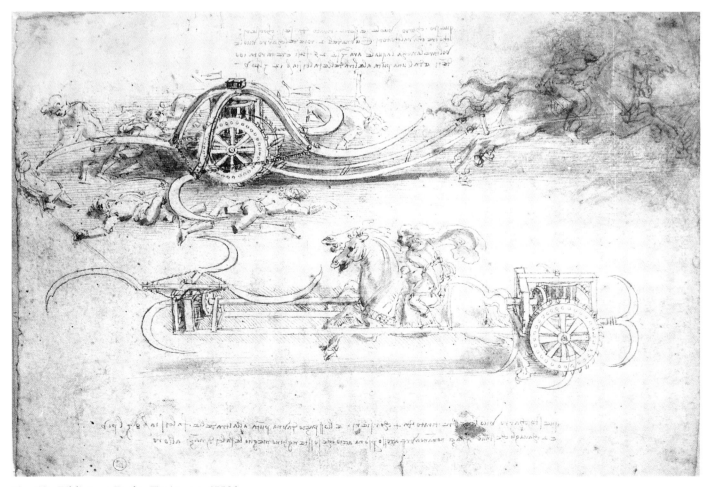

Fig. 62. Biblioteca Reale, Turin, no. 15583.

equipped; or in the gigantic crossbow with highly technological methods of loading and activating the release (CA, f. 149 b–v/53 v–b: Fig. 60). These studies, along with the "*architronito*" in Paris MS. B (f. 33 r: Fig. 61) which Reti identified as a steampowered cannon,[57] belong to the group of Leonardo's technological "dreams" that constantly recur in his studies. Leonardo was able to create, through his highly effective, dynamic drawings, the impression that these improbable mechanisms would work. This is the case of the extremely heavy, impractical armoured car ("I will make covered chariots, safe and unattackable", Leonardo had promised Lodovico Sforza), the model of which is presented in many museums[58] as an invention of Leonardo, thereby ignoring the practically identical drawings in earlier manuscripts. The same can be said of various cars with scythes, the drawings of which (for example the beautiful drawing in the Royal Library at Turin: Fig. 62)[59] dramatically illustrate the disastrous effects produced in the enemy ranks, but which Leonardo admitted "often did no less injury to friends than to enemies" (Paris MS. B, f. 10 r).

Naturally Leonardo also occupied himself with the production of firearms, such as the hydraulic milling machine that produced segments of barrel to be successively welded together (CA, f. 10 r/2 r–a: Fig. 63) to obtain large-scale barrels for firing, like the one being raised by an excited group of workers using a powerful crane in a magnificent drawing at Windsor (RL 12647: Fig. 64), which offers a spectacular image of the chaotic, noisy activity in a cannon foundry.

As he had promised Lodovico Sforza, in the event of war at sea Leonardo could provide "many machines most efficient for attacking and defending vessels". We have already pointed out that some of Leonardo's studies of submarine warfare and devices for breathing underwater, which have been traditionally related to his brief stay in Venice in 1500, are unquestionably from his early years in Milan.

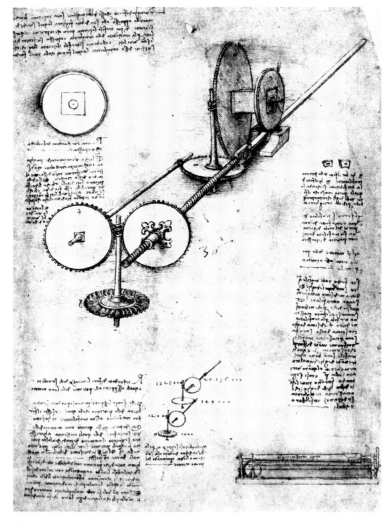

Fig. 63. CA, f. 10 r/2 r–a.

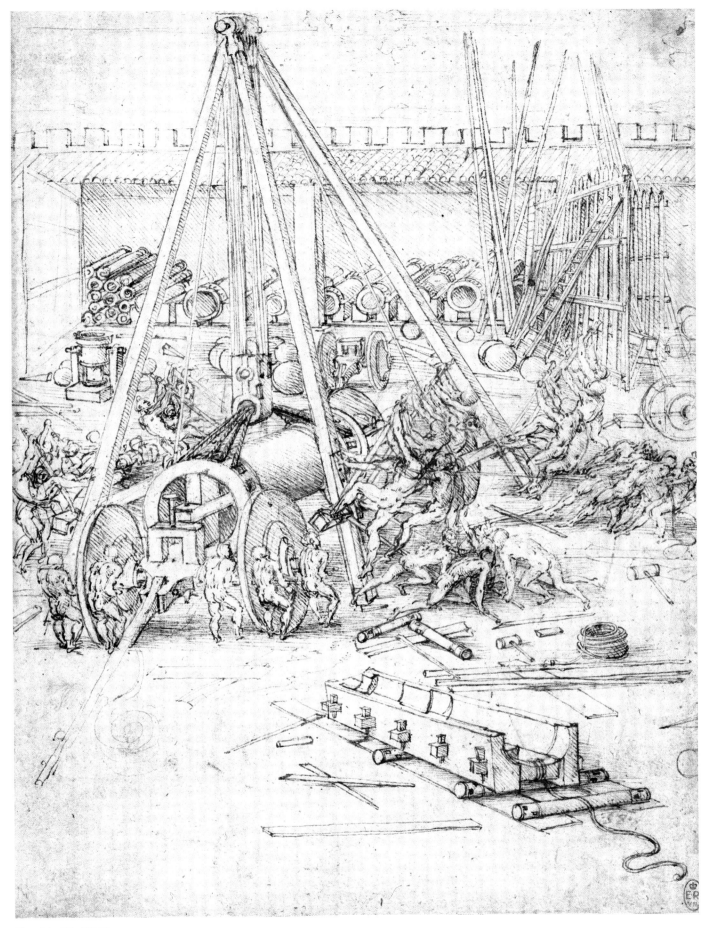

Fig. 64. RL 12647.

These studies were probably inspired by Lodovico Sforza's intention of defending Genoa, which came under his dominion in 1487, from continual pirate raids. On a sheet of the Codex Atlanticus (f. 881 r/ 320 v–b: Fig. 65), along with various interesting but not new devices for breathing underwater, we find sketches and notes that seem to be evidence of a project for an underwater vessel, "Leonardo's submarine", as it was quickly baptized by traditional scholarship. But the evidence is sparse and does not permit a precise reconstruction of Leonardo's project. Carlo Pedretti, interpreting the drawings and various references to this vessel scattered throughout Leonardo's papers (see especially Paris MS. B, f. 11r), has conjectured that Leonardo was thinking of immersing a hermetically sealed, completely watertight vessel by releasing the air from the leather bags placed along its sides to keep it afloat.[60] This is probably another of Leonardo's technological dreams, founded upon the development of a chain of daring ideas which led him to materialize, in his imagination and on paper, projects that were beyond the possibilities of the technology of his time. But these great possibilities produced by his vivid imagination also troubled Leonardo. In a later note he stated that he had destroyed this invention to prevent "the evil nature of men" from transforming it into an instrument of death by using it to make unseen attacks on enemy ships (Codex Hammer, f. 22 v).

It has often been stressed that Leonardo felt repugnance for war. And in fact his studies of military technology do not reflect a genuine interest on his part, even though he was fascinated by certain technical details. Such studies were the result of his obligations to lords, like Lodovico Sforza, who saw war as the chief means of defending and increasing their power.

Leonardo's activity as a hydraulic engineer during his first Milanese period was characterized by elements of uncertainty. The once widespread tendency of Leonardo scholars to attribute to him a fundamental role in the definition of the extensive canalization works in Milan at the end of the fifteenth century is less common today. There is no lack of documentation attesting to his involvement in works of hydraulic engineering; and it is not surprising that Lodovico Sforza required Leonardo's services in this field. And yet one has the impression that Leonardo experienced difficulties at the

Fig. 65. CA, f. 881 r/320 v–b.

beginning of his activity in this area. In fact, his knowledge was based on his experience with the problems presented by a capricious, unpredictable river like the Arno. He lacked the necessary tools and experience for dealing efficiently with a complex system composed of rivers of constant flow (the Adda and the Ticino), numerous tributaries, lakes, and canals which were to be used as a network of communication and for the transportation of goods to a city — Milan — that was distant from the main waterways. When Leonardo arrived in Milan the structure of the Milanese canals had already been determined to a great extent. The Martesana canal, constructed by Bertola di Novate, made it possible to link Lake Como and Milan by means of the Adda River. Another network of canals connected, via the Naviglio Grande, the city of Milan to the Ticino River, on the banks of which there rose Pavia — the second most important city in the duchy of Milan — with its famous Studio.[61] Leonardo's attention was caught by many of the technical solutions used in the great projects: basins, systems of locks, dredges to keep the canals clean, adjustable apertures in the banks of the canals to supply water, and so on. Understandably, one of Leonardo's main concerns seems to have been to orient himself within this complex system. In fact, there is evidence of his efforts to grasp the main coordinates of this unfamiliar territory by making personal expeditions, taking measurements, and drawing up schematic maps. Obviously, he concentrated on the navigable network; there is evidence of this in the sketch of the map of Milan with indications of a project for replanning the area between Porta Romana and Porta Tosa, which can be dated 1493 (CA, f. 184 v/65 v-b: Fig. 66). One of the tasks given to Leonardo by Lodovico Sforza at the beginning of the 1490s was to draw a plan for the enlargement of the city of Milan, reviving the mediaeval structure of the city by exploiting to the full the advantages offered by the abundance of water.[62].

In 1490 Leonardo went to Pavia in connection with a project to build the Cathedral. There are traces of his observations of the Ticino River, in particular of the way to reinforce the foundations of the city walls, against which the river flowed. And he was certainly fascinated by the multiple locks of the Naviglio Bereguardo. Leonardo's first drawings of locks in the Codex Atlanticus (f. 935 r/341 v-b:

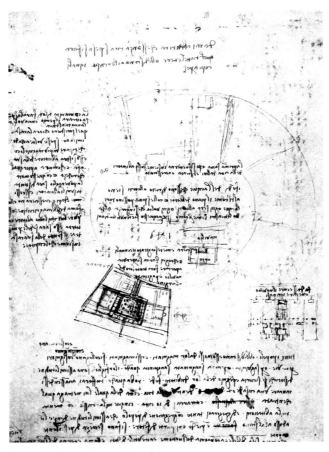

Fig. 66. CA, f. 184 v/65 v-b.

Fig. 67) and in Paris MS. B (f. 64 r: see Fig. 39) may have been inspired by this visit to Pavia, or possibly by another earlier visit around 1487-8, and may reflect an original project for a movable lock to regulate the flow of water in canals. In Pavia, where navigation from Milan to the Ticino was interrupted by the insurmountable obstacle of the fluvial terrace, Leonardo must certainly have begun to reflect on a solution to that extremely bothersome barrier.[63]

Leonardo's manuscripts from the early 1490s show that his interest in hydraulic technology was unflagging; there are numerous references to canals and to Milanese localities linked by the system of waterways. And he continually referred to problems that were yet to be satisfactorily overcome: how to keep a constant level of water in the canals; how to design high-capacity locks (like the ones with their gates at an angle); how to operate effective devices for supplying precise quantities of water from the apertures in the banks of the canals (an important problem, since the water supply granted by Lodovico Sforza was based upon a payment "per ounce"). It is more difficult to establish the extent to which this impressive series of drawings and notes represents original ideas, or is simply a matter of Leonardo recording work he saw in progress. It seems that for a considerable period of time Leonardo was more involved in learning than in teaching in this field. He sought contacts with Lombard experts in hydraulics, of whom he had a thousand questions to ask: "find a master in waterworks, and get him to explain to you the fortification of them, and what it costs"; "Paolino Scarpellino, called Assiolo, is a good master of waterworks". These notes, from a memorandum of 1489 (CA, f. 611 Ar/225 r-b), provide solid evidence of a new period of training to which Leonardo dedicated himself passionately.

But while he was striving to learn from the experience of those who were well versed in hydraulics, Leonardo was developing a highly personal method, which becomes increasingly evident in his papers. Between the end of the 1480s and the beginning of the 1490s, in fact, Leonardo's career as an engineer took a decisive turn — a turn that was determined by his studies of hydraulics and that led him to change his method. He became convinced that experience could help him only up to a certain point. The problems posed by flowing rivers, canals, locks, and those of providing a water supply for domestic and agricultural uses, demanded that the engineer be well acquainted with the element water before he could succeed in turning it, with the proper mechanical instruments, to the use of man. Leonardo's first "theoretical" studies, of which water was most frequently the object, date from these years. "A grandson of the painter Gian Angelo has a book on water that belonged to his father", we read in the memorandum of 1489 cited above. Paris MS. A, of 1490-1492, contains the first relatively comprehensive prospectus of Leonardo's study of water: "beginning of the treatise on water".[64] This is a fundamental statement, the first to document Leonardo's intention of dedicating himself to the compilation of a "treatise". And the fact that it was to be not merely a collection of practical precepts but a comprehensive text is also clear from Leonardo's stated intention of returning to and further developing what the ancients had written on the subject. This was a very ambitious project. In Leonardo's fertile brain it already appeared as the principal section of a vast encyclopaedia destined to contain other closely related chapters: on motion and weight, on human anatomy, on the earth. For Leonardo, water is a universal factor: it carves out valleys, it circulates in the bowels of the earth giving rise to springs, it flows as blood through the human body, and everywhere its incessant movement is subject to ironclad laws. It is not by chance that Leonardo's very first mention of a treatise on water in Paris MS. A contains a specific reference to the similarity between the human body and the earth: "Man has been called by the ancients a lesser world, and indeed the term is rightly applied, since, as man is composed of earth, water, air, and fire, this body of the earth is similar".

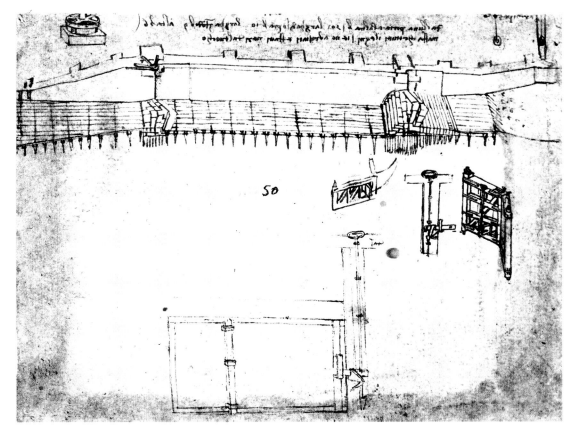

Fig. 67. CA, f. 935 r/341 v-b.

Hence Leonardo saw a unity between the animate and the inanimate worlds — and consequently he believed in the validity of a rigorously mechanical investigation of man. As a result he conducted a series of systematic dissections that began during the years under consideration, constantly insisting upon the relationship between man and the earth (respiration, circulation of humours, and so on) — a recurring analogy the main component of which was the element of water.

During these same years, because Leonardo was also an artist who strove to achieve a perfect imitation of Nature (which is impossible without a precise knowledge of its laws), he began his theoretical studies of optics and mechanics. The latter are found above all in the Codex Atlanticus, in Madrid MS. I, and Forster MSS. I², II¹⁻², and III. The pattern is the same: Leonardo studied classical and mediaeval sources (there is evidence of his search for important texts: Archimedes, works on the mediaeval science of weights and the texts of the *impetus* theory); he would then establish useful contacts with experts of his time (the Marlianis,[65] Fazio Cardano,[66] etc.); and, finally, he would attempt to establish the general mechanical principles involved, testing them in concrete applications. Leonardo soon discovered that the basic unifying tool for these studies was geometry, of which he was totally ignorant. So he enthusiastically dedicated himself to filling this gap in his knowledge. The first signs are found in a memorandum of 1489, and show Leonardo's usual method of searching for texts and seeking out experts in the field: "Get Messer Fazio [Cardano, the father of Gerolamo] to show you about proportionality"; "Get the master of arithmetic to show you how to square a triangle"; "the proportions of Alchino [Al Kindi], with Marliani's notes; Messer Fazio has it"; and "Try to get Vitolone [Witelo], which is in the library at Pavia, and which treats of mathematics". Moreover, in 1497, Leonardo had the good fortune to meet Luca Pacioli, one of the many Tuscans attracted by the Sforza court, who became his great friend and from whom he received a course of geometrical instruction based on Euclid's *Elements*.[67]

73

It is not possible to dwell further on this remarkable turning point in Leonardo's career, which was to have direct, striking repercussions on his activity as an engineer. By the middle of the 1490s, Leonardo had already outlined his theory of the four *"potenze"* of Nature (movement, weight, force, and percussion), the four basic powers upon which every physical phenomenon depends. And already at this time, air and water, which Leonardo was to increasingly associate with one another (influenced also by his study of the flight of birds), are presented as powerful natural forces in perennial motion that man can harness and turn to his own benefit.[68]

And yet there remain obvious contradictions — which never disappear — between Leonardo's ambitious programmatic declarations and the concrete development of his observations and comments, which unfolds in a fragmentary fashion, by "cases". The studies in Paris MS. A, after the formulation of a project as ambitious as the treatise on water, are quite disappointing (the same can be said of the later Paris MS. I, *c.* 1497, which deals with the same problems). Leonardo focused his attention primarily on water courses. He attempted to determine the variation of the velocity of their various levels in relation to the variations in the breadth and depth of the bed and the velocity of the current. He also studied the effects of the impact of water on bodies immersed in it and on the edges of the bank.[69] On the one hand Leonardo outlined the contents of ambitious theoretical works as if they had already been written; on the other hand, he continued to conceive his own studies as a series of disconnected observations.

Although Leonardo never actually compiled the *summae*, as he so often solemnly promised, his efforts to base practical applications on general principles led to considerable changes in his technological activities. The first evidence of this change is found in a series of drawings and notes from 1494 relating to hydraulic projects. In that year Leonardo was at Vigevano, the birthplace of Lodovico Sforza and the setting for ambitious Sforza projects. Leonardo's notebooks from this time contain various observations on the canals of the town and on the water stairs used at the Sforzesca, Lodovico's model farm, to keep the sloping meadows green. Among the many pages that refer to this visit in Madrid MS. I, which was compiled between 1492 and 1499, and in Paris MS. H, from the same years, those dedicated to the mills at Vigevano are of particular interest.[70] Leonardo took precise measurements of the grain mills he observed; he calculated the cost of building one, estimating its daily production capacity (Madrid MS. I, f. 151 v: Fig. 68). Moreover, he thought about the

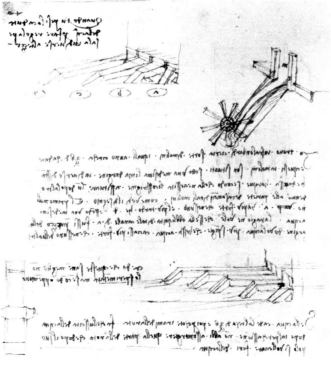

Fig. 68. Madrid MS. I, f. 151 v (detail).

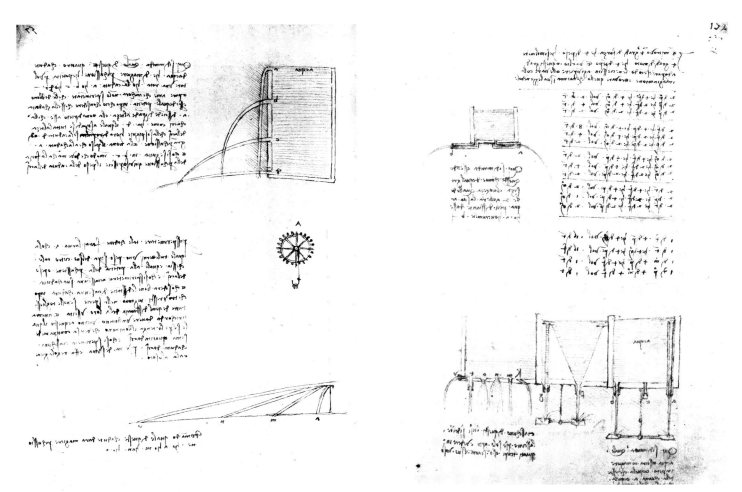

Fig. 69. Madrid MS. I, f. 134 v. Fig. 70. Madrid MS. I, f. 152 r.

deficiencies of the mills in Lombardy ("I found among the Lombards a certain type of mill..."), and he proposed solutions which, albeit confusedly, were obviously based upon principles of hydrostatics and hydrodynamics. Leonardo criticized the solution he had observed at Vigevano where various mills were placed in a line along the same bank and their blades powered by jets of water coming from spouts of uneven diameter (wider where the water entered) at different angles from the flow of water from which they drew. In this case, Leonardo observes, recalling his studies of currents and the flow of rivers, the output of the mills cannot be uniform. To make it so, he proposes to divert from the water course horizontal ducts of uniform diameter.

Elsewhere in Madrid MS. I (ff. 134 v and 152 r: Figs 69-70), Leonardo investigates the causes that make a fall of water more or less effective, experimentally analyzing the effect of four falls of water from four equal openings made at different heights in a container full of water. His analysis depends on a theoretical argument based upon the conviction that the power of the jet of water is a result of the combined effect of the weight of the water and of its percussion, where the percussion, by virtue of its *impetus*, is proportional to the height from which the water falls. Leonardo concludes that the four falls "should be of equal power". He notes that "where the force of percussion is lacking, the weight compensates", taking for granted that the power of the lower and upper jets is equal because the former has more weight (due to the pressure of the water above it) and less percussion (since it falls from a lower height), while the latter has more percussion and less weight.

These notes are telling evidence of a change in method consequent upon the appearance in Leonardo's manuscripts of a theoretical approach not yet quantitatively oriented, but no less important

75

for that. These studies opened up new perspectives for Leonardo as an engineer, enabling him to design mills with a better output and to calculate the flow of water from the mouths of canals in relation to the height of the opening. It is not accidental that in both studies in Madrid MS. I relating to mills, Leonardo advances his proposals solely on the basis of theoretical previsions, stating explicitly that he has not tested them: "And it seems to me, although I have not yet tested it, that they should be of equal power"; and again, "I believe that these will be better. I have not tested it, but I believe so". What we have here are truly "thought experiments": Leonardo's faith in the theoretical foundations from which the foreseen effects derived made experimental verification perfectly useless.

This was the fruit of a major change which appears clearly in several technological studies by Leonardo from the late 1400s and early 1500s. Nevertheless, Leonardo's practical applications never came to depend totally on his theoretical knowledge; his manuscripts up to the time of his death contain a remarkable number of specific technical projects, isolated cases in a world of mechanical possibilities, each one of which apparently possessed its own individuality. In spite of this contrast, however, at this point in his career Leonardo showed himself quite different from other engineers of his day, who also operated by "cases". The "disciple of experience" was immersed in the study of mathematics, of the mechanics of solids and liquids, of geology. He was striving to enrich and refine his vocabulary, to perfect his knowledge of Latin, and to measure up to the great minds of the past.

Hence the last decade of Leonardo's first Milanese period marks a decisive turn in his career, a turning point that is particularly evident in the series of studies in Madrid MS. I. These studies constitute the most significant example of Leonardo's efforts to combine theoretical foundations with practical applications, using mechanical principles as his point of departure. We will return later to this aspect of Leonardo's activity in order to subject it to a special analysis, imposed by its centrality, and also to clarify the approach, based largely upon theoretical studies of mechanics, which Leonardo took toward human anatomy during these years.

Alongside these signs of innovation, there are other technological studies from the last years of Leonardo's first Milanese period which retain the traditional character of ingenious solutions to special problems, based on practical experience. This is the case of the series of studies for the casting of the gigantic horse (almost seven metres high) for the equestrian monument to Francesco Sforza commissioned from Leonardo by Lodovico il Moro (Fig. 71). The various solutions recorded in the magnificent red-chalk drawings in Madrid MS. II[71] for transporting the form and turning it in the casting pit, and pouring the molten bronze, are truly remarkable (Figs 72-73). But Leonardo was unable to test their efficacy because the enormous amount of bronze necessary for the process went to Ercole d'Este for military purposes.[72]

Also characteristic of Leonardo's habitual method of analysis is the series of drawings, all dating from the last five years of the fifteenth century, which present various machines and devices for the textile industry with remarkable visual effectiveness. We should make clear, however, that there is no concrete proof that Leonardo was the inventor of the automatic spinning machine, the loom (Fig. 74), the cloth shearing machine (Fig. 75), the gig mill (Fig. 76), and so on, as has been suggested by Giovanni Strobino in what remains a useful study for the technical knowledge with which Strobino reconstructs the way that the devices sketched by Leonardo must have operated.[73] While living in a region where there was an extremely active textile industry, the technology of which we know almost nothing about, it is likely that Leonardo recorded the most advanced solutions then available, perhaps taking as his point of departure the functional deficiencies about which the people who operated the

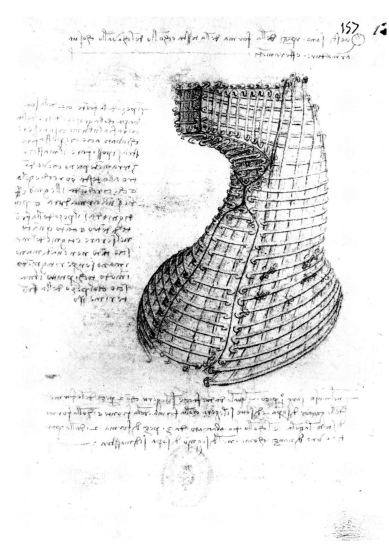

Fig. 71. Madrid MS. II, f. 157 r. The casting mould of the
Sforza horse's head.

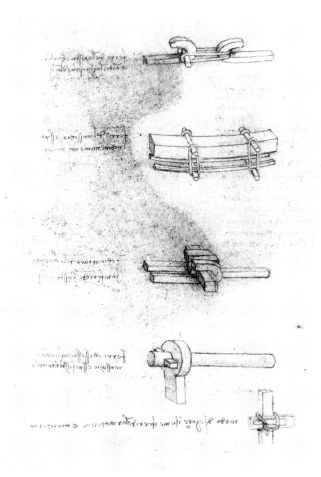

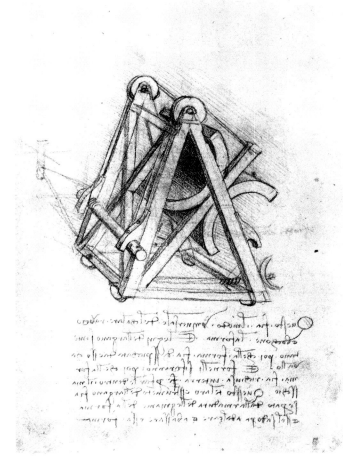

Fig. 72. Madrid MS. II, f. 156 v.

Fig. 73. Madrid MS. II, f. 154 v.

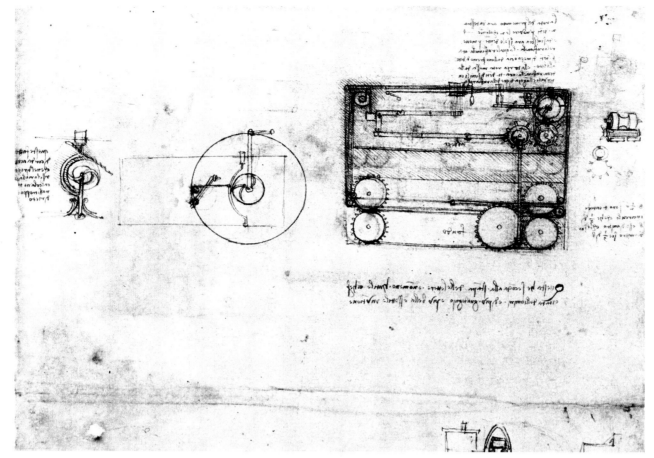

Fig. 74. CA, f. 985 r/356 r–a (detail).

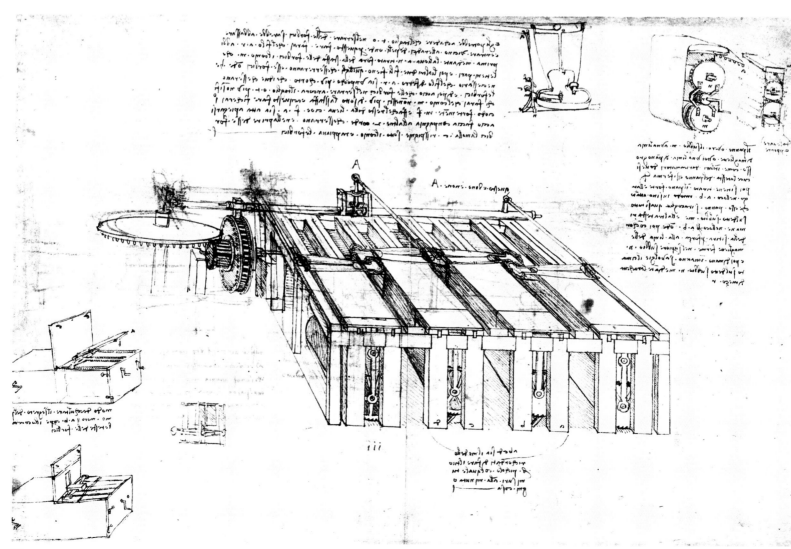

Fig. 75. CA, f. 1105 r/397 r–a.

machinery complained, in order to propose his own solutions. As a whole, this series of projects represents an attempt to automate the production cycle, from which Leonardo could reasonably expect to derive great financial advantage: "this is second" — wrote Leonardo beside the drawing of the mechanical loom — "to the letterpress machine, no less useful, and as practiced by men it is of more profit and is a more useful and subtle invention" (CA, f. 85 r/356 r-a). The need for automation is a constant feature in Leonardo's designs of machines, and he has been rightly called the "prophet of automation".[74] But he often filled that need with the help of his imagination and the extraordinary persuasiveness of his technological drawings. Powerful machines capable of producing an enormous amount of work, such as the mechanical shearing machine (CA, f. 1105 r/397 r-a: Fig. 75), could be conceived by Leonardo's lucid mind, but they were difficult to realize because of the precision of assembly and the solidity of materials they required.

The same type of consideration can be repeated with regard to the many magnificent studies of mechanical clocks in Madrid MS. I. In fact, in a recent, very acute study of these sheets, Silvio Bedini maintained that they are works of astonishing accuracy.[75] But, with the problematic exception of Leonardo's attempts to introduce the escapement of the pendulum to regulate a weight-driven clock (Fig. 78) these studies cannot be considered sensational anticipations of modern inventions. The precision technology of the watch led Leonardo, whose attention was focused on systems of transmission and regulation of movement (Fig. 77), to a new exercise in automation. Moreover, it is not certain that all of these studies are related to clock mechanisms. We should not forget that clocks and automatons (i.e. machines capable of carrying out a series of predetermined movements) were

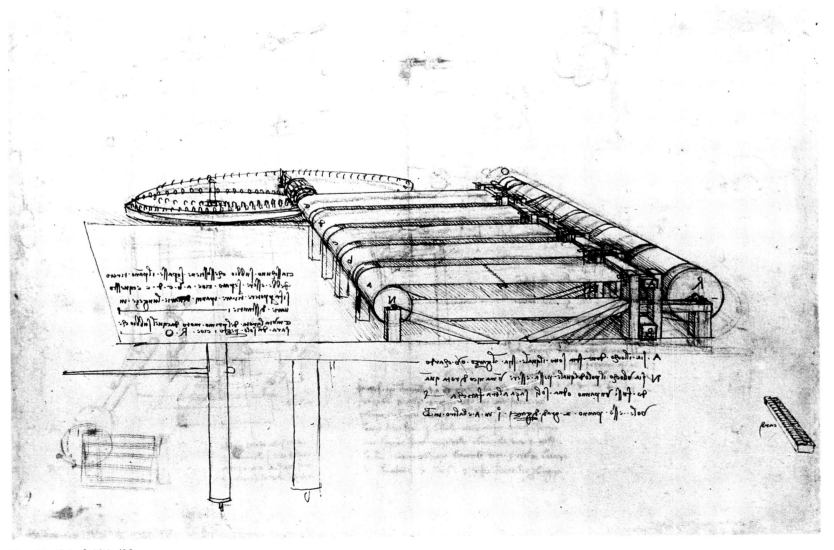

Fig. 76. CA, f. 106 r/38 r-a.

devices usually produced by the same technician. We also know that Leonardo devised automatons for festivals at the Sforza court and that later (1515) he produced a mechanical lion for the Florentine Republic.[76]

Before concluding this summary of Leonardo's activity as an engineer during his first Milanese period, we should mention his study of flight. As has recently been demonstrated, Leonardo had already begun to study flight during his years in Florence;[77] in Milan these studies underwent remarkable progress as can be seen in many pages of Paris MS. B (Fig. 79) and of the Codex Atlanticus which contain projects for flying machines — Leonardo's "airplanes" (Fig. 80). Raffaele Giacomelli has shown that in his early studies Leonardo concentrated on machines with movable wings.[78] And he illustrated various types of them in Paris MS. B. In some the man is prone and moves the wings with his arms; in others, the lower limbs of the man provide the thrust, or else the man is in a standing position and moves all four of his limbs (Fig. 81). These are fascinating designs which seem to have led Leonardo to believe that it was not impossible for such machines to work. There is evidence of an apparently unsuccessful attempt at human flight from the roof of the Sforza Palace (CA, f. 1106 v/361 v-b), and the subsequent choice of a less perilous location: "You will try this machine over a lake, and wear a long wineskin around your waist, so that if you should fall you will not drown" (Paris MS. B, f. 74 v).

The flying machines designed by Leonardo during these years have beating wings with extremely complicated devices for operating them. Leonardo also considered using springs continually rewound during flight. He seemed to concentrate on mechanical systems for advantageously transmitting the force exerted by the man and for transforming the constant thrust of the motor into an alternating motion like that of beating wings (Fig. 82 and Pl. IX). These are powerful and heavy machines

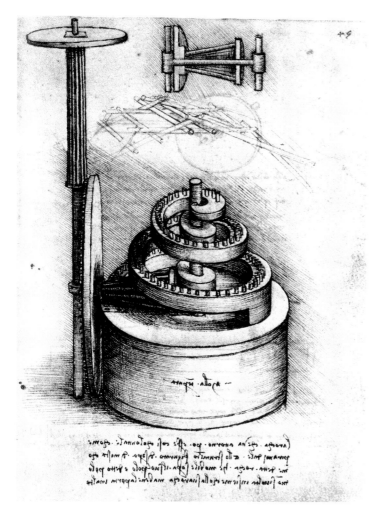

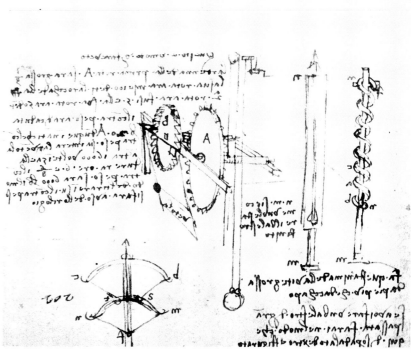

Fig. 78. CA, f. 754 r/278 r-b (detail). Study of pendulum escapement.

Fig. 77. Madrid MS. I, f. 45 r. System for equalizing the release of a spring.

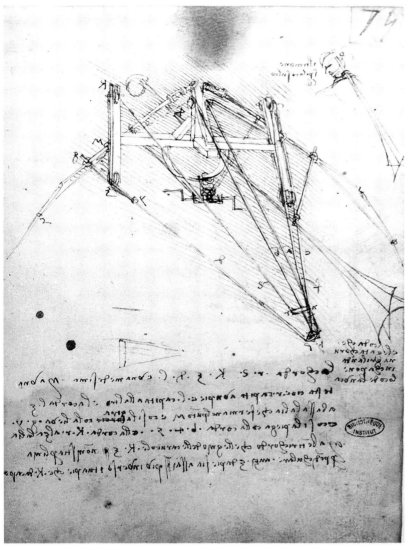

Fig. 79. Paris, MS. B, f. 75 r.

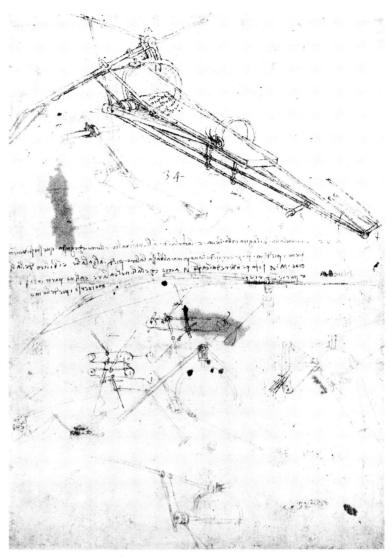

Fig. 80. CA, f. 824 v/302 v-a.

Fig. 81. Paris MS. B, f. 79 v (detail).

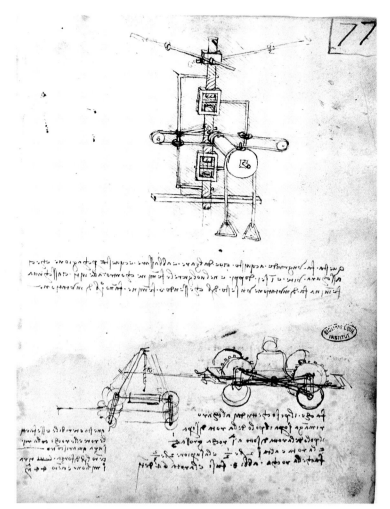

Fig. 82. Paris MS. B, f. 77 r.

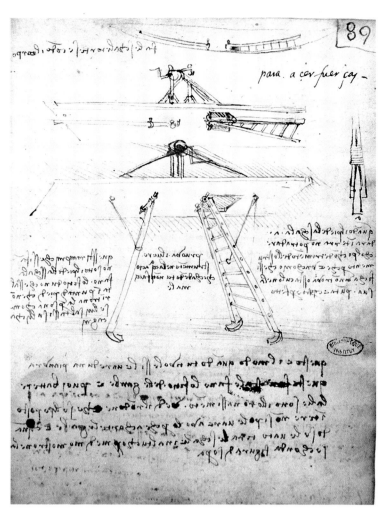

Fig. 83. Paris MS. B, f. 89 r.

to which, in the not unlikely event of a fall, Leonardo attached ridiculous shock absorbers (Fig. 83). It seems impossible that he could really have believed that a man could fly with one of these devices. And yet all the evidence indicates that for several years he worked feverishly and with great expectations on this project. The study of the anatomy of birds, which Leonardo undertook with great meticulousness, convinced him that man could imitate the natural "equipment" of flying animals: "A bird is an instrument which operates according to mathematical laws, which instrument it is in the power of man to imitate" (CA, f. 434 r/161 r-a). Leonardo's studies for flying machines seem to have been based more than any other of his studies on his conviction of the substantial mechanical uniformity of Nature. He believed that the mechanical formulas and principles used by Nature in its creatures, such as birds, could be imitated and reproduced by man. During these years this same faith led Leonardo to immerse himself in the study of human anatomy and to frequently emphasize that the principles of mechanics constitute the indispensable introduction to a treatise on human anatomy.

Leonardo's studies of flying machines were a dream, but a dream nurtured by the hope of opening up vast horizons through a new approach. His dream was rooted in the intuition of the substantial unity of the entire realm of Nature, which used the same simple, necessary laws to produce man, the earth, and the animals.

Leonardo's studies of flight broke off at the end of the 1400s without having reached a real conclusion; he took them up again around 1505, compiling that extraordinary manuscript known as the Codex on the Flight of Birds, now in the Royal Library at Turin. By this time, through a careful

comparison between the muscular power of birds and that of man, Leonardo had realized that man did not have the strength necessary to lift a flying machine. From this point on, flying machines with beating wings disappeared from his studies, and he devoted himself passionately to another, much more realistic possibility: that of "sail flying" like a glider. This new attempt also failed to produce concrete results. Nevertheless, it led Leonardo to important investigations of the mechanics of the flight of birds, of the nature of air, and of the formation and role of winds and air currents. These studies occupied a significant part of Leonardo's activity from 1500 to 1514, and in them the comparison between water and air, swimming and flying, fish and birds becomes increasingly important: "Write of swimming underwater and you will have the flight of the birds through the air" (CA, f. 571 Ar/214 r-d). The universal rule of the four powers of nature found new applications in these studies of the mechanics of fluids, which, although rich in fundamental intuitions, remained at the stage of fragmentary notes and drawings. They awaited a comprehensive reformulation which Leonardo continually promised to do but which he never succeeded in carrying out.

Continual Wanderings (1499–1519)

Leonardo's first Milanese period came to a close with the tumultuous end of the Sforza domination of Milan in 1499 as a result of Louis XII's successful struggle to claim sovereignty over the region. At the beginning of 1500, in Venice, where he had moved with his friend and mathematics teacher Luca Pacioli following a brief stay in Mantua, Leonardo wrote a note on the cover of Paris MS. L that is worthy of the pen of Machiavelli in its conciseness and bluntness: "The duke lost his state, his property, and his freedom, and none of his works was completed for him".[79]

For Leonardo, who was almost fifty years old, there followed a period of continual exhausting travel in search of new patrons who could guarantee him the freedom to study and the comfortable life he had enjoyed while in the service of Lodovico Sforza. Among the few traces of Leonardo's brief stay in Venice are his studies of a series of fortifications on the Isonzo River (CA, f. 638 Dv/234 v-c: Fig. 84) intended to impede access from the mainland into the Venetian lagoon. In the Arundel MS. (f. 270 v) we find drawings and notes which refer to a "movable lock" which "I ordered in Friuli"; these certainly relate to Leonardo's stay in Venice.

When he left Venice, in the company of Pacioli, Leonardo headed South. In March 1501 he was in Florence, where he stayed until the summer of 1502. Leonardo's return to Florence after an absence of twenty years does not appear to have aroused any particular emotion in the city, which was now ruled by a republican government. Nor does he appear to have found great work opportunities there.

Fig. 84. CA, f. 638 Dv/234 v-c (detail).

In a letter dated 3 April 1501, Pietro da Novellara, an agent of Isabella d'Este, described Leonardo as lacking in commissions and hence free to devote himself, in accord with his own inclinations, to those same scientific studies to which he had dedicated a large part of his later years in Milan: "he is hard at work on geometry, and cannot bear to touch a paintbrush". In a second letter of the same year, dated 14 April, Novellara provided more detailed information, recounting a visit to the master; "in short, his mathematical experiments have distracted him so much from painting that he cannot suffer the brush".[80]

This lack of commissions probably led Leonardo to abandon his pleasant *otia* and to accept, in the summer of 1502, the invitation of Cesare Borgia, the notorious Duke Valentino, to follow him as Architect and General Engineer in the military campaign intended to give him, with the support of his father Pope Alexander VI, a vast dominion in central Italy. Leonardo travelled with Cesare through the Marches, Umbria, and Romagna, inspecting strongholds and proposing systems of defence, with ample authority and substantial responsibilities.[81] He participated in the capture of the town of Urbino, where he was undoubtedly attracted by the treasures collected by the Montefeltro family in their famous library, which Cesare sent to Rome. Leonardo probably searched there for the scientific texts he had begun to collect so ardently during his years in Milan. "There is a complete Archimedes in the possession of the brother of Monsignor of Santa Giusta in Rome. The latter said that he had given it to his brother, who lives in Sardinia. It was formerly in the library of the Duke of Urbino, and was carried off from there in the time of the Duke Valentino", Leonardo wrote in a memorandum of 1515 (CA, f. 968 Br/349 v-f). Wherever he went, Leonardo observed and took measurements; in Paris MS. L he recorded the most diverse observations. His most important achievement from this phase is the famous map of Imola preserved at Windsor (RL 12284: Fig. 85). This map reveals the skill developed by Leonardo in map making, a fundamental tool of urban planning and military architecture (this particular map was made for the latter purpose). Here Leonardo adopted and perfected the geometrical relief methods which Alberti had used in the *Descriptio Urbis Romae*. The town of Imola is inscribed in a circle radiating from a centre. From this point the town spreads out in a perfectly detailed drawing, maintaining, thanks to accurate measurements, the exact proportions of streets, squares, and buildings. Leonardo also used different colours to distinguish streets from squares, waterways, and houses.[82]

After his experience with Cesare Borgia, Leonardo returned to Florence in the late spring of 1503, at the height of the war between the Florentine Republic and the city of Pisa. This circumstance led to his first technical commission from the city government. He was asked to give his opinion on how to deviate the course of the Arno in order to flood the city of Pisa and force it to surrender. It is not clear what part Leonardo played in this project of an unmistakably Brunelleschian flavour, a project which also involved other engineers. The digging of the deviation canals was begun in the summer of 1504 with the use of powerful equipment and the participation of about two thousand workers. But the results were extremely disappointing and work was soon abandoned. We can relate to this project several maps and reliefs of the Pisan territory in Madrid Codex II (Fig. 86 and Pl. XI), in which Leonardo gave special attention to the river network. Following a method he had initiated during his years in Milan and developed while in the service of Cesare Borgia, Leonardo inserted his projects into a scrupulous cartographic, hydrographic, and orographic documentation of the region in question.[83]

It is possible that the two drawings of excavating machines (CA, ff. 3 r/1 v-a: Fig. 87; and 4 r/ 1 v-b: Fig. 88) are also related to Leonardo's participation in this project. As Carlo Pedretti has

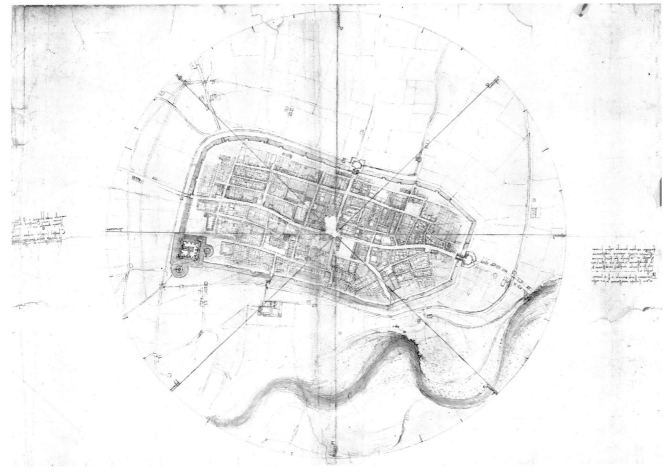

Fig. 85. RL 12284. The plan of Imola.

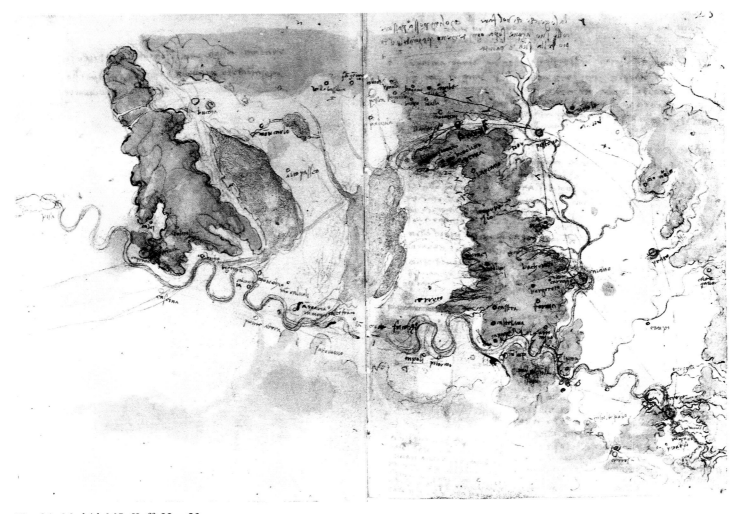

Fig. 86. Madrid MS. II, ff. 22 v–23 r.

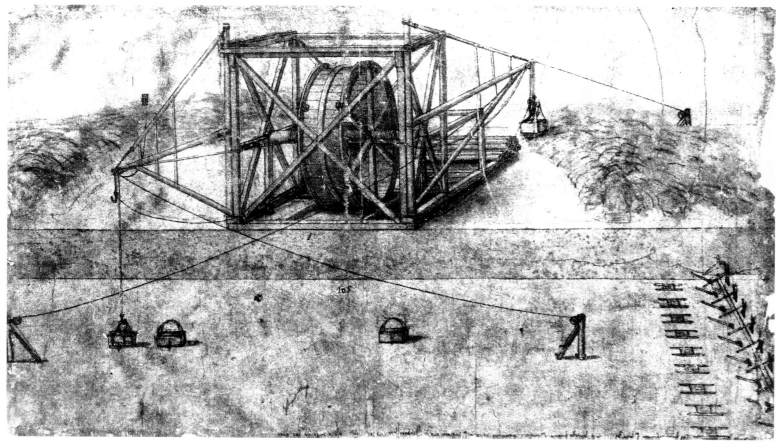

Fig. 87. CA, f. 3 r/1 v-a.

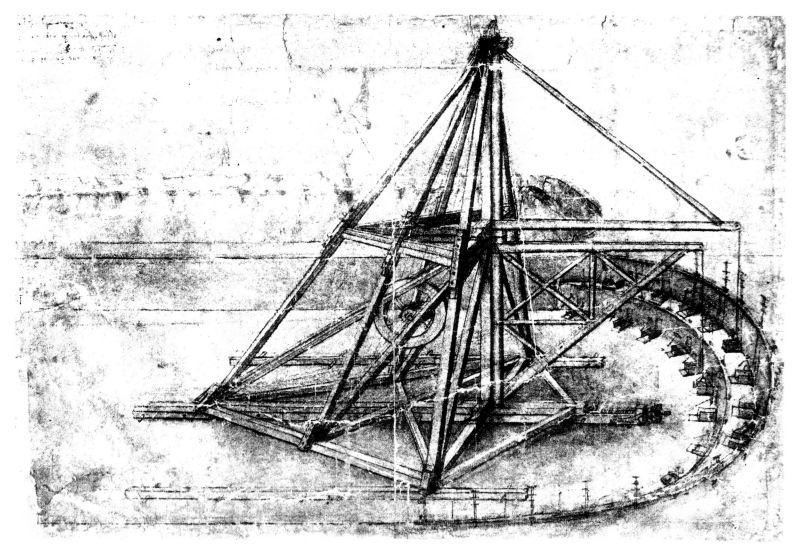

Fig. 88. CA, f. 4 r/1 v-b.

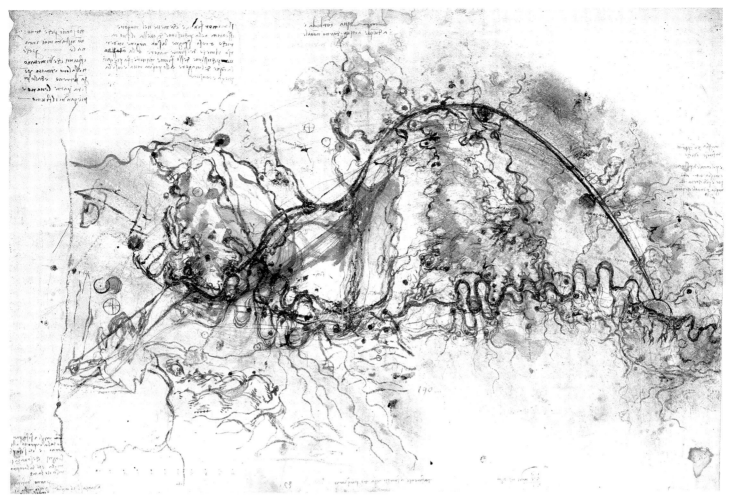

Fig. 89. RL 12279. Project for a canal to make the Arno navigable from Florence to Pisa.

established, the two sheets were originally joined and show the different operation of each of the two gigantic excavating machines working on the same canal.[84] In this way Leonardo intended to clearly demonstrate the superiority of the machine proposed by him (f. 4 r) as opposed to the traditional one (f. 3 r). This superiority consisted in the fact that his machine operated inside the canal and could move forward on rails thanks to a screw device. In addition, it had an effective counterweight to the heavy buckets of earth, in the form of other buckets in which the workers were lowered into the canal and lifted back up to ground level.

The design for the excavating machine with the counterweight system (see also the earlier drawing of an excavating machine in Madrid MS. I, f. 96 r) might, on the other hand, be related to a different series of studies, also from 1503, dealing with a project for the canalization of the Arno River in order to circumvent the unnavigable section between Florence and Empoli. There are a considerable number of studies in Madrid MS. II and in several magnificent drawings at Windsor (Fig. 89) where we see once again Leonardo's characteristic close attention to cartographic, orographic, and hydrographic detail. This project envisaged the construction of a canal that would extend from Florence along the plain between Prato and Pistoia, circumventing the tortuous bends in the Arno between Montelupo and Empoli, and rejoining the course of the river near Vico Pisano. The new canal, which had a semicircular shape, implicated large-scale works such as the construction of a tunnel through the hill at Serravalle, outside Pistoia (see Madrid MS. I, f. 111 r: Fig. 90). In order to keep a steady flow of water in the canal, Leonardo envisaged the construction of a large reservoir in

the Val di Chiana.[85] At a certain point he must have submitted this project to the government of the Florentine Republic, as suggested by several notes in which he insisted, undoubtedly to justify the size and cost of the undertaking, upon the economic benefits that would be derived from it: "this canal will benefit the country, and Prato, Pistoia, and Pisa as well as Florence will gain two hundred thousand ducats a year, and will lend a hand and money to this useful work..." (CA, f. 127 r/46 r-b). Despite Leonardo's optimistic predictions, the Florentine government did not let itself be tempted to undertake a project which it must have considered impossible to carry out.

The important artistic commission that Leonardo received in 1503 from the Florentine Republic (to paint a fresco commemorating the victory of the Florentine army over the Milanese troops at Anghiari in 1440) absorbed much of his energies, but did not cause him to neglect his beloved studies of geometry, which he was probably still conducting under the guidance of Pacioli. Leonardo was particularly involved in the compilation of a treatise on the transformation of geometrical figures. A new commission, this time from Jacopo IV Appiani, lord of Piombino, took Leonardo away from Florence in 1504. In all likelihood with the encouragement of the Florentine Republic, which was allied to Appiani, Leonardo acted as his consultant in matters of military fortifications (Fig. 91).[86] When he returned to Florence, he once again immersed himself in the study of geometry and in the preparation of the *Battle of Anghiari*. In 1505 he again took up the study of anatomy with some intensity. As we have already mentioned, 1505 was also the year Leonardo compiled the Codex on the Flight of Birds. In May of 1506 he was again forced to interrupt his studies when he was imperiously recalled to Milan by the French governor, Charles d'Amboise, apparently for works of painting and architecture. Between 1506 and 1507 he continually travelled back and forth between Milan and Florence, where he had to return because of his litigation with his brothers over their uncle's estate; he was also being pressured by the Florentine government to finish the *Battle of Anghiari*. Needless to say, it was difficult for Leonardo to complete anything under such conditions.

Leonardo spent the last part of 1507 and a good part of 1508 in Florence. He continued to study anatomy (this was his most intense, fruitful period in this field), taking advantage of the access he had gained to the city hospital. And while he was dissassembling the constituent organs of the human machine in order to understand its mechanical secrets, Leonardo also turned his attention to the

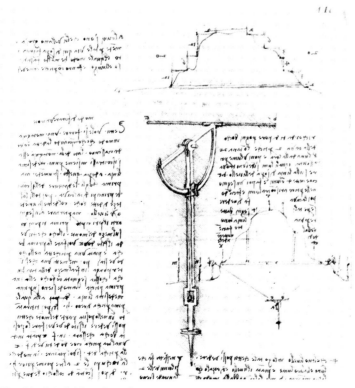

Fig. 90. Madrid MS. I, f. 111 r (detail). Project for a tunnel at Serravalle.

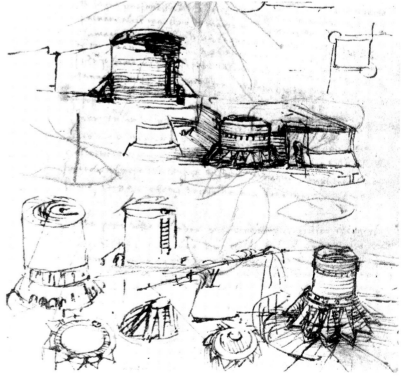

Fig. 91. Madrid MS. II, f. 37 r (detail). Studies of fortifications at Piombino.

machine of the earth, which he explored with equal anatomical carefulness in his search for solid proof of the close symmetry between man (the "lesser world") and the cosmos.[87] By this time geometry and mechanics, anatomy and geology, in a continual exchange of concepts, principles, and analogies, were Leonardo's preferred field of activity, as can be seen in his manuscripts from these years: the Codex Hammer, the anatomical sheets at Windsor, and the Arundel MS., which was begun in Florence at the home of Piero di Baccio Martelli in 1508.

During this period of restlessness Leonardo's interest in practical technical applications seems to have dwindled to the point of disappearing altogether. His propensity for studies of a theoretical nature grew with his conviction that all knowledge presupposes the mastery of geometry. The few surviving applied studies from this time were increasingly based upon the natural laws which Leonardo was in the process of formulating. He displayed the same tendency in Milan, where he moved at the end of 1508. There he further developed the anatomical and geological studies he had begun in Florence, always insisting upon the close connection between cosmos and microcosm. He intended to compile treatises on these subjects. He maintained his interest in geometry, especially in the geometrical transformation that he believed to be a formidable tool for the art of painting and the investigation of solid bodies. He used such transformations in his studies of myology (the lengthening and shortening of muscles) and hydrodynamics (the flow of blood in the arteries and valves of the heart, but also the flow of water in winding rivers).[88]

Leonardo's attempt to derive practical applications from theoretical premises is evident, for example, in the treatise he was planning to write on water, the key element in his dynamic universe. The table of contents of this treatise shows that the first chapters were to deal with theoretical questions, from which the sections of hydraulic engineering would be derived (Codex Hammer, f. 15 v: "Book 10: Of River Repairs. Book 11: Of Conduits. Book 12: Of Canals. Book 13: Of Machines Turned by Water. Book 14: Of Raising Water..."). Only occasionally do technological projects of the type seen so frequently before 1500 appear in Leonardo's studies from these years. His progressive involvement in theoretical questions seems to have brought with it a lessening of his interest in practical applications. We find confirmation of this even in the kind of celebratory scholarship which we have so often warned against here, which presented Leonardo as the sensational inventor of every modern device: it is widely recognized that all of his supposed discoveries took place before the end of the fifteenth century.

By this time Leonardo worked on specific technical projects only when asked to do so by his patrons. This is the case of the project he worked on between 1508 and 1510, probably by order of Louis XII, to bypass the narrow portion of the Adda River near the Tre Corni at Paderno, of which there remain elements of the complicated and perhaps unrealizable (at any rate, unrealized) solutions devised by Leonardo (Fig. 92).[89] Taking advantage of the generous patronage of the king of France, who allowed him a great deal of free time, Leonardo was able to develop his "vocation", which seems no longer to have been that of an engineer, but rather that of a scientist.

This tendency to abandon the activity of engineer remained evident during the years Leonardo had still to live after he was forced to leave Milan in 1513 as the result of the French defeat and the return of the dukedom of Massimiliano Sforza. Leonardo, now an old man, was once again forced to set out on tiring travels in search of new patrons. He stopped in Florence, where his old patrons the Medici had returned to power. Then he went on to Rome, in the service of one of the members of that family, Giuliano de' Medici, the brother of Pope Leo X. In exchange for a salary and protection,

Leonardo placed his skills as a hydraulic engineer at Giuliano's disposal, advising him on the project for draining the Pontine marshes (see Pl. XV). This was later carried out but it is unlikely that Leonardo played a significant role in it. In Rome Leonardo occupied himself with making parabolic mirrors (Arundel MS., f. 279 v) by connecting many pieces of glass. He also studied devices for manufacturing

Fig. 92. RL 12399.

rope, which are found among his last technological drawings in the Codex Atlanticus (ff. 12 r/2 v–a: Fig. 93; and 13 r/2 v–b: Fig. 94): one of these bears the Medici symbol of the diamond ring, which proves that he received the commission from Giuliano. This sporadic return to practical technical activities can be explained by the pressure of immediate, specific demands. But as soon as possible he resumed the study of geometry, optics, and anatomy; the latter led him to frequent the Roman hospital of Santo Spirito, which at a certain point he was forbidden to visit on account of an accusation of necromancy.

In the summer of 1516 the lily of France once again brought good fortune to Leonardo. The new king, François I, invited Leonardo to follow him to France, offering him exceptional rewards and honours. Leonardo's main activity during these years was the project for a new royal palace at Romorantin, which was linked to a whole series of projects for the canalization of the waterways of the region.[90] None of these projects was ever carried out. In reality, Leonardo did not work a great deal in France. His mere presence in a court that would attract talents of every kind, particularly from Tuscany (Cellini, Guido Guidi, and so on), justified the excellent treatment he received and the payment of a pension to him as "*premier peinctre et ingénieur et architecte du Roy*". The account of Antonio de Beatis, who came to France with Cardinal Luigi of Aragon and visited Leonardo on October 10,

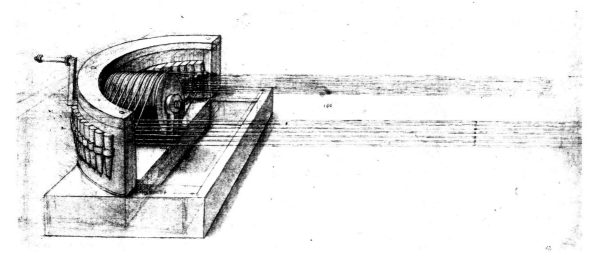

Fig. 93. CA, f. 12 r/2 v–a.

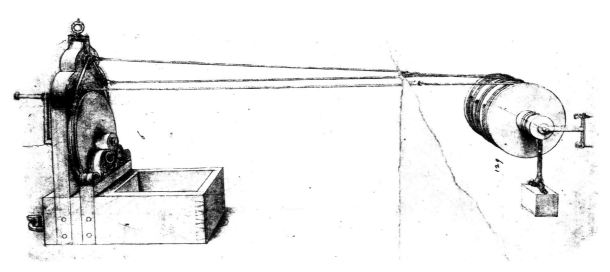

Fig. 94. CA, f. 13 r/2 v–b.

1517, describes a man who evoked admiration not so much for his present activities, which were impeded by his age, as for the extraordinary knowledge he had succeeded in acquiring in every field of learning.[91] The accounts of those who saw Leonardo during the last years of his life paint a picture of a wise, learned old man, quite removed from that of a modest technologist. In a passage describing the extraordinary affection of François I for Leonardo, Benvenuto Cellini, correctly interpreting the metamorphosis that had taken place, calls the aged Leonardo "a very great philosopher":

> King François, who was extremely taken with his great virtues, took so much pleasure in hearing him speak, that he was separated from him only for a few days out of the year... I do not wish to neglect to repeat the words I heard the king say of him, which he said to me... that he believed that there had never been another man born in the world who knew as much as Leonardo, not so much about sculpture, painting, and architecture, as that he was a very great philosopher.[92]

Leonardo and the Engineers
of the Renaissance

In recent years several scholars have suggested that the traditional view of Leonardo as an engineer and inventor should be revised. Solidly basing their work on a series of important studies of formerly neglected manuscripts of the many engineers who were active before and during Leonardo's time, these scholars have shown that many of his presumed sensational discoveries can be found in earlier works (especially in Taccola and Francesco di Giorgio and, at times, even in mediaeval manuscripts of the French and German tradition, which echoed the great classical tradition). This holds true for the diving suit, the automobile, the parachute, the crankshaft, the tank, and the multiple-barreled cannon. Beck[93] and Feldhaus,[94] the first great historians of Renaissance technology, had already indicated that this was the case, but other scholars did not follow them. More recently the work of Reti,[95] Gille,[96] Prager,[97] Scaglia,[98] and others has provided evidence that is too probing to be ignored.

At the same time, proof has been found in Leonardo's manuscripts that he carefully attempted to master the technical solutions introduced by the engineers of antiquity and by the most respected engineers of his own time. Suffice it to mention his fruitful contact with Francesco di Giorgio and the evidence in his notes of the attention he dedicated to the studies of that great Sienese engineer. In fact, Leonardo copied many passages from a treatise by Francesco di Giorgio into Madrid MS. II.[99] At a certain point he also had at his disposal a magnificently illustrated copy of Francesco di Giorgio's treatise on architecture, with its wealth of carefully executed drawings of machines and mechanical devices; there are several autograph notations by Leonardo in this manuscript (Fig. 95).[100]

This more serious historical approach, which assesses Leonardo's career within the framework of the context in which it developed, considerably modifies our vision of him. He appears, in fact, to have had a background, interests, working method, and type of career similar to the other Renaissance engineers with whom traditional historiography had disdainfully contrasted him. Thus, present-day scholars, instead of dwelling on the great loss represented by the dispersal of Leonardo's manuscripts, use his papers as a source for the reconstruction of fundamental aspects of the technical knowledge of the fifteenth and sixteenth centuries, for many of which they provide the only surviving documentation.

This is the result of a complete reversal of historical orientation, of which the most significant example is the book on Leonardo and the engineers of the Renaissance by the outstanding philologist and historian of technology, the late Bertrand Gille.[101] Overturning the traditional celebratory image of Leonardo as a solitary, misunderstood innovator in every field of technology, Gille emphasized the many similarities between Leonardo and other engineers of his time, based upon a remarkable amount of documentary evidence. But Gille's strongly polemic stance toward the traditional adulatory view of Leonardo led him to excesses in the opposite direction. In Gille's work, in fact, the characteristic aspects of Leonardo's technology disappear into the melting pot of technical solutions, working methods, and professional activities typical of all the Renaissance engineers.

This is an equally unacceptable conclusion, which neither helps us to understand Leonardo nor to

Fig. 95. Francesco di Giorgio, Ashburnham MS. 361, f. 44 v. Leonardo's autograph writings are at the top of the two columns of writing.

grasp the nature of his relationship to other engineers of his time. Gille's work, in addition to suffering from a view of the evolution of technology as a linear process without abrupt developments, also reflects the limitations of a study of Leonardo's texts which lacks a criterion for chronological ordering. Gille was unaware of the distorting effects of his separation of Leonardo's studies of applied technology (machines and mechanical devices) from his more theoretical scientific studies, which he unjustly neglected. Following Gille, other scholars have stressed the substantial similarities between Leonardo's work and that of other great engineers of the Renaissance.[102]

The brief outline of the chronological development of Leonardo's career as an engineer given in the preceding pages offers the possibility of posing the problem in more balanced terms. Leonardo's early career is characterized by attitudes, practices and interests, that were common among other engineers of his time. The evidence that he was trained in Verrocchio's workshop is incontrovertible;

and it is safe to assume that at the very beginning of his career as an engineer Leonardo chose Brunelleschi as his model. But in the course of a half century Leonardo's career underwent a significant evolution, which must be taken into account. The turning point occurred a few years after Leonardo moved to Milan. His manuscripts began to record with increasing frequency the evidence of his effort to base his technological studies on entirely new foundations. He desperately sought books and experts who could help him with Latin or Greek texts; he struggled to learn Latin, asked himself new questions, investigated the causes of mechanical effects of which he had a practical mastery. With the passing years this tendency became increasingly marked and involved every aspect of Leonardo's activity, not only engineering. Indeed, it was as a painter that Leonardo first raised fundamental questions. In the mid–1480s Leonardo's entire professional personality began to undergo a process of transformation. He systematically practised the observation and imitation of Nature in every field: man, animals, the earth, the great physical agents of water and air. The science of mechanics seemed to offer him, with its law of the four powers, the key to understanding every natural phenomenon. Following classical and mediaeval tradition (Archimedes and the science *de ponderibus*, in particular), often with the assistance of others, Leonardo realized that mechanics was useless without geometry (it was not by chance that he defined mechanics as the "paradise of the mathematical disciplines"). In the geometrical studies, in which he passionately immersed himself at the end of the fifteenth century, we can recognize Leonardo's habitual method: he drew upon the knowledge of friends (in this case, Pacioli), took as much as he could from diligently acquired books and manuscripts (Euclid, Archimedes, etc.), and then undertook original research and reflection.

No other Renaissance engineer reveals a similar evolution. Nor did any of them achieve results like those that Leonardo obtained. This is not to say that he formulated a coherent system of knowledge, i.e. a well-founded, comprehensive scientific encyclopaedia. As we have said, he achieved both spectacular and modest results in every field of activity: he never mastered Latin perfectly; in the field of mechanics, apart from some brilliant ideas, he never succeeded in bringing into focus the fundamental concepts of force, percussion, and movement; his prolonged efforts to learn geometry did not produce great results, nor did his splendid drawings and acute insights change the face of the science of anatomy, or geography, or physics, or optics (where he achieved what were perhaps his most advanced results). He was planning to write general works in each of these fields, recording many solemn beginnings or ambitious tables of contents which he never followed up. He did not escape the limitations of his early training, maintaining to the end the characteristic "workshop" style of jotting down brief notes, each unrelated to the other. This typical procedure by "cases", is also found in Leonardo's more thematically organized manuscripts such as the Codex Hammer or Madrid MS. I.

Hence it is necessary to recognize that the limitations of Leonardo's training (which for that matter he never regretted, proudly declaring himself to be an "unlettered man" and a "disciple of experience"), and the scope of his ambitions, determined the substantial failure of his project of re-founding all of the arts and sciences on unified principles and procedures. But Leonardo felt the need to devote tremendous energy to this undertaking. And it is precisely this that distinguishes him from the other engineers of his time. It is likely that some of Leonardo's colleagues were more capable than he was as military architects, as builders of mechanical devices and machines, as hydraulic engineers. And it is certain that most of them kept the commitments they had made with greater regularity. But it does not appear that any of them ever felt the need to provide a more solid foundation for their

activity, which remained based exclusively on procedures and practices acquired in the exercise of their art.

In fact, by the end of the fifteenth century there were considerable differences between Leonardo and other engineers of his time or of earlier generations. It was not by chance that this inconclusive, unreliable, moody man was the most sought after and honoured by patrons who were accustomed to treating their engineers in a very different way, by paying them for specific tasks. Perhaps the only Renaissance personality who can be compared to the mature Leonardo is Leon Battista Alberti. And it is not surprising that Alberti was not a practical technician but a highly learned humanist who had compiled influential artistic treatises and had used his vast knowledge of the classics to show the profession of the architect-artist in all of its complexity. He illustrated perfectly, in fact, how this profession implied — over and above a mastery of *"disegno"* — geometrical knowledge, complex technical know-how, and a precise notion of statics, not to mention notable capacities for the creation of "form" imbued with precise symbolic connotations. Such implications were the consequence of Alberti's awareness of the unity of principles and forces, which led him to insist upon the constant symmetries linking man, buildings, and the universe. A considerable amount of evidence shows that these Albertian themes attracted Leonardo, who at a certain point probably recognized in Alberti a model to follow.[103]

It is not, however, only the evolution and importance of Leonardo's investigations of general causes and laws, or the consequences that these produced on his way of dealing with practical applications, that distinguish him from other engineers of his time. As is made evident by a simple comparison of Leonardo's manuscripts with those of his colleagues, his technological drawings have a totally unique character and power. In this field as well, Leonardo's studies clearly reveal an evolution, from his early, somewhat uncertain, technological drawings to the progressive definition of a precise strategy of technological rendering which reached its height between the end of the 1480s and the beginning of the 1490s. Leonardo's incomparable ability as a technical draughtsman was not merely the fruit of his superior artistic ability. It derived from a deliberate "intellectual" attempt to consistently replace the working model, which he had previously used extensively, with the technical project in the form of a drawing. To obtain this result, in architecture as in sculpture, in the design of dynamically operating machines as well as in the depiction of human organs and their functions, Leonardo was the first to perfect a series of remarkable techniques that were destined to change the style, method, and function of scientific illustration. One would search in vain for anything similar in the notebooks of other Renaissance engineers. Carlo Pedretti's introduction to the present catalogue masterfully demonstrates the importance of the revolution in illustration introduced by Leonardo and its many important implications; hence I need not insist upon it here.

Leonardo's Method: From the Anatomy of Machines to the Man–Machine

The originality of the results that Leonardo's new approach enabled him to achieve is particularly evident in an important group of studies dating from the last decade of the fifteenth century, which I propose to analyze for their extraordinary character. These are highly effective studies of mechanics, of which it is impossible to find even vague precedents in the notebooks of Leonardo's contemporaries or in those of engineers of earlier generations. In addition, these studies are an eloquent indication of how the formulation of universal mechanical principles and the systematic use of geometry led Leonardo to project technological analysis beyond its traditional boundaries (i.e. machines and mechanical devices), and transform it into, among other things, a formidable tool for the study of the human body.

I wish to refer to the treatise on the mechanical elements (*elementi macchinali*) which Leonardo stated several times he had compiled, making numerous references to specific "propositions". The identification of this work has been discussed by, among others, Arturo Uccelli in his ponderous attempt to reconstruct Leonardo's books on mechanics in 1940.[104] Uccelli's work is a typical example, not advisable today, of the type of scholarship that was intent upon transforming into a comprehensive treatise a work that had been conceived in fragmentary form and had remained incomplete.[105] Uccelli conjectured that Leonardo's treatise on mechanics was divided into two parts, the first of which dealt with theoretical mechanics (motion, weight, force, and percussion), while the second collected and organized his notes on the "mechanical elements",[106] that is, according to Uccelli, on applied mechanics (mechanisms for pulling and lifting, pulleys, axles and wheels, screws).

The sensational discovery in 1966 of two Leonardo manuscripts in Madrid,[107] that offered fascinating new material related to his proposed treatise on mechanics, led historians to return to this question. In Madrid MS. I, which is devoted entirely to mechanics, we find a clear distinction between a section on theoretical mechanics and one on applied mechanics and specific mechanisms.[108]

Ladislao Reti, who played an important part in the discovery, was entrusted with producing the edition of the two manuscripts, which saw the light shortly after Reti passed away in 1974. He also wrote several essays on these manuscripts, particularly on the notes on mechanics in Madrid MS. I.[109] Reti was especially attracted by the initial section of the manuscript (which is the second in chronological order), in which he believed he could identify an advanced stage of the treatise on "mechanisms". Reti believed that this treatise corresponded to some extent to the "mechanical elements" to which Leonardo so often referred.

Reti's work, which strongly reflects his astonishment at the discovery of so much new Leonardo material, sometimes runs the risk of oversimplification. He believed that Leonardo's "mechanical elements" corresponded to an orderly series of reflections upon the "elements of machines", i.e. upon simple mechanisms, based on logical models which would, in actual fact, appear only three centuries later with the École Polytechnique in Paris, finding their definitive canonization with Franz Reuleaux in the mid-nineteenth century.[110]

Once again, the urge to emphasize Leonardo's sensational prophecies led to serious misunderstandings. In reality, Leonardo's many references to the treatise on "mechanical elements" leave no

room for doubt as to the nature of the text, nor do they allow it to be related to a detailed analysis of mechanical devices. In a text in the Codex Atlanticus (f. 444 r/164 r-a), which Pedretti dates to about 1500,[111] Leonardo states that a body that descends along a 45° angle "becomes half its natural gravity, as I proved in the fifteenth conclusion of the fourth book of mechanical elements composed by me". In another passage in the Codex Atlanticus (f. 161 r/58 r-a, *c.* 1503-5)[112] we read: "Of two cubes which are double the one of the other, as is proven in the fourth [book] of mechanical elements composed by me"; and again in the Codex Atlanticus (f. 220 v/81 v-b, *c.* 1508):[113] "Mechanical elements. Of a weight proportional to the force that moves it, we must consider the resistance of the medium in which that weight is moved, and I shall write a treatise on this". We find other references in Paris MS. I (f. 22 v, 1499): "By the ninth [proposition] of the second [book] of elements, which says: The centre of every suspended weight comes to rest beneath the centre of its support..."; and finally, in the Codex on the Flight of Birds (f. 12 v, *c.* 1505): "If the bird wishes to descend head first, with such obliquity as would turn it upside down, this cannot happen because the lighter part would be below the heavier, and the light would come to descend before the heavy, which is impossible, as proven in the fourth [book] of mechanical elements". Other references to the "mechanical elements" are in the anatomical studies at Windsor,[114] especially the ones dating from 1508-10, where Leonardo mentions the "book on mechanical elements, with its practice" (RL 19009 r; K/P 143 r); on another sheet he again refers to the "fourth [book] of mechanical elements", where it is proven that "a longer lever has more power" (RL 19010 v; K/P 147 v).

The tenor of the passages quoted above unequivocally shows that Leonardo's references have nothing to do with a treatise on the "elements of machines", but rather with his "elements of mechanics". In fact, Leonardo refers to a division of the treatise into two parts, one theoretical and one practical. In addition, it is clear that the treatise included sections on the duplication of the cube and the theory of centres of gravity, of levers, and the inclined plane. In particular, the fourth book, which is the one Leonardo mentions most frequently, presented questions of general theoretical mechanics, while the only reference to practical applications is in the passage from the Codex Atlanticus which suggests taking into account the interfering influence of the medium when calculating force and resistance.

In all likelihood, "mechanical elements" is the title under which Leonardo intended to collect his reflections on mechanics. Following the model of classical and mediaeval statics, the role of geometrical analysis was crucial for Leonardo. He must have intended including in this treatise sections on the theory of the four "powers" of Nature (motion, weight, force, and percussion), and reflections upon centres of gravity and on methods for determining them, as well as the traditional analysis of simple machines. The practical portion would have included single and combined uses of mechanical devices and systems for optimizing them, along with the machines for producing them.[115] This also corresponds to the overall ordering indicated in many of Leonardo's memoranda.

Thus Leonardo's "mechanical elements" do not indicate a treatise on mechanisms, but rather on all mechanics. The very expression "mechanical elements" precisely reflects this function, in keeping with traditional terminology. "Mechanical elements" is an expression much like Euclid's "geometrical elements", where the word "elements" is equivalent to "foundations" or "principles". Another even more direct model was provided by a text which strongly influenced Leonardo, the *Elementa Jordani super demonstrationem ponderis* — a text on theoretical mechanics (i.e. mechanical principles) like the one Leonardo intended to compile.

Having clarified the true nature of Leonardo's treatise on "mechanical elements", we must recognize that the emphasis placed by Reti on the extraordinary penetration with which Leonardo analyzed the principles and criteria of the functioning of machines in Madrid MS. I is totally justified. The most remarkable portion of the manuscript is certainly the first part, where Leonardo analyzed in detail a series of mechanical devices, lingering over their most efficient characteristics and evaluating their power and resistance, construction materials, and methods of application (Figs 96-98).[116] He also gave great attention to the friction produced during operation, attempting to devise solutions for lessening it (Fig. 99). What we have here is a veritable "anatomy" of machines, often presented with powerful drawings that reveal an exceptional graphic mastery. The idea of a "dissection" of machines was, in fact, very clear in Leonardo's mind:

> All such instruments will generally be presented without their armatures or other structures that might hinder the view of those who will study them. These same armatures shall then be described with the aid of lines, after which we shall describe the levers by themselves, then the strength of the supports... (Madrid MS. I, f. 82 r).

Technological drawing plays a leading role here. It allows Leonardo to skilfully analyze these devices and to reassemble them with an illuminating range of different techniques of illustration based upon an exceptional mastery of perspective. The devices are seen from various points of view, in plan, in exploded views, in geometrical diagrams. Often the relationship between a device and a machine is captured with synthetic effectiveness by a drawing, as in the screw-jack with anti-friction bearings on Madrid MS. I (f. 26 r: Fig. 100), or in the note referring to the device for transforming circular motion into alternating motion (Madrid MS. 1, f. 12 v: Fig. 101) as particularly appropriate for a mechanical saw, like that drawn on folio 1078 Ar/389 r-a of the Codex Atlanticus (Fig. 102). Leonardo attempted to break down into a numerically finite catalogue the components or "organs" which make up the infinite variety of machines or "organisms": "Once the instrument has been created, its operational

Fig. 96. Madrid MS. I, f. 25 v. Composite water pipes.

Fig. 97. Madrid MS. I, f. 85 r. Various kinds of spring.

Fig. 98. Madrid MS. I, f. 17 v (detail). Toothed wheel and worm screw.

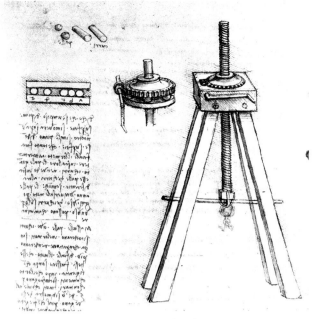

Fig. 100. Madrid MS. I, f. 26 r (detail).

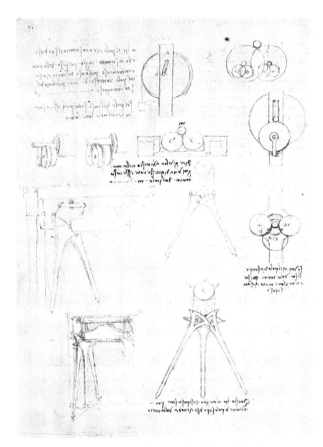

Fig. 99. Madrid MS. I, f. 12 v. Studies of devices to reduce friction.

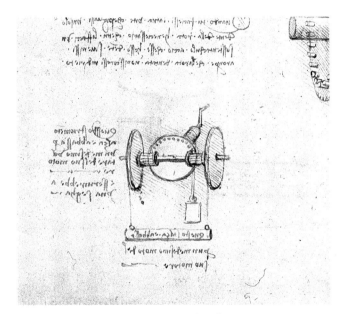

Fig. 101. Madrid MS. I, f. 17 v (detail).

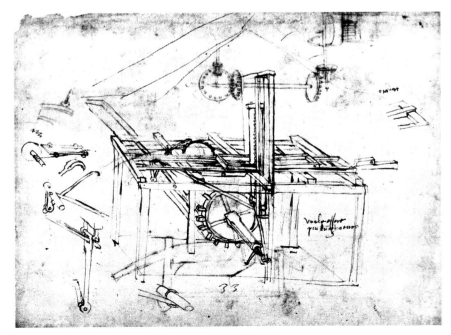

Fig. 102. CA, f. 1078 Ar/389 r-a. Sawmill.

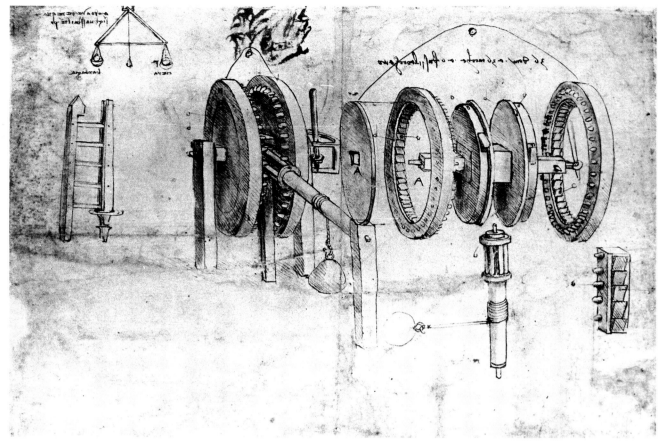

Fig. 103. CA, f. 30 v/8 v–b. General and exploded view of a hoist.

requirements shape the form of its members, which may be of infinite shapes, but all are subject to these rules of the four volumes" (Madrid MS. I, f. 96 v).

In other cases, the entire machine is presented in an exploded view (CA, f. 30 v/8 v–b: Fig. 103) to expose the complexity of the devices that ensure its smooth running.

Nevertheless, the extraordinary, almost rhetorical power of these drawings and notes, which Leonardo arranged with such care on the pages of these manuscripts, should not lead us to take for granted that these pages contain sensational discoveries. It is only with extreme caution that the invention of devices such as the ball bearing[117] (Fig. 104) or the universal joint[118] (Fig. 105) should be attributed to Leonardo. The most we can say is that we find in Madrid MS. I their first illustration.

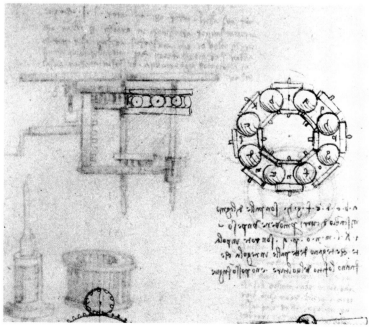

Fig. 104. Madrid MS. I, f. 20 v (detail).

Fig. 105. Madrid MS. I, f. 100 v (detail). The universal joint is in the centre.

Leonardo's true originality lies in his approach and his "style". No one had ever attempted to insert a section so rich in details of practical applications into a treatise on mechanics. Nor had anyone before him approached mechanical applications with such a determination to derive them from general principles and subject them to rigorous quantitative analysis and geometrical schematization. Madrid MS. I bears witness to Leonardo's efforts around the 1490s to unite two mechanical traditions which until then had proceeded along substantially separate paths: on the one hand, classical and mediaeval mechanics which, with the partial exception of the "cases" of Aristotelian mechanics, had for the most part neglected practical applications; and on the other hand the mechanics practised in workshops by craftsmen who had only second-hand knowledge, or none at all, of texts on geometrical statics. At the beginning of his career Leonardo had been one of these "unlettered" craftsmen. But he made an enormous effort to train himself professionally. He came into contact with the sources of the great mechanical tradition and strove to assimilate the "elements" of geometry. Yet he never forgot his workshop training, nor the importance of *giovamenti* (practical benefits); he attempted to enlarge the boundaries of the science of mechanics to include real machines that operated with physical structures, encountered friction and obstacles in the medium, or made use of materials of limited resistance. And he always derived every investigation from general principles, subjecting every anomaly to a precise quantitative analysis.

What we should appreciate is Leonardo's attempt to redefine the science of mechanics, rather than the concrete results he obtained, which were not exceptional and which were even, at times, incorrect. This attempt corresponds to a project for the radical reformation of the profession of the engineer and clearly indicates how removed Leonardo was from so many of his admittedly able, worthy colleagues.

★

These mechanical investigations were not destined to remain an end in themselves. In the more than twenty years between the last notes and drawings in Madrid MS. I and the death of Leonardo, his "anatomy of machines" does not seem to have made great progress. And yet these investigations provided a model which Leonardo steadfastly attempted to transfer to other fields of research. It is no coincidence that references to the "mechanical elements" become more frequent in his papers after 1500. By this time, the four powers of Nature had come to be seen by him as the cause behind every effect. In addition, Leonardo strove to achieve a complete geometrical analysis, concentrating on dynamic processes and on the mechanical instruments by which they could be carried out. This method found an application in Leonardo's architectural studies, where he introduced the laws of the "mechanical elements" to account in quantitative terms for the lateral thrusts of arches (Madrid MS. I, f. 143 r: Fig. 106). He analyzed buildings and their components as if they were "machines", not merely static structures based on precise proportions, but living organisms in dynamic equilibrium. Hence the evocative analogy between the physician and the architect — a *topos* widely used by Renaissance architects which Leonardo took up, shifting the emphasis from the similarities between the human body and buildings, to the mechanical knowledge necessary to understand both:

> Just as doctors... should understand what man is, what life is, what health is... and with a good knowledge of the things mentioned above, he will be better able to repair than one without it... The same is necessary for an invalid building, that is a doctor-architect who has a good knowledge of what a building is, and

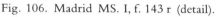

Fig. 106. Madrid MS. I, f. 143 r (detail).

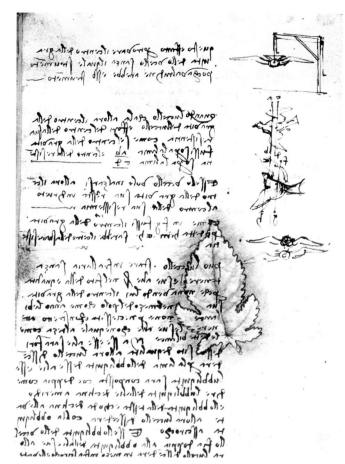

Fig. 107. Codex on the Flight of Birds, f. 15 v (detail).

from which rules good building derives, and the origin of those rules and into how many parts they are divided and what are the causes that keep a building together and make it last and what is the nature of the weight and the thrust of the force... (CA, f. 730 r/270 r-v).

Even the earth appeared to Leonardo as a huge living, breathing organism traversed by a constant circulation of humours, where every ebb and flow, every rise or fall of water follows mechanical laws. In the animal world, his study of the bird-machine revealed the mechanical secrets governing the marvel of flight, which Leonardo often referred to as "balancing in the air", while he compared the action of wings to that of a wedge:

> The hand of the wing is what causes the impetus; and then the elbow is held edgewise in order not to check the movement which creates the impetus; and when this impetus is afterwards created, the elbow is lowered and set slantwise and in slanting it makes the air upon which it rests almost into the form of a wedge, upon which the wing raises itself... (Codex on the Flight of Birds, f. 15 v: Fig. 107).

After 1500, man became Leonardo's preferred field of mechanical investigation. Under the significant influence of Ptolemy's cosmography, Leonardo outlined his own programme for a universal mechanical geography, a new, amply illustrated encyclopaedia based upon a limited number of fundamental mechanical principles and on rigorous geometrical analysis. Leonardo radically transformed the encyclopaedic idea of the Renaissance. He no longer saw it as a system of universal

correspondences and harmony of proportions, but as a unity of processes and functions, a unity based on motion, with constant mechanical laws and models for every type of organism: machines, buildings, the earth, animals, and man. Obviously, man occupied a prominent place in this ambitious project, and Leonardo devoted many of his most striking drawings and writings to the description of the marvellous human machine.

In the extraordinary series of anatomical drawings from the first decade of the 1500s, Leonardo's mechanical approach, influenced by the model of the "mechanical elements", becomes strikingly evident. In essence, Leonardo's study of human anatomy appears to a great extent to be an offshoot of his study of the "anatomy" of machines, which preceded his anatomical studies both conceptually and chronologically.[119] Leonardo's studies of human anatomy are indebted to his mechanical investigations not only for their general physical principles, but also for certain characteristic features of vocabulary, techniques of illustration, and several striking analogies. The corpus of Leonardo's anatomical studies at Windsor abounds in explicit statements about their dependence on mechanical models:

> Arrange it so that the book on the mechanical elements with its practice precedes the demonstration of the movement and force of man and of other animals, and by means of these you will be able to prove all of your propositions (RL 19009 r; K/P 143 r).

And again, in a note with the heading "On machines":

> Why Nature cannot give movement to animals without mechanical instruments, as I demonstrate in this book, in the active movements made by Nature in animals; and for this reason I have drawn up the rules of the four powers of Nature, without which Nature cannot give local motion to these animals (RL 19060 r; K/P 153 r).

Leonardo's anatomical investigations present the human body as a remarkable ensemble of mechanical devices:

> It does not seem to me that coarse men with lewd habits and little reasoning power deserve so beautiful an instrument or so many varieties of mechanism [*machinamenti*]... (RL 19038 v; K/P 80 v).

He continually stresses the necessity to look beneath the "armatures" of the human body, exactly as he had suggested doing with machines: "Break the jaw from the side, so you can see the uvula" (RL 19002 r; K/P 134 r: Fig. 108); and "I want to remove that part of the bone which is the armature of the cheek... to reveal the breadth and depth of the two cavities that are hidden behind it" (RL 19057 v; K/P 43 v).

In these drawings the articulations of the human body are presented as revolving axles (*poli*). In the notes and the beautiful drawings on a Windsor sheet (RL 19005 v; K/P 141 v: Fig. 109) the shoulder joint is analyzed in exactly the same way as the universal joint or "*polo*" is in Madrid MS. I (f. 100 v). Again, the term "*polo*" is systematically used to indicate the axis of rotation of the ankle in a passage which stresses the analogy between the constituent organs of the human body and mechanical devices:

> The fulcrum [*polo*] *a* is the one where a man balances his weight through the tendons *m n* and *o p*, which are to the shank of the leg above the said fulcrum what the shrouds are to the masts of ships (RL 19144 r K/P 102 r).

Here we find the mechanical analogy of the mast of a ship, with its supporting stays, which Leonardo would later use extensively in his magnificent studies of the spinal column (RL 19049 r and

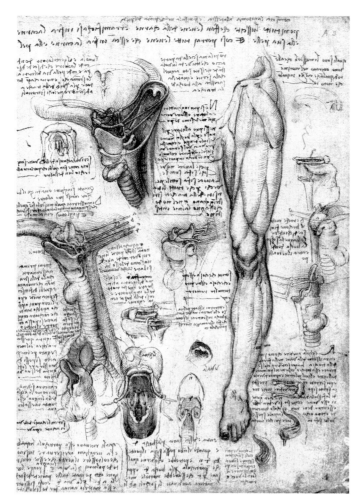

Fig. 108. RL 19002 r; K/P 134 r.

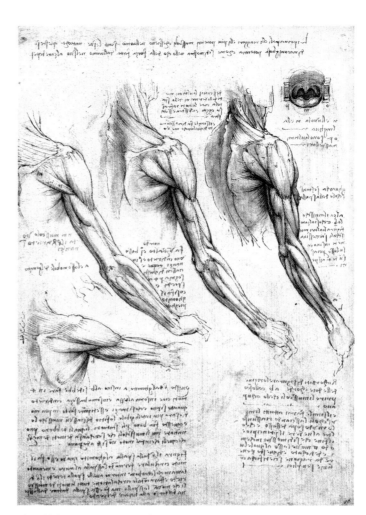

Fig. 109. RL 19005 v; K/P 141 v. Studies of the shoulder.

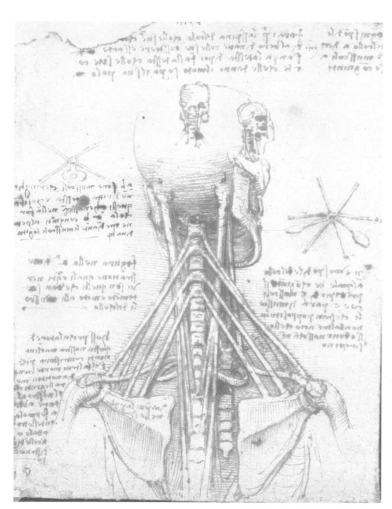

Fig. 110. RL 19075 v; K/P 179 v. Anology between the spinal column and a ship's mast.

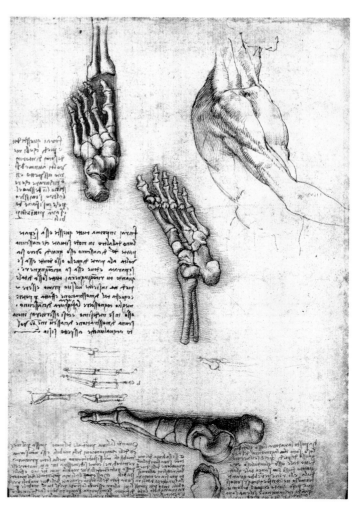

Fig. 111. RL 19000 r; K/P 135 r.

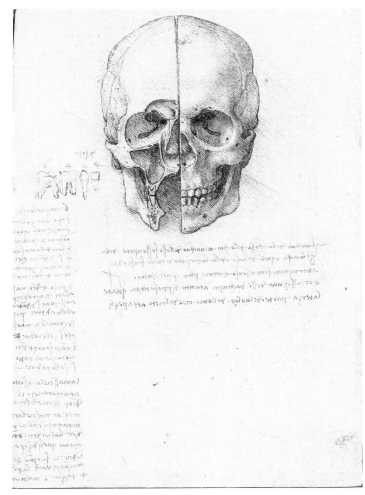

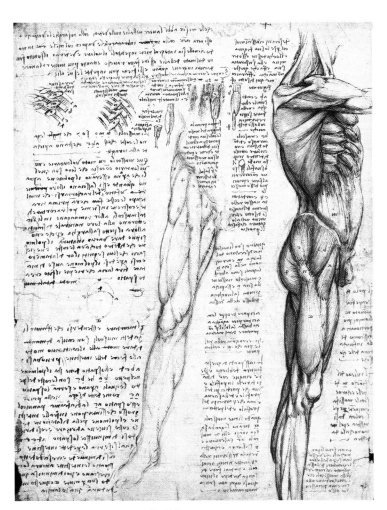

Fig. 112. RL 19058 v; K/P 42 v.

Fig. 113. RL 19014 v; K/P 148 v.

19075 v; K/P 58 r and 179 v: Fig. 110). As in the treatise on mechanical elements, the study of joints and *poli* led Leonardo to look for anti-friction mechanisms in the human body, which he found in the "glandular bones":

> Nature has placed the glandular bone under the joint of the great toe of the foot because if the tendon to which this sesamoid bone is joined were without the sesamoid, it would receive great damage in the friction made under so great a weight (RL 19000 r; K/P 135 r: Fig. 111).

Leonardo frequently compared the action of the muscles to a "wedge" (RL 19020 v; K/P 57 v). Moreover, he habitually rendered muscles as lines of force, calling them "powers" (*potenze*). Finally, he regularly used the terms "lever" and "counterlever" to explain the various motions of the upper and lower limbs (RL 19009 r; K/P 140 r).

Further evidence attests to the fact that the "mechanical elements" provided a clear model for Leonardo's analysis of the human machine. In fact, he examined individually many of the devices and mechanisms of the human body using the technique he had tested in Madrid MS. I. This approach is evident in the drawings of single teeth (RL 19058 v; K/P 42 v: Fig. 112), where Leonardo derives their respective shapes and functions from their mechanical actions. This is also true of a significant group of drawings of various components of the man-machine: nerves, sinews, veins, arteries, and muscles — each one associated with a specific function (RL 19014 v; K/P 148 v: Fig. 113). Finally, Leonardo often resorted to geometrical schematizations of the functions of organs in order to illustrate the

105

mechanical laws on which they depend, as in the actions of the intercostal muscles (RL 19061 v and 19015 v; K/P 154 v and 149 v: Fig. 114), or in the comparison of the motions of the jaw to those of a lever (Fig. 115), where the related texts display the characteristic conciseness of the propositions of the traditional texts on geometrical statics:

> That tooth has less power in its bite which is more distant from the centre of its movement (RL 19041 r; K/P 44 r).

The mechanical geography of man, the "lesser world", also offers striking analogies with the "mechanical elements" in terms of the role played by drawing. The complexity of the subject — man — impelled Leonardo to perfect the remarkable gifts as a technical draughtsman that he had displayed in the mechanical drawings in Madrid MS. I. The number of views is increased, exploded views are continually used, techniques of penetrating structures are refined (RL 12281 r; K/P 122 r: Fig. 116). Finally, Leonardo introduced a new technique. On a single sheet he produced drawings of successive strata of the organs he was dissecting, starting from the bare bones and ending with the skin:

> You will first draw each part of the instruments which move and define them separately, and then put them together little by little so that the whole can be composed with clear knowledge (RL 19002 r; K/P 134 r: see Fig. 108).

Returning to a precept he had advanced in the passage from Madrid MS. I quoted above, about removing the "armatures" of machines so they will not impede the view of the inner workings, Leonardo substitutes muscles with lines of force, recommending that they be rendered not as lines but as cords so as to show their three-dimensionality.[120]

Fully aware of the capabilities he has reached in the field of illustration, Leonardo was carried away by his enthusiasm:

> And you who wish to describe with words the figure of man with all the aspects of the formation of his limbs, do away with such an idea, because the more minutely you describe, the more you will confuse the mind of the reader... Therefore it is necessary to draw as well as to describe (RL 19013 v; K/P 144 v).

In another note, Leonardo returned to the fundamental role played by illustration:

> This depiction of mine of the human body will be demonstrated to you just as if you had the real man in front of you... Therefore it is necessary to perform more than one dissection; you need three in order to have a full knowledge of the veins and arteries... and three more for a knowledge of the tissues and three for the tendons and muscles and ligaments and three for the bones, which should be sawn through to show which is hollow and which not, which has marrow and which is spongy... Therefore through my plan you will come to know every part and every whole through the demonstration of three different aspects of each part. For when you have seen any part from the front with the nerves, tendons, or veins which originate at the part opposite from you, the same part will be shown to you turned to the side or from the back, just as

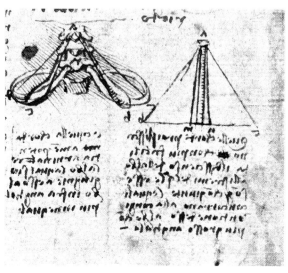

Fig. 114. RL 19015 v; K/P 154 v (detail).

Fig. 115. RL 19041 r; K/P 44 r (detail).

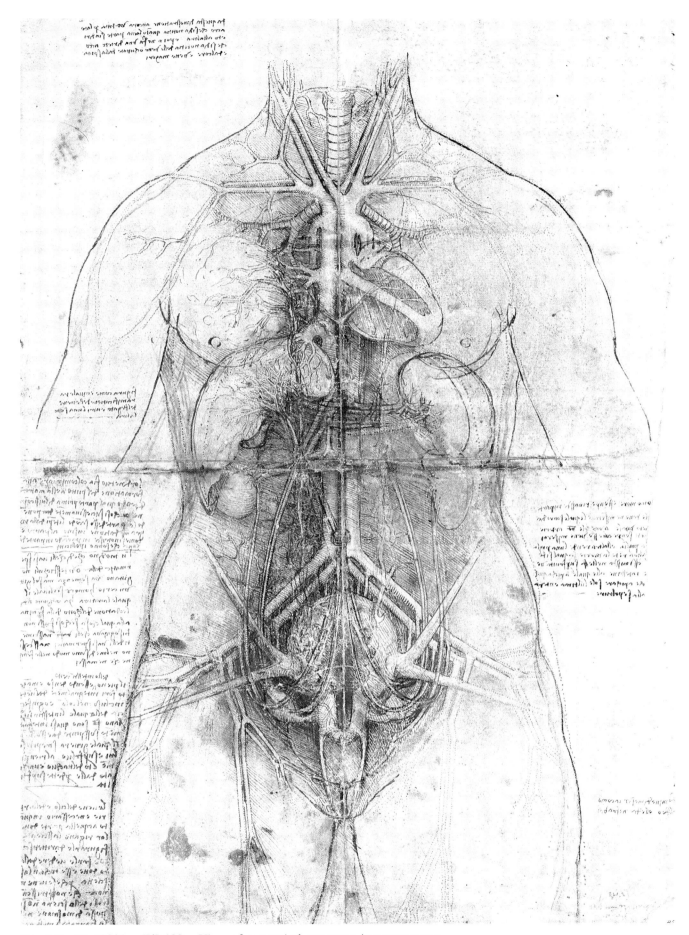

Fig. 116. RL 12281 r; K/P 122 r. View of anatomical structures in transparency.

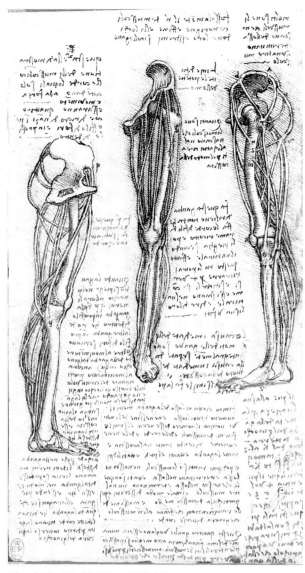

Fig. 117. RL 12619 r; K/P 152 r.

Fig. 118. CA, f. 579 r/216 v-b. Study for an automaton.

if you had that member in your hand and were turning it over from one side to the other until you had obtained full knowledge of what you want to know (RL 19061 r; K/P 154 r).

The final remark about turning the "member" over in one's hands suggests leaving the confines of a two-dimensional plane to become three-dimensional, where the perfect illustration becomes equivalent to a three-dimensional model. And Leonardo made many such models during these years, such as the one of the lower limb (RL 12619 r; K/P 152 r: Fig. 117) with the lines of force of the muscles schematically rendered as copper wires, or the ones of the eye (Paris MS. D, *c.* 1508, f. 3 v: see Fig. 2), and of the aorta (RL 19117; K/P 115 v). But Leonardo was familiar with models — as Vasari recalls — in other areas as well. He made architectural, sculptural, mechanical, and hydrodynamic models. In fact, the use of models by Leonardo is a subject that merits further attention.[121] It was the extraordinary power of the analogy between man and machine that suggested to Leonardo the use of techniques of illustration such as lines of force. This is even more true for the anatomical models that were a translation of the organ into a functioning mechanical device. Pedretti has related the project for an automaton recorded in the Codex Atlanticus (f. 579 r/216 v-b: Fig. 118) to the theme of the model.[122] It

is difficult to say whether this can be considered the ultimate outcome of Leonardo's rigorously mechanistic approach to the study of the human body. More than a century after Leonardo, Descartes' equally rigorous mechanistic approach, albeit totally different in methods and principles, was to inspire some extraordinary mechanical realizations that effectively reproduced human functions and movements.

There remains the coherence with which, with the anatomy of machines as his point of departure, for more than a decade Leonardo carried out an analysis of the human body that was based on direct observations and yet was strongly conditioned by a rigid interpretation which, at a certain point, he was tempted to extend (as indeed Descartes was to do) to the analysis of human passions:

> And would that it might so please our Creator that I were able to demonstrate the nature of man and his customs in the way that I describe his shape (RL 19061 r; K/P 154 r).

However, here and there in the tight fabric of Leonardo's mechanistic conception some dangerous cracks appear through which the awareness of an irreducible distinction between machines and man tries to break out:

> Although human ingenuity in various inventions with different instruments yields the same end, it will never devise an invention either more beautiful, easier, or more rapidly than does Nature, because in her inventions nothing is lacking and nothing is superfluous, and *she does not use counterweights* [my italics] but places there the soul, the composer of the body... (RL 19115 R; K/P 114 r).

This passage seems written purposely to contrast the human body with the automaton, that is, to oppose natural creatures to artificial devices. But Leonardo reacts violently to this, adding a disdainful note to his own text:

> This discussion does not belong here, but is required in the composition of the bodies of animals. And the rest of the definition I leave to the minds of the friars, fathers of the people, who by inspiration know all secrets (RL 19115 r; K/P 114 r).

It was precisely when confronted with a difficulty which seemed to shake the very foundations of his tenaciously pursued plan of unification that Leonardo once again stressed the validity of an investigation of man according to rigorously mechanical guidelines. And it was an effective way for him to emphasize once more that the engineer and the physician, like the artist and the architect, used methods and skills that were essentially the same, based on the same set of principles derived from the diligent imitation of Nature.

I.2

Leonardo's Impossible Machines⋆

by
Augusto Marinoni

In the famous letter in which he offers his services to the Milanese duke Lodovico Sforza, called Il Moro, Leonardo dwells at some length on his abilities in the field of military engineering. It is only in the closing lines of the letter that he speaks of the value, even "in time of peace", of his talents as a civil engineer, an architect, and a sculptor well qualified to execute the equestrian monument to be dedicated to the memory of Lodovico's father, Francesco Sforza. In a subsequent letter, however, addressed to the churchwardens of the Cathedral of Piacenza, Leonardo states that he has been summoned to Milan to build the equestrian monument but adds, rather gloomily, that it is such a major undertaking that he doubts he will ever finish it — a remark illustrative of a state of mind to which Leonardo was frequently subject. In fact, the great attraction that unusual projects held for him and the doubts engendered by the unattainability of perfection — a source of dissatisfaction even in relation to his most admired masterpieces — combined to nourish an unconquerable sense of self-criticism which, all too often, was the cause of abandoned and uncompleted work.

Leonardo remained in the service of the Sforzas for seventeen years. During this period he modelled in clay a gigantic horse, which was undoubtedly magnificent, but which was never actually cast in bronze. Some scholars believe this to have been the result of insuperable technical difficulties; others assume there was simply a shortage of the necessary metal, which was used exclusively in the manufacture of cannons. They all seem to forget that the duke wanted more than a horse without a rider.

Before examining some of the various machines designed by Leonardo, it seems worthwhile to

⋆ The aim of this essay is to highlight one of the characteristic facets of Leonardo's technology, through an examination of a group of projects considered to be impracticable, or, at least, considerably ahead of their time. The introductory section deals with several commissions given to Leonardo in his capacity as a "military engineer". But there is also a large number of drawings of weapons and fortifications that bear witness to intense research and possibly even represent preparations for specific practical projects, although the significance — and even the existence — of such projects remains doubtful and undocumented. On the subject of fortifications, the reader is advised to consult a recently published work by Marani, 1984[2]. As far as the machines are concerned, we will mention only a few of the many works published on the subject.

recall the main points of his activity as a military engineer. It has often been repeated that while in Milan, Leonardo also fulfilled certain military duties, but the nature and extent of these have never been clearly defined. The ducal administration had at its disposal excellent, very active engineers whose energies were devoted entirely to military questions. Nevertheless, Leonardo's manuscripts contain numerous studies of fortifications, offensive weapons and instruments of defence of all kinds, and it is yet to be decided just how these should be classified: were they exercises in pure research, or were they created in response to particular orders? Several pages of his earliest manuscript — Paris MS. B — contain extremely detailed descriptions of ancient weapons copied from Valturius' *De re militari* and frequently accompanied by quotations from classical authors. These sheets represent a short-lived attempt on Leonardo's part to adapt to the humanist customs of his contemporaries. The Codex Atlanticus, on the other hand, includes an extensive series of weapons designed by Leonardo himself and drawn with the greatest of care, as if the sketches were to be presented to a prospective manufacturer. Milan, at that time, was home to various highly reputed factories well equipped to construct the war machines invented by Leonardo; nothing, however, indicates that they actually did so. Whatever the case, the aesthetic value and originality of these inventions were no doubt less appreciated than their practical and economic qualities.

The magnificent drawing on folio 1070 r/387 r-a of the Codex Atlanticus is an example from this series. It shows a huge wheel, approximately four metres in diameter. The outer surface consists of a series of steps which are being scaled by a group of men whose weight sets the wheel in motion. The whole is protected by a sturdy defence structure containing a loophole. Attached to the four spokes are four crossbows loaded with large, heavy arrows. When a crossbow falls in line with the loophole, the wheel stops, a soldier activates the release mechanism and an arrow is shot towards those of the enemy within range of the fixed target. However, the large number of soldiers by which this machine was to be manned would have been able, armed with ordinary bows, to select and shoot at moving targets, thus claiming far more victims than the huge machine; the device would clearly have been effective only in particular situations — for example, to keep certain clearly-defined, crucial points under heavy and constant fire during a siege. There is no proof, though, that the structure was ever built.

In 1499, when Milan fell to the French, Leonardo travelled to Venice where he was consulted by the authorities concerning ways of repelling a possible attack by the Turks. There remain only a few traces in the Codex Atlanticus of the report Leonardo submitted — unfortunately not enough to gain any real insight into his plan.

In 1502, Leonardo's skill as a military engineer was acknowledged in the highest quarters: in a letter patent, dated August 18 of that year, Cesare Borgia, Duke of Romagna, ordered his subjects to give free passage "to our excellent and beloved friend, the architect and general engineer Leonardo da Vinci... who, by our order, is to examine the towns and fortresses of our States in order that we may act taking all requirements into account and in accordance with his judgement". Leonardo had apparently already been in Cesare Borgia's service for some time; in his work *De viribus quantitatis*, Luca Pacioli tells of an episode that took place early in 1501. It seems that Cesare Borgia was obliged to cross a river at a spot where there were no bridges and, according to Pacioli, Borgia's "noble engineer" quickly found a solution to the problem by making use of a pile of tree trunks lying nearby. As the trunks were shorter than the width of the river, he placed them jutting out diagonally from both banks, their ends meeting in the middle. The other ends were firmly embedded in the earth and

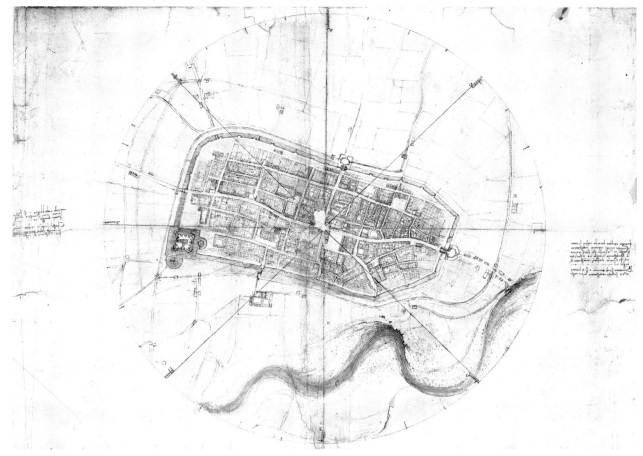

Fig. 119. RL 12284.

weighed down so as not to give way under the force of the water. This account does not mention Leonardo by name, but it seems unlikely that the adjective "noble" would have been applied to anyone other than the "excellent... architect and general engineer Leonardo da Vinci" who, furthermore, left many drawings in the Codex Atlanticus of military bridges that could be constructed extremely fast. Proof that Cesare Borgia ordered Leonardo to visit the fortresses of Romagna is provided both by the drawings in Paris MS. L and by the Windsor sheets depicting the fortified walls of Cesena and Urbino, and the famous map of Imola (Fig. 119). It should be noted, however, that a map of Imola had been drawn approximately thirty years before by another military engineer of the Sforza court. Leonardo made use of this earlier map, partially modifying it to suit new requirements.

After the death of his father, Alexander VI, in 1503, Cesare Borgia's fortunes declined. The war between Pisa and Florence broke out anew, and the Florentines embarked on a particularly difficult enterprise: the diversion of the waters of the Arno River so as to make them reach the sea without passing through Pisa. In July of the same year Leonardo was asked to examine the work already begun and to give his opinion. Although we have no definite information concerning any concrete intervention on his part, we do know, through sheet 12278 at Windsor (Fig. 120), of an extremely bold plan conceived by him, the execution of which would have actually been impossible. In order that the flow of water in the canal running between Florence and the sea remain constant (see Pl. X), even during summer droughts, Leonardo contemplated flooding the valley of Chiana by means of a dam situated to the south of Arezzo, thus forcing the Tiber to run into Lake Trasimeno through a tunnel.[1]*

* The notes of chapter I.2 are on page 319.

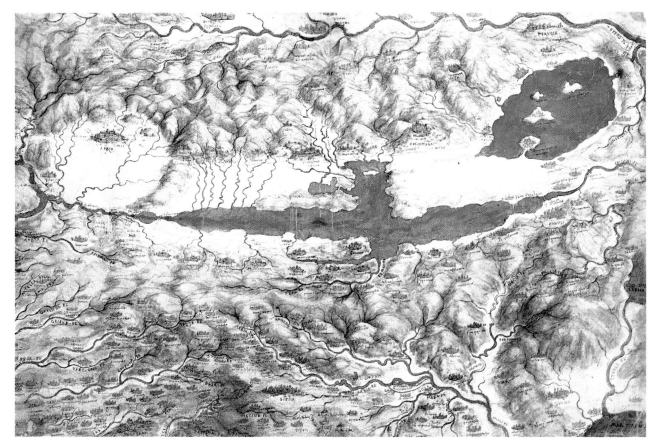

Fig. 120. RL 12278 r.

Unfortunately, Leonardo's hydrographical and orographical knowledge of the area was incomplete, and he was unaware that the Tiber lies at a lower altitude (164 metres) than the lake (258 metres). Fascinated by the daring grandiosity of the scheme, he allowed himself to dream of a fundamental transformation of geographical reality.

In 1506, back in Milan, Leonardo became friendly with the French — the new rulers of the duchy. Indeed, according to Edmondo Solmi,[2] he apparently participated to a certain extent in the preparations for the war against Venice on which Louis XII was about to embark. Evidence for this is said to be provided by certain sketches on Windsor sheets 12673 r (Fig. 121) and 12674 r (Fig. 122), which are maps of the hydrographic systems of the Bergamo and Brescia valley regions. Baratta, on the other hand, interprets these sketches as a hydraulic development, possibly involving a canal between the Adda River and Lake Iseo. Both these hypotheses remain, however, conjectural and unfounded.

One thing that seems certain is that around 1510 Leonardo was occupied with a non-military hydraulic problem that had concerned the people of Milan for some time. Several centuries earlier, Milan had been linked to Lake Maggiore by a navigable waterway — the Naviglio — which made possible the barge transportation of marble from the Toce valley directly to the site of the cathedral. By 1510, the lengthy construction of this edifice was nearly complete. A similar project had been proposed that would join Milan to the Lake of Lecco, thus opening the Valtellina area to the markets of Germany. By 1471, the Milanese had already built the Martesana canal as far as the Adda; the navigability of this river was hampered, however, by the narrowing at the Tre Corni. After studying

114

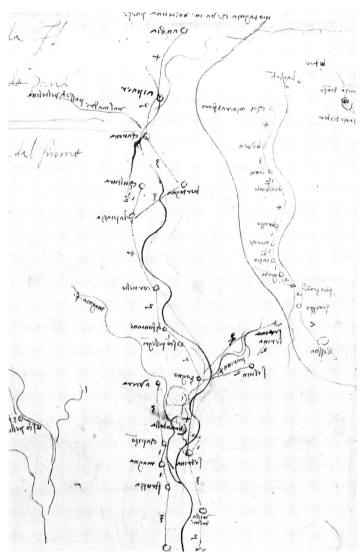

Fig. 121. RL 12673 r. (detail).

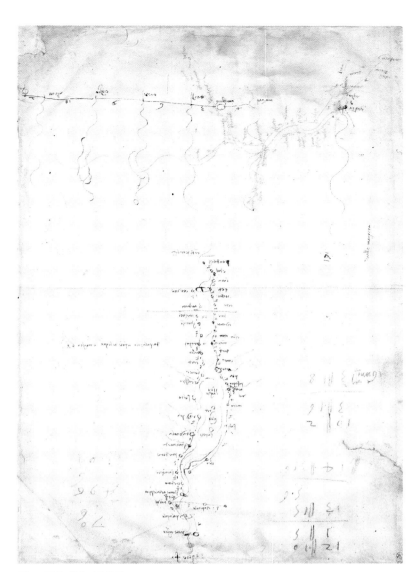

Fig. 122. RL 12674 r.

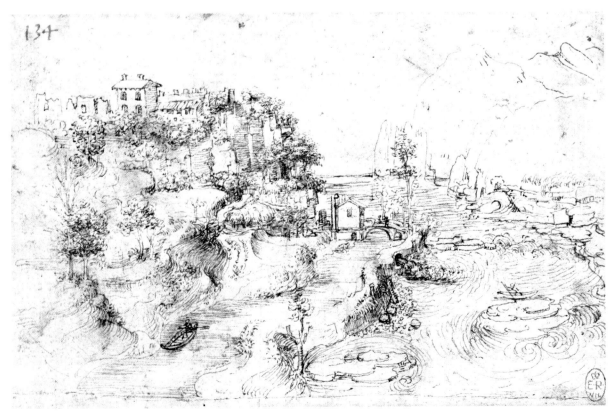

Fig. 123. RL 12399.

Fig. 124. CA, f. 388 v/141 v–b.

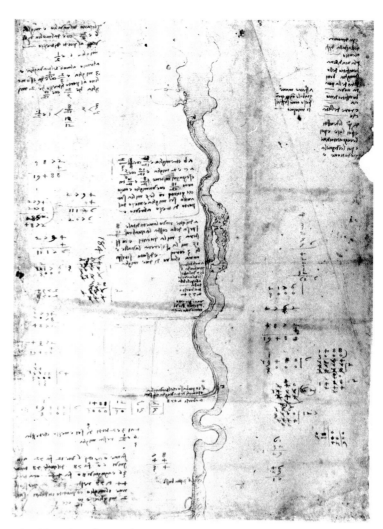

Fig. 125. CA, f. 911 r/335 r–a.

Fig. 126. CA, f. 642 Ar/236 r–b.

the feasibility of a new canal between the Lake of Lecco and the Lambro River, which would cross the Brianza lakes, Leonardo concentrated his efforts on the possibility of overcoming the obstacle of the Tre Corni (Fig. 123). Folios 388 v/141 v–b (Fig. 124) and 911 r/335 r–a (Fig. 125) of the Codex Atlanticus provide a reasonably clear idea of Leonardo's plan. His solution, which involved the construction of a dam, a lock and a tunnel, was an ambitious one that was not to be allowed to pass unnoticed by posterity. "At the mouth of the canal, at Brivio" wrote Leonardo (on CA, f. 642 Ar/236 r–b: Fig. 126), "there should be a commemorative plaque". But the plan — like many similar ones conceived in France toward the end of Leonardo's life — was destined never to be realized.

We have chosen to begin with a discussion of Leonardo's activity as a military engineer for two reasons: firstly, because it was in this capacity that he introduced himself in his letter to Lodovico Sforza and, secondly, because the military projects attributed to him by experts, although few, are well documented. His role in these endeavours seems nonetheless to have been exclusively consultative. The only reference we have to Leonardo being directly engaged in a military operation is the episode recounted by Luca Pacioli. His involvement in the war between Florence and Pisa went no further than the abortive attempt to build a canal linking Florence directly to the sea, the importance of which it is impossible to evaluate. Finally, the theory that he participated in the French war against Venice is extremely vague. As a result of the considerable space devoted to rivers and waterways throughout Leonardo's writings, many scholars have undoubtedly overestimated his activity as a builder of locks and canals. These references represent, for the most part, comparative studies of movement in a fluid medium as opposed to a solid one (mechanics). The Milanese were heirs to a centuries-old tradition of canal building, and Leonardo, once established in Milan, had far more to learn from the highly experienced Lombard engineers than he had to teach them.

We must be careful, however, not to minimize the extent of Leonardo's interest in the study, invention and development of machines. It is not possible to examine here all of his many drawings

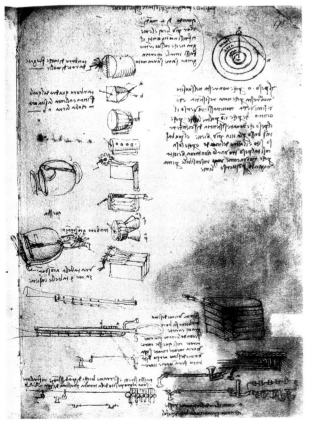

Fig. 127. Arundel MS., f. 175 r. Musical instruments.

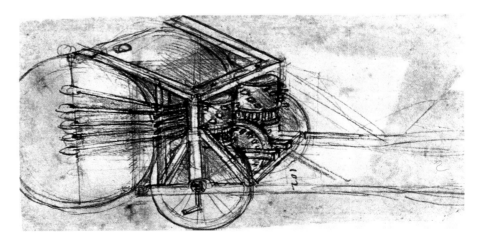

Fig. 128. CA, f. 837 r/306 v–a. Automatic drum.

depicting mechanisms of all sorts — including excavators, looms, chains, hoists, ventilators, musical instruments (Figs 127-128), swing bridges, cranes, lathes, presses, and so on — nor to investigate his research into automation. It is true that at a time when knowledge of mediaeval technology was very slight, certain ideas were attributed to Leonardo that were not, in fact, absolutely new. During the Middle Ages and in classical times, engineers were often illiterate and generally chose to execute their projects in the strictest secrecy. Libraries in Munich, Florence and London nonetheless possess fifteenth-century manuscripts that include numerous drawing of instruments that are strikingly similar to certain of Leonardo's best-known drawings. These sketches illustrate, among other things, underwater excavations (Fig. 129), paddle boats (Fig. 130) and diving suits (Fig. 131 and Pl. VI). Owing to their lack of mechanical detail, however, and the resulting doubt as to their capacity to function, they are distinctly inferior to Leonardo's designs. The parachute by an anonymous author that appears in a manuscript in the British Library (Add. 34113, f. 189 v) is clearly a work of the purest imagination, as is another illustrated a few pages further on (f. 200 v: Fig. 132). The latter is in the form of a cone and has a totally inadequate braking surface. Admittedly, Leonardo's own parachute — despite being somewhat larger — is not operable either. But what emerges from a comparison between Leonardo's machines and those of his predecessors is the remarkable development in the treatment of mechanical detail. Leonardo was heir to the dreams of Taccola, Fontana, Guido da Vigevano, and many other, anonymous, inventors; but he replaced their crude sketches with more convincing images — images that had moved out of the realm of fantasy and into the realm of potential realization.

It is important to recall here the significance of a Leonardo innovation brought to light only recently by one of the Madrid Manuscripts, which were discovered in 1966 and published in 1974, but which remain relatively little known. Madrid MS. I is a genuine treatise, if such a term can be applied to the unique type of document produced by Leonardo. The work is divided into two parts: the second section is devoted to theoretical research into the laws governing movement, or the science of mechanics; the first, though, is given over to the detailed study of individual mechanisms. As Ladislao Reti[3] has noted, apart from one absence (the bolt) and three additions, this treatise examines and describes all the mechanisms that appear on the list drawn up by Reuleaux in the late eighteenth century. When designing machines, engineers working prior to Leonardo were obliged to draw all the separate components every time. Leonardo, by contrast, studied each mechanism individually and then

Fig. 129. Additional MS. 34113, f. 72 v, British Library, London.

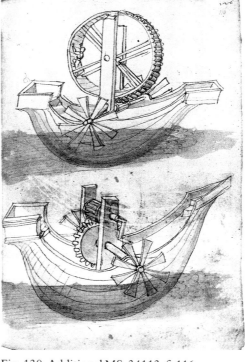

Fig. 130. Additional MS. 34113, f. 116 r, British Library, London.

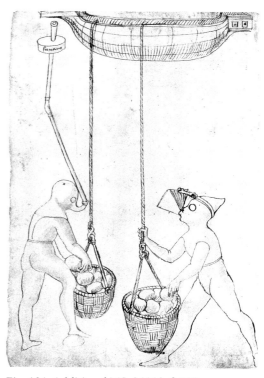

Fig. 131. Additional MS. 34113, f. 180 v, British Library, London.

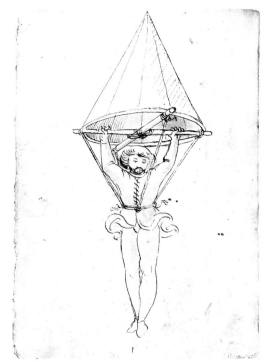

Fig. 132. Additional MS. 34113, f. 200 v,
British Library, London.

employed them many times over in a broad variety of machines. In folio 82 r of Madrid MS. I, he states quite specifically: "Here we shall discuss the nature of the screw and of its lever... and how it has more power when it is simple and not double...". Clearly, the object of his study was not a particular machine, but the screw itself — its many forms and properties, and the method of its fabrication. Nor did he restrict himself to the screw, but also examined the "endless screw" and the "ratchet wheel... the flywheel... hoists, pulleys, winches, rollers" and so on. The science of mechanisms came into being in 1794, with the foundation of the École polytechnique in Paris, but its principles had already been presaged by the work of Leonardo. It is his meticulous analysis of each mechanism that renders Leonardo's machine designs more concrete and more functional (or more nearly functional) than those of his predecessors. But just how well would they actually work?

<p style="text-align:center">★</p>

Let us examine first of all a few of Leonardo's most extravagant schemes. Folio 83 v/30 v–a of the Codex Atlanticus illustrates a device consisting of twenty-four revolving shafts (Fig. 133) arranged horizontally and connected by cogwheels in such a way that one complete revolution of the first shaft would give rise to twenty revolutions in the second and 20^{23} revolutions in the last. Leonardo was aware that the enormous friction involved would result in a correspondingly enormous degree of heat. In fact, the whole point of the machine was to create the greatest speed and the highest temperature ever recorded: "The sun, which heats the whole world on which it shines and which, in twenty-four hours, travels such a lengthy path, would seem, in comparison to this instrument, stationary and cold". The heat of the third wheel would be so great that any inflammable object coming into contact with it would "immediately burst into flame"; and anyone touching the last wheel would "die instantly". Leonardo suggests various devices designed to limit the damage caused by such intense heat, including "diamond pintles", "tempered steel wheels" and water-fed cooling systems. If, however, what was required was an instrument producing "instant fire", the machine could be limited

119

Fig. 133. CA, f. 83 v/30 v–a.

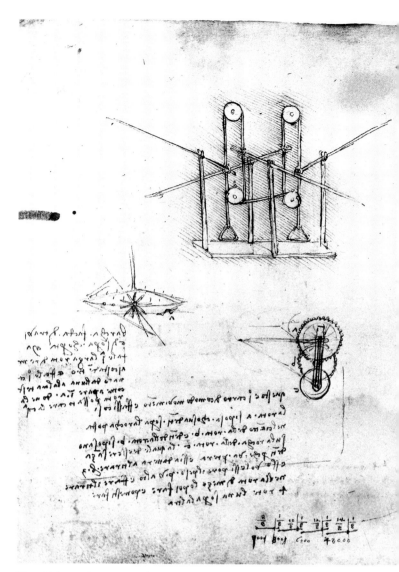

Fig. 134. Paris MS. B, f. 76 v.

to only six wheels. In his desire to know and state the number corresponding to 20^{23}, Leonardo invented an ingenious sytem of so-called "arithmetical proof". He wrote out, on twenty-four lines, the results of twenty-three multiplications and arrived at the following final number: "one hundred thousand million million million million million million million". Unfortunately, in completing this complicated operation he made a series of mistakes — a not unusual occurrence in his early writings — including losing, on the way, about six final zeros! This particular machine was never actually constructed, of course, but if it had been no one would have been able to counteract the enormous degree of friction.

A little further on in the same manuscript there is another sheet (f. 88 r/32 r-b) covered with drawings of pulley systems among which may be discerned two notes that make reference to another impossible dream: "A thirty-second part of a grain lifts two hundred pounds"[4] and "a silk thread raises up to 120 wheels with ten pounds of force; it raises six men weighing two hundred pounds each". The ancient hope of succeeding in developing limitless sources of energy clearly led Leonardo to forget the realities of friction — a subject that was nonetheless a notable preoccupation in his later writings.

Coupled with these dreams of tremendous power were the dizzyingly huge numbers — billions, trillions and quadrillions in contemporary language — that the limitations of Leonardo's vocabulary

120

obliged him to express by repeating "a million million million...". On folio 57 r of Paris MS. I, dating from 1497, he designed certain complex mechanisms in which he reduced friction to a minimum by thinning down the pintles and establishing a ratio of 1:72 between the lever and the counter-lever; he came to the conclusion that one pound of force "will move in counter lever 26,873,280 pounds". (He raised seventy-two to the fourth power, but made an error in the three final figures). Another rule is stated on the verso of the same sheet: "One pound of force at *b* results in ten thousand thousand million pounds at *m*... and know that when the first one above makes one hundred thousand thousand million revolutions, the one below makes only one complete revolution". And he concludes triumphantly, "these are the marvels of mechanical invention".

About ten years earlier, Leonardo had drawn in Paris MS. B (ff. 76 v and 77 r: Figs 134 and 82) an "easily moving wagon" capable, so he maintained, of both lifting and transporting heavy weights. Two drawings appear on folio 77 r. On the right, we see a wagon on whose ordinary wheels is mounted a second series of cogged wheels, each of which rests on an eight-toothed pinion situated near the hub of the ground wheel. The weight — a huge bell — is not resting directly on the axles of the ground wheels, but on those of the wheels with sixty-four cogs; these are geared to the eight-toothed pinions so that each revolution of the ground wheels corresponds to an eighth of a revolution of the cogged wheels. The drawing on the left shows a wagon with another series of cogged wheels that are meshed to the ones below in the same increasing ratio so that each revolution of the ground wheels corresponds to one sixty-fourth of a revolution of the upper wheels. It is not clear how the bell is loaded onto the first wagon. In the second, however, the load consists of a mortar that is held by cables linked to a pulley attached to the top of a derrick frame which rests on the axles of the upper wheels. Giovanni Canestrini[5] has redrawn and constructed a version of this wagon in which he installs the derrick frame of the second drawing onto the cart of the first. In his interpretation, Canestrini assumes that the machine works by raising the weight as it moves forward: "Leonardo, installing on the two axles of the cart — which are linked to the lower wheels — two eight-toothed pinions or trundles that are meshed with two large wheels comprising sixty-four cogs placed above, on the uprights of the fulcrums, activates the drums of the winches, which are linked to these large cogged wheels, and makes use of the wheels themselves of the drawn cart" which thus fulfil a "crank function". (Leonardo's notes indicate that the diameter of the first cogged wheel exceeds that of the ground wheel by only five centimetres). The movement thus starts in the ground wheels and extends to the upper wheels at diminishing speed. On folio 76 v, which is the facing page, Leonardo sketched what can only be a detail of the second wagon (the one with the mortar on it), illustrating a close-up of one of the ground wheels on top of which two cogged wheels are placed, labelled from top to bottom with the letters *a*, *b* and *c*. The inscription reads: "Wheel *a* rests, with its cogs, on the pinion situated at the centre of wheel *b*; the cogs of wheel *b* rest on the pinion of wheel *c*, which should not be cogged, as it runs on the ground; and on the ground the traction is three *braccia*; and if you wanted to put on a heavier weight and have the traction done by the middle wheel, it would be possible — you could have four wheels one on top of the other". Canestrini does not believe that the third drawing represents a detail of the second, but interprets it as being "another device, similar in its basic design" which works in the opposite direction. The reason for this — unstated but clear — is that if the ground wheels are seen as "cranks", they would have to make eight revolutions for the second cogged wheels

to make a sixty-fourth of a revolution; the wagon, meanwhile, would have to move forward at least thirty-seven metres (the circumference of the ground wheels being, according to Leonardo's indications, one and a half metres) before the "traction" was activated. Since this is impossible, Canestrini reverses the procedure and suggests that the upper wheel *a* should be "driven by a drop weight attached to a cable wound around its drum axle". As support for his view, he refers to a drawing of another wagon which was originally on a sheet in the same manuscript.[6] Canestrini fails to take into account, however, the fact that the similarity between the two drawings is quite superficial. This last wagon has only four ground wheels and carries a column which is raised at one end and resting on two converging trestles. The wagon is placed near the edge of a deep trench; a heavy weight descends by gravity from the stationary cart into the trench, pulling a rope linked to pulleys and thus raising one end of the column and moving it from a horizontal to a slanting position. The aim of the experiment, as the inscription indicates, is to discover how the weight "behaves depending on its slanting or horizontal position". The only point of the "traction", then, is to alter the position of the load on the stationary wagon; consequently, the cogged wheels of the preceding cart are unnecessary. The inversion of the action from top to bottom eliminates both the problem of moving the wagon before the weight is raised and of halting the upward movement of the load, which cannot last the whole time that the wagon is advancing. But this is not all: in the wagon on the left of folio 77 r, whatever the direction of the action, the three wheels, which are linked, work together and cause the wagon to move. The only logical interpretation is that the mortar is designed to be somehow raised and suspended from the upper pulley. Then, the downward force of the load would activate the "traction", which would be transmitted in an increasing ratio from one wheel to the next. Once the weight has completed its descent, the wagon should have moved forward somewhere between fifty and a hundred metres. What we have here is, in fact, a self-propelling vehicle designed for the transportation of heavy weights over short distances, with the weights themselves acting as the driving force. The traction, as Leonardo points out, can start with the second, third or fourth wheel depending, almost certainly, on the weight of the load and the distance to be covered. Whatever the case, the design remained an exclusively theoretical one and was never actually put into practice. Leonardo's accompanying words do nothing to clear up the mystery; they do, however, provide evidence of the inventor's excitement in contemplating the incredible amount of energy that would be produced: "This [wagon] is of tremendous power, and if you construct the wheels and the pinions according to the indications opposite, one hundred pounds of force will pull one million one hundred and forty-four thousand pounds!"

Rather than actual machines, many of Leonardo's drawings represent theoretical principles, intuitions or the germ of a mental process still a long way from its conclusion. We have already mentioned his sketch of a parachute that was never actually tested — or if it was, only at the cost of the tester's life. Another design worth noting is the drawing in Paris MS. B (f. 83 v: see Fig. 1) which is known today, somewhat sententiously, as the "helicopter". Leonardo wrote: "If this screw-like device is well made — that is, made of linen of which the pores are stopped up with starch — and it is turned swiftly, the said screw will make its female in the air and will rise high". He planned to experiment first of all with a "small paper model" and it is quite probable that, reduced to the size of a small toy, the contrivance would be able to turn at the required speed. The drawing, however, features a canvas spiral nearly ten metres in diameter; it is hard to imagine either how this could be "turned swiftly" or how it could be made sufficiently strong to bear the weight of the machine and its pilot.

Furthermore, if all the small holes in the canvas were stopped up, it would become impenetrable without actually being any stronger. It seems reasonable to conclude, then, that the drawing represents an important experiment expressing a scientific principle that was to find its application much later in the propeller or helicopter.

Many other sheets in Paris MS. B show mechanical flight devices intended for specific experiments, the aim of which was to calculate the force required to raise the machine, and to aid in the development of other systems of propulsion. Leonardo's confidence in the eventual practical result of these experiments seems to have been unbounded. He even went so far as to design a huge contraption (f. 89 r: see Fig. 83) fitted with a ladder (not unlike the retractable undercarriage of a modern airplane) and feet quite clearly designed for soft landings. And yet the central problem remained unsolved. Even larger is the airship illustrated on folio 80 r (Fig. 135). Despite the obvious disproportion between the weight of the machine and its inadequate means of propulsion, Leonardo believed he was close to success and proposed to test the device above a lake where, if problems arose, impact with the water would be unlikely to prove fatal. The persistence with which Leonardo continued to design machines and systems that were fundamentally impossible to realize is nonetheless impressive. It bears witness to an even greater faith than that with which Christopher Columbus faced the ocean. For the navigator did at least possess reasonably efficient and previously tested instruments; the risks he ran concerned the length of the voyage and possible exposure to unheard-of natural forces. The facing of these great enigmas required a level of physical courage analogous to Leonardo's intellectual daring. In 1505, sustained by his great conviction, Leonardo considered his triumphant success in this field to be imminent. He set about analyzing the flight of the great birds of prey and evaluating the possibility of launching his machine from the top of a mountain, whence — by moving the wings — he could keep it airborne for an extended period. These studies are actually the source of the traditional but false story that tells of an actual attempt at flight.

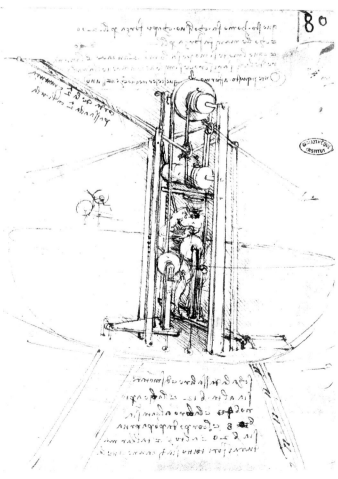

Fig. 135. Paris MS. B, f. 80 r.

The most sophisticated of all the wings designed by Leonardo was recently constructed and displayed in an exhibition of his machines organized by IBM. Even this device appeared to be too heavy. If, however, Leonardo had had today's ultra-light metals at his disposal, and if he had abandoned the moving wing and concentrated on the fixed wing, he would certainly have been able sooner or later to construct the first hang-glider, the conception of which was already almost complete in his mind.

<div align="center">★</div>

One of Leonardo's best-known machines is the famous self-propelling wagon (CA, f. 812 r/ 296 v-a: Fig. 136) that has been the focus of studies by various experts, including Semenza[7] and Canestrini.[8] Canestrini even constructed a model that is still exhibited regularly. The concept of a self-driven wagon was not an entirely new one: Francesco di Giorgio Martini's treatise includes vehicles "for hauling without beasts" which combine elements dating back even earlier. These teamless wagons were in the form of large, rectangular boxes containing the various mechanisms that caused the ground wheels to turn. The energy was provided by men positioned on the wagon, who turned the crank handles; these were linked to the ground wheels by a series of cogged wheels, pinions and an endless screw.[9] Leonardo's innovation resides in the introduction of springs that retain the energy with which they have been charged. Leonardo frequently introduced into his machines springs that had this capacity to release energy rapidly and to be as quickly recharged. It is not clear in this design, however, just how the essential operation of recharging is to be accomplished, given the enormous amount of energy necessary for continuous movement. It has been calculated that 370 springs would be required to cover a distance of only one kilometer on a flat surface. Despite the fact that they are reinforced, the two suspension springs visible in Leonardo's drawing would provide only a brief initial push.

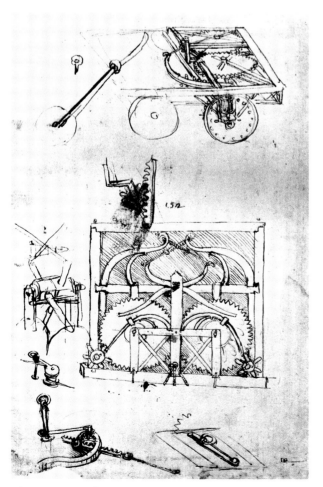

Fig. 137. CA, f. 114 r/40 r-b (detail).

Fig. 136. CA, f. 812 r/296 v-a.

The interpretation of folio 812 r/296 v-a of the Codex Atlanticus is indeed problematic and controversial. A first drawing at the top of the page shows a perspective view of the wagon, but the picture given is incomplete: a preliminary lead-point sketch has been gone over in ink and only the rear section is drawn in full detail. This completed section includes the driving mechanism and part of the transmission, consisting of a trundle gear which conveys movement to the wheel by acting on a ring of pegs located inside it. The front part of the vehicle is practically non-existent: from the few strokes that have been drawn over in ink we can decipher a sort of steering shaft attached to the front edge of the wagon and, sketched in the lightest and briefest of strokes, the front left-hand wheel. On the other side, we can just make out at least two other wheels drawn in lead-point — these are not visible in photographs — which are clear evidence of Leonardo's indecision regarding the steering system of the wagon. The design was obviously abandoned before completion. The shaft, as it appears in the drawing, is certainly no guarantee of the effective manoeuvrability of the wagon.

On the bottom part of the page can be seen a carefully executed ink sketch of the driving mechanism (this time seen from above) that features various modifications to the upper drawing: a counter-spring has been added to each of the suspension springs and one series of pegs has been removed. A tenaille has also been added, along with straps equipped with counter-springs that end between the six teeth of the two small pinions. Even the structure of the chassis itself (the cross and side members) has been altered. Certain imperfections apparent in the drawing — the fact that, for example, as the chassis base is shorter on the left than the right it is not absolutely rectilinear — are not important; what is significant is the distance between the two horizontal cogged wheels. According to Semenza, "they are meshed so as to turn in opposite directions and are thus the equivalent of the part known in the modern automobile as the differential". It is our view, however, that these wheels are too far apart to be geared together; in any case, their centres are rigidly fixed, which excludes the possibility of one wheel turning around the other while the latter remains stationary. The six mechanical devices sketched around the chassis pose another serious problem. It is impossible to interpret them as tools; they are more likely mechanisms forming part of the machine itself.

Two conclusions can be drawn regarding this sheet of the Codex Atlanticus. The first concerns the incomplete nature of the upper drawing: this indicates that the steering mechanism of the vehicle was as yet undefined. The second focuses on the six mechanisms, the integration of which into the machine would alter it radically. If we are correct — and it seems that we might be — in attributing a special function to each of the mechanisms, we are obliged to conclude that they represent a later phase in the development of Leonardo's design and that both drawings of the wagon can be considered to have been superceded by them.

The reconstruction of the self-propelling wagon executed by the engineer Canestrini is not an absolutely accurate rendition of Leonardo's drawing. The springs are very near the front edge of the wagon, and the doubtful area of the original sketch that was not gone over in ink has been resolved somewhat arbitrarily, the wheel placed by Leonardo under the left-hand edge having been moved to the centre. We are far from convinced, however, that Leonardo's aim was to construct a tricycle. Furthermore, the central wheel in Canestrini's reconstruction turns freely on its axis. The addition of a tiller handle would transform it into an excellent steering system, rendering the awkward, cumbersome steering-shaft quite superflous. The wagon cannot move, of course, for neither the problem of the transmission of motion nor that of energy production has been solved.

★

Until recently, Leonardo scholars generally used the Hœpli edition of the Codex Atlanticus, which was published between 1894 and 1904. At that time, photographic plates were not very sensitive and as a result only a small part of another drawing of a vehicle (f. 114 r/40 r-b: Fig. 137) was visible in that facsimile edition.[10]. Leonardo made his drawing in pencil — or rather in the ancestor of the modern pencil, which consisted of a stick of lead and tin whose traces on the paper were too faint to leave an impression on early photographic plates. Only a small head was visible and this almost certainly because a greasy mark — probably a fingerprint — had caused more of the metallic powder to adhere in this area than on the rest of the drawing. Even on the original, deciphering is complicated by the transparency of the paper and the presence of an ink drawing on the verso, the bolder lines of which interfere with the more delicate sketch on the recto. A recent photograph, executed using special techniques, has made the drawing clearer and eliminated the disturbing effects of transparency. It is now possible to see that the small head belongs to a man who is seated on a box with wheels and a backrest. The man's legs are crossed and his feet are apparently resting on a small rectangular platform; above this is an unusual vertical chassis that partially conceals a semicircular shape that might possibly be a wheel. We believe that the chassis is actually double and that the circular shape — the wheel — is situated between its two halves. The man's arms are open and slightly bent; his right hand appears to be operating some kind of mechanism, while the left is just barely sketched in. Many of the original lines have virtually disappeared, but it seems evident that the drawing represents a vehicle being driven by a seated man. Indeed, the rear part of the sketch comprises various highly detailed elements — the ring of pegs on the right-hand rear wheel that is connected to a trundle gear, for example — that link the vehicle closely to the one depicted on folio 812 r/296 v-a of the Codex Atlanticus. The gear system itself possesses an interesting new feature not present in the wagon on folio 812 r: its diameter is reduced twice between the top and the base, indicating a three-speed mechanism. This requires a system that moves the gears both horizontally and vertically, so as not to lose contact with the wheel pegs. This mechanism is probably represented by the half-visible rectangle that juts out above the trundle. Given that the drawing is a rough preliminary sketch — somewhat rudimentary and full of omissions — of a general view of a self-propelling wagon, its interpretation is, in various ways, difficult and ambiguous. The one that we suggest, although carefully considered, does not profess to be entirely beyond doubt.

The driving force for the trundle-wheel-wagon arrangement is provided by two large suspension systems with semicircular springs (one concave and one convex) the exact nature of which — due to the fragmentary character and roughness of the drawing — is not immediately clear. They cover the whole width of the wagon. Various well-defined features, such as the motor device and the transmission mechanism, are grouped within a triangular chassis. Even if each vague, confused line, of the drawing were submitted to a detailed analysis, the answers would not necessarily be obvious. Nevertheless, it does at least seem clear that the hub of each of the two wheels is joined to converging, rather than parallel rods. The point, or rather the line, of convergence of the rods and of junction with the front section of the wagon appears to be indicated by a double vertical line that can be seen on the box on which the driver is seated. What we seem to have here, then, is a new model of self-propelling wagon with two articulated sections, one providing the power and the other bearing the steering mechanism. The problem of steering, with which Leonardo failed to come to terms on folio 812 r/

Fig. 138. CA, f. 133 v.

296 v-a, seems to have been resolved here. As the wagon is articulated the steering section receives the thrust in only one direction, around which there is a broad angle of rotation both to the right and the left. Difficulties in the interpretation of this drawing are due not only to the faintness and incompleteness of the strokes, but also to the presence of lines which Leonardo, in making corrections, partially erased or redrew (in the area of the man's left arm, for example). Some scholars have expressed doubts concerning the position of the driver and the whole steering section. Is the man seated facing in the same direction as the movement of the wagon, or sideways? In the former case, two rear wheels must be situated behind the driver (hidden by the backrest), making a total of six wheels in all. The two front wheels would then be represented by the one in the foreground and the one on the extreme left; but if we look closely, we see that these are neither parallel nor of the same diameter. Furthermore, if the front section was indeed positioned in this way, it would receive the thrust of the motor section from the side rather than from the rear, which is patently absurd. The wagon must, therefore, have five wheels: two on the motor section, and three on the steering section. The first — which Leonardo has made transparent so as to render the man's legs visible — is quite clear; the second is partially concealed by the vertical double chassis and the third is hidden by the second. The driver is seated sideways (as is still the case in many agricultural machines). His right arm controls the steering and, if the drawing were more complete, his left hand might possibly be recharging the springs. Although the design is in its early stages and its presentation is cursory, all the essential elements are there: the ring of pegs on the wheel, the three-speed trundle gear system, the two-spring suspension propulsion system and the two articulated sections which improve steering efficiency. The weak point is still the motor, which could never provide the necessary power. But the force of Leonardo's extraordinarily creative, indefatigable personality is as evident as ever.

This drawing dates from a period several years later than the sketch on folio 812 r/296 v-a, but both were apparently executed before Leonardo left Florence and settled in Milan.

★

127

Another even more astonishing drawing has recently come to light. It appears on the verso of folio 133 v (previously f. 48) of the Codex Atlanticus (Fig. 138), which was originally part of the same sheet as folio 132 r/48 r-a. This sheet was one of the many that Leonardo passed on to his pupils who, to practise their drawing skills, would copy the master's sketches and devise new ones, frequently adding — for amusement — various caricatures and obscenities. This must have been the fate of this particular sheet. But the pupils' additions remained undiscovered in this case until the 1960s. The sheet, although scribbled all over on one side, was not thrown away. Leonardo, who was extremely economical in his consumption of paper, used it (along with other similar ones that have also been discovered) on the back, which was still blank. Having folded the sheet in half, and keeping the fold toward the top, he covered the two half-pages with notes and drawings in such a way that when the sheet was unfolded the two halves were upside down in relation to one another. Towards the end of the sixteenth century, almost the entire treasure of Leonardo's manuscripts came into the hands of Pompeo Leoni. To prevent the scattering of so many loose papers, Leoni assembled them in two albums, one of which — due to its format — was called the Codex Atlanticus ("atlas-sized collection"). When a sheet bore Leonardo's writings and drawings on both sides, Leoni would insert it into an empty "window" cut out of one of the pages of the album, thus rendering both faces visible. The same visibility was, however, denied the pages that had been sketched and scribbled on by Leonardo's pupils. If the sheets that had been folded in two were opened up to be glued, they appeared too big. Leoni thus cut them near the fold, trimmed the edges of the two halves and turned one of them around so that the writing all went in the same direction. He then inserted the two pieces into the album, inevitably concealing the students' work. This would have been their ultimate fate had the Codex Atlanticus not undergone restoration during the period between 1960 and 1970. Once they had been detached from the old album, the original unity of folios 132 and 133 became obvious and a detailed examination of their content was made possible. The most interesting — and unskilful — of all the drawings depicts a two-wheeled vehicle that we are tempted to call a bicycle, although it is a contraption very different from any bicycle that ever existed. The person who drew it was almost certainly a young, inexperienced boy. The compass he used to draw the wheels (which are ordinary cartwheels) was obviously a little slack, and the spokes are sketched in a shaky, unsteady fashion. The frame consists of a single rod, at the centre of which is installed a cogged wheel attached to two exaggeratedly long pedals. The cogs are in wood and are cube-shaped to avoid breakage during the strain of traction; they are designed to mesh with the large openings of a chain that links them to a

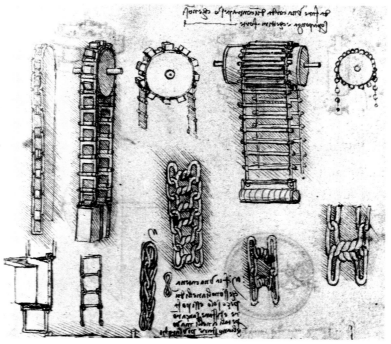

Fig. 139. Madrid MS. I, f. 10 r (detail).

second, smaller cogged wheel situated at the hub of the rear wheel and that thus transmits the movement from the large wheel to the smaller one. The rather strange saddle is attached to both sides of the hub of the rear wheel and to the centre of the frame to prevent buckling. Attached to the hub of the front wheel are two curved rods that support a pair of primitive handlebars; the rods are positioned so as to minimize friction with the wheel. There does not appear to be any steering device. This deficiency, combined with the cubic shape of the cogs, means that the vehicle could never function like a real bicycle. But these details are important, for Madrid MS. I, (f. 10 r: Fig. 139) contains a drawing by Leonardo that illustrates an identical chain and a wheel with cubic cogs. The fact that the machine could never work is nothing unusual — it is even a guarantee of its authenticity. In fact, these were not actual machines, but simply ideas: this sketch represents the first conception of a bicycle that ever took root in a man's imagination. And that man could only have been Leonardo.

Once he had designed this type of cogged wheel with a transmission chain, Leonardo must have had the idea of applying it to a two-wheeled vehicle, the propulsive force of which could be provided by a pair of human legs. The machine was certainly neither built nor tested; if it had been, Leonardo would soon have discovered the need for a steering system and pointed cogs.

Leonardo's original drawing of this "bicycle" must have been lost, but — according to our highly probable reconstruction of the facts — not before an inexpert copy was made by a student. The nickname of this young person is the only word that appears on the sheet; his real name was Giacomo Caprotti, and he entered Leonardo's studio in 1490 as a servant and model. On what was originally the first page of Paris MS. C (now f. 15 v), Leonardo himself notes the young man's misdeeds, and describes him as "a thief, a liar, obstinate and greedy". Among other things, he apparently stole money from his comrades Marco d'Oggiono and Gian Antonio Boltraffio. The nickname given to this rascal was taken from Luigi Pulci's mock-epic poem *Morgante Maggiore*: "*Salaï*", meaning "devil". It was almost certainly one of the young scamp's victims who, anxious for revenge, drew his caricature — which includes a ridiculously long nose shaped like a chicken's beak — next to the sketch of the bicycle. The same caricaturist, or one of his fellows, also added an image of a phallus pointing towards an anus, above which appears the word "*salay*".

Certain scholars, although ready, as a rule, to laud the innovative brilliance of Leonardo the "universal genius", nonetheless find it difficult to accept that he actually invented a bicycle. As a result, they suggest that the drawing in question may be a recent forgery. It is not enough, however, simply to put forward a hypothesis: it must be supported by plausible arguments.

Since the invention of the bicycle chain dates from the second half of the nineteenth century, at which time the Codex Atlanticus was safely ensconced in the Ambrosiana Library, we have to imagine — if we want to reconstruct the forgery theory — that a young man (or some other individual without drawing experience) gained entrance to the library, perhaps in the early years of our own century, and requested permission to consult the Codex — permission not readily granted. Having nonetheless obtained it, the presumed forger would have had to remove a glued sheet (a long, delicate operation) and then, using a compass, a pencil and a brown pastel to render the wooden portions, draw a bicycle quite different from any he had ever seen, inventing peculiar handlebars with no steering device and — a brilliant final touch — adding a wheel with cubic cogs and a strange chain the like of which was to be found only in an as yet undiscovered manuscript in Madrid. After all this, he would have had to glue the sheet back into the Codex, under the indifferent gaze of the librarians. A perfect crime and one utterly without motive — unless, of course, its author somehow foresaw that the Codex Atlanticus would one

day be restored and that the bicycle, once it had come to light, would sow confusion among scholars. This hypothesis takes no account, furthermore, of the connections between the bicycle and the other drawings that surround it. It is up to the reader to choose the most plausible explanation.

★

Not all of Leonardo's machines are as daring or as unworkable as the ones we have discussed. In any event, it would be impossible to examine them all here. Our selection is designed to emphasize the most important features of Leonardo's activity as an engineer, not while under the orders of any particular patron, but when he was working and inventing freely, his own master, pursuing all the visions his imagination could conjure up and not halting even when faced with the impossible. Leonardo's technogical "whims" seemed, to his contemporaries, both odd and dangerous, for they distracted him from art. But art, science and technological invention were all closely linked in Leonardo's philosophy. His approach — which was based on a belief in the absolute inertia and passivity of matter — necessarily included an acceptance of those philosophers who perceived behind the movement that animates nature and creates life, the action of immaterial forces such as light, heat, energy and gravity. Beauty itself could not be the result solely of the balanced proportions of bodies, but had its source also in the emanation from their surfaces of incredibly dynamic intangible forces. Leonardo, who accepted Ficino's definition of beauty as *actus vivacitas*, was constantly reminding painters that they should imbue their figures with the "vivacity of action", the very throb of life. In creating movement and life, these forces are controlled by Necessity; they are subject to the laws of mathematics and are dependant on material structures established *ab aeterno*. It is for this reason that Leonardo believed that the painter must become a scientist whose aim is to discover underlying principles and structures (of anatomy and of the mechanics of motion in liquids and solids). Once these laws are revealed to him, his imagination — now virtually divine — must invent new devices which even Nature does not create. But the full extent of Nature's power, which allows her to breathe life into her animal and plant creations, is denied him. Man's machines must always receive their power from an outside source. They thus have no life of their own, but represent only its shadowy likeness.

I.3

The Inventions of Nature and the Nature of Invention

by
Martin Kemp

The more Leonardo studied the forms and functions of the natural world, the more he came to stand in awe of the inventive powers of nature. When he characterized the task of the human inventor as the creation of a "second world of nature", modelled on the first, he could not have been setting man a more demanding programme.

This "second world", as we will see, is to be created in a spirit of profound obedience to the principles underlying the original creation of nature; but human inventions are not "secondary" in the sense that they are to be regarded as poor reflections of nature's prowess. The inventiveness of nature and the inventiveness of man are, according to Leonardo's view, exercised from different starting points. Nature produces a series of elementary forms and species according to the invariable archetypes established for all time at the moment of creation, while man can build upon nature to produce a never-ending abundance of new compounds:

> Where nature finishes with the production of her species, there man begins with natural things to make, with the assistance of nature, an infinity of species. (RL 19030 v; K/P 72 v)*
> Man is the greatest instrument of nature, because nature is concerned only with the production of its basic forms but man from these basic forms produces an infinite number of compounds, though he has no power to create any basic form except another like himself, that it to say his children. (RL 19045 v; K/P 50 v)

A number of Leonardo's most rapturous acclamations of man's inventive power occur specifically in the context of his praise of painting, but can be applied equally well to any sphere of his activity as an inventor:

> Design [disegno] is of such excellence that it not only studies the works of nature but is more infinite than those made by nature... and, on account of this, we conclude that it is not only a science but a divine power to be accorded a worthy title. (CU, f. 50 r)
> It surpasses nature because the basic forms of nature are finite and the works that the eye demands of the hands are infinite. (CU, f. 116 r)

* All translations are the author's.

131

This emphasis recalls the point made by his contemporary and acquaintance, the Sienese artist and major architect-engineer, Francesco di Giorgio Martini, who argued that the constructions of animals — such as the honeycomb and spider's web — always follow the same pattern, whereas the inventions of man are infinitely varied.

Leonardo's reverence for the inventive power of man was not only the result of a deeply held personal conviction, but was also related to a Renaissance tradition. The great artist-engineers of the fifteenth century, at the head of whom stood Brunelleschi, had developed a clear sense of their own powers of original invention. Brunelleschi took pains to guard his inventions against ignorance and misuse. He also expected to be accorded a certain status as a result of them, and the epitaph composed for him in 1444 by the humanist Chancellor of Florence, Carlo Marsuppini, indicates that public recognition was forthcoming:

> How valiant Filippo the architect was in the art of Daedalus is documented both by the wonderful vault of this celebrated temple [the dome of Florence Cathedral] and by the many machines invented by his divine genius.

Leonardo, in true Renaissance spirit, cites a precedent from classical antiquity that bears witness to the proper status of the inventor. He tells us that Cato — it was actually Cicero — "rejoiced in no act more than being able to honour Archimedes" by restoring and ornamenting the tomb and temple in which the great inventor was buried (Arundel MS., f. 279 v). The true inventor is to be praised above those windy scholastics who puff themselves up with derivative learning from books:

> They go about inflated and pompous, dressed and adorned not with their own labours but with those of others, and they will not credit me with my own, and they disparage me as an inventor. How much more they — who are not inventors but trumpeters and reciters of the works of others — should be scorned. (CA, f. 323 r/117 r-b)

Although certain of the bookish scholastics may have cast aspersions on Leonardo's level of Latin learning, there is ample evidence to suggest that patrons and fellow scientists respected his genius as an inventor. The great mathematician, Luca Pacioli, not only admired Leonardo's abilities as an artist and investigator of nature but also specifically praised him as a "tireless inventor of new things". Much of his value to his patrons arose from his ability to devise ingenious solutions to technical conundrums, many of which were concerned with the construction of devices of an ephemeral or perishable nature that have consequently left no trace in the historical record.

The ability to invent, for Leonardo, depended upon the exercise of imagination (*fantasia*) as one of man's supreme faculties. But it is important to realize that his notion of imagination — or fantasy — was rather different from our customary present-day interpretation of this term. For Leonardo, the inventor's *fantasia* should not only work in accordance with the principles of nature, but should also be founded upon the most rigorous intellectual analysis of the causes and effects apparent in the natural world, ranging from the grandest patterns of universal order to the minutest functions of natural detail. At the heart of this analysis stands the study of man himself, "the greatest instrument of nature".

In attempting in this essay to characterize the role of the human inventor in relation to the inventions of nature, I intend to adopt this Leonardesque pattern of thought, beginning with a study of his analysis of the human machine and progressing to an examination of the way in which his inventions were extensions of the lessons he learned.

"The Greatest Instrument of Nature"

Leonardo's analysis of nature's inventions was founded upon an unwavering teleology; that is to say, upon a conviction that every natural form has been designed perfectly to fulfil its function with no inadequacy or redundancy. This doctrine, shared implicitly or explicitly by all the authorities he consulted, was summarized by the catchphrase "nature does nothing in vain". For Leonardo, this doctrine was to be applied at every level in the study of man, from the examination of gross functions such as locomotion, to the explanation of the minutest details of natural form like the smallest protruberances on a single vertebra. And as Leonardo explored these questions of cause and effect in the human body, so he was led to express his sense of wonder at its perfection.

> O speculator on this machine of ours, let it not distress you that you gain knowledge of it through another's death, but rejoice that our creator has placed the intellect in such a superb instrument. (RL 19075 v; K/P 179 v)

After he had considered in detail the "twenty-four muscles... serving the tongue for its necessary motions, which are many and varied" and given due attention to the range of sounds produced by man's voice (Fig. 140), he was moved to a characteristic expression of praise:

> Although human genius through various inventions makes instruments corresponding to the same ends, it will never discover an invention more beautiful nor more ready nor more economical than nature because in her inventions nothing is lacking and nothing is superflous. (RL 19115 v; K/P 114 r)

Adopting an ancient analogy, Leonardo regarded nature's creation of the structure of the body as comparable to the construction of a building by an architect. In the late 1480s, when he was involved in plans for the tiburio of Milan Cathedral, he wrote to the authorities emphasizing that his sound knowledge of natural principles gave him special qualifications for the task:

> Doctors, instructors and nurses of the sick must understand what man is, what life is, what health is and in

Fig. 140. RL 19115 v; K/P 114 r. Plan of Milan and notes on the sounds of the voice.

what ways an equilibrium and a harmony of the elements maintain it, and accordingly how a discordance of these ruins and destroys it; and if the nature of the above things is well understood, he will be better able to effect a repair than one who lacks such understanding... The same is necessary for the infirm cathedral, that is to say a doctor-architect, who well understands what a building is, and from what rules the correct manner of building arises. (CA, f. 730 r/270 r–c)

A good example of the principles of equilibrium he sought and found within the human body is provided by the system of muscular stays which nature has provided to support the head and neck in an upright position. With the aid of diagrammatic demonstrations (Fig. 141), he explains that "each chord attached to the vertebra has another chord as an opponent which supports that vertebra" (RL 19015 v; K/P 149 v). This system of chords in antagonistic tension has evolved because "such a convergence of muscles on the spine holds it erect just as the ropes of a ship support its mast, and the same ropes, tied to the mast, also support in part the framework of the ship to which they are attached". He also explains, with reference to the most schematic of the diagrams, that the greater the angle of attachment of the "stays", the greater the measure of support they will afford the neck. This simple principle is applied by the builder of the bodily machine with infinite cunning in a complex system of muscular rigging which achieves the compound effects of stability and motion exhibited by the neck and shoulders, as depicted on the recto of this sheet (Fig. 142).

In looking at Leonardo's anatomical drawings, we are frequently reminded of architectural structures: the dome of the skull is echoed by the dome of a church, and the vaulted chambers of the heart (Fig. 143) are paralleled by the colonnaded structure of his design for an elegant block of stables (Fig. 144). These similarities are not mere concidences; nor are they simply the result of Leonardo's obsession with certain formal and spatial patterns. Rather, they reflect the way in which nature and man react analogously in response to the design of forms in the context of natural law. If we understand "the sagacity of nature" (RL 19010 v; K/P 147 v), we will be able to adopt her principles in our own works.

Fig. 141. RL 19015 v; K/P 149 v (detail). Demonstration of the system of muscular "stays" in the neck.

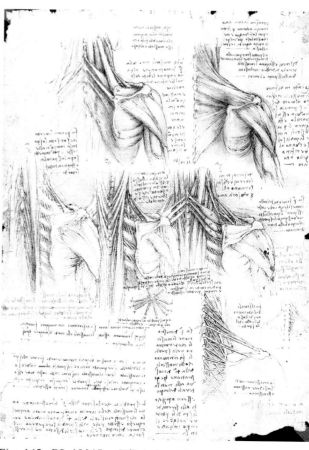

Fig. 142. RL 19015 r; K/P 149 r. The muscular system of the neck and shoulders.

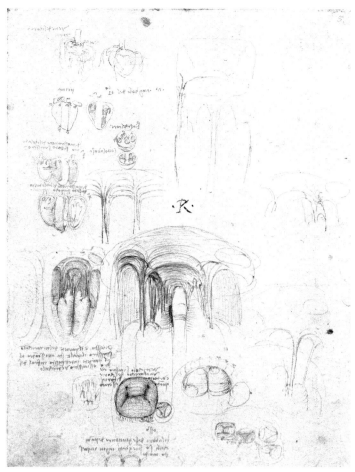

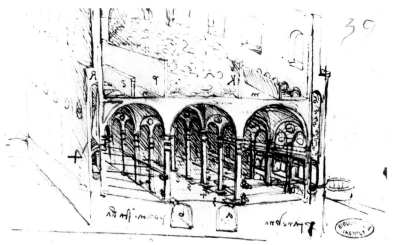

Fig. 144. Paris MS. B, f. 39 r (detail). Design for stables.

Fig. 143. RL 19080 r; K/P 170 r. Demonstrations of the internal structure of the heart, including the *chordae tendineae* of the papillary muscle.

Fig. 145. RL 19061 v; K/P 154 v (detail). System of levers in the rib cage.

Leonardo's vision embraces both the statics of architectural structures and the dynamics of mechanical action. Working on the principle that "every muscle uses its force in the line of its length" (RL 12636 r; K/P 111 r), he proceeds to analyze the motion of the parts of the body according to the principles of levers and pulleys (Fig. 145). The muscles responsible for raising the rib cage in respiration act "according to the second class of levers displayed here in the margin; that is to say to the extent that... the nearer the chord [*a n*] is attached to *b* rather than *c*, so much the greater will be the movement". The diagram shows the action of the muscle on the rib as analogous to a "beam" hinged on an upright and pulled by a rope over the pulley with a counterweight. As he says elsewhere, the human body does not need the service of counterweights because the powers of the soul give it its own built-in source of motion. But the mechanical law operating is essentially the same. It is not surprising that he concludes by describing the bodily system as a "marvel of artifice" (RL 19001 r; K/P 136 r).

Comparable principles of leverage can be seen at work elsewhere in the body — in the action of the biceps, the motion of the ankle or the closing of the jaws. Leonardo explains that the configuration of the teeth reflects their relative positions along the axes of the lever: those nearest the fulcrum, where

the motion will be shortest and most powerful, are the broad crushers of food, while the front teeth play their cutting role in relation to the less powerful but swifter motion of the distal end of the lever (RL 19041 r; K/P 44 r).

The compound action of the levers and chords of the body results in the infinitely complex motion of the figure as a whole, as it performs diverse tasks which require minutely co-ordinated adjustments of balanced weight. The apparently simple act of stepping upwards involves a series of carefully synchronized shifts of our centre of gravity (Fig. 146):

> The first thing a man does in mounting steps is to unload from the leg he wants to lift the gravity of the torso which was placed above this leg; in addition to this he loads the opposite leg with all the remaining weight of the body together with the other leg. Then he lifts his leg and places his foot on the step... Having done this he transfers to the raised foot all the other weight of the torso and leg and supports his hand on his thigh and thrusts his head forwards and makes a movement on to the point of the upper foot, quickly lifting the heel of the lower foot and with this impetus he raises himself, and at the same time extends the arm that was supported on the knee. This extension of his arm pushes the torso and the head upwards and this straightens the curve of the spine. (RL 19038 v; K/P 80 v)

The smallest sketch at the bottom of the page illustrates how, "when a man wishes to stop running and to consume his impetus, it is necessary for him to lean backwards and to take small, rapid steps". The words used — "*consumare l'impeto*" — indicate that the analysis is being undertaken within the broad framework of his theory of dynamics, in which a key role was played by the concept of impetus; it was seen as a "potential" for a certain degree of motion over a finite period which was impressed on bodies by an agent of force. The theory of impetus, which should not be confused with the Newtonian concept of inertia, had been developed to a high level of sophistication by mediaeval philosophers such as Oresme and Buridan, whose ideas were undoubtedly known to Leonardo.

Human and animal bodies are the machines or "instruments" through which force can establish impetus and achieve motion:

> Why nature cannot give motion to animals without mechanical instruments is shown by me in this book on the mobile operations of nature made in animals. And to this end I have formulated the rule of the four powers of nature without which nothing can give local motion to these animals. (RL 19060 r; K/P 153 r)

He proceeds to explain that the "four powers" are natural weight, force acting against natural weight, percussion and local motion, and that "every local motion of an inanimate kind is generated by an animate mover, as in a clock the counterweight is moved by man, its motor". He adds:

> Weight and force, together with material motion and percussion are the four accidental powers by which the human species in its marvellous and various works appears in this world to be manifested as a second world of nature. (Arundel MS., f. 151 r)

Behind all instruments in motion lies the presence of force that belongs to the life of the natural world:

> Force is nothing other than an immaterial power, an invisible potency, which is created and propagated by accidental violence by animate bodies in inanimate ones, whereby these bodies acquire the semblance of life. This life is of marvellous efficacy, compelling and transforming the position and shape of all created things, racing with fury to its destruction and continuing to exercise diverse effects according to the laws. (CA, f. 826 r/302 v-b)

The ultimate source of all force, whether animate or inanimate, is the "Prime Mover", the agent of the creator's power, which is responsible for setting the celestial and terrestrial worlds in motion.

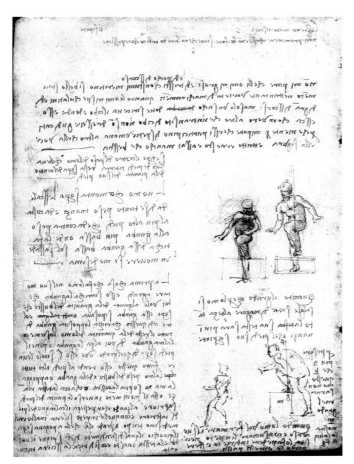

Fig. 146. RL 19038 v; K/P 80 v. Studies of a man stepping upwards and stopping after running.

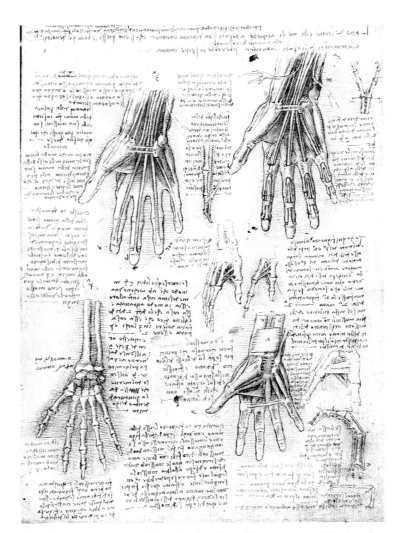

Fig. 147. RL 19009 r; K/P 143 r. Studies of the anatomy of the hand.

Since Leonardo saw the workings of the bodily machine within the context of mechanical principles, it is understandable that he wished to ensure that "the book of the elements of machines with its applications shall precede the demonstration of the motion and force of man and the other animals". He continues: "by these means you will be able to prove all your propositions" (RL 19009 r; K/P 143 r). This is written on a sheet of beautiful studies of the mechanics of the human hand (Fig. 147) in which he illustrates how the system of "chords" can result in motions of such infinite subtlety as to serve the painter and musician — and the inventor. Typically, in turning to the elements of machines in their own right, he plans to progress from principles to practice: "the book of the science of machines must precede the book of useful applications" (RL 19070 v; K/P 113 r).

Only once the principles and the applications — the causes and effects — have been fully mastered, can the inventive man hope to proceed productively on his own account. Accompanying one of his studies of the nerves of the neck and shoulders, Leonardo wrote: "this demonstration is as necessary to a good draughtsman as is the derivation of Latin vocabulary for a good grammarian, because he will but poorly make the movements and actions of such figures if he does not know what are the muscles that are the cause of their movement" (RL 19021 v; K/P 62 v). The necessity of such knowledge for the painter, who has to "remake" figures in his pictures, is more obvious than it is for the designer of machines. It is true that the inventor of machines does not necessarily "imitate" nature

137

in the same way as a figurative artist. But, as we will see, the difference is largely superficial and concerns only the immediate end or function of the particular invention. In fact, the ways and means through which an inventive man can aspire to create "a second world of nature" are basically shared by the artist and the technician with the "Creator" of nature.

"A Second World of Nature"

The way in which Leonardo perceived the human inventor as being obliged to work with respect to (and with respect for) the natural world can best be examined through the study of an engineering project in which the degree of direct imitation is unusually high: the attempt to achieve man-powered flight. The starting point, inevitably, must be a remorseless scrutiny of nature's own structures, which themselves can only be understood in the context of natural law:

> To give the true science of the motion of birds in the air it is necessary first to give the science of the winds, which will be confirmed by means of the motion of water in itself, and by means of this visible science [i.e. currents in water] you will arrive at understanding. (Paris MS. E, f. 54 r)

Elsewhere, the inventor reminds himself that:

> Before you write on flight, make a book on inanimate bodies that descend through the air in the absence of wind and another book on those which descend with wind. (Paris MS. F, f. 53 v)

Understanding the rudimentary principles will not in itself dictate the form of an invention, but it will provide a secure foundation. As he wrote in a different context, concerning the science of perspective in painting, "these rules will enable you to obtain a free and good judgement, because good judgement is born from good understanding" (CA, f. 597 Br/221 v–d).

Since Leonardo's goal in creating his flying machine was very similar to nature's aim in inventing flying creatures, the underlying principles could naturally be expressed in his device in details of form closely modelled on nature:

> A bird is an instrument operating according to mathematical law. It lies within the power of man to make this instrument with all its motions, but without the full scope of its powers; but this limitation only applies with respect to balancing itself. Accordingly we may say that such an instrument fabricated by man lacks nothing but the soul of man. (CA, f. 434 r/161 r–a)

He then proceeds to explain that the mind and body of man will be constitutionally separate from the invented machinery of artificial flight, whereas the bird is an integrated flying organism in which mind and body act as one. Man cannot, therefore, hope to achieve the full potentiality of bird flight, with all its subtle, instantaneous and instinctive shifts of weight and adjustments of power.

The problem of balance — which, as a result of prolonged study of birds wheeling on eddies of air in the Tuscan hills, Leonardo had come to regard as of extreme importance — was one of the two main technical difficulties that most exercised him in the design of his "bird". The other was the problem of the necessary power. He was aware that the specialized muscular power of birds, in which "all the muscles which lower the wing... have in themselves a greater weight than those of all the rest of the bird" (RL 19011 v; K/P 145 v), could not be rivalled by a man in a machine. However, he

argued that birds possess a power in excess of that needed simply for keeping themselves in the air, since — in their search for food and other activities — they perform complex acrobatics.

Leonardo endeavoured to find a formula for the ratio of wing-span to weight in birds which could be used to calculate the size of wing necessary to sustain a man. He was encouraged by the fact that, whereas small birds and bats are equipped with relatively long wings, the larger birds such as pelicans and eagles do not apparently need wings of a directly proportional size. An average-sized bat, for example, possesses a wing-span of half a *braccio* and weighs two ounces, while an eagle weighing 240 ounces requires a wing-span of only three *braccia* (Paris MS. B, f. 89 v). He accounts (rather unconvincingly) for the relatively smaller wings of large birds by an analogical reference to a bundle of reeds, which possesses a combined strength far in excess of the simple sum of the strength of the individual reeds (Paris MS. B, f. 88 v).

Once he had acquired some idea of the necessary wing-span to weight ratio, Leonardo planned a practical test (Fig. 148). A model wing was to be anchored to a block of wood weighing two hundred pounds. As a man levered vigorously downwards, the wing would descend. If the lift was adequate, the two-hundred-pound block should rise. He notes that one hundred pounds of lift should be credited to the wing and one hundred to the man. Two wings together would therefore achieve the two hundred pounds of force necessary to sustain a man in the air.

The model wing shows clearly how Leonardo took his cue directly from nature. He invented a series of palmate wings similar to those of bats and not unlike human hands (Fig. 149). He instructed himself to "make an anatomy of a bat, and conform to this and arrange your instrument on this basis" (Paris MS. F, f. 41 v). The feathery wings of birds, being partly permeable, demand much greater muscle power than the membranous wings of bats, which are supported by a light armature (Codex on the Flight of Birds, f. 16 r). The inventor accordingly sought materials possessing the lightness, flexibility, resilience and strength that would permit the construction of membranous wings. He considered various materials: "strong leather treated with alum" for the joints; "very strong raw silk" and wire for its nerve-like "chords"; "greased ox-hide" for thongs; horn or steel for springs for return motions; green fir branches and cane or willow for the "skeleton"; and fustian, taffeta or starched linen for the "skin".

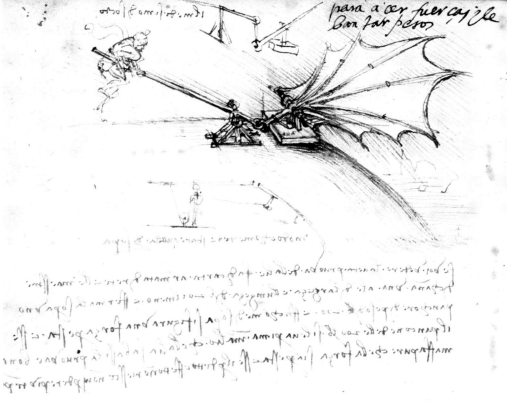

Fig. 148. Paris MS. B, f. 88 v (detail). Device to test the lifting power of an artificial wing.

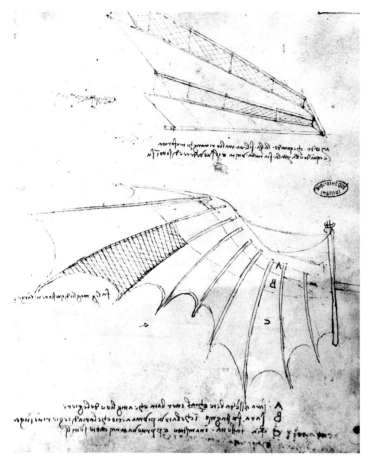

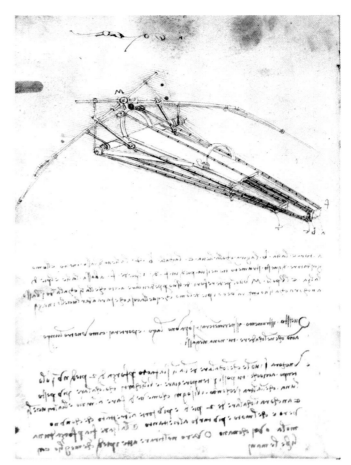

Fig. 149. Paris MS. B, f. 74 r. Armature for the wing of the flying machine.

Fig. 150. Paris MS. B, f. 74 v. Design for a flying machine to be operated by a man in a lying position.

A number of the sketches for this project demonstrate a high degree of finish (Fig. 150), suggesting that their author was optimistic about having reached a solution. He explains in detail that:

> ...*a* twists the wing; *b* turns it with the lever; *c* lowers it; *d* raises it from the bottom to the top, and the man who is in control of this instrument fixes his feet at *f* and *d*, and the foot *f* lowers the wings and the foot *d* raises them. The pole *M* must always lie outside the perpendicular [slanting forwards], so the wings as they descend to the bottom will also descend towards the man's feet, because this is the means by which the bird is made to go forwards. (Paris MS. B, f. 74 v)

However, he later added another note on the same page to the effect that the man would need to use both feet simultaneously to create the necessary power for the down–thrust of the wings, and that the machine would require a means of regulating the degree of motion of each wing independently — a conclusion based on his observation of the flight of a kite. He considered the alternatives of raising the wings by means of a spring or by the action of the pilot's hands, but finally decided that activating the wings by the retraction of the feet would be preferable, as it would leave the hands free.

As Leonardo contemplated the different options, he was seeking that elusive design in which "nothing is lacking and nothing superfluous". Once he had achieved this perfect tuning of his instrument to the proportional laws of motion, the subtlest motion of each part of his machine would give rise to remarkable effects. The action of a ship's rudder provides a suitable analogy:

> We see that a tiny, almost indiscernible movement of the rudder has the potential to turn a boat of remarkable size, laden with a mighty weight, and in such pounding seas that it is assaulted from every side, and against the rushing of impetuous winds and with the bellying of great sails. (CA, f. 845 v/308 v–b)

140

One of Leonardo's most beautiful descriptions of a flying bird shows how similar effects of great potency can be achieved by small but precisely tuned actions in flight:

> The bird maintains itself in the air by imperceptible balancing when near to the mountains or lofty ocean crags: it does this by means of the curves of the winds which, as they strike against these projections and are forced to conserve their original impetus, bend their straight course towards the sky with diverse revolutions, at the beginning of which the birds come to a halt with their wings open, receiving underneath themselves the continued buffetings of the rebounding course of the winds. By the angle of their bodies they acquire as much weight against the wind as the wind makes force against this weight. And so by such a condition of equilibrium the bird proceeds to apply the smallest beginnings of every variety of power that can be produced. (Paris MS. E, f. 42 v)
> It is necessary to calculate the slant for in no degree of slant, either of an object on the water or a bird in the air do they stop, but their speed will be greater or less as their position slants less or more. (Paris MS. E, f. 43 v)

Leonardo's optimism that man's inventions could ultimately achieve effects of subtlety and power comparable to those of natural organisms did not blind him to the inherent and inevitable differences between even the most sophisticated human flying machine and a flying animal. We have already noted his observation that the automatic weight shifts of a bird in flight cannot be equalled by the less integrated mechanism of a man piloting a machine. He eventually broadened this differentiation to arrive at a general definition of the difference between the muscular systems of organisms and the mechanical systems of instruments invented by man:

> There are two kinds of moving forces, of which one is animate and one is not; that which is animate possesses life, and the other lacks life. But that which has life moves its movable elements by means of the expansion and contraction of the muscles that form part of its limbs. This expansion and contraction is made with a greater or lesser amount of speed with the same power, the cause that is swiftest not being the most powerful. (Paris MS. E, f. 52 r)

Whereas such muscular systems can vary their performance, moving swiftly but weakly or slowly and strongly (and vice versa) across a continuous range of possibilities, a mechanical system — such as that of a catapult or crossbow — has the parameters of its performance established according to the simple ratios of inanimate action.

Descartes' kindred awareness of the similarities and differences between man's inventions and muscular systems in nature led him, much later, to conclude that "it is said that it is possible — metaphysically speaking — to make a machine which will support itself in the air like a bird; for birds themselves, according to me at least, are such machines. But it is not possible — speaking scientifically or practically — because it would require means too subtle and at the same time too forceful to be fashioned by man".

Leonardo, in spite of his failure to achieve the flight that he believed would win him eternal acclaim, does not seem to have reached the same conclusion. He does appear, however, to have been increasingly reluctant to ape the structure and action of flying creatures too closely, and to have directed his efforts more and more towards other possible mechanisms of flight and gliding. Clearly, his repeated failure simply meant, for him, that he had not hit on the right solution, rather than that man-powered flight was inherently impossible.

Although the instruments invented by man differ from nature's inventions in that they lack the animate life force which is such an integral part of the organic transformations of shape and position in

animals, the nature of human inventions is not to be disparaged on this account. We have already emphasized that Leonardo characterized the results of man's inventiveness as a potentially infinite number of compound structures having their source in the building blocks of nature. This infinite potentiality is, according to him, made manifest in a series of ends, ways and means distinct from (though in harmony with) nature. A properly designed instrument, such as a system of levers, pulleys or screws, could amplify "the smallest beginnings" to an almost unbelievable degree, far surpassing the force that could be exercised by men or animals without mechanical assistance:

> Force is infinite, since by it infinite worlds might be moved if instruments could be made by which the force could be propagated... The quality and quantity of the force of a man can give birth to another force that will be proportionately so much the greater as the movement of one is longer than the other. (Arundel MS., ff. 151 r and v)

Although founded on false mechanical premises, this vision of the infinite potentiality of mechanical systems in achieving effects of incredible magnitude from small sources of power is an authentic expression of the questing optimism which must underly any technological revolution. One of its consequences, in Leonardo's case, was the conception of devices in which sheer size was seen as providing the solution to the problem of achieving greater power (see Fig. 60); he conveniently ignored, in these projects, the constraints imposed on large machines by such factors as friction and the physical limitations of the materials.

The fantastic, visionary and sometimes prophetic aspects of Leonardo's inventiveness have tended to distract attention from his ability to focus on a specific technical problem of a practical kind and to use his understanding of the anatomical "elements of machines" to visualize the structures necessary to achieve the required form of motion in the context of mechanical law. In the Madrid MS. I, which contains designs from the late 1490s and early 1500s, solutions to a variety of technical problems are illustrated in compact drawings of splendid explanatory clarity, such as those for particular kinds of hinges (Fig. 151) for use in articulated structures such as portable pavilions, camp beds and other folding furniture. Leonardo explains that the lower hinge "cannot be opened beyond the straight line *n f m*, and the one above is useful for the folding walls of wooden pavilions".

Leonardo's sense of the dynamic anatomy of machines gave him a great ability to visualize the

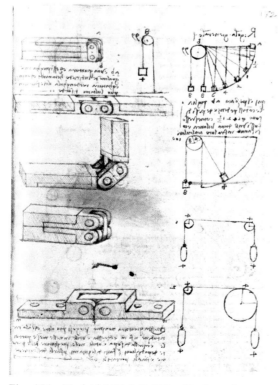

Fig. 151. Madrid MS. I, f. 172 r. Designs for hinges and studies of weight.

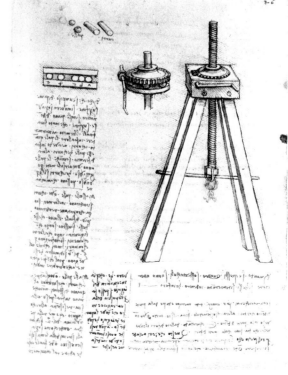

Fig. 152. Madrid MS. I, f. 26 r. Design for a screw-jack.

transformation of one kind of motion into another. His design for a windlass to raise heavy loads, depicted in assembled and exploded views (CA, f. 30 v/8 v-b: see Fig. 103), uses two wheels with built-in ratchets, mounted on opposite sides of a lantern gear so as to transform the back-and-forth action of the upright hand-lever on the right into a turning motion which works uninterruptedly during both of the lever's linear motions. Many such devices were designed with the aim of amplifying the "small beginnings" of man's power to achieve great effects. The use of a screw-jack to lift heavy weights was well established by his day, but Leonardo's illustration of the solutions to two of its most pressing problems (Fig. 152) displays an altogether remarkable sense of how a machine can perform its action. Two of the major problems associated with the screw-jack are the transmission of power and the considerable degree of friction likely to be caused by the weight pulling against the plane of the turning motion. To solve the former, Leonardo uses a worm gear — possibly of his own invention — turned conveniently by a crank handle. He minimizes the frictional forces by a ring of ball bearings between the large nut and load-bearing plate on the jack. The diagram emphasizes that the balls must not touch if they are to rotate freely. Thus a simple turning motion in one plane is transmitted into a slower turning motion at right angles and into the rolling motion of the bearings. The screw transmits the second turning motion into the slow but immensely powerful linear ascent of the hooks on the jack. The design as a whole is a perfect expression of his special feeling for co-ordinated motions within a compact, three-dimensional form.

Such designs work *with* nature rather than against it. Leonardo stresses this point as a hydraulic engineer, no doubt on the basis of unfavourable experiences in trying to force water to behave against its "natural desire":

> A river which has to be diverted from one place to another ought to be coaxed and not coerced with violence; and in order to do this it is necessary to build a sort of dam projecting into the river and then to pitch another one below it projecting further; and by proceeding in this way with a third, a fourth, and a fifth, the river will discharge itself into the channel allocated to it, or by this means may be turned away from the place where it has caused damage, as happened in Flanders according to what I was told by Niccolò di Forzore. (CH, f. 13 r)

The apparent success of the Flemish engineers stood in sharp contrast to the Florentines' unavailing efforts to force the Arno from its natural bed around Pisa during their attemps to recapture that city.

Leonardo's drawings also suggest that an arrangement of double weirs was actually in place up-river from Florence on the stretch of the Arno between the Africo and the Mensola (Fig. 153). The purpose of the weirs appears to have been to gather the disorderly waters of the Arno into a single, relatively deep channel, but the drawing shows that the resulting vortices had caused two substantial areas of erosion in which the containing wall was undermined. Leonardo records that one of the areas of damage is sixty *braccia* long and six *braccia* wide, while the other extends to one hundred *braccia* in length. Since the labelling on this and a related map (RL 12679) is written neatly for left to right, the drawings were probably produced as part of a report for the Florentine government on a section of the Arno that was giving problems. There is little doubt than Leonardo would have been ready with a solution.

If, as a hydraulic engineer, he required a model of how he could utilise rather than try to oppose the remorseless vortices of liquids in turbulent motion, Leonardo needed to look no further than the human heart; his studies of this organ had shown him how the energy of the vortices in the blood are

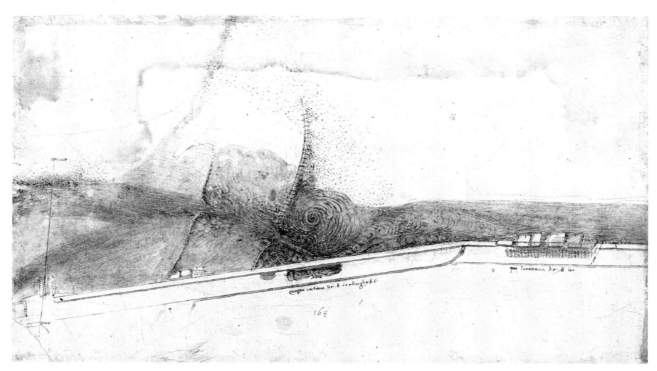

Fig. 153. RL 12680. Study of erosion caused by weirs on the Arno near Florence.

harnessed to generate life-giving heat and to operate the delicate but superbly engineered valves at the bases of the aorta and other arteries.

During the course of this essay, we have come full circle, returning — entirely appropriately — to anatomical design. For Leonardo, all aspects of nature and of man are linked, both to each other and to certain basic, underlying principles. The rule of these principles is absolute, being the result of the overall principle of "Necessity" which governs all causes and effects: "Necessity is the theme and inventor of nature — the curb, the rule and the theme" (Forster MS. III, f. 43 v). As we have seen, however, these rules do not stifle or limit human inventiveness within its own sphere of action. Rather, the "second world of nature" invented by man is of potentially infinite scope provided it is securely founded on the unalterable rules of the "first world of nature".

The bibliography of chapter I.3 is on page 319.

I.4

A Typology of Leonardo's Mechanisms and Machines

by
Gustina Scaglia

Masons and carpenters began to understand and work from architectural and machine drawings during the period between 1418 and 1447, when Filippo Brunelleschi first used them instead of wooden models for his buildings, hoists and cranes. Although no drawing from his hand has come down to us, mechanisms copied some forty years later from original drawings appear in the sketchbooks of Buonaccorso Ghiberti, Giuliano da Sangallo, the Anonimo Ingegnere Senese and Leonardo da Vinci, all of whom lived during the same period in Florence. A recurring theme in Antonio Manetti's biography of Brunelleschi — although Vasari gives it less emphasis — is his constant drawing and making of *disegni brieve*, scale drawings also known as *a braccia piccoli*. Before workmen were able to understand these mathematically formulated drawings, however, Brunelleschi was obliged to give them oral instructions and train them in new work methods. His three-speed hoist consisted of components made to his specifications outside Florence and then assembled by other workmen in the cathedral, which was under construction at the time. Despite these precautions, once the hoist was operating his rivals lost no time in making similar designs. And as a result of these attempts at secrecy the only record of the separate elements of the three-speed hoist is found in the copies of Brunelleschi's template drawings of its parts, reproduced in Giuliano da Sangallo's *Taccuino Senese*.

Leonardo pursued Brunelleschi's initiative by sketching a great many machines, which are listed in the Typological Index which follows. It is yet to be established, however, whether any were built as he designed them, which were his own experiments, which were modifications of already existing mechanisms and what relation they bear to the designs of his predecessors and contemporaries. The fact that certain of Leonardo's designs are so highly finished with colour, ink washes and details of fixtures and linkages suggests that since Brunelleschi's time drawings had replaced the traditional wooden models for presentation purposes. Drawings allowed artisans and patrons to visualize a machine in its assembled form, to understand the interplay of components shown in the perspective view and to be suitably impressed by the mechanical ingenuity displayed. In the field of architectural drawing — as shown by Wolfgang Lotz in his 1956 study — architects developed various types of

145

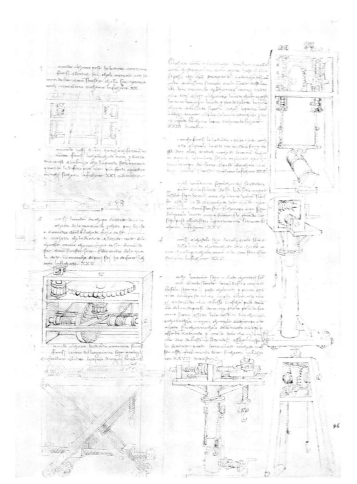

Fig. 154. Francesco di Giorgio, Ashburnham MS. 361, f. 46 r.

Fig. 155. Francesco di Giorgio, Ashburnham MS. 361, f. 15 v. Page with Leonardo's autograph notes (top).

projection, moving from a strict profile projection to a perspective or axonometric rendering in about 1500, and to a geometric projection in about 1519.

While the drawings of Leonardo's predecessor Francesco di Giorgio Martini (1439-1501) always represent the assembled machine (Fig. 154), Leonardo himself often sketched many of the separate components, partly to show each element, but also to "think out" how he might revise the form, improve the operation and reduce friction. His notes clearly illustrate his intellectual interests and major preoccupations, just as the straight or curved lines and spacing of his diagrams demonstrate, in geometrical terms, the mechanical principles of movement, tension and interrupted action. He was also aware and made use of the materials — drawings and sometimes texts — contained in the sketchbooks and treatises of his precursors and contemporaries. For example, he copied both Brunelleschi's hoists and cranes from Buonaccorso Ghiberti's drawings (*Zibaldone*), and his fortifications from a copy of Francesco di Giorgio's *Trattato II*. It has been known for some time that Leonardo wrote brief notes in a parchment copy of Francesco di Giorgio's *Trattato I* (Fig. 155); it is also known that the two met in Milan in 1491 when Francesco di Giorgio was completing his *Trattato II*.

Among the many machines and mechanisms that Leonardo sketched throughout his life, clock designs recur frequently, but Vasari maintains that mills and pumps stimulated his imagination most (see Index of Mechanisms). Vasari does not seem to have been aware, however, of the many drawings of such machines by Jacopo Mariano, called Taccola (*c.* 1382-before 1458), who knew Brunelleschi and whose technical ingenuity was the source of his nickname "the Archimedes of

Siena". In 1427, Taccola conducted tests related to four problems that interested him: the construction of gristmills, pier foundations, harbour structures and cofferdams. He also made drawings of Brunelleschi's hoist that he based on a verbal description of its components and horse-powered mechanism. Brunelleschi's characteristic inventiveness led him to devise festival machines (*ingegni*) for use in churches, that included highly theatrical light and sound effects.

The brilliant "ingenuity" (*ingegno*) of this new breed of *maestri ingegneri* — "engineers" — was expressed in the vast range of machines and "engines" (*ingegni*, today *congegni*) that they designed. Taccola was the author of an illustrated treatise actually called *De ingeneis ac edifitiis non usitates*, which was dedicated to King Segismund (before whom he had discoursed on technology in Siena in 1432) as he hoped to be employed on waterworks being built in Hungary. The personal sketchbook (MS. Add. 34113, British Library, London) of another *maestro ingegnere*, the Anonimo Ingegnere Senese, is a compendium of Taccola's *oeuvre* translated into Italian, but also includes hundreds of mechanisms developed after Taccola's time, which are known as the "machine complexes" (various hoists, cranes, mills, pumps, clocks, haulers, lifts and military devices (Fig. 156). Many of these mechanisms reappear in Francesco di Giorgio's *Opusculum de architectura* (MS. 197.b.21, British Museum, London) and in two parchment copies of his *Trattato I*. Leonardo clearly had access to the manuscripts of these various *ingegneri*.

The practice of giving a prospective patron a gift that revealed one's technical imagination was also indulged in by Francesco di Giorgio. After being assembled in Siena, his copybook — a textless set of engine drawings (*Opusculum*) — was ultimately dedicated (in about 1478) to Federico da Montefeltro, Duke of Urbino, with an epistolary essay as frontispiece. It includes machine complexes or designs for mills, pumps, iron-bar cutters, haulers, lifts and other instruments, many of which make use of the endless-worm gear system. This system never appears in Taccola's drawings, nor in Leonardo's, whose sketches illustrate his preference for the cogwheel-lantern system commonly used in mills and pumps. Francesco di Giorgio's *Opusculum* mechanisms set a standard of representation that had no follow-up in Leonardo's drawings. Every time one of Francesco di Giorgio's drawings was

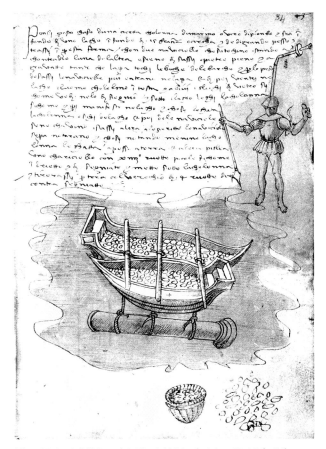

Fig. 156. Additional MS. 34113, f. 34 r, British Library, London. Diver with boat.

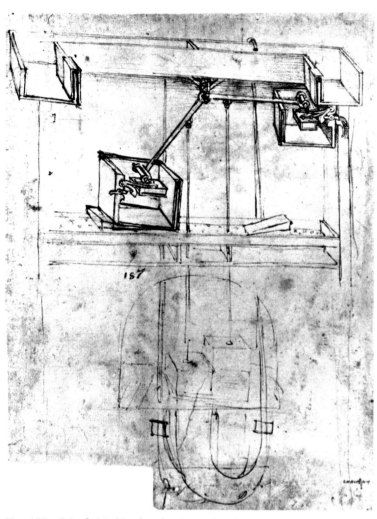

Fig. 157. CA, f. 25 r/6 v–b. Floating valve for a hydraulic pump.

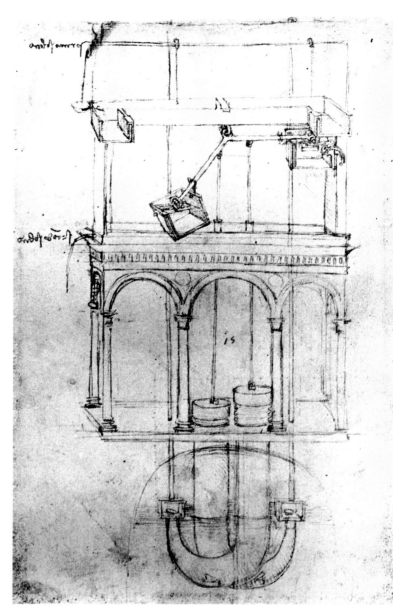

Fig. 159. CA, f. 179 v/63 v–a. Plunger pump.

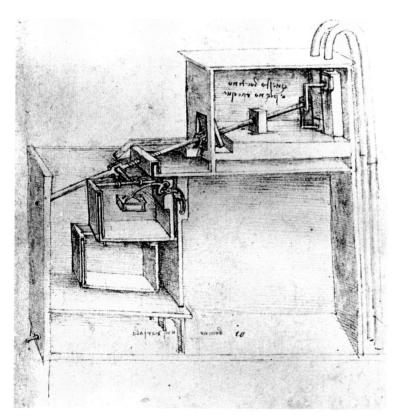

Fig. 158. CA, f. 137 r/49 r–b (detail). Hydraulic pump.

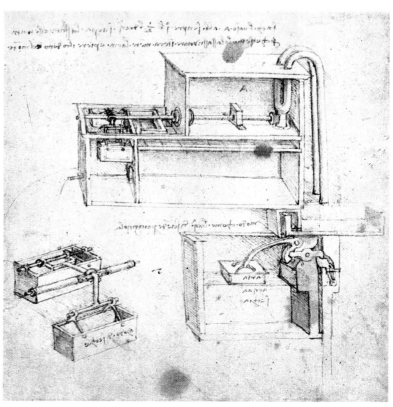

Fig. 160. CA, f. 1116 r/401 r–b. Floating valve for a pump.

copied into a new manuscript or selected by Francesco himself to appear in his *Trattato I* or *Trattato II*, its form and viewpoint remained unchanged.

By the middle of the fifteenth century, the drawing of engines had become quite widespread. However, Leonardo's fertile imagination and instinct for drawing were the source of a quite different approach. One of his earliest technical drawings, executed in about 1478, is a pump with vertical bellows and an horizontal transfer rod with self-closing clamps installed rather strangely on several levels of a fine, arcaded building similar to the Loggia Rucellai (CA, ff. 25 r/6 v–b, 112 Br/39 v–d, 137 r/49 r–b, 179 v/63 v–a, 279 r and 281 v/102 r–a, 798 Br/292 v–c, 1116 r/401 r–b, 1117 r/401/v–a: Figs 157–161). Its assembled form is somewhat enigmatic, but no more so than some of Taccola's engines and certain of Francesco di Giorgio's machine complexes. A number of Francesco di Giorgio's *Opusculum* mechanisms, especially those with an endless-worm gear system, were studied in Urbino during the 1570s by scientists in the circle of Guidobaldo dal Monte and Federico Commandino; they concluded that these mechanisms would be slow and inefficient. But they were investigating new questions on mechanics, dynamics, hydraulics and theorems of movement and statics, and none of them expressed any opinion on the basic question of whether any of the ingenious devices could operate as shown.

Taccola's drawings clearly illustrate to the ordinary viewer how the assembled machines could be operated by men or animals working in outdoor settings, how rivers could turn the waterwheels and how water could be forced by pumps into fountains and reservoirs. Francesco di Giorgio's *Opusculum* mechanisms, by contrast, are not shown in landscape settings, and Leonardo seldom depicts outdoor scenes. A practised carpenter would nonetheless know from their drawings how their mechanisms might be modified or actually built. As far as the accompanying texts are concerned, Taccola's and Francesco di Giorgio's usually express a theory or explain the functioning of the mechanism, its capacity, time-saving advantages and other practical points. Leonardo's cryptic notes, on the other hand, while clearly meaningful to him, are often a riddle for us. He sketched in response to his own needs and curiosity. In the field of science, he initiated some ideas on paper that were taken up by the academicians and natural scientists of the late sixteenth century. The drawings of Francesco di Giorgio

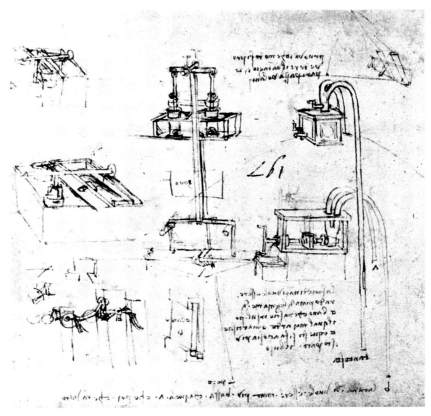

Fig. 161. CA, f. 1117 Ar/401 v–a (detail). Plunger pump.

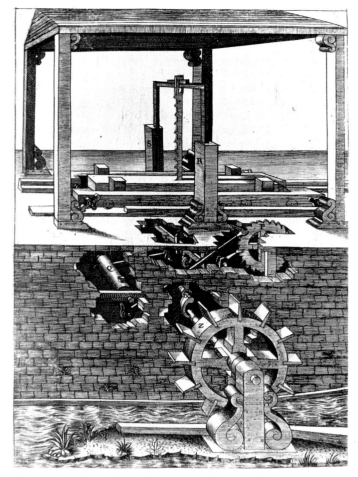

Fig. 162. A. Ramelli, *Le diverse et artificiose machine*. Paris, 1588 (Fig. CXXXVI). Hydraulic saw based on drawings by Francesco di Giorgio.

Fig. 163. Francesco di Giorgio, Ashburnham MS. 361, f. 36 r. Wind mill and water mills.

were nonetheless more influential, as witness — in the *Theatre of Machines*, published in 1588 — "The Various and Ingenious Machines of Agostino Ramelli", many of which can be traced to Francesco's machine complexes (Fig. 162). Although in Ramelli's work the settings are more realistic and operators are shown in the act of working the mechanisms, his method of illustration (and Leonardo's before him), in which the inner component is shown through a transparent outer surface, originated — like the "exploded view" technique — in Taccola's drawings of pumps and cannons.

Leonardo paid a great deal of attention to minute details, especially meshing gears, wheels, ratchets, linkages and so forth. Not restricting himself to the traditional straight-on and profile views, he examined these details from an infinite variety of viewpoints, analyzing them as if he were studying their fittings and connections through a magnifying glass. Leonardo's designs for mills and pumps are quite unlike Francesco di Giorgio's (Fig. 163). And while Taccola and Francesco di Giorgio illustrated only a few examples of the military snapper or *catapulta* (Fig. 164), Leonardo conceived about seventy designs for the snapper mechanism, despite the fact that is must have been virtually useless against the cannon. These designs reflect his interest in coiled springs and the principles of torsion and tension. In Paris MS. B, as was noted fifty years ago, Leonardo adopted many of the illustrations and pseudo-antique names for military engines that appear in Valturius' Italian edition of *De rei militari* (1483).

Other writings that Leonardo incorporated into his notebooks have come to light only recently. Since the rediscovery in 1966 of Madrid Manuscripts I and II, it has been established that Leonardo's library included a manuscript by Francesco di Giorgio and that he transcribed and

150

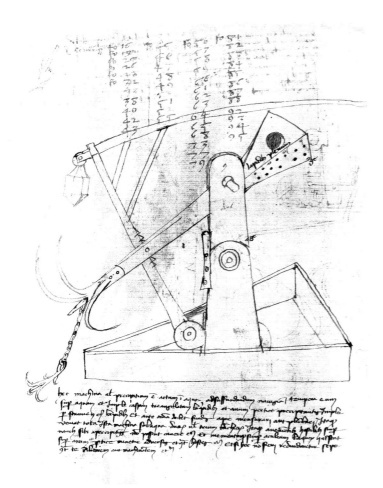

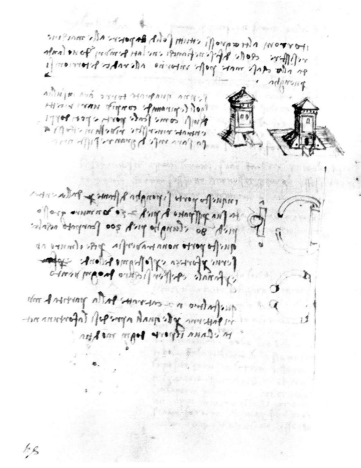

Fig. 164. Taccola, *De ingeneis*, f. 8 v.

Fig. 165. Madrid MS. II, f. 89 r. Notes and drawings derived from Francesco di Giorgio.

paraphrased large portions of Francesco's texts on forts and bombards and copied their illustrations into Madrid MS. II (Fig. 165). The manuscript of Francesco di Giorgio's *Trattato II* in Leonardo's possession was an illustrated copy similar to a document still extant that is unique for its illustrations and its unusually large format. An illustrated *Trattato II* and two parchment copies of the *Trattato I* were also in the scriptorium of Monte Oliveto Maggiore, near Siena, in the late 1490s. Notes in Leonardo's Madrid MS. II are dated 1503-1504, a period when he was working on the harbour and fortifications in Piombino, which is on the same latitude inland from Siena. The discovery of extensive transcriptions and illustrations from Francesco di Giorgio's *Trattato II* into Leonardo's Madrid MS. II leaves no doubt in my mind that the manuscript in Leonardo's library was a small-sized paper copy of *Trattato II*. That he owned a copy seems clear: it would have taken some time to extract the long quotations from widely separated folios, to transcribe them and integrate them with his own paraphrasing of ideas from other paragraphs, and to present the whole without alterations or changes, as if there had been a preliminary draft.

It seems certain that Leonardo saw other technical manuscripts when he was in Siena. Proof of this is slight, but significant: his Codex Atlanticus includes sketches that he could only have copied from manuscripts in Siena. Obvious example are the steam-blower that appears in the manuscript of the Anonimo Ingegnere Senese (MS. Add. 34113, f. 73 v: Fig. 166) and the gun-wielding horseman from Taccola's notebook (CLM 197, II, f. 21 r, Bayerische Staatsbibliothek, Munich: Fig. 167). This last document was at that time at the Studio in Siena, where Taccola lived and worked; it is very probable that Leonardo met there with teachers of medicine, philosophy, metaphysics and astrology,

151

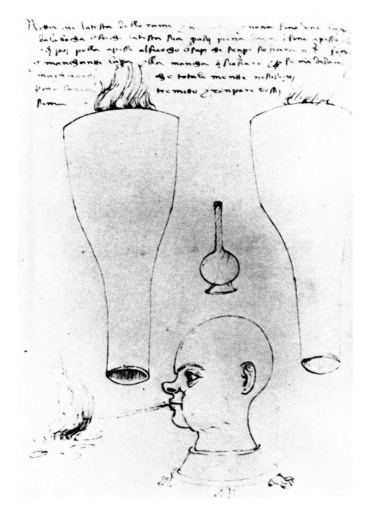

Fig. 166. Additional MS. 34113, f. 73 v, British Library, London.

Fig. 167. Taccola, *De ingeneis*, f. 21 r.

who were investigating the very questions that his drawings of anatomy and the books in his library prove were uppermost in his mind.

It appears likely that the item in Leonardo's library referred to as *Libro di Filone de acque* was an Italian translation that he obtained in Siena of texts and diagrams transcribed by the Anonimo Ingegnere Senese into his manuscript on folios entitled *Il libro di Filone degli ingegni ispirituali*. The title of another book in his library — *De re militari* — resembles the Italinate-Latin title of the previously mentioned *De rei militari* by Valturius, published in 1482. While a very similar title appears on the Italian edition of 1483, and the illustrations are the same in both, we are certain that Leonardo used the 1483 edition, since his notes in Paris MS. B quote the Italian wording.

In 1939, Guido Semenza and Roberto Marcolongo composed classified indices of Leonardo's scientific texts and drawings for the facsimile publications of his manuscripts in France and England. Ladislao Reti's 1974 edition of Madrid MSS I and II includes (in Volume III, Commentary) abbreviated and selective lists of correspondences of texts and drawings between Madrid MS. I and certain early notebooks, including Paris MS. A, Paris MS. H, Forster MSS. I, II and III, and the Codex Atlanticus. It seems an appropriate moment to publish a comprehensive Typological Index of Leonardo's machine drawings and sketches that appear in the existing manuscripts.

In the Typological Index, I have not taken into account the sketches of common tools, agricultural implements and weapons (such as lances, cross-bows and daggers) most of which appear in Paris MS. B among Leonardo's adaptations of Valturius' terminology. Nor have I concerned myself

with aeronautical drawings or with incomplete designs (for example, details of wheels, gears, ratchets and springs), or those designs which have not yet been explained by authorities on Leonardo's technology and which remain unintelligible to me. I have been obliged to classify a great many drawings as "mechanisms of undetermined purpose", due to the absence of any clue that might reveal their functions in any specific industry (such as textiles, milling, etc.). If their functions have been identified in other publications, these have escaped my attention. In summary, the Typological Index is a list of drawings of assembled machines, identified by function when one is at least suggested by some component or by evidence in Leonardo's notes.

A Typological Index in English and Italian of Leonardo's Mechanisms and Machines

The Index includes references to drawings
by other Renaissance engineers related to those by Leonardo.

Acciarino (automatic ignition of cannons)
— See Flintlock.

Acqua, attingere e tirare
— See: Fountain-jet; Pump; Water-screw; Waterwheel.

Alambico
— See: Siphon and Still.

Anchor, Ground-, winch or capstan (*argano*)
Paris MS. B, ff. 52 v, 53 r, 55 r; Madrid MS. II, f. 125 v.
[Others: Francesco di Giorgio, *Opusculum*; *Trattato I*]

[Anonimo Ingegnere Senese]
He is cited in the items: Equestrian with Gun; Fountain-jet; Ladder, Foldable; Steam-blower.

Apparecchi da nuoto
— See: Diving and Flotation Equipment.

Archimedes Screw
— See: Pump.

Argano
— See: Hauler; Hoist.

Argano di Brunelleschi
— See: Hoist by Brunelleschi.

Astrolabio
— See: Level.

Bagno della Duchessa Isabella
— See: Bolt with special screw-lock.

Bar Cutter, Iron- (*tenaglia; sega overo lima*)
CA, ff. 23 Ar/6 r-a, 23 Bv/6 v-a 34 r/9 v-b, 54 v/16 r-c, 56 Ar/16 v-b, 1046 r/375 r-a, 1094 r/394 r-b; Madrid MS. I, f. 53 r; Uffizi, no. 4085 A (by Anon. XVIth

153

century); Munich, Staatliche Graphische Sammulung, no. 2152 b.
[Others: Francesco di Giorgio, *Opusculum*; *Trattato I*; Taccola, *De ingeneis I*]

"Battiloro"
— See: Machine for gold-beating.

Bell-suspension bearings and hoisting device (*campana*)
— See also: Clockworks.
Paris MS. B, ff. 70 v, 71 r; CA, ff. 277 r/101 r-b, 941 r/343 r-a, 1019 r/365 r-b, 1086 r/392 r-b; Paris MS. H, 72 [24] v; Paris MS. L. ff. 23 v, 33 v; Forster MS. II, 1, f. 10 v; Forster MS. III, f. 43 r; Madrid MS. I, ff. 9 r, 12 v, 23 r; Madrid MS. II, f. 75v; RL 12716.
[Others: Taccola, *De ingeneis I, II*; *De machinis*; Francesco di Giorgio, *Opusculum*; *Trattato I*]

Bellows (*mantice*)
— See also: Pump.
Paris MS. B, ff. 40 v, 66 v, 81 r, 82 r; CA, ff. 26 r/7 r-a, 46 Br/13 v-b, 47 v/14 v-a, 971 v/350 v-b; Arundel MS., f. 24 r; Madrid MS. I, ff. 111 v, 114 v; Paris MS. A, f. 15 v.
[Others: Taccola, *De ingeneis I, II*; *De machinis*]

Bit-brace (*menarola*)
Forster MS. III, f. 31 v; Madrid MS. I, f. 24 v.
[Others: Francesco di Giorgio, *Opusculum*; *Trattato I*]

Boat, armoured
— See also: Ship-sinking methods.
Paris MS. B, f. 82 v; RL 12652 r.
[Others: Taccola, *De ingeneis I, II*; *De machinis*; Francesco di Giorgio, *Trattato I*]

Boat, Paddle or Treadle-powered (*barca*)
Paris MS. B, f. 83 r; CA, ff. 876 v/319 v-a, 945 r/344 r-b, 1063 r/384 r-b; RL 12649 v, 12650 v; Uffizi, no. 4085 A (by Anon., XVIth century).
[Others: Taccola, *De ingeneis I, II*; *De machinis*]

Bolt with special screw-lock (*chiavatura, sciavatura*); for the door of the room called *Bagno della Duchessa Isabella*
CA, ff. 289 r/104 r-b, 547 v/205 v-a; Paris MS. I, ff. 28 v, 31 v, 32 v, 33 v; RL 12282 v.

Bolter (*pigiatrice?*) and Grist-mill
Madrid MS. I, ff. 21 v, 22 r.

Bombarda
— See: Cannon; Mortar.

Bridge, Covered, Scaling Ladder (*ponti e scala mobile*), Scaling-tower (*castello*) and Bridges of Inflated Skins and of Tree-branches
Paris MS. B, ff. 21 r, 24 v, 30 r, 62 v; CA, ff. 49 r/15 r-a, 50 r/15 r-b, 53 r/16 r-a 55 r/16 v-a, 57 v/17 v-a, 69 Ar/22 r-a, 71 r/23 r-a, 71 v/23 v-a, 868 v/316 v-a, 977 v/353 v-a, 1074 r/387 v-a, 1084 r/391 v-a, 1087 r/392 v-a, 1117 Br/401 v-b; Codex Trivulzianus, f. 28 v; Forster MS. I, f. 46 v.
[Others: Taccola, *De ingeneis I, II, III*; *De machinis*; Francesco di Giorgio, *Opusculum*; *Trattato I*]

[Brunelleschi, Filippo]
— See: Crane and Load Positioner by Brunelleschi; Crane and Load Positioner Accessories by Brunelleschi; Crane on Revolving Platform for Brunelleschi's Lantern; Crane by Brunelleschi's Competitors; Hoist, "Secret" by Brunelleschi; Hoist, Three-speed by Brunelleschi.

Campana
— See: Bell-suspension.

Canal-excavation rig (*escavatrice di canale*)
— See also: Crane in Trench.
CA, ff. 905 v/331 v-a, 944 r/344 r-a.

Cannon (*bombarda*)
— See also: Equestrian with Gun; Mortar.
Paris MS. B, ff. 24 v, 31 r, 31 v, 32 r, 32 v, 33 r, 33 v, 54 r, 82 v; CA, ff.37 r/10 v-a, 46 A and 46 B/13 v-b, 53 r/16 r-a, 60 r/19 r-a, 61 r/19 r-b, 62 r/19 v-a, 63 r/19 v-b, 68 r/21 v-b, 71 v/23 v-a, 79 v/28 v-a, 80 v/28 v-b, 83 r/30 r-a, 88 r/32 r-b, 92 r/34 r-a, 113 r/40 r-a, 143 r/51 r-c, 149 Ar/53 v-a, 931 Ar/340 v-b, 937 v/342 v-c; RL 12652 r, 12647; Codex Trivulzianus, ff. 16 v, 33 v; Madrid MS. I, f. 81 v; Madrid MS. II, f. 138 r.
[Others: Taccola, *De ingeneis I, II*; *De machinis*; Francesco di Giorgio, *Opusculum*; *Trattato I*]

Cannon or Gun-carriage (*carro per bombarda*)
Paris MS. B, f.33 r; Paris MS. H, ff. 106[37v]r, 109 [34v] r, 132 [11 v] r; Venice, Accademia, no. 235 v; CA, ff. 16 r/3 v-a, 18 r/4 r-b, 32 r/9 r-b, 47 v/14 v-a, 49 r/15 r-a, 67 Br/21 r-b, 73 Ar/24 r-b, 75 v/26 v-a, 76 v/26 v-b, 88 v/32 v-b, 94 r/34 v-a, 111 r/39 v-a, 114 v/40 v-b, 149 Ar/53 v-a, 154 Br/55 v-b, 157 r/56 v-a, 168 r/60 r-a, 172 r/61 r-a, 929 Ar/340 r-b, 930 Br/340 r-e, 930 Cr/340 r-f, 931 Ar/340 v-b, 931 Br/340 v-c, 932 Ar/340 v-d, 932 Br/340 v-e, 1080 r/390 r-a, 1110 r/399 r-a, 1110 v/399 v-a; Madrid MS. II, f. 36 r; RL 12647.
[Others: Taccola, *De ingeneis I, II*; *De machinis*; Francesco di Giorgio, *Opusculum*; *Trattato I*]

Canvas Stretcher (*tirante di tela per pittura*)
CA, ff. 78 v/27 v-b, 84 v/30 v-b; Madrid MS. I, ff. 53 v, 54 r.

Car or Cart (*carro*)
— See also: Hauler; Cannon or Gun-carriage.
Paris MS. B, f. 77r; CA, ff. 17 v/4 v-a, 168 r/60 r-a, 893 r/326 r-b, 1049 r/376 r-c; Paris MS. H, ff. 117 [26r] v, 123 [20v] r, 129 [14v] r; Madrid MS. I, ff. 58 r, 69 v, 93 v; RL 12632 r.
[Others: Francesco di Giorgio, *Opusculum*; *Trattato I*]

Car, Armoured- (*carro armato*)
CA, ff. 837 r/306 v-a, 877 r/319 r-b; Paris MS. B, f. 83 v; RL 12653.
[Others: Taccola, *De ingeneis I, II*; *De machinis*].

Car, Automated (*carro semovente*) and Car, Horse-powered
Paris MS. B, ff. 59 r, 76 v; CA, f. 812 r/296 v-a.
[Others; Taccola, *De ingeneis I*; Francesco di Giorgio, *Opusculum*; *Trattato I*]

Car-Hodometer (*carro hodometro*) and Car-podometer (*carro podometro*)
CA, ff. 1 r/1 r-a (both), 855 v/312 v-a (hodometer).

Car, Scythed (*carro falcato*)
Paris MS. B, f. 10 r; CA, ff. 113 v/40 v-a, 868 r/316 r-a; Turin, Biblioteca Reale, no. 14 [15583].
[Others: Taccola, *De ingeneis I*; *De machinis*; Francesco di Giorgio, *Opusculum*; Valturius]

Catapulta
— See: Snapper.

Cave sotterrannee
— See: Tunnelling.

Chiavatura
— See: Bolt; Latch; Lock.

Cimatrice
— See: Mill, Gig; Shearing Mill.

Clockworks, Clock Springs and Equalizer, Clock with Mechanized Ringer and Water-clock (*Orologio, oriolo con acqua, orologio a suono, clessidra, orologio idraulico*)
Paris MS. B, ff. 20 v, 50 v; CA, ff. 42 v/12 v-a, 579 r/216 v-b, 782 r/288 r-a, 941 r/343 r-a, 943 r/343 v-a, 964 r/348 v-d, 1011 r/362 v-a, 1044 r/374 r-b, 1077 r/388 v-a, 1106 r/397 r-b, 1106 v/397 v-b, 1111 v/399 v-b; Paris MS. H, f. 110 v; Paris MS. L, f. 25 v; Arundel MS., ff. 191 v, 242 v; RL 12688, 12716; Forster MS. II, 1, ff. 13 r; Madrid MS. I, ff. 4 r, 8 r, 9 r, 9 v, 10 v, 11 r, 11 v, 12 r, 14 r, 14 v, 15 r, 19 r, 27 v, 31 r, 45 r, 48 v, 61 v, 70 r, 74 r, 85 r, 115 v, 145 v, 152 v, 157 v; (Clock at Chiaravalle: CA, f. 1111 v/399 v-b; Madrid MS. I, ff. 10 v, 11 r, 11 v).
[Others: Francesco di Giorgio, *Opusculum*]

Cloth Mills
— See: Textile Machine; Textile Machines.

Cofferdam and Caisson (*fondazione in mare; steccato*)
— See also: Forts and Bombards; Harbour Works.
Paris MS. B, f. 6 r; Madrid MS. II, ff. 88 r, 88 v.
[Others: Taccola, *De ingeneis I, II, III*; *De machinis*; Francesco di Giorgio, *Trattato I, II*. For the latter, see: Forts and Bombards]

Copper-strip Rolling Mill (*laminatoio; trafila*)
— See also: Drawplate.
Paris MS. G, ff 70 v, 71 r, 72 r, 72 v, 73 r, 82 v (?), 83 r; CA, ff. 86 r/31 v-a (?), 159 Ar/57 r-a (?), 180 v/63 v-b (?); RL 12432 v.

Crane and Load-positioner Accessories (Stone-lifting devices) by Brunelleschi (grip-tongs, stone-hangers or lewises, turn-buckles: *tenaglia, tenditori, ulivellae*)
CA, ff. 37 r/10 v-b, 926 v/339 v-a, 1001 r/359 v-b, 1054 v/379 v-a, 1055 v/379 v-b, 1078 Bv/389 v-b; Forster MS. II, 1, ff. 13 v; Madrid MS. I, f. 22 r.
[Copied from B. Ghiberti, *Zibaldone*, ff. 116 r, 116 v, 117 r, 119 r; others in Taccola, *De ingeneis*, I; *De machinis*; Giuliano da Sangallo, *Taccuino Senese*, ff. 48 v, 49 r]

Crane (*gru*) and Load-positioner by Brunelleschi's Competitors
CA, ff. 105 Bv/37 v-b, 847 r/309 r-b (*viticcio di Lanterna*, one of the two cranes).
[Others: B. Ghiberti, *Zibaldone*, ff. 107 v, 114 v, 128 v, 129 r; Francesco di Giorgio, *Opusculum*; *Trattato*]

Crane and Load-positioner by Brunelleschi (*gru girevole*) and Detail
— See also: Hoist by Brunelleschi.
CA, ff. 965 r/349 r-a, 1083 v/391 v-b.
[Copied from B. Ghiberti, *Zibaldone*, f. 106 r; variants: Francesco di Giorgio, *Opusculum*; *Trattato I, II*]

Crane as Bale-lifter (*gru da scaricare le navi*)
Codex Trivulzianus, f. 32 r.
[Others: Taccola, *De ingeneis I*; Francesco di Giorgio, *Opusculum*; *Trattato I*]

Crane in Trench (*gru girevole e circolare*)
— See also: Dredger
Paris MS. B, ff. 49 r, 49 v; CA, ff. 54 Ar/16 r-b, 56 Cr/16 v-d, 444 r/164 r-a, 733 v/271 v-d, 944 r/344 r-a, 1012 r/363 r-a, 1012 v/363 v-b, 1019 v/365 v-c; RL 19096 v.

Crane (*gru*), Lift and
— See also: Lift.
CA, ff. 77 v/27 v-a, 888 v/324 v, 1038 r/372 r-b.
[Others: Taccola, *De ingeneis I, III*; *De machinis*; Francesco di Giorgio, *Opusculum*; *Trattato I*]

Crane Mounted on a Wall (*gru fissa sul muro*)
CA, ff. 35 r/10 r-a, 38 r/10 v-b, 43 v/12 v-b, 141 r/51 r-a, 408 r/151 r-b, 818 r/298 r-b, 834 r/306 r-b, 888 v/324 v, 905 v/331 v-a, 1012 r/363 r-a, 1012 v/363 v-b, 1079 r/389 r-b;
Forster MS. III, ff. 14 v, 15 r; Madrid MS. I, f. 96 r.
[Others: B. Ghiberti, *Zibaldone*, f. 94r]

Crane on Revolving Platform (*gru a piattaforma anulare, girevole*) for Brunelleschi's Lantern
CA, ff. 808 r/295 r-b, 808 v/295 v-b.
[Copied from B. Ghiberti, *Zibaldone*, ff. 104 r, 105 r; Giuliano da Sangallo, *Taccuino Senese*, f. 12 r.]

Crane (*gru*), Revolving, for city-wall defence
CA, ff. 89 r/32 v-a, 94 r/34 v-a, 169 r/60 r-b, 1039 r/372 v-b, 1095 Ar/394 v-a.
[Basis in Calias' *carchesio versatili*, in Vitruvius X, xvi, 3]

Crane, Travelling (*gru o stella su carrello*)
CA, ff. 138 r/49 v-a, 891 r/325 v-b.
[Others: B. Ghiberti, *Zibaldone*, f. 95 v]

Cross-bow (*balestra*) Mounted on Wheel Mechanisms
CA ff. 57 v/17 v-a, 142 r/51 r-b, 147 Av/52 v-a, 147 Bv/52 v-b, 149 Ar/53 v-a, 149 Br/53 v-b, 182 Br/64 v-b, 1070 r/387 r-a, 1071 r/387 r-b; Uffizi, no. 7 v (446 Ev).

Die-plate
— See: Drawplate.

Distillazione
— See: Siphon and Still.

155

Diving and Flotation Equipment (waist-belt, helmet and vest, snorkel) (*apparecchi da nuoto*)
Paris MS. B, ff. 10 v, 18 r, 60 v, 61 v, 62 r, 62 v, 81 v; CA, ff. 26 r/7 r-a, 748 r/276 v-a, 909 v/333 v, 950 v/346 v-a, 1069 v/386 r-b.
[Others: Taccola, *De ingeneis II, III*; *De machinis*; Francesco di Giorgio, *Opusculum*; *Trattato I*]

Drawplate, Draw-rod, Drawing-tongs, Wire-pulling device (*trafila*; *tirari*; *laminatoio*)
— See also: Copper-strip Rolling Mill.
CA, ff. 10 r/2 r-a, 11 r/2 rb, 15 v/3 v-b, 41 Av/11 v-b, 1035 r/370 v-b, 1106 v/397 v-b; Madrid MS. I, ff. 14 v, 84 r, 86 r; RL 19147.

Dredger with either Mud-scoops, Lever, Treadwheel or Fish-hooks (*macchina escavatrice*; *cavare i fossi*)
— See also: Crane in Trench.
CA, ff. 3 r/1 v-a, 4 r/1 v-b, 30 r/8 r-b, 54 Ar/16 r-b, 56 Cr/16 v-d, 905 v/331 v-a, 904 r/330 r-b, 842 r/307 r-b, 1048 Bv/376 v-a, 1095 Br/394 v-b; Paris MS. E, f. 75 v.
[Others: Taccola, *De ingeneis I*; Francesco di Giorgio, *Trattato I*]

Dredger-boat with a Long Bow (*traino da fango*)
Paris MS. B, ff. 49 v, 50 r; RL 12649 r.

Drill, Earth (*succhiello da forare la terra*; *trivello*; *tanivella*, *trapano*) and other Drills
— See also: Bit-brace
CA, ff. 34 r/9 v-b, 720 r/266 v, 953 r/346 v-b; Paris MS. B, ff. 50 r, 65 r; Forster MS. III, ff. 28 v, 31 v; Madrid MS. I, ff. 20 v, 23 v.
[Others: Taccola, *De ingeneis I*; Francesco di Giorgio, *Trattato I*]

Drill for Piercing a Boat-frame
— See also: Ship-sinking Methods.
CA, ff. 909 v/333 v, 950 v/346 v-a; Ashburnham MS. 2037, f. 6 v.

Drill, Stone-cutting
— See also: Saw, Stone-cutting.
Paris MS. B, f. 51 v.

Drilling, Log-, horizontally (*trapano orizzontale*)
CA, ff. 108 r/38 v-b, 1092 r/393 r-b.
[Others: Taccola, *De ingeneis I*]

Drilling, Log-, vertically (*trapano verticale*)
Paris MS. B, f. 47 v.

Elevatore
— See: Lift.

Embossing Metal Ornaments for Textiles (*magli con punzoni da fare bisantini*).
— See: Textile Machines, "*battiloro*" and "*punzoni*".

Engine at Carmino (clock?)
CA, f. 691 r/257 r-a; Madrid MS. I, f. 133 r.

Equestrian with Gun, and Notes about the Gun (*equestro con scoppietto*)
Paris MS. B. f. 46 v.
[Adapted from: Taccola, *De ingeneis I*, 21 r. Copy by Anonimo Ingegnere Senese, London, British Library, Add. MS. 34113, f. 148 v]

Escavatrice
— See: Dredger.

Filatoio
— See: Loom; Spinning Mill; Textile Machines.

File-making Machine (*fabbricazione di lima*)
CA, ff. 24 r/6 r-b, 1022 v/366 v-c.

Flintlock or Gun-trigger ("*acciarino*" *del cannone*)
CA, ff. 158 r/56 v-b, 580 v/217 v-a, 978 Br/353 r-c, 987 r/357 r-a, 987 v/357 v-b, 1060 Av/382 v-a; Madrid MS. I, f. 18 v; Paris MS. H, ff. 103 [40 v], 122 [21 r] v.

Forts and Bombards, Harbours and Towers, Texts for and Sketches of Madrid MS. II, f. 86 r-98 v.
[Copied from Francesco di Giorgio, *Trattato II*, on pp. 317-491 of the 1967 edition; see the correspondences in Vol. III of the Madrid MSS., I-II, pp. 85-88].

Fountain-jet (*schizzatoio*) and Heron's Fountain
— See also: Siphon and Still; Pump.
Paris MS. B, ff. 20 r, 52 v, 70 v; CA, ff. 65 v/20 v-b, 365 v/132 v-b, 564 r/212 r-a, 782 r/288 r-a, 798 Br/292 v-c, 802 r/293 r-b, 810 r/296 r-a, 943 r/343 v-a, 1011 r/362 v-a, 1016 r/364 r-b, 1069 r/386 r-b; Arundel MS., ff. 24 v, 47 r; Madrid MS. I, ff. 114 v, 115 r, 124 v, 125 r; RL 12282 v, 12675 v, 12690, 12691.
[Others: Taccola, *De ingeneis III*; Francesco di Giorgio, *Opusculum*; Anonimo Ingegnere Senese, London, British Library, Add. MS. 34113, ff. 1-8 (text of Philo of Byzantium in translation)]

[Francesco di Giorgio] Texts and Drawings as Source for Leonardo
— See: Forts and Bombards; Hauler.
Mechanisms derived from the *Opusculum* or related technical copybooks of Francesco di Giorgio are on a folio of sketches wrongly attributed to Leonardo: Uffizi, no. 204 Av.

Fune
— See: Rope-making Machine.

Girrarosto
— See: Skewer.

Gru
— See: Crane.

Hand-position for Hurling a Missile
CA, f. 144 r/51 v-a.
[Others: Taccola, *De ingeneis I*, f. 67 v]

Harbour Works (*fondare in mare*)
— See also: Cofferdam and Caisson.
Madrid MS. II, ff. 89 r, 89 v, 90 v, 91 r, 92 v.
Adapted from Francesco di Giorgio, *Trattato II*, as cited above at Forts and Bombards.
[Others: Taccola, *De ingeneis I*; *De machinis*]

Hauler, Stone-block or Obelisk- (*argano orizzontale; tirare*)
CA, ff. 77 v/27 v-a, 1055 v/379 v-b; Madrid MS. I,
ff. 35 v, 36 r.
[Others: Taccola, *De machinis*; Francesco di Giorgio,
Opusculum; *Trattato I*]

Hinges, Back-flap (*giunti snodabili*)
— See also: Pavilion, Portable
CA, ff. 95 r/34 v-b, 97 r/35 r-b, 408 v/151 v-b, 769 r/
283 r-b, 769 v/283v-c; 987 r/357 r-a; Arundel MS.,
f. 150 v; Codex Trivulzianus, f. 4 r; Madrid MS. I,
f. 172 r.

Hoist
— See: Lift (for raising weights to limited height).

Hoist by Brunelleschi (its parts and *palei*)
CA, f. 1083 v/391 v-b.
[Inspired, perhaps, by B. Ghiberti's drawing]

Hoist, "Secret", by Brunelleschi (*argano leggero*) ·
CA, ff. 105 Bv/37 v-b, 1078 Bv/389 v-b (detail of hori-
zontal wheel), 1112 v/400 v-a (variant mechanism).
[Others: B. Ghiberti, *Zibaldone*, ff. 95 r, 98 v]

Hoist, Three Speed-, by Brunelleschi (*argano a tre velocità*)
CA, f. 1083 v/391 v-b (rear-view of the hoist).
[Others: B. Ghiberti, *Zibaldone*, f. 102 r, 103 v (side-
views); Giuliano da Sangallo, *Taccuino Senese*, ff. 47 v-
48 r (rear-view and the separate parts); Anonymous,
Cod. S IV 6, Biblioteca Comunale, Siena, f. 49 r (sepa-
rate parts)]

Hoist (*argano*) with Rope-winding Drum, Cogwheel-
lantern Gear
CA, ff. 21 r/5 v-a, 30 v/8 v-b, 148 Ar/53 r-a, 165 v/
59 v-a, 929 Br/340 r-c; Forster MS. II, 2, f. 82 r.
[Others: Taccola, *De ingeneis I, II, III*; *De machinis*;
Francesco di Giorgio, *Opusculum*; *Trattato I*]

"*Istrumento bocconi*", a Machine of Undetermined Purpose
CA, ff. 74 Ar/25r-a, 74 Br/25 r-b, 74 Av/25 v-a, 933 r/
341 r-a.

Iron-rod (*trafila*) Machine
— See: Draw-rod.

Ladder, Scaling-
— See: Bridge.

Ladder, Foldable, Operated by Crank and Screw (*scale*)
Madrid MS. I, ff. 24 v, 157 v.
[Copied from one of the following: Valturius, 1483 ed.;
Anonimo Ingegnere Senese, Add. MS. 34113, f. 152 r;
B. Ghiberti, *Zibaldone*, f. 207 r (copy after Valturius)]

Latch (*serratura brieve*)
— See also: Lock.
Paris MS. B, f. 21 r; CA, ff. 574 Ar/214 v-g, 656 Br/
240 r-c.

Lathe (*torno*)
— See also: Screw-thread Cutter.
CA, ff. 47 r/14 r-a, 1059 r/381 r-b; Arundel MS., f. 84 v.

Leather-work Apparatus(?) (*corame*)
— See also: "*Maschereccio*" Apparatus.
CA, ff. 27 r/7 r-b, 56 Er/16 v-f.

Level (*astrolabio; sesto*)
— See also: Tunnelling.
Paris MS. B, f. 65 v; CA, ff. 1068 v/386 v-a, 1083 r/391
r-c; RL 12654 r, 12668 r; Madrid MS. I, ff. 32 r, 111 r.
[Others: Taccola, *De ingeneis I, IV*; B. Ghiberti,
Zibaldone, f. 117 v]

Lever-lifted Box for Soldiers
— See also: Mechanisms by Valturius.
CA, f. 165 r/59 r-a.
[Others: Taccola, *De ingeneis I, II*; Francesco di Giorgio,
Trattato I, B. Ghiberti, *Zibaldone*, f. 196 v (after Val-
turius)]

Lift, to limited height (*elevatore*) with rope-pulley or
cogwheel
— See also: Hoist; Screw-jack.
Paris MS. B. ff. 5 r, 5 v; Forster MS. III, f. 56 v;
CA, ff. 30 r/8 r-b, 77 v/27 v-a, 88 r/32 r-b, 88 v/32 v-b,
818 r/298 r-b, 818 v/298 v-b, 888 v/324 v; 1068 v/
386 v-a, 1083 r/391 r-c; RL 12349 r, 12647; Madrid
MS. I, ff. 35 r, 43 r.
[Others: Taccola, *De ingeneis I-IV*; *De machinis*; Fran-
cesco di Giorgio, *Opusculum*; *Trattato I*]

Lift with Screws, also called Screw-jack (*elevatore a vite*).
CA, ff. 18 r/4 r-b, 77 v/27 v-a, 88 v/32 v-b, 94 r/34 v-a,
138 r/49 v-a, 818 v/298 v-b, 830 r/304 r-d, 888 v/324 v,
928 v/340 v-a; Madrid MS. I, ff. 26 r, 34 r; Paris MS. H,
f. 73 [25] r; Paris MS. B, f. 27 r; RL 12349 r, 12647.
[Others: Taccola, *De machinis*; Francesco di Giorgio,
Opusculum; *Trattato I*]

Lifting by sideways rocking or on upright posts
CA, ff. 1021 r/366 r-b, 1029 r/368 r-d; Madrid MS. I,
ff. 29 r, 33 v, 34 v, 43 v, 44 r.

Lifting-jack with Gear-rack (*martinei, martinello*)
CA, ff. 35 r/10 r-a, 75 r/26 r-a, 113 r/40 r-a, 155 r/56 r-a,
812 r/296 v-a, 883 v/321 v-b, 880 r/320 r-d, 998 r/
359 r-c, 1038 r/372 r-b, 1054 v/379 v-a; Paris MS. H,
f. 122 [21 r] v; MS. Forster II, I, f. 55 r.

Lima
— See: File-making Machine.

Livellare
— See: Tunnelling; Level.

Lock (*serratura*), Lock Plate, Lock Springs, Lock-bolt
Paris MS. B, f. 21 r; CA, ff. 63 r/19 v-b, 78 v/27 v-b,
797 r/292 v-a, 830 Av/304 v-a, 987 v/357 v-d, 1018 v/
365 v-a, 1057 r/380 r-b; Paris MS. H, ff. 119 [24 r] v,
120 [23 v] r; Forster MS. II, f. 11 r; Forster MS.
III, f. 42 r, 54 v, 57 r, 58 r; Madrid MS. I, ff. 23 v, 47 v,
49 v, 50 r, 98 v, 99 r, 99 v.

Locking and Self-releasing Tool or Sling
CA, f. 1106 r/397 r-b; Madrid MS. I, ff. 9 v, 18 v, 94 r,
96 r.

Loom, Automatic (*telaio e macchine tessili; filatoio*)
— See also: Spinning Mill; Textile Machine(s); Machine for gold-beating.
Forster MS. II, 1, ff. 49 v, 50 r; Madrid MS. I, f. 68 r.

Loom (*telaio*) for Weaving a Horse's Covering (*telaro da fare barde di bambagia*)
Paris MS. B, f. 90 r (?); CA, f. 985 v/356 v-a, 994 v/358 v-a.

Macchine di funzioni sconosciute
— See: Machines of Undetermined Purpose.

Machine for gold-beating ("*battiloro*") and punching ("*punzoni*") (*macchina tessile*)
— See also: Textile Machine (s).
CA, ff. 14 r/3 r-a, 22 r/5 v-b(?), 29 r/8 r-a, 39 r/11 r-a, 67 Ar/21 r-a, 67 Av/21 v-a, 99 r/35 v-b, 106 v/38 v-a, 1029 v/368 v-c, 1091 r/393 r-d; Munich, Staatliche Graphische Sammlung, no. 2152 r; Uffizi, no. 4085 A (Anon., XVIth Century).

Machines of Undetermined Purpose (related drawings collected under one number)
(1) CA, f. 1 r/1 r-b; (2) CA, f. 22 r/5 v-b, Madrid MS. I, f. 92 v; (3) CA, f. 96 r/35 r-a; (4) CA, ff. 102 r/36 v-a, 883 v/321 v-b; (5) CA, f. 803 r/294 r-a; (6) CA, f. 804 r/294 r-b; (7) CA, f. 805 r/294 v-a; (8) CA, f. 823 Ar/301 r-c; (9) CA, f. 866 r/315 v-a; (10) CA, f. 874 v/318 v-a; (11) CA, f. 883 v/321 v-b; (12) CA, f. 994 v/358 v-a; (13) CA, f. 996 v/358 v-b; (14) CA, f. 994 v/358 v-a; (15) CA, f. 999 Br/359 r-e; (16) CA, f. 999 Ar/359 r-d; (17) CA, f. 1044 r/374 r-b; (18) CA, f. 1019 r/365 r-b; (19) CA, f. 1037 r/372 r-a; (20) CA, f. 1045 r/374 v-b; (21) CA, f. 1080 v/390 v-a; (22) CA, f. 1092 r/393 v-b; (23) RL 12432 v; (24) Forster MS. II, 1, ff. 11 v-12 r; (25) Forster MS. III, f. 54 v; (26) Paris MS. B, f. 22 r; (27) Paris MS. G, f. 47 r; (28) Paris MS. G, f. 47 v; (29) Paris MS. G, f. 83 v; (30) Paris MS. L, f. 34 v; (31) CA, ff. 1017 r/364 r-c, 1016 r/364 v-b, 1036 Ar/371 r-a, 1036 Av/371 v-a, 1036 Bv/371 v-b; (32) CA, ff. 1106 r/397 r-b, 1108 r/398 r-b.

Macinare colori
— See: Pulverizer.

Mantice
— See: Bellows; Pump.

Martinello
— See: Lifting-jack.

"*Maschereccio*" Apparatus for leather work (?).
CA, ff. 27 r/7 r-b (?), 56 Er/16 v-f (?), 86 r/31 v-a, 159 Ar/57 r-a.

Measuring Mileage at Sea, Device for
CA, f. 675 r/249 v-a.

Mechanisms or Nomenclatures from or related to Valturius' 1483 edition of *De re militari*
Paris MS. B, ff. 5 v, 6 r, 7 r, 7 v, 8 v, 9 r, 9 v, 10 r, 30 v; Madrid MS. I, f. 24 v, 157 v.
[Basis for each type of device in Taccola's *De ingeneis I, II; De machinis*]

Menarola
— See: Bit-brace.

Mill (*mulino*)
— See also: Pulverizer; Press, Printing.
CA, ff. 169 r/60 r-b, 1059 r/381 r-b, 1084 v/391 r-b; Forster MS. I, f. 46 r; RL 12353, 19091 v.
[Others: Taccola, *De ingeneis I*; Francesco di Giorgio, *Opusculum; Trattato I*]

Mill, Gig, to raise the nap of cloth (*cimatrice, garzatrice*)
— See also: Textile Machine(s); Shearing Mill.
CA, ff. 106 r/38 r-a, 814 r/297 r-a, 994 v/358 v-a.

Mill, Grist- (*mulino da macinare grano; mulino a palmenti*)
CA, ff. 45 Br/13 r-c, 46 Ar and 46 Br/13 v-b, 47 v/14 v-a, 87 r/32 r-a, 91 r/33 r-b, 170 r/60 v-a, 745 r/275 v-c, 856 r/312 r-b, 1065 r/385 r-b, 1084 v/391 r-b; Madrid MS. I, ff. 21 v. 22 r.
[Others: Taccola, *De ingeneis I-IV; De machinis*; Francesco di Giorgio, *Opusculum; Trattato I, II*; Giuliano da Sangallo, *Taccuino Senese*, f. 49 v]

Mill, Mercury-
Paris MS. G, f. 45 r.
[Others: Taccola, *De ingeneis I*]

Mill, Post-, windmill (*mulino*)
Paris MS. L, f. 35 v; Madrid MS. II, f. 43 v.
[Others: Taccola, *De ingeneis II, IV*; Francesco di Giorgio, *Trattato I*; addenda in Taccola, *De ingeneis II*, f. 130 v]

Mill, Shearing
— See: Shearing Mill (*cimatrice*)

Mill, Water-driven, with Paddle-wheels or other Wheel
CA, ff. 103 r/36 v 1072 r/387 r-c, 1115 r/401 r-a; Paris MS. B, f. 53 v; Arundel MS, f. 165 r.
[Others: Taccola, *De ingeneis I, II*; Francesco di Giorgio, *Opusculum; Trattato I*]

Mills and Mill Races
CA, ff. 830 Dr and Dv/304 r-d and v-d; Paris MS. H, ff. 31 r, 38 v, 94 v; Madrid MS. I, f. 151 v.
[Others: Taccola, *De ingeneis I, II*]

Mirror-polishing Apparatus (*istrumento da spera; specchio*)
Paris MS. B, ff. 13 r, 21 v; CA, ff. 17 v/4 v-a, 18 v/4 v-b, 87 r/32 r-a, 801 r/293 v-a, 879 r/320 r-b, 1001 r/359 v-b, 1057 v/380 v-b, 1068 r/386 r-a, 1083 r/391 r-c; Madrid MS. I, ff. 61 r, 119 v, 163 v.

Mitre Gate and its Metalwork
CA, ff. 408 v/151 v-b, 656 Br/240 r-c; Madrid MS. I, f. 48 r.

Mortar (*bombarda*)
— See also: Cannon; Cannon or Gun Carriage.
CA, ff. 31 r/9 r-a, 33 r/9 v-a, 59 Bv/18 v-b, 71 r/23 r-a, 85 Br/31 r-b; RL 12647, 12652 r.
[Others: Taccola, *De ingeneis I*]

Mulino
— See: Mill.

Noria
— See: Pump.

Nuoto
— See: Diving and Flotation Equipment.

Orologio
— See: Clockworks.

Palificazione
— See: Pile-driving.

Pavilion, Portable (*padiglione portabile di legno*) and other Pavilion in Garden-labyrinth
— See also: Hinges, Back-flap.
Paris MS. B, f. 12 r; CA, ff. 95 r/34 v-b, 769 r/283 r-b, 769 v/283 v-c; Paris MS. H, ff. 38 r, 50 v, 89 [41] r, 44 v-45 r, 78 v-79 r, 88 v-89 r, 124 r-123 v; Madrid MS. I, f. 172 r.

Pialla
— See: Planer, Wood-.

Pile-driving (*palificazione*; manual and drop-weight structures)
Paris MS. B, ff. 66 r, 69 v, 70 r; CA, ff. 785 Br/289 r-e, 953 r/346 v-b, 1018 v/365 v-a, 1034 r/370 r-b; Paris MS. H, f. 80 v; Arundel MS., f. 202 v; Madrid MS. I, ff. 149 r, 157 v.
[Others: Taccola, *De ingeneis I, II*; Francesco di Giorgio, *Opusculum*; *Trattato I*; Francesco di Giorgio's addenda in Taccola, *De ingeneis II*, f. 128 v]

Pincers or Claw-clamp (*tenaglia*) with Screw, Gear-rack and Pliers (*forbice dentate*)
— See also: Bar-cutter, Iron; Crane and Load-positioner, Brunelleschi.
CA, ff. 18 v/4 v-b, 18 r/4 r-b, 30 r/8 r-b, 75 r/26 r-a, 94 r/34 v-a, 774 v/285 r-a, 867 r/315 v-b, 896 r/327 r-b, 962 v/339 v-a, 1018 v/365 v-a, 1054 v/379 v-a; Codex Trivulzianus, f. 2 v; Madrid MS. I, f. 63 r.
[Others: Taccola, *De ingeneis I, II, IV*; *De machinis*; Francesco di Giorgio, *Opusculum*]

Planer, Wood- (*pialla*)
CA, f. 108 r/38 v-b; Madrid MS. I, f. 83 v.

Pompa
— See: Pump.

Porto
— See: Harbour Works.

Press, Oil- (*strettoio da olio*)
CA, f. 47 r/14 r-a; Madrid MS. I, ff. 46 v, 47 r.

Press, Printing- (*torchio tipografico*)
CA, ff. 993 v/357 r-f, 995 r/358 r-b.
[Others: Taccola, *De ingeneis I*]

Pulverizer (*mulino da macinare colori*)
— See also: Mill.
CA, ff. 765 r/282 r-b, 766 r/282 v-c, 830 Cv/304 v-b, 904 r/330 r-b, 954 Ar/346 v-c.
[Others: Taccola, *De ingeneis II*]

Pump, Bellows with Suction Pipe (*pompa aspirante*)
Paris MS. B, ff. 20 r, 52 v, 54 r; CA, ff. 5 r/1 bis r-a (*olim* 386 v-a), 6 r/1 bis r-b (*olim* 386 v-b), 26 r/7 r-a, 26 v/7 v-a, 165 r/59 r-a.
[Others: Taccola, *De ingeneis I, II*; *De machinis*]

Pump, Bucket on Rope
CA, ff. 26 r/7 r-a, 26 v/7 v-a, 1069 v/386 v-b.
[Others: Taccola, *De ingeneis I, III*; *De machinis*; Francesco di Giorgio, *Opusculum*; *Trattato I*]

Pump, Bucket-wheel or Bucket-chain (*noria*) and Piston
CA, ff. 6 r/1 bis r-b (*olim* 386 v-b), f. 7 r/1 bis v-a (*olim* 386 r-a), 26 v/7 v-a, 869 r/316 r-b, 1069 v/386 v-b; Forster MS. I, ff. 50 v, 51 r, 51 v; Arundel MS., f. 165 r; Munich, Staatliche Graphische Sammlung, no. 2152a; Uffizi, no. 4085A (Anon., XVIth century).
[Others: Taccola, *De ingeneis I, III, IV*; Francesco di Giorgio, *Opusculum*; *Trattato I*; addenda to Taccola, *De ingeneis*, f. 130 v]

Pump, Cogwheel and Lantern
CA, ff. 26 r/7 r-a, 34 r/9 v-b, 156 r/56 r-b, 1069 r/386 r-b, 1069 v/386 v-b.
[Others: Taccola, *De ingeneis I, II*]

Pump, Copper Discs as Piston
Paris MS. B, f. 54 v; CA, ff. 6 r/1 bis r-b (*olim* 386 v-b), 1069 v/386 v-b.
[Others: Taccola, *De ingeneis II, III*; Francesco di Giorgio, *Opusculum*; *Trattato I*]

Pump, Double, Quadruple or Single Pistons
Paris MS. B, ff. 20 r, 53 v, 54 r; CA, ff. 7 r/1 bis v-a (*olim* 386 r-a), 20 r/5 r-b, 26 r/7 r-a, 26 v/7 v-a, 792 r/291 r-a, 885 r/322 r-b, 904 r/330 r-b, 1069 r/386 r-b, 1099 r/395 v, 1117 Ar/401 v-a; Codex Trivulzianus, f. 3 r; Forster MS. I, ff. 45 r, 45 v, 46 v, 47 r; Uffizi, no. 4085 A (Anon., XVIth century).
[Others: Taccola, *De ingeneis I, II, III*; *De machinis*; Francesco di Giorgio, *Opusculum*; *Trattato I*]

Pump, Flexible Piston-
Paris MS. B, ff. 20 r. 52 v, 54 r; CA, ff. 5 r/1 bis r-a (*olim* 386 v-a), 6 r/1 bis r-b (*olim* 386 v-b), 26 r/7 r-a, 26 v/7 v-a, 1069 r/386 r-b, 1080 v/390 v-a; Forster MS. I, ff. 48 r, 50 r.
[Others: Taccola, *De ingeneis II*; *De machinis*]

Pump, Flexible Pistons and Transfer Rods with Clamps
CA, ff. 25 r/6 v-b, 112 Br/39 v-d, 137 r/49 r-b, 179 v/63 v-a, 281 v/102 r-a, 798 Br/292 v-c, 1116 r/401 r-b, 1117 Ar/401 v-a.

Pump, Rack or Gear and Wheel
CA, ff. 26 r/7 r-a, 1069 r/386 r-b, 1080 v/390 v-a; Arundel MS., f. 269 v; Paris MS. B, f. 53 v; Forster MS. I, f. 52 r.
[Others: Francesco di Giorgio, *Opusculum*; *Trattato I*]

Pump, Treadwheel
Paris MS. B, f. 54 v; Forster MS. I, f. 47 v.
[Others: Taccola, *De machinis*]

Pump Tubes, How to make
Madrid MS. I, f. 25 v.

Pump, Water Screw (Archimedes)
CA, ff. 6 r/1 bis r-b (*olim* 386 v-b) 26 v/7 v-a, 651 r/ 239 r-a, 972 v/351 v-a, 1048 Bv/376 v-a, 1069 r/386 r-b, 1068 v/386 v-a, 1069 v/386 v-b; Paris MS. B, ff. 20 r, 52 v; Forster MS. I, ff. 41 r, 41 v, 42 r, 42 v, 43 v, 45 v, 46 r, 48 r, 49 v, 51 v, 52 r, 52 v, 53 r, 53 v, 54 r, 54 v; Paris MS. E, ff. 13, r, 13 v; Paris MS. I, ff. 21 v, 23 r; RL 12687.
[Others: Taccola, *De ingeneis I*; Francesco di Giorgio, *Trattato I*]

"Punzoni"
— See: Machine for gold-beating and punching.

Rockets, Pronged-
Paris MS. B, f. 76 r.
[Others: Chigi Saracini drawings in Siena; Lorenzo Donati, Florence, Accademia MS, (Coll. E.2.1.28, f. 35)]

Rope-making machine (*fabbricazione di funi*)
CA, ff. 12 r/2 v-a, 13 r/2 v-b.

Saw, Hand- (*sega*)
Paris MS. B, ff. 66 r, 66 v; CA, f. 1055 v/379 v-b.

Saw, Stone-cutting (*da segare pietre*)
CA, f. 2 r/1 r-c; Madrid MS. I, f. 31 v.

Sawmill (*sega da legno*) and Details
Paris MS. B, f. 26 v; Paris MS. H, f. 120 [23 r] v, 121 [22 v] r. CA, ff. 1013 v/363 v-a, 1059 r/381 r-b, 1078 Ar/ 389 r-a.
[Others: Anonimo Ingegnere Senese, London, British Library, Add. MS. 34113, f. 224 r; Francesco di Giorgio, *Opusculum*; *Trattato I*]

Scala mobile
— See: Bridge.

Schizzatoio
— See: Fountain-jet; Pump.

Screw, Disjointed or Inverted
CA, ff. 114 r/40 r-b, 306 v/110 v-b, 1054 v/379 v-a, 1059 v/381 v-b; Madrid MS. I, ff. 57 v, 58 r.

Screw-jack
— See: Lift with screws.

Screw-thread Cutter (*fare la chiocciola alla vite; fare una vite al tornio*) and Test of Strength in Screws
CA, ff. 47 r/14 r-a, 156 r/56 r-b, 895 r/327 r-a, 984 v/ 355 v-b, 1054 v/379 v-a, 1058 r/381 r-a, 1059 v/381 v-b; Paris MS. B, ff. 70 v, 71 r; Forster MS. III, ff. 81 v, 82 r; Madrid MS. I, f. 91 v.

Sega
— See: Saw; Sawmill.

Serratura
— See: Latch; Lock.

Shearing Mill (*cimatrice*), Pressing or Calendering
— See also: Textile Machines; Gig Mill.
CA, ff. 19 r/5 r-a, 29 v/8 v-a, 39 v/11 v-a, 56 Er/16 v-f, 67 Av/21 v-a, 164 v/58 v-c, 435 r/161 r-b, 435 v/161

v-b, 814 r/297 r-a, 936 r/342 r-a, 1024 r/367 r-b, 1024 v/367 v-c, 1056 r/380 r-a, 1056 v/380 v-a, 1105 r/ 397 r-a, 1105 v/397 v-a, 1106 v/397 v-b, 1107 r/398 r-a, 1107 v/398 v-a; Forster MS. III, f. 43 v.

Ship's Rudder
RL 12650 r.

Ship-sinking Methods (*sfondare un naviglio*)
Paris MS. B. ff. 9 v, 75 v, 90 v; Ashburnham MS. 2037, ff. 3 r, 9 r, 9 v.
[Others: Taccola, *De ingeneis I, II*; *De machinis*; Francesco di Giorgio, *Opusculum*; *Trattato I*]

Siphon and Still (*alambicco per distillazione*) and Siphon for Quick-silver
CA, ff. 216 r/79 v-c; 914 Br/335 v-b, 971 v/350 v-b, 989 r/357 r-c, 1113 r/400 r-b, 1114 Ar/400 v-b, 1114 Br/ 400 v-c, 1113 v/440 v-d; Paris MS. G, f. 48 r; Forster MS. III, f. 49 v; RL 12641 v.
[Others: Taccola, *De ingeneis I, II*; Francesco di Giorgio, *Opusculum*; *Trattato I*]

Siphon over Mountain (*sifone*)
Paris MS. B, f. 26 r.
[Others: Taccola, *De ingeneis I, II, III*; *De machinis*; Francesco di Giorgio, *Opusculum*; *Trattato I*]

Skewer, Rotating- (*girrarosto*)
CA, f. 21 r/5 v-a (two types); Codex Trivulzianus, f. 26 v.
[Others: Giuliano da Sangallo, *Taccuino Senese*, f. 50 r; Uffizi, no. 4075Ar (attributed to Antonio da Sangallo)].

Snapper (*catapulta*) (sometimes six on a sheet)
Paris MS. B, ff. 5 v, 6 r, 6 v, 7 r, 7 v, 8 r, 8 v; CA, ff. 75 r/26 r-a, 85 Ar/31 r-a, 140 Ar/50 v-a, 140 Br/ 50 v-b, 141 r/51 r-a, 145 r/51 v-b, 148 Ar/53 r-a, 148 Br/53 r-b, 149 Ar/53 v-a, 150 r/54 r-a, 151 r/54 r-b, 152 r/54 v-a, 159 Br/57 r-b, 160 Br/57 v-b, 172 r/ 61 r-a, 181 r/64 r, 182 Ar/64 v-a, 482 v/177 v-a (?), 595 r/ 221 r-b, 756 r/278 v-b, 827 v/303 v-a, 902 Br/329 r-b, 1073 v/387 v-b, 1094 r/394 r-b, 1095 Br/394 v-b, 1100 r/396 r-a; RL 12453 v; Uffizi, no. 4085-A (by Anon., XVIth century).
[Others: Taccola, *De ingeneis I, II*; Francesco di Giorgio, *Opusculum*; *Trattato I*]

Snapper, Double-capstan and Rope
CA, f. 165 v/59 v-a; Uffizi, no. 7 v (446 Ev); Uffizi, no. 4085 A (Anon., XVIth century).

Spera, Instrumento da
— See: Mirror-polishing Apparatus.

Spinning or weaving Mills (*filatura*) and Braid-making, Parts of
— See also: Textile Machine(s).
CA, ff. 103 Ar and 103 Br/36 v-b, 177 v/62 v-b, 549 v/ 206 v-a, 558 r/209 v-a, 753 r/278 r-a, 872 v/317 v-b, 884 r/322 r-a, 884 v/322 v-a, 892 r/326 r-a, 892 v/ 326 v-a, 985 r/356 r-a, 985 v/356 v-a, 1017 r/364 r-c, 1023 r/367 r-a, 1023 v/367 v-b, 1030r/369r-a, 1050r/ 377r-a, 1085 r/392 r-a, 1090 r/393 r-a, 1090 v/393 v-a; Madrid MS. I, ff. 30 v, 65 v, 66 r, 67 r, 67 v, 68 r, 68 v, 103 v, 104 r, 104 v, 105 .

Stamping Medals, Machine for
 Paris MS. G, f. 43 r; Madrid MS. I, f. 45 v; MS. Forster II, 1, 54 v(?).

Steam-blower (*vaporatore*)
 CA, ff. 218 r/80 r-b, 1112 v/400 v-a.
 [Others: Taccola, *De ingeneis I*: Anonimo Ingegnere Senese, London, British Library, Add. MS. 34113, f. 73]

Steccato
 — See: Cofferdam and Caisson; Pile-driving.

Stone-cutting Machine (*macchina per tagliare marmi*)
 Paris MS. B, f. 51 v; CA, f. 2 r/1 r-c.

Stone-polishing Wheel
 — See also: Mirror-polishing Apparatus; Stone-cutting Saw.
 CA, ff. 879 r/320 r-b, 1057 v/380 v-b.

Strettoio
 — See: Press, Oil.

Succhiello
 — See: Drill.

[Taccola, Japoco Mariano called]
 Mechanisms that Leonardo adapted from Taccola's manuscripts: Diving Equipment; Lever-lifted Box; Car, Scythed; Ship-Sinking Methods; Siphon over Mountain; Steam-blower.

Tenaglia
 — See: Bar-cutter; Pincers; Crane and Load-positioner Accessories of Brunelleschi.

Tessile, Macchine
 — See: Textile Machine(s).

Textile Machine (*macchina tessile*)
 CA, ff. 56 Er/16 v-f(?), 164 v/58 v-c(?), 435 v/161 v-b (carding mill; *carda, cardatura*); CA, ff.872 v/317 v-b, 985 r/356 r-a (automatic weaver; *tessitura o maglia automatica*).

Textile Machines
 — See: Embossing-Metal Ornaments Machine ("*punzoni*"); Gig Mill; Loom; Machine for "*battiloro*" and "*punzoni*"; Shearing Mill (*cimatrice*); Spinning Mill (*filatoio*).

Tirante di tela
 — See: Canvas Stretcher.

Tongs, Grip-
 — See: Crane and Load-positioner Accessories; Pincers.

Torchio
 — See: Press.

Torno
 — See: Lathe.

Trafila
 — See: Drawplate.

Trapano
 — See: Drill; Bit-brace.

Trebuchet (*trabocco; sbaratrona; fromboliere; fulminaria*)
 — See also: Snapper.
 CA, ff. 56 Br/16 v-c, 113 v/40 v-a, 160 Ar/57 v-a, 182 Ar/64 v-a, 900 r/328 r-b, 974 r/352 r-a, 1080 r/390 r-a, 1094 r/394 r-b; Paris MS. B, ff. 6 v, 8 v, 33 v, 34 r, 55 v, 75 v; Venice, Accademia, no. 234 v; Madrid MS. I, f. 184 r.
 [Others: Taccola, *De ingeneis I, II, IV*; *De machinis*; Francesco di Giorgio, *Opusculum*; *Trattato I*]

Tunnelling into Mountains by Levelling (*cave sotterranee; la cava livellata*)
 Madrid MS. I, ff. 110 v–111 r.
 [Others: Taccola, *De ingeneis I, II*; *De machinis*; Francesco di Giorgio, *Opusculum*; *Trattato I*].

Valturius-derived Mechanisms (1483 ed. of *De re militari*)
 — See: Mechanisms from Valturius.

Vite
 — See: Screw; Screw-cutter.

Water-driven Mill
 — See: Mill.

Water-lifting devices
 — See: Pump.

Water-scoop or Water-dipper
 CA, ff. 156 r/56 r-b, 171 r/60 v-b, 1048 Bv/376 v-a, 1095 Ar/394 v-b; Forster MS. I, ff. 45 v, 47 r, 49 r.
 [Others: Taccola *De ingeneis I, II*; *De machinis*; Francesco di Giorgio, *Opusculum*; *Trattato I*]

Water-screw
 — See: Pump.

Waterwheel
 — See: Pump.

Weapons and Tools, often adopted from Valturius
 Paris MS. B, ff. 4 r, 7 r, 9 r, 9 v, 10 r, 41 r, 46 v.
 [Others: Taccola, *De ingeneis*; *De machinis*]

Weaving Machine
 — See: Textile Machine(s); Loom.

The bibliography of chapter I.4 is on page 319.

I.5

Leonardo, Brunelleschi and the Machinery of the Construction Site

by
Salvatore Di Pasquale

Noble Birth and Usefulness, those two qualities
which more than any others are of value to mankind in the gaining of wealth and advantage,
seem to have joined forces to enrich the science of Mechanics and to make it beloved of many minds.

If we wish, as is nowadays more and more our desire,
to study and assess this nobility of birth from its origin and inception,
we find on the one hand Geometry and on the other Physics.
From their happy union and harmonious conjunction
is born at length the noblest of all the arts, that of Mechanics.

Guidobaldo del Monte, *Mechanicorum Libri VI*, Preface

Any ideal collection of Leonardo's drawings concerned with the practical activities of the worksite would of necessity include certain pages of the Codex Atlanticus on which he depicts cranes, hoists rotating on circular bases, systems of cylinders for winding ropes, and pulleys with multiple wheels, together with diagrams which clearly show how the ropes should be wound around the grooves of the pulley wheel. Devices such as these, at first sight both fantastic and of dubious functional value, can still be seen today in the Museo dell'Opera del Duomo in Florence, in so wide a variety of shapes and sizes that there can be no doubt as to their actual use and effectiveness.

The originality of the construction machinery found in Leonardo's drawings compared to that in general use from the time of the earliest builders till the dawn of the industrial revolution has not gone unnoticed by scholars. However, only recently has it become possible to establish through intensive research that these machines derive from prototypes by Brunelleschi, and that they may be found, depicted from various angles, in drawings by other artist-engineers working in the region of Florence at that time. Although the same machines are easily recognizable in the drawings of the various authors, there are sufficient variations to indicate that each artist was producing his own version of objects he had actually seen in reality, although at times he may have modified certain mechanisms,

163

adding or removing components according to their degree of usefulness. This re-working also implies a critical evaluation of the efficiency of machines seen in operation and then drawn.

Essentially, these drawings refer back to the three machines designed and constructed by Filippo Brunelleschi for building the cupola of Florence Cathedral. In Leonardo's version these machines appear in all their staggering modernity, entirely different from other contemporary building apparatuses, because they were invented specifically to facilitate the construction of the cupola and deliberately designed for a particular method of construction. This explains, if only in part, why they were forgotten once the building was completed, so that thereafter only the traditional machinery based on Vitruvius' models continued to be used. It was not until much later, at the dawn of the industrial revolution, that these machines were re-invented and began to resemble, in their operating principles if not in their material composition or sources of energy, those we see on construction sites today.

<p style="text-align:center">★</p>

The last stone of the lantern in the cupola of Santa Maria del Fiore was laid in 1461, and in 1468 Andrea Verrocchio was given the task of smelting the bronze required to cast the great gilded ball that in 1472 would be placed on top of the lantern. A little later the cross would be added, thus completing the undertaking Brunelleschi had begun more than fifty years before.

We know that the young Leonardo was brought to Florence in 1466 and worked until 1476 in Verrocchio's studio. In Florence he was able to admire and study in detail the machinery Brunelleschi had designed for the construction of the great dome. It may be surmised, although there is as yet no documentary evidence for the supposition, that the two versions of the revolving crane — for use outside and inside the building — were left in place at the top of the cupola awaiting the completion of the lantern with the gilded ball and its surmounting cross. Recent studies have in fact shown that the most important drawings of construction machinery in the Codex Atlanticus do not depict inventions by Leonardo, but rather objects he saw and copied into his notebook to help him remember them.

Among the studies mentioned the most valuable is that of Ladislao Reti, who points out that these same machines, shown from other angles, appear in the notebook or *Zibaldone* of Buonaccorso Ghiberti, the grandson of Lorenzo. The probability that Buonaccorso was taken on as a young apprentice in the years when the cupola was being built inclines Reti to the view that they are indeed Brunelleschi's machines. Gustina Scaglia, Frank Prager and Howard Saalman have recently confirmed this hypothesis by studying documents from the period of the construction of the dome which are preserved in the archives of the Opera del Duomo in Florence.

The organization of the worksite, the supplying of materials, the labourers' qualifications and the rigorous subdivision of tasks are subjects which have only recently attracted the attention of scholars. John Fitchen and J. Acland have provided documentary reconstructions of Gothic building sites, and Pierre Du Colombier has written an excellent book on the construction sites of the cathedrals. By reading this material we can get a fairly precise picture of building methods, work organization and the machinery used on the worksite.

The question of hoisting machinery seems inseparably linked, according to the studies cited above, with devices inherited from the remote past, seen in Roman bas-reliefs or in descriptions in the work of Vitruvius. But the machines drawn by Leonardo have nothing in common with these, nor do

they bear any resemblance to those drawn by artist-engineers of his own time. This observation does not, of course, hold true for everything Leonardo designed with a view to worksite use: it is however true of the three Brunelleschian machines, for which there is not even an explanatory note in Leonardo's hand regarding the convenience and advantages of using them. In this case he confined himself to drawing the three machines, enlarging details of them and making plain how they worked. It is, indeed, as though he felt no need to explain in words the job done by these machines. He simply saw and drew them, just as Buonaccorso Ghiberti and Giuliano da Sangallo saw and drew them: the way they work is apparent to anyone who has seen them in action. Inevitably, then, our thoughts turn to Brunelleschi, the architect who designed the cupola built without supports and the inventor of the machinery that simplified its building.

<p style="text-align:center">★</p>

It is necessary at this point to outline briefly the problem of this machinery, even at the risk of repeating what has already been stated. Such an approach is particularly important in Brunelleschi's case, in order to attempt to award him his rightful place in the history of technology. In this field, even more than in that of his building methods, Brunelleschi's contributions must be deduced through a series of conjectures for which documentary proof has then to be sought where that is possible.

The lack of a systematic study of techniques in this area, and particularly in the Italian part of it, is lamentable. The mediaeval heritage which Brunelleschi had at his disposal is not completely known. Facts which appear certain at a given moment of historical research are successively modified by the discovery of other manuscripts and codices, and so we find that technical inventions attributed to a given person belong in reality to one of his predecessors. Brunelleschi is a notable case in point: his machines, at least the most important of them, of which no trace remains save in the confused and at times indecipherable documents of the Opera del Duomo archives, were widely copied by his successors, to whom credit was given for inventing them. Of course, the self-same argument might hold for Brunelleschi himself. No one can be certain that machines attributed to him today are not the result, if not of copies, at least of modifications and compilations of things he had already seen.

It seems of interest, therefore, to attempt to retrace the line of development that leads to Brunelleschi, with the evidence of drawings by Leonardo and by other contemporary artist-engineers, in search of references to machines like these. This line of investigation may be helped by comparisons with machinery that was being produced elsewhere at the time, even if what we know of it is incomplete and sketchy.

Such an enquiry, if we may anticipate its verdict, demonstrates that any comparison is clearly in Brunelleschi's favour. Even when we look beyond his own time into the future, his machines appear remarkably modern, full of ingenious solutions and innovations anticipating ideas and concepts that would only come into general use at the beginning of the nineteenth century.

From the Middle Ages until the Renaissance, and perhaps even up to the industrial revolution, building techniques do not seem to have evolved a great deal: indeed, for purely physical reasons they could not have done so. The arrival first of iron and then of steel as construction materials would eventually pose new problems requiring solutions different from those developed during the centuries when the only building materials were wood, stone and brick, but until that time, very little remained to be invented in the fields of large-scale building or of machinery. Brunelleschi's and perhaps

Michelangelo's domes are the exception to the generally held belief that the Gothic cathedrals represent the highest achievement in building techniques. In the area of worksite technology, in particular of machinery, the studies and research on this other aspect of innovations in construction technology are too recent and insufficiently known for us to speak of a generally held opinion on the subject.

What we have learned from the seminal contributions of Friedrich Klemm, Charles Singer and Bertrand Gille among others helps to give a general picture, clear in its outline but incomplete in detail; and hoisting machines constitute an important aspect of it. To revert to what has already been stated, the fanciful images in the notebooks of the artist-engineers of the Renaissance are so vague as to suggest that for the most part these are graphic representations of ideas or designs which would be difficult to put into practice, or that would produce unworkable machines. The pictures of Brunelleschi's machines, in Leonardo's version, however, are so well drawn that one grasps immediately the significance and the part played by each separate component in the general scheme. This is not of course to detract in any way from the reputations of Taccola, Francesco di Giorgio or Conrad Kyeser, nor to give greater credit to Brunelleschi. Their drawings are simply manifestations of their different ways of thinking, of handling concrete reality or merely of dreaming or imagining.

Let us take the case of the most complex machine attributed to Brunelleschi — the great crane between twenty and thirty metres high which also carried an apparatus for the horizontal displacement of the lifted weight. To grasp the significance of Brunelleschi's invention, one might resort to comparisons with the solutions to this particular problem chosen by his predecessors and his successors. It turns out that mechanisms of this sort never existed and would not exist until the end of the eighteenth or the beginning of the nineteenth century. Nothing resembling Brunelleschi's invention can be found in the whole line of descent from Vitruvius through successive stages down to

Fig. 168A. G. Rondelet, *Traité théorique de l'art de bâtir*, pl. CLXXII. Hoisting devices.

the threshold of the industrial revolution. Yet even a cursory examination shows that his crane is in every way similar in concept to the cranes in use on construction sites today. The illustrations in Diderot and d'Alembert's Encyclopedia — incontrovertible evidence of what existed three centuries later — show without substantial modification the types of crane already known in Vitruvius' time. Rondelet's illustrations depict some innovations, particularly as regards the problem of variable trajectory: but these are far from Brunelleschi's solution, which is the one used today, namely, the introduction of the counterweight, which moves in synchrony with the lifted object so as to centre the weight on the vertical shaft. The innovation pointed out by Rondelet (Fig. 168) concerns the possibility of moving the load horizontally while it is being lifted; he had seen this machine on the site of the church of Sainte Geneviève in Paris and had at once spotted its limitations:

> The second inconvenience is that since the trajectory is predetermined, [the machine] can only be used for one particular case. In all other cases the trajectory is too long or too short, so that it is almost always necessary to pull the load in order to put it down, and this increases the stress on the shaft so much that in such circumstances it habitually breaks.

In modern terms we would say that Brunelleschi solved this problem by giving the lifted load a degree more of freedom than that allowed by the crane Rondelet describes. He did this by introducing a mechanism that permitted variable horizontal displacement of the lifted object. But that was not all. With the same machine he solved the problem of the rotatory movement of the crane, equipping it with a vertical axle around which it rotated freely by means of a tiller worked from below. This also controlled the exact positioning of stone blocks which had been carved and shaped before being lifted into place, thus avoiding the use of levers which could cause damage to the stone.

In this machine, as in the others, Brunelleschi made use of elements which were already known, but in a totally different way: hoists, pulleys, cogged wheels, levers and endless screws are mechanisms

Fig. 168B. G. Rondelet, *Traité théorique de l'art de bâtir*, pl. CLXXIII. Revolving cranes.

that can be found before and after his time, together with the technical (certainly not scientific), knowledge that they presuppose or imply. In this sense Gille's definition of Brunelleschi seems very appropriate indeed:

> Brunelleschi is a contemporary of Kyeser: here is the ideal model of the artist-technician of the Renaissance... Unfortunately he left no written work... He is the foremost representative of that generation of Italian engineers: his training, his taste, his curiosity which borders on science, make him clearly different from his contemporaries.

<div align="center">★</div>

The first author to discuss the question of weight-lifting machines was Vitruvius, who gives an elementary definition: "[this] machine is a solid joint of timber specially used for moving weights. It is moved by the artful turning of wheels". The three machines described are very similar to each other, differing only in the size of the weight they can lift or in the means of lifting. Indeed, *mutatis mutandis*, they are still in use today.

Their structure is very simple: to a strong tripod of wood firmly fixed to the ground is attached at the apex a pulley with two wheels around which is wound the cord. This runs on one side to the lower pulley from which is hung in a fork grip the load to be lifted, and on the other side to the winch that produces the lifting power. Two versions of the winch are given: as a device in itself, independent of the tripod, or as an integral part of the latter. Either of the two possible versions may be used according to the weight to be lifted. The other machine is more complex in its operation and requires greater experience in the handler, as Vitruvius himself admits. It consists basically of a single beam, rotating around a fixed spot on the ground and held in a more or less inclined position by means of cords which function as moorings. It could be used to lift considerable weights by the use of pulleys with multiple wheels — *polispasti* — around which are wound the cords which run at one end to an identical pulley to which the fork grip is attached, and at the other to handles to be pulled by several workmen. Galiani's commentary, among the many critical editions of Vitruvius, is very precise, full of technical information and on occasion uses diagrams to clarify Vitruvius' real meaning, since as is well known his work has come down to us without the drawings that must presumably have originally accompanied the text.

As Drachmann has rightly pointed out, there is no mention in Vitruvius' work of the problem of the horizontal displacement of loads, unless we choose to believe that the single-beam rotating crane could be used for this purpose by means of well-timed handling of the mooring ropes, an operation that would, as Galiani is correct in saying, be extremely dangerous if carried out when the load was in the air, but feasible before it was lifted.

Vitruvius' text is very clear and leaves no room for any interpretation of the machines described other than the one provided by Galiani (Fig. 169), whose commentaries, to the extent that they relate to their period, constitute an excellent source of reference for the outline of any history of the development of these machines. After Vitruvius there is no further trace of this problem until the end of the fourteenth century. Du Colombier writes:

> Once the stone was on the worksite, brought from the quarry or carved from the pile of stones on the spot, it had to be put in place. This was done either by hand or by means of very simple lifting machines.

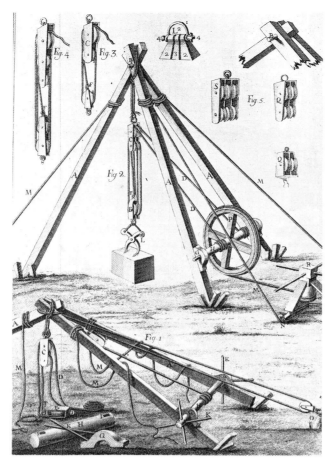

Fig. 169. Galiani's Vitruvius (1790), Pl. XXIV.
Hoisting devices.

And again,

> Above, against the sky, are silhouettes of simple hoisting derricks or the jibs of cranes. Some of these cranes can turn, and some are quite effective. It goes without saying that they are made of wood, but the system of support is well worked out and adequate to give sufficient solidity.

The rich pictorial documentation provided by Du Colombier fulfills one of M. Bloc's recommendations: "Three great categories of documentation seem in themselves able to cast some light on the technical mediaeval legacy — the texts, the iconography, the objects". Some objects can be found depicted in the work of C. Czarnowsky, but no trace remains of the texts. However, in the treatises of the Italian Renaissance one often finds the occasional more or less extensive reference to this problem. Leon Battista Alberti, in books VI, VII and VIII, refers to it with splendid explanations of a general nature aimed at establishing the principles on which the machines are based:

> But all these implements, whether driven by wheels into which men climb to move it with their weight, or hoists, or screws, for which it is necessary to make use of the lever, or pulleys, or whatever other tools of the kind, all are based on the principle of balances.

Here there is no description of a particular machine, as there is in Vitruvius: instead, there is an attempt to explain general principles in a language which is not mathematical but technically understandable. Alberti does not disdain to make practical suggestions on friction, the shape of ropes, and materials to be used in building those parts of the machine that are most subject to wear.

Vincenzo Scamozzi in his treatise adds little that is new to what Vitruvius has already written.

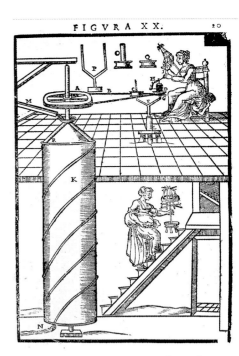

Fig. 170. F. Veranzio, *Machinae Novae*, fig. 14. Water mill.

Fig. 171. G. Branca, *Le Machine*, fig. 20. Hydraulic spinning wheel.

What does seem new, however, is the description of a crane on a fixed base which supports a vertical shaft, to the top of which is attached a horizontal girder that functions as an arm.

The treatise of Francesco di Giorgio, in which numerous drawings simplify enormously the interpretation of the text, contains more descriptions of technical and structural details of machinery. Here we find the description of a machine that uses the endless screw for the horizontal displacement of heavy loads, and accounts of other machines in which cogged wheels and gears are widely used.

Alberti, Francesco di Giorgio and Scamozzi are all later than Brunelleschi: a copy of Francesco di Giorgio's treatise in the Laurentian Library bears marginal notes by Leonardo, who studied it. The contributions of these three engineers in the field of machinery are strictly linked to the heritage of Vitruvius, and possibly of Heron of Alexandria, although from substantially different points of view. It is not surprising that in none of their treatises is there any reference, implicit or explicit, to Brunelleschi's machinery. Probably the unique character of his devices, assuming the memory of them had been handed down, made them inappropriate to their works, of which the more or less explicit aim was to make known a body of rules and concepts useful for planning and construction. Nevertheless, apart from the work of Vitruvius, whose text is known to have been discovered around 1410 and first published in 1514, the treatises of Alberti and of Francesco di Giorgio constitute a most useful source of reference, both for their content and because they are near in time to Brunelleschi.

Little can be learned from Scamozzi's text, which is further confirmation of the fact that nothing similar to Leonardo's or Buonaccorso Ghiberti's drawings of the machinery of Brunelleschi is to be found in Scamozzi's or Brunelleschi's own time, nor indeed later, until we come to the encyclopaedias and manuals of the eighteenth and early nineteenth centuries. In treatises of the intermediate period, for example in Veranzio (Fig. 170) and in Branca (Fig. 171), the topics covered are of a more general nature, not confined to weight-lifting machines. These treatises depict a large number of devices for the mechanizing and speeding up of routine manual tasks and demonstrate the shift of interest toward a search for new energy sources such as wind or water. But not one of these mechanisms is reminiscent of the gigantic and astonishing machines of Brunelleschi. The principles applied are the

same, as are the technological innovations, but the objective is, as it were, on a human scale and in the common interest, not for exceptional tasks. Nor, as has been stated, can anything similar to Brunelleschi's inventions be found in later works or in architecture manuals. Mechanics by this time had become a science, an autonomous subject separate from the body of learning which constituted the architect's stock in trade.

There were treatises on mechanics which analyzed the five simple machines by means of abstract diagrams to explain the mathematical formulae of the equations of balance which governed them. There were also treatises on architecture, which provided outlines of different sorts of machinery, their functioning and their use on the worksite. But in both cases the machines referred to were still in essence those of Vitruvius.

For the reasons briefly outlined here, therefore, it is apparent that Brunelleschi as an inventor and builder of machinery should occupy a position in the history of technology which until now has been denied him. As an engineer he seems much closer to us, and more understandable, than he did to his contemporaries, to the extent that today we are better able to grasp and thoroughly evaluate the significance of his work.

Of course, to reveal that these drawings were not Leonardo's own inventions but depictions of objects he had seen, is not to denigrate his reputation. But it does suggest the urgent need, already pointed out by other scholars in the field, of further research into the sciences and technology more closely linked to everyday life within that gigantic cultural phenomenon which we call Renaissance humanism.

The total lack of documents in Brunelleschi's own hand may be attributed to the fact that they were never written, or, as Vasari maintains, that "through the laziness of ministers of works they were left in the wrong places and lost". Thanks principally to Leonardo's drawings — precise, careful designs which retain the relative proportions of the components — and to the sketches of Buonaccorso Ghiberti and of Giuliano da Sangallo (in whose work these proportions appear considerably altered), it has been possible to carry out a critical reconstruction of Brunelleschi's machinery. Another documentary source of considerable importance is provided by a register of the most important documents relating to the building of Florence Cathedral, edited by Cesare Guasti in the second half of the nineteenth century. Here can be found direct quotations on the machines built by Brunelleschi, on the materials used, on the time it took to build them and, an item of some prominence, on the sums of money disbursed by the Opera del Duomo to Brunelleschi for the planning and building of these "constructions".

The enormous sums paid, if compared to the monthly wages of Brunelleschi or of Lorenzo Ghiberti, are evidence, if only indirect, of the uniqueness of the machines in question and of the indubitable advantages of their use in building the cupola.

In the case of just one of these machines, the light hoist, Leonardo's drawing seems less clear than those of Buonaccorso Ghiberti. The latter does not confine himself to merely depicting the crane, but adds a description, in easily decipherable code, which gives the measurements of the component parts of the machine. Buonaccorso Ghiberti's drawings are on folios 95 r and 98 v of the *Zibaldone* (Figs 172-173), those by Leonardo on folios 105 Bv/37 v–b and 847 r/309 r–b of the Codex Atlanticus (Figs 174-175).

On Ghiberti's folio 95 one can see that the hoist consists of a horizontal driving wheel (the two rods for applying force are clearly visible) and a vertical driven wheel, the axle of which is connected

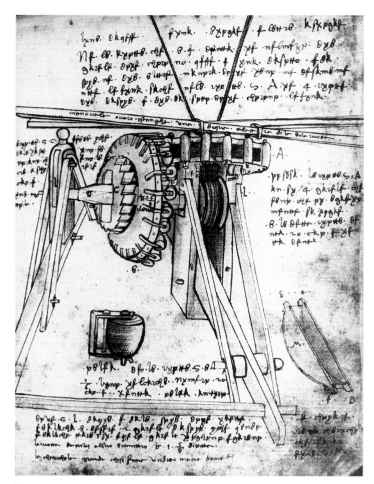

Fig. 172. Buonaccorso Ghiberti, *Zibaldone*, f. 95 r.
The light hoist.

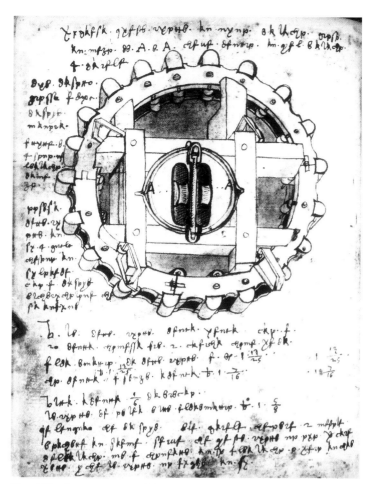

Fig. 173. Buonaccorso Ghiberti, *Zibaldone*, f. 98 v.
The horizontal wheel of the light hoist.

to the roller on which the lifting cable or rope is wound. The whole mechanism is supported by a solid wooden frame. This drawing shows that the lifting cable or rope passes — both going and coming — through the centre of the horizontal wheel, which is drawn with great care and attention to detail on folio 98 v of the *Zibaldone*. It is made up of several circular segments (at least three) dovetailed together and held firmly in position by a wooden frame in which are fixed four metal rings through which pass two rods to set the wheel in motion. At the centre of the wheel can be seen a disc surrounding a pulley or *polea* through which the lifting cable runs.

At first sight it looks as if the pulley turns together with the wheel, but that is impossible, since if it did, at a given angle of rotation of the wheel the cable would slip out of its groove in the pulley and rub directly against the wheel itself, thus becoming rapidly frayed. Besides — and this makes it even less credible — the two ends of the rope, one running in and the other running out, would become entangled, rendering the machine practically useless.

In actual fact, the wheel must have turned around the pulley. The disc in the centre is a cylindrical piece of wood which acts as a centering device and axle for the rotation of the wheel, while the pulley is set inside it. This cylinder appears in the drawing encircled by a metal ring which acts as the axle block of the wheel and is held in place by a brace.

One technical detail that is fascinating in its novelty is the use of rolling gears with the apparent dual purpose of lessening the stress of lifting and reducing the wear on the teeth of the cog wheels. One of these rollers, a barrel-shaped one, is drawn separately down to the smallest detail. Another interesting component is the cogged wheel fixed next to the vertical wheel. This is probably part of a

172

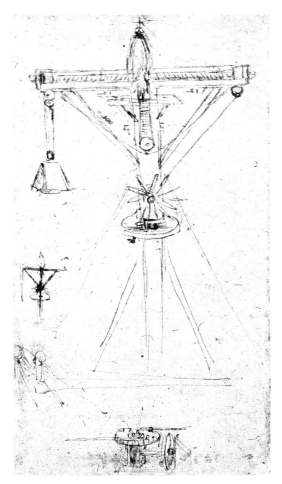

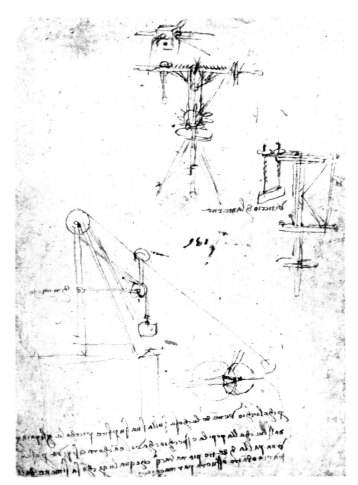

Fig. 174. CA, f. 105 Bv/37 v-b. Hoisting apparatus.

Fig. 175. CA, f. 847 r/309 r-b. Lifting devices.

system, not shown in its entirety, for blocking the horizontal axle and consequently the whole mechanism by means of a pivot inserted through the teeth of the wheel to block it.

Leonardo, on folios 105 Bv/37 v-b and 847 r/309 r-b of the Codex Atlanticus, also depicts such a hoist. In his drawing can be seen what must be the "instrument of recapture", that is, the system of pulleys fixed on the scaffolding on to which the weight was to be lifted. Looking at Buonaccorso Ghiberti's drawing and at Leonardo's on folio 105 Bv, one can see that Leonardo has drawn the same hoist as Ghiberti but from a different perspective: Ghiberti depicts it from behind and below, Leonardo from above and in front, which is to say, from the opposite point of view. The fact that it is the same machine in both drawings may be deduced from the similarities between the structure of the horizontal wheel, the position of the lifting cable, the position of the winding roller for the same cable, the framework (though this is barely sketched in by Leonardo), and the presence of the two driving rods in both authors' drawings.

Nothing of what is demonstrated above constitutes any sort of proof that this hoist was in fact Brunelleschi's, but such a proof, probably definite, is provided by Leonardo himself. In the sketch on folio 847 r/309 r-b of the Codex Atlanticus can been seen at top right the note "*viticcio di lanterna*" ("tendril" of the lantern). There is no doubt that Leonardo is here referring to the lantern of the cupola of Santa Maria del Fiore. In fact, on October 23, 1453 the officers of the Opera del Duomo "debated whether the tendrils or buttresses decreed for the lantern should be made in the way and shape designed on paper by Antonio Manetti, guild master". The stonemasons were commissioned to build, among other pieces, "a tendril, weighing 17,000 pounds". The "tendril of the lantern" is therefore a

173

very heavy piece of carved stone employed in the building of the lantern. The sketch described must show in that case the hoisting apparatus used on the building site of the cupola for constructing the lantern.

But this cannot be the "new construction for pulling" built by Brunelleschi in 1421, since that one included a screw that does not appear in this hoisting device.

From a perusal of Leonardo's and Ghiberti's sketches it can be seen that the functioning of this hoist depended essentially on the movement of the rollers. It is difficult to find anything similar to this machine of his in the work of Brunelleschi's predecessors or contemporaries. Nevertheless, one can proffer comparisons to establish whether something of the sort had already been built.

In the Middle Ages, for example, the system of rollers with gears was already known: some clocks worked by this method, while mills used a system of two wheels. Contemporaries of Brunelleschi such as Taccola and Francesco di Giorgio made use of gears to lift weights.

But the machine used for the same purposes as the light hoist was and would remain for many years to come — and there are innumerable examples of it, including the one shown by Brueghel in his famous painting of the Tower of Babel (Fig. 176) — the hand-driven wheel consisting of a single roller which allowed the pulley to lift weights. This, however, was a machine of much simpler conception, without any gears at all.

The "new construction for pulling" is the machine described as a "*colla grande*" (big strappado) which Brunelleschi built in 1421 to facilitate the operations of lifting and depositing loads. The constituent parts of this enormous machine include those already seen in the light hoist, as well as the screw device listed among the materials assembled for the construction of the apparatus. This machine was drawn by both Leonardo and Buonaccorso Ghiberti, and taken up and studied by Giuliano da Sangallo as well. The extant drawings in which the structure of the mechanism is clearly visible are on folios 102 r and 103 v of Ghiberti's *Zibaldone* (see Fig. 29), on folio 1083 v/391 v-b of Leonardo's *Codex Atlanticus* (Fig. 177), and in Giuliano da Sangallo's *Taccuino Senese* (see Fig. 20).

The machine has on one side a vertical axle to which are fixed two wheels of equal diameter which transmit the power to a system of horizontal axles. The whole apparatus is supported by a strong wooden framework. Below the lower horizontal wheel can clearly be seen the "system" of powering, composed of four "levers" to which draught animals were harnessed. This block is

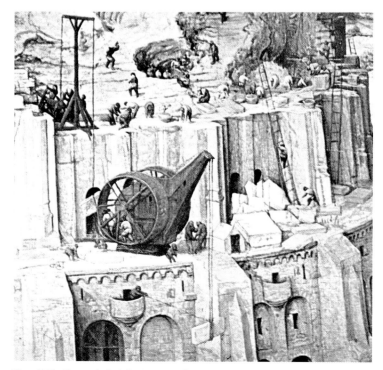

Fig. 176. Brueghel, *The Tower of Babel*, (detail) Kunsthistorisches Museums, Vienna.

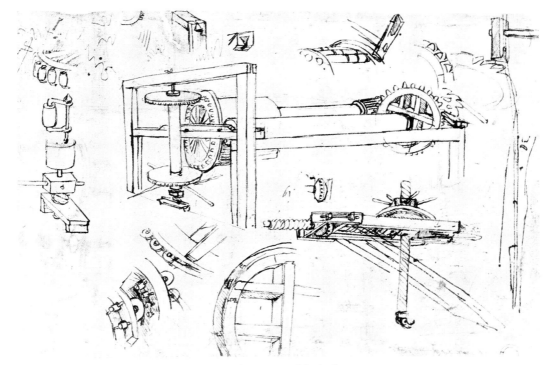

Fig. 177. CA, f. 1083v/391v-b. Brunelleschi's reversible hoist.

positioned between the vertical axle and the screw, while the latter permits the whole mechanism joined to the central axle to move vertically either up or down, so as to interlock with one of the gear wheels that transmit the power to the horizontal wheel.

In all the drawings an axle like this appears below the screw and joined at the top to the framework by a small hinge, probably of bronze. The join between the vertical axle and the screw, clearly seen in Sangallo's drawing, shows that the connection between the two parts is of the "puntiform" type, which appears problematical. In fact this type of connection requires the motive forces at all four ends of the two levers, whether powered by humans or by animals, to be equal, that is, to be a perfectly balanced system of forces, a state very hard to achieve in practice. In other words, this coupling could not withstand any normal amount of stress on its axle if, as Sangallo depicts it, it consisted of a simple puntiform connection. It seems likely that Sangallo had neglected to work out this detail — Brunelleschi's machine could not have been built in such a way — but Leonardo depicts it with great precision.

On folio 1083 v/391 v-b of the Codex Atlanticus can be seen on the left a detail which seems to be an enlargement of the displacement mechanism of the vertical axle. Unlike the one depicted by Sangallo, the axle here is joined via a hinge to a prismatic dowel which is probably just the head of the screw. Such a likelihood seems confirmed by the presence in the dowel of a "lever" which serves to turn the screw and therefore to move the axle vertically.

The apparatus described is an inverter of the motive power. Depending on whether the lower or the upper horizontal wheel is engaged with the vertical wheel (the one on the horizontal axle), the latter revolves in one or the other direction.

The cylinders on the horizontal axle constitute a sort of three-speed "gearbox" which is engaged according to where the lifting rope is wound. In fact, the first axle to be driven is made up of two parts of different diameters, while the second is of uniform dimensions approximately equal to the smaller part of the first axle. In this machine one can see, at least in Leonardo's drawing, the safety

175

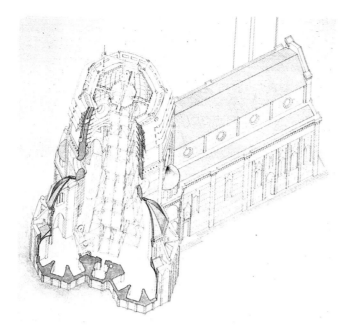

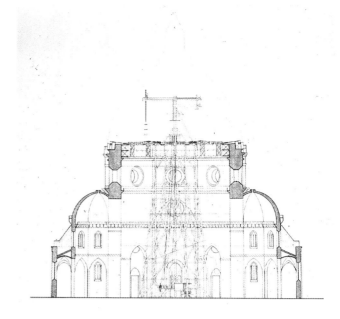

Fig. 178.

Fig. 179A.

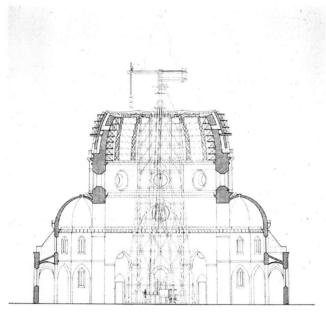

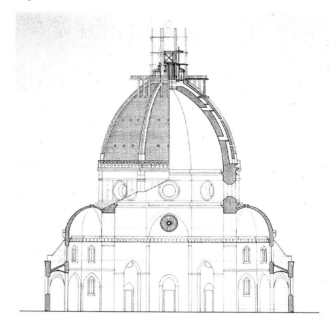

Fig. 179B.

Fig. 180.

Fig. 178. General view of the construction yard of the dome of Florence cathedral with the central hoist and the revolving crane. Figs. 179A. and 179B. Front view of the "castello" supporting the revolving crane. Fig. 180. The scaffolding and the crane used in the construction of the lantern. (Drawings by L. Betti and M.R. Masciocco, Dipartimento di scienza delle costruzioni, University of Florence).

mechanism for the blocking of the axles, analogous to the one already seen in the simple hoist. This apparatus consists of a wooden pivot fixed between the teeth of the last vertical wheel (on the second horizontal axle), forming a system of the hinge type.

A system like this, given the arrangement of the hinges of such a pivot, can work only if the second horizontal axle turns in one fixed direction. We must therefore assume the existence of an

analogous system to block the axles when the rotation takes place in the opposite direction. Probably a mechanism like this, exactly the same as the one just described, was placed so as to act on the teeth of the second vertical wheel (on the first horizontal axle). Many sketches by Leonardo on the same sheet show studies of blocking systems.

Leonardo's drawing also provides evidence as to the joints between the beams of the supporting framework: there are sketches of a mortice joint of parallel surfaces, and of two dovetailed joints. In this machine as well the gears are cylindrical bronze rollers. The fact that it is one of Brunelleschi's machines may be deduced, as Reti has done, from documents in the archives of the Opera del Duomo which record payment to Brunelleschi for its main components. It is even recorded that because of the uniqueness of such a machine "never before seen" Brunelleschi was granted a recompense of one hundred gold florins.

This machine was commissioned in 1421, during the early years of the building of the cupola. We may surmise that it was placed on the ground, in the middle of the space to be covered, and that by means of the cable wound on the three rollers it served to lift the construction materials on to a deck or reinforced platform at the foundation level of the dome. Incidentally, it may be noted that the three rollers, with their different diameters, could perform different tasks according to the motive force applied: greater speed meant less power.

At the centre of the platform, the upper level of which was presumably raised as the building of the cupola progressed, stood the other large, splendid machine invented by Brunelleschi — the rotating crane with a counterweight (Figs 178-180). It was drawn by Leonardo (CA, ff. 965 r/349 r-a: see Fig. 31; and 926 v/339 v-a: Fig. 181) and by Buonaccorso Ghiberti (on folio 106 r of the *Zibaldone*: Fig. 182).

This mechanism consists of a fixed base reinforced by four struts to which the mobile part is coupled. The latter is composed of a cylindrical column on which are fixed the various mechanisms for lifting the weight. The lifting system operates essentially by means of a screw — expertly drawn on folio 926 v of the Codex Atlanticus — and is flanked by another system of two horizontal screws at

Fig. 181. CA, f. 926 v/339 v-a. Detail of the lifting system of the revolving crane.

Fig. 182. Buonaccorso Ghiberti, *Zibaldone*, f. 106 r.

two separate levels for the horizontal displacement of weight and counterweight so as to keep the whole structure balanced.

At the side of the rotating column are fixed two rails between which run two poles attached in turn to a triple brace from which the load is hung. This device is clearly intended to limit as far as possible the inevitable swinging of the load caused by the rotation of the crane and hence to avoid undue pressure on the fragile vertical screw. At the base of the rotating column can be seen a small wheel connected to a hollow circular disc which serves as its "track". Onto this wheel, the obvious purpose of which is to reduce the friction caused by the rotation of the upper part on the lower, is discharged the pressure exerted by the vertical weights, that is, by the load and the counterweight.

In both Leonardo's and Ghiberti's versions one can see clearly a handle or tiller which goes down to the ground from the upper, moveable, part of the crane. This component must have performed the dual role of a tiller to control the rotation of the crane, and of a ground support countering the momentum of the lowered weight, to prevent the counterweight from jerking and thus capsizing the crane or exerting too much strain on it. The handle or tiller always remains in contact with the ground and turns with the crane: in this way it provides the main counterbalance to the vertical force that is exerted on the wheel eccentrically from the axis of rotation, which might otherwise cause the crane to overturn. Of course there is also the problem of the handle dragging along the ground while the crane is rotating. Neither Leonardo nor Ghiberti is clear about this difficulty. But it can be shown that the handle is called upon to balance only the force resulting from the eccentricity of the wheel, a force minor in comparison with the other forces in play, given the minimal eccentricity of the wheel compared to the axis of the machine.

In both Leonardo's and Ghiberti's drawings the crane is shown lifting a block of carved stone with the handle resting on the ground; this position must therefore have been the normal working one. Of course one may also surmise that the handle could have been slightly shorter, so as not to touch the ground during rotation, that is, when the machine was in perfect equilibrium, and that when the lifted load was dropped, contact with the ground was re-established by means of a pair of wooden wedges.

The possibility of using a single rotating machine to serve the whole complex building site of the cupola of Santa Maria del Fiore — a cupola built using the same technique as for hemispherical domes although it rests on a polygonal base — in all likelihood constitutes the first and only example of a machine designed and built to serve precise, unique purposes. This may indeed be the reason why the record of it was lost with the passage of time.

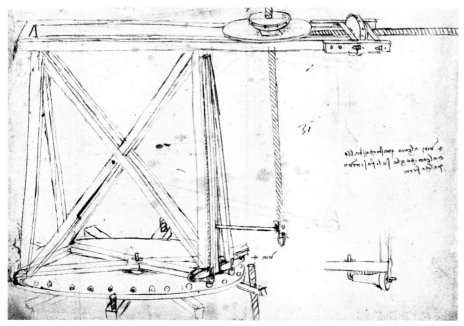

Fig. 183. CA, f. 808 v/235 v-b. The revolving crane for the lantern.

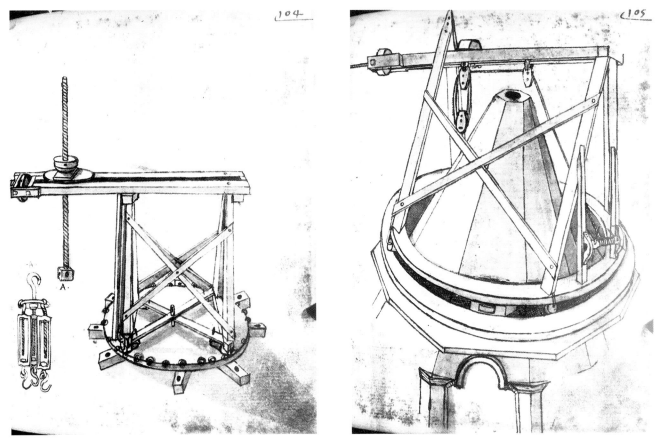

Fig. 184A and B. Buonaccorso Ghiberti, *Zibaldone*, ff. 104 r and 105 r.

Similar machines, planned and constructed for unusual tasks, are also shown by Leonardo, Buonaccorso Ghiberti and Giuliano da Sangallo. These were the machines for the building of the lantern of the dome of Santa Maria del Fiore, which was completed only after the death of Brunelleschi, who had won the competition to design it. Once again the drawings of the three artists clearly depict exactly the same machinery, with one detail, in Ghiberti's drawing, which dispels all doubt: the machine is shown constructing the final part of the lantern of the dome of Santa Maria del Fiore.

One of Leonardo's sketches on folio 1083 v/391 v–b of the Codex Atlanticus (see Fig. 177) shows the detail of an apparatus consisting of a vertical screw which could carry out both vertical and

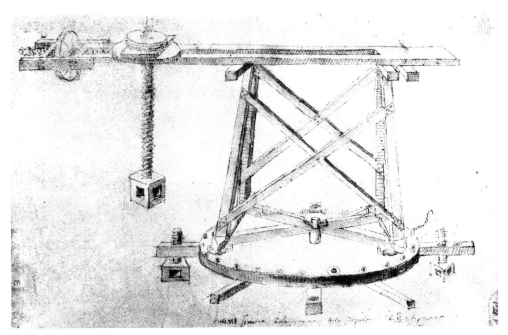

Fig. 185. Giuliano da Sangallo, *Taccuino Senese*, f. 12 r.

horizontal displacement, the former by means of a nut turned by a series of pivots, the latter by another, horizontal screw which rotates with the nut.

This same apparatus is depicted again by Leonardo on Codex Atlanticus folio 808 v/295 v-b (Fig. 183), by Buonaccorso Ghiberti on folios 104 r and 105 r (Fig. 184), and by Giuliano da Sangallo on folio 12 r of his *Taccuino Senese* (Fig. 185). These drawings show a crane on a rotating platform, with the mechanism depicted in the act of lifting a load. At the bottom of Giuliano da Sangallo's sheet, just below the drawing of the crane, is written, "How the lantern of the cupola of Santa Liparatta was built". On Leonardo's folio, to the right of the drawing, can be read the words "four screws lift this structure, mounted on a strong scaffold". In the documents of the Opera del Duomo we read, "For four oak screws made for the scaffold by the builder Ser Filippo Brunelleschi to construct the lantern".

These screws are clearly visible at the bottom of all three drawings cited, and their purpose is obvious. To be able to lift the construction materials gradually higher and higher, the crane used for building the lantern rested on a base which was raised by means of the screws as the building progressed.

The framework of the crane revolves on the lifting platform on a series of bell-wheels, the shape of which is clearly shown in a separate part of Leonardo's drawing. On the platform may be seen a vertical pivot that functions either as the axle for rotation or as a block to prevent collapse. In fact, as Sangallo's drawing indicates, the top of the pivot contains a plug the purpose of which is to stop the crane from capsizing. The load was attached to the lifting screw by a triple brace, as Ghiberti and Leonardo show. The circular platform must have occupied the empty space within the walls under construction, which was carried out around it. Once the side walls of the lantern were complete, the platform became a hollow circle inside which the final stage of construction took place. Thus the same machine was still used, with only its supporting base being changed.

The only significant variation between the two versions of the crane is the mechanism for the vertical displacement of loads. In fact the previous system with its rather rigid screw, which was particularly useful for cylindrical construction, was replaced by a system of pulleys that was much simpler and more versatile for this purpose. The load was lifted by means of a small hoist built into the side of the crane and manually operated. Naturally, in this case it was impossible to raise the crane itself. It had to be constructed in such a way as to permit the building of the top of the dome inside of it. It is in this way that Ghiberti and Leonardo show the crane, with inside of it the topmost part of Florence Cathedral.

★

The great hoisting machines used by the Romans (Fig. 186) as they are recorded by Alberti and drawn by Brueghel, consisted of enormous wheels in which one or more men, scrambling like squirrels, provided sufficient power to produce movement through the momentum generated by their eccentric weight against the axle of the wheel. Other men outside the wheel controlled the ropes and pulleys for the lifting operation. Men, at least when used as mobile weights, were no different from animals as they laboured at that interminable task which brought them always back to the starting point. Unlike Sisyphus, who was compelled to fruitlessly drag a burden which continually rolled back

down the hill, they were obliged to drag their own weight to provide energy for the machine: but like him, they were condemned to repeat endlessly the same movements.

In Brunelleschi's machinery man was no longer used as a beast of burden. His machines were planned and built so that draught animals provided the necessary motive power and men the guiding intelligence to control the movements of the machine. And this was, perhaps, the other great achievement of Filippo Brunelleschi.

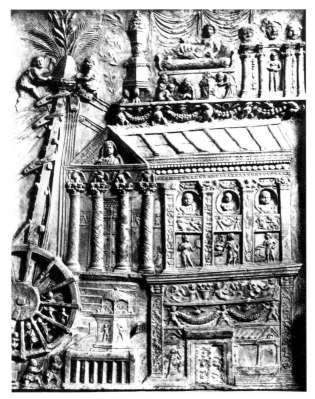

Fig. 186. Bas relief (detail), Lateran Museums, Rome. Hoisting apparatus.

The bibliography of chapter I.5 is on page 320.

II
LEONARDO ARCHITECT

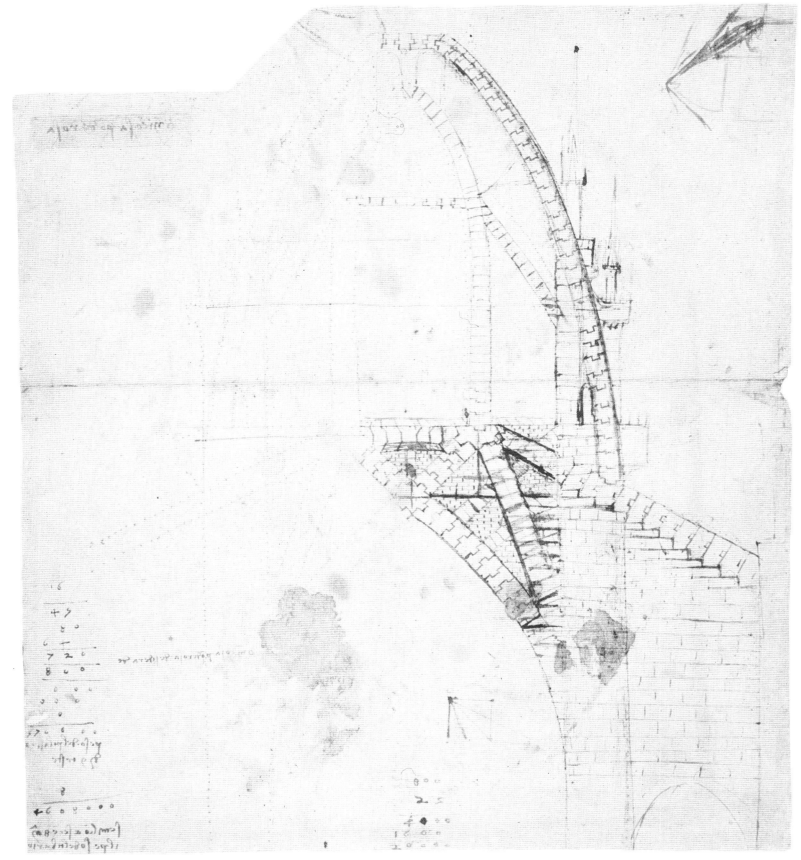

Pl. XVI. CA, f. 850 r/310 r-b. Project for the tiburio of Milan Cathedral: section of the crossing piers and projection of a double cupola.

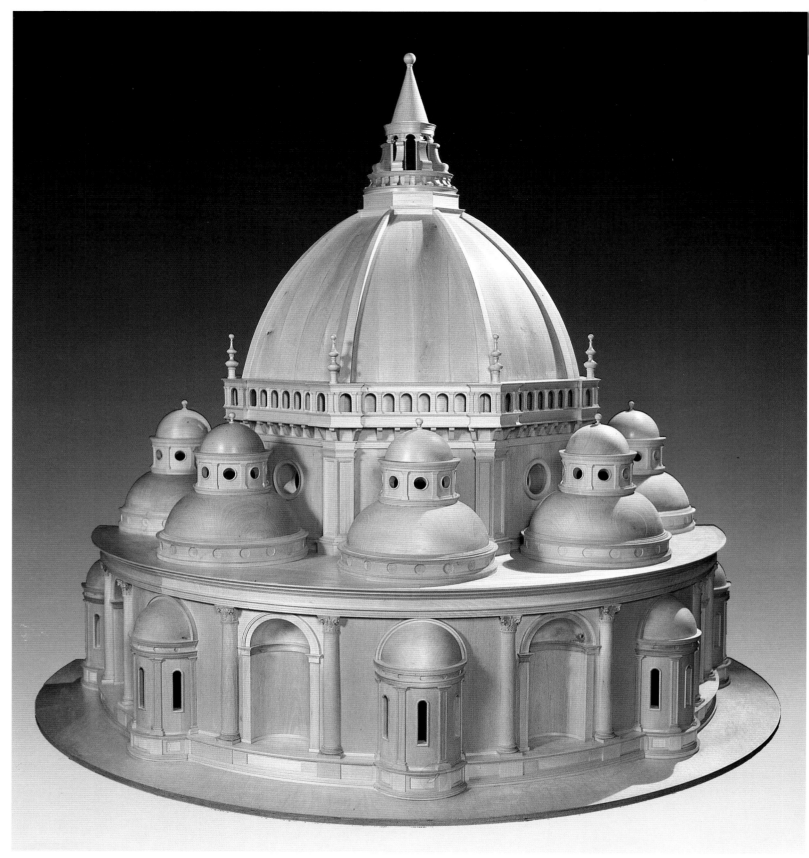

Pl. XVII. Model of a church after Ashburnham MS. 2037, f. 5 v (Pl. XVIII).
Reconstruction: J. Guillaume/K. De Jonge; model: S.A.R.I., Florence.

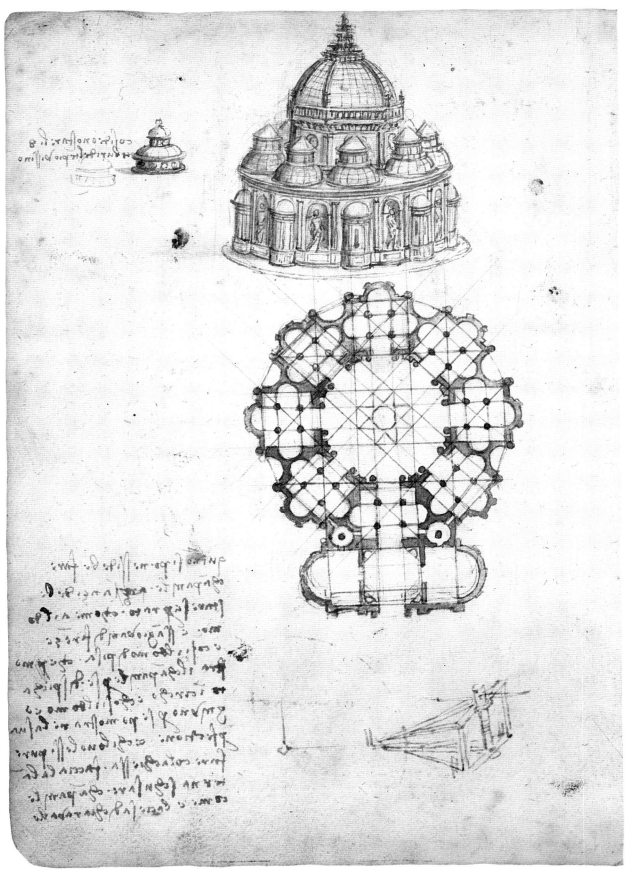

Pl. XVIII. Ashburnham MS. 2037, f. 5 v. View and plan of a centrally planned church with eight radiating chapels; top left: second proposal for the small domes.

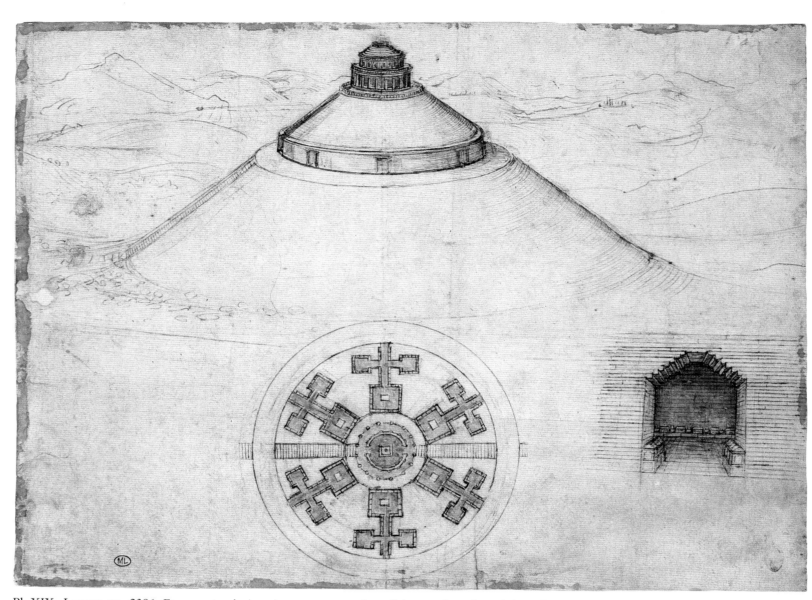

Pl. XIX. Louvre, no. 2386. Etruscan tomb: imaginary reconstruction of the exterior, plan of the galleries and view of an underground chamber.

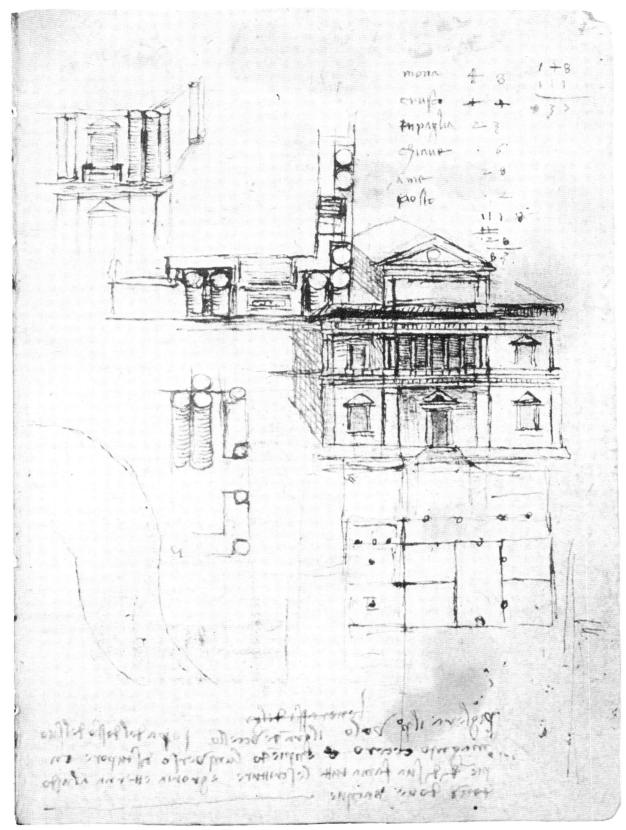

Pl. XX. Codex on the Flight of Birds, cover. Left: variations on the Palazzo Caprini; right: façade of a palace-villa.

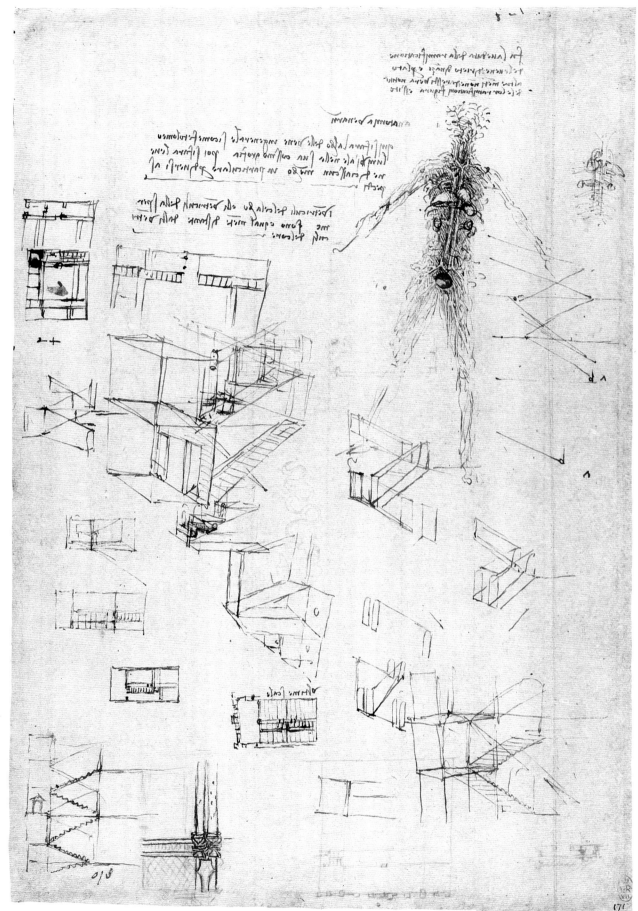

Pl. XXI. RL 12592 r. Anatomical drawing (showing veins); sketches of staircases.

Pl. XXII. RL 12552. Head of an apostle (study for *The Last Supper*); towers surmounted by pavilions.

Pl. XXIII. RL 12292 v. Ideal view of the castle at Romorantin.

II.1

The Problem of Leonardo's Architecture in the Context of his Scientific Theories

by

André Chastel

All his "philosophical" declarations confirm it: no matter what field preoccupied Leonardo, it was his aim to approach it both as a theoretician and as a practitioner. His notebooks are dotted with thousands of notations — concrete, specific, prosaic — which give the impression, frequently erroneous, of novelty and which convey a need, sometimes a clear intention, to develop a system which is never, in fact, realized.[1]* This is particularly evident in the realm of painting. The appeal to *esperienza*, which consists both of the observation of concrete problems and the testing of solutions, does not exclude the proclamation (in the form of a soliloquy) of a *trattato*: in other words, the need to enter the region of theory. All artistic activity is, or ought to be, "*cosa mentale*", and this double action is no less evident where architecture is concerned. Leonardo devoted himself to the subject — as to all others — only sporadically, but his commitment was far more serious than was originally believed.[2] The famous Paris Manuscript B (*c.* 1490), for example, gives a clear indication of the earnestness of his approach.

Roughly one hundred thousand drawings, large and small, are scattered through the five to six thousand pages of his known sketchbooks. They touch on every subject: hydraulics, optics, movement, gears, clocks and armaments. But they also deal with all aspects of construction: arches, the cutting of stone, machines — some of which it has been shown were borrowed from the teachings of Brunelleschi — and, of course, the plans and sketches of buildings that gave rise to the idea of Leonardo as an architect.[3]

But the relationship between these drawings and the accompanying texts is neither simple nor constant. Often the notations are explanatory, particularly when the plan demonstrates that mathematical character so dear to Leonardo. In these cases, the general effect is one of theorems and thus of demonstrations intended for inclusion in theoretical works. Such works, as we know, were never realized. The manner in which these notations are formulated encourages their examination within the framework of the history of science or of scientific techniques. Lacking the requisite knowledge in these fields, I am unfortunately among those who must, when dealing with this aspect

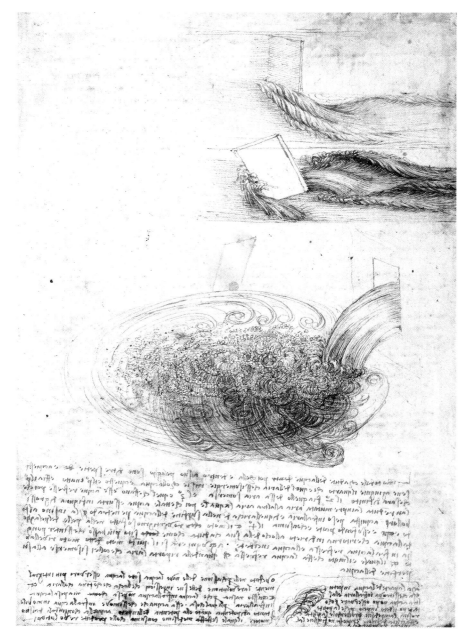

Fig. 187. RL 12660 v. Swirling whirlpools.

of the Master's work, rely heavily on the studies of competent historians — particularly those of Ladislao Reti and Martin Kemp[4] — as will be obvious in what follows.

Leonardo's method of analyzing physical phenomena such as those manifested by water — which so fascinated him — or the resistance of materials — which specially concerns us here — nonetheless warrants some general observations. His prodigious graphic skill is sometimes the source of an ingenious and unexpected representation of a concrete example that remains unexploited in the commentary. One such example has been noted on folio 139 r of Madrid Manuscript I, in the remarkable illustrations of stress loads on arches.[5] This discrepancy is also particularly marked in the famous drawing of the swirling whirlpools produced on the surface of a pool fed by falling water (RL 12660 v: Fig. 187), which provides a fine illustration for the study of hydraulics.[6] The graphic representation portrays the totality of the phenomenon, and other sketches provide details of particular aspects. In order to capture this visual ensemble, to represent it as fully as possible, it was necessary to employ analogies from nature that would give power to the amazing image.

The whirlpools are represented as floral knots which we cannot help but compare with the drawing of the "star of Bethlehem" (RL 12424) and with certain sketches concerning the circulation of blood. A visual "synthesis", with all sorts of calculated resonances, precedes or accompanies the analysis of each particular phenomenon.

Architecture is not a phenomenon of nature, but the two realms are not, in essence, so very different. Actual construction requires so much attention to questions of resistance and statics, that there is a considerable body of knowledge common to the art of building and the study of physics. On the other hand, the focal point of architecture is the building itself; it requires a global vision, a plan, a preliminary form. When, in the letter to Lodovico Sforza, called Il Moro, written in 1481-2, Leonardo boasts of being as well-equipped as anyone to "*soddisfare in compositione di edifitii e publici e privati*", it is clearly understood that he means models, in any case projects suitably "represented".[7] He appears to have been, in this sense, not unlike Alberti, whose inventive dexterity is as well known as his aversion to working on the construction site.

More of an "engineer" than the author of the *De re aedificatoria* ever was, trained in the workshop milieu, Leonardo was late in discovering Vitruvius and Valturius. He does not fit into any of the traditional categories. We know little of his discussions, speculations and studies with Pacioli and Bramante, but that he worked with them is clear.[8] Transported, by his ambition, to the level explored by the greatest minds, Leonardo seems to have been obliged to fall back on his own resources as he advanced step by step into new theatres of endeavour. Faithful unto himself, Leonardo the "architect" could not help but develop an original approach. It is surely interesting to compare what we know of this approach to the basic premises and development of his "scientific" thought, by which it must inevitably have been influenced.

<p style="text-align:center">★</p>

The earliest manifestations of his interest in architecture are the silhouettes of buildings that appear in the background of two large, unfinished compositions produced in his youth. The Alberti-like *tempio*, a distant view of whose façade appears in the painting of the penitent *Saint Jerome*

Fig. 188. *St. Jerome* (detail), Vatican Museum, Rome.

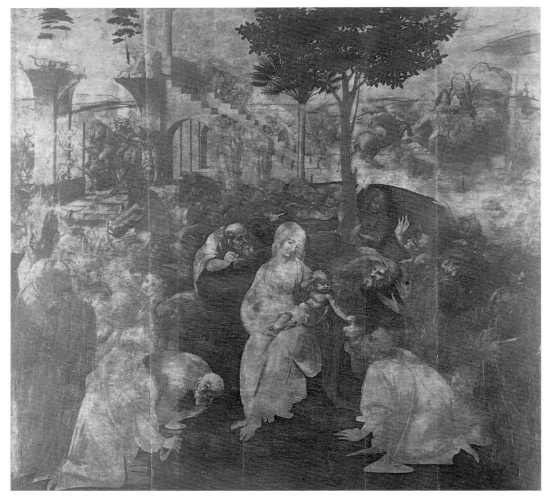

Fig. 189. Uffizi Gallery, Florence. Drawing for *Adoration of the Magi*.

(Fig. 188), certainly warrants an explanation. It occupies the hazy landscape in a disquieting way, introducing, as it does, a modern structure into the rugged cavity of the grotto. The most we can say is that this tiny drawing occupies the place of the crucifix that the saint is supposed to be contemplating and which is always present in such compositions. There is incidentally a curious resemblance between this roughly-drawn façade and a famous drawing in the Accademia, dating from at least ten years later.[9]

The vast construction that occupies the background of the *Adoration of the Magi* is the result of a visual inquiry the successive stages of which can be reconstructed: Leonardo's self-imposed task is to include more and more figures in a structure that is ever more complex. The divided courtyard featured in the painting — rather strangely traversed by two staircases — can be quite well perceived in a drawing in the Uffizi (Fig. 189). While the dispute between the horsemen who appear on the right is a fairly common motif in Italian Epiphanies, less comprehensible is the sort of *disputatio* or discussion surrounding the architecture. It is as if the aura of surprise and wonderment which reigns in the central group around the Infant, is extended to the incomplete — rather than ruined — building, so utterly different from the classical architecture generally used in this type of scene. The modest shed of the Gospels has become a vast stable, and the excited witnesses of the wondrous event scale one of the two staircases rendered in oblique profile. Leonardo wished to draw attention to this element of the edifice, which he was to analyze typologically twenty-five years later, when he came back to the study of loggias, porticos and arcades[10] in the planning of a villa for Charles d'Amboise in Milan.

★

196

The controversies surrounding the construction of the cathedral of Milan (1487-1490) have been thoroughly chronicled.[11] The undertaking provided Leonardo with what was apparently his first opportunity to participate in the construction of an actual building. His retreat from the responsibility of designing the *tiburio* in 1490 is not surprising if we take into account the rough draft of a project-letter that appears on folio 730 r/270 r-c of the Codex Atlanticus.

What, in fact, does Leonardo say? Adopting the comparison of the architect and the doctor already formulated by Alberti (Book X) and Filarete (Book XV), he calls for "a doctor-architect, who understands what construction is, the rules that provide for good construction and the origin of these rules". This famous text recommends that one start with a methodical study, a scientific inquiry that pre-supposes an exact knowledge of the effects of statics: "...the nature of weight, the tendency of the forces and the manner in which they are related and composed".[12]

If Leonardo appears to proclaim the superiority of the theoretician who has solved all the problems in advance, it is because he is, as usual, calling for a methodological and not an empirical approach to problems. This profession of faith means that the building is a *cosa mentale*, an object of knowlege, of reflection, of calculation, and not of practical experience. It was not in Leonardo's nature to proceed in the same way as others.

The formula of the architect-doctor is neither gratuitous nor a rhetorical image. It is part of the "analogical" doctrine that Leonardo was formulating and elaborating during the years between 1485 and 1490. As has been frequently noted, this was also the period of the dissections and anatomical studies. For verification of these various investigations, he was drawn to the notion of the microcosm. Common to all architect-theoreticians, this notion had for Leonardo an even greater significance. According to the doctrine, the human body is a sort of mediator between the works of nature, in which its organization is repeated, and the works of man, which should be governed by it, according to the same proportions. This is clearly illustrated by anatomy: the sagittal section of the human skull matches the measurements of capitals and bases.

The common principle that unites the ancients and the moderns in a sort of *doctrina perennis* is presented by Luca Pacioli in a text, based on numerous precursors, entitled *De divina proportione*, which is worth rereading even today:

> Nature, that divine agent, has endowed the human fabric with a head conceived in proportions that correspond to all other parts of the body. Thus the ancients, having taken into consideration the rigorous structure of the human body, constructed all their works, and above all their sacred temples, according to these proportions; for here they discovered the two principal figures without which no realization is possible: the perfection of the circle, first among all regular forms, and the equilateral square.[13]

This passage, in the first chapter of the section on architecture, was written in 1508, but it summarizes a doctrine that had been circulating among intellectuals for fifteen to twenty years. Like the Neo-platonists, Pacioli was convinced that here was a common point of doctrine between Christian theologians (he cites Pseudo-Dionysius) and the ancients (more precisely, Vitruvius, in Book III, 1.3). The "Vitruvian man", conceived as the reciprocal inscription of the circle and the square in a figure centered on the umbilicus, had been illustrated in an astonishing and abiding manner in the famous drawing in the Accademia in Venice (Fig. 190). Thus, as early as 1487 Leonardo seems to have appropriated the doctrine of the *omo... simulacro dell'architettura* with all its implications.[14]

This diagram was simultaneously an emblem and a mathematical condensation. We will recall, a little further on, how certain favoured configurations were derived inevitably from it. But first let us consider how this axiom of proportions functions; in nature, it is reasonable to explore the

Fig. 190. *Homo ad circulum*, Accademia, Venice.

innumerable harmonies, and in architecture, where things are not so different, to begin by considering the construction as the *fabrica* of the body, and thus as a resolution of contrary forces and the inherent conflicts of the physical world. Even the vocabulary — *desiderio della forza*, for example — reveals the deliberate anthropomorphism which governs the analysis of the structures. The notions of force and of percussion, elements of all physical research, are of crucial importance in this domain: in the technology associated with the construction of the arch, for example.

But before embarking on a brief examination of it, one last aspect of Leonardo's scientific approach should be emphasized — an aspect which, it seems to me, helps to explain why the many, repetitive drawings were so necessary to him. One might call it "mental experimentation". An unusual text in Paris Manuscript B, unfortunately without an accompanying illustration, gives an account of a *sperienza*.

> Demonstration that a weight placed on an axis is not entirely carried by the columns. The greater the weight placed on the arch, the lesser will be the weight transferred to the columns. The experiment should be carried out as follows: place a man on a balance over the centre of a well. Have him spread his arms and legs so that they touch the walls of the well. You will see his weight on the balance diminish. Place a weight on his shoulders and you will see by experience that the more weight you add, the more he will spread his arms and legs and the more he will push against the sides of the well and the less will be the weight registered on the balance.[15]

Leonardo illustrates here a sort of theorem by "experience", which remains, of course, entirely fictitious. Unable to manipulate the objects of nature and human *artefacts* at will, intellectual research conducts imaginary experiments. New situations are examined in thought; variations on these thoughts, on the problems of equilibrium, are studied on paper. These aspects of Leonardo's scientific thought have become far more comprehensible since the reappearance of the Madrid Manuscript I.

On one sheet of this precious notebook, are the words: "I have four degrees of force and four of weight as well as four degrees of movement and four of time. I want to use these degrees and augment or reduce them according to necessity in my imagination, in order to discover the will of the laws of nature" (see Fig. 70).[16] Leonardo imagines and draws revealing variations based on fixed data, and all is as if — the mind functioning like nature — an objective experiment had taken place. It is an example, in fact, of what we would call today a simulation. Leonardo's preoccupation with a vast array of hypothetical solutions is difficult to understand except in terms of this approach.

Even art becomes involved. Any category of imaginative research ought definitely to include the extraordinary "composition" for the *Sala delle Asse* (Fig. 191); coming undoubtedly after the battle of Fornoue, this "natural" architectural décor celebrates Il Moro's proclamation as duke in 1495 with an appropriate symbolic device. All sorts of allegorical elements, chosen and arranged within a tree motif — one of the *imprese* (heraldic devices) associated with Il Moro — are united in the work. Together, they glorify and make use of the concept of "natural" architecture taken from Vitruvius (II, 1), that had already been tried out by Bramante in the cloister of San Ambrosio and by Leonardo in graphic exercises like those on folio 864 r/315 r-a of the Codex Atlanticus.[17]

In a purely fictional structure problems of statics no longer exist, and yet Leonardo creates from the interlacings and counter-movements of the branches an effect of tension that, despite heavy repainting, remains visible even today. The forces at work resolve their conflicting efforts in the *nodi*, where they seem to cancel each other out. The exposure of the bedrock, where we see the roots working into the rocky faults, adds a dramatically natural note to the composition that is doubly if not triply revealing. The static effect of the stable structures is an illusion, for every construction conceals

Fig. 191. *Sala delle Asse*, Milan.

Fig. 192. Madrid MS. I, f. 142 v (detail). Fig. 193. Madrid MS. I, f. 143 r (detail).

the conflict of forces; it is the resolution of a series of tensions, because this is the way of the universe. Architecture is a particular case of the interplay of universal forms rendered eloquent through the concentration of their effects and the implicit knowledge of their laws.

<center>★</center>

The theory of construction ought thus to explicate the manner in which the fabrication of complex material bodies derives from the "necessity" that governs the order of things. In order to establish the rules of painting correctly, one must examine the premises of optics and define the "pyramidal" law of vision, whence springs the theory of perspective.[18] In the case of the *edificatio*, the notion of *potenze* is required to account for the physical phenomena — weight, movement, force and percussion — that are in effect everywhere. "I have sketched", Leonardo writes in the margin beside a series of drawings of the uterus, "the laws of the four powers of nature without whose presence there is no possibility of putting any creature into movement".[19]

The Madrid Manuscript I provides a coherent and explicit set of remarks on the interplay of two principles — weight and resistance — with respect to the form of arches and, by extension, to the problem of vaulting (Figs 192-193). Weights are displaced on graduated measuring sticks in order to calculate the corresponding displacement of counterweights needed to maintain the equilibrium. Regarding the arch, Leonardo calculates for each voussoir the value of the counterweight supposedly needed to hold it in place. On the following page, he deals with the round-headed arch and, pursuing the same complicated but fascinating detour, Leonardo analyzes the composition of forces in the stone supports, without the famous polygon of forces clearly appearing. Historians of science have observed that Leonardo was very close to discovering the correct solution "by pure intuition".[20] But it is interesting for us to realize that Leonardo could never have discovered the polygon, except by accident, precisely because of his principles.

The numerous notations dating from around 1490 concerning the problem of supports reflect Leonardo's persistence in tackling, analyzing and schematizing every fault and weakness of the arch and its supports; these notes amount to what he called a *trattato* of causes and remedies.[21] Having no

Fig. 194. Codex Trivulzianus, f. 8 r (detail). Inverted arch.

Fig. 195. Madrid MS. I, f. 84 v (detail). Flexible architrave.

Fig. 196. CH, f. 12 v (detail). The bubble.

competence to judge the validity of this study of the resistance of materials, which covers so many leaves of the notebooks, we can nonetheless point out its application of the powers of physical nature. The key factor is the capacity of the architectural member to resist and to transmit. An example is the role of the voluted buttress, mentioned in passing: "the inverted arch bears a load better than the ordinary one because the inverted one has beneath it the wall which supports its weakness while the ordinary arch has only air under its weakest area" (Codex Trivulzianus, f. 8 r: Fig. 194). The reasoning regarding the resistance of supports is perhaps not impeccable, but it is a good example of the approximate reasoning that led to the identification of a future form. In another notebook, Leonardo examines how to reinforce the haunches of an arch in order to create a counter-stress capable of balancing the thrusts indefinitely (Paris MS. A, f. 49 v).[22]

One often-cited note in Madrid Manuscript I (f. 84 v) examines the flexion of the lintel; the mathematical language serves only as the framework for various analogical demonstrations (Fig. 195). When the flexible lintel bends inwards, the intrados shortens and the extrados lengthens creating a small fissure in the form of an inverted triangle; but the central part, the *linea neutra*, is not modified. The terms employed by Leonardo are "to thin down" (*si rarifichi*) for "to lengthen" and "to thicken" (*si condensi*) for "to shorten". The description has none of the mathematical purity with which we imbue it by introducing the terms "concave" and "convex", which do not figure in the text, and by forgetting that Leonardo calls "pyramidal" (by analogy to the theory of optical rays) what should properly be called "linear".

Undoubtedly the most revealing note is the one concerning the theory of the bubble, which can be found in the Codex Hammer amidst studies on the hydrology of the earth (Fig. 196):

When the air enclosed in water arrives at the surface, it immediately forms a hemisphere, enclosed within a fine film of water... the air enveloped by a thin skin of water is not perfectly spherical because the part of the water that covers it is heavier where it is most perpendicular to the centre of the circular base of that half sphere; there it sags a bit, for those parts of an object that repose on the extremities are weaker the further they are from the centre of the base; for that which has the weakest support descends the most quickly. The bubble in the third section of its curvature breaks the median sphere of the air enveloped by water, as is proven by the arches of walls. I shall not deal with this subject here but in its proper place in the appropriate book.[23]

201

Such are the laws of nature. We can throw light on the formation of the bubble through architecture, and vice versa. The long note on the minute movements of water ties in unexpectedly with the theory of architecture. With the kind of speculative innocence so characteristic of him, Leonardo, having established the analogy, carefully separates the two realms — hydraulics and the *edificare* — which he has so naturally interwoven. But he separates them again only after having established the intimate unity of the phenomena of nature and their illustration in art. Graphic representation occupies a place of privilege the reasons for which we have perhaps not yet fully penetrated.

<div align="center">★</div>

Leonardo's ideas concerning construction developed throughout his successive stays in Milan and Florence, from which he emerged as an active military engineer. In around 1502 and the years following, he had the opportunity to develop some reflections on ballistics and to examine in depth the effects of violent movement and percussion. Perfecting his principles of physics, he applied the results to a type of architecture he had barely hinted at before.[24] It is here, in fact, that there is the closest link between "scientific" theory and practical application. In one of the clearest examples, Leonardo tries to justify a structure with triangular spurs by means of an analysis of the force of the impact of a projectile: at the end of its trajectory, the cannon ball (*ballotta*) will not strike a surface frontally, but rather the two oblique tangent faces, and the "line of its force will deviate in two directions, whence its efficacy...". The *loco piramidale* is the scientific response to the problem. It is a simple case, but one rich in practical consequences. In another study, Leonardo examines the possibility of flattening contiguous arches so as to reduce the impact of cannon balls.[25] On a sheet of the Codex Atlanticus (f. 135 r/48 v–b: see Fig. 368), which has been dated to 1502-1503, are two unusual drawings, one in sanguine, the other in crayon overdrawn in ink, of a "stellar fortress", designed as an octagon with apexes alternately pointed or indented. The principle is made explicit in a tiny drawing nearby, pointed out by Marani (1984[2]), which features a central circle, in the middle of the octagon, from whence radiate the shots. This design is closely akin to certain well-tested examples of "multiple defence".

The similarity between the construction studied here and the diagrams of the reflection of light rays is striking: the fortress sends out its murderous trajectories just as the light source disseminates "spiritual virtue" through its rays.[26]

The universe is, in sum, a system of coincidences. If the "percussion" effect aimed at with artillery projectiles is no different from that produced by optical rays, it is because ballistics is simply one illustration of the radiation of forces in movement. The construction of military defences was a current problem at the end of the fifteenth and the beginning of the sixteenth centuries. Leonardo's contribution to the field is typical of him in its requirement that practice be subjected to theory.[27]

<div align="center">★</div>

On folio 4 r of the Codex Trivulzianus, we read: "medicine is the reparation of unbalanced elements; sickness is the discord of vital elements in the body". This page is contemporary with Paris Manuscript B and thus datable to around 1490, which brings us back to the period with which we began. This notation confirms that the anatomical studies were already under way around that date.

Fig. 197. CA, f. 1010 v/362 v-b. Diagrams of central plan building.

But this same sheet also displays a series of drawings which all focus on a form that seems to have taken on a fundamental importance at that time: the octagon.[28]

It would be wrong to speak of an obsession. Given that the original formula is provided by the Vitruvian man, inscribed simultaneously in a circle and a square, the most interesting geometric figure to be derived easily from it is the octagon. This form, which may be obtained by slicing off the angles of a square, or by either extending the axes of a circle or dividing it internally, is omnipresent in Leonardo's work. It appears in the most diverse contexts: diagrams, ornamentation, ground plans, edicules and, as we have just seen, fortresses, where the combination of the cube and the sphere bursts into "stellar" shapes.

Of course, Leonardo studied, employed and drew many other figures; he showed a preference at times for spirals, which provided an analogical base in various different fields, including mechanics and the flight of birds. In decorative exercises, the hexagon — mother of the rose form — crops up often. In the realm of construction, however, and the study of vaulting supports or the composition of an edifice, the octagon seems to have been the favoured figure (Fig. 197).[29] In Paris Manuscript B, it dominates the studies of the centralized plan which, of all Leonardo's architectural work, are the most frequently and thoroughly examined. These marvellous variations — *sperienza in imaginazione* — are contemporary with the drawing of the Vitruvian man which supported and directed the research. Of course, the memory of the dome at Florence and the design of San Lorenzo in Milan influenced these

203

*la fronte del quale e' posta quiui in margine, et sia
che la linea centrale, v, a, la quale s'astende dal
centro del luminoso, r, al centro del lato, s, c, e sia
ancora che la linea centrale, v, d, che s'astende
dal centro d'esso luminoso e'il centro del lato, c, f,
dico che tal proporzione sara dalla qualita del*

*lume che riceue da esso luminoso il lato, s, c, a'
quello che dal medesimo luminoso riceue il secon-*

Fig. 198. CU, f. 223 v. The octogonal column.

studies and added fuel, moreover, to the problem of the *tiburio*, placed at the crossing of the transept, where the same conditions existed. Art, also, is a series of coincidences. It is from this rich fabric of ideas that Leonardo drew his inventive virtuosity.[30]

The octagon's application is not limited to religious architecture. A unique combination of octagonal rooms may be observed in plans dating from 1515 (CA, ff. 967 Cr/349 v-c, 963 r/348 v-c and 317 r/114 v-a). The honeycombed courts suggest a beehive; the same form is found later among the plans for Romorantin, in the design for a sort of pavilion that has — not without reason — intrigued many scholars.

A small sketch in the Codex Urbinas accompanies — in Leonardo's usual manner — an analysis of the play of light and shade on a polygonal form, or, more precisely a *"collunnato octangulare"* (Fig. 198). The intensity of the light received may be expressed as a function of the angles of incidence *c a b* on the one hand, on the oblique face, and *c d a* on the other — the right-angle on the frontal face. The octagonal configuration lends itself extremely well to the mathematical representation of the phenomenon under study. In fact, this polygonal figure is one that Leonardo always tends to favour as being both simple and *"pregnante"*.[31]

He even applies it to small mechanisms, employing it in a drawing of a circular ring fitted with ball bearings capable of eliminating friction (Fig. 199).[32] Comparison with the functioning of modern ball bearings is inevitable, but what is most remarkable is that the diagram in question matches quite perfectly the figure of the octagon, demonstrating yet again its empirical validity. The ball bearing mechanism echoes the series of cells in the centralized plan and helps to explain the "dynamic" effect sought after in this architecture. If we push the comparison with mechanical models even further, we might say that the composition of the many-celled centralized plan resembles a gear system.

Leonardo's attention was perhaps drawn to the properties of the octagon by a preoccupation, common to many mathematicians of the past, with the notion of "squaring of the circle". He cites Archimedes and Vitruvius frequently on the subject,[33] but does not mention the treatise published in Venice in 1503 by Campano da Novara, entitled *Tetragonismus id est circuli quadratura*. In this work, the octagon is first represented as a square with the angles cut off; it is then doubled into a hexadecagon and doubled again into a figure with thirty-two sides which rejoin the circumference of the circle. These "conversions" appear in the exercises scattered through the leaves of Leonardo's notebooks.

The famous *nodi* or interlacings of the Accademia Vinciana, conceived around 1495, are also constructed on a hexagonal module.[34] Its use here underlines the favour accorded a figure desirable both for its combinatory possibilities and for the convenience of the constructions and calculations to which it gives rise. But one must also see it as a "symbolic" form, easily linked with the *Vir quadratus* and affording the mental satisfaction associated with the combining of two basic figures of the natural order — the circle and the square; and indeed, by extension, the sphere and the cube, which possess ideally the same properties.

One cannot help but be struck by Leonardo's reserve with regard to the "orders" and the classical heritage; what he received from the past is manifestly borrowed, imposed by his own period.[35] He prefers to concentrate his attention on the relationship between the centre and the periphery, annular forms and gravitating cellular structures, the intersection of axes and proliferation of rose-forms, inverted and multiplied images, in which the elements of a universal order are finally brought together. With a figure like the octagon and the solid forms that proliferate from it, it is the *necessità* of nature, the mathematical secret of the visible universe that one is trying to capture.

A "symbolic form" or a "model", to use the language of twentieth-century epistemology?[36] Judging by his use of it, Leonardo seems to be very conscious of the nature and role of this type of representation. It allows him to manoeuvre in the confusion of the real world and to provide convincing support for speculation and invention. The octagon is one of the forms with which Leonardo experimented most readily in his drawings.

In the dizzying mass of his illustrated notations, Leonardo's predilection for this form — which is not, of course, exclusive but which makes itself felt very strongly at times — cannot be explained without considering the situation as a whole, or, in linguistic terms, without taking a "synchronic" view of Leonardo's intellectual activity. This has been the aim — somewhat unevenly and tentatively achieved — of this study. The justification is that it seems legitimate to coordinate the theoretical propositions and the graphic preferences of the person who proclaimed, entirely in tune with his time, that the very act of vision was itself the model of knowledge.

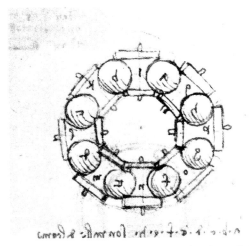

Fig. 199. Madrid MS. I, f. 20 v (detail). Ball-bearing.

II.2

Leonardo and Architecture

by
Jean Guillaume

*Every attempt to communicate an understanding of the thought and creative work
of a man like Leonardo will always remain, simply, an attempt.*

L.H. Heydenreich

Strange as it may seem, no comprehensive study of Leonardo's architectural ideas has ever been made, except by Luigi Firpo (1963), who unfortunately wrote only a brief, though excellent, introduction to the problem. Paradoxically, this *lacuna* is the result of the nature of the studies carried out by the two great scholars specializing in the subject. Ludwig Heinrich Heydenreich, who in 1929 published an admirable study of Leonardo's church drawings and pondered the master's architecture throughout his life, revealed his thoughts in several key articles, but never wrote the comprehensive work which he was still planning in 1969[1]* and which, by its mere announcement, could only discourage all other similar research. In the next generation — the present one — Leonardo studies have been dominated by the figure of Carlo Pedretti, who has completely transformed our knowledge of Leonardo's drawings and written a number of fundamental books on the subject we are concerned with here, including a recent comprehensive work, *Leonardo architetto* (1978). However, the point of view adopted by this undisputed specialist in Leonardo studies is not Heydenreich's, nor is it ours. Pedretti seeks above all to date Leonardo's drawings and writings, and to relate them to specific projects and commissions — in short, to reconstruct the artist's activity. From this standpoint, occasional work, of no great originality, becomes important, while theoretical studies such as the remarkable church drawings in Paris MS. B lose much of their interest, except that of connecting them with a hypothetical project for a mausoleum.

The purpose of the following essay is therefore not to make erudite additions or corrections to the fine work of Carlo Pedretti, although we sometimes question his conclusions on some point or other. We have not concerned ourselves with Leonardo's "career", but with his ideas and their place in the history of architecture in Italy and France. We have consequently disregarded drawings that we consider ordinary or too sketchy to allow clear interpretation.[2] Nor have we gone into his "utopian" proposals, such as the 130-metre-high tower at the entrance to the Sforza Castle (Fig. 200), the bridge

*The notes of chapter II.2 are on page 320.

207

Fig. 200. Louvre no. 2282 r. Study for tower of the castle in Milan;
top right: quadruple winding staircase.

with a span of 240 metres over the Golden Horn (see Fig. 347), or the spherical theatre for preaching (see Fig. 259 top right), which anticipates, to an extraordinary degree, the "visionary" architecture of the late eighteenth century.[3] These "architectural dreams" are of the same order as the "technological dreams" — the automobile, the submarine and the flying machine — which Paolo Galluzzi rightly refuses to take into account in his study of Leonardo's technical thought.

We have therefore concentrated mainly on the subjects that held Leonardo's lasting attention, whether they were studied continuously for several years or on several different occasions over the course of his life. The studies he did for the tiburio of Milan Cathedral during the period from 1487 to 1490 make up one group; this series of drawings is the largest Leonardo ever devoted to one project and the only one in which he showed himself to be a complete architect, a new Brunelleschi, as concerned with technical problems as with formal appearance. The studies for churches with centralized plans date from the same period, with just a few exceptions that basically underscore the constancy of his interests; they form a coherent whole, the only one that has been studied systematically. His drawings of civil architecture, finally, constitute a third group that is more extensive, more dispersed and therefore more difficult to grasp, but in which we have nevertheless been able to isolate four main themes. These drawings also enable us to trace the evolution of Leonardo's style after 1500 and to examine the role he may have played in France in the last years of his life. The order used, while not exactly chronological, follows fairly closely the shift in his interest from religious architecture to civil projects, from cities to castles. Finally, we have left out only one major series, the drawings of military architecture, because they have recently been studied in detail by Pietro Marani (1984)[2].

The Tiburio of Milan Cathedral

The Problem of the Tiburio

The construction of Milan Cathedral, which began in 1386, was nearly complete a century later; by 1480, the choir, transept and five bays of the nave had been vaulted. The most difficult task remained to be done, however: raising, at the crossing of the transept, at a height of fifty meters, over four piers only 2.67 metres wide, a tiburio or crossing tower made up of an octagonal cupola[4] enclosed in a tower of the same shape (Figs 201-202). Such a structure was traditional in Milan, but never had one of such a height been put up on such slender supports. Furthermore, it was to be surmounted by a central spire, in the spirit of the Gothic architecture of the cathedral.

The four piers could support the weight of the tiburio, but the pointed arches joining them, which were 1.05 metres wide, were not strong enough. In addition — and this was the trickiest point — the horizontal stability of the structure had to be ensured; that is, the piers had to be prevented from spreading apart under the pressure of the arches, and forces caused by wind had to be neutralized. A buttressing system that could immobilize the tiburio was therefore needed.

In 1481, the Fabbrica del Duomo or Works Department of Milan Cathedral, which was in charge of the site, considered it wise to solicit advice, especially since Guiniforte Solari, who had designed the project and put up the four pendentives determining the octagon at the base, had just died. The Fabbrica called upon several German architects, as well as Luca Fancelli, Francesco di Giorgio, Bramante, Leonardo and, of course, the local masters, in particular Amadeo and Dolcebono. After all kinds of discussions which need not be repeated here, a plan developed jointly by Amadeo, Dolcebono and Francesco di Giorgio was adopted on June 27, 1490 and executed by the first two (after most of Francesco di Giorgio's suggestions had been dropped) between 1490 and 1500.[5]

Fig. 201. Milan Cathedral: section over the transept (after *Il Duomo di Milano*, 1871).

Fig. 202. Milan Cathedral: plan (after *Il Duomo di Milano*, 1973).

Contrary to what might have been expected and what historians have often said, the ideas of the most illustrious masters — Bramante, Leonardo and Francesco di Giorgio — had almost no impact on the implementation of the additional work.[6] A recent study of the building has shown, in fact, that the simple, efficient structure that was adopted, very "Lombard" in its massiveness, bore no relation to the complicated solutions advocated by Leonardo and Francesco di Giorgio (Fig. 203).[7] As actually built, four semicircular arches, 1.80 metres wide, behind and above the pointed arches and consequently invisible, carry the weight of the tiburio. They are buttressed by the exterior walls of the centre aisle, which rise almost as high as the vaults; the metal tie rods which Francesco di Giorgio wanted in great numbers (Fig. 5) play only a secondary role (or even no role, since two quickly broke). The only question still open, it seems to us, is whether these four arches, probably planned as early as 1470, were built before or after the period of discussion.[8]

Leonardo's Ideas

Leonardo pondered the problem of the tiburio from 1487 to 1490: during this period he executed drawings, had a model built and expounded on his ideas in a letter written to the Fabbrica, of which only the beginning is known.[9] We have no information about the model, which has long since disappeared, and cannot draw any definite conclusion from the fragment we have of the letter, which

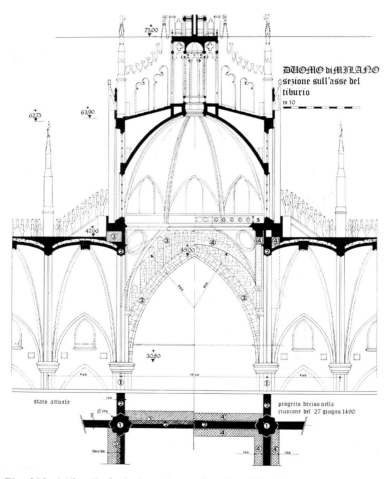

Fig. 203. Milan Cathedral: section at the axis of the tiburio, showing the actual structure (on the left) and the one planned on June 27, 1490 (on the right). 1: crossing piers; 2: original pointed arches; 3: semicircular supporting arches, 1.8 metres wide; 4: double semicircular arches, 1.05 metres wide, planned in 1490. Drawing by C. Ferrari da Passano, in *Il Duomo di Milano*, 1973, I, p. 80.

is primarily a general consideration of the principles that should guide the "architect-doctor" taking action to treat an "invalid" building. This leaves the drawings: twenty or so rough sketches and two large sections, which develop all kinds of most extraordinary ideas for the bearing structure — that is, the problem posed since 1481 — as well as the form and structure of the upper part. We cannot arrange these drawings in chronological order, as they were all done within such a short time; still less can we identify a "final plan", if such a notion can even be applied to a mind that was constantly searching for new solutions.

Actually, Leonardo paid little attention to satisfying the very concrete concerns of the Fabbrica. The problem of the tiburio was, for him, the opportunity for research into the subjects of "weights" and "forces" (to use the terms in the letter) and the structure of domes. His responses go far beyond the question raised, and do not always take the architectural reality into account.

The Stability of the Tiburio

Leonardo devised a novel support system. A theoretical diagram (Paris MS. B, f. 27 r: Fig. 204), to which other drawings may be compared (Codex Trivulzianus, f. 27 v, RL 19134 v, Madrid MS. I, f. 139 r), demonstrates the principle. The four arches joining the piers of the crossing are replaced by eight larger, intersecting arches, which go from one of the crossing piers to the pier of the side aisle opposite it. The arches extend mainly above the vaults, since the springs located in the centre are the only elements visible (they may be identified with the four pointed arches joining the piers of the

Fig. 204. Paris MS. B., f. 27 r (detail).
Intersecting arches.

Fig. 205. The intersecting arches of the preceding drawing in the actual space of the cathedral. Reconstruction: J. Guillaume/S. Kühbacher.

crossing). The intersection of the arches gives rigidity to the system, which is also reinforced by diagonal flying buttresses located in the angles (Fig. 205).

Since the keystones of the eight arches form an octagon, the angles of the tiburio and the ribs of its dome may be supported directly by these keystones, whereas they rest on the haunches of the arches, at a weaker point, when there are only four arches.[10] In the case of Milan Cathedral, where the centre aisles are twice as wide as the side aisles (which Leonardo takes into account in his drawing), the eight keystones would form an irregular octagon, since the sides diagonally above the pendentives would be substantially shorter that the others. This irregularity is inconsistent with the existing structure (the pendentives had already been built) but it certainly did not constitute a flaw for Leonardo, who, as we shall see, often used irregular octagons in his schemes for centrally-planned churches.

The intersecting arches have no real precedent, but are reminiscent of Gothic structures in which judiciously arranged arches combine their "weaknesses" to turn them into a "strength".[11] Convinced that the stability of buildings results from interplays of forces which must be brought out by analysis, Leonardo certainly was much more interested than his contemporaries in "German" architecture (as it was then called in Italy).[12] This type of building clearly gave him the idea of these light, strong arches, capable of supporting very high vaults: "taking Gothic as a starting point, he endeavours to go beyond it".[13]

Since this ideal solution was not applicable in a building that was already largely built, Leonardo

Fig. 206. CA, f. 851 r/310 v-b. Section of the crossing piers and, above, projection of a double dome: first state.

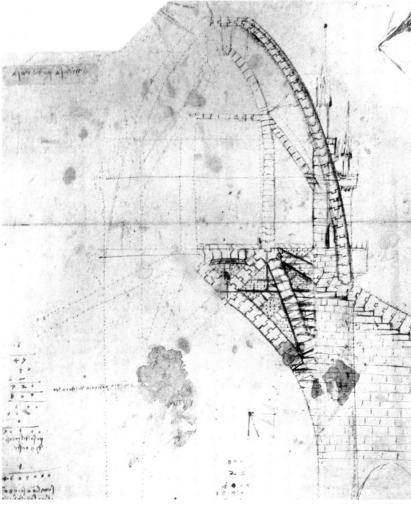

Fig. 207. CA, f. 850 r/310 r-b. Section of the crossing piers and, above, projection of a double dome: second state. The dotted lines on the left correspond to the holes used for the copying of the drawing by *spolvero*. See Pl. XVI.

Fig. 208. The support system of the tiburio after the preceding drawing.
Reconstruction: J. Guillaume/S.Kühbacher.

studied a more easily executed alternative in two large drawings that are the most detailed of all the ones he did for the tiburio (CA, ff. 851 r/310 v–b and 850 r/310 r–b: Figs 206–207; reconstruction: Figs 208 and 220).

Let us consider, for the moment, only the bottom half of these drawings. In both instances, we see a section drawn on one side of the crossing of the transept, between two piers. The section cuts lengthwise through the large arch joining the piers, the wall built over this arch and, to the right, the wall erected over the arch of the side aisle (sketched roughly below).

The two rises of the large arch (A and B in the reconstruction drawings: Fig. 220) are extended by short, stone ties that end at the starting points (C and D) of the ribs of the octagonal cupola. Two other ties go off from these two points. One of them (E) ends at the spring of the large arch; it carries down the weight of the cupola onto the corner piers. The other (F), inclined much less, joins the wall built over the arch of the side aisle; it gives horizontal stability, with the wall acting as a buttress. This latter tie replaces the exterior spring of the arches in the theoretical solution.

It is found again in the overlapping, which is now produced, however, by a combination of arches and ties embedded in the masonry. To give greater rigidity to the overall structure, Leonardo called for stones that would fit into one another, and showed them with anatomical precision. The

213

Fig. 209. Paris MS. B, f. 78 v (detail).
Inverted arches. Underneath,
Leonardo has written: "very strong,
very light arches".

drawing brings out wonderfully the interplay of forces: the members alone are bearing elements, and not the mass of the wall. The design of the structure remains "Gothic", in contrast to the heavy structures characteristic of the Milanese style.[14]

A small sketch (Paris MS. B, f. 78 v: Fig. 209) shows another alternative for the system. The stone ties are replaced by inverted arches — a form which Leonardo was fond of and which we will see again in his plans for the dome. The arches seem to rise out of one another in a flexible movement, and the bearing structure takes on an ornamental value. We cannot help being reminded of the X-shaped arches over the crossing in Wells Cathedral, which Leonardo was obviously not familiar with. The note accompanying the drawing gives a good summary of the artist's objective: "very strong, very light arches".

A final group of drawings, made up solely of diagrams (Codex Trivulzianus, ff. 8 v, 12 r, 21 r: Figs 210-211) shows that Leonardo may also have planned an entirely different solution in which the horizontal stability would be provided by a system of metal tie-bars which would connect the tiburio to the piers of the side aisles. As these drawings predate Francesco di Giorgio's arrival in Milan, it is tempting to think that they foreshadow the solution recommended by the Sienese architect and even influenced him, since the relations between Leonardo and Francesco in Milan were very close. We must beware of this type of deduction, however; the drawings are too sketchy for us to be certain that they indicate ties and not arches, and Leonardo, in a note written at about the same time (1490-1492), condemns the use of metal tie-rods: "Arches which depend on ties for their support will not be very durable".[15]

Figs 210 and 211. Codex Trivulzianus, f. 8 v and 12 r. Plans of the tiburio showing metal tie-rods.

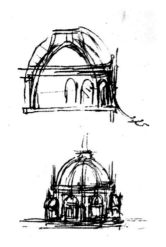

Fig. 212. Codex Trivulzianus, f. 9 r. The tiburio: section (with double dome) and elevation.

Fig. 213. Paris MS. B, f. 4 v (detail). Exterior view of the tiburio: the roofs of the nave and transept of the cathedral are drawn in barely visible strokes.

The Exterior Appearance: Dome Preferred to Tiburio

When he was invited to submit a plan for the tiburio of the cathedral, Leonardo never considered giving the top part the appearance of a tiburio. Obsessed by the memory of Brunelleschi, he always drew a dome. This type of solution, however, did not suit Milan Cathedral, since the size of the crossing did not allow a large dome in proportion to the huge volume of the church to be erected. Consequently, Leonardo made all kinds of efforts to enlarge and raise the dome. He envisaged four possible solutions for this:

1. The dome, itself surmounted by a very high cap, stands on an octagonal drum inscribed within the square of the crossing. To enlarge this drum and, at the same time, increase the stability of the dome, Leonardo applied, onto each face, apses (Codex Trivulzianus, f. 9 r, Paris MS. B, f. 4 v: Figs 212-213; see also Fig. 211) or buttressing walls ending in inverted arches and pierced by an arcade, following the system devised by Brunelleschi for the lantern of Florence Cathedral (CA, f. 719 r/266 r-a: Fig. 214). This solution would have been difficult to carry out because half of the apses (and all the buttressing walls) are located over vaults of the side aisles, which would

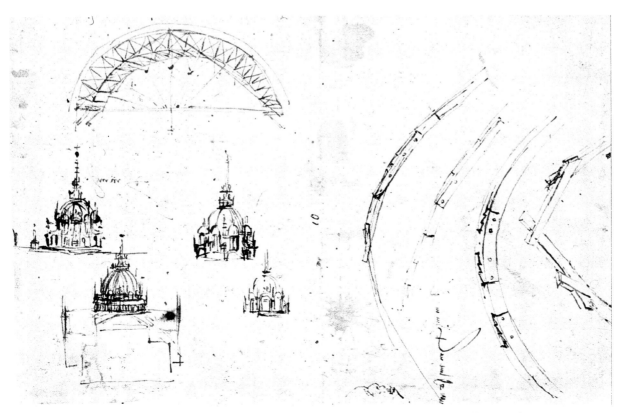

Fig. 214. CA, f. 719 r/266 r (detail). Centre left: Drum dome reinforced by buttressing walls pierced by an arcade; top and right: structural studies.

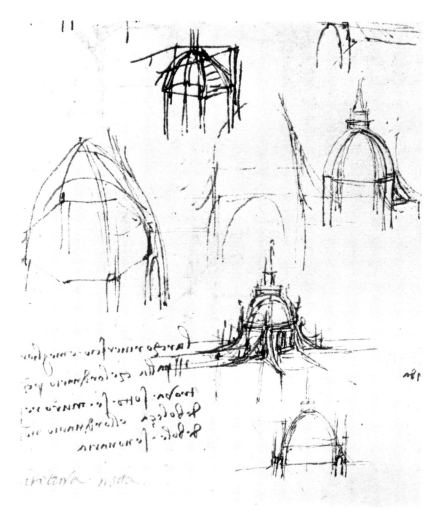

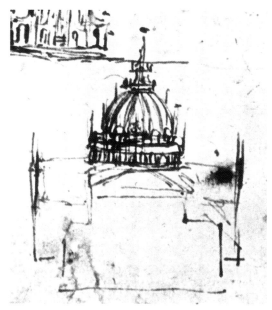

Fig. 216. Dome on circular drum on top of the cathedral (detail of Fig. 214).

Fig. 215. Codex Trivulzianus, f. 8 r (detail). Bottom: dome on a circular drum reinforced by buttressing walls in the form of inverted consoles; top: square dome.

therefore have to be reinforced, as the double lines on folio 21 r of the Codex Trivulzianus seem to indicate.

2. Another drawing (Codex Trivulzianus, f. 8 r: Fig. 215) shows a dome, also surmounted by a high cap, and a circular drum. This volume is a little larger than the preceding octagonal volumes, since the crossing of the transept is inscribed within the inside of the circle: the buttressing walls in the form of inverted consoles built over the outside walls of the centre aisles necessarily join over the piers of the crossing.

3. An even grander solution appears in the Codex Atlanticus, on folio 719 r/266 r (Fig. 216), in which the polygonal dome (12-sided?) is inscribed within a square corresponding to the crossing and the bays next to it; the drum, proportionately lower, is surrounded by a circular portico. Below, Leonardo has taken care to draw the volume of the cathedral, with some simplifications (the centre aisles and first side aisles have the same roof), thereby indicating his interest in this proposal, the most beautiful of all — and the least feasible. Leonardo doubtless thought about the problems posed by the construction of such a volume, however, because the same sheet contains studies of semicircular frames (Fig. 214) that could suit a dome with an outer surface supported by a framework which is much lighter than one made of bricks. This type of technical solution could easily be devised using the example of Venetian churches, in which the cupolas are surmounted by a substantially higher outer dome. The technique for assembling a frame made of small, curved elements was new, however, and prefigures to an astonishing extent the "inventions" of Philibert de L'Orme.[16]

216

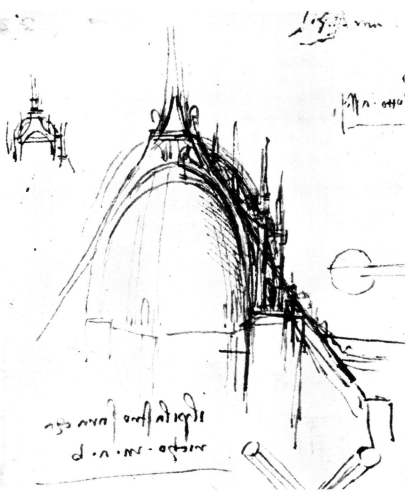

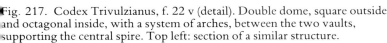

Fig. 218. Square plan dome. Anonymous, drawing, *c*. 1500 (Biblioteca Ambrosiana, MS. 251, inf. 218, detail).

Fig. 217. Codex Trivulzianus, f. 22 v (detail). Double dome, square outside and octagonal inside, with a system of arches, between the two vaults, supporting the central spire. Top left: section of a similar structure.

4. Finally, Leonardo studied one last solution, no doubt less grand, but more original as it was without precedent in Italy. This was a square dome (actually a cloister vault) that was massive in form and had no drum (Codex Trivulzianus, ff. 8 r and 22 v: Figs 215 and 217). This structure was the easiest to build, because the four cells come down onto the walls built over the arches of the crossing. Bramante, who for the same reason favoured a square tiburio, might have approved of it. In any case, the square dome must have pleased Leonardo, because he also adopted it in the two large structural drawings in the Codex Atlanticus which we will discuss further below (Figs 206-207). Thus, in this case, the need to "conform" to the existing structure took Leonardo away from the Brunelleschian model and led him to devise a new form that reappeared several years later, in a drawing by Bramantino (Fig. 218)[17] but which, in the end, did not become at all popular in Italy.

The same concern for *conformità* led Leonardo to give all his domes a Gothic appearance; he drew large numbers of ridge ornaments, which are apparently very high, and placed at the top of the dome a spire as high as the dome itself, thus reproducing — perhaps unknowingly — the solution adopted in 1420 for the tower of Frankfurt Cathedral.[18]

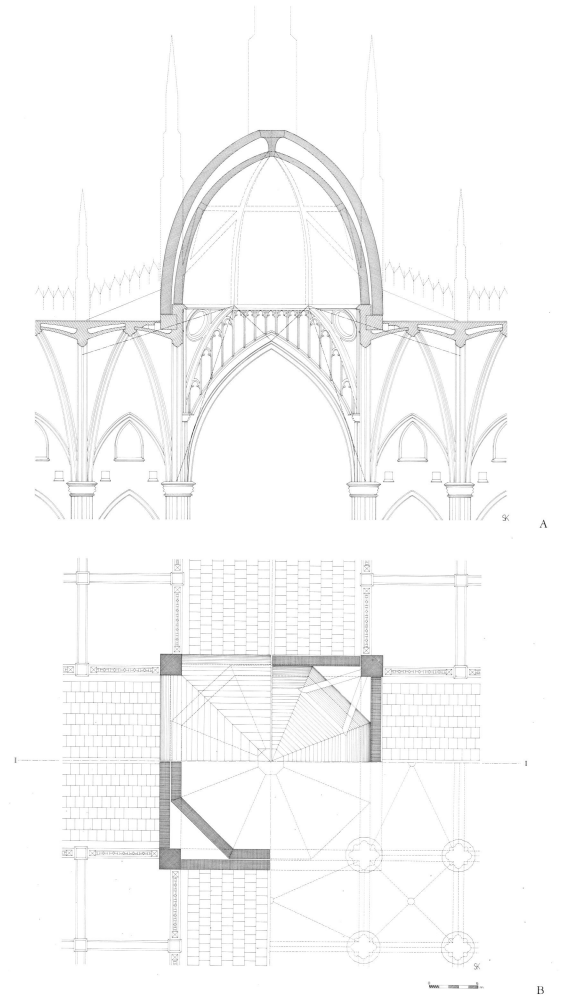

Fig. 219. Octagonal cupola inside a square plan dome. Reconstruction: J. Guillaume/S. Kühbacher after CA, f. 850 r (Fig. 207).
A: Cross section at the axis of the tiburio (I-I).
B: Outside dome, inside cupola, plan at the base of the two domes, plan at the level of the piers of the cathedral.

The Structure of the Dome

All the sections accompanying the views of domes and the two large drawings in the Codex Atlanticus show a structure with two cupolas, one exterior and the other interior. This system, devised by Brunelleschi to strengthen the vault and better distribute the thrusts, would allow Leonardo to create an exterior volume that was larger than the interior volume, which was necessarily limited because it was inscribed within the crossing of the transept. In one of the sections, small but precise, the difference between the two vaults is considerable (Codex Trivulzianus, f. 22 v, Fig. 217, top left).

As soon as the two vaults diverge, they can be given different forms. Leonardo understood this possibility, and made use of it in the two large structural drawings in the Codex Atlanticus (ff. 851 r/ 310 v-b and 850 r/310 r-b: Figs 206-207 and Pl. XVI).

To properly interpret the upper part of these sheets, it should not be read as a section, but as the projection (or extension) on the plan of the section of the ribs located in front (with the observer placed inside the transept crossing). The centre ribs (the left one merely outlined) define one of the cells of the interior, octagonal cupola; the right-hand rib forms the groin of the exterior dome, which is square in plan because the rib comes down on the corner pier: the "Gothic" ridge ornaments near the angle of the dome act as buttresses for a kind of flying buttress that rests on a stone chain reinforcing the inner shell. The reconstruction drawings clearly illustrate the system (Figs 219-220).[19]

If the interior dome forms an octagon, the four sides parallel to the exterior dome are tangent to the latter dome, because the starting points of both domes must be located over the arches joining the

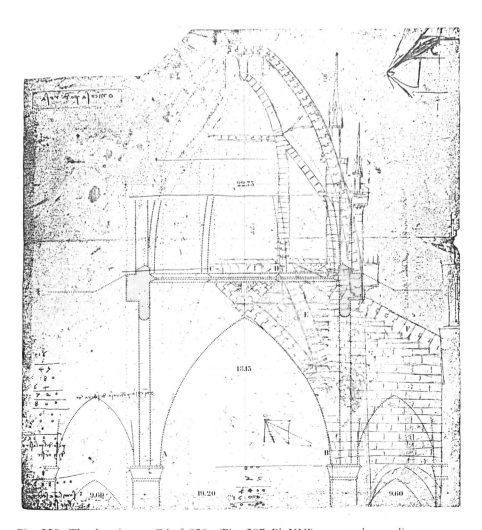

Fig. 220. The drawing on CA, f. 850 r (Fig. 207, Pl. XVI) corrected according to
the actual dimensions of the cathedral and the existing structures.

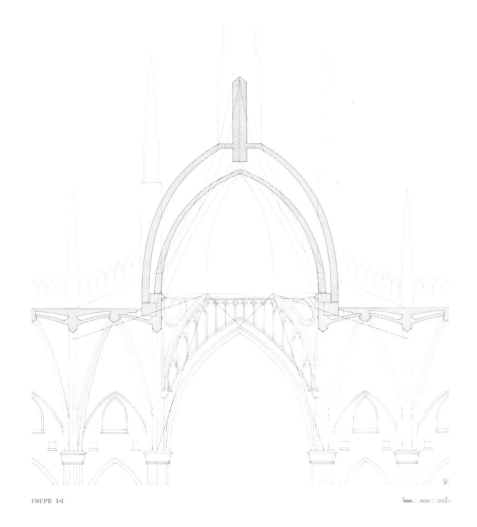

COUPE I-I

A

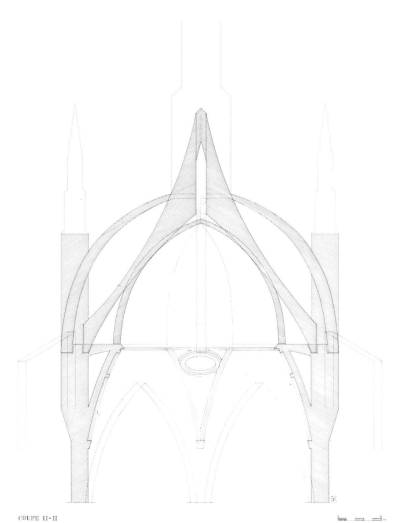

COUPE II-II

B

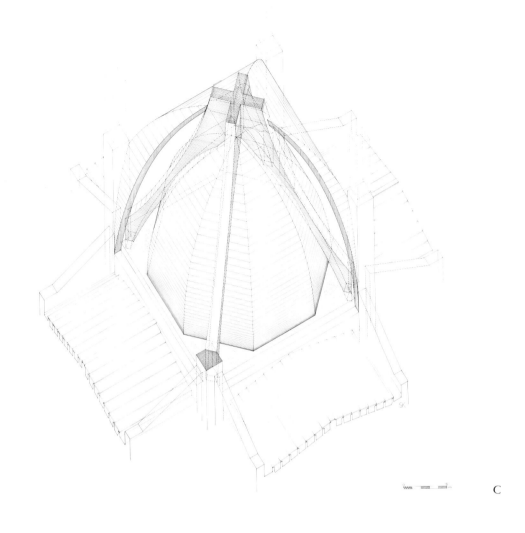

C

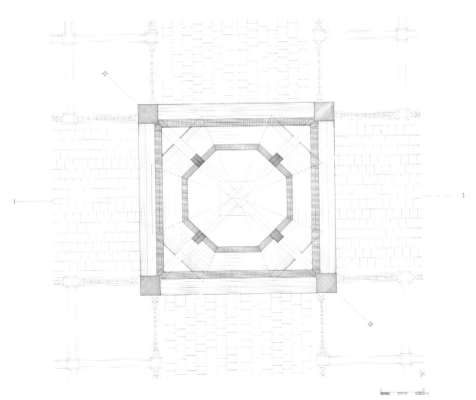

D

Fig. 221. Double dome in which circle–on–circle arches support the crown.
Reconstruction: Jean Guillaume/S. Kühbacher after drawings reproduced in Figs 217 and 222.
A: Cross section at the axis of the tiburio (I–I): the crown and the pinnacles are sketched in
dotted lines; B: Diagonal section (II–II); C: axonometric view; D: plan half way up the domes.

piers.[20] The sides that were parallel then diverge from one another, but relatively little, as the keystones above appear to be close. The space between the two structures is really significant only in the angles, where the small flying buttresses are indeed located.

Leonardo takes up the idea of an inner dome, in the shape of a very irregular octagon, and a square exterior dome in a quick, but ultimately clear enough sketch in the Codex Trivulzianus (f. 22 v: Fig. 217). In this plan, the exterior dome is much higher, so much so that there is, at least in the angles, a great gap between the two vaults, throughout the entire height. This gap is clearly brought out by the drawing which represents, it seems to us, two diagonal sections placed at right angles, which appear to be on the same plane, as the interior space is "opened up" by an exaggerated perspective effect.

Within this gap, a novel type of structure takes shape: sharply inclined arches carry, above the first dome (and without having to be supported by it), the considerable weight of the large "Gothic" spire which the exterior dome, which is too thin, could not support alone. The same idea reappears in the small sketch next to it (top left), Codex Trivulzianus, folio 9 r (Fig. 212) and on folio 400 r/148 r–a of the Codex Atlanticus (Fig. 222), in which the stone bond of the arch is even studied in detail in the centre drawing (which might better be read vertically). A special feature of this arch is its circle-on-circle design — a form Leonardo also used in a study for the tiburio supports (Fig. 209). In proposing these "very strong, very light" arches, Leonardo no doubt thought he would be able to distribute the forces, namely the weight on the lower arch and the tangential thrusts on the inverted arch. Our reconstruction drawings (Fig. 221) show how arches of this type, like certain flying buttresses, could be used in the structures described in the Codex Atlanticus, folio 850 r/310 r-b, and Codex Trivulzianus, folio 2v; they thus give an idea of what may have been the complete plan, of which no drawing remains.

Leonardo returned to this idea in France, around 1517. On Codex Atlanticus folio 44 r/13 r–a (Fig. 223) he provides, it seems, a section of the tiburio (vault and exterior shell) as built, and indicates over it the spire which was planned but was only executed in the eighteenth century.[21] To support this

Fig. 222. CA, f.400 r/148 r-a. Circle-on-circle arches; left: door frame.

Fig. 223. CA, f. 44 r/13 r–a. Section of the tiburio as actually built, reinforced by circle-on-circle arches (about 1517).

spire and avoid breaking the vault half way up — which he appears to suggest in his drawing — he proposes introducing circle-on-circle arches (hatched) which are supported on the outside by buttressing walls in the form of inverted consoles, similar to those in the Codex Trivulzianus, folio 8 r (Fig. 215).

Leonardo's elongated, circle-on-circle arches had no success in Renaissance architecture, but were rediscovered later by builders such as Wren, who erected the spire of St. Dunstan in the East on four arches of this type.

The Science of Building

The structures which Leonardo devised to support the spire of the cathedral and stabilize the tiburio are of the same type. They entail providing stability by a balanced interplay of forces and not by means of a massive structure. This design takes its inspiration from a study of Brunelleschi's dome, but it must above all be related to Leonardo's anatomical research, which was going on during exactly the same period. The displaying of the muscles, bones and nervous system has its equivalent in the singling out of the arches and ties in the "body" of the structure. The expression "architect-doctor" which Leonardo used in his letter to the Fabbrica therefore has a very definite meaning: it is a matter not only of caring for the cathedral, but also of knowing all the secrets of the "anatomy" of the building.[22]

The problem of the tiburio of Milan Cathedral was thus an opportunity for Leonardo to carry out detailed research into building techniques — the most extensive research he ever conducted. The solutions he proposed, based on the bold use of arches and stone ties, could not had been well received in a city where a Gothic cathedral was built without using flying buttresses, and even less in Rome, where massive structures had always been preferred. It would not be until the time of the engineer-architects of the late eighteenth century, who were keenly aware of the technical achievements of the Gothic style, that similar solutions would appear, as for example at Sainte Geneviève in Paris.[23]

Nor could the forms proposed by Leonardo — skilful combination of a dome (or a cloister vault) and Gothic superstructures — have pleased the Milanese of that time, who were too attached to the traditional look of the tiburio, or the following generations, who were fascinated by the dome of the Pantheon. However, one cannot help thinking that Leonardo's most ambitious plan, the enormous dome with twelve (or more) sides, surrounded at its base by a portico (Fig. 216), must have left a lasting memory in the mind of Bramante, as we find the same combination of dome and encircling colonnade in the latter's plan for St. Peter's in Rome.

Churches: The Centralized Plan

Centralized plans are massed plans, all parts of which are arranged symmetrically in relation to axes (generally two or four) passing through their centre. Frequently found in Byzantine architecture, this type of plan is less common in the West, where nave churches have traditionally been preferred. In the fifteenth century, however, the most innovative architects — Brunelleschi, Alberti, Michelozzo, Filarete, Francesco di Giorgio, Giuliano da Sangallo, Coducci — became interested in centralized plans because they allowed a unified organization of spaces and volumes that was so flawless it seemed to express divine perfection. These plans were therefore designed mainly for churches.

Leonardo gave a great deal of thought to the centralized plan in the period between 1487 and 1490 in Milan. The major projects being discussed at that time, the new Pavia Cathedral and the choir of Santa Maria delle Grazie, certainly stimulated Leonardo's interest in this type of plan, but his studies are not specifically related to these two undertakings. The systematic nature of his research and the homogeneity of his method of presentation — plans accompanied by bird's-eye views — give the impression, rather, that at a certain point he was envisaging a kind of treatise on domed churches.[24] In any event, he left us the most complete and most imaginative set of church "projects" ever designed. In just a few years, Leonardo said it all in some thirty drawings in Paris MS. B and on several other sheets from the same period. The drawings he did later on, which are less numerous and for which we will always indicate the date, generally repeat the same ideas.[25]

Types of Plan

Centralized plans may be simple or complex. In the former case, they comprise only one space — circular, polygonal or square — generally surrounded by a peristyle which creates a play of volumes on the exterior. We will not dwell on this type, which is exemplified by Bramante's Tempietto, as it was of little interest to Leonardo.[26]

Complex centralized plans, on the other hand, which combine a central space and peripheral spaces and offer many more possibilities, were the focus of Leonardo's entire attention. We will classify them in two groups: radiating plans and cross-shaped plans. Radiating plans contain peripheral elements (generally eight) arranged convergently around a much larger, polygonal (usually octagonal) or circular central section. Cross-shaped plans, instead, are based on the meeting of two perpendicular axes; the central space is a "crossing", square in plan, and the peripheral elements are "arms" as wide as the central space.

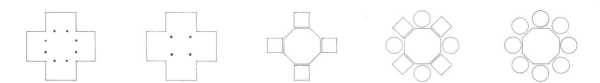

Fig. 224. The five types of centralized plan★.

★ All the graphic reconstructions illustrating this chapter were executed by Sabine Kühbacher, except the drawings in Fig. 232, which are by Krista De Jonge.

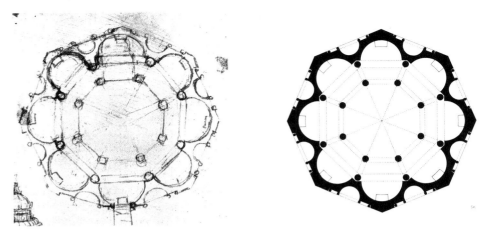

Fig. 225. Paris MS. B, f. 56 v (top). Eight-apse plan.

This theoretical distinction, based on a contrast between convergence and intersection, does not adequately describe all the possible arrangements. When the eight peripheral elements in radiating plans are of unequal size, there is actually a contrast between two major axes and two minor axes. The greater the contrast, the closer the plan comes to being a cross — without, however, reaching that point, since the peripheral elements of the radiating plans are never arms; convergence always prevails over intersection. Conversely, it is possible to introduce one element of the radiating plan — the central, polygonal or circular part — into cross-shaped plans and thus to create a new type.

We will therefore distinguish five types of centralized plans: three radiating and two cross-shaped (Fig. 224). Each of these types itself contains forms of varying degrees of complexity depending on whether the spaces are subdivided by piers setting off ambulatories or side aisles, but these variations seem less important than the distinctions based on the contrast between the radiating plan and the cross-shaped plan.[27]

1. Homogeneous Radiating Plans

In this type, the simplest one, the peripheral elements (apses or chapels) are identical to one another.

(a) Plans with apses

Semicircular apses (sometimes with additional apsidioles) open onto the central part. The latter generally has piers setting off an ambulatory. The simplicity of the peripheral spaces is "compensated for" by a greater complexity of the central space (Paris MS. B, f. 25 v and f. 56 v: Figs 225-226).

Leonardo drew his inspiration from earlier buildings: the choir with ten apses in the Annunziata of Florence, derived from classical examples, and, for plans with ambulatories, certain early Christian churches like Santa Maria in Portica (destroyed) of Pavia, the plan of which he had seen (Paris MS. B, f. 55 r).

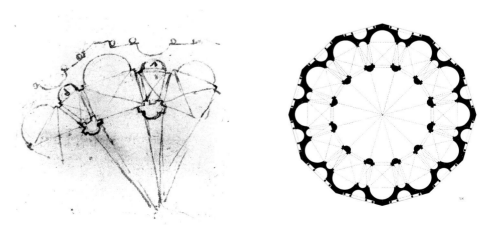

Fig. 226. Paris MS. B, f. 56 v (bottom). Detail of a twelve-apse plan and suggested reconstruction.

(b) *Plans with chapels*

Chapels with centralized plans are connected to the central space via a fairly narrow passegeway. Instead of taking in the interior in a single glance, as in the previous examples, the viewer must discover each part in turn: the central space, which is the largest, and then the peripheral "cells". This complexity explains the absence of ambulatories in these plans. The chapels may be circular (Paris MS. B, ff. 18 r and 25 v, CA, f. 1010 v/362 v-b: Figs 227-229), octagonal (Paris MS. B, f. 21 v: Fig. 230, and f. 30 r) or have a centralized plan themselves, in this instance a cross-shaped plan (Ashburnham MS. 2037, f. 5 v: Figs 231-233 and Pl. XVII-XVIII).

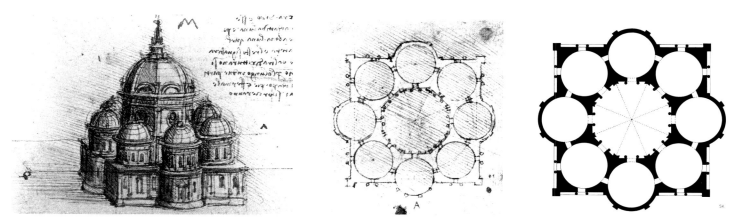

Fig. 227. Paris MS. B, f.17 v (bottom) and f. 18 r (top). Church: view, plan and suggested clarification.

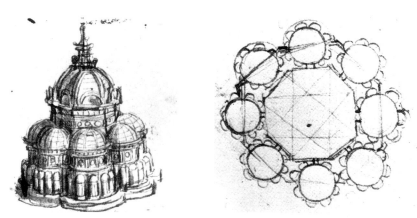

Fig. 228. Paris MS. B, f. 25 v (details). Church: view and plan.

Fig. 229. CA, f. 1010 v/362 v-b. Plan with circular chapels (detail of Fig. 197).

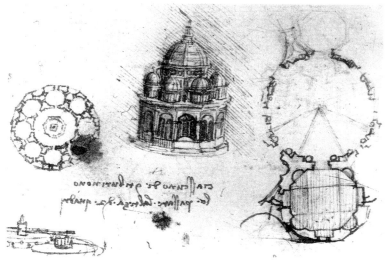

Fig. 230. Paris MS. B, f. 21 v. Church: plan and suggested reconstruction.

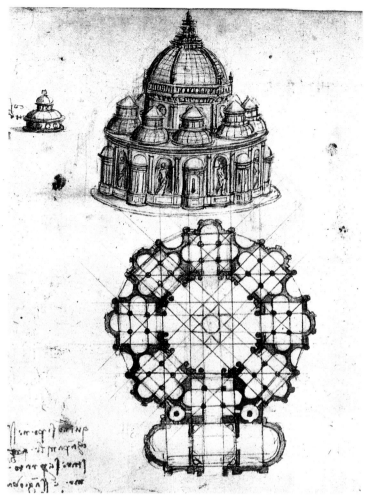

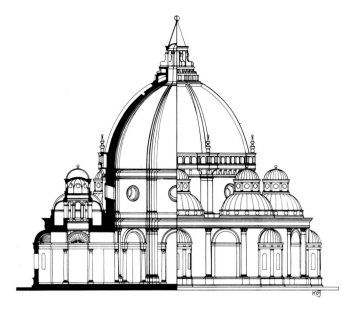

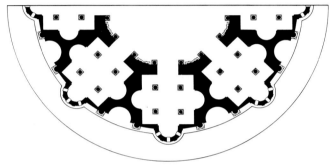

Fig. 231. Ashburnham MS. 2037, f. 5 v. Church: view and plan; top left: second proposal for the small domes. See Pl. XVIII.

Fig. 232. Section, elevation and plan of the preceding church. Reconstruction: J. Guillaume/K. De Jonge. See Pl. XVII.

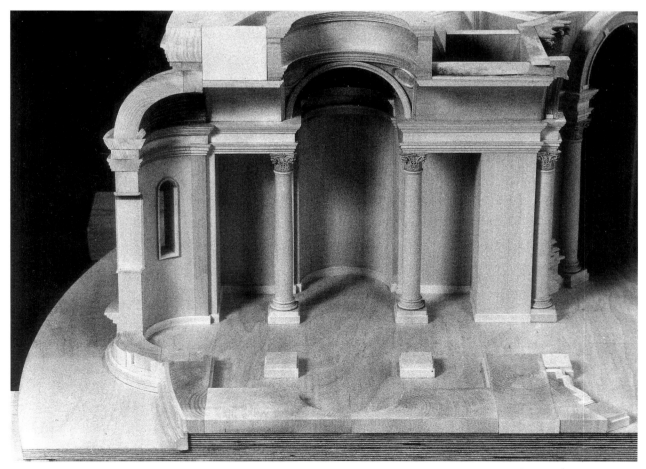

Fig. 233. Chapel of the preceding church. Model by S.A.R.I., Florence, after the reconstruction.

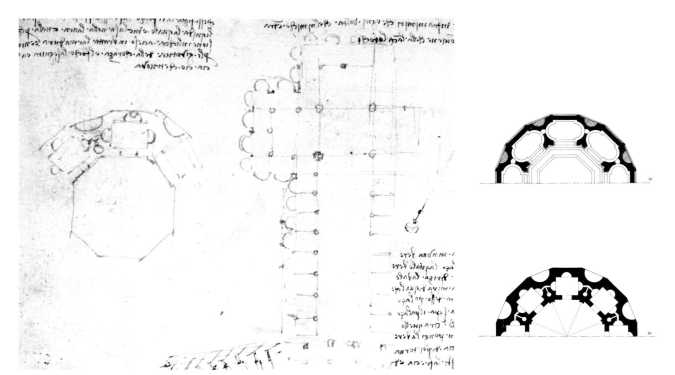

Fig. 234. Paris MS. B, f. 11 v: Florence, Santa Maria dei Angeli and San Spirito: plans drawn by Leonardo.

Fig. 235. The plan of Santa Maria dei Angeli compared to Leonardo's interpretation.

In devising this type of plan, Leonardo almost certainly recalled Brunelleschi's Santa Maria degli Angeli, which was never completed. Leonardo made a drawing of this building, with one significant change: he added a third apsidiole to the rectangular chapels so that the latter would appear more "centralized" and would therefore be more autonomous in relation to the central space (Paris MS. B, f. 11 v: Figs 234-235). The idea of grouping eight chapels, closed onto themselves, around an octagon and thus creating a spatial composition full of surprises and even mystery (if we think of the lighting effects this allows) therefore seems to be Leonardo's. The only precedents might be certain classical mausoleums, as these were interpreted in drawings by Leonardo's contemporaries.[28]

2. *Alternating Radiating Plans*

Two different types of peripheral elements are arranged in alternating fashion here.

Leonardo was very interested in this type of organization, which allowed him to vary the form of the peripheral elements and to change the way they related to the central space. The latter point was certainly the more significant one; by emphasizing the contrasts, it is in fact possible to give two axes greater importance and to introduce into the radiating plan certain effects characteristic of the cross-shaped plan. We will therefore distinguish between alternating plans with little contrast, in which the peripheral elements carry approximately the same weight, and more strongly contrasting plans with satellite chapels, in which Leonardo stressed two of the directions.

(a) *Alternating Plans with Peripheral Elements of the Same Weight*

— *Alternating apses*: Paris MS. B, folios 25 v and 24 r (Fig. 236). In the former case, Leonardo proposes a simple alternation of rectangular and semicircular forms. In the latter, he studies a more complex solution with an ambulatory; however, the result is unsatisfactory, because he attempts to inscribe the whole within a square. The bays of the ambulatory are alternately rectangular and square, and the apses wide and narrow. It seems that the alternation was not sought for its own sake but

228

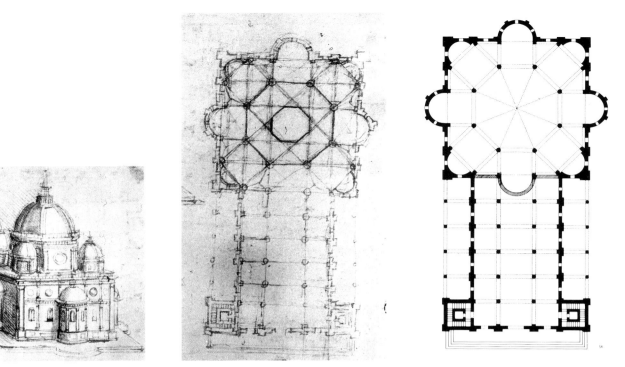

Fig. 236. Paris MS. B, f. 24 r (details). Church: view, plan, suggested clarification (shaded areas: sections drawn and then rubbed out).

results from the combination of the octagon and the square, which Leonardo was to attempt one other time, with just as unfortunate results, in Ashburnham MS. 2037, folio 4 r (Fig. 242). Leonardo then went over his drawing, erasing one of the apses to introduce a nave.[29]

— *Alternating chapels*: Paris MS. B, folios 18 r, 19 r, Arundel MS., folio 270 v (1517: Figs 237-238 and 295). In the second drawing (subsequently partly redrawn with smaller chapels corresponding to the viewpoint), the principle of alternation extends to the central octagon, which is irregular here. As a result, two of the axes are emphasized. This is the first manifestation of a tendency which found full expression in the plans with two major axes.

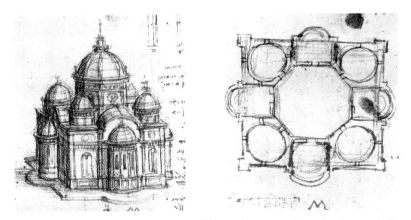

Fig. 237. Paris MS. B, f. 17 v (top) and f. 18 r (bottom). Church: view and plan.

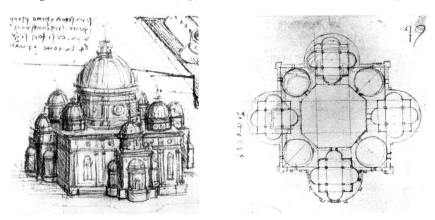

Fig. 238. Paris MS. B, ff. 18 v and 19 r (details). Church: view and plan.

(b) *Alternating Plans with Satellite Chapels*

Four chapels or apses alternate with large niches that give access, through a narrow passageway, to satellite chapels located away from the central octagon. This central space is fairly often irregular in form, with the short sides corresponding to the niches.

— *Alternating chapels and niches/satellite chapels*: Paris MS. B, folios 22 r and 39 v, Codex Atlanticus folio 1010 v/362 v-b (Figs 239-240 and see Fig. 197, top). A special feature of the first drawing is that one of the satellite chapels is a porch providing access to the church.

— *Alternating apses and niches/satellite chapels*: Paris MS. B, folio 25 v, Codex Atlanticus, folio 1010 v/362 v-b (Fig. 241 and see Fig. 197, left). The latter drawing, with an irregular octagon and apses with wide openings onto the central space, is close to a cross-shaped plan, but is still radiating because the satellite chapels, connected diagonally to the central space, converge towards the centre.

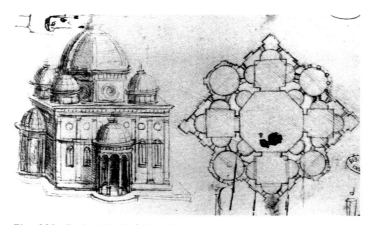

Fig. 239. Paris MS. B, f.22 r. Church: view and plan.

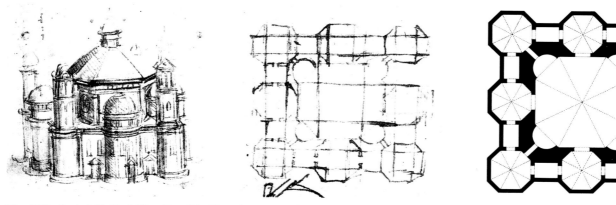

Fig. 240. Paris MS. B, f. 39 v (details). Church: view and plan.

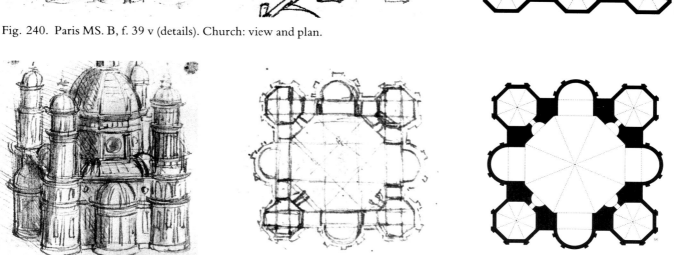

Fig. 241. Paris MS. B, f. 25 v (details). Church: view and plan.

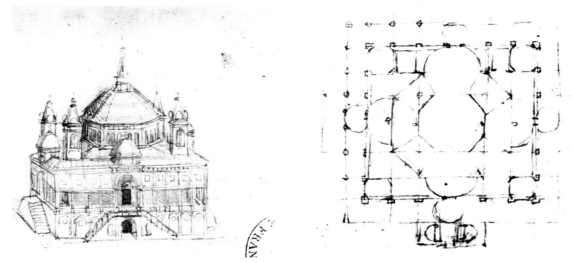

Fig. 242. Ashburnham MS. 2037, f. 4 r (details). Two-level church: view and plan.

Another plan, with an ambulatory, is related to this type (Ashburnham MS. 2037, f. 4: Fig. 242). This incomplete drawing is difficult to interpret. The regular, central octagon does not match the irregular, exterior octagon, the short sides of which could contain niches (not indicated) communicating with the satellite elements, which carry bell towers.

If we set aside the simplest form (alternating rectangular and semicircular apses), the alternating plans have almost no precedents: a few studies of classical buildings[30] and a drawing by Filarete — the plan of the temple at Plusiapolis (Cod. Magl., f. 108 r) — which Leonardo may have seen in Milan. However, it is hard to believe that such a clumsy drawing, in which the spaces are merely juxtaposed without any hierarchy, could have been a source of inspiration for him.

3. Radiating Plans with Two Axes

When the contrast between the axes is taken to its ultimate limit, all that remains are two axes, as in the cross-shaped plans. However, the drawings which we have grouped under the contradictory designation of "radiating plans with two axes" are not cross-shaped plans, because the peripheral elements are chapels, generally centralized in plan, and not arms.

(a) Alternating Chapels and Niches

This group stems directly from the alternating plans with satellite chapels. The latter disappear and the minor axes are indicated only by niches (corresponding most often to a shorter side of the octagon). The plan on Paris MS. B, folio 30 r (Fig. 243) is thus identical to the one on folio 22 r (Fig. 239), but the satellite chapels have disappeared, to be replaced, so to speak, by open niches in the

Fig. 243. Paris MS. B., f. 30 r (detail).
Radiating plan with two axes.

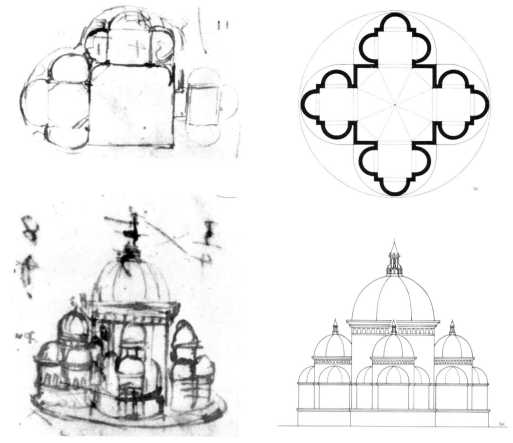

Fig. 244. CA, f. 717 r/265 v-a (details). Church: plan, elevation and suggested clarification of plan and elevation.

centre of the façades (one, framed by two columns, may act as an entrance). The two axes are shown more clearly in folios 717 r/265 v-a and 962 r/348 v-b of the Codex Atlanticus, in which the plan becomes quatrefoil on the exterior (Fig. 244). In Louvre drawing 2282 v, Leonardo seems to hesitate between this solution and a polygonal plan enlivened by niches.

(b) *Plans with Four Chapels*

In this second group, the niches disappear and only the chapels remain. Two drawings show four square or rectangular chapels joined to a central octagon (Paris MS. B, f. 21 r: Figs 245-246); two others show four circular chapels grouped around a central space which is also circular and which may contain an ambulatory (RL 19134 v and 12626 r: Fig. 247). This play of circular forms reappears on just one other, later sheet, dating from about 1505-06 (CA, f. 547 v/205 v-a: Fig. 248). This last drawing, however, is a special case because of the method of representation (which combines section and plan in perspective) and the nature of the building: the form of the dome, the proportions, and the treatment of the walls, which are enlivened by alternating niches, are reminiscent of the Pantheon, which Leonardo had just seen.[31] Rather than a church "project", this is a variation on a classical theme; however, the plan with five circles is still the one Leonardo had tested fifteen years earlier.

The radiating plans with four chapels are the simplest and least original of Leonardo's plans. No doubt this explains the fact that he was satisfied with very rough sketches (except in the last example, which is different from all the rest). The plans with square chapels may have been derived from the baptistery of San Giovanni in Laterano (although it has only two), while the plans with circular chapels may be seen in some of Francesco di Giorgio's drawings.[32]

232

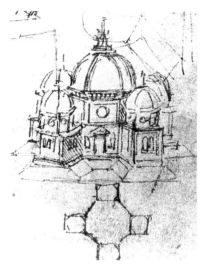
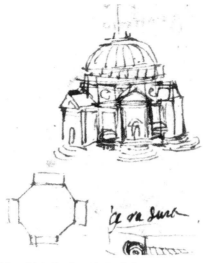
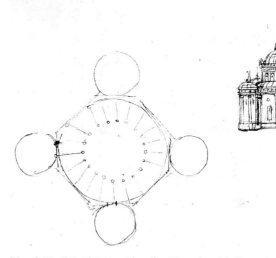

Fig. 245. Paris MS. B, f. 21 r (bottom). Church with four chapels.

Fig. 246. Paris MS. B, f. 21 r (top). Church with four chapels.

Fig. 247. RL 19134 v (detail). Church with four circular chapels.

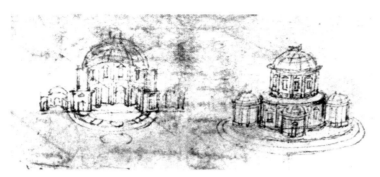

Fig. 248. CA, f. 547 v/205 v–a (detail). Building with four circular satellite spaces: section and plan, view.

4. Cross-shaped Plans with a Central Crossing

The cross-shaped plans differ from all the preceding plans, including those with the most pronounced alternation, in that they are based on another principle: the meeting of two perpendicular axes which form a square "crossing" in the centre. One of Leonardo's drawings from around 1517 (CA, f. 849 v/ 310 v–a: Fig. 249) clearly expresses the logic of this type of plan.

The cross-shaped plan had a practical advantage: by simply extending one of the axes on one side, a plan in the shape of a Latin cross would be produced. The transformation is so easy that these plans do not seem to constitute a separate group in this case. The same does not hold true for the radiating plans, in which it is very difficult to join the nave to the choir in the centralized plan, as we can see in the only drawing in which Leonardo attempted such a combination (Fig. 236).

Fig. 249. CA, f. 849 v/310 v–a (detail). Sketch of a cross-shaped plan.

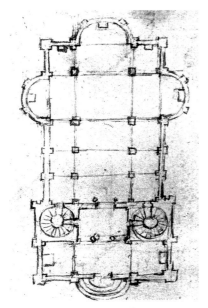

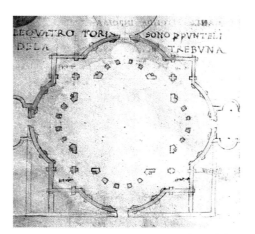

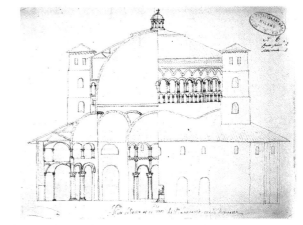

Fig. 250. Paris MS. B, f. 57 r (detail). Milan, San Sepolcro: plan drawn by Leonardo.

Fig. 251. Milan, San Lorenzo. A: Plan of the central section by Giuliano da Sangallo, (*Taccuino Senese*, f. 18 v). B: Sixteenth-century section and elevation (anonymous drawing, Milan, Castello Sforzesco).

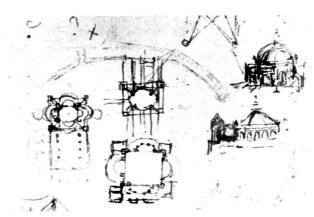

Fig. 252. CA, f. 28 r/7 v-b (detail). Variation on San Lorenzo.

Fig. 253. CA, f. 733 v/271 v-d (detail). Variation on San Lorenzo.

Leonardo showed little interest in plans in the shape of a simple Greek cross or in crosses inscribed within a square — the *quincunx* — used at that time or soon thereafter by Giuliano da Sangallo and by Mauro Coducci,[33] but was more interested in two less common types he may have seen in Milan: the inscribed cross with projecting apses and the tetraconch with ambulatories combined with a large, square, central space. In the period from 1487-1490, he drew an example, with a nave, of the first type, San Sepolcro (Paris MS. B, f. 57 r: Fig. 250), and the only example of the second type, San Lorenzo (Fig. 251), the interior of which he reproduced, with a few variations (CA, f. 28 r/7 v-b: Fig. 252).[34] The latter building so impressed him that, having been reminded of it by the sight of the new plan for St. Peter's, he drew the plan of it again in Rome, around 1514 (CA, f. 733 v/271 v-d: Fig. 253).

Leonardo used the first type several times, without alteration, for churches (Paris MS. B, f. 21 v, Ashburnham MS. 2184, f. 3 v, CA, f. 104/37 r-a, [1508]: Figs 254-255), and for chapels (Ashburnham MS. 2037, f. 5 v: Fig. 231), and he combined it with a nave in folio 119 v/42 v-c of the Codex Atlanticus (Fig. 256). However, this traditional type did not satisfy him. He therefore devised a more complex plan, apparently without precedent, in which the apses all have ambulatories (Paris MS. B, ff. 55 r and 35v; Paris MS. H³, f. 123 r [1493-1494], Fig. 257). This use of ambulatories, so seldom seen in Italy, was clearly suggested by San Lorenzo, as was the idea of the square spaces in the angles,

234

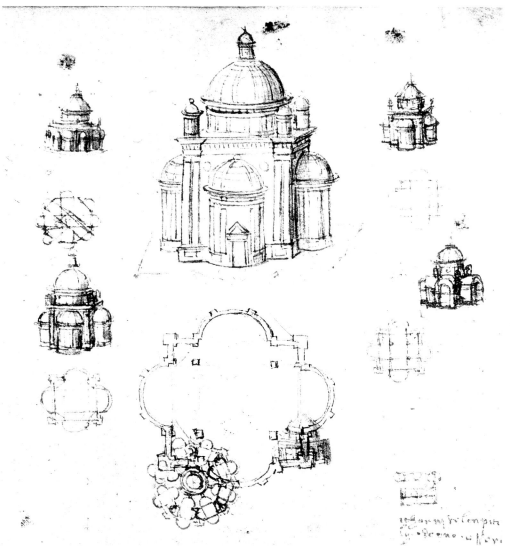

Fig. 254. Ashburnham MS. 2037, f. 3 v. Church with cross-shaped plan (and two with radiating plans).

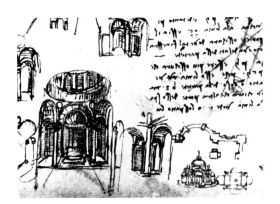

Fig. 255. CA, f. 104 r/37 r-a. Cross-shaped plan and interior views corresponding to the plan.

Fig. 256. CA, f. 119 v/42 v-c (detail). Interior elevations and plans.

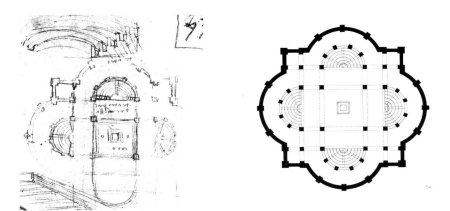

Fig. 257. Paris MS. B, f. 55 r (detail). Church with cross-shaped plan (with tiers in the apses): plan and suggested clarification.

Fig. 258. Paris MS. B, f. 57 v (detail). Cross-shaped
plan: traced by Geymüller (original: Fig. 363).

between the apses, where the bell towers are located in the Milanese church.[35] The first plan contains indications on the layout of the church: altar at the centre of the crossing, tiers of seats in the apses for members of the congregation; forgetting about the liturgical practices of his time, Leonardo imposed on the logic of the centralized plan all the interior arrangements, thus bringing the church closer to the utopian "theatre for preaching" (Paris MS. B, f. 52 r: Fig. 259). The third plan, in contrast, is a compromise. The centralized choir is joined to a fairly short nave, preceded by a vestibule similar to that in Ashburnham MS. 2037, folio 5v (Fig. 231), and the altar is moved towards the apse.

Apparently satisfied with this spatial organization, Leonardo developed it further in a drawing that is highly expressive but unfortunately not very visible (Paris MS. B, f. 57 v: Fig. 258). In it, the arms, which are longer, contain two straight bays (a solution already sketched on an arm in Paris MS. B, folio 55 r: Fig. 257), and satellite chapels (or, rather, bell towers) are planned in the angles.

5. *Cross-shaped Plans with an Octagonal Central Space*

In devising radiating plans with a strong sense of alternation, Leonardo sought to introduce certain values of the cross-shaped plan into the radiating plan. He attempted, and achieved, the opposite operation in an exceptional drawing in Paris MS. B. Here he placed, in the centre of a plan similar to the preceding one (combined with a nave), the large octagonal space characteristic of churches with radiating plans (Paris MS. B, f. 52 r: Figs 259-260). Instead of simply intersecting, the axes converge towards a much larger space; the hierarchy of the parts is more pronounced, the centrality more apparent, especially since the four satellite spaces disappear, and the bell towers now rise at the meeting of the apses. The sketch on the lower left of this sheet (Fig. 259), and two other drawings in the Codex Atlanticus (ff. 1010 r/362 r-b and 763 v/281 v-b: Fig. 261), develop the same idea (judging by the diagonal lines drawn in the angles), but these very sketchy plans are simpler and less interesting since the apses have no ambulatories.

Leonardo did not invent the cross-shaped plan with a central octagon — the plan used for the choir of Florence Cathedral — nor the irregular-octagon plan, which had already been used in the Basilica of Loreto and which has the advantage of lessening the contrasts between the arms (which have become wider) and the centre and thus allows a better articulation of the parts.[36] But he did something truly innovative in introducing ambulatories which create a masterly hierarchy of spaces and "close" the centralized plan on itself (whereas the extended arms ending in apses appear to diverge from the centre on). For the first time, in fact, the interior space grows progressively larger from the ambulatory to the centre aisles and from these aisles to the central octagon dominated by the dome.

236

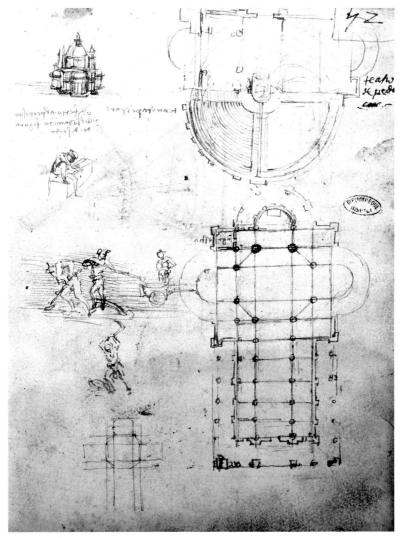

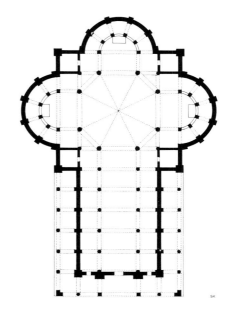

Fig. 259. Paris MS. B, f. 52 r. Church with octagonal central space. Top left: view; right: plan (Leonardo has marked off a space at the top left and written "sacristy").

Fig. 260. Clarification of the preceding plan.

Moreover, the interior space is visible from everywhere through the supports (piers and columns), a feature never found in radiating plans with chapels: the immensity of the building is perceived at the same time as the spatial dynamics that gradually make its volumes expand. There is no doubt that this arrangement was suggested by San Lorenzo, but Leonardo gave it a totally different character by lengthening the arms and creating a clearer hierarchy of the parts. The complex organization of the classical building is subjected to a wholly "Florentine" logic. This judgement, which is also Heydenreich's, may further be applied to most of Leonardo's centralized plans. Leonardo rationalized and clarified the spatial combinations he had the opportunity to observe in classical, early Christian and Byzantine buildings in northern Italy. His inventions arose out of the meeting of two architectural cultures.

Fig. 261. CA, f. 1010 r/362 r–b (detail). Cross-shaped plan.

Plans Expressed in Volumes

Leonardo's study of spatial articulations was accompanied by research on the way they were expressed in volumes. Most of the plans are therefore accompanied by bird's-eye views, which do not always correspond exactly to the plans.

Viewed from the exterior, all of Leonardo's churches are organized around a higher central element, most often a dome on a drum, surmounted by a small lantern. This hierarchized conception of volumes has its source in Florence Cathedral, where the volumes corresponding to the apsidioles, the arms of the cross and the central octagon are very clearly superimposed.

A great admirer of Brunelleschi, Leonardo generally adopted the form of his cathedral dome, without modifying it (but occasionally adding, at the base, the arcade that was planned but not built or else, less often, a capping of semicircular pediments); he also used a different form, however, never seen in central Italy during the Quattrocento: the hemispherical dome on a high circular drum, the sources of which may be Venetian (Paris MS. B., f. 18 v, Ashburnham MS. 2037, f. 3 v: Figs 238 and 254).[37] Finally, some of his plans have an eight-sided roof covering reminiscent of the Baptistery or, rather, of the usual Milanese style of tiburio (Paris MS. B, f. 39 v, Ashburnham MS. 2037, f. 4 r: Figs 240 and 242).

In any case, Leonardo was much less interested in the central element, the form of which he scarcely varied except by means of the peripheral elements. His imagination was thus brought to bear primarily on radiating plans that offered the greatest possibilities for invention.

1. *Buildings with Eight Similar Peripheral Elements*

This kind of organization necessarily goes with homogeneous radiating plans. Leonardo experimented with two solutions that each derive from unfinished works by Brunelleschi. The first consistes of clearly expressing the spatial layout in the exterior volumes: the domes on drums correspond to the chapels, the ring-shaped roof coverings to the ambulatories, and the semi-domes to the apsidioles (Paris MS. B, ff. 25 v and 56 v: Figs 228 and 262). In this system, planned by Brunelleschi for Santo Spirito (Fig. 234) (but not built, as the apsidioles that run all around the church were hidden behind a wall), the walls do not have any reality of their own; they simply serve to enclose the spaces.

Applied systematicaly to a polygonal building, this principle leads to a monotonous repetitio of many small volumes. Leonardo therefore looked for another solution, in which the radiating chapels are "absorbed" in a single, ring-shaped volume covered with a terrace,[38] over which the domes loom

Fig. 262. Paris MS. B, f. 56 v (detail).
Church with twelve apses.

(Paris MS. B, f. 21 v and Ashburnham MS. 2037, f. 5 v: Figs 230-231). In this case, Leonardo again drew his inspiration from Brunelleschi, who had designed a polygonal structure including the chapels in his scheme for Santa Maria degli Angeli. We have already pointed out the importance of Brunelleschi's idea in the origin of the plan with radiating chapels (Fig. 235). However, Leonardo did not confine himself to variations on this model. In the first drawing, he arranged a hemispherical dome on each drum above each chapel, so that the volumes above the flat roof are as individualized as in the preceding scheme. In the second drawing, he softened the contrasts: at the lower level, which is now circular (in the view, but not in the plan), the play of volumes is complicated as a result of the projection of the apsidioles, while at the upper level, the domes (which are much wider than the central crossing of the chapels and have a huge lantern) are lower. But this relative unobtrusiveness must not have pleased Leonardo, as he immediately added a drum (on the left).[39] The individualization of the chapels by means of eight highly visible domes thus remains his main concern, and is what basically sets him apart from Brunelleschi and all his Florentine predecessors.

2. *Buildings with Eight Contrasting Peripheral Elements*

An examination of the preceding drawings helps us to understand the major problem Leonardo was continually striving to solve: how to reconcile his liking for individualized volumes with a unified, hierarchized building conception inherited from Brunelleschi.

Leonardo thought he could overcome the difficulty by devising a novel system in which the peripheral elements are arranged alternately around and over a volume in the form of a parallelepiped (Fig. 239). Such a system implies that the peripheral elements are themselves different in nature. It therefore applies only to alternating plans, and to some cross-shaped plans, confirming the distinction made earlier between homogeneous and alternating radiating plans.

The idea may have appeared, however, during his study of a homogeneous radiating plan, as the two systems are shown together on Paris MS. B, folio 17 v (Fig. 227). On the upper level, the eight circular chapels are individualized by domes on drums, all of them similar, as in the previous examples; on the lower level, however, four chapels, which have become angle chapels, have been absorbed into a parallelepipedal volume, with the other four now appearing only as apses. A notation (which clearly confirms the theoretical nature of the drawing) explains that this building could be constructed "as it is [shown] above the line *a b c d*", which would actually be more logical with this type of plan.

Leonardo adopted the system of the "central parallelepiped" in most of his alternating radiating plans.[40] In the simplest plans, the horizontal projection of the apses contrasts with the vertical projection of the domes around the central dome (Paris MS. B, ff. 22 r and 24 r: Figs 239 and 236). Using this basic premise, Leonardo devised other combinations. He introduced barrel-vaulted roof coverings that could correspond to the arms of a cross-shaped plan if these "arms" were not almost closed chapels (the plan is admittedly very sketchy) (Paris MS. B, f. 17 v: Fig. 237). In another view, which does not correspond to the plan, he abandons the semicircular volume indicated on the plan and expresses, on the exterior, all the volumes of the chapels (Paris MS. B, f. 18 v: Fig. 238). He also raises the domes of these chapels above the terrace level, thus affirming the autonomy of the chapels in relation to the central body. Finally, he gives extraordinary life to the base diagram by replacing the angle domes with circular bell towers projecting over the angle (Paris MS. B, ff. 25 v and 39 v: Figs 241 and 240), arrangements clearly inspired by the four towers of San Lorenzo in Milan.

3. Buildings with Four Peripheral Elements

Radiating plans with two axes do not allow as wide a variety of combinations of volume as the preceding plans, but they still offer the possibility of emphasizing or toning down the contrasts, as we can see on a sheet in Paris MS. B in which Leonardo uses the same plan as a basis for two different organizations. In the first drawing, the chapels are closely connected at the centre by their extended roofs which converge towards the centre; in the second, they are invididualized by domes and constitute satellite volumes (Paris MS. B, f. 21 r: Figs 245-246).

The second possibility, we presume, was the one Leonardo preferred. It gave the greatest autonomy to the chapels, which appear clearly separate from the central element (CA, f. 717 r/265 v-a: Fig. 244) and are even autonomous when the plan is circular (RL 19134 v and CA, f. 547 v/205 v-a [*c.* 1505-1506]: Figs 247-248]. In the first drawing, the interplay becomes highly complex as the four chapels are themselves made up of three apses grouped around a central element, following an arrangement already used in Paris MS. B, folio 18 v (Fig. 238). This plan, in fact, differs from the preceding type only in the width of the chapels, which totally surround the central element.

4. Treatment of Cross-shaped Plans

The expression in volumes of cross-shaped plans was of much less interest to Leonardo, because a system based on the intersection of two axes does not, in theory, allow autonomous peripheral elements to be introduced (unless he adopted an arrangement using five domes similar to that of San Marco in Venice, but Leonardo never considered such a solution because it does not allow the central volume to be emphasized). Three drawings show a very simple, thoroughly "Tuscan" layout, in which the arms clearly contrast with the central volume, without peripheral elements (Ashburnham MS. 2037, f. 3 v: Fig. 254, centre right; CA, f. 1010 r/362 r-b: Fig. 261; and CA, f. 1060 Ar/382 r-a, dated 1510-1515).

However, the plan that uses four supports, which Leonardo preferred, allows some play of volumes as it contains secondary spaces in the angles. Leonardo consequently applied to this type the "central-parallelepiped" system used in the alternating radiating plans.[41] Since the square bays located in the angles are narrower and lower than the chapels in the alternating plans, the domes on drums become purely decorative elements placed on the terrace, with no connection to the interior, following

Fig. 263. Paris MS. B, f. 25 r (detail). Church with cross-shaped plan.

Fig. 264. Venice, Treasury of
St. Mark's: incense-burner.

an arrangement already tested in other forms at the Portinari Chapel (Ashburnham MS. 2037, f. 3 v,
Paris MS. B, f. 25 r: Figs 254 and 263).[42]

Unfortunately, no view corresponds to the cross-shaped plans with ambulatories devised by
Leonardo, in which the play of volumes would have been more complex. The cross-shaped plan with
a central octagon, however, is accompanied by a rough sketch in which we can clearly make out the
central parallelepiped and the apses (but not the ambulatories) as well as four bell towers located in the
angles (Paris MS. B, f. 52 r: Fig. 259). The play of volumes is much more successful than in the two
projects with bell towers looked at earlier: the towers no longer project and consequently are better
integrated into the central volume and, at the same time, their very slender form contrasts more clearly
with the dome. This latter feature distinguishes the building from San Lorenzo, the towers of which
are more massive, and brings it closer to the apse of the church of Sant'Antonio in Padua, and to
Filarete's church drawings, which were probably inspired by it.

The drawing we have just examined sums up reasonably well what Leonardo was always seeking
to achieve: unity, provided by the preeminence of the central dome, and variety, produced by the
individualization of the peripheral elements. The first characteristic is easily explained by Leonardo's
Florentine origins, but the second has sources that are less obvious, as groups of domes are found only
in the Veneto and the Byzantine world. Nothing could be closer to his churches with alternating
radiating plans than the *chiesola* of the treasury of San Marco (Fig. 264)! Leonardo's liking for lively
volumes, which is apparent in his civil-architecture drawings, could no doubt account for these
inventions, but it is more plausible to assume that he travelled to Padua and Venice during his years in
Milan.[43] A "Venetian-Byzantine" experience, combined with his Florentine background and his
interest in early Christian Lombard architecture, would offer a fairly good explanation for the
singularity of his churches with "hierarchized groups of domes", which are different from anything
seen in Florence, Milan, or Venice.

Elevations

Interested above all in spatial combinations and the resulting plays of volumes, Leonardo did not pay the same attention to the treatment of elevations, especially since the scale of his drawings hardly allowed him to go into detail. Only on exceptional occasions did he pose the problem of the entrance façade, one that was always difficult to solve in a centralized church,[44] and he did not draw any façades to correspond to his nave plans. Nevertheless, his elevations are worthy of closer examination than has been given them so far, because they sometimes show highly original arrangements.

Exterior Elevations

Leonardo used organizations with pilasters most of the time (and always in composition with a "central parallelepiped"), as well as a few arrangements with columns in homogeneous radiating plans.

If we exclude, as always, the curious scheme for a church on two levels and with an exterior portico which has a façade with three superimposed orders (Fig. 242), the arrangements using pilasters generally comprise a major order corresponding to the central volume, and a minor order for the apses, with both resting on the same stylobate which goes all around the building. Leonardo seems to have been very attached to this latter arrangement (used by Bramante in Santa Maria presso San Satiro and in the apse at Pavia Cathedral), as he used it in all his designs, whatever the type of plan.

Once or twice, he tried to intersect the two orders, as Alberti was able to do in the façade of Sant'Andrea in Mantua, but he does not appear to have understood the logic of this arrangement: in the only drawing in which the organization is clearly visible, he juxtaposes a major order and two superimposed minor orders, instead of contrasting a major order with one minor order with a different function (Paris MS. B, f. 24 r: Fig. 236).[45] Conversely, he did not think of extending the entablature of the minor order in the most monumental composition he ever drew, in which the large pilasters are separated by niches and oculi which would "call for" a horizontal moulding between them (Paris MS. B, f. 25 r: Fig. 263). Another, more successful attempt consisted of using a minor order exclusively and superimposing an attic order on it, over the central volume (Paris MS. B, ff. 17 v and 18 v: Figs 237 and 238). The introduction of an attic, which seems to be something new, allows a more unified composition, with the attic responding to the stylobate of the bottom part.

The problem of façade treatment does not occur in the same terms in the churches with eight similar peripheral elements, in which the exterior appearance is determined primarily by the play of

Fig. 265. Reconstruction of Palladian windows
indicated on the plans shown in Figs 225-226.

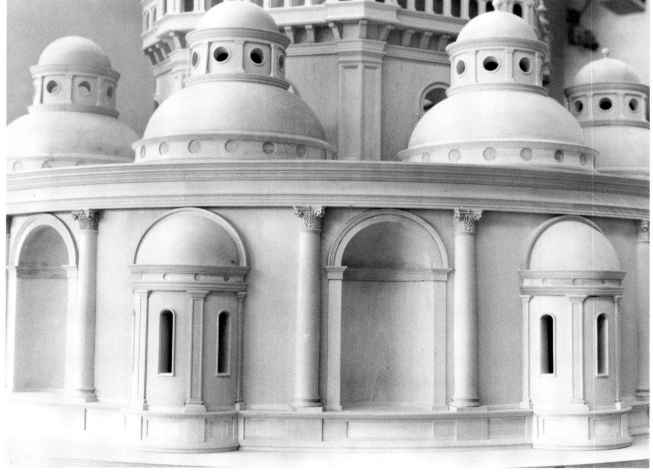

Fig. 266. Detail of the exterior elevation of the church reproduced in Fig. 231, after the reconstruction model.

volumes: projecting apsidioles or niches hollowed out of the thickness of the walls. The drawings belonging to this group thus give us little information on the role assigned to the orders, with the exception of three of them, in which Leonardo seems to have been interested — exceptionally — in the use of the column in a façade.

Two plans with eight and twelve apses (Paris MS. B, f. 56 v: Figs 225-226) contain, on each side, recesses filled by four small, unevenly spaced columns. It is not difficult to imagine the motif used: a Serlian window, the central part of which corresponds to the semicircular niche. Leonardo's originality lies in his use of this motif, usually left "open", as a wall ornament (Fig. 265).[46]

In another, more remarkable plan, made into a model for the present exhibition, large, engaged columns on a stylobate give rhythm to the alternation of niches and apses (Ashburnham MS. 2037, f. 5 v: Figs 231 and 266). The strong contrast of these two volumes is no doubt the reason Leonardo used a column which, in turn, forms a significant projection from the entablature. The power of this motif is exceptional in Leonardo, and without any equivalent in the architecture of the day, apart from a few Roman buildings and the loggia at Brescia.[47]

Interior Elevations

Leonardo's drawings of church interiors are few in number, show little variety, and generally bear no relation to the plans and views studied above.

We will immediately eliminate Codex Atlanticus folio 547 v/205 v-a (Fig. 248), drawn around 1505, which seems to be a variation on classical themes. The ordinariness of the interior organization (arcades opening onto niches, surmounted by windows capped by pediments) gives the impression

Fig. 267. RL 12609 v. Church interior: cross-shaped plan.

Fig. 268. Ashburnham MS. 2037, f. 4 r (detail). Section of a chapel with a cross-shaped plan with tribunes.

Fig. 269. Paris MS. B, f. 21 v (detail). View of the central space of a church with a radiating plan.

that Leonardo was more interested in the play of volumes and the representational technique, which was new for him, than in the interior elevation.

All the other drawings are of cross-shaped churches with four piers, sometimes combined with a nave. Some are simple variations on San Satiro (CA, f. 104 r/37 r-a [1508]: Fig. 255). Others (CA, f. 119 v/42 v-c and RL 12609 v: Figs 256 and 267), done during the same period as Paris MS. B, show two-level elevations — those of San Sepolcro perhaps? The double arcades that run around the entire church may correspond to tribunes in the nave, or constitute a purely ornamental motif in the apses, which seem to have no ambulatories.

The only drawing — a very rough, even clumsy one — from the original Paris MS. B that shows the whole of an interior (which is not that of the church just above it, contrary to what is written below it)[48] is much more interesting (Ashburnham MS. 2037, f. 4 r: Fig. 268). In our opinion, it represents a cross-shaped building with four piers, of the San Satiro type, with a ring-shaped tribune on the second level. A dome, which could have a frame structure and is much larger than the dome corresponding to the central space, covers the whole building. This structure using a tribune, which is different from the one used by Bramante in the sacristy of Santa Maria presso San Satiro, is highly original and corresponds (except for the large exterior dome) to the one we have reconstructed over the chapels from Ashburnham MS. 2037, folio 5 v (Fig. 232, on the left).[49]

The radiating plans, which are by far the most numerous, are never accompanied by an interior elevation, the sole exception being a difficult-to-read sketch representing two arcades in the angle of an octagon, at the top of Paris MS. B, folio 21 v (Fig. 269). This omission on Leonardo's part has led some scholars to believe that he was concerned exclusively with abstract spatial combinations and did not care about the religious function of his buildings and the decorum this implies.[50] The reality, in our opinion, is not so simple, since there are several church plans of the same type (homogeneous radiating) that reveal a very fine, original interior disposition (Paris MS. B, ff. 18 r and 21 v; Ashburnham MS. 2037, f. 5 v; CA, f. 1010 v/362 v-b: Figs 227, 230, 231 and 229).

In these plans, Leonardo juxtaposes two systems of orders: bent pilasters (probably on pilaster strips, considering their projection) in the angles of the octagon, and attached columns, which project even further, framing the entrances to the chapels. The bent pilasters, used in the sacristy of Santa Maria presso San Satiro and (on pilaster strips) on the piers of Pavia Cathedral, are not surprising.

244

Fig. 270. Interior elevation at the first level of the church reproduced in Fig. 231, after the reconstruction model.

Leonardo must have appreciated this angle solution, because he replaced Brunelleschi's double pilasters with bent pilasters in his variation on Santa Maria degli Angeli (Fig. 235). The columns, on the other hand, pose a problem of interpretation, as no comparable organization is found in church interiors of the late Quattrocento. In fact, when the front arch of the vault of a chapel is carried by two columns, these are always built against the walls that carry that vault and not the perpendicular wall of the centre nave, so that the archivolt of the arch alone projects (Masaccio's *Trinity* offers the first example of this classic arrangement). In Leonardo's four churches, on the other hand, the columns, built against the wall of the central octagon, carry a strongly projecting arch, which can be guessed at from the sketch on Paris MS. B, folio 21 v (Fig. 269): the barrel vault covering the chapel entrance (or one of the arms when the chapel is cross-shaped) thus penetrates within the central space.[51]

The design of attached columns carrying an arch appears as a door-framing motif in Venice, in the church of Sant'Elena (Cappello monument, 1467) and the Scuola di San Marco (around 1487), and then in Milan at the entrance to Santa Maria delle Grazie (just being completed in 1489). As Leonardo's drawings are from exactly the same period, we do not know whether he introduced the motif into Milanese architecture, but he definitely used it at a new location and transformed it by eliminating the tympanum and opening up the arcade. The model in which we have reconstructed this organization demonstrates the interest offered by this arrangement (Fig. 270): the vault and columns of the chapel are already present in the central octagon; the peripheral spaces that, in plan, constitute autonomous units, are actually connected to the principal space. The eight "doors" make the logic of the radiating plan clear; they announce what follows, draw one in towards other spaces.

245

Fig. 271. Venice, Accademia. Façade of a nave church.

A Church Façade

Leonardo took an interest in façades for nave churches only at the end of his life. Paris MS. B does not contain any drawing of this type; its nave churches are always seen from the apse. The façade Leonardo painted in 1481 in the background of his *St. Jerome* is very ordinary (See Fig. 188). The one sketched around 1510 on folio 641 r/235 v-a of the Codex Atlanticus could be more interesting, since it foreshadows, with its giant order, the façade of Peruzzi's Sagra at Carpi, but it is very sketchy. The only one we can really judge dates from about 1515 (Venice, Accademia: Fig. 271).[52]

This façade is completely different from the projects for San Lorenzo in Florence, which date from the same period and are all more developed widthwise and thus more "horizontal" (although Michelangelo attempted to give a certain amount of verticality to the central element). Leonardo, on the other hand, was able to create, using very simple means, a dynamic composition in which all the parts are closely linked. He achieved this horizontally through a rapid succession of alternately wide and narrow bays (a solution already sketched out in 1508 in a château façade: Fig. 327), and vertically by means of the projections of the first entablature over the central pilasters. In the liveliness of the rhythms and the vertical thrust of the centre section, this drawing resembles the façade of San Spirito in Sassia (in which the pilasters are still spaced regularly) and, most of all, the façade of the Gesù, in which the same dynamism can be seen, with obviously more pronounced projection. However, this premonitory drawing probably did not play any role in the development of church façades in Rome in the mid-sixteenth century, any more than the enclosed pediments drawn in the same years (Fig. 283) were an inspiration to Michelangelo.

Leonardo and Renaissance Religious Architecture

Since the Venice drawing constitutes a separate case, we must return to the "models" offered in Paris MS. B to assess the role played by Leonardo in the history of Renaissance religious architecture.

The radiating plans, which are the most numerous, most varied, most original in plan and in their volumes, and the only ones to show a totally new kind of interior elevation, had almost no influence.

246

The only church in the area of Milan in which we see an echo of Leonardo's ideas is Santa Maria della Croce in Crema (Fig. 272), in which Battaggio took up the idea of the circular plan with four chapels (the simplest of all the arrangements devised by Leonardo) without, however, following his model through to the end, as the interior is octagonal and the chapels are cruciform.[53] Nevertheless, the lively play of the domes (reconstructed) over the chapels and their relationship to the large, central volume are reminiscent of the combinations of volumes sketched in Paris MS. B, folios 18 v and 21 r, and Codex Atlanticus folio 717 r/265 v-a (Figs 238, 246 and 244). Leonardo's imagination partially inspired this creation, which is exceptional in an area where centralized-plan churches, so numerous in the latter part of the century, all derived from Bramante's sacristy at Santa Maria presso San Satiro.[54]

Fig. 272. Crema, Santa Maria della Croce.

Cross-shaped plans were of greater importance, and many of the arrangements studied in Paris MS. B, folio 52 r (Fig. 259) are to be found in the plan of Pavia Cathedral, which was designed between 1487 and 1490 with the probable participation of Bramante and the possible participation of Leonardo.[55] The relationships of the short and long sides of the central octagon are approximately those indicated in the drawing; the sacristies with apsidioles housed in the angles have apparent octagonal domes without precedent in Milanese architecture (and occupy the same position as the square sacristy shown in the plan); and finally and most importantly, the church demonstrates the effect of transparency and spatial expansion sought by Leonardo. However, the most original part of Leonardo's drawing — the ambulatories around the ends of the arms — does not reappear in Pavia. The centre and side aisles terminate at walls in which smaller apses open up.[56] It is therefore impossible to see the "source" of the Pavia plan in Paris MS. B, folio 52 r; what this is rather (as Heydenreich clearly understood) is a plan freely conceived by Leonardo in the course of his reflections on the centralized plan, at a time when he and Bramante must often have discussed the grandiose project for the cathedral of Pavia conceived by Cardinal Ascanio Sforza, the Duke's brother.[57]

The problem of the connections between Bramante's designs for St. Peter's and Leonardo's cross-shaped plans presents itself in different terms which are in one sense clearer. It is a question of knowing to what extent the solutions studied in Paris MS. B may have inspired Bramante's creation. Heydenreich placed a great deal of emphasis on this point[58] and saw in the sketch in Paris MS. B,

folio 57 v (Fig. 258), in particular, an "anticipation" of the plans for St. Peter's conceived in 1505–06 (see Uffizi A 1 and chiefly A 20 in which can be found the ambulatories inspired by San Lorenzo which constitute the most original aspect of Leonardo's cruciform plans). Bramante's designs, in fact, were produced shortly after Leonardo's first visit to Rome in 1505[59] — just as the great plan with ambulatories created for Leo X and the design for a dome with a circular colonnade, similar to a design for the tiburio (Fig. 216), were completed after Leonardo's second visit, when he made drawings both of the old San Lorenzo and the new St. Peter's (CA, ff. 733 v/271 v-d and 429 r/159 r-c: Figs 253 and 273).

Despite all this, the 1505-1506 plans present particular arrangements that we never see in Leonardo's drawings. Bramante considerably increased the difference between the short and long sides of the central octagon (1 to 3 instead of 1 to 1.4) in order to replace the eight traditional supports with four huge piers, triangular in plan, with large niches carved out of them, a massive solution which is truly Roman in spirit but which was foreshadowed by the thick walls hollowed out with niches and apses in Leonardo's plans with radiating chapels (in particular, Paris MS. B, f. 22 r: Fig. 239).[60] Further-more, the chapels housed in the angles, between the arms of the cross, themselves have centralized plans, whereas Leonardo's cross-shaped plans always provide only for square spaces at this location. On this point, Bramante's plan is much closer to the radiating plans with alternating apses (which became arms) and chapels (now opening onto the arms instead of converging towards the centre).

Bramante's project thus does not reproduce the arrangements studied fifteen years earlier by Leonardo, but it follows the same logic. In 1505 as in 1490, the idea was to create a spatial system organized in a hierarchy and in continuous "expansion" in which very different parts are brought together in a unified whole. There is no doubt that the systematic research carried out in Milan by Leonardo — in probable contact with Bramante — enabled Bramante to come to grips with the problem of St. Peter's and to create a new type of plan.

The role played by Leonardo in the history of Renaissance religious architecture therefore seems fairly limited, in the final analysis. It was very slight in the area of Milan and in central Italy (where the church of Santa Maria della Consolazione at Todi, no matter what anyone says, has no relation to Leonardo's drawings),[61] and difficult to define in Rome, as a result of Bramante and Leonardo's "shared past".[62] This situation, which is paradoxical if we consider the extraordinary variety of solutions proposed in Paris MS. B, is explained by the fact that Leonardo was mainly interested in radiating plans with individualized chapels and complex groupings of domes.[63] The kind of architecture he advocated has a surprising, lively, colourful character that must have confounded his contemporaries and seemed positively old-fashioned when the taste for spatial unity and "grand forms" asserted itself. Although, in some of his few cross-shaped plans, he foreshadowed the future plan of St. Peter's, he generally created buildings on the fringe of the "normal" development of Italian art. His wonderful drawings, like those of Peruzzi thirty years later,[64] prove that at all times the range of what is possible is much greater than we think, and that a different Renaissance architecture might have arisen had Rome not suddenly become the new artistic centre of Italy.

Fig. 273. CA, f. 429 r/
159 r-c (detail). Schematic
plan of St. Peter's.

Civil Architecture

Leonardo's drawings of civil architecture do not form a coherent whole as his church drawings do. They date from all periods in his life, although a majority come after 1500, and they often deal with specific projects for which he was consulted. Most of them are plans, often rather sketchy. Some represent architectural motifs, and a few show façades or an entire building. The bird's-eye views which Leonardo systematically used for his centrally planned churches become the exception to the rule: this proves that Leonardo used that representational technique in connection with a specific project for a treatise.

These drawings are therefore more dispersed, harder to read and of varying interest. For these reasons, they have long been neglected, except for the urban-planning studies in Paris Manuscript B and all the "extraordinary" projects. Thanks to Heydenreich, who identified the drawings for Romorantin, and especially to Carlo Pedretti, who has concentrated on this aspect of Leonardo's work, we can now understand them more clearly, follow Leonardo's activity from year to year, and identify the themes to which he devoted special attention.[65]

Leonardo's "style"

The drawings of architectural motifs and façades give us an insight into the "language" used by Leonardo from 1490 to 1519 and answer a fundamental question, namely: did he contribute significantly to the stylistic change that took place in Rome in the early sixteenth century? As we have seen, Leonardo's drawings of centrally planned churches, from 1487 to 1490, have a style very close to that of Bramante. Some are distinguished, however, by the use of the attached column supporting a strongly projecting arch (Fig. 270). This graceful motif, clearly detached from the wall and undoubtedly inspired by Venetian architecture, is original, but it does not herald the art of the High Renaissance. The arrangement of columns in a central arcade, which was used in 1497 in a design for a villa (Paris MS. I, f. 56 r: Fig. 317), has been interpreted as prefiguring the garden façade on the Palazzo del Te in Mantua and sixteenth-century loggias featuring Serlian windows, but the sketchy nature of the drawing does not allow us to judge how the orders would have been used in it: typological novelty does not imply innovation in the means of expression.

Actually, the first instances of orders used by Leonardo in the "Roman" spirit date from 1506-1507, and we believe they are explained by a direct knowledge of Bramante's work. The axonometric section drawn on the cover of the Codex on the Flight of Birds (Fig. 274) does not really represent pairs of columns embedded in a wall, as was thought by Heydenreich and all commentators after him, but pairs of columns arranged on either side of a projecting balcony which is much thinner than the wall. Far from foreshadowing the organization of the Laurentian Library, this drawing reflects that of Bramante's Palazzo Caprini or "House of Raphael". To read it, we simply have to compare it with an axonometry of the first floor of the palace (Fig. 275).[66] The early date of the Palazzo Caprini and the hypothesis of a trip by Leonardo to Rome in 1505 are thereby also confirmed.[67]

Leonardo does not reproduce his model exactly: the balconies have a solid parapet, and the engaged columns set on pedestals become attached columns the entire height of the storey, although

Fig. 274. Codex on the Flight of Birds, cover. Palace façades (detail of Pl. XX).

Fig. 275. Rome, Palazzo Caprini, first floor: view (London R.I.B.A.) and axonometric view (drawing K. De Jonge).

Fig. 276. CA, f. 885 r/322 r-b (detail). Palace façade.

they are paradoxically thinner (an "error" corrected in the view at the top left). This latter alternative is clearly the more important one: it shows that Leonardo was highly sensitive to the plasticity of the façade and sought to give even greater emphasis to its relief. In the top sketch, rhythm is added to the ground floor by wide projections below the columns, a solution also applied in two other variations for the Palazzo Caprini (CA, f. 885 r/322 r–b and Arundel MS., f. 160 v: Fig. 276) dating from exactly the same period, but even more like the original model since the columns rest on pedestals. Leonardo was thus not interested in the rustications of the palace, which never appear in his drawings, but in the first-floor orders, the structural value of which he expressed very successfully.

Leonardo appreciated other inventions by Bramante, such as the Tempietto, which he imitated in 1508–1510 in a design for the Trivulzio monument and a drawing of a mausoleum (RL 12353 and Louvre 2386: Fig. 277 and Pl. XIX), and the alternating bay of the upper Belvedere Court, the outline

Fig. 277. RL 12353 (left).
Plan for the Trivulzio monument.

Fig. 278. CA, f. 316 r/114 r–b (detail).
Alternating bay.

Fig. 279. CA, f. 583 r/217 v–b (detail). Octagonal palace
(elevations, schematic plan) and suggested reconstructions:
elevation (J. Guillaume/S. Kühbacher) and plan (C. Pedretti).

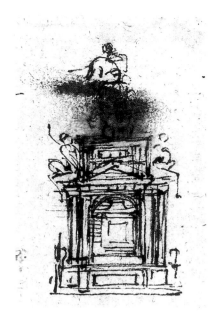

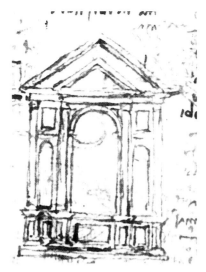

Fig. 280. RL 12353 (right).
Project for the Trivulzio monument.

Fig. 281. CA, f. 104 r/37 r-a (detail).
Arch with central projection.

Fig. 282. CA, f. 316 r/114 r-b (detail).
Alternating bay with central projection.

of which he reproduced in a drawing dating from his second visit to Rome (CA, f. 316 r/114 r-b: Fig. 278)[68] Finally, the organization using a giant order on a ground-floor base planned for the towers of the Palazzo dei Tribunali was applied by him to the façades of an octagonal palace in a drawing from 1517 (CA, f. 583 r/217 v-b: Fig. 279).[69] In the last example, the relationship is even more certain since the giant order is used exclusively on the angles of the façade, as it would have been for the Palazzo towers. However, Leonardo gives his own interpretation to Bramante's idea and, for the first time, makes the giant order surmounted by an entablature the principal motif of the façade (whereas the play of volumes remains of prime importance in the Rome building). This general arrangement was seen again soon afterwards in the long façade for Villa Madama, but Raphael's design, done around the same time as Leonardo's drawing, cannot explain it.[70]

Other drawings also prove that Leonardo was able to create new forms using classical vocabulary. In one of the designs for the Trivulzio monument, next to the variation on the Tempietto mentioned earlier (RL 12353: Fig. 280), he devised a kind of triumphal arch with a projecting central bay, surmounted by a pediment, which seems to be a variation on the Arco dei Gavi in Verona, of which he apparently reproduced the central section and modified the side parts, which he then rejected in the second plan.[71] This arch is original in that the central projection, frequently seen in Venice, had until then been used with a minor order (in which the columns rise as far as the level of the imposts). Leonardo must have liked these "Venetian" arches, which were unknown in central Italy, because he drew two of them on a sheet also dated 1508 (CA, f. 104 r/37 r-a: Fig. 281); however, he introduces an innovation in the Trivulzio design in applying the central projection to a "triumphal" composition with a major order (in which the columns rise up to the entablature above the arch). This arrangement, rarely imitated, fulfilled a need to give vitality to compositions using orders, which are also found in the altar for the Annunziata in Florence as early as 1500, and on folio 316 r/114 r-b of the Codex Atlanticus (Fig. 282) in about 1515. In both cases, the central columns, carrying a projection from the entablature, contrast with the side pilasters. The attribution of the altarpiece to Leonardo, based solely on later testimony, is consequently justified on stylistic grounds.[72]

One of Leonardo's most remarkable creations, which we have attempted to execute for this exhibition in its natural size, dates from 1515-1516. It is a portal framed by attached columns supporting a segmental pediment which is in turn surmounted by another, triangular pediment that is supported by corbels and therefore projects much less (CA, f. 757 v/279 v-a: Figs 283-284).[73] This

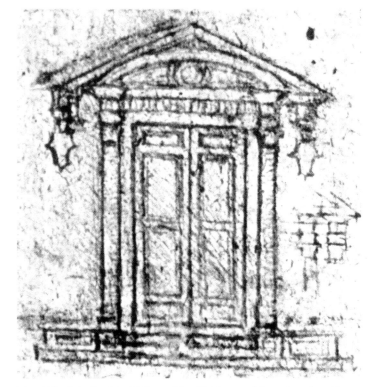

Fig. 283. CA, f. 757 v/279 v–a (detail). Door with enclosed pediments.

Fig. 284. Suggested reconstruction of the preceding drawing (J. Guillaume/S. Kühbacher).

Fig. 285. CA, f. 505 v/184 v–c (detail).
Elevation with arcades.

Fig. 286. RL 12579 v (detail). Palace façade.

Fig. 287. CA, f. 865 r/315 r–b (detail). Bottom, left and right: tree-columns; top centre: baluster-columns;
top right: project for the transformation of the centre of Florence.

Fig. 288 (detail). Codex on the Flight of Birds, cover. Palace façade (detail of Pl. XX).

Fig. 289. Cremona, Palazzo Raimondi.

motif "follows" from the organizations with a central projection, since placing a pediment on each pair of supports, if these are close enough together, is sufficient to obtain both the enclosure and the projection. Leonardo appears to have understood that the consoles and the cut-out shields, "Milanese" in spirit, were too light to carry a pediment, for he proposes, on the right, replacing them with corbels in the form of capitals (supported by pilasters?). Apart from this detail, the composition has great plastic force. It foreshadows the inside door of the Laurentian Library, but this does not mean it was the source for it. In any case, it is certain that Leonardo was the first to design the motif of narrowly enclosed pediments, to which Michelangelo gave such extraordinary power soon afterward.

The three creations we have just looked at — the façade using a giant order, the triumphal arch with a central projection, and the enclosed pediments — to which the 1515 church façade (Fig. 271) should be added, nevertheless do not suffice to rank Leonardo among the masters of the new style, since these drawings are found next to others, just as numerous, that reveal entirely different preferences.

The biforous windows and the arrangements with double arcades on a large arcade, sketched in 1515-1516 in Codex Atlanticus folios 762 v/281 v-a and 505 v/184 v-c (Fig. 285), testify to an attachment to the forms used in Milan and Venice in the late Quattrocento. The bay of a palace façade drawn around 1513 (RL 12579 v: Fig. 286) could belong to a palace in Pavia, especially since the mouldings shown on the left resemble those used in the apse of Pavia Cathedral.[74] The columns in the form of tree trunks dating from about 1515 (CA, f. 865 r/315 r-b: Fig. 287) are reminiscent of those of the Canonica of Sant'Ambrogio, and the baluster-columns drawn on the same sheet recall those of the tiburio of Santa Maria delle Grazie, and of Fra Giocondo's edition of Vitruvius.[75] The alternating bay which Leonardo borrows from the Belvedere (Fig. 278) itself undergoes a significant transformation: the proportions are more slender, the arcade is occupied by a biforous window surmounted by an oculus, and the lightened entablature carries a balustrade decorated with knobs. The Roman motif loses its massiveness and becomes transparent, thus taking on an almost Venetian character.

255

Fig. 290. CA, f. 374 v/136 v-b (detail). Split entablature.

It consequently is less evocative of the Belvedere than the Loggetta, in which Sansovino made the same kind of transposition twenty years later.

Finally (and what is most interesting), the only palace façade which Leonardo drew in detail — besides the variations on the Palazzo Caprini — owes nothing to Bramante (Fig. 288 and Pl. XX). In this scheme, designed in 1506-1507 in Milan for Charles d'Amboise, four well-spaced pairs of pilasters divide the façade into three compartments, in which the windows, the door and a large loggia surmounted by an attic with a pediment are placed. If we leave out the capping, which is the most original part of the design, this façade is reminiscent of those of northern Italian palaces, which are enlivened by a lightweight grid of pilasters and entablatures (Fig. 289). More specifically, because of the loggia, it recalls early sixteenth-century Venetian façades.[76] Since the drawing on the right is undoubtedly the first, as always, we can thus reconstruct the origin of this sheet. Wishing to give shape to an original idea — a palace façade with loggia and pediment — Leonardo first used the architectural vocabulary of northern Italy. He then attempted to lend a Roman character to the façade, and drew the system used in the Palazzo Caprini, in a axonometric projection and emphasizing its relief, and repeated it, at the top left, on two levels. However, the adaptation proved impossible, because the loose articulation of the first façade could not be transposed into the forceful language used by Bramante.

Hence Leonardo's "style" is not homogeneous. While he was attached to the forms of the late Quattrocento, which constituted his "natural" means of expression, so to speak, after 1505 he occasionally used Bramante's language and even created, during his second stay in Rome or a little later, original compositions in the Roman spirit. In this sense, there is a real evolution in Leonardo's manner, but this does not imply a conversion to the new style. Leonardo continued to use the Lombard-Venetian vocabulary and no longer paid attention to antique forms. His few studies from antiquity do not concern orders (Pl. XIX), and his very rough theoretical drawings of bases or capitals are quite ordinary.[77] This indifference to what was becoming the "system of orders" fundamentally sets Leonardo apart from Bramante and Raphael and explains, for example, the fact that he did not hesitate to draw an entablature split by an arch, between 1506 and 1508 (CA, f. 374 v/136 v-b: Fig. 290).[78] We can therefore guess that he felt no aversion for the forms of the early French Renaissance, which he was also not above noting (CA, f. 583 r/217 v-b: Fig. 335).

These contradictory attitudes are more easily understood if we realize that Leonardo took only limited, or rather occasional, interest in what we call architectural "style", whereas he was able to transform, with just a few works, the entire language of painting. What really excited him in architecture was not the formal elements, but architectural ensembles and how they can be organized in terms of human needs.

256

The Two-level City

Leonardo's urban-planning schemes date mainly from the years 1487-1490, coming soon after the plague of 1485 that made evident the overcrowding and unhealthy living conditions in Milan. Utilitarian and functional concerns thus take precedence in his mind over formal considerations. This contrasts these studies with the church designs drawn in the same manuscript.[79]

In fact, Leonardo did not actually propose plans: he was not interested in speculations on the "ideal city" nor in the symbolic value of the concentric plan of which Filarete and Francesco di Giorgio were so fond. No doubt he believed, like all his contemporaries, in the microcosm-macrocosm analogy, but he derived new consequences from this principle. Instead of drawing abstract diagrams supposed to reproduce the form of the universe, he studied practical solutions, in keeping with the nature of things: just as man and the earth are vitalized by the movements of blood and water,[80] a city should have a system of circulation that provides a pleasant, healthy life for its inhabitants. The theme of the "ideal city" consequently gives way to a concrete problem, that of the "ideal circulation", for which Leonardo proposes an unprecedented solution: two-level circulation.

The simplest system, applicable only in regions with an ample water supply, like the Milan area, combined canals and streets. Goods travelled by boat along the canals and were delivered directly to the backyards of the houses via underground passageways (Paris MS. B, f. 37 v: Fig. 352). The quays, located six *braccia* (3.5 metres) above the canals, were therefore not burdened with these utilitarian activities, and the streets, lined with porticos, could be reserved for noble activities. The canals had another function: the water flowing through them kept the air of the city healthy. It was therefore essential that this water be clean, maintained at a constant level and flushed through the system at least once a year to prevent sludge from accumulating at the bottom of the canals. A plan and bird's-eye view (Paris MS. B, f. 38 r: Fig. 351) show how a river (the Ticino) could irrigate a city covered with an orthogonal network of canals which was controlled upstream by a system of locks.

Since not all cities could be planned this way, Leonardo proposed another system with two street levels (Paris MS. B, f. 16 r: Fig. 355). The streets used to transport goods were located at the ground level, along with the service entrances to the palaces, water-drainage ditches and, no doubt buried somewhat, sewers. Six *braccia* higher (as in the preceding system), the streets reserved for "persons of quality", which were twenty *braccia* (12 metres) wide, were built on walls and vaults. They gave access to the palaces, which had their main entrances on this level. Their porticoed courtyards, visible in the drawing, dominated the service yard (or garden?) which was connected to the street meant for carriages. The drawing next to this one (Paris MS. B, f. 15 v: Fig. 353) shows an overall view of the city: ramps lead to the noble, upper level, through monumental gates, while the lower streets end in doors that open in the wall, near the ditches.

Leonardo added specific details in his text. The upper streets are always clean because the water flows out through a central slot into the "underground" street which is actually a sewer. Stairs allow people, but not vehicles, to go from one level to the other (somewhat lessening the strict hierarchy of this urban organization). These spiral stairs are housed in round stairwells, so that people would not be tempted to urinate in the corners; public latrines are planned on the side. Such details reveal Leonardo's practical concerns, his interest in the "physical" life of the city and all forms of circulation. The identification between the city and the human body was not just a figure of speech for him.

Two other drawings take up the same notion. Folio 36 r of Paris Manuscript B (Fig. 356) shows a building covered with a terrace opening onto a high street — which must be as wide as the building is

Fig. 291. CA, f. 184 v/65 v–b. Project for the expansion of Milan.

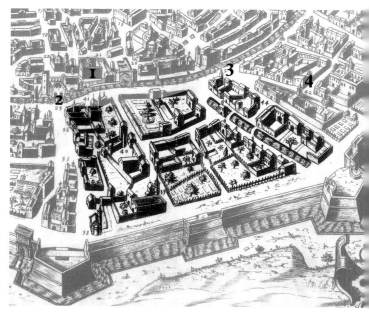

Fig. 292. The new section planned by Leonardo shown on Lafréry's plan (1573): 1. Ospedale Maggiore; 2. Porta Romana; 3. Porta Tosa; 4. San Pietro in Gessate (the fortified outside wall dates from the middle of the sixteenth century).

high — with, below, the sewer for draining the water. Folio 37 r (Fig. 357) provides a more complete representation of the system, all the more clear since Leonardo indicated only the ground floor of the buildings (once again we must admire the efficiency of his means of graphic expression). We see, from left to right, the lower street (joined to the upper street by a straight set of stairs, and not a spiral staircase), the service yard, then the vaulted ground floor of the palace and, finally, the porticoed high street above the "underground way".[81]

In this drawing, as in the preceding ones, the streets are laid out in a regular grid and all the buildings indicated seem intended for human habitation, because no churches or public buildings are visible. However, this uniform organization does not in any way imply an egalitarian, "bourgeois" society, without either God or prince, as it was rather hastily described.[82] It simply proves that between 1487 and 1490 Leonardo was exclusively interested in circulation systems and in what today we would call the city's "infrastructures".[83]

In 1493, Leonardo believed he had the opportunity to carry out some of his ideas. He studied a scheme for expanding the city of Milan (CA, f. 184 v/65 v-b: Figs 291-292) which had a political purpose, namely to oblige the rich inhabitants of the duchy to build houses in Milan in order to ensure their loyalty.[84] The drawing represents, in outline form, the city surrounded by a double ring of canals (only the inner ring existed at that point) and, in more precise form, one of the new neighbourhoods

that would be built on the outskirts. The centre of the drawing is occupied by a square space lined with buildings (the dots refer to porticos opening onto the central square) and surrounded by a canal connected at the top (and possibly at the bottom) with the circular canals. The handwritten notes explain that the canals must be kept absolutely clean, with nothing thrown into them, and be flushed out periodically.

Twenty-five years later,[85] another, even better opportunity was presented to Leonardo: the design of a completely new city, intended for the king of France and his court, which would have been built near Romorantin, on either side of the Sauldre (CA, f. 920 r/336 v-b: Figs 293-294). Leonardo proposed a solution similar to the one studied in 1487 (Fig. 351), namely a system of parallel canals on either side of a wider, central canal that occupies the riverbed (Arundel MS., f. 270 v, CA, ff. 583 r/217 v-b, 582 r/217 v-c, and 806 r/294 v-b: Figs 295-298).[86] Since the Sauldre is not the Ticino, Leonardo planned to increase its volume by digging canals that would add to it part of the flow of the

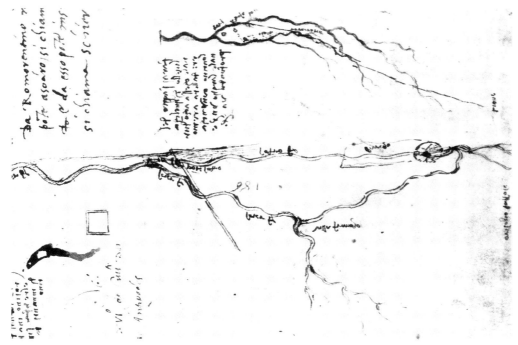

Fig. 293. CA, f. 920 r/336 v-b. Topographical study.
Top: the Loire, the Cher and the Sauldre (next to which is indicated Romorantin).
Bottom: the Sauldre (the circle on the right represents Romorantin), the Cher and the canal to run between Villefranche-sur-Cher and Romorantin.

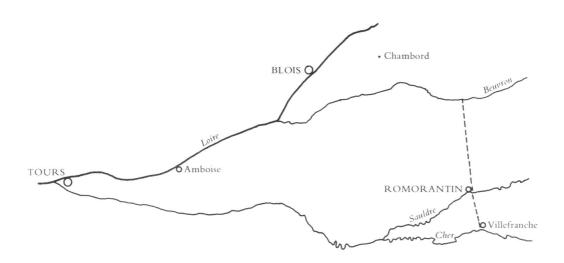

Fig. 294. Simplified map indicating the rivers and (in broken lines) the planned canals.

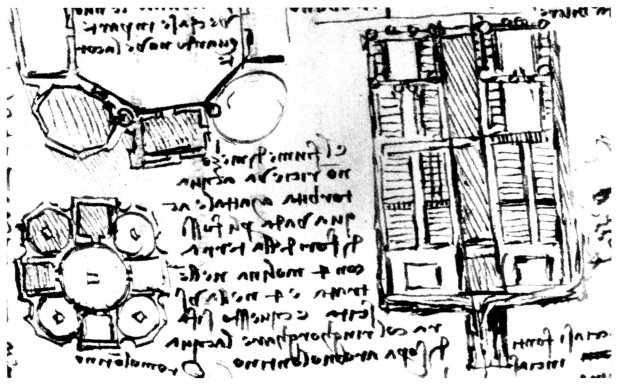

Fig. 295. Arundel MS., f. 270 v (detail). Project for Romorantin and octagonal plans.

Fig. 296. CA, f. 583 r/217 v–b (detail). Project for Romorantin.

Fig. 297. CA, f. 582 r/217 v–c. Project for Romorantin.

Fig. 298. CA, f. 806 r/294 v–b (detail). Project for Romorantin.

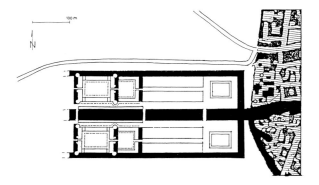

Fig. 299. The new town of Romorantin and its surrounding area. Reconstruction: J. Guillaume/J.L. Delagarde after the drawings reproduced in Figs 295 and 338. Right: the old town.

Cher and even of the Beuvron.[87] He was interested in seeing that the system worked properly: "running water served to clean the streets and latrines, the canals were to be kept clean, locks regulated the current…"[88] All his concerns from the Milan period thus reappear in this plan. We note one new feature, however. For the first time, Leonardo considered the form of the city. As might have been expected, he did not propose an ideal plan, but a design suited to the site (a valley) and the programme (a royal city organized around two castles). The solution adopted is perfectly logical:[89] on each side of the central canal, the houses are laid out along a single street that runs off from a large square (occupied in one drawing by a church: Fig. 298) and leads to the castle. Leonardo thus created a large, urban perspective ending in a building, which would have brilliantly illustrated the monarchal order (Fig. 299).[90]

Leonardo did not say whether the canals in the royal city were to be used to transport goods to the backyards of the houses, but we may suppose so since, in this design, the artist took up the ideas developed in Paris Manuscript B. In France, in a region where people had no idea of such a system, and on a river whose flow would have to be increased, at great expense, he applied the scheme of the two-level city with a network of canals, because it alone seemed to suit an "ideal" city in which the physical and social requirements, from keeping the streets permanently clean to dramatizing the royal power, would be fulfilled.

Multiple Staircases

Stairs play a similar role in buildings to that of canals or streets, in that all movement passes through them. Obsessed as he was by problems related to how things worked, Leonardo could not fail to be interested in this means of circulation. We therefore find original ideas from him on the subject of stairs, the novelty of which has not been sufficiently emphasized.[91] Leonardo invented systems of stairs that were more complex than the two types commonly used by his contemporaries: the newel (sometimes open-well), which had always been known, and the dogleg stairs, rediscovered in the mid-fifteenth century and used since then as a grand staircase. His research is original, as the Italian "staircase" imagination was brought to bear exclusively on the second type, except in Venice, where Mauro Coducci created symmetrical stairs with converging flights late in the century.[92]

Even before these were built, Leonardo planned exterior stairs of this type in his two-level city (Paris MS. B, f. 37 r) and transposed them immediately after that to an interior (Fig. 357, bottom drawing).[93] He also devised a more complex system, with ascents that diverged and then converged (Paris MS. B, f. 15 v: Fig. 300), built twenty years later by Bramante at the Belvedere, in which a central niche replaces the passage that is connected here to the dual circulation system.

Fig. 300. Paris MS. B, f. 15 v (detail). Symmetrical staircase.

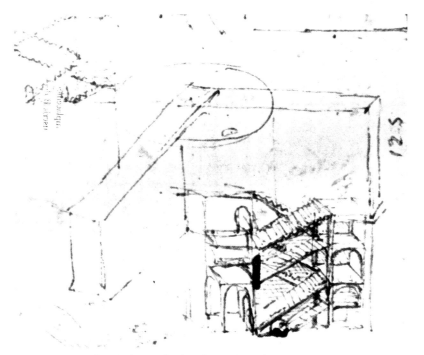

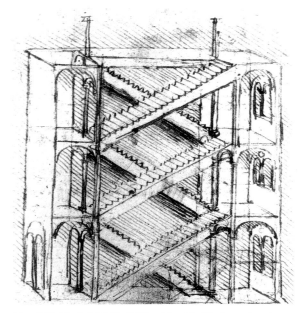

Fig. 301. CA, f. 763 r/281 r-b (detail). X-shaped staircase.

Fig. 302. Paris MS. B, f. 68 v (detail). X-shaped staircase.

The other (and most extraordinary) staircases designed during the same period are all related to studies of military architecture: double dogleg stairs with different-size ramps (CA, f. 763 r/281 r-b: Fig. 301) or with similar ramps (X-shaped staircase) (Paris MS. B, f. 68 v: Fig. 302), double newel stairs inside a tower (Paris MS. B, f. 69 r: Fig. 303), and quadruple winding stairs with straight flights (and with a fifth staircase in the centre) in the middle of an enormous square tower (Paris MS. B, f. 47 r: Fig. 304). This last solution must have pleased Leonardo, for he used it again in outline form in a rough sketch that is also related to a fortification drawing (Louvre 2282) and later (1506-1508) in Arundel MS. folio 133 v (Fig. 200, right, and Fig. 305).

Leonardo's notes explain the reason for these curious arrangements. As in the two-level city, it was a matter of separating the types of circulation. The captain of the castle and his soldiers used their own set of stairs in the X-shaped staircase, which were obviously separated by a newel wall and not open as is shown in the drawing that tries to explain the structure. The five groups of mercenaries defending the large tower each used a different one of the four ramps or the central staircase, without ever meeting. This separation of circulation was necessary in order to limit the risk of treachery, as Leonardo explained two pages further on (Paris MS. B, f. 48 r: Fig. 306). The drawing shows a round tower divided into eight sectors totally isolated from one another and served by eight independent spirals which, according to the plan and section, can only be eight spirals built one on top of the other. This octuple spiral staircase, if we may describe it thus, leaves a wide space in the middle for a newel staircase serving the captain's quarters located at the top of the tower, as the drawing on the next page shows (see Fig. 364). Fascinated by this idea, Leonardo developed it further and drew, on the opposite page (Paris MS. B, f. 47 v: Fig. 307) "ten spiral staircases around a tower". No explanation accompanies the drawing of the double newel staircase (Fig. 303), however. We understand only that it ends in two passages separated by a wall, apparently indicating that here as well it was a question of separating the types of circulation for security reasons, and not of organizing a one-way system.[94] This staircase is the only one placed in a normal position; all the other stairs for which Leonardo specified the location are in the middle of the tower (Figs 304 and 306), like the single spiral depicted in Paris Manuscript B, folio 52 v (Fig. 308) which seems to act as a central element for the structure.[95]

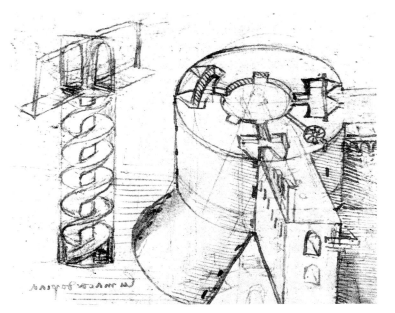

Fig. 303. Paris MS. B, f. 69 r (detail). Double newel staircase.

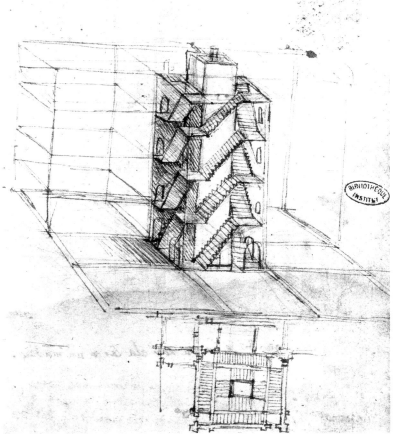

Fig. 305. Arundel MS., f. 133 v (detail). Quadruple staircase.

Fig. 304. Paris MS. B, f. 47 r. Quadruple staircase in the middle of a square tower.

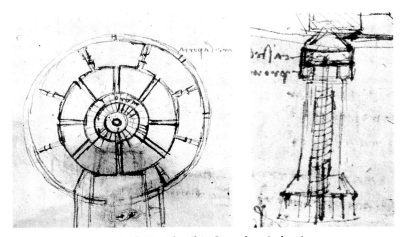

Fig. 306. Paris MS. B, f. 48 r (details). Octuple spiral staircase.

Fig. 307. Paris MS. B, f. 47 v (detail). "Ten spiral staircases around a tower".

Fig. 308. Paris MS. B, f. 52 v (detail). Spiral in the middle of a tower.

Fig. 309. CA, f. 593 v/220 v-b (detail). Symmetrical dogleg staircases.

Fig. 310. CA, f. 592 r/220 r-c (detail). Villa with a symmetrical dogleg staircase.

Leonardo's early research therefore deals exclusively with stairs with multiple ramps capable of serving both sides of a street in a two-level city or handling separate types of circulation in a fortress. None of the three possible types escaped his attention: symmetrical stairs (used in the city), double, quadruple or octuple winding staircases and, finally, concentric stairs.[96]

Some twenty years later, when he was back in Milan in 1506, Leonardo again became interested in stairs, but in another context, for civil-architecture designs. He was then drawing plans for villas and proposed placing, in the centre, in the axis from the loggia to the hall, a symmetrical dogleg staircase, the second (or the first) flight of which was divided into two (CA, ff. 593 v/220 v-b and 592 r/220 r-c: Figs 309-310). This type, which is very clearly explained on folio 593 v/220 v-b (in which it is compared with a single dogleg staircase shown below on the right),[97] had doubtless already been thought of before 1500, because it appears in the album of Il Bramantino, all of whose drawings of double or quadruple winding stairs must be related to Leonardo's.[98]

At the same time, Leonardo was studying another type of symmetrical staircase in his design for the villa of Charles d'Amboise (CA, f. 629 Br/231 r-b: Fig. 318 B). The stairs shown on the right, opposite the private apartments, are not easy to interpret. Carlo Pedretti sees them as being a

Fig. 311. The villa of Charles d'Amboise: staircase.
Reconstruction: J. Guillaume/K. De Jonge.

symmetrical dogleg staircase, similar to those we have just looked at, the second flight of which (not shown) would run from the central hall of the villa, which would be reached by a passage located under the intermediate landing and the second flight.[99] One argument in favour of this hypothesis would be a staircase description originally written on the same sheet (f. 732 Bv/271 v-a), but that one concerns a single dogleg staircase which is too small (each flight is from 1 to 1.20 metres wide) to be suitable for the villa of the envoy of the king of France. The description bears no relation to the drawing which, in any case, does not indicate a symmetrical staircase because the middle flight is not shown, unlike in the other drawings of the same type.[100] Furthermore, it would be absurd to enter the villa through a low door below a landing located midway between the floors, and to walk as far as the central hall only to backtrack. We therefore believe that the staircase was made up of two parallel straight flights leading directly from the entrance to the first-floor hall and leaving a passage between them leading to the ground-floor hall (Fig. 311). This arrangement, which had never before been used for a palace interior, is the only logical one in an in-depth organization, and it fits in well with another description which Carlo Pedretti rightly relates to the design of the villa: "the stairs [here Leonardo uses the plural, but this is not conclusive] should be wide, so that the people in passing along them may not push against the masqueraders and damage their costumes".[101]

A sheet covered with diagrams of stairs (RL 12592 r: Fig. 312 and Pl. XXI) shows how interested Leonardo must have been at that time in vertical circulation. It shows four types of stairs side by side:

Fig. 312. RL 12592 r (detail). Four types of staircase: with diverging flights (A); X-shaped (B); dogleg (C); with two parallel ramps (D). See Pl. XXI.

a symmetrical staircase with diverging flights (A), an X-shaped staircase (B), dogleg stairs (C) and a staircase with two parallel ramps (D) leading to an upper floor (the line on the right is too long to indicate a landing). This last staircase is similar to the one planned for the villa of Charles d'Amboise, but elaborated further, since it contains a central, returning flight leading to a second floor. It is therefore a symmetrical dogleg staircase developed on two floors, with the central ground-floor passage not indicated. It will be noted that in all of these drawings, as in those examined earlier, Leonardo always planned flights enclosed within walls and covered with an inclined barrel-vault roof. While he devised many novel solutions and, in his villa designs, sought to expand the space set aside for stairs, Leonardo never considered that the stairwell could form a unique space. That idea appeared later, outside the Italian world.[102]

Leonardo's thoughts on multiple staircases may have been of some interest to Antonio da Sangallo, who drew a symmetrical dogleg staircase in a plan designed immediately after Leonardo's visit to Rome, but they had no real permanent influence on Italian architecture.[103] We will see shortly that they had more success in France.

Open Architecture

Leonardo's drawings dealing with urban planning and multiple staircases, in other words, two-level circulation and vertical circulation, form two coherent groups. His other civil-architecture drawings, which are scattered and often very rough, are more difficult to interpret, especially since the most legible of them are not always the most interesting. We will single out two groups that seem to correspond to constant concerns of Leonardo's and not just occasional interests related to some "commission" or other. The former deals with a programme of his — open architecture — and the other, a type defined by its formal organization, relates to the centrally planned castle.

The "open" buildings are combined with gardens or extended views. They have porticos and loggias[104] and most often seem devoted to entertainment or pleasure. This theme consequently appears to be associated right from the start with life at court.

In 1487, Leonardo drew the plan of a pavilion located "in the middle of the labyrinth of the Duke of Milan" and an interior section of the domed "pavilion in the garden of the Duchess of Milan" (Paris

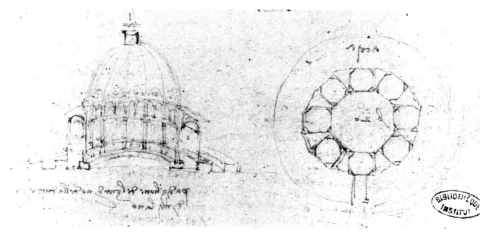

Fig. 313. Paris MS. B, f. 12 r (detail). Garden pavilions. Left: the pavilion of the Duchess; right: the Duke's pavilion in the middle of a labyrinth.

Fig. 314. RL 12552 (detail). Pavilions on the towers of a castle. See Pl. XXII.

MS. B, f. 12 r: Fig. 313). The two drawings are certainly not for the same building, because the plans, the immediate surroundings and the location indicated are not the same.[105], but in both cases we find wooden pavilions, which were probably designed by Leonardo since we cannot see who else could have proposed, on the right, such a Brunelleschian plan and, on the left, a structure so similar to the enormous dome on a ring-shaped drum planned at the same time for Milan Cathedral (Fig. 216).[106]

The garden and its open architecture are in stark contrast to the castle next to them. We may wonder whether the idea in Milan was to soften this contrast by introducing some "pleasure areas" into the fortress without, however, affecting its defence. In any case, Leonardo was responding to concerns of this type when he devised, in 1495, a pavilion similar to the one for the Duchess, but without a ring-shaped portico, at the top of a corner tower, above the parapet walk (RL 12552: Fig. 314 and Pl. XXII). In the Italian world, where castles were always massive in appearance, such a proposal had no precedent, although it would appear less strange in France, where castles could have very ornate high parts pierced with many openings.[107] Leonardo, curious about everything, may have known these castles, but it is more reasonable to think that he discovered this type of effect when he devised a dome decorated with ridge ornaments and a spire over the terrace roofs of Milan Cathedral. At that time, as we have seen, Leonardo was looking at mediaeval architecture, vertically rising forms and the effect of lively silhouettes, and he enjoyed creating the same kind of effects in this belvedere surmounted with a "Gothic" spire.

Judging by the surviving drawings, Leonardo does not appear to have been interested in complete plans for villas or palaces prior to 1497. When he began to be, he devised open compositions: a palace in which the courtyard portico is lined on the exterior by a loggia on the side opposite the entrance

Fig. 315. Paris MS. I, f. 18 v. Plan of a palace.

Fig. 316. CA, f. 426 v/158 v-a (detail). Plans for a palace-villa. Top: the garden; bottom right: the end of the left wing (with a room opening onto the garden) and the corner of the courtyard.

Fig. 317. Paris MS. I, f. 56 r. Villa with a tiburio.

A

B

C

Fig. 318. CA, f. 629 Br/231 r-b. Projects (A, B, C) for the villa for Charles d'Amboise.

(Paris MS. I, f. 18 v: Fig. 315),[108] a palace with an open courtyard connected to the garden by a portico (CA, f. 426 v/158 v-a: Fig. 316) and, finally, a villa made monumental in style by an organization using a central arcade and a kind of tiburio (Paris MS. I, f. 56 r: Fig. 317). The first solution, from what we understand of it, is similar to the one for the palace of Lodovico Sforza in Ferrara. The second is much more original, since the back wing is a simple portico, too narrow to be built upon. The courtyard, closed on the ground floor by this portico and probably covered with a terrace, was open on the upper storeys in a manner similar to that found later on in the Palazzo Pitti.[109] In this drawing, which seems to be a design for a palace in Milan,[110] Leonardo re-examined the urban-residence system that involved an enclosure of space; he transformed the palace into a villa, thickened the wings to make up for the disappearance of the fourth section, replaced by a portico (supporting a terrace?), and set out the master's apartments (detailed in the drawings next to it) at the end of the left wing, facing the garden. In the villa with the tiburio, finally, Leonardo adopted the organization of the façade of the Pazzi Chapel, which he combined with a circular tiburio supporting a conical roof and a small lantern, similar to the one at Santa Maria presso San Satiro. This amazing creation, probably impossible to build because of the lightness of the supports, responds to the same concerns as the Villa Medici at Poggio a Caiano. Like Giuliano da Sangallo, Leonardo sought to give new dignity to the villa by applying to it motifs borrowed from religious architecture.[111]

Unfortunately Leonardo never returned to these ideas. When he became interested again in the theme of the villa, in 1507 (CA, f. 592 r/220 r-c: Fig. 310), he seemed less concerned with the façade — the one he drew was very ordinary — than with the introduction of a monumental staircase along the axis of the loggia and the hall. Such a large staircase seems absurd in this type of building in which the main rooms are always on the ground floor, but Leonardo's proposal is more readily understood if we relate it to the design, from exactly the same period, of a villa intended for Charles d'Amboise, the French governor of Milan and the king's envoy, which is known through a sheet of drawings with several annotations (CA, f. 629 Br/231 r-b: Fig. 318) and two texts.[112] The villa is actually a suburban residence to be built outside the city, on the Porta Orientale side, along a waterway called the Fontelunga (or Acqualunga), and not within the city walls, near San Babila (Fig. 319).[113] The residential function of the villa, and the need to affirm its quasi-regal dignity, no doubt explain the special features of the design.

Plans B and C (Fig. 318) clearly show two gardens. The one on the left, divided into three, runs along the canal (Fontelunga); it is reserved for the governor. The bottom one, which is bigger and planted with trees (?), is decorated with one or more fountains.[114] The three rectangles laid out in a "U", which appear in the governor's garden in plan C, doubtless represent the aviaries made of copper mesh or the slabs (of masonry) mentioned in the description of the garden originally written on the same sheet. This text conjures up plantations of orange and lemon trees, canals crossing the garden, water running down the centre of the slabs (and keeping wine chilled!) and fountains for keeping visitors cool.[115] The mill that raises the water also activates musical instruments that blend their sounds with the singing of the birds. A drawing dating from the same years (CA, f. 961 r/348 v-a), showing a fish pond surrounded by arcades and ornamented with fountains at the four corners, appears to be explained by the same concerns: the desire to create, in Milan, a magical garden around the villa.[116] However, the charm of the description should not make us forget that gardens of this type were customary in princely residences and that this one would doubtless only be distinguished by the ingeniousness of the machines and the fountains.

The building itself is much more original. The loggias give it the character of a villa. Plan A shows two loggias located on the long side on either side of a hall, and the notes written below

Fig. 319. Possible site of the villa for Charles d'Amboise, to the east of the Porta Orientale; 1: S. Babila; 2: Neron di S. Andrea; 3: Porta Orientale; 4: Ospedale S. Dionigi; 5: Acqualunga (now corso Venezia); 6: Lazaret (plan by Lafréry, 1573: the fortified outside wall dates from the middle of the sixteenth century).

drawing B indicate that the "master's room" on the short side may also be "completely open". The interior layout, on the other hand, brings it closer to a palace. The importance given to the stairs (Fig. 311), the care taken in organizing the rooms in a hierarchy — large reception room, master's hall, bedrooms, smaller rooms — prove that the intention was to make visitors follow a certain route, a gradual approach to the master of the house[117]. These concerns set the villa of Charles d'Amboise absolutely apart from Poggio Reale, the plan of which Leonardo sketched (inaccurately) on the same sheet to the left of plan B:[118] they explain this in-depth development, from the grand staircase to the most "secret" rooms, something utterly unusual in a villa. Furthermore, this "sequence" occupies the first floor, accessible via an interior staircase, while the main level of a villa, when it is raised as at the Villa Medici at Poggio a Caiano, is always associated with an exterior staircase providing a direct link with the garden and underlining the "accessibility", the openness of the villa.

The probable location of the great hall and the master's apartments on the first floor confirm the comparison made by Carlo Pedretti between the villa and the palace façade on the cover of the Codex on the Flight of Birds (Fig. 288) and the villa.[119] The first-floor loggia would thus correspond to the master's apartments which are "wide open" onto the private garden. Better yet, the existence of an attic storey limited to the central part of the palace (because it supports the pediment), but developed along the entire length of the villa, as may be seen in a contemporary drawing (RL 12497: Fig. 320),

Fig. 320. RL 12497 (detail). Fantastic drawing: a horse coming out of a palace.

Fig. 321. Hypothetical reconstruction of the villa for Charles d'Amboise: axonometric view, plans of the ground and first floors. Reconstruction: J. Guillaume/K. De Jonge.

would offer an explanation for the lines that divide the great hall longitudinally on all the drawings; at this point, a series of arcades would have been necessary to support the walls of the attic.

In gathering all this information, we are able to attempt a reconstruction, obviously hypothetical, of the palace-villa of Charles d'Amboise (Fig. 321). Plan A, which shows, on the right, a single passage (the one located between the two flights of stairs) could correspond to the ground floor, which is occupied in the centre by a hall opening onto two loggias. The passage on the left ends in a square which could be the outside steps visible on the façade drawing. Plan B, which is longer and indicates the stairs, corresponds to the first floor. The lines dividing the great hall probably represent the arcades supporting the attic. We cannot know whether the sides of this hall are open, forming a loggia like the ground floor. Plan C describes the state apartments in more exact terms; each bedroom has one corresponding smaller room, and not two, as might be implied by a detail in the preceding plan. The (approximate) measurements of the building may be deduced from those of the stairs if we follow Carlo Pedretti's reasoning based on a modular conception of the plan, which is perfectly conceivable.[120] A straight flight leading to a floor located at a height of about 5 metres must be at least 10 metres long. In this hypothesis, the flights (and the central passage) would be 3 metres wide and the overall dimensions of the building would be some 30 × 50 metres. If we assign this width of 30 metres to the façade drawing, the height of the balustrade (which is very visible in the loggia) amounts to 1 metre, and the floor is about 6 metres high; these two measurements are also possible. On the other hand, the ground floor would be 9 metres high, which is impossible because the stairs would then have to be much longer. We cannot expect perfect consistency in preliminary drawings, however.

A final set of drawings, masterfully related to one another by Carlo Pedretti, concerns a project for enlarging the Villa Melzi at Vaprio d'Adda, that dates from about 1513 (CA, ff. 1098 r/395 r-b and 173 r/61 r-b: Fig. 322).[121] Leonardo proposed extending the main façade of the villa, which ended in two pavilions individualized by their four-sided roofs, by building two other, rectangular pavilions, served by a spiral staircase and lit on all sides by large, biforous windows. The terrace that covers them supports, in the centre, a polygonal or circular kiosk capped with a dome. Beyond, porticos lead

271

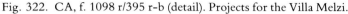

Fig. 322. CA, f. 1098 r/395 r–b (detail). Projects for the Villa Melzi.

Fig. 323. CA, f. 414 Br/153 r–c. Silhouette of the Villa Melzi.

to two other separate pavilions of the same type. Terraced gardens joined by stairs occupy the slope down to the river. An extremely evocative rough sketch (CA, f. 414 Br/153 r–e: Fig. 323) shows the silhouette of the villa against the sky; this seems all the more clear since the pavilions are drawn with high roofs here.

Much more so than the villa for Charles d'Amboise, this project is reminiscent of Leonardo's first Milanese period, of the villa with the central tiburio and the open pavilion at the top of a tower. The taste for lively, totally open volumes rising skyward which he had acquired in Milan in the late Quattrocento is expressed once again here and leads him to draw what Heydenreich rightly called "a presentiment of Chambord", without it being necessary to assume a direct contact with French architecture.[122]

The designs for the Villa Melzi at Vaprio d'Adda emphasize Leonardo's very isolated position in the Italian world: villas by his contemporaries generally have simple volumes, and the most innovative are distinguished primarily by their classical style. In spite of some occasional similarities,[123] Leonardo's open architecture does not foreshadow that of the High Renaissance.

The Centrally Planned Castle

The theme of the centrally planned castle was not related to that of the church. It was not of real interest to Leonardo until after 1505–1508 and took on major importance only in the latter years of his life. In the years from 1487–1490, during the time of his research on domed churches, "civil" centralized plans were very rare in Leonardo's drawings, while Francesco di Giorgio's manuscripts[124] start to show them from this period on. The most enigmatic one (CA, f. 969 d–r/349 v–k: Fig. 324) represents the central part of a palace with bedrooms and halls organized around a central chapel in the form of a cross, like the courtyards and rooms in a plan for a hospital (it is not clear, however, why the arms of the cross are sometimes designated as halls and sometimes as bedrooms). The most evocative one (Paris MS. B, f. 60 r: Fig. 325) is a kind of symbolic image of a castle: a building, square in plan, dominated by an enormous central keep with a set-back upper floor, inspired by Filarete's tower at Milan Castle, which leaves no room for a courtyard.[125]

Other drawings show Leonardo's interest in square plans divided into nine equal squares, in which the central section may be occupied by a staircase in a huge tower (Paris MS. B, f. 47 r: Fig. 304) or by a courtyard, in a palace plan drawn in 1497 (Paris MS. I, f. 18 v: Fig. 315).

272

Fig. 324. CA, f. 969 Dr/349 v-k. Centrally planned mansion.

Fig. 325. Paris MS. B, f. 60 r (detail). Castle.

This type of plan reappears, combined with the theme of the castle with four towers and a central keep, in two drawings dated 1507-1508 (Paris MS. K³, f. 116 v, RL 12591 r: Figs 326-327). The annotations accompanying the first drawing leave no doubt as to the interior organization, which is also shown in the plan below (which is difficult to see because it is covered with another sketch). The castle measures about 30 *braccia* (18 metres) along the side, the central hall is 30 × 10 *braccia*, and the four angle rooms, heated by chimneys, are square. Leonardo does not write about the two remaining spaces, which are also square. One of them necessarily contains the stairs that serve the upper floor and then lead to the "keep" built on the central square, itself surmounted by an octagonal belvedere.[126] The building no longer has any military function, but it retains several features of the castle in Paris Manuscript B: the corner towers, the three-level pyramidal composition and the forms rising skyward, which are now chimneys. Leonardo drew one of these chimneys on the left: their "neo-Gothic" appearance is well suited to this whimsical "fortified castle".[127]

The second drawing takes up the same ideas, but less coherently. The plan and view, if we leave out the façade, suggest an enormous building: a square keep with four towers in the middle of an enclosure of the same shape. However, the façade (enlivened by orders and an alternation of doors and niches) corresponds to a small building similar to the preceding one. We get the impression that two designs using different scales have been superimposed.

Fig. 326. Paris MS. K³, f. 116 v. Castle: view, detail of the chimneys and of the belvedere, plan (bottom, below another drawing); suggested clarification of the plan.

Fig. 327. RL 12591 r (detail). Castle.

Fig. 328. RL 12401 r (detail). Castle in a fantastic landscape.

These two drawings are totally original. The square plan with four towers (generally square and not round) are doubtless found in other buildings from the same period, particularly villas, but nowhere else do we see this pyramidal superimposition of volumes that is poetically evocative of the fortress, and that actually imitates nothing real.

The theme of the central keep recurs in a fantastic landscape in the *Deluge* series (RL 12401: Fig. 328), but not in the centrally planned castles from 1515–1518, all of which have courtyards. The first plan of this type, with towers and an octagonal courtyard, is from the same period as the plan of the centre of Florence drawn beside it (CA, f. 865 r/315 r-b: Fig. 329); this led to the belief that the castle with the centralized plan was a design for a new Medici palace planned across from the old one

Fig. 329. CA, f. 865 r/315 r-b. Castle with an octagonal courtyard (detail of Fig. 287).

Fig. 330. CA, f. 294 r/106 r-b (detail). Plans of castles.

Fig. 331. CA, f. 967 Cr/349 v-c. Corner of a castle.

(even though the plan shows, at this location, a building with a square courtyard and no towers).[128] In reality, it is doubtful that the Medici, ambitious but clever, would ever have considered such a palace in Florence, especially since the structure drawn could not be built in the city since it has, around its base, a fausse-braye intended to run along a ditch. Moreover, the recessed second storey is reminiscent of those we observed in the two castles designed ten years earlier, and curiously foreshadows the continuous walkways that would appear soon afterward in France at Bonnivet and then Chambord.[129] Leonardo was therefore thinking of a castle and even, for the first time, a castle with a courtyard, to which he gave an original form, which Francesco di Giorgio had already used in several palace plans.[130] However, unlike his predecessor, Leonardo does not apply an abstract outline: he draws an irregular octagon in order to be able to house spiral stairs behind the short sides, in the angles of the courtyard. His imagination never made him forget practical requirements, first and foremost those of circulation.

The theme of the square castle with towers and that of the octagonal courtyard, which were combined in the "Florentine" project, continued to inspire Leonardo during his time in France, but the two themes were now separate. Three drawings (Arundel MS., f. 264 v, CA, ff. 294 r/106 r-b and 659 v/242 v-a: Figs 330 and 336) depict square castles with four towers. The most interesting one (CA, f. 294 r/106 r-b) has a round courtyard and octagonal towers (surrounded by apses?). Another drawing (CA, f. 967 Cr/349 v-c: Fig. 331) describes in detail the angle of a building with no towers, but with an octagonal courtyard that is even more irregular than in the "Florentine" project. The rooms, octagonal or rectangular, are themselves organized according to a cross-shaped plan around an octagonal chapel(?). This organizing principle reappears in the Codex Atlanticus, folio 963 r/348 v-c (Fig. 332), applied to a huge palace with five octagonal courtyards which also has a precedent in the drawings of Francesco di Giorgio.[131] This truly royal scheme foreshadows the palace plans with multiple courtyards which Serlio devised thirty years later for François I.[132]

Leonardo seems to have been obsessed with the octagonal plan in the last years of his life.[133] It is

Fig. 332. CA, f. 963 r/348 v-c. Castle with five octagonal courtyards.

Fig. 333. CA, f. 317 r/114 v–a. Octagonal plans.

found again in a curious drawing of a building with eight octagonal rooms around a cross-shaped courtyard decorated, it seems, with a central fountain (CA, f. 317 r/114 v–a: Fig. 333), in the enigmatic plans in the Arundel Manuscript, folio 270 v (Fig. 295),[134] and especially in the palace with a giant order on a podium (CA, f. 583 r/217 v–b: Fig. 279).

The centrally planned castle, originally designed as an enormous square keep with set-back storeys, thus takes on different, more varied forms starting in 1515, when Leonardo became increasingly interested in this type of palace. The principles of composition and the goal remain the same, however: it was still a question of organizing the parts around a central volume or space, imposing a massive, vertical, "dominating" character on the structure, and thus creating an extraordinary building that would stand out from all other residences.

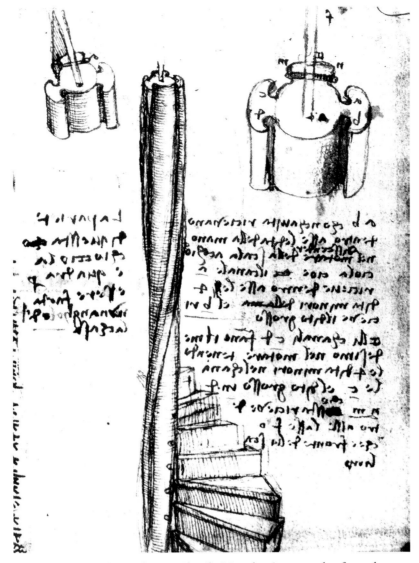

Fig. 334. Arundel MS., f. 264 r (detail). Newel staircase made of wood.

Leonardo and French Architecture

The victor at the Battle of Marignano and lord of Milan, François I, called upon Leonardo, as had Charles d'Amboise ten years earlier. The young king (he was twenty-one in 1515) had a profound admiration for the aged artist. He expected wonderful things of him, starting with the plans for a castle and a city he dreamed of building near Romorantin. Leonardo accepted François's invitation. He knew that he would find at the French court the privileged status he had enjoyed in Milan with Lodovico Sforza and Charles d'Amboise, and he no doubt hoped to carry out some of his ideas, with the monarch's support.

Upon arriving in Amboise, Leonardo immediately studied the Romorantin project (he first travelled to the site in January 1517), but he also observed the things around him. Several drawings and a text attest to his curiosity about French architecture. He was interested in wood-framed construction, commonly used for the houses there, and the prefabrication and assembly of the components. Easy to put together, these houses could also be dismantled and transported elsewhere: this gave Leonardo the idea of moving the inhabitants of Villefranche-sur-Cher to Romorantin... along with their houses.[135] Similarly, he carefully drew a newel staircase the newel of which was made of a single piece of wood containing two spiral-shaped mouldings acting as handrails (Arundel MS., f. 264 r: Fig. 334). Ever in

Fig. 335. CA, f. 583 r/217 v–b. French dormer window (detail of Fig. 296).

Fig. 336. CA, f. 659 v/242 v–a (detail). Open newel staircase.

search of functional explanations, Leonardo made sure that the person's hand was placed on one of the mouldings when going up the stairs, and on the other when going down.[136] He also looked at dormer windows, used in connection with high roofs (CA, f. 583 r/217 v–b: Fig. 335), as well as the large newel staircases of castles, wide open onto the courtyard, the winding movement of which could be followed from the exterior (CA, f. 659 v/242 v–a: Fig. 336).[137] Finally, he discovered a tower plan of which he had had no previous idea, because it never appears in drawings prior to his stay in France. This is the circular tower occupied by a square room. A detail drawing, beside the plan for the royal place at Romorantin (CA, f. 209 r/76 v–b: Fig. 338), exactly indicates its typical features: the two windows, the location of the chimney and the diagonal entrance passage, in the corner of the castle.

If we compare these observations with what we said earlier about Leonardo's lack of prejudice, his interest in the Gothic style and his taste for lively volumes rising skyward, we can guess that he was not disoriented by his new surroundings, especially since, in Italy, he had sketched buildings similar to the French châteaux. No doubt Leonardo continued to draw innovative compositions inspired by Roman creations, such as the façade using a giant order (Fig. 279), but the projects he designed for King François and which were intended for execution take French practices into account.

Romorantin

The new city planned on either side of the Sauldre would, as we have seen, have comprised two castles (probably intended for the king and his mother) built at the ends of two long streets. On the opposite side, these streets would have led to squares occupied by churches (Figs 295 and 299).[138]

The castle on the right bank — in all likelihood the only one that was seriously contemplated — is known through two drawings (CA, f. 209 r/76 v–b: Figs 337–339): on the right, a preliminary sketch in which the towers are not indicated (this does not mean they were not planned)[139] and, on the left, a plan of unusual precision representing the castle as a whole. The indications written on the sheet allow

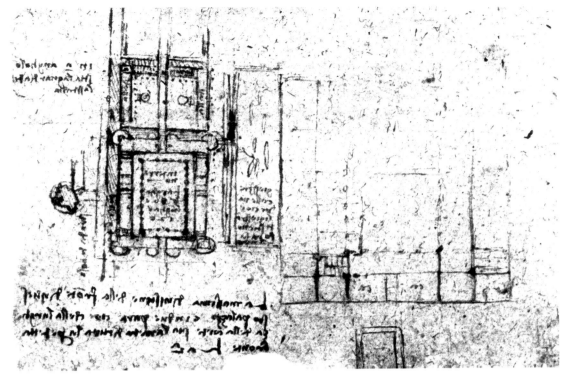

Fig. 337. CA, f. 209 r/76 v–b (detail). Projects for the castle at Romorantin.

Fig. 338. Projects for the castle at Romorantin: left–hand plan with usual orientation.

Fig. 339. Plan of the castle at Romorantin. Reconstruction J. Guillaume/J.L. Delagarde.

a reconstruction of the project.[140] The castle, which was probably organized on a grid of 10 *braccia* (a little less than 6 metres), forms a rectangle 120 × 160 *braccia* (72 × 96 metres); the courtyard (80 × 120 *braccia* with the porticos, 60 × 100 *braccia* without the porticos) is surrounded by buildings 20 *braccia* wide served by four dogleg staircases located in the angles. Four towers occupied by square rooms, as is specified in the detail drawing next to it, rise at the angles along with four others on either side of the two main entrances. A forecourt built on three sides houses the outbuilding and stables, the stalls of which are visible in the plan. Ditches that are part of the canal system surround the whole and separate the castle from the forecourt.

In order to fully appreciate Leonardo's design, it should be compared with the two most innovative (in terms of their plans)châteaux that had been built in France since the end of the fifteenth century: Le Verger and Bury (Figs 340-341).[141] The plan with four angle towers, the towers framing the entrance and the axis of symmetry, already existed at both Verger and Bury, the forecourt separated from the castle by a ditch, at Verger, and the dogleg stairs, at Bury. Of course, the symmetrical organization and the stairs were new developments brought in from Italy, but they had been introduced before Leonardo arrived. A French master who was well informed about Italy, like the architect of Bury, could have designed a good many of the arrangements at Romorantin. It is consequently pointless to invoke the four-tower castles and the plans with forecourts (RL 12585: see Fig. 359) drawn by Leonardo in Italy to explain this project.

Other features of Leonardo's plan, however, are entirely new. The two identical entrance façades and the perfect unity of the courtyard, surrounded on all sides by galleries, are incompatible with the hierarchized system of the French château, which typically emphasized the principal residence and the entrance and limited its use of galleries to one or two sides of the courtyard. The dogleg stairs placed in the corners, concealed behind the porticos, are also arranged following Italian practice; stairs of this type are always clearly shown in the centre of the main building in the Loire Valley.[142] Even the number of these staircases — one in each corner — is certainly explained by the memory of the grandiose scheme devised by Bramante for the Palazzo dei Tribunali, the only example of a palace with four staircases of equal size.[143]

The plan proposed by Leonardo is therefore a combination, ultimately not very original, of elements borrowed from the great "Italianized" French châteaux, and the palaces of Italy, first and foremost Bramante's Palazzo dei Tribunali. The centrally planned castles that he designed during the same period are more unusual, and the great contemporary French creations — Bury, Azay-le-Rideau, Chenonceau and Bonnivet — combine French and Italian elements in a more subtle way.[144]

Fig. 340. The castle at Verger (engraving by Boisseau).

Fig. 341. The castle at Bury (drawing by Du Cerceau).

We therefore believe that Leonardo's special genius was expressed primarily in the treatment of the façade on the Sauldre. On this side, a dotted line allows us to imagine a series of arcades: a gallery or galleries built one on top of the other on several levels run along the exterior façade of the castle and the forecourt, wrapping around the angle tower on its way. In front, the wharf is lined with steps that go down to the water level. Leonardo drew small boats on the river and offered a brief explanation of this disposition: "jousting in boats, the jousters are to be on the boats". The open-architecture theme which we have followed from the Duchess' pavilion to the belvederes and porticos of the Villa Melzi at Vaprio d'Adda thus reappears at Romorantin on a new scale, worthy of a royal palace. From the galleries of the castle, or rather of the two castles facing each other, as well as from tiers set up on both sides of the river, the entire French court could have watched nautical displays. The whole thing would have constituted a kind of "theatre" comparable to the lower Belvedere Court, also conceived of as a place of spectacle. In devising these façades on the Sauldre, Leonardo must have been recalling the galleries and tiers in Bramante's design, or else *naumachiae* that might have been fought there in days of old.[145]

A remarkable drawing (RL 12292 v: Pl. XXIII), certainly related to the Romorantin project,[146] reveals what at one time Leonardo was dreaming of building. This "vision" differs somewhat from the plan we have just analysed, because the corner towers are replaced by quadrangular pavilions and the two towers framing the entrance become a single central pavilion. Nor does it resemble the plan sketched to the right of the preceding one, in which there is no trace of a central pavilion. Two features, however, correspond exactly to the plan: the long façade on the Sauldre and the steps going down to the river, the number of which Leonardo exaggerated, unless he was contemplating massive excavations that would have substantially raised the level of the castle.

In this drawing, all the façades appear to be enlivened by arcades that may be open bays (on the river side?) or simple wall ornaments (as would soon be the case in the wooden model of Chambord). The pavilions, which are higher, carry domes that logically should have four sides — like the outer shell of the tiburio. These pavilions, without any equivalent in Italian architecture, which only has towers with low roofs, must be compared with the pavilions of the Villa Melzi at Vaprio d'Adda (Fig. 323). Leonardo's taste for lively vertical forms explains the fact that he devised this "civil" version of the tower that would be a huge succes later on in France, for the same reasons. The Windsor drawing has thus rightly been seen as an extraordinary anticipation of French architecture of the mid-sixteenth century, although we cannot speak about influence because the first corner pavilions only appeared around 1530.[147]

On the other hand, the palace using a giant order on a base (Fig. 279), drawn on a sheet covered with Romorantin plans, bears no relation to either the château or a hypothetical "hunting pavilion".[148] An elevation this Roman, a volume this massive, with no towers or high roofs, a plan this strange, this "theoretical", could not be seriously proposed to the king of France, any more than the Florence castle could have been to the Medici. The proximity of the drawings does not prove that they concern the same subject. When he drew a square in front of the Medici palace, Leonardo was dreaming of an almost "French" château; when he studied Romorantin, he sketched a "Roman" palace. His imagination never settled on just one idea.

Is it possible that a project conceived in 1517 and abandoned in 1518 could have had any influence on French architecture? The most Italian features of Leonardo's castle — the galleries surrounding the courtyard, and the dogleg stairs situated in the corners — were too contrary to local habits to be imitated. The Romorantin *cortile*, however, around 1520 inspired the courtyard of

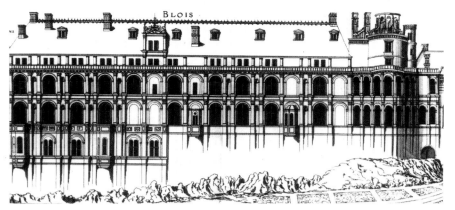

Fig. 342. The castle at Blois: façade with loggias (engraving by Du Cerceau).

La Rochefoucauld, the only château with galleries of this type, and, ten years later, that of the Hôtel de Ville in Paris, where we also find the dogleg stairs concealed in the corner. But this second, and last, example constitutes a special case, because the Hôtel de Ville was the work of an Italian who was in contact with Leonardo during his stay in France.[149] The open street in front of the castle could not have had much of an impact either, but it probably gave the idea of the long tree-lined drives laid out around 1520 in the axes of Chenonceau and Bonnivet,[150] since such a "perspective placement" of a château seems to have been unprecedented.

In the final analysis, the most original part of Leonardo's project is the only one that had any real influence. The open loggias on the exterior and the galleries running along the façades were certainly already known, but no one had ever imagined that galleries could form a sort of external façade, since the image of the castle enclosed within walls had remained so strong. The concept devised by Leonardo reappeared, starting in 1519-1520, at Blois, where François I suddenly decided to line the new wing on the other side of the enclosing wall to create a façade with two storeys of arcades, which was open onto the garden. The construction system differs from that at Romorantin, since the façade is made up of separate loggias, and not galleries, but the exterior appearance and function are similar.[151] Furthermore, the arcades wrap around one of the towers of the château, as they do at Romorantin (Fig. 342). Blois can therefore provide us with information about its model: the stacked loggias of the royal château are more understandable if the façade planned at Romorantin itself comprised several levels of galleries and not a single portico covered with a terrace, similar to the one at Gaillon. At Chambord, a few years later, galleries run along the façades of the "keep", on the first and second floors. They offer views and also allow easy circulation from the central halls to the apartments and towers. The desire to open up the building joins together with the French requirement of convenience to give rise to a system of circulation via exterior galleries (or terraces on galleries) which next reappears at Madrid, at the château Neuf de Fontainebleau, and at La Muette.[152]

The open façade of Romorantin therefore enjoyed immediate and lasting success in a small number of royal châteaux: Leonardo's most original idea was really understood and appreciated only by the king.

Chambord

Once the Romorantin plan was abandoned, the Chambord project immediately succeeded it. It was not a question of building a city this time, but of erecting, at the edge of a large forest near Blois, an extraordinary château that would stand as permanent testimony to the glory of the king of France.

When the project was conceived in 1518, Leonardo was living at Amboise and taking part in the court activities. In June, François I gave a celebration at Clos-Lucé.[153] It is difficult to imagine that the

king would not have asked Leonardo for plans for the new château. The fact that no drawing by Leonardo for Chambord exists today does not constitute a valid objection, since the drawings that served to build the models, and then were used by the builders, remained in France and consequently disappeared. Furthermore, we know that the author of these models, Domenico da Cortona, was well known to Leonardo;[154] this allows us to suppose that there was some sort of collaboration between the two men, with Domenico implementing Leonardo's ideas, in specific projects.

We will not return to a detailed study of these projects.[155] A brief discussion of the two most original features of the château is all that is needed to understand the role played by Leonardo in the origin of Chambord.

The "keep", the only part originally planned, is a centrally planned castle with four towers, organized around a central, cross-shaped space. This type of plan, similar to that of St. Peter's in Rome, was unprecedented in actual examples of civil architecture, but it appears in a few drawings by Filarete and Francesco di Giorgio,[156] as well as in two sketches by Leonardo: the small castle with four towers and a central keep (Fig. 326), in which the cross does not yet form a single space, and the enormous building with five octagonal towers (Fig. 332) which could be an initial idea for the "extraordinary" château of the king of France. In Francesco di Giorgio's drawings (when stairs are shown) and in Leonardo's design for a castle with a central keep, the staircase always occupies one of the arms of the cross, so that the plan is not perfectly centralized. The same holds true in the first design for Chambord, which is known through its model, or rather the drawing made of this model (Fig. 343). In the final design, however, the spiral staircase is placed at the centre of the cross-shaped space and supports, on the exterior, the large lantern that dominates the entire keep, like the dome in a centrally planned church (Fig. 344). This final choice of a spiral staircase, which has wrongly been seen to represent the triumph of a French idea, is both extraordinary and perfectly logical. To deduce such a concept of the plan, the designer had to have thought of stairs in the middle of towers, of "keeps" built in the centre of castles, and to have sketched fifteen years earlier plans that apparently anticipate this solution (Figs 308, 326 and 345). The theme of the centrally planned castle, which haunted Leonardo's imagination during the last years of his life, thus finds its most perfect expression

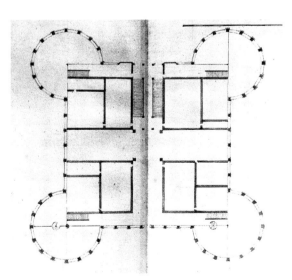

Fig. 343. First project for Chambord (drawing by Félibien).

Fig. 345 Madrid MS. II, f. 135 v (detail). Diagrams of square plans with cross-shaped halls.

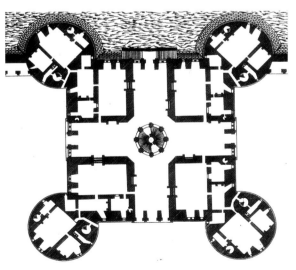

Fig. 344. The castle at Chambord: plan of the "keep" (engraving by Cerceau).

at Chambord by being combined with the theme of the central staircase, which Leonardo had developed thirty years earlier in the fortress studies in Paris Manuscript B.[157]

Leonardo's research on stairs also explains the highly unusual form of the two staircases successively designed for the château. The straight stairs in the model are symmetrical: two flights of stairs separated by a passage lead directly to the T-shaped hall on the first floor; a second, central flight, in the opposite direction, then leads to the second floor. This structure, of which no example existed at the time, is identical to the one we have reconstructed in the villa for Charles d'Amboise (Fig. 311) and corresponds to the outline sketched on the right in Windsor drawing 12592 r (Fig. 312 D). In the second design, the spiral staircase almost certainly comprised four ramps, reduced to two during the construction, which would have distributed the four arms of the cross-shaped halls independently.[158] This extraordinary arrangement — no grand staircase is double, much less quadruple! — has only one precedent, the quadruple winding staircase, also placed in the centre of a square tower, which Leonardo designed in Milan between 1487 and 1490 (Paris MS. B, f. 47 r: Fig. 304). The idea thus reappears here, given new meaning. It is no longer a question of ensuring castle security, but of building, in the centre of the halls, a marvellous staircase in which people pass one another without ever meeting.

A château with no equal, and intended as such from the beginning, Chambord could not have any great influence on French architecture. The centralized plan recurs in very different form at Madrid and La Muette; the multiple staircases inspired the symmetrical dogleg stairs at Fontainebleau around 1540, the first of this type ever built, and the double winding staircase at La Muette.[159] These buildings are the same ones we cited in studying the influence of the Romorantin façade.

The architectural ideas introduced into France by Leonardo therefore recur only in châteaux built by François I from 1520 to 1540. For twenty years, the solutions proposed in 1517-1519 stimulated the imagination of the king's architects and inspired extraordinary arrangements that set this group of buildings apart from all other French châteaux.

Leonardo and the Architecture of his Time

The grouping together of Leonardo's architectural drawings according to certain themes and the treating of them as ends in themselves, as if they had been projects, without taking account of the artist's other preoccupations, leads to inevitable simplifications. But this rather stark spotlighting does allow us to make more sense of the "œuvre" as a whole and to situate it within its historical context.

Leonardo's exact position remains nonetheless hard to define, for he is an artist that cannot be fitted into the "mainstream" of Italian art, anywhere from the Florentine and Milanese experiments to the full blooming of the High Renaissance in Rome. Heydenreich's commentary — the most penetrating of all — is impaired by this type of historical interpretation. In spite of his avoidance of oversimplifications and his deliberate stressing, of the "seismographic" character of Leonardo's creations,[160] the great historian still finds it necessary to credit the artist with a crucial role in the changeover "from the fifteenth to the sixteenth century": for him, Leonardo's drawings are important

precisely because they are forerunners of St. Peter's, the Caprini palace, the Te palace, the vestibule of the Laurentian library or the façade of the Gesù.

But the real situation seems to us somewhat different. First of all, Leonardo's interest in architecture was not constant. Of the total of 113 sheets of drawings that we have referred to in this study, fifty-nine belong to the period between 1487 and 1490: at this time the artist was deeply preoccupied by structural problems, the centrally planned church, urban circulation, fortifications and multiple staircases. The Leonardo of this period was like a new Brunelleschi: a logical and daring spirit, capable of drawing all the conclusions imposed by his own principles. In fact, the highly systematic character of the solutions he proposed and the clearness of his drawings suggest that he intended to rival Alberti by writing a new type of treatise, conceived rather like an album of models. After 1490 (perhaps as a result of the failure of the tiburio projects) and until 1506, Leonardo's original propositions were rather scarce (six sheets noted by us), although this does not mean that he did not play an active role as a consultant architect. The early years of his second stay in Milan were, by contrast, productive (seventeen sheets): encouraged by the requests of Charles d'Amboise and the admiration of his new patrons,[161] Leonardo drew villas, castles, churches and staircaises. During the years that followed, his interest in architecture diminished (five sheets): it gained notable new stength, however, from 1515 onwards (twenty-six sheets), as if his visit to Rome and the proximity of Bramante and Raphael, followed by the warm welcome he received in France, spurred on his will to create.

The discontinuous character of these investigations, together with the fact that the projects were never executed and hence were never "put to the test", explain that Leonardo's ideas demonstrate no real evolution, but rather a series of limited shifts of interest. In fact, most of the solutions he proposed during the 1487-1490 period reappear later on: centrally planned churches reoccur until 1517 (albeit with diminishing frequency); the town irrigated by canals reappears in 1508 and again in 1517-1518; multiple staircases are still a concern in 1506-1508 and also later, in 1518-19, when he makes use for Chambord of an arrangement first studied thirty years earlier. Even the circle-on-circle arches planned for the tiburio can be seen in a drawing from 1517! However, two themes did not become really important until after 1506: the open architecture employed first for villas and later on for the royal palace, and the centrally planned castle which seems to have supplanted the church and to have become a major preoccupation around 1513[162].

Leonardo's "language" also changed from 1505 onwards, as the result of the influence of Bramante's Roman works; these clearly made quite an impression on him, for we find in his drawings traces of the Tempietto, the Caprini palace, the Belvedere and the Palazzo dei Tribunali. But this change did not constitute a conversion to a new style; till the end of his life, the artist remained close to the concepts of the early Renaissance: the complex interplay of volumes and the lively vertical forms which he had admired so much in northern Italy. The architecture of the Milanese and Venetian regions (which he certainly knew before 1500) had forever conditioned his architectural vision; indeed, he was so strongly influenced by it that several drawings from his last years are still reminiscent of San Lorenzo, the tiburio of the cathedral and the duke's castle.

In contrast to Bramante, Leonardo did not find new ideas and forms in the ruins of Rome. He did not invent palaces with orders and rustication or the enormous supports and massive vaults typical of St. Peter's; nor did he ever design grand compositions in the antique style, as exemplified in the Belvedere. Furthermore, his investigations of "strong and light" arches, of churches with clustered cupolas, of cities with independent thoroughfares, and of centrally planned castles, held no interest for

Fig. 346. The castle at Chambord: the double staircase in the middle of the cross-shaped halls.

the new generation; only the symmetrical dog-leg staircase seems to have captured Sangallo's attention for a while. Ultimately, Leonardo's central plan studies were the only ones to exert a real influence, and this through Bramante: the spatial design and the ambulatories of St. Peter's have their roots, if not their model, in the drawings from the 1487-1490 period.

It seems to us, then, that Leonardo occupies a special position in the history of Italian architecture. The indirect role he played in the genesis of St. Peter's, the remarkable but rare drawings he executed in the new style — the centrally-projecting arch, the two-pedimented door, the church façade — are not sufficient to make this artist one of the creators of the High Renaissance. His most brilliant inventions (the cluster-domed church, the two-level city, the multiple staircase, the square castle with set-back levels, the villa with a tiburio and the belvederes of the Villa Melzi), herald the arrival of a different type of architecture, lively, unusual, functional and in complete contrast to the Roman "grand manner".[163]

On the other hand, the characteristics which led to Leonardo's isolation in Italy, assured his success in France. The artist did not introduce new forms into this country, where architecture evolved through the selective assimilation of elements borrowed from Italy; but he brought with him new ideas, which pleased the king and which could be executed by using architectural forms adapted to the national taste.

François I's projects — a royal town and a château with no equal — gave Leonardo the opportunity to examine one last time the themes so dear to his heart: the canals of the two-level city were transformed into a place to put on shows in front of the palace's open façade, and the multiple staircase became the axis of a centrally-planned castle. To use Carlo Pedretti's term,[164] we can say that Leonardo's "apotheosis" took place in France, far away from Rome or Florence; the tortuous path traced by this artist ended unexpectedly in a "meeting" with a new milieu which was not altogether alien to him and with a young prince full of enthusiasm and imagination, far better able to understand him than Leo X.[165]

These remarkable affinities explain why the only project Leonardo ever realized was the last one and why, today, one must go to Chambord and stand at the bottom of the double staircase, in the middle of the cross-shaped halls (Fig. 346), to understand what Renaissance architecture "according to Leonardo" could have been: an art in which the most rigorous logic is fused with an imagination that knows no bounds.

II.3

Leonardo as Urban Planner

by
Luigi Firpo

1. Realist or Visionary?

Until the early 1960s most of what was written about Leonardo consisted of florid verbiage celebrating the romantic, picturesque aspects of his work, or conventional eulogies of the man's universal genius and sublime dilettantism. The bewildering number and complexity of Leonardo documents led to the most arbitrary theories and a wide divergence of opinions concerning his work as an architect, until Gerolamo Calvi began a genuinely systematic reading of Leonardo's notebooks and sheets. By transcribing the writing as well as interpreting the drawings and dating the folios, Calvi attempted to relate each piece of evidence to a specific experiment or idea, proving that the material, if studied with "persistent rigour,"[1]* provides clear, indisputable proof of Leonardo's intentions. That this is the only proper course to follow has been further demonstrated in recent years by the lucid, systematic and extensive research carried out by Carlo Pedretti.[2]

One of the main reasons for disagreement among Leonardo scholars was the subject itself: could Leonardo be considered an architect in the true sense? Some saw him as an impractical dreamer who drew imaginary buildings, a hobbyist whose theories and plans were pure hypotheses. Others found in his folios "embryonic ideas, imaginative compositions perhaps conceived as the background of a painting, but no concrete, feasible designs". But Leonardo's work does include analytical studies and detailed plans for buildings of different sorts, elevations, cross sections and ground plans of mansions, churches, houses, villas, fortresses, stables, laundries and baths. And one cannot dismiss as a visionary a man who studies and designs joinery, scaffolding, composite beams, supports for arches and vaulting, roof and wall coverings, lead tiles and sheeting, basins and canals, harbours and breakwaters. The pages of Leonardo's notebooks show sketches of fireplaces, wash houses, locks, lavatories, mechanisms for security locks; we also find studies of stone, mortar, timber, the resistance of pillars and columns, of arches and roofs, the cracking and erosion of walls, of recesses and galleries, of land subsidence and even of anti-seismic foundations. There are volumetric calculations, tools, machines

*The notes of chapter II.3 are on page 328.

287

for dredging and digging canals, for transporting stone blocks or heaps of smaller stones, for hoisting and placing blocks and columns. Faced with this mass of material, some scholars treat it as a series of undeveloped projects, of fascinating but short-lived explorations, a random assortment of irreconcilable and unrelated ideas, underlining the fact — which remains indisputable — that we know of not a single fragment of an actual building that can be confidently attributed to Leonardo. In their opinion, his was a speculative intellect intent simply on establishing precepts, on elaborating abstract theories on statics, resistances and thrusts, modelled on the treatises of Vitruvius, Alberti or Filarete, and the solid individual buildings he depicted are to be considered merely as tiny models to be fitted one by one like toys into the complex design of some imaginary perfect city. For these critics Leonardo's overriding theoretical interest in architecture, which might have found an outlet in the drafting of a systematic architectural manual, remained merely a "luminous fantasy" of drawings which are the fleeting, impossible dreams of an architectural visionary.

The reality, in view of the evidence we possess, is quite different. It is undoubtedly true that there exists a nucleus of notes which seem from their correlation and content to have been intended for a theoretical treatise, but these are exclusively concerned with the problem of statics and the uses of building materials. This was a normal process of crystallization for Leonardo whenever his accumulated jottings about devices, solutions, the secrets of his innumerable trades, began to cohere into a system. But this almost miraculous ability to focus on and analyze unifying theories went hand in hand with Leonardo's pursuit of an ideal, simultaneous and total knowledge from all possible viewpoints gathered into one enormous encyclopaedic synthesis. Leonardo was a theorist in architecture in the same way he was a theorist in painting, hydraulics, anatomy, mechanics, geometry or ballistics — that is, he postulated theories by drawing on a myriad of technical or functional subjects of interest to him, while never neglecting his artistic research. Knowledge is boundless, unique, full of infinite hidden links that — in their reaffirmation of the indivisible unity of all things — remain unaffected by the innumerable artificial divisions dear to pedagogues.

In his notes for a treatise he planned to write on hydraulics, compiled around 1505, Leonardo expresses his intention of writing "a book on building or rebuilding bridges over rivers". This is a subject clearly linked to the science of construction and to architecture, while two other books he hoped to write were directly concerned with urban planning: one "on diverting the flow of rivers, so that they do not run through cities", and the other "on ensuring that the waters and beds of rivers which run through cities are kept clean"[3].

But this treatise would have been useful only to a builder, not to a scientist, much less an artist. Most of Leonardo's architectural drawings either depict structures, buildings or ornamentation actually in existence at the time — and the difficult task of identifying the originals is not yet complete — or are designs for buildings planned with absolute realism. In some cases the latter were drawn up for real patrons with a view to immediate construction; in others he was committing to paper for his own interest ideas for more ambitious and grandiose projects, which were nonetheless perfectly feasible from a technical point of view.

In order to grasp Leonardo's realism, let us dwell for a moment on the small drawing dating from 1502 that depicts his grandiose project for a bridge to span the Corno d'Oro, the Golden Horn at Constantinople. A brief explanation accompanying the drawing (Fig. 347) underlines the boldness of the project — the bridge was to be twenty-four metres wide, 360 metres long and forty metres above sea level at the highest point of the span. The sketch of the ground plan and the perspective view of the bridge show the access ramps opening out into a fork to withstand the force of the crosswinds,

Fig. 347. Paris MS. L, f. 66 r. Leonardo's project
for the Pera bridge.

and include a high-masted ship, also shown from above and in profile, sailing gracefully under the single span which has a chord length of 240 metres.[4] Leonardo's well-known interest in the Islamic East was probably stimulated by his Florentine friend Benedetto Dei, a merchant and political agent who had lived for a long time in Constantinople before returning to Milan, where he resumed his friendship with Leonardo and died in 1492. This interest of Leonardo's in the Orient was considered to be merely a fanciful love of the exotic, as unrealistic as the grandiose "dream" of the "bridge from Pera to Constantinople", until the discovery in 1952 among the archives of the Serraglio of an astonishing letter from Leonardo to the Sultan Bajazet II in which he outlined this project, together with others for mills and other mechanisms, all realistically thought out and immediately feasible.[5] Leonardo must have realized that to persuade the Sultan to embark on a venture that was destined to fail would be to risk his own neck!

Besides, it is difficult to believe that the man asked to supply models and advice for the tiburio of Milan Cathedral or for the Cathedral of Pavia was a mere peddler of insubstantial architectural projects devoid of reliability and common sense. To understand Leonardo's proud awareness of his professional skill, his longing for it to be put to the most demanding tests, one has only to read a few lines of his letter to Lodovico il Moro in which he proffers examples of his technical capabilities: "in time of peace I believe I can give perfect satisfaction to equal any other in architecture and in the composition of buildings, public and private; and in guiding water from one place to another"[6].

Why was it, then, that out of so many projects not a single one was realized? On the psychological level it has been said that what Leonardo lacked was not realism in his designs but "professional energy, the craftsman's ability to immerse himself completely in carrying out a job of work". It is significant that throughout his whole life futile proposals and unfinished works recur, from the *Adoration of the Magi* to the Sforza "horse", from the *Battle of Anghiari* to the Trivulzio monument. But it must be remembered that Leonardo was unlucky in his dealings with the powerful. Had it not been for the rapid ruin of patrons such as Lodovico Sforza in Milan, Cesare Borgia in Romagna, Giuliano the Magnificent in Florence and Rome, they might have provided Leonardo with the financial means and the political security essential to bringing great buildings to fruition.

Leonardo the architect, then, lives only in his drawings. But it is important to remember as we look at them that these buildings were imagined not merely as castles in the air but as forms with a functional beauty intended to be executed in marble, in stone, in brick, and to stand among living men in the hearts of cities.

2. Leonardo and the Urban Planning Projects for Milan

Some of Leonardo's most avant-garde, brilliant architectural concepts were in urban planning. However, the ideas contained in these sheets demand a rigorously critical reading, and in order to do this it is necessary to clarify a few points at the outset. First of all, most of Leonardo's notes and drawings on this subject are contained in Paris MS. B and date therefore from one particular period in his life, around 1490. This material makes definite reference to the socio-political requirements of the Sforza regime. The analogies that have been made with several drawings from Leonardo's later life connected with the plans for the royal palace at Romorantin are purely adventitious: very little similarity can be postulated between a populous city, or at least a whole urban district, swarming with movement and traffic, and the restricted purlieus of a luxurious castle built to house courtiers and servants.[7] Similarly, the alleged town-plan of Florence (RL 12681 r: Fig. 348) — with its almost regular ten-sided perimeter, the altered course of the river Arno and the network of main streets at right angles to each other — may have been inspired by a desire to impose order on a chaotic mediaeval conglomeration, but it is even more likely, as Kenneth Clark suggested, that it represents a simplified outline done from memory in Milan after 1506.

Fig. 348. RL 12681 r.

As for the drawings in Paris MS. B, I am unable to discern in them, or in the accompanying notes, the abstract, rigid dogmatizing seen in them by certain scholars, who consider them to be notes for a theoretical treatise, the dreams of an idealist pursuing impossible, utopian fancies. Undoubtedly, lack of means, political unrest, and the backwardness of the times made it very difficult to carry out Leonardo's plans at that period. It is also true that Leonardo himself was ultimately responsible for the collapse of his hopes: his ideas were perhaps too bold, complex and subject to change, and he was temperamentally incapable of implementing them patiently and methodically. But none of this invalidates the originality and solid worth of Leonardo's plans, which spring directly from an observation of the social malaise in the overcrowded cities of the period and constitute a direct response to real problems. One has only to compare Leonardo's projects with the monstrous, megalithic oddities dreamed up by Alberti, or with the simplistic abstractions and academicism of Filarete's or of Francesco di Giorgio's plans for many-sided cities with streets radiating from a fixed centre, to realize that Leonardo had his feet firmly on the ground. If anything, he was faithful to the technical and practical criteria of Vitruvius. He did not attempt to distort reality by fitting it into preconceived schemes, but only to combat confusion and anarchy, to give back to man and to the cities of men order and dignity, rescuing them from chaos, squalor and unrest. Architects attempting to create an ideal city had up to this time concentrated on a single building — a palace or a church, a convent or a market, a prison or a mint — and then fitted these finely finished models into the complex geometric schemes of urban layouts. Leonardo, on the other hand, did not attempt to solve isolated problems in his town-planning projects, even though he designed many buildings individually for specific functions. He did not care what sort of structures would occupy the sites he leaves in his designs for that purpose, so long as they left undisturbed the overall balance and function of his plan, the complex network of communications and services which are, as it were, the arterial system through which the city's life blood must flow. In this respect he was undoubtedly the first real urban planner in the modern sense, foreseeing solutions that would only be implemented much later and with great difficulty. It should be remembered that it was not until 1492 that Lodovico Sforza demolished the slums of Vigevano to create the Piazza Grande, that the "Addizione Ercole" at Ferrare, designed by Biagio Rossetti, dates from the same year, and that Bramante did not begin the layout of the apostolic palaces and of the Via Giulia in Rome until 1505.

The feasibility and practicality of Leonardo's plans derive from genuine feeling and political rather than aesthetic reasoning. Between 1484 and 1485 he saw 50,000 people — a third of the population of Milan — die of the plague. This sensitive, solitary artist, brought up in crowded Florence and then moving to an appallingly overcrowded city like Milan, was horrified by the lack of privacy, the disorder, noise, filth and overwhelming stench in the narrow twisting steets and the huddle of slums where the common people were crammed together "like herds of goats".[8] He developed a loathing for the old-style mediaeval city — anarchic, shapeless, chaotic, jammed full of ramshackle impermanent buildings, slow-moving vehicles and filthy crowds — a city suffocating in its strait-jacket of walls which suppressed natural demographic forces, prey to devastating epidemics that spread like wildfire through the fetid, unwholesome air. Leonardo has left us an adaptation of an allegorical fable with a melancholy tone:

> A stone of some size recently uncovered by the water lay on a certain spot somewhat raised, and just where a delightful grove ended above a stony road; here it was in the company of delicate grass, and was adorned by various flowers of diverse colours. And as it saw the great quantity of stones collected together in the roadway below, it began to wish it could let itself fall down there, saying to itself: "What have I to do here

with these plants? I want to live in the company of those, my sisters". And letting itself fall, its rapid course ended among these longed-for companions. When it had been there some time it began to find itself in constant travail under the wheels of the carts, the iron-shod feet of horses and of travellers. This one rolled it over, that one trod upon it; sometimes a piece of it fell off, sometimes it was covered with mud or the dung of some animal, and it was in vain that it looked at the spot whence it had come as a place of solitude and tranquil peace. Thus it happens to those who choose to leave a life of solitary contemplation, and come to live in cities among people full of infinite evils.[9]

Leonardo did not invent this fable himself: it had already appeared in elegant Latin, in the *Intercoenales* of Alberti (1404-1472), inspired by the dialogues of Lucian and collected in ten books around 1450. But the story in question (Book III, *Lapides*) remained unpublished until 1964, and it is possible that Leonardo took it from some other, as yet unidentified, source.[10] In any case the "moral" is different. Alberti stresses the importance of contemplative solitude, free from worry and thankless duties ("*per otium et quietem consenescere in libertate*"), whereas Leonardo, while praising solitude and tranquil peace, the life of solitary contemplation, and lamenting that he has lost this vocation, emphasizes the intolerable confusion and disorder of the filthy, crowded city which he is obliged to endure as a man involved in active life.

To liberate the people from these "infinite evils", Leonardo suggests radical, almost surgical, remedies: demolition, slum clearance, spacious courtyards and streets, running water, sanitation, moving people from the working-class districts to rural areas, the building of numerous noble residences to beautify the capital. The city walls were to disappear, together with the very concept of the fortress-city, the menacing stronghold that protected the sovereign and his dominion. Without these stone barriers, once erected to withstand sieges, city life would take on a peaceful aspect, as if portending a more widespread political security and a transition from tyrannical regimes to the modern state. To encourage — indeed to compel — the wealthiest families in the duchy to build palaces in Milan, which would both embellish the metropolis and place their inheritance in the power of the Duke, Leonardo thought of a magnificent and also coercive plan for the city. Its main elements, from what little we can glean from the rough draft of a letter to Lodovico il Moro that has been preserved, essentially comprised an insistence on "beauty" or dignity, and the particular importance of a network of canals of flowing water running through the whole city. This is the text of the notes for the petition to the Duke, in which we can glimpse a flash of tough Machiavellian political thinking:

> Give me authority whereby without any expense to you it may come to pass that all the lands obey their rulers... The first renown[11] will be eternal together with the inhabitants of the city built or enlarged by him. All communities obey and are led by their magnates, and these magnates ally themselves with the lords and subjugate them in two ways: either by consanguinity, or by fortune; by consanguinity, when their children are, as it were, hostages, and a security and pledge of their suspected fidelity; by property, when you make each of these build a house or two inside your city which may yield some revenue,[12] and he shall have from ten towns five thousand houses with thirty thousand inhabitants, and you will disperse this great congregation of people which stand like goats one behind the other, filling every place with fetid smells and sowing seeds of pestilence and death.
>
> And the city will gain beauty worthy of its name[13] and to you it will be useful by its revenues, and the eternal fame of its aggrandizement.
>
> To the stranger who has a house in Milan it will often befall that in order to be in a more imposing place he will go and live in his own house; and whoever is in a position to build must have some store of wealth, and in this way the poor people will become separated by such settlers...[14] And the revenue will increase and the fame of it increase. And even if he should not wish to reside in Milan he will still remain faithful, in order not to lose the profit of his house at the same time as the capital.[15]

Dating from the same year, 1493, is a brief, incomplete plan of Milan (see Fig. 291), sketched in red chalk, showing the four city gates and the convent of San Pietro a Gessate located outside the gates.[16] Leonardo indicates by two concentric half circles the mediaeval walls — the stifling boundary of the existing city — and an enlarged perimeter, destined for the new sites to be built upon. Smaller, more detailed plans show the uniform repeated outlines of the new adjoining sites, which are trapezoidal in shape to fit between the radiating spokes of the major streets and waterways, while the inner edge follows a slightly curved line to follow the circular layout of the defensive moat. The latter, no longer serving as a defence, becomes a branch of the Naviglio canal which feeds it, while its waters are also diverted into the new lots to irrigate gardens and fish farms. In the centre of another small plan we find the word "*Spesa*", probably to indicate a space reserved for the marketplace.[17]

But any plan for urban renewal in Milan had to take into account the network of small rivers (the Nerone and Seveso) and of artificial canals that ran through the city. Leonardo, who was passionately interested in hydraulics, gave much thought to the problem of maintaining these waterways, which were as valuable for commerce as they were for sanitation. Indeed, he remarks on the same sheet:

> Let the bottom of the reservoirs which are behind the gardens be as high as the level of the gardens, and by means of discharge-pipes they will be able to bring water to the gardens every evening every time that it rises, opening the sluice-gates half a *braccio*; and let the senior officials be in charge of this.
> And nothing is to be thrown into the canals, and every barge is to be obliged to carry away so much mud from the canal, and this is afterwards to be thrown on the bank.
> Construct in order to dry up the canal and to clean the (lesser) canals.
> The municipality of Lodi will bear the expense, and keep the revenue which once a year it pays to the Duke.[18]

In the same year, 1493, Leonardo wrote in one of his notebooks:

"Let nothing be thrown into the canals, and let the canals go behind the houses".

And again, in two notes for a petition to Lodovico Sforza:

> There are, my Lord, many gentlemen who will undertake this expense among them, if they are allowed to enjoy the use of admission to the waters, the mills, and the passage of vessels, and when it is sold to them the price will be repaid to them by the canal of Martesana.
> May it please you to see a model which will prove useful to you and to me, and it will also be of use to those who will be the cause of our usefulness.[19]

It is known that Lodovico Sforza had ambitious ideas for urban renewal. One of his decrees, also dating from 1493, conceding expropriation to landowners wishing "*laute edificare*", that is, to build in a sumptuous manner, encouraged the grandeur and dignity of new buildings. Lodovico was certainly not indifferent to the obvious advantages of the scheme that Leonardo pointed out: ensured obedience from his subjects, the glory of being a great builder, the cleaning up of the city, increased tax revenues, the return to the capital of the wealthy classes and the consequent strengthening of the unity of the domain and the prestige of its overlord. But the political climate was becoming stormier and was soon to unleash a tempest that would sweep away not only Leonardo's plans but the very independence of the Sforza regime.

About fifteen years later, under the new French rule, Leonardo resumed his study of the map of Milan and its network of waterways, with reference to the projects for canals to be incorporated into the proposed villa of Charles d'Amboise. He drew up two new plans: the first (Fig. 349) restricted to one half of the city perimeter,[20] the second (Fig. 350), on the back of the first, extending to cover three

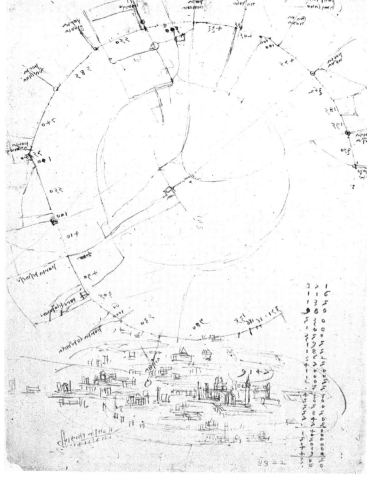

Fig. 349. CA, f. 199 r/73 r–a.

Fig. 350. CA, f. 199 v/73 v–a.

quarters of the circle, with detailed explanations and a perimeter calculated at between 8,822 and 9,147 *braccia*, about five and a half kilometres. Below the topographical plan Leonardo drew a bird's-eye view of the urban installations, sketching in with rapid strokes the most important buildings, including, to the right of the castle, the large enclosed precincts of the Lazzaretto or quarantine station built by Lazzaro Palagi in 1488 to isolate those suffering from contagious diseases.[21]

3. Canals and Streets

The most brilliant and logical of Leonardo's urban planning schemes is, however, the one preserved in the very precise drawings in Paris MS. B, datable between 1487 and 1490. These drawings may be divided into two distinct groups which, although they share certain similarities, essentially belong to two different projects: on the one hand the river city, and on the other the city built on different levels. Folio 38 r (Fig. 351) shows two rough sketches for the first project, with lengthy explanatory notes. At the top is a schematic plan of the city, square in shape with a grid of lines intersecting at right angles in a checkerboard design. These lines do not represent streets, but rather a network of waterways, as the heading makes plain: "System of canals for the city". The drawing to the left shows more clearly a system of parallel canals intersecting crosswise with each other and linked to a main

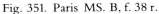

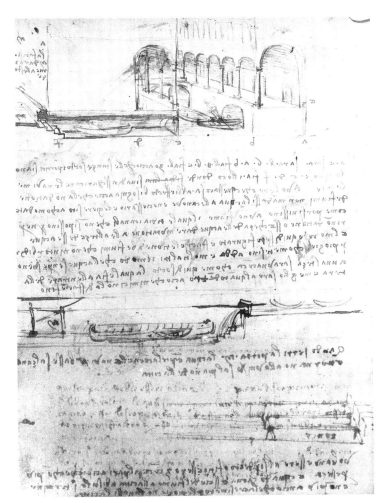

Fig. 351. Paris MS. B, f. 38 r.

Fig. 352. Paris MS. B, f. 37 v (detail).

canal, thus ensuring the flow of water. This larger waterway is separate from the urban system of canals, and runs at a significantly higher level. The caption on this drawing reads:

> Main canal, so that when necessary one can have the whole river go through it, that is, when the river is too swollen; and close the other entrances so that the river will not go through any other canal.

The full explanation on the right-hand side of the sheet clarifies the concept:

> One needs a fast running river to prevent unwholesome air produced by stagnant waters from polluting the air of the city; and the running water is also convenient for cleaning the town frequently once the lock below that town is lifted; and with rakes and hooks one can remove the mud which has accumulated at the bottom of the canals and which may cause the water to become turbid. And this should be done once a year.
> Let the level of the cellars be three *braccia* higher than the surface of the water of the canals, and they should slope toward the canals, so that if a flood should come, the water will run off and leave the cellars clear.

The support or lock mentioned in the text was to allow the cleansing of all the canals by a swift rush of water, to prevent unhealthy stagnation and to permit the removal of muddy deposits and jetsam, which would be dredged from the bottom with rakes and hooks. This cleansing operation could be made even more thorough by opening the sluice-gate planned up river from the city, which served the dual purpose of a lock to regulate the water level and of a reservoir which could release a sudden torrent of purifying water. Since the river is specifically named as the Ticino ("Tesino"), this is

295

evidently not a plan for Milan but more probably for Vigevano, the town Lodovico was most concerned with improving and which was near the Sforzas' country residence.

Folio 37 v of Paris MS. B (Fig. 352) depicts an important detail of the same project: in the foreground two houses, with arcades a little less than five metres wide supported by pillars and arches, overlook a canal. The latter is of remarkable width — eighteen metres — to ensure light in the area shaded by the arcades. The passageway under the arcades is 3.6 metres above water level, so that boats may easily pass under the bridges and along the connecting canals which run under the houses, allowing merchandise to be unloaded directly at the level of the cellars. The lengthy caption explains:

> The surface *a M* will reflect light into the rooms; *a e* will measure six *braccia*, *a b* eight, *b c* thirty, so that the rooms under the arcades will be well lit; *c d f* will be the place where the boats unload into the houses. For this to be effective it is necessary to choose a convenient site close to a river so that floodwaters do not penetrate into the cellars. The river would run into canals where the water level would remain constant whether the river was in spate or low. The way to do this is shown below; a good river, one that does not become turbid from the rain, must be chosen, such as the Ticino, the Adda and many others. The method of maintaining the water level constant will be by means of a lock, like the one shown below, which should be made at ground level, or even better, below ground level, so that enemies cannot destroy it.

This plan does not relate to a definite location, since the Adda and other clear rivers run alongside the Ticino, but the structural details are clear, and Leonardo also depicts the triple locks with watertight gates which adjust the level of the river to the lower level of the town canals. The text describes the closing of these as follows:

> When the gate *M* closes, water fills the lock and the boats rise to the level of the city.
> To carry out the above-mentioned operation there should be three identical locks, so that when the water flows from the river to the city more rapidly, it may be kept back by this initial barrier, so that the city will not be flooded when the river is swollen with rain.

For all his foresight, there is no indication that Leonardo went so far as to incorporate means of adapting to changes of weather into this dense network of waterways. His object was to provide a unified system for sanitation and drainage and to confine the carrying of merchandise to boats and floating craft, keeping pedestrian traffic separate. Both concepts clearly derive from Filarete, who in his plan for an ideal city had provided waterways along the streets and squares to facilitate transportation and clear away waste; but in Leonardo's sketches there is a more radical solution, with arcades giving directly on to the canals, so that no animals, whether riding horses, draught or pack animals, would have access to the city area.

The absolutely revolutionary nature of this proposal, which would make obsolete all the usual means of transport, was the starting point for a later plan for a city with two levels of streets or passages. The new project allows for a series of "upper" streets bordering the façades of the *palazzi* or mansions with their usual line of arcades. These streets, running at the *piano nobile* or second-storey level of the buildings, would be prohibited to all vehicles and reserved for "gentleman" pedestrians. At extended intervals of about 180 metres, connecting cross streets supported on high arches run above the underlying network of "lower" streets which run at ground level. It is these lower streets, extending behind the *palazzi* at the level of the courtyards, the stables and the storehouses, which carry the traffic of provisions and merchandise, the noisy carts, the smelly beasts, the whole swarming proletarian world of work and commerce. In this scheme Leonardo abandoned the notion of using waterways for transport. The canals have a purely hygienic function, and he conceived an ingenious plan for a network of interconnected conduits running underneath the "upper" streets and draining off

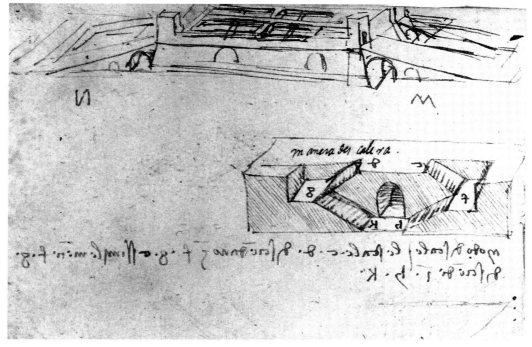

Fig. 353. Paris MS. B, f. 15 v (detail).

the refuse and waste from the residences as well as rainwater. For the same reason the surface of the streets above slopes sharply towards a central gutter with numerous drain holes to allow run-off into the canal below, and also to allow some light on to the canal from above.

A sketch at the top of folio 15 v (Fig. 353) gives a view of the entire city, which appears almost like one single immense building with square towers at the corners and surrounded by a moat into which the covered canals flow through large arches. Inside, one glimpses the rectangular intersecting network of the two levels of streets, the lower and the upper. From each of the four towers at the upper level a long sloping ramp supported by arches runs out towards the countryside outside the city. The first of these supporting arches, a particularly wide one, spans the moat, which would indicate that Leonardo initially intended to allow vehicles and saddle horses access to the upper level.

The second of the sketches also seems to be a first draft which was later amended. It depicts a "system of steps" to connect the two levels, consisting of a double staircase with two flights with the caption: "The stairs *c d* go down to *f g*, and similarly *f g* goes down to *h k*". This must be a note from the first version since Leonardo immediately afterwards rejected these square steps (for reasons of hygiene and perhaps also because they were awkward) and turned to "snail-shaped" or spiral staircases.

An interesting drawing on folio 19 v (Fig. 354) shows the vertical section of a mansion with three floors, the lowest of which is underground and supports at the second-storey level a hanging garden, separated from the main building by an arch and supported by the earth left over from digging the foundations. This design does not necessarily belong among the plans for the ideal city, but it shares with the latter the basic concept of separate levels. Leonardo notes: "The earth that is dug out from the

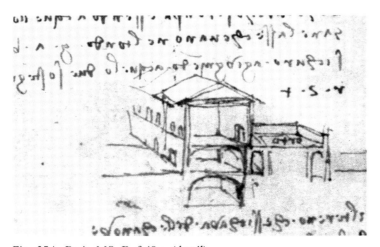

Fig. 354. Paris MS. B, f. 19 v (detail).

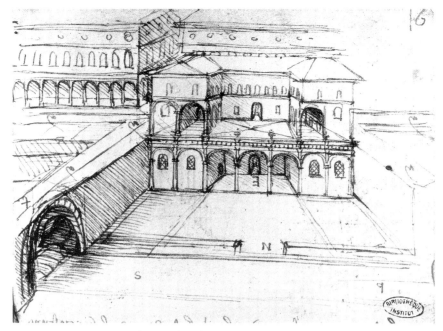

Fig. 355. Paris MS. B, f. 16 r (detail).

cellars must be raised on one side so high as to make a terrace garden as high as the level of the hall; but between the earth of the terrace garden and the wall of the house leave an interval so that the dampness does not destroy the principal walls".

On folio 16 r (Fig. 355) we find a beautiful design for a nobleman's house, showing the details of the connections between the two street levels. The drawing shows the upper steets at the level of the second storey with its interior courtyard-terrace raised on pillars, together with the arcades that line the streets. The drainage holes in the street are indicated by a continuous line along the street which is shown foreshortened to the left, while the slope towards the centre line of the street is faintly marked by a wide V sign on the corresponding street to the right. On the level below can be seen the main courtyard, separated from the lower street by a low wall with a gateway for carriages. A long explanatory note takes up the bottom half of the page and continues on folio 15 v, because Leonardo, in conformity with his "backwards" handwriting, wrote in his notebooks starting from the end and going backwards toward what for us is the beginning:

> The streets *M* are 6 *braccia* higher than the streets *P S*, and each street must be 20 *braccia* wide and have 1/2 *braccio* slope from the sides towards the middle; and in the middle let there be at every *braccio* an opening, one *braccio* long and one finger wide, where the rainwater may run off into hollows made on the same levels as *P S*. And on each side at the extremity of the width of the said road let there be an arcade, 6 *braccia* broad, on columns; and understand that he who would go through the whole place by the high-level streets can use them for this purpose, and he who would go by the low level can do the same. By the high streets no vehicles nor similar objects should circulate, but they are exclusively for the use of gentlemen. The carts and burdens for the use and convenience of the inhabitants must go by the low ones. One house must turn its back to the other, leaving the lower streets between them. Provisions, such as wood, wine, and such things, are carried in by the door *N*, and privies, stables, and other fetid matter must be emptied away underground. From one arch to the next must be 300 *braccia*, each street receiving its light through the openings of the upper streets, and at each arch must be a winding stair on a circular plan because the corners of square ones are always fouled; they must be wide, and at the first vault there must be a door entering into public privies; and the said stairs lead from the upper to the lower streets and the high-level streets begin outside the city gates and slope up till at these gates they have attained the height of 6 *braccia*. Let such a city be built near the sea or a large river so that the waste of the city may be carried off by the water.

A similar attention to detail is found in the drawing on folio 36 r (Fig. 356) which shows the vertical section of a three-storeyed nobleman's mansion with arcades giving on to an upper street and

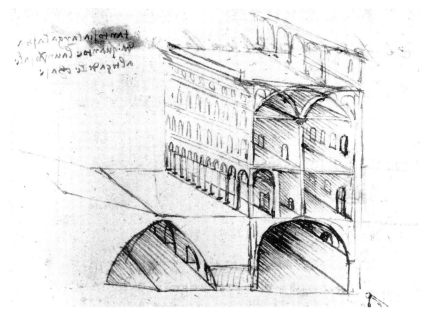

Fig. 356. Paris MS. B, f. 36 r (detail).

crowned by a flat terrace roof with a parapet and a covered loggia. What is noteworthy here is the width of the street (the caption above states: "The street should be as wide as the houses are high"), and the noticeable slope of the street-level ground floor towards the drain holes of the gutter. The canal below is connected by tunnels to the large storerooms of the lower level and to the cellars of the building.

On folio 37 r (Fig. 357) is a rough sketch of the component parts of the urban structure, demonstrating a wealth of different possibilities for interconnections. On the right is drawn an upper street (marked *a*) flanked by arcades, with the drainage holes to the canal below clearly indicated, as is the accentuated slope, particularly noticeable at the point where the street intersects another "upper" street at right angles to it. The cellars of the buildings are marked *b* and *c*, the courtyards and the entrances in the linking stairways *d*, with *e* either a lower street or perhaps an open canal crossed by a bridge. The second drawing develops in greater detail a double stairway, while the rest of the sheet is taken up by sketches and notes on incendiary grenades.

It is important to note Leonardo's very real concern that buildings should be salubrious, open to

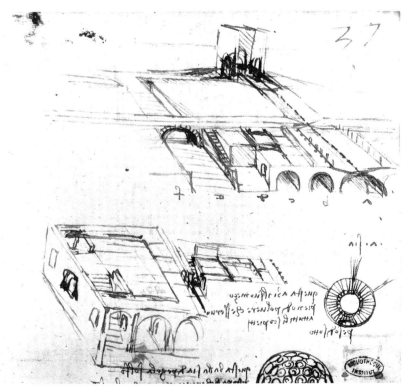

Fig. 357. Paris Ms. B, f. 37 r.

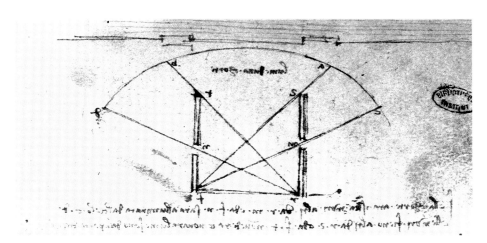

Fig. 358. Paris MS. B, f. 25 r (detail).

Fig. 359. RL 12585 v.

air and light. On folio 25 r (Fig. 358) a neat sketch shows how the light in courtyards is inversely proportional to the height of the buildings that surround them. A drawing at Windsor (RL 12585 v, contemporary with Paris MS. B: Fig. 359) carries the following advice: "The courtyard wall must be half as high as it is wide, that is, if the courtyard is forty *braccia* wide, the wall of the house should be twenty *braccia* high, and the courtyard must be half as wide as the whole façade".[22]

4. Conclusions on Leonardo as an Urban Planner

It remains to draw some conclusions from this evidence. First of all, it is not surprising that the man whose desire it was to demolish the old cities with their unhealthy overcrowding and rebuild them in more open spaces and with a new dignity, should propose totally new solutions based on concepts of cleanliness, convenience, the circulation of air and exposure to light — in short, on the creation of surroundings which would safeguard the dignity of human beings even in the midst of dense crowding. Hence Leonardo affirms the importance of breathing space, of a rigorous balance between built-up areas and free spaces, of the need for distance between monuments. It is true that he does not foresee the need for green spaces, and his straight or right-angled streets are abstractly geometrical. Aside from that of hygienic sanitation, Leonardo's most original idea is the one for separating traffic into two different localities on two levels. Here the doubtful reading of his drawings has led to some misunderstanding. A city of three levels has been interpreted as if below the lower streets there ran a third network of canals serving the function of waterways for the transportation of merchandise,

300

which would have obliged the common people to toil in damp confines among noxious sewer gases in a darkness scarcely broken by the light from open vents in the vaults above. It has been said, moreover, that Leonardo was not attempting to solve the problems — non-existent in his time — of the cross-currents of traffic or the speeding-up of circulation, but was aiming instead at a hierarchical division of the classes, motivated by his own fastidious revulsion against indiscriminate mixing, and by his search for isolation and aristocratic dignity. According to this theory, Leonardo, incapable of rising to a real ethical understanding of the equality of man, himself a slave to the social conventions of his time, conceived a cold and inhuman project, a city divided into tight, artificial compartments, "where the citizens stand in their places like horses at the hayracks of a model stable". It is thought that this man, who devoted himself so passionately to inventing machines destined to ease the toil of the working man, nonetheless cherished in his heart, as Baroni believes, a profound disdain for the "poor", and chose to invent a privileged city for gentlefolk, a hygienic, quiet place of luxury reserved for the nobility, which was none other than the inaccessible stronghold of the spirit in which he himself would have liked to live.

A more accurate reading of the drawings, however, would serve to temper the harshness of these judgements. If we reject the gloomy picture of the unfortunate condemned to labour underground, the lower level of streets has nothing humiliating or unhealthy about it: it is simply the service level for transportation and for work, which is different from the level for walking, for relaxation, for churchgoing and socializing. Leonardo says nowhere that a section of the population must actually live on the lower levels; the hierarchy remains, but it is a hierarchy of function, not of class, and discrimination, stripped of all aristocratic connotations, reverts to its true functional meaning. The fact remains that Leonardo's concept was of an aristocratic city, or rather a distinct separate district of noble mansions located in a spacious area outside the stifling walls, or at the least a grouping of residences of more or less equally well-to-do burghers, perhaps interested in an integrated and efficient transportation network that would facilitate trade, but who were seeking above all tranquility, leisure, and a more refined form of intercourse with their neighbours.

In the final analysis, what Leonardo has bequeathed to us is a rigorously technical and critical approach to the problems of urban planning. He teaches us to reject aesthetic values which have no functional basis, makes us aware of the need for integral planning with its inevitable ethical, political, and social implications. Geometrical abstractions and monumental rigidity take on life and meaning in the form of a flexible, open organism rich in dynamic possibilities, designed by an artist with limitless faith in the creative and healing power of reason.

II.4

Leonardo, Fortified Architecture and its Structural Problems

by
Pietro C. Marani

Leonardo's enduring interest in the study of fortifications is clearly attested by the large body of documentation in his own hand. At least two hundred Leonardo sheets, divided among nine codices, three miscellanies and various loose pages, have survived as visual proof of his activity in this field. Each of these sheets contains between one and twenty drawings of fortified architecture (e.g. CA, f. 120 r/43 v-a), adding up to a total of about six hundred studies or sketches. In addition to this impressive quantity of drawings, there exists a significant number of notes and texts which, while not specifically referring to fortifications, nevertheless demonstrate the theories underlying Leonardo's designs for military architecture. These latter texts are by their very nature difficult to classify, consisting as they do in many cases of scientific observations on physical forces and the movement of projectiles. In calculating the number of Leonardo texts related to fortified architecture, therefore, we could also include numerous theoretical observations, and perhaps entire manuscripts,[1*] dating from the last decade of the fifteenth century.

Indeed, considering how much of Leonardo's work has been lost, when we examine the mass of surviving material touching on this topic and the continuing interest in the field that it demonstrates, covering more than three decades of Leonardo's life from 1485 to around 1517 or 1518, the evidence would suggest that the study of fortified architecture was one of the most important aspects of his work, one to which he seems to have devoted greater enthusiasm and effort than to other fields of research. Few other topics in his entire opus show so intense a commitment. Even the anatomical studies — both scientific and artistic — which are so essential to an understanding of Leonardo's work, and which incidentally also have a bearing on his research in mechanics and architecture, are only fractionally more numerous[2] than the group of sheets relating to fortified architecture.

In comparison with the relatively few drawings that have come down to us by Francesco di Giorgio Martini, Giuliano da Sangallo, Baldassare Peruzzi, or Michelangelo, of whose actual involvement in the field of permanent fortifications we have evidence and who left notable buildings as testimony of that involvement, the figure of Leonardo, at least as a theoretician, seems much more

*The notes of chapter II.4 are on page 328.

impressive. But in reality his considerable legacy of writings and drawings must be weighed against the total absence of any military edifice that can be proven through documentary evidence to be by him. Equally paradoxical is the lack of any building of his of any sort, whether civil or religious, a lacuna which led Corrado Maltese in 1954 to coin the phrase "Leonardo's architectural thought".[3] This description, despite the progress of Leonardo scholarship and a proliferation of research including hypotheses of attribution and the reconstruction of lost designs, still remains valid, particularly as regards fortified architecture.[4] There is still, moreover, a lack of consensus on the interpretation of Leonardo's graphic legacy in general. It is necessary to establish whether and to what extent these six hundred drawings and sketches can be interpreted in whole or in part as "plans" (and if they are, to decide where they rank in the development of planning at the time), or if they are to be considered as ideas or musings quite separate from the practical requirements of defensive building — intellectual flights the artist embarked upon as a result of his other studies along similar lines. I admit that no drawing by Leonardo, much less any one of his depictions of fortified architecture, is on a level with the sort of project design his own studies helped to bring into being in the course of the sixteenth century. Some of these studies, which are thorough, highly finished works that simultaneously present ground plans, elevations, and perspective or axonometrical views, might lead us to consider the possibility that they contain the germ of a practicable plan. It is tempting to think so, but one must not generalize. It is advisable, when applying the term "project" to one of Leonardo's architectural drawings, to use it in the sense of "potential project", that is, the plan of a proposal which Leonardo himself would have liked to put into more precise, concrete form had he been given the time and the means.[5] The enormous amount of graphic material that has come down to us would not by itself indicate that Leonardo was concerned with real plans for military architecture, much less with developing the sort of innovative fortifications that were beginning to be seen at the turn of the fifteenth century, if it were not for the fact that dozens of archival documents attest to his genuine involvement in practical matters. The work he offered to carry out as architect and engineer in the service of Lodovico il Moro, Cesare Borgia, the king of France and Giuliano de' Medici[6] at various times when his help was requested, is proof of this practical involvement. Another deeply rooted presumption on the part of Leonardo scholars, one which justifies itself by going to the opposite extreme, holds that in addition to the lack of completed works by Leonardo, many of his designs were impossible to put into practice with the technology available in his time.

On the contrary, a more careful examination of Leonardo's proposals for fortifications, together with a look at his studies of building techniques, reveals the feasibility of several of his most innovative ideas. Some of the most famous fortresses, those created on principles far different from the traditional canons of mediaeval architecture and hence regarded as the most "theoretical", were built not only as a consequence of the mechanical and ballistic researches carried out by Leonardo in the 1490s,[7] but also, as I shall seek to demonstrate, in connection with and as a result of his studies of the science and techniques of building.

It is not by chance that Leonardo's early interest in military architecture coincides in time with the great architectural projects set in motion in Milan at the end of the 1480s, and in particular with his involvement, together with the greatest architects of the day, in the debate over the construction of the tiburio or crossing tower of Milan Cathedral between 1487 and 1490. For the tiburio, which was probably the largest structural undertaking in Italy at the time, Leonardo was mainly concerned with the problem of stability and the balance of weight, studying the distribution of weight and of the vertical thrust on the four supporting pillars by means of arches of variable section holding up, as has

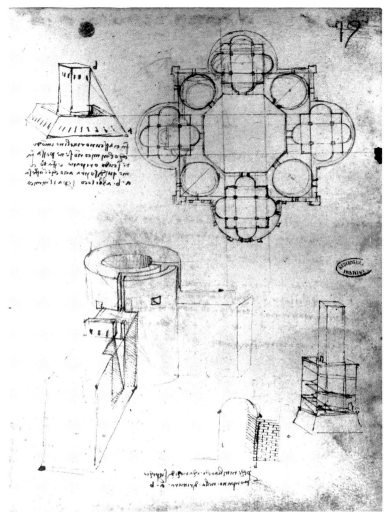

Fig. 360. Paris MS. B, f. 19 r.

only recently been proven,[8] a cupola with an octagonal dome contained within a square. Drawings such as those on folios 850 r/310 r-b, 851 r/310 v-b and 400 r/148 r-a of the Codex Atlanticus (see Figs 206–207 and 222) show how carefully he studied the ribbing of the dome and its power to distribute the weight by means of joining blocks of stone. In using this method he seems to be applying and extending the principle of trapezoidal stone blocks according to which an arch is built. In my opinion the question of the antecedents of this kind of building technique has been hitherto insufficiently studied. Is what we see here a legacy from Tuscan or Brunelleschian building methods — an attribution apparent in the attempt to create a self-supporting structure similar in conception to the one that inspired the cupola of Florence Cathedral? Or is it not perhaps an initial, immediate reflection of the northern construction techniques Leonardo could very well have become acquainted with by frequenting the largest worksites in Lombardy?[9] The latter would appear to be the most probable answer, given Leonardo's apparent preference, to be discussed later in terms of his fortification studies, for stone rather than brick as a building material, and for the arch rather than the semi-circular brick curtain wall as the most appropriate structure for supporting and distributing not only vertical weight but also horizontal and oblique weight. This use of the arch will become apparent in some of the drawings of fortifications to be shown here.

Leonardo's earliest studies of fortified architecture, those contained in the oldest of his extant manuscripts which reveal his earliest ideas on defence, are almost contemporary with his drawings and designs for the tiburio of Milan Cathedral, and can be found in Paris MS. B which can be dated

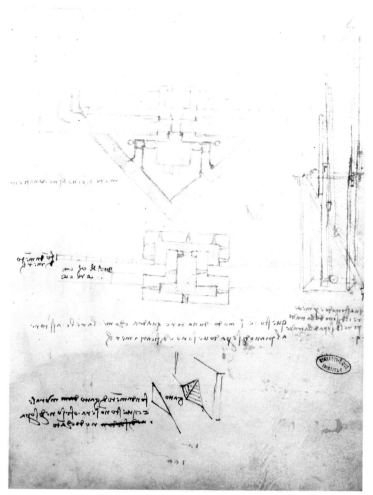

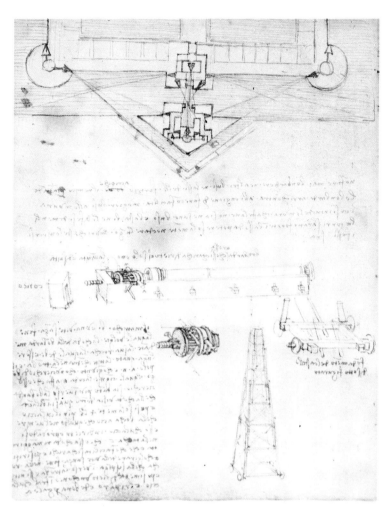

Fig. 361. Paris MS. B, f. 5 r.

Fig. 362. Paris MS. B, f. 24 v.

between 1485 and 1490. Drawings such as those on folios 12 r, 48 r, 69 r and 19 r (Fig. 360 and see Fig. 303) in the clarity of their shape and in the masterly use of technique — perspective, axonometry, cross sections, structures presented as "transparent bodies" in the manner of anatomical drawings of the same time — reflect that particular moment of transition in Italian military architecture which gave birth to the triangular bastion with sloping sides. In some cases, as on folios 5 r, 24 v and 57 v of Paris MS. B (Figs 361–363), Leonardo's drawings are very much in advance of the structures that mark the progressive introduction and perfecting of this sort of bastion in central Italy.[10] Nevertheless, from the point of view of Leonardo research these drawings remain merely "theoretical", not only because they were never put into practice but above all because in them one finds not the slightest hint of his studies on construction science such as those he made for the tiburio of Milan Cathedral, nor any connection with the practical problems of building.

Up to this point in Leonardo's work there is no study or specific investigation of the techniques for building the constructions depicted, which means that he intended to use the ordinary methods of his time. It is possible therefore that he was thinking of using bricks for the walls and stone for the supports, as in round corner towers (see for example the drawing on Paris MS. B, f. 69 r, perhaps connected with the Sforza Castle in Milan) or in rusticated towers (see f. 51 r of the same manuscript). Hence these designs, innovative though they are, were to be built using traditional methods: even when Leonardo expatiates on the structural details of some military edifice, it turns out to be an absolutely typical mediaeval castle. This is the case with some studies on Paris MS. B, folio 48 v (Fig. 364) toward the top of the page, where he depicts an imaginary fortress composed of rectilinear

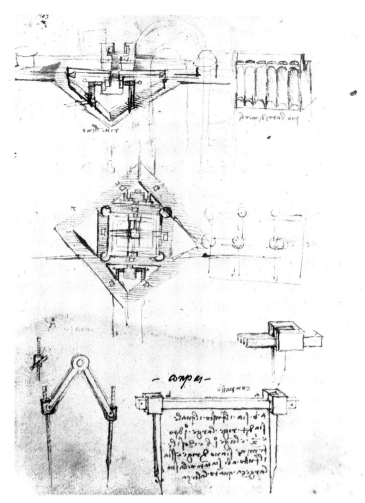

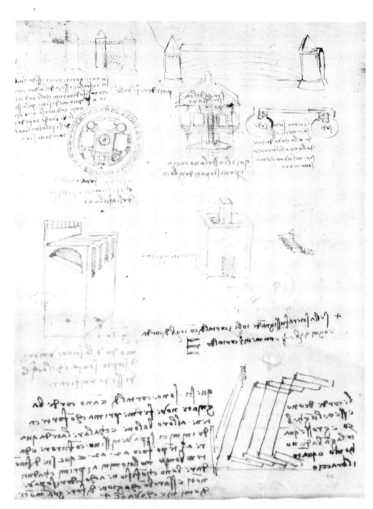

Fig. 363. Paris MS. B, f. 57 v.

Fig. 364. Paris MS. B, f. 48 v.

walls contained within cylindrical towers by means of the inclusion within the thickness of the wall of arches superimposed upon each other and "founded", that is, resting upon, a number of pillars. Leonardo himself explains:

> Let there be alternating arches within the thickness of the wall, that is, they should not be built with their bases set in one same pillar but rather in several, so that if the bombardment breaks one of these pillars the arches will not collapse. To enclose a valley.

Leonardo always had recourse to arches for reinforcing walls. On the last sheet cited we see one of the earliest applications of this principle to fortified architecture, literally "made strong" by arches embedded in the curtain wall, which as in ancient Roman architecture laterally distribute the weight bearing down on them vertically from above.

Although the technical knowledge revealed in the studies in Paris MS. B seems to follow the traditional pattern of classical and mediaeval building, an architectural scheme of Leonardo's from the

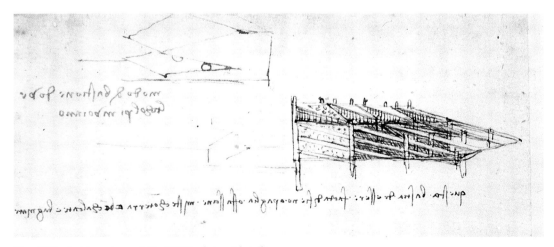

Fig. 365. Ashburnham MS. 2037, f. 4 v (detail).

same period on folio 4 v of Ashburnham MS. 2037 (Fig. 364) seems to reveal more advanced building concepts. (It is of course possible that the date of this drawing could be later than that of others on the same page.) Here Leonardo shows a "bastion were the cannon shots die" with the enemy cannon balls embedding themselves in a pointed projecting structure of very innovative design. This latter presupposes an elementary knowledge, nonetheless based on theoretical speculation, of the laws of distribution of the force of impact on the sloping surfaces of the fortress, anticipating studies and drawings in Paris MSS. I and M of almost a decade later.[11] We cannot know how Leonardo intended to build the upper part of the bastion, which projects forward toward the attacking forces and is largely suspended in mid-air. If the studies below on the same page, which deal with a bastion to be built with "hay or straw or twigs mixed with earth", have any connection with the structure, he was possibly thinking of building it with wooden beams or something of the sort. Nevertheless, its shape and structure are astoundingly revolutionary.

It is at the beginning of the 1490s that Leonardo's notes and drawings begin to reveal a greater interest in construction techniques and in methods for preventing buildings from collapsing. From 1490, possibly influenced by studying the "invalid cathedral" of Milan, he became more deeply interested in the reasons for the collapse of walls and arches, pillars and columns, in terms of the weight they bear and whether this is centred on the axes of the "supports" or is eccentric. He also analyzed the deformations to which the supports are prone. At the same time, attracted by the study of motion, impact and percussion, he devotes several notes and experiments to analyzing the effects of impact on walls, availing himself of his earlier observations on cannon balls and bombards in his studies on the art of warfare and developing the investigations begun during the period of Paris MS. B and of the Codex Trivulzianus, and possibly even before that. During the 1490s fortified architecture seems to have been the starting point and the support for much of Leonardo's research. He makes use

Fig. 366. Paris MS. A, f. 28 r.

of empirical knowledge of warfare, ballistics, geometry and mechanics, in a surprising interrelation of themes and problems, to produce eventually a "projectural" proposal in the form of a drawing. The note to a drawing in Paris MS. A, folio 28 r (Fig. 366) reads as follows: "The blow that strikes a rounded fortress and the air that at once resists it from the opposite side is the reason why this fortress will split in her flanks". Here we have a glimpse of a mind vacillating between an unconditional reliance on mediaeval schemes and formulas for architecture (the circular form), and lucid scientific reasoning, between forms laid down in the collective consciousness of his era as abstract symbols, and the physical or mechanical analyses destined to render those same forms obsolete. And it was in following this path — the study of physics and mechanics — that around 1498 Leonardo arrived at the formulation of new architectural proposals as a result of investigating the behaviour of projectiles against fortresses with sloping surfaces. Numerous drawings and notes on Paris MS. M, folio 82 v, elaborate on defensive screens formed by series of triangular salients jutting out from steeply sloping inclines.[12] Paris MS. L, which dates from 1497–1502, presents various pointed buttresses or salients with embrasures in them for throwing bombs, as do several sheets of the Codex Atlanticus. This is the moment of greatest contact between Leonardo's studies of military architecture and his geometrical studies, resulting in several cases of drawings which are similar in style and concept but different in intent. The consequences of this application of geometrical theories, which also had some symbolic significance, may be seen in the famous designs of star-shaped fortresses on folios 134 r/48 v-a and 135 r/48 v-b of the Codex Atlanticus (Figs 367–368), which are identical to geometric patterns such as those on folio 6 v of Ashburnham MS. 2038, which were drawn to illustrate theories and experiments in optics. Leaving aside the structural problems involved in building these buttressed structures (the apex of the pointed salients would have proved very fragile to bombardment, while the embrasures would have weakened the curtain walls), let us look at how Leonardo gradually transforms these

Fig. 367. CA, f. 134 r/48 v-a.

Fig. 368. CA, f. 135 r/48 v-b.

Fig. 369. Paris MS. L, f. 63 r.

triangular salients, obtained by reversing as it were the trajectory of projectiles, into rounded, blunt structures. This process of transformation is evident in Paris MS. L, for example on folios 49 v, 50 v, and 61 r. Sheets of the Codex Atlanticus dating from about 1502–1503 also show the gradual change of the top of the salient from a simple thatched roof to a rounded covering that slopes backwards. Leonardo found rounded or circular forms more suitable for deflecting blows and better adapted for building purposes. On folio 63 r of Paris MS. L (Fig. 369) he depicts the structure of the salients as made up of large blocks laid head first and converging towards the centre of each salient. A series of arch-stones are incorporated into blind dividing arches within the wall so that the extremity of each arch described by the external salients rests on the keystone of the internal one. We see here a remarkable transposition onto the horizontal plane of the ancient Roman technique of building in brick whereby arches embedded in the vertical walls distributed the vertical weight in two lateral thrusts, notably above doors or windows. Here the system is applied to the horizontal plane, and the thrust which in the walls acts vertically on the arches is replaced by the horizontal force of impact of the projectiles. Furthermore, contrary to what I previously believed,[13] I now think that here Leonardo intended to use not bricks but specially shaped stone blocks, since these structures with rounded salients are so obviously connected with the theories and studies on the resistance and breaking-point of arches such as those in Paris MS. A and Madrid MS. I, as well as in studies for the tiburio of Milan Cathedral. The resorting to a circular shape is a constant in Leonardo's drawings of military architecture, resulting perhaps by chance from his phase of applying geometrical and optical theories to architectural planning. He was always fascinated by circular forms, and the logical outcome of his ballistic and architectural researches may be seen in plans for fortifications of concentric circular construction sloping upwards (CA, ff. 132 r/48 r-a and 133 r/48 r-b: Figs 370–371). These studies have always been admired as astonishingly innovative: Martin Kemp considers them, and with reason, as representing one of the highpoints of Leonardo's entire opus, demonstrating a perfect balance between the theoretical principles at work and Leonardo's sense of form and extraordinary powers of

observation.[14] On the other hand, the fortresses depicted in these drawings have always been considered unlikely to be able to withstand bombardment as well as the more recently invented bastion. They have been defined as merely "passive" structures, capable only of resisting attack because of the retreating surfaces of which they are composed. Furthermore, once we have ceased to marvel at their polished appearance and we begin to speculate on their actual strategic use or on how they could have been built with the technology of the time, the problems that arise are considerable. According to some authorities of our own century,[15] who deem it a merit and not a defect, these fortifications could only be built using "recent precepts of the art of fortification", that is, only with the modern technique of reinforced concrete. We know now, however, that the circular shape was still

Fig. 370. CA, f. 132 r/48 r–a.

Fig. 371. CA, f. 133 r/48 r–b.

Fig. 372. CA, f. 120 r/43 r–a.

a valid one at the beginning of the sixteenth century in spite of the innovation caused by the introduction of the triangular bastion with sloping sides, and, moreover, we know also that Leonardo's circular fortresses combine different structural concepts, many of which are studied separately in Paris MS. L and on numerous sheets of the Codex Atlanticus. One of these is the roof which is not simply circular but describes a parabola. The theoretical justification for such a roof may be found on folio 120 r/43 r–a of the same Codex (Fig. 372). The text, commenting on two different sorts of roof, one "shaped like a bird's beak", the other, which Leonardo prefers, a parabola, states:

> If what is above is perfectly good [there follows a drawing of the parabolic roof] what is below is good from the centre upwards, since from the centre downwards it awaits such a percussion that obliquity is required where that percussion occurs. And what is above always flies behind to its centre.

Without considering here other aspects of Leonardo's drawings, one of the most fascinating details is certainly the design in the centre of folio 132 r/48 r–a of the Codex Atlanticus. This shows a view in cross section of a variation on the shape of the curved roof sloping away upwards shown in the larger drawing above. This variation, unlike the others, postulates a structure with a dolphin-back roof of rounded form rearing back toward the inside of the fortress like the curling back of a wave. This invention, at first sight unconvincing and apparently unrealizable in practice, has the same shape as the salient that runs through to emerge in the inner courtyard of the fortress, and seems indeed to require for its building a twentieth-century construction material such as reinforced concrete, something obviously unknown to Leonardo and his contemporaries. But the impracticality of this structure is more apparent than real. It is in fact simply a section of a precinct we should imagine as circular, with each block of which it is composed leaning against its neighbours so that they support each other, as is the case with cupolas and arches. In this regard it is worthwhile to take another look at a late sheet of the Codex Atlanticus (f. 38 r/10 v–b: Fig. 373), which shows a cylindrical tower with its component stone blocks drawn in detail. Below is the note: "All this is a sort of arch".[16] For Leonardo, therefore, circular forts and cylindrical towers are, in terms of their wall structure and reaction to external pressures, extensions of the arch, and it is to the arch that he has recourse in order to explain their structure. The detail of the dolphin-back curtain wall shown on folio 132 r/48 r–a of

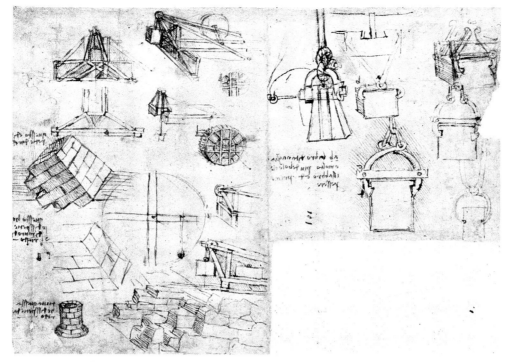

Fig. 373. CA, f. 38 r/10 v–b.

the Codex Atlanticus could be compared to the schematization of a half arch supported by a counterweight to keep it from falling, like the one on folio 142 v of Madrid MS. I (see Fig. 192). Even more relevant, in the case of the drawing under discussion, is a comparison with a drawing on folio 113 v of the same manuscript (Fig. 374), where a sketch of a section of an arch or of a cupola ("*archi delle Grazie*") is accompanied by a note which reads:

> That part of the disunited weight burdens more, which is nearest to its centre of gravity. It is evident that an arch or a tiburio is burdened more at its inner parts *b c* than at its outer parts *a d*".

Tiburio is the Lombard word for cupola. It is not necessary to point out that Leonardo's remarks are as valid for arches as for cupolas. I believe that this design in Madrid MS. I is the key to understanding both the section of the dolphin-back curtain wall and all of Leonardo's plans for fortifications built sloping upwards that appear on folio 132 r/48 r–a of the Codex Atlanticus. In fact, the fortifications, which are folded back upon themselves and which seem to stretch toward the inner part of the fort, behave like the internal partition walls of a cupola, pressing against the top of the ring that encloses the vaults and describing a wide circle equivalent to the one on which, in domes, the

Fig. 374. Madrid MS. I, f. 113 v (detail).

lantern is placed. It is clear that the apparently jutting out parts of these curtain walls act as interdependent supports. Such a construction would have had to be made of stone blocks, not of brick. The sketch in which Leonardo suggests the convexity of the shape seems to indicate stone blocks, and the outline of the curtain wall looks reminiscent of the placement of the vaulting ribs made of stone blocks in the tiburio of Milan Cathedral. Rather than impracticable, therefore, Leonardo's plan for a circular fortress seems on the contrary to present an alternative to the Florentine technique used by Brunelleschi or depicted by Antonio da Sangallo in his famous Uffizi drawing probably taken from a contemporary cupola.[17] Although the static conception and the structural method imagined by Leonardo do not seem different from those used for arches and cupolas, the apparently illogical choice of stone rather than brick (which would probably have provided greater cushioning power and attenuation of the force of impact of projectiles) can indeed be justified. Only stone blocks supporting each other could have created the sloping outline of the fortress. It would be nice to think that the surfaces of the stones were smooth and polished like a mirror, reflecting light rays in the same way that they "refracted" projectiles, turning them aside into the surrounding space.

Here ends this brief attempt to demonstrate the connection between Leonardo's studies of military architecture and the researches he undertook in other fields, particularly in that of building techniques (see other publications of mine on this subject).[18] We stop, in fact, at the point at which the descending parabola described by Leonardo's work doubles back on itself, that is, about 1504-5, when he gave up experimenting with other forms and possibilities of construction, perhaps because of the powerful influence of Francesco di Giorgio's military studies, and does not seem to have pursued the possibility that a new science of architecture might prove to be the culmination of all his twenty years of research in so many fields. His plans for military architecture from his second period in Milan, under French domination, and his designs for a royal residence at Romorantin, while they paved the way for the establishment in France of palatial residences like that of Chambord,[19] show a strong link in structure and design to the Quattrocento tradition, or even to that of the Middle Ages.

Notes and
Bibliography

Notes and
selected bibliographies

Introduction

1. The Leonardo text is given, except for the last paragraph, by Richter, §§ 1502 and 1503, and, unabridged, by MacCurdy, *Mathematics*. Both translations are unsatisfactory, and Richter gives only one of the illustrations. A complete transcription and new translation of Paris MS. L, f. 53 v follow:

"djce vetruvio che imodellj picho[li] / non sono inessuna operatione confer/mj dalleffecto degrandj la quale co/sa quj dj socto intendo dj mosstra/re tale conclusione . essere falsa / emassima mente allegando que me/desimj termjnj coiqalj luj cõ/clude tale. sententia coe colla esspperienta . della triuella laqua[le] luj mosstra essere fatto dalla po/tentia dellomo vno buso dj cier/ta quantita dj djamjtro e che poj / vn buso dj duppljcato dj amjtro nõ / sara fatto da duppli cata potenti[a] / dj detto homo ma da molto piu al/a qual cosa sipo molto ben risspõ/dere allegando. che il trivello / [f. 52 r] / dj dupplicata po/tentia con co sia chella superfitie / dognj

corpo dj figura simjle e dj du/plicata quantita alla superfitie dj / quadruplata quãtita luna allaltra come mosstrã le due / figure. a.he.n...

Quj si leua dacasscuno / dj quesstj 2 trivellj vna / medesima grosseza dj le/gnjame daciasscun bu/so dalloro facto ma per / essere . busi over trivellj / dj dupplificata quantjta luno allaltro / essi son dj superfitie quadrupla e dj potenti[a]". In translation:

"Vitruvius says that small models are not confirmed in any operation by the effect of large ones. I intend to show here below that this conclusion is false, and chiefly by adducing the same terms with which he arrived at this conclusion, that is, with the experiment of the auger, with which he shows that when a hole of a certain diameter is made by the power of a man, a hole of double diameter will not be made by double the power of the said man, but by much more. To which one can very well reply by adducing the fact that an auger of twice the size cannot be moved by double the power, inasmuch as the surface of any body of the same shape and twice the size is four times the quantity the one of the other, as the two figures, *a* and *b*, show.

Here with each of these two augers is removed the same amount of wood from each hole made by them; but for the holes or rather the augers to be of double quantity the one to the other they must be of four times the surface and power."

The Vitruvius text which prompted this discussion was available to Leonardo either in the original Latin form as first published in 1486, or more probably in an unpublished translation into Italian. The first published Italian translation is that by Cesariano of 1521, in which the word "*exemplaribus*" is translated as "*exemplari*", not as "*modelli*". The word "*modelli*" appears in later editions, e.g. in the one by Daniele Barbaro of 1556, Bk. X, ch. XXII, p. 273: "percioche sono alcune cose che riescono tanto in modelli piccoli, quanto in forme grandi, altre non possono hauer modelli, ma da se si fanno, altre ancho à modelli s'assimigliano, ma quando si fanno maggiori non riescono, come da quello, che io dirò, si può bene auuertire. Egli si fora con una triuella, & si fa un foro di mezzo dito, d'un dito, & d'un dito e, mezzo, il che se con la istessa ragione far uorremo d'uno palmo, non si può, ma di mezzo piede del tutto non si deue pensare, cosi à questa simiglianza si può far alcuna cosa in una forma nõ molto grande, presa da un picciolo modello, il che all'istesso modo in molto maggior grandezza non si può conseguire". In the standard English translation by Morris Hicky Morgan (Vitruvius, *The Ten Books on Architecture...*, Cambridge, Mass., Harvard University Press, 1914, p. 316), this passage reads as follows:

"[5] For not all things are practicable on identical principles, but there are some things which, when enlarged in imitation of small models, are effective, others cannot have models, but are constructed independently of them, while there are some which appear feasible in models, but when they have begun to increase in size are impracticable, as we can observe in the following instance. A half inch, inch, or inch and a half hole is bored with an auger, but if we should wish, in the same manner, to bore a hole a quarter of a foot in breadth, it is impracticable, while one of half a foot or more seems not even conceivable. [6] So too, in some models it is seen how they appear practicable on the smallest scale and likewise on a larger."

I.1 *The Career of a Technologist*

1. The most recent general biography of Leonardo is that of Kemp, 1981, to which I also refer for the comprehensive bibliographical indications in the appendix.

2. On the engineers of the Renaissance and their vast field of activity see Parsons; Gille, 1964; and Pedretti, 1978.

3. For the life and works of Mariano di Jacopo, called Taccola, see *DSB* XIII, pp. 233-4 (P.L. Rose).

4. For Brunelleschi, see *DSB*, II, pp. 534-5 (B. Gille).

5. For Francesco di Giorgio, see *DSB*, IX, pp. 146-8 (L. Reti).

6. Maltese, 1971 and Scaglia, 1985.

7. See the introduction by Carol Herselle Krinsky to Vitruvius 1969; see also Zoubov, pp. 67-90; and Scaglia, 1985.

8. For mediaeval statics, see Clagett.

9. Usher.

10. I am referring here to Gille, 1964. I will discuss his views later.

11. For the complex history of the scattering of Leonardo's manuscripts from the time of his death to the present day, see Marinoni, 1954, pp. 231-74 and Pedretti, 1964, pp. 252-9. For additional and more recent information (especially with regard to the subsequently discovered Madrid Manuscripts), see Pedretti, 1977, II, pp. 393-402.

12. An important manifestation of this attitude was the huge Leonardo exhibition held in Milan in 1939, in which a number of functioning models based on Leonardo "inventions" were exhibited without any scientific scruples.

13. CH, f. 22 v.

14. See Brugnoli, pp. 86-108.

15. See Steinitz, pp. 249-74.

16. See Pedretti, 1978, pp. 328-9.

17. See Koyré, pp. 99-116.

18. There has not been any systematic work on Leonardo's sources since the pioneering but now outdated papers of Solmi, 1908 (pp. 1-334) and 1911 (pp. 297-358). On Leonardo's library, see Maccagni; Garin, 1961; and Reti, "The Library of Leonardo", in the edition of Madrid MS. I-II (vol. III, pp. 91-107).

19. For the history of the Codex Atlanticus, see Marinoni's introduction to CA, Transcriptions, 1975-80, I, pp. 9-17.

20. For the history of the Leonardo collection at Windsor Castle, see Clark, 1968, I, pp. IX-LXV.

21. Calvi, G.

22. Codex Hammer (formerly Codex Leicester), 1909.

23. Pedretti has adopted a chronological reading of Leonardo's sheets in all of his impressive essays on Leonardo.

24. Pedretti has planned and directed the restoration, re-ordering, and new edition, presently under way, of the Leonardo drawings at Windsor.

25. Pedretti, 1957.

26. Pedretti, 1979.

27. See Kemp, 1981, pp. 13-76; and Pedretti, 1978, pp. 9-17.

28. See Vasari, 1912-14, IV, p. 90.

29. See Calvi, G., chapter I ("Avviamento ad una selezione di fogli anteriori al Manoscritto B nel Codice Atlantico"), pp.9-77.

30. The most recent work of a comprehensive nature on the construction of the cathedral is by Saalman.

31. For the solution to the technical problems posed by the construction, see Scaglia, 1981, especially pp. 5-16. For the relationship between Leonardo and Brunelleschi, see the essay by Salvatore Di Pasquale in the present catalogue.

32. Paris MS. G, f. 84 v.

33. See Scaglia, 1960-1, pp. 45-67; and Reti, 1964, pp. 89-130.

34. Biblioteca Apostolica Vaticana, Rome, Codex Urbinas Lat. 1757, f. 127.

35. Buonaccorso Ghiberti. On Buonaccorso, the grandson of Lorenzo Ghiberti, see Prager and Scaglia, 1970, especially pp. 65-83.

36. Giuliano da Sangallo.

37. Buonaccorso Ghiberti, ff. 102 r and 103 v.

38. Giuliano da Sangallo, ff. 47 v-48 r.

39. Scaglia, 1960-1.

40. Reti, 1964.

41. Pedretti, 1979.

42. See Pedretti, 1978, pp. 9-12.

43. *Ibid.*, p. 9.

44. See Vasari, 1912-14, p. 91.

45. Pedretti, 1978, pp. 15-18.

46. Vasari, 1912-4, p. 91.

47. See Pedretti, 1978, p. 15 (Gabinetto Disegni e Stampe, Uffizi Gallery, Florence, no. 4085A).

48. See Reti, 1964, pp. 114-16.

49. See Pedretti, 1978, p. 32.

50. Marani, 1984². See also Marani's essay in the present catalogue.

51. See Kemp, 1981, pp. 64 ff.

52. On Toscanelli, see Garin, 1967, pp. 41-67.

53. See Kemp, 1981, pp. 76 ff. See also Ady.

54. See Calvi, G., pp. 79-146.

55. Marani, 1984².

56. On Leonardo's use of Valturius, see Marinoni, 1944, II, pp. 236-67.

57. See Reti, 1956-7, pp. 1-31.

58. British Museum, Drawing and Print Collection, no. 1860-16-99. See Popham, Pl. 309.

59. Royal Library, Turin, No. 15583. See Pedretti, 1975¹, p. 31.

60. See Pedretti, 1978, pp. 28-9.

61. See the catalogue of the 1982 exhibition in Milan, *Leonardo e le vie d'acqua*.

62. For Leonardo's urban planning projects for Milan, see the essay by Luigi Firpo in the present catalogue.

63. See Pedretti, 1978, pp. 19-26.

64. Paris MS. A, f. 55 v.

65. For the Marlianis, see Brizio, 1974, pp. 9-26.

66. Fazio was the father of Gerolamo Cardano; see Pedretti, 1978, p. 27.

67. On the relationship between Leonardo and Pacioli, see Marinoni, 1982.

68. See Kemp, 1981, pp. 260 ff.

69. See Brizio, 1954, pp. 275-89.

70. See Reti's remarks in his edition of Madrid MSS. I-II, vol. III, pp. 41-3.

71. These are illustrated in the final sheets of the manuscript, (ff. 141 r-157 v).

72. Brugnoli.

73. Strobino.

74. Dibner, "Leonardo Prophet of Automation", in Reti and Dibner pp. 34-59.

75. See Bedini, pp. 240-63.

76. See Kemp, 1981, pp. 327-8.

77. CA, f. 1069 r/386 r-b.

78. Giacomelli.

79. See Kemp, 1981, pp. 195 ff.

80. See Pedretti's introduction to the exhibition catalogue *Leonardo dopo Milano*, pp. 11-23.

81. See Pedretti, 1953, pp. 165-200.

82. See Kemp, 1981, pp. 211-13.

83. See Reti's commentary to his edition of the Madrid MSS. I-II, vol. III, p. 54.

84. See Pedretti, 1978, pp. 180-1.

85. See Heydenreich, 1974, pp. 143-7.

86. *Ibid.*, pp. 152-65.

87. During these same years, Leonardo, in addition to his anatomical studies, dedicated his attention to research in geology and physical geography. This is evident in many sheets of the Codex Hammer.

88. See Kemp, 1981, pp. 276 ff.

89. See Zammattio, pp. 204 ff. See also *Leonardo e le vie d'acqua.*

90. Pedretti, 1972².

91. See Beltrami, 1919, no. 238.

92. See Cellini, p. 859.

93. Beck.

94. Feldhaus.

95. See Reti, 1963, pp. 287-98; see also Reti, 1964.

96. Gille, 1964.

97. Prager and Scaglia, 1970.

98. In addition to the works by Scaglia cited in the bibliography, see her essay in the present catalogue.

99. See Reti's commentary to the Madrid MSS. I-II, vol. III, pp. 85-8.

100. Laurentian Library, Florence, MS. Ashburnham, 361. See Marani, 1979.

101. Gille, 1964.

102. See, for example, the exhibition catalogue *Laboratorio su Leonardo*, and in particular the introduction by Marinoni (pp. 11-35).

103. On Alberti as Leonardo's model, see the observations of Garin, 1971, pp. 324-5.

104. Uccelli, 1940.

105. Uccelli produced a similar work on Leonardo's numerous notes on "flight". See Uccelli, 1952. In the seventeenth century a similar attempt to reconstruct Leonardo's treatise on water was made (see Arconati).

106. See Uccelli, 1940, pp. 465-550.

107. On the controversial circumstances of the discovery, see the official version provided by Reti in his edition of the Madrid MSS. I-II, vol. III, pp. 9-21.

108. *Ibid.*, pp. 23-32.

109. See in particular Reti, 1974¹, pp. 264-87.

110. *Ibid.*.

111. See Pedretti, 1979, I, p. 209.

112. *Ibid.*, I, p. 89.

113. *Ibid.*, I, p. 115.

114. See K/P or *Corpus of the Anatomical Studies*. Where single sheets are indicated I first give the old Royal Library (RL) reference number, and then the new Keele/Pedretti (K/P) numbering, introduced by the editors of the new edition.

115. For a general presentation of Leonardo's mechanics, see the entry "Leonardo da Vinci" in the *DSB*, VIII, pp. 215-34 (especially the section by M. Clagett).

116. Reti, 1974¹.

117. Madrid MS. I, f. 20 v.

118. Madrid MS. I, f. 100 v.

119. Recently Kenneth Keele, in his book devoted to the reconstruction of Leonardo's science of man, repeatedly emphasized the fundamental role played by mechanics. See Keele.

120. RL 19003 v; K/P 137 v.

121. See, in addition to Carlo Pedretti's introduction to the present catalogue, his important observations on the *modello* in his "Commentary on the Reassembled Sheets and their Chronology", in K/P, III, pp. 868-71.

122. *Ibid.*

I.2 *Leonardo's Impossible Machines*

1. See Zammattio, p. 195. The traditionally asserted link with the Arezzo revolt of 1502 is only a hypothesis. The aim of the plan was to ensure navigability between Florence and the sea.

2. See Solmi, 1912, p. 8 and Calvi, G., pp. 149 ff.

3. See Zammattio, p. 272.

4. At that time a pound was equivalent to 317 grams.

5. See Canestrini, pp. 98-103.

6. Ashburnham MS. 2037, f. 2 v, which is one of a group of sheets stolen from Paris MS. B during the 1830s.

7. Semenza, 1908.

8. See Canestrini, pp. 112-29.

9. Recent attempts to construct certain gear systems and endless screws designed by Leonardo have revealed that there must have been numerous intermediary studies and drawings of them and have brought to light difficulties which make it unlikely that the designs for such devices by engineers prior to Leonardo were ever actually constructed.

10. For this drawing and the one of the bicycle on CA, f. 133 v, see Marinoni, 1981.

I.3 *The Inventions of Nature and the Nature of Invention*

Selected bibliography

CU [McM].

Hart.

Keele.

Kemp, 1981.

MacCurdy, 1939.

Marani, 1984².

Pedretti, 1977; 1978.

Vezzosi.

I.4 *A Typology of Leonardo's Mechanisms and Machines*

Selected bibliography

Gibbs-Smith.

Gille, 1964.

Giuliano da Sangallo.

Maltese, 1967.

Pedretti, 1975².

Ponting.

Prager, F. D. (ed).

Prager and Scaglia, 1972.

Reti, 1964.

Scaglia, 1960-1.

Scaglia, 1971.

Scaglia, Prager and Montag.

Strobino.

Von Stromer.

I.5 *Leonardo, Brunelleschi and the Machinery of the Construction Site*

Selected bibliography
Acland.
Alberti, 1966.
Bloc.
Branca.
Czarnowsky.
Drachmann.
Du Colombier.
Fitchen.
Gille, 1978.
Klemm.
Maltese, 1967.
Prager and Scaglia, 1970.
Reti, 1964.
Rondelet.
Saalman.
Scamozzi.
Singer.
Vasari, 1912-14.
Veranzio.
Vitruvius, 1790.

II.1 *The Problem of Leonardo's Architecture in the Context of his Scientific Theories*

1. Among the reasons why the system was never developed Kemp has judiciously suggested that of the "crisis of inherited knowledge". See Kemp, 1982, p. 27 ff.

2. This view is stressed, after Richter's edition, 1939, in the dissertation by Heydenreich, 1929, and the study by Firpo, 1963. Also important is the anthology presented by Maltese in *Scritti rinascimentali di architettura*.

3. See Prager and Scaglia, 1970; Pedretti, 1978, p. 9 ff.

4. Reti, 1974[2]; Kemp, 1981.

5. Madrid MS. I-II; see Zammatio, p. 231.

6. RL 12660v (*c.* 1508); see Clark, 1968, and the entries on p. 150 ff concerning this group of drawings. See also Gombrich, 1969, p. 39 ff.

7. On the programme of 1481-1482, CA., f. 1082 r/391 r-a (Richter, § 1340); Brizio, 1952, pp. 631-633.

8. On the Milanese milieu, Malaguzzi Valeri remains fundamental.

9. See Pedretti, 1978, p. 280.

10. Thiis; Pedretti, 1978; and Guillaume in this volume.

11. See Marani, 1982[3], pp. 81-92.

12. See Kemp, 1981, p. 107 ff.

13. See *Scritti rinascimentali di architettura*, p. 97, with notes by Andrea Masini. On the problem of the *homo ad quadratum*, see Wittkower, p. 12, which remains fundamental.

14. See Richter, § 343. In his edition of Vitruvius (Venice, 1511) Fra Giocondo gave two distinct images: *ad circulum* and *ad quadratum*. Cesariano, like Leonardo, combined them into one in his edition (Como, 1521), but gave the figure an X formation which cancelled the "dynamic" effect of Leonardo's schema.

15. Paris MS. B, f. 27 r. (Richter § 788). Text cited by Firpo, 1963, p. 26 (with reference to a drawing *"appena abbozzato"*, Paris MS. B, f. 16 v, which we have not been able to find).

16. Madrid MS. I, f. 152 r. See also Madrid MSS I-II, IV, p. 145.

17. See Marani, 1982[2], p. 103 ff.; see also Kemp, 1981, p. 185 ff.

18. Keele.

19. RL 19060 r (*c.* 1509): see Clark, 1968, III, p. 26.

20. See Zammatio, p. 211.

21. See Richter, chapter XIII of vol. II, § 770 ff.

22. See Truesdell, p. 315.

23. CH, f. 12 v; see Kemp, 1986.

24. Marani, 1984.[2]

25. See Marani, 1984[2], pp. 205 and pp. 60-1.

26. See Vasoli, p. 283 ff.; Marani, 1982[1], p. 121.

27. See Pedretti, 1978, ill. p. 40.

28. See Firpo, p. 34 ff. Paris Manuscript B, f. 10 v offers an astonishing series of vaults conceived on the octagonal module: Richter, pl. CIII, 2.

29. See the contribution of Guillaume in this volume.

30. Arundel MS., f. 270 v; Firpo, XVI, *le torri ottagone*; Pedretti, 1962[1], p. 143 ff.

31. See McM, f. 223 v, text no. 667, p. 230.

32. Madrid MS. I, f. 101 v; Reti, 1974[1], p. 286.

33. See Richter, §§ 1475 and 1504; Kemp, 1981, p. 150.

34. On the *nodi*, see Pedretti, 1978, p. 296 ff.

35. On Leonardo and the classical past, see Clark, 1976.

36. Serres. The recently published collection: *Le modèle à la Renaissance*, concerns only the literature.

II.2 *Leonardo and Architecture*

1. Heydenreich, 1929 [1971], p. 6 (introduction to the second edition).

2. Two examples: the views of palace courtyards on RL 12585 v (see Fig. 359) which are reminiscent of Urbino, show no originality, and the square building surrounded by a double wall with a straight staircase on one of the sides, which appeared around 1487 (Paris MS. B, f. 12 v, CA, f. 217 r/80 r-a and RL 12692), is incomprehensible.

3. Louvre 2282 r, and Paris MS. B, f. 23 v, Paris MS. L, f. 66 r, Paris MS. B, f. 52 r and Ashburnham MS. 2037, f. 5 r.

The Tiburio of Milan Cathedral

[A complete bibliography on this subject is found in Scaglia, 1982, pp. 238-9. See also Marani, 1982[3], pp. 81-92, as well as *Il Duomo di Milano*, published privately and, no doubt for this reason, unknown to most authors. On the whole, studies on the tiburio suffer from two deficiencies: (1) Leonardo's drawings have not been studied in depth, except by Heydenreich, 1929 [1971], and, for ff. 27 r of Paris Ms. B and ff. 849-850/310 of the Codex Atlanticus, by Fergusson, pp. 175-92 (the only one to have understood this latter drawing and attempted a reconstruction); and (2) authors have focused their attention on Bramante, Leonardo and Francesco di Giorgio, without taking sufficient account of the architectural reality of the time and, consequently, the role played by the Milanese.]

4. We have kept the Italian word *tiburio*, which is always used in studies of this particular structure, which is actually a domical, ribbed vault with eight radiating sections.

5. See the clear account of the discussions and the exemplary edition of the three texts by Leonardo, Bramante and Francesco di Giorgio given by Bruschi, 1978.

6. Papini, I, pp. 180-6 and 263, believes that Francesco di Giorgio's plan (of which he gives an inaccurate drawing) was generally executed. Fergusson believes that Francesco di Giorgio took up Leonardo's ideas and made them applicable in practical terms by substituting metal tie rods for the stone ties and arches; Pedretti, 1978, pp. 32-52, adopts this point of view and even believes that Francesco di Giorgio used Leonardo's wooden model, with slight alterations. None of these authors saw that the double semicircular arches recommended by Francesco di Giorgio bear no relation to the semicircular arches actually built. A more qualified point of view may be found in Bruschi, and Marani, 1982[3], who take into account the studies referred to in the following note.

7. Ferrari da Passano and Brivio, pp. 3-36; Ferrari da Passano and Romanini (in particular pp. 40-8 and 184-5); Rossi.

8. The arguments in favour of establishing a date prior to 1481, which are developed in the studies listed in the preceding note, are very solid. However, it is difficult to understand the discussion of the 1480s and especially the solution officially adopted in 1490 (providing for thinner, double reinforcing arches) if these four arches had already been built. To resolve these contradictions, we probably have to suppose that the semicircular arches had been decided on and prepared (the stone bought and cut), but not built, before 1480. After ten years of hesitation, the builders carried out what had been planned and prepared for: this would explain the speed of execution.

9. CA, f. 730 r/270 r-c. Letter published for the first time with all necessary explanations by Bruschi, pp. 349-53. The wooden model dates from late 1487; Leonardo returned to it to make repairs in May 1490. It does not figure among the models presented at the final deliberations on June 27, 1490.

10. "An arch constructed on a semicircle and bearing weights on the two opposite thirds of its curve will give way at five points of the curve" (Arundel MS., f. 158 r; Richter § 777).

11. "What is an arch? An arch is nothing else than a force originated by two weaknesses" (Paris MS. A, f. 50 r; Richter § 779).

12. Drawings of complicated ribbed vaults appear on f. 10 v of Paris MS. B, accompanied by the note "*del Tedesco in Domo*", a reference to one of the German architects who had come to work on the cathedral. See Scaglia, 1982, pp. 232-5, who conducted research on the models of these vaults.

13. Bruschi, p. 342.

14. Contrast seen very clearly by Beltrami, 1903; Cassi Ramelli, 1964 (see p. 370 in particular).

15. Paris MS. A, f. 49 v; Richter § 786, p. 73.

16. The idea is the same, but the technical solution is different: Leonardo used thick, T-shaped pieces of wood arranged like sawteeth, while Philibert de L'Orme used thin planks assembled with pins.

17. The anonymous drawing in the Ambrosiana we refer to here has been compared to a design of Il Bramantino by Maria Phillips (see below n. 98). It is unnecessary to point out that the square dome would become very popular in France later on.

18. The plan of 1420 was eventually carried out in the 19th century. We do not understand why Heydenreich, 1981, p. 203, says that Leonardo made no concessions to the Gothic style of the cathedral. The need for "conformity" is one of the topics of Leonardo's letter as well as of Bramante's *Opinio* (see Bruschi, pp. 352 and 369).

19. Our reconstruction (developed with Sabine Kühbacher) is based on CA, f. 849 r/310 r-a, which is fairly precise (more, in any case, than one might have expected of Leonardo), and one survey of the present structure published in *Il Duomo di Milano*. If we take as our point of departure the space (axis to axis) contained between two ribs in the central dome, we can easily deduce the interior width of this dome following the assumption that it forms a regular octagon. This width must be equal to the present interior width of the tiburio, itself equal (or almost equal) to the space between the large arches of the crossing, or about 18 metres. This gives us the scale of the drawing, and we can corrects its inaccuracies. The centre aisle, at the piers, is a little too wide (16.75 metres instead of 16.25 metres), the piers roughly sketched in are much too wide (3.75 metres instead of 2.67 metres). The exterior dome is a little wider than the exterior sheath of the present tiburio (23 metres instead of approximately 22.5 metres). Even if we reduce this width to 22.5 metres, as we did in our reconstruction, Leonardo's plan requires a widening of the support system similar to the one actually carried out in order to be executed: the arches and ties shown in the drawings have to be made about 2 metres wide or else doubled with other arches (which Leonardo does not talk about). The drawings do not provide any information on this point (we have therefore confined outselves to indicating the section of the present reinforcing arch with a dotted line); all that can be seen is that Leonardo widened the piers considerably, as if they were intended to bear a very wide arch, but it is doubtful that he actually considered such a solution, which would have seriously altered the interior of the cathedral. Finally, the height of the domes cannot be accurately determined since Leonardo's drawing seems approximate on this point — somewhere between a projection and a development.

20. The proximity of the two vaults would have allowed windows to be opened up at the bottom of the dome, but Leonardo apparently did not deal with the problem of lighting, since he does not show any windows on f. 22 v of the Codex Trivulzianus (Fig. 217).

21. The method of indicating the point where the arch breaks, upward or downward, is the same as that used by Viollet-le-Duc, I, p. 64! Two other contemporary drawings from the same period — small sketches in the top right corner of CA, f. 294 r/106 r-b — also represent circle-on-circle arches. The fact that these drawings date from Leonardo's French period does not mean they must be related to French Gothic churches, as Pedretti, 1970, does (p. 290). Leonardo was also drawing, at the same time, a plan of the Sforza Castle in Milan (CA, f. 272 v/99 v-b).

22. This connection between Leonardo's anatomical studies and architecture has rightly been emphasized by Murray, pp. 346-51, and by Bruschi. Leonardo's ideas go well beyond the traditional identification between a man and a building developed by Alberti.

23. See diagonal section reproduced in *Soufflot et son temps*, p. 116.

Churches: The Centralized Plan

24. The problem of the treatise planned by Leonardo, of which the "treatise on domed architecture" (Geymüller) would have been a part, was perfectly presented by Heydenreich, 1929, pp. 77-84. Lang attempted to show, against all evidence, that Leonardo's drawings were projects for a Sforza mausoleum, even going so far as to state the order in which these projects were conceived.

25. On this series of drawings, see Geymüller's contribution in Richter, II, pp. 27-50, and especially Heydenreich, 1929, pp. 45-76. Pedretti, 1978, on the other hand, has shown little interest in these drawings, which are barely mentioned.

26. Square and circular plans with exterior porticos are seen only in CA, f. 1010 v/362 v-b, on the right (see Fig. 197). These simple plans occur frequently in the work of Francesco di Giorgio, however.

27. This point distinguishes our classification from that of Heydenreich, 1929, who differentiates between plans in which the space is divided by supports (forming side aisles and ambulatories) and those in which several spaces are juxtaposed. In addition, he separates centralized plans with naves. We emphasize two contrasts, however: radiating plans/cross-shaped plans, and homogeneity/alternation. It goes without saying that Leonardo was not interested in one type or other in succession, evolving towards a solution that would suit his preference. We may simply note that the first two types of radiating plans are more frequent at the beginning of Paris MS. B, and the cross-shaped plans come more in the middle, as well as in the few drawings done after 1500.

28. A number of drawings prove that classical buildings with individualized satellite "chapels" connected by a relatively narrow passageway to the central space were known in the late 1400s. These include Album B, attributed to Fra Giocondo, at the Hermitage, f. 106 v, and Francesco di Giorgio, Turin MS. T, f. 87 v, top left. On the subject of these drawings, which are often very free reconstructions, we will soon be able to consult the thesis of Hubertus Günther (Rome, Hertziana, to be published). Finally, we should remember that Leonardo had a *libro di anticaglie* (see below, n. 78).

29. This plan should be compared with a geometrical diagram by Francesco di Giorgio (Florence MS. M, f. 42 r, later drawn over with modifications for a church plan). Francesco di Giorgio rejected the alternation and avoided its difficulties by placing a circle rather than an octagon at the centre.

30. The finest example of a classical radiating plan, clearly known to Leonardo as it was drawn very frequently in the latter part of the fifteenth century, is the Oratory of Santa Croce (destroyed in the seventeenth century), near the Baptistery of San Giovanni in Laterano; it had four hexagonal chapels alternating with rectangular "apses". This plan (known through a drawing by Giuliano da Sangallo, Cod. Barberinianus, f. 30 v) is close to Paris MS. B, f. 25 v (Fig. 241). We also find examples of alternating chapels and even satellite chapels in the "discoveries" of Il Bramantino (ff. 79 r, 80 r; see below n. 78).

31. Regarding Leonardo's trip to Rome in 1505, see below, n. 67.

32. Turin MS. T, f. 13 v and 14 r.

33. Cross-shaped plans were the only ones used in the late fifteenth century: a simple greek-cross plan in Santa Maria delle Carceri in Prato (Giuliano da Sangallo), *quincunx* with five domes at San Giovanni Crisostomo in Venice (Coducci), cross-shaped plan with five domes in the Milan region in Santa Maria di Bressarono. All the "temples" drawn in Filarete's treatise, except one, also have cross-shaped plans.

34. The originality of the first type, the one used in San Satiro, was emphasized by Dimitrokallis. On San Lorenzo, see in particular Giordano, 1985.

35. These square spaces at the meeting of the apses do not allow us to speak of an alternation of apses and satellite chapels (type 2b) because these rooms do not relate in any way to the centre; their doors do not open towards the centre, but onto the ambulatories, perpendicular to the axes. The orthogonal logic of the cross-shaped plans is imposed on the peripheral elements. In Paris MS. B, f. 35 v, a staircase can be noted at this location, suggesting the presence of a bell tower.

36. The eight piers of the irregular central octagon of the Basilica of Loreto seem to have been built between 1470 and 1480. The relationship of the short and long sides (1 to 1.35) is approximately the same as at Pavia and in Paris MS. B, f. 24 r. To understand the role played by the irregularity of the octagon in the articulation of the parts, it is enough to compare Paris MS. B, f. 52 r with f. 24 r (Figs 259 and 236).

37. As we will see further on, at the end of this study of the volumes, Leonardo must have travelled to Padua and Venice during his years in Milan.

38. One of the rare notations accompanying the centralized plans states that "It never looks well to see the roofs of a church; they should rather be flat..." (Paris MS. B, f. 18 v).

39. The note on the left leaves no doubt as to Leonardo's final decision: "This is how the eight *tiburi* of this temple are to be placed". We have followed this indication in our reconstruction. The size of the domes in relation to the dimensions of the central crossing of the radiating chapels leads us to assume a complex structure with a double dome, one of which might have been a frame structure (see below nn. 43 and 49).

40. The only exceptions: Paris MS. B, f. 30 r, square in plan, which Leonardo did not translate into volumes, and the square church on two levels (Ashburnham MS. 2037, f. 4 r: Fig. 242), which constitutes a separate case in every respect.

41. In the case of the cross-shaped plans, another possible source could once again be San Lorenzo, where the apses with ambulatories butted against a parallelepiped-shaped body divided by the four towers (Fig. 251).

42. Later, around 1513, in sketches that are difficult to interpret, Leonardo seems to have wanted to place flying buttresses here, similar to those planned in some designs for the tiburio (CA, f. 733 v/271 v-d: Fig. 253).

43. Proof of this visit to Venice may lie in a note on drum-type domes that are "totally independent" of the interior space and therefore of the vaults of the church (Paris MS. B, f. 24 r). These domes could have a frame structure, following the Venetian style, of which the Colleoni Chapel offers an example closer to Milan (we thank Mrs. Colmuto Zanella for checking the dome structure for us).

44. Four proposals for façades. Two are shown only in plan: the vestibule in Ashburnham MS. 2037, f. 5 v (Fig. 231), and the portico connected to a nave in Paris MS. B, ff. 35 v and 52 r (Fig. 259); two are drawn in elevation: the stairs ending in an exterior arcade in the curious two-level church (Ashburnham MS. 2037, f. 4 r: Fig. 242), and the circular chapel transformed into a porch in Paris MS. B, f. 22 r (Fig. 239). This last solution, which shows a great deal of skill, foreshadows Bernini's façade for Sant'Andrea al Quirinale.

45. In Paris MS. B, f. 22 r (Fig. 239), Leonardo seems to hesitate between one or two orders. At the same time, Bramante was not much more successful in combining two orders in the Via del Falcone façade of Santa Maria presso San Satiro.

46. The elevation drawn beside, with twelve apses, does not correspond to the plan. It is interesting to compare this plan with Paris MS. B, f. 21 v (Fig. 230), in which the volume has sixteen sides (as at Santa Maria degli Angeli), and in which eight biforous windows alternate with niches.

47. We will return to Leonardo's Milanese style compared with that of Bramante in our contribution to the symposium *Bramante a Milano* (to be published in *Arte Lombarda*, 1987).

48. Leonardo wrote, "interior of the above building". The section could more easily be compared with the left-hand drawing on the preceding page (Fig. 254), in which the central dome appears to cover the entire parallelepipedal body and not just the central crossing.

49. This reconstruction is the only one that reconciles the cross-shaped plan with four piers for the chapels with a dome that covers the entire chapel. The lantern is unusually wide because it corresponds to the central crossing.

50. See Maltese, 1954, p. 345.

51. We could obviously assume a projection of the wall over this arch, a common arrangement in Venetian tombs, for example, but such a projection would necessarily produce a projection from the entablature because the large angle pilasters are set back in relation to the columns. This complicated solution seems unlikely. On the other hand, it is doubtful if the entablature should have columns within the central space: it may not be necessary to extend it out to the large pilasters as it is shown in the model.

52. Pedretti, 1962[1], (pp. 130-36) and 1978 (p. 209), has attempted to compare the drawing with the designs for San Lorenzo (or San Marco) around 1515.

53. In-depth analysis of the building (planned in 1490) by Giordano, 1982, pp.27-68.

54. Comprehensive study in Scurati-Manzoni, pp. 193-209. An exception, in figured architecture, could be a church similar to the one on Ashburnham MS. 2037, f. 3 v, painted by Butinone and Zenale in the Grifi Chapel at San Pietro in Gessate (reproduced on the cover of *Arte Lombarda*, no. 63).

55. The study by Cadei, clearly shows that this type of building cannot be attributed to a specific individual. The exact role played by Bramante and, *a fortiori*, that of Leonardo (of whom we know only that he visited the site with Francesco di Giorgio and Amadeo, at the Duke's request, in June 1490), is therefore impossible to define precisely.

56. Leonardo drew a similar arrangement in Paris MS. B, f. 52 r (lower left) and CA, f. 1010 r/362 r-b (Figs 259 and 261).

57. Heydenreich, 1929 (pp. 70-3), gives a perfect presentation of all the details of the problem. Further information may be found, however, in Cadei and Brizio, 1974 (pp. 9-18).

58. Heydenreich, 1929, p. 64; 1934, pp. 39-53; and 1963 (1981), pp. 46 and 156.

59. Regarding this visit, see below, n. 67.

60. Heydenreich, 1929 (pp. 48-53 and 85-9), contrasting *Pfeilerbau* to *Wandbau*, rightly emphasizes these pier-walls, the form of which is determined by the plan of the spaces that surround them. Santa Maria degli Angeli was also used as an example.

61. The comparison made by Wittkower, p. 17, may, if necessary, be accepted for the exterior volumes (although the projection of the central cube is much less pronounced), but it cannot apply to the plan. The very simple plan with four apses used in Santa Maria della Consolazione did not interest Leonardo, who was always looking for more complex combinations.

62. Heydenreich, 1969 (1981; p. 204).

63. The variation on Florence cathedral (CA. f. 57 v/17 v-a) (c. 1487) shows this tendency clearly: the arms and the sacristies become radiating chapels.

64. There was a spiritual affinity between the two artists (who may have met in Rome between 1513 and 1516) and similarities between their drawings; Peruzzi devised radiating plans with alternating chapels or chapels and apses (see, among others, Uffizi A 529 v and 107 v: Wurm, nos. 374 and 382). A drawing on Uffizi A 529 v may be compared with a plan for a château with five octagonal courtyards (Fig. 332).

Civil Architecture

65. Heydenreich, 1952, pp. 100-7; Pedretti, especially 1962[1] and 1972[2].

66. The axonometry has been established on the basis of the partial plan of the first floor (Munich, Staatsbibliothek) reproduced by Frommel, 1973, III, pl. 33 a. The drawing on the lower left (Pl. XX), on the other hand, does represent recessed columns, but these are located in the corners of the wall; Leonardo may have seen a similar arrangement in Venice, at the Ca' del Duca.

67. This hypothesis is based on an archival document (Leonardo had to clear through customs luggage arriving from Rome containing his clothes). Complete presentation of the question by Pedretti, 1983, pp. 191-8. The early dating of the Palazzo Caprini (work starting in 1501) was proposed by Frommel, 1973, II, p. 85.

68. Leonardo was all the more familiar with this motif since he had stayed in the Belvedere during his second visit to Rome (1513-1516); see Pedretti, 1962[1], p. 82. Alternating bays without an arcade (similar to those of Santa Maria di Loreto) appear in 1508 in a castle façade (Fig. 327).

69. Our reconstruction follows the one done by Pedretti, 1972[2], fig. 160, for the plan, and is different for the elevation. The drawing does not tell us whether the corner motifs are pilasters with capitals, probably Doric (drawing on right), or simple wall projections, decorating a kind of abstract order (drawing on left). The solution suggested by Carlo Pedretti to the left of this reconstruction (a pilaster supporting a simple cornice) seems, in any case, out of the question to us. The corner motif of the Palazzo dei Tribunali is not fully known, either. It may also have been a giant order or a simple projection (see Frommel, 1973, II, p. 334). The idea of the giant order on a base is in any case implicit in the Palazzo Caprini.

70. We do not share Puppi's opinion on this point (pp. 269-70), which suggests a relationship to Villa Madama and does not take into consideration the Palazzo dei Tribunali.

71. The monument does not seem to be an independent structure, with four sides, because the "prisoners" seated on the entablature, over the set-back columns, do not allow us to imagine side pediments similar to the central pediment. The theme of the prisoners, developed in other drawings for the Trivulzio monument, has been rightly compared with Michelangelo's

design for the tomb of Julius II, but the motif of human figures seated on the entablature, which is peculiar to RL 12353, has a Lombard flavour and is already found in CA, f. 400 r/148 r-a (Fig. 222, left), which dates from 1487-1488.

72. On the main altar (destroyed) of the Annunziata, see Pedretti, 1978, pp. 144-147, who cites all the texts, but wrongly bases his reconstruction on Allori's picture, and Heydenreich, 1937, who on the contrary chooses for study the drawing from the Archives published by W. Lotz, p. 403. The alternated system with a major order, central projecting bay supported on columns and side projection, reappears rarely thereafter (see Serlio, *porte delicate XVIII* and *XVIIII*). Our observations on the different types of alternating bays are based on the work of De Jonge, carried out under our supervision.

73. The supports of the segmental pediment are columns, because the drawing shows, on the right, that the support rests on a small cubic base, seen in perspective, the width of a step. The reconstruction, obviously hypothetical in its details, which we present here was developed with Sabine Kühbacher.

74. The façade drawn by Leonardo is reminiscent, on the ground floor, of that of the Palazzo Carminali-Bottigella, (in which the pilasters are more spaced, however). The rustication and the foliage sketched on the pilaster are obviously painted decorations. On the left, Leonardo drew above an entablature, a double pedestal which has approximately the same proportions as the double stylobate of the apse of Pavia Cathedral.

75. Leonardo had already drawn tree-shaped columns in the periods from 1487 to 1490 (CA, f. 988 Av/357 v-a) and 1506 to 1508 (RL 12592 r: Pl. XXI, bottom). On the interpretation by Fra Giocondo of Vitruvius' *barycephala* as a baluster-column (which seems to reflect an opinion in Milanese circles), see the very complete study by Davies and Hemsoll.

76. We are referring in particular to the Contarine delle Figure palace, in which the columns of the loggia are surmounted by an entablature. A "Venetian" façade by Serlio (Book IV, f. 177 v) still retains this character, and thus supports the comparison made by Pedretti, 1972², p. 49. The pilasters are closer together, however.

77. Leonardo's finest drawing of antique architecture (the authenticity of which has been disputed) is the drawing of the Etruscan mausoleum discovered near Castellina in Chianti in 1507 (Louvre 2386, Pl. XIX) (see Martelli). The only discovery made during Leonardo's stay in Rome (1513-1516) concerned a building in the port of Civitavecchia (CA, f. 180 v/63 v-b). For the drawings of capitals and bases, see Firpo, 1963 (pp. 13 and 15), who reproduces many of these. Leonardo's indifference to the Antique is emphasized by Heydenreich, 1963, pp. 140-1, who cites a revealing text (CA, f. 890 r/325 r-b). We may wonder what was contained, in these circumstances, in the *libro de anticaglie* mentioned in Madrid MS. II, f. 3 r: possibly only the plans? One of them, in any case, appears in the "Bramantino album", f. 68 r (reproduced in Pedretti, 1978, p. 234).

78. Leonardo specifies, on the side, that the arch begins over the architrave and rises up to the moulding of the cornice, which is decorated with an egg pattern. The arrangement next to it was sketched around 1515 on CA, f. 865 r/315 r-b (Fig. 287, top left).

79. On Leonardo's ideas on urban planning, so different from those of his contemporaries, see in particular Firpo, 1963, pp. 63-81; Garin, 1971, pp. 311-25, and Firpo's contribution to this catalogue.

80. On the subject of underground water circulation, see the

text assembled by Richter, 1939 §§ 961-969; on the world-man-city physical analogy, see the texts cited by Garin, 1971 (1974, pp. 319-20).

81. The idea of two-level circulation recurs in a drawing of a bridge (Paris MS. B, f. 23 r). Leonardo changed his first drawing to create two circulation routes one on top of the other.

82. Maltese, 1954, p. 351: this "Gramscian" reading of Leonardo's city as a bourgeois city contrasting with the feudal city of the Sforzas is curious, to say the least.

83. The attention thus paid to how things work explains the fact that Leonardo was concurrently interested in the semi-automatic supplying of stables with hay and chimneys with wood (Paris MS. B, f. 39 r, 20 r and 23 v).

84. Is this idea the Duke's or Leonardo's? The text at the bottom of the page, written in the second person, seems to be a note addressed to Lodovico to the effect that 5,000 houses containing 30,000 apartments must be built (text below in Firpo's contribution). There is no proof that the Duke ever seriously considered such a project or, conversely, that Leonardo was involved in the very real projects the Duke was undertaking at the same time at Vigevano (on this controversial subject, see the excellent evaluation by Schofield, pp. 115-6.

85. We are not discussing the 1515 urban-planning projects for the centre of Florence, revealed by Pedretti, 1962¹, pp. 112-18, because they are not connected with the theme of the two-level city; what was involved here was simply an expansion of two squares, in particular in front of the Medici palace (CA, f. 865 r/ 315 r-b: Fig. 287 centre). The project is an ambitious one, but the idea itself is not at all original.

86. On the Romorantin project, see Heydenreich, 1952; Pedretti, 1972², and Guillaume, 1974. Another drawing, not very legible, can be found in the Arundel MS., f. 263 r. The plans in the form of an extended oval in CA, f. 583 r/217 v-b, are identical to the drawing in Paris MS. B, f. 38 r (Fig. 351) and the small outline of a city drawn around 1508 (RL 12641 v, reproduced in Pedretti, 1972², fig. 148). These ideas show remarkable continuity.

87. The river indicated by two letters on f. 270 v of the Arundel MS. (Leonardo had forgotten its name!) is the Beuvron (or its tributary the Bonneure), about 20 kilometres away, whereas the Cher at Villefranche is only 9 kilometres from Romorantin (a very imprecise outline of the canal is shown in CA, f. 920 r/336 v-b). In the first case, Leonardo may have been under the impression that the water would flow naturally from the Beuvron to the Sauldre, but in the second case, where the relief is much more visible, he had to consider large-scale earthworks, the principle of which he explains at the top of the sheet (Pedretti 1972², p. 90); in fact, it would have been necessary to dam the Cher and raise its level some fifteen metres!

88. Texts quoted in Pedretti, 1972², pp. 98-9.

89. The concept, in itself, offers nothing original. Similar arrangements had been planned or executed in Rome and in Ferrara, where the main street of the new quarter ends in the castle. Leonardo himself had devised, between 1513 and 1515, a street along the axis of the Sforza Castle which would have ended in the cathedral square (CA, f. 260 r/95 r-a).

90. Our reconstruction differs from that of Pedretti, 1972², fig. 113, in that we assign smaller dimensions to the castle, as we will explain further on. In taking as a basis the castles shown in the most detailed plan (Fig. 295) we obtain the dimensions of the new city, namely approximately 270 × 400 metres. This calculation

is obviously highly theoretical, but it offers the attraction of showing that the whole plan presented in f. 270 could fit perfectly well into the site, between the old city (where the old castle occupies the angle) and the bend in the river.

91. There is no study on this subject. An overall study of the problems of stairs in fifteenth and sixteenth-century architecture may be found in *L'escalier dans l'architecture de la Renaissance*.

92. On Coducci's stairs, see Sohm; on the development of the dogleg staircase, see Frommel, 1985, pp. 135-43. Leonardo clearly realized the importance of the Urbino stairs, which he drew (Paris MS. L, f. 19 v), but he was interested in other types.

93. This interior transposition is the more important one, since exterior symmetrical stairs were less unusual. Leonardo painted stairs with parallel ramps in the *Adoration of the Magi* (1481) (see Fig. 189) and Giuliano da Sangallo used a similar type soon afterwards at the Villa Medici at Poggio a Caiano. Comparable arrangements are found in Filarete (f. 38 v) and Francesco di Giorgio (MS. M, f. 23 v). In Manuscript T, folio 18 v, bottom, Francesco di Giorgio seems to have devised a more interesting solution, an interior symmetrical staircase with flights that diverge then converge, but he did not develop this idea in other drawings.

94. An identical staircase appeared in France in the late fourteenth century at the Château de Saumur. However, its sole aim was to allow dual circulation (see *L'escalier dans l'architecture*, fig. 26).

95. The only precedent is Filarete's Tower of Virtue and Vice (f. 144 v), the plan of which, divided into seven sectors, is similar to the one in Paris MS. B, folio 48 r. Furthermore, the staircase is "divided into two" ramps which are probably concentric (Filarete did not give any specific details and even admitted his inability to draw the stairs!

96. A "theory" of multiple staircases may be found in *L'escalier dans l'architecture*, pp. 210-12.

97. Text quoted in Pedretti, 1977, § 765.

98. An isolated example of this type is seen in the work of Francesco di Giorgio (Paris MS. M, f. 24 v). The Ambrosiana album (published by Mongeri and incorrectly attributed by him to Il Bramantino) will soon be dealt with in a critical edition by Maria Phillips. We know that one of these drawings was borrowed from a collection that had belonged to "*M.ro Lionardo*" (see above, n. 77). The album contains at least four extraordinary staircases that are totally "Leonardesque": a symmetrical dogleg staircase, the newel walls of which seem to be pierced by perforated openings (f. 54 r), and double or quadruple staircases housed within the thickness of the walls around a central hall (ff. 74 r, 28 r and 82 r). The quadruple staircase on f. 28 r has ramps that are more or less rapid, the former for going down, the latter for going up, without fatigue! A "functional" idea worthy of Leonardo, and no doubt inspired by him.

99. Pedretti, 1962¹, pp. 38-9. This reconstruction is discussed in Guillaume, 1968, pp. 98-100.

100. There is a similar drawing from 1492, however, in which the centre area has been left blank (Paris MS. A, f. 114 v, lower left; reproduced in Pedretti, 1978, fig. 63), but we do not see exactly what Leonardo wanted to represent.

101. CA, ff. 570 Br/214 r-b, quoted in Pedretti, 1962¹, pp. 41-2.

102. We should also not confuse (as does Vliegenthart, pp. 443-54) the symmetrical dogleg staircase with ramps separated by newel walls and the "imperial" staircase from Spain.

However, we have noted (n. 34) that this perforated newel wall, a first step towards a single space, may exist in a drawing by Il Bramantino.

103. On the staircase in the Medici palace planned around 1516 (Uffizi A 1259), see Frommel, 1985, p. 141. The central flight of this staircase would have been twice as wide as the double return flight, as in one of the drawings in the Codex Atlanticus, f. 592 v/ 220 v-a and in the plan by Il Bramantino. Sangallo's design, which was exceptional in Roman circles, is more readily understood when we know that Leonardo was in Rome between 1513 and 1516 and that the two artists therefore met. The first symmetrical dogleg staircase in Italy, the one in the Scuola di San Rocco in Venice, came thirty years later and is derived, it seems to us, from the second staircase in the Oval Courtyard at Fontainebleau (see below, n. 159).

104. In talking about Italian architecture, it is hard not to use the word loggia in its Italian sense, which is broader than its French meaning, and not to call "loggia" a ground-floor portico opening onto a garden.

105. On the right is a structure with a cellular plan (eight-sided in the centre) surrounded by a ditch full of water; on the left, a structure (with twelve sides) with a ring-shaped gallery surrounded by a narrow ditch or clipped hedges. There was a maze in Milan in 1480, with a pavilion in the middle (Ridolfi's text quoted in Pedretti, 1978, p. 66), but it does not follow that the pavilion drawn is this one, much less that the plans for it were provided by Brunelleschi in 1430.

106. The plan with eight interior sides and sixteen exterior sides resembles that for Santa Maria degli Angeli, drawn on the preceding page (Fig. 234). Drawings of fences and fountains, also dating from 1487-1490, prove that Leonardo was then interested in the decoration of the ducal gardens (Pedretti, 1978, figs 461, 491 and 492).

107. The belvedere does not constitute a new feature in itself, but it most often took the form of a loggia on the top floor of a palace. What is original in the late Quattrocento is the erection of a belvedere at the top of a defensive tower. Such a superimposition appears at the castle in Ferrara in the mid-sixteenth century. It had existed as early as the fourteenth century in France at Mehun-sur-Yèvres.

108. From left to right we can see an access road (across a courtyard?), a portico, the square courtyard, another portico, a wall with a door in it, and the loggia. The measurements indicated do not correspond to the drawing (see Pedretti, 1978, p. 77).

109. The wall at the back of the portico, with a door opening in the middle, could also be pierced by windows overlooking the garden, as in the Medici Palace.

110. Pedretti, 1972², pp. 16-23, sees in these drawings plans for a Guiscardi Palace near Santa Maria delle Grazie. The suburban location would explain the importance given to the gardens and the open plan; it might have been a palace-villa, which the Palazzo Pitti was later on.

111. The two motifs had already been combined more or less satisfactorily in a church façade (Ashburnham MS. 2037, f. 4 r: Fig. 242). Since the circular form of the tiburio of Santa Maria presso San Satiro was exceptional, the relationship with Bramante's work seems certain.

112. The two texts, unfortunately, do not explain the drawings. The first one (CA, f. 732 b-v/271 v-a) is a description of a garden. Pedretti, 1962¹ pp. 37-43, showed that it was originally written to the left of the villa plans drawn on

CA, f. 629 Br/231 r-b (we do not understand Augusto Marinoni's criticisms of this comparison made in his Codex Atlanticus transcription, 1975, Vol. IX, p. 49), allowing us to suppose that the description relates to the garden of the villa (it will be noted, however, that the preceding staircase description cannot be for the grand staircase of the villa, as we saw earlier). The second text (CA, f. 570 Br/214 r-b) talks about an assembly room and grand staircase which are arranged the same way as in the plans for the villa, with the stairs located opposite the master's quarters.

113. The only certain topographical indication is the name of the canal located on the left in plan C: *Fonte lunga*. The indication *Neron di San Andrea* which led to locating the villa in town, near San Babila (Calvi, G., 1925 [1982: p. 164], then Pedretti, 1960), appears only on the verso of the sheet and does not necessarily bear any relation to the project. We believe, on the contrary, that an *intra muros* location for the project is unlikely because there was no vacant space large enough to accommodate a villa 30×50 metres, surrounded by gardens, between the Porta Orientale and San Babila, along the inner (underground) course of the Acqualunga. In this densely built-up neighbourhood, where the Casa Fontana is located, the only somewhat empty space was the one occupied by the *Umiliati* convent, on which St. Charles Borromeo was to build his seminary. Since the terms Fontelunga and Acqualunga apply to the waterway both inside and outside the city, it is much more reasonable to think of a location outside the Porta Orientale (the gate in the mediaeval wall), a location which might be pinpointed through further research. We are greatly indebted to Luisa Giordano for the topographical indications she supplied.

114. Drawing B represents the garden as a whole, with a fountain along the axis of the villa, and drawing C, the left part of the garden, close to the *Fonte lunga* and the private garden, with a fountain in the middle of the trees.

115. Similar features (fountains, slab with a canal running over it) are found in the garden of the Villa Lante in Bagnaia.

116. The drawing does not tell us whether it is an enclosed garden or a fish pond, but the handwritten notes refer to fish swimming around in the canals. The theme of the magical garden reappears at the same time in the description of the "Seat of Venus" in Cyprus (RL 12591 r).

117. Leonardo simply failed to indicate the "secret" staircase that was to lead from the private apartments to the private garden, on the side opposite the grand staircase.

118. The villa of the king of Naples was rectangular in plan. Leonardo only kept the principle of the four angle pavilions, without any relation to the Milanese villa; it is a free association of ideas, and not a matter of a "source" of the design.

119. Pedretti, 1972², p. 46, believes that the drawing of the façade on the cover of the Codex on the Flight of Birds is the entrance façade, on the same side as the main staircase. We see it, on the contrary, as the façade on the private garden because of the "master's hall" which "may be wide open" and which we locate on the first floor.

120. Pedretti, 1972², p. 44, reconstructs a much smaller villa, since he takes as his starting point the measurements of the dogleg staircase described at the top of CA, f. 732 Bv/271 v-a (see above, nn. 112 and 99).

121. Pedretti, 1972², pp. 53-57.

122. Heydenreich, 1954, p. 83. The hypothesis of the trip to France in 1508-1509 is formulated by Pedretti, 1972², pp. 57 and 104. The only certainty is that Leonard wrote a note at that time on the conduits in the gardens at Blois (Paris MS. K³, f. 20 r), but he may have got his information from the French in Milan or from Fra Giocondo who came back to Italy in 1506.

123. The loggia with central arcade in Paris MS. I, f. 56 r foreshadows, very remotely, the garden façade of the Palazzo del Te and, more closely, the loggia of the Villa Medici.

124. Florence MS. M, ff. 20 v, 21 v and 24 v.

125. There is a drawing of the same type but, as always, much less expressive, by Francesco di Giorgio (Turin MS. T, f. 30 v).

126. In the square in the middle of the right part of the plan, we can make out parallel lines that could indicate stairs. We may compare Leonardo's drawing with two drawings by Filarete: a cross-shaped plan in a square (f. 49 v) and a square castle with fifteen (!) set-back storeys (f. 110 r). The octagonal capping is reminiscent of the top level in the towers with several set-back storeys of the Milan and Vigevano castles, but it is much more developed; it is a real belvedere, an open architecture.

127. The persistence of these symbolic forms was thoroughly examined by Von Moos. The relationship with rural buildings and villas with a central "tower", suggested by Lazzaro, pp. 358-9, seems wrong to us; Leonardo's "model" is the castle with set-back storeys.

128. Pedretti, 1962¹, pp. 112-18, who identified the plan, first assumed (and rightly so) that the "palace" drawing was a fancy of Leonardo's, then presented it as a project designed for Lorenzo, governor of Florence (Pedretti, 1972², pp. 58-63; 1978, p. 208). We do not believe, either, that the tree-shaped columns drawn below are a reference to Lorenzo's symbol (a cutoff tree trunk with a new branch growing out of it), nor that they are intended to ornament the exterior façade of the palace.

129. The work at Bonnivet began in 1516. For the first time, a continuous walkway was developed along the façade and around the towers, so that the high parts stand on a kind of platform, exactly as in Leonardo's drawing.

130. Centralized plans with octagonal courtyard: Turin MS. T, ff. 18 r and 91 r, Florence MS. M, ff. 20 v, 21 r and 24 v. Octagonal courtyard with stairs in the angles: Turin MS. T, f. 92 v.

131. Turin MS. T, f. 91 r; Florence MS. M, f. 20 v. Leonardo drew, on one of the sides, a kind of axonometric projection that makes the play of volumes clear: the octagonal elements located in the angles project. The "tower" effect therefore remains, tremendously enlarged; this is enough to distinguish Leonardo from Francesco di Giorgio, who was exclusively interested in geometric combinations.

132. *Sebastiano Serlio*, projects XL and LXXI.

133. Pedretti, 1972², pp. 108-112.

134. The two plans at the top, which Heydenreich, 1952, wrongly interpreted as houses that could be dismantled, are possibly church plans (Pedretti, 1962¹, p. 143). The bottom plan is reminiscent of the classical building of which Leonardo had the plan (see above, n. 77).

135. Arundel MS., f. 270 v. Firpo, pp. 125-6, clearly understood that this was a usual practice in France, and not a new type of house (Heydenreich, 1952), much less "the introduction into modern history of the concept of the prefabricated house" (Maltese, 1954, p. 356).

136. Text quoted in Pedretti, 1972², p. 97. Leonardo's drawing seems inaccurate (unless he had discovered an exceptional example). The zone where the steps fit in (*m-n*) never has the outline he indicated.

137. The window drawn is probably a dormer, because cappings with pediments and candelabras are theoretically only seen on dormers and doors. The transparent staircase with its terminal, set-back belvedere could be a memory of François I's staircase at Blois, then under construction (which admittedly turns in the other direction).

138. In fact, only one plan (CA, f. 806 r/294 v-b: Fig. 298) contains a church in the centre of the square — a church with an ordinary basilica plan that might be compared with contemporary drawings of church naves in CA, f. 309 r/111 r-b and the Geneva fragment. In this latter drawing, in particular, the church seems to stand apart in a square (Pedretti, 1978: figs 380 and 381).

139. We should recall that the towers are not indicated in the 1506-1507 plan for the castle with four towers (Fig. 326).

140. For the details of this reconstruction, see Pedretti, 1972[2], pp. 79-83, and Guillaume, 1974, pp. 88-9, in which we take up once again the calculation. We actually think that the dimensions indicated for the "ground-level" courtyard (80 × 120 *braccia*) are those of the courtyard plus the porticos; the courtyard itself probably measured only 60 × 100 *braccia* (these measurements allow for a regular succession of accades 6⅔ *braccia* wide). The exterior dimensions, without the towers, would therefore be 120 × 160 *braccia*. The (entrance) façades would be thus actually twice as wide as the courtyard itself, as Leonardo indicates at the bottom of the sheet, taking up an idea already formulated, with an explanatory drawing, around 1508 (RL 12585 v; Fig. 359). A castle 160 × 200 *braccia* as reconstructed by Pedretti seems unlikely to us, as we cannot imagine in France (or even in Italy, all around the courtyard) buildings 30 *braccia* wide (40 *braccia* with the portico).

141. Le Verger was under construction at the end of the fifteenth century, and Bury was started before 1515. These two buildings (destroyed) are the only châteaux that were entirely new constructions built on a regular plan between 1495 and 1515.

142. The French château "system" has recently been studied by Prinz and Kecks. For the use of the Italian staircase in France, see Guillaume, 1985[2].

143. The particular function of the courthouse explains this grandiose layout which Leonardo thus considered suitable for a royal palace. The Palazzo Strozzi, with its two entrances and two staircases (which could simply have been repeated on the other side) might be another source of inspiration.

144. Our views on this point are in Guillaume, 1986.

145. Ackerman, 1951. Before devising this open façade, Leonardo may have thought of belvederes at the top of towers, as was formerly done in Milan (see the small sketch for a castle on the right of CA, f. 806 r/294 v-b: Fig. 298, compare with Fig. 314).

146. Pedretti, 1972[2], p. 104, questioned the identification made by Heydenreich, 1952, under the pretext that the castle was drawn on the verso of a drawing of a horse's leg for the Trivulzio monument project (around 1508). However, there was nothing preventing Leonardo from reusing the same sheet ten years later. The similarities with the Romorantin project are too great for us to be able to doubt this identification (see, along the same lines, the review of Pedretti, 1972[2], by Wasserman).

147. Rectangular pavilions housing a dogleg staircase had existed as early as 1515 at Bury, but the first angle pavilions, replacing towers, appeared at Fontainebleau between 1527 and 1530. They spread rapidly after that.

148. Pedretti, 1972[2], pp. 110-111.

149. Domenico da Cortona provided the plans for the Paris Hôtel de Ville, begun in 1532. He had lived in the royal entourage since 1496, and organized festivities at Amboise in 1518. At that same time, Leonardo made mention of *Mastro Domenico* (CA, f. 475 v/174 v-a).

150. On Chenonceau, see Guillaume, 1969, p. 37; on Bonnivet, see our thesis *La première Renaissance en Poitou* (to be published).

151. Besides Romorantin, other sources may be evoked: the upper Belvedere Court for the (partial) use of the alternating bay, and the façade of the *Logge* on the Court of San Samaso, another "open" exterior façade. The colonnade of the top floor which seems to confirm this comparison does not constitute an argument, however, as it was added subsequently.

152. On this "series" of châteaux, see Guillaume, 1985[1], p. 33, and M. Chatenet, *Le château de Madrid* (to be published). The comparison made by Heydenreich, 1952, p. 282, between the entablature cut by an arch in the second storey of Chambord and a drawing by Leonardo (Fig. 290) cannot however establish proof of a link, since Leonardo clearly never drew the elevations of Chambord in any precise manner. There is simply a similarity between Leonardo's lack of prejudice and French openmindedness.

153. Solmi, 1904, pp. 409-10.

154. See above, n. 149. The attribution of the model to Domenico da Cortona is based on a payment for "wood models" of Tournay, Ardres and Chambord, these places where work was indeed carried out or begun in 1519-1520 (see Guillaume, 1968, nos. 2, 3 and 22).

155. Guillaume, 1968, and 1974. For an overview of the problems presented by the château, see Guillaume 1983[1], and in particular the major study by Martin-Demezil.

156. Filarete, f. 49 v; Francesco di Giorgio, MS. M, ff. 20 v, 21 v bottom right, and 24 v.

157. On this point, we totally agree with Heydenreich, 1954, p. 83, in our opinion the best account of Leonardo and Chambord and disagree with Prinz, who proposes an entirely different interpretation of the château. The cross-shaped plan and the role played by the central spiral would have symbolic reasons, in his opinion; the king and the scholars advising him apparently wanted to express the universal power of the king by the crossing of the two axes of the world, and his wisdom by the rising of the stairs, identified with the king, towards the light. See, on this subject, Guillame, 1983[2], and for an opposing view, Burroughs.

158. The hypothesis of the quadruple staircase is based on Palladio, L. I, pp. 64-5. We have shown (Guillaume, 1974, pp. 79-81) that such a staircase was feasible in the actual space of the château. More recently, Pérouse de Montclos, p. 86, proposed a very interesting, different reconstruction that exactly follows Palladio's indications: the stairs would have completed three-quarters of a revolution, ending at the first floor.

159. On this group of stairs, see Guillaume, 1968, pp. 101-106 and 1985[2], p. 38 (with reconstruction of the Fontainebleau staircase). Another possible, but more remote, derivation is the central staircase of the pentagonal Château de Maulne (Miller, p. 210).

Leonardo and the Architecture of his Time

160. See Heydenreich, 1963; 1981, p. 157.

161. The terms in which Charles d'Amboise praised Leonardo in his letter to the governors of Florence, dated December 1506, are well known (see Gaye, p. 94; Pedretti, 1978, p. 205).

162. The centrally planned churches, extremely rare after 1490, disappear after 1508 with the exception of the sketches of St. Peter's and San Lorenzo from around 1515, and of the mysterious octagonal plans next to the plan of the town of Romorantin. One wonders if the new interest in the centrally planned castle (not the fortress) did not arise as the result of contact with the French in Milan, for whom the residential castle was the focal point of civil architecture.

163. We agree with J. Ackerman's opinion, 1981, as expressed in his account of Pedretti, 1978.

164. See Pedretti, 1978, p. 205, Pedretti rightly stresses the importance of the 1506-1519 period, of which he was the first to measure the importance: however, the word "apotheosis" must be reserved for the French period.

165. The pope's reaction to his guest's inability to actually execute anything at all has been preserved for posterity: "Here is someone who won't get on with the world; he is thinking about the end of the work before it is even started!". See Vasari, 1983, p. 46).

II.3 *Leonardo as Urban Planner*

1. "*Hostinato rigore*", the motto Leonardo wrote under the emblem of a plough on RL 12701 (*c.* 1498), reproduced in Clark, 1968, II.

2. Significant contributions in this area are: Firpo, 1962, with bibliography on pp. 131-8; Pedretti, 1978, with bibliography on pp. 345-52; Carpiceci (with many reconstructions of drawings and buildings which are only roughly sketched by Leonardo). On fortified architecture: I. Calvi and Marani, 1984[2].

3. Arundel MS., ff. 35 r and v, 157 r.

4. Paris MS. L, f. 66 r. The caption reads: "The bridge of Pera at Constantinople, 40 *braccia* wide, 70 *braccia* high above the water, 600 *braccia* long; that is, 400 over the sea and 200 on the land, thus making its own abutments".

5. Babinger and Heydenreich, pp. 1-20. A less scholarly account is given by Babinger, 1952[1], and 1952[2], p. 3.

6. CA, f. 1082 r/391 r-a; this is a draft of a letter, not in Leonardo's hand. For the date see Pedretti, 1977, II, p. 274.

7. On the plans for this royal residence see Pedretti, 1972[2].

8. The simile with goats recurs in the letter to Lodovico Sforza which I transcribe below. In his description of an imaginary cataclysm Leonardo had written: "...we stay here in the ruins of some churches, men and women mingled together, small and great, just like herds of goats" (CA, f. 573 Av/214 v-d, *c.* 1497-1500). A more vivid image of the horrors of the plague is found in Leonardo's "lament" to Benedetto Dei on the deadly disease, CA, f. 265 v/96 v-b, *c.* 1487-1490. For the date see Pedretti, 1977, II, p. 22, and I, p. 131.

9. CA, f. 477 v/175 v-a, 1493-1494; dated by Pedretti, 1977, I, p. 224.

10. Alberti, 1964; *Lapides* is on pp. 136-7. On the analogy between the two texts see Garin, 1971, particularly pp. 313 ff.

11. The "first renown" (*prima fama*) is the initial fame of the politician, a new, fragile prestige, which can be perpetuated in the enduring monuments of the city.

12. A measure dictated by cold political realism: the leaders in nobility and wealth dominate the populace; the lord in turn can dominate them through fear and economic interests.

13. "*Compagnia del suo nome*"; one adapts to one's own fame also in the artistic sense.

14. The districts destined for the *palazzi* of the "magnates" would rise outside the perimeter wall, inside which the "poor" are crowded together.

15. CA, f. 184 v/65 v-b, from 1493; the first section is written in red chalk on the upper part of the sheet; the second is in the centre, in pen and ink; the rest, below. The passages on the canals, which I transcribe below, are partly intermingled with the text I have assembled here. For the date see Pedretti, 1977, p. 100. On the urban planning projects for Milan see Pedretti, 1962[3], pp. 137-47.

16. CA, f. 184 v/65 v-b. The captions read: "Sinese" (Ticino Gate), "Rensa" (Rensa Gate, formerly the Argentea Gate), "Giessa" (Gessate), "Tosa" (now Porta Vittoria), "Romana".

17. The caption reads: "*Navilio. Orto. Pesciera*" (Canal. Garden. Fishery). As for "*Spesa*", Marinoni, in his transcription of the Codex Atlanticus, II, p. 32, suggests the interpretation "*dogana*" (customs), the place where transit duties were paid; but the location, far from the waterways and streets, seems to make this explanation less plausible.

18. I would interpret this as: "Will assume the maintenance expenses, and in return will be exempt from paying the annual tribute".

19. Forster MS. III (1493), ff. 23 v, 15 r, 68 r. The Martesana Canal ("Martigiana") was linked to the city only in 1497. The "model" referred to in the last line could be either for hydraulics or urban planning.

20. CA, f. 199 r/73 r-a, 1508-1510; dated by Pedretti, 1977, I, p. 106. Clockwise from the right are indicated the names of the city gates and width of the intervals in *braccia*: "Monforte 330, Rensa 189 195, acqua 362, Nova 475, Strada 100 100, Navilio, Vachiara, Cumasina [Comacina], Barco [the ducal park], Giove [Porta Giovia or Porta del Castello], Vercelli [Porta Vercellina]".

21. CA, f. 199 v/73 v-a, which dates from the same time as the recto; and also RL 19115 v, with the note: "Put the true middle [i.e. centre] of Milan". See Pedretti, 1960 (particularly pp. 77-78).

22. The caption to Paris MS. B, f. 25 r, reads: "Light of a courtyard. If the courtyard has its wall high from *n-m* and from *f-n*, it will be illuminated by the sky *c-d*, and if the walls are high from *r-s* and from *f-*', it will not see and will have light only from the part of the sky *a-b*". On RL 12585 v a large building with an arcaded courtyard is shown both in plan and in elevation; Leonardo allocates 10 *braccia* (6 metres) to the width of the rooms, 10 *braccia* to the arcade, and 40 to the courtyard.

II.4 *Leonardo, Fortified Architecture and its Structural Problems*

1. On the subject of Leonardo as an engineer, leaving aside the long series of eulogistic contributions which tended to stress his supposed mechanical "prophecies" and technological discoveries, it is wise to refer to more recent studies by Augusto Marinoni

which use a methodological approach to correct many of the erroneous assumptions made by Leonardo scholars for more than a century. (See for example his essay in the exhibition catalogue *Laboratorio su Leonardo*. However, this essay is perhaps too severe in its assessment of Leonardo's education and formative training; on this exhibition, see Marani, 1982[4], pp. 126-31).

For a methodological approach to the problem and for an overall view I recommend Marinoni's contribution to the present exhibition catalogue. An attempt at a comprehensive collection of Leonardo's drawings and texts on military architecture can be found in Marani, 1984[2], in which the material is arranged in chronological order. In addition to my book, see the paper by Carlo Pedretti presented to the 1984 Conference at Vicenza, C.I.S.A. Andrea Palladio, on the military architecture of the sixteenth century in the Veneto (forthcoming).

2. See K/P, which includes all of the anatomial sheets at Windsor, including the Weimar sheet and those on anatomy in art, for a total of two hundred sheets. To these must be added all the sheets in the Codex Atlanticus and other manuscripts, which are all reproduced in the Keele-Pedretti edition. For the links between anatomical research and military architecture see also Murray, pp. 346-51.

3. Maltese, 1954, pp. 331-58.

4. I am thinking particularly, and also for their connections with Italian and French castle architecture of the early sixteenth century, of the reconstruction of Leonardo's "projects" for the Villa Melzi at Vaprio d'Adda and for the Royal Palace at Romorantin carried out by Pedretti, 1962[1] and 1972[2]. On this topic see also Heydenreich, 1964, pp. 400-8, and Ackerman, 1981, pp. 66-8.

Little if anything could be contributed to the non-existent catalogue of Leonardo's architecture by the discovery of Madrid MS. II, despite the many sketches and long annotations (often copied from Francesco di Giorgio's treatise) referring to fortifications in progress at Piombino in 1504. For an account of this see Heydenreich, 1974, pp. 136-65. The same is true of the recent discovery of information on Leonardo's inspections at La Verruca, on the basis of drawings of the Verruca mountain in Madrid MS. II (see Pedretti, 1972[1], pp. 417-25, and 1978, pp. 174 ff). Although the basic problem is still the same, the question of what happened to Leonardo's drawings and studies of fortifications during the sixteenth century is a slightly different one. On this, see the studies cited above and in particular Marani, 1984[2], *passim*,

and also Bury, pp. 499-500.

5. I have used the term "project" in this sense in my book (Marani, 1984[2]) and not in the accepted modern sense. This nuance is misunderstood by Scalini, pp. 51-2, in his nonetheless intelligent and stimulating review.

6. For the documents see Beltrami, 1919, to which may be added some recently discovered evidence, e.g. the document referring to Leonardo's inspections at La Verruca (see note 4 above).

7. See Marani, 1984[2], especially pp. 43-4 and 150.

8. See Fergusson, pp. 175-92; Marani, 1982[3], pp. 81-92.

9. Zammattio, especially pp. 208-15. On Leonardo's visits to Lombard building sites and the effect of northern Italian techniques and mechanisms on his technological studies, see Marani, 1985, which postulates Leonardo's familiarity with certain hoists and other mechanisms in use in Bergamo at the end of the fifteenth century.

10. Hale; Marani, 1984[1].

11. See again Marani, 1984[2], pp. 97 ff.

12. Attention was called to this sheet, Paris MS. M, f. 82 v, for the first time in Marani, 1982[1], p. 120, and again in Marani, 1984[2] pp. 43-4 and 150.

13. See Marani, 1984[2], p. 158.

14. See Kemp, 1981, p. 234.

15. See I. Calvi, pp. 193 ff.

16. Dated *c.* 1514-15 by Pedretti, 1979, I, p. 37.

17. On this drawing by Sangallo, which bears the inscription "round dome of tile like those built without framework in Florence", and on Alberti's observations on Brunelleschi's technique of "turning cupolas", see the recent essay by Bartoli, pp. 186-9, fig. 1.

18. See Marani, 1984[2], *passim*, and particularly pp. 61-95 and 220-78.

19. On this question see Guillaume, 1975, p. 29-39 (see also, for more detailed references, Guillaume, 1974, p. 71-91); see Pedretti, 1972[2], *passim*. For other views concerning Leonardo's influence on French castles and on Chambord in particular, see Prinz and Kecks, pp. 399-415. See also Prinz, 1986, pp. 291-305. On the subject of the influence of Leonardo's drawings of circular fortresses during the sixteenth century, I have often quoted in my studies two drawings from the Uffizi (nos. 3877A r and v), attributing them to Giovanni Antonio Dosio; they must now be attributed to Gianvittorio Soderini (see Morrogh, pp. 69-72).

General bibliography

Editions of Leonardo da Vinci manuscripts

Anatomical MSS A-C
See K/P.

Arundel MS.
I manoscritti e i Disegni di Leonardo da Vinci pubblicati dalla Reale Commissione Vinciana, I. *Il Codice Arundel 263*, 4 vols. Rome, 1923-30.

Ashburnham MS. 2037 (formerly part of Paris MS. B)
See Paris MSS A-M, vol. VI (1891), and *I manoscritti e i disegni di Leonardo da Vinci. Il Codice B* (Rome, 1941).

Ashburnham MS. 2038 (formerly part of Paris MS. A)
See Paris MSS A-M, vol. VI (1891), and *I manoscritti e i disegni di Leonardo da Vinci. Il Codice A*, vol. II (Rome, 1938).

CA - Codex Atlanticus *
Il Codice Atlantico di Leonardo da Vinci. Trascrizione diplomatica e critica di A. Marinoni (new edition after restoration), Florence and New York, 1973-5 (12 volumes of facsimiles); Florence, 1975-80 (12 volumes of transcriptions). First published by G. Piumati, 35 portfolios, Milan, 1894-1904.

CH - Codex Hammer (formerly Codex Leicester)
Il Codice di Leonardo da Vinci della Biblioteca di Lord Leicester in Holkham Hall., ed. Gerolamo Calvi, Milan, 1909. New facsimile edition with translation into English, ed. Carlo Pedretti, Florence, 1987.

Codex on the Flight of Birds
Codice sul volo degli uccelli. Trascrizione diplomatica e critica di A. Marinoni, Florence 1976 (translation into English with foreword by Carlo Pedretti: New York, 1982). First published by T. Sabachnikoff (ed. G. Piumati; French translation by C. Ravaisson-Mollien): *Codice sul volo degli uccelli e varie altre materie*, Paris, 1983.

Codex Trivulzianus
Il Codice di Leonardo da Vinci nella Biblioteca Trivulziana di Milano. Trascrizione diplomatica e critica di A.M. Brizio, Florence, 1980. First published by L. Beltrami *Il Codice di Leonardo da Vinci nella Biblioteca del Principe Trivulzio in Milano*), Milan, 1891; republished by N. De Toni (*Il Codice Trivulziano*), Milan, 1893.

CU - Codex Urbinas (Treatise on painting)
Ed. by H. Ludwig, *Leonardo da Vinci. Das Buch von der Malerei*, 2 vols. Vienna, 1882. New edition by A.P. MacMahon, *Treatise on painting by Leonardo da Vinci*, 2 vols. Princeton, 1956.

Disegni
I manuscritti e i disegni di Leonardo da Vinci. I disegni. Fasc. V, ed. A. Venturi, Rome, 1939.

Forster MSS I-III
I manoscritti di Leonardo da Vinci pubblicati dalla Reale Commissioine Vinciana, Serie minore, I. Il Codice Forster, I-III, 5 vols. Rome, 1930-6.

K/P - Corpus of the Anatomical Studies **
Leonardo da Vinci. Corpus of the Anatomical Studies in the Collection of Her Majesty the Queen at Windsor Castle, ed. Kenneth D. Keele and Carlo Pedretti, 3 vols. London and New York, 1978-80 (Italian ed.: Florence, 1980-5). This includes Anatomical MSS A and B, first published as *Dell'Anatomia, Fogli A e Fogli B*, ed. Giovanni Piumati (Paris, 1898; Turin, 1901), and Anatomical MS. C, first published as *Quaderni d'Anatomia*, 6 vols., ed. O.C.L. Vangensten, A. Fonahn and H. Hopstock (Christiania, 1911-16).

Lu
See Codex Urbinas, ed. Ludwig.

Madrid MSS I-II
Leonardo da Vinci, *The Madrid Codices*, ed. Ladislao Reti, 5 vols. New York, 1974.

McM
See Codex Urbinas, ed. MacMahon.

Paris MSS A-M
Les manuscrits de Léonard de Vinci. Manuscrit A [to MS. M] de la Bibliothèque de l'Institut, publiés par Charles Ravaisson-Mollien, 6 vols. Paris, 1881-91. New Commissione Vinciana facsimile edition forthcoming (Florence, 1987). For Paris MS. A see also: *I manoscritti e i disegni di Leonardo da Vinci. Il Codice A*, 2 vols., Rome, 1936 and 1938. For Paris MS. B, see also *I manoscritti e i disegni di Leonardo da Vinci. Il Codice B*, Rome, 1941. For Paris MSS A-D see also the A. Corbeau-N. De Toni edition (facsimiles, transcriptions and French translations), Grenoble, 1960 (Paris MS. B), 1964 (Paris MSS C and D), 1972 (Paris MS. A, 2 vols.).

RL
Corpus of the drawings of Leonardo da Vinci in the Royal Library at Windsor (see Clark, 1968).

Treatise on painting
See CU or Codex Urbinas.

* All references in this catalogue to folios from the Codex Atlanticus are given with the new numbers preceding the old.
** In the case of the anatomical drawings from Windsor, the new numbers established by Keele and Pedretti (K/P) follow the Royal Library (RL) numbers.

Other sources and reference works

Ackerman, J.S.
1951 "The Belvedere as a Classical Villa". *Journal of the Warburg and Courtauld Institutes*, XIV, pp. 70-91.
1978 See *Sebastiano Serlio*.
1981 Review of Pedretti, 1978. *Journal of the Society of Architectural Historians*, XL, n. 1, p. 66-8.

Acland, J.H.
1972 *Medieval Structure: the Gothic Vault*. Toronto.

Ady, C.M.
1907 *A History of Milan under the Sforza*. London.

Alberti L.B.
1964 "Alcune Intercenali inedite". In Garin, *Rinascimento*, IV, pp. 125-258.
1966 *L'Architettura (De re aedificatoria)*, 2 vols. Milan.

Arconati, F.
1923 *Leonardo da Vinci. Del moto e misura dell'acqua. Nove libri ordinati da F. Arconati*. Ed. E. Carusi and A. Favaro. Bologna.

Averlino, A. (called Filarete)
1972 *Trattato di architettura*. [Codex Magliabechianus II, I, 140, Biblioteca Nazionale, Florence] Ed. A.M. Finoli and L. Grassi. Milan.

Babinger F.
1952[1] "Eine Brücke von Galata nach Stambul wollte Leonardo in die Dienste der Sultan treten". *Die Neue Zeitung*, VIII, n. 87-8
1952[2] "Un inedito di Leonardo da Vinci. Leonardo e la corte del Sultano". *Il Nuovo Corriere*, 23 March, p. 3.

Babinger, F., and Heydenreich, L.H.
1952 "Vier Bauvorshläge Lionardo da Vinci's Sultan Bajezid II (1502-3)", in *Nachrichten von der Akademie der Wissenschaften in Göttingen*, Phil. Hist. Klasse, pp. 1-20.

Balavoine, C.
See *Le modèle à la Renaissance*.

Barbaro D.
See Vitruvius, 1556.

Bartoli, L.
1985 "Il Brunelleschi commentato da L.B. Alberti. La 'volta tonda di mezzana', la 'volta a creste e vele', la 'testudo spherica angularis". *Antichità viva*, XXIV, n. 1-3, pp. 186-9.

Beck, T.
1900 *Beiträge zur Geschichte des Maschinenbaues*, Berlin (1st. ed.: 1899).

Bedini, S
1974 "Leonardo and Mechanical Clocks", in Reti, 1974[2], pp. 240-63.

Bellincioni, B.
1493 *Rime dell'arguto et faceto poeta B.B. fiorentino*. Milan.

Bellone, E. and Rossi, P. (eds.)

1982 *Leonardo e l'età della ragione*. Milan (see Kemp, Marani, Scaglia, Truesdell).

Beltrami, L.
1903 *Leonardo da Vinci negli studi per il tiburio della Cattedrale di Milano*, Milan (reprint: *Luca Beltrami e il Duomo di Milano*. Milan, 1964, pp. 357-86).
1919 *Documenti e memorie riguardanti la vita e le opere di Leonardo da Vinci*. Milan.

Bloc, M.
1963 *Mélanges*. Paris.

Bonelli, R.
See *Scritti rinascimentali di architettura*.

Branca, G.
1629 *Le Machine*. Rome (reprint: Turin, 1967).

Brivio, E.
See Ferrari da Passano and Brivio.

Brizio, A.M.
1952 *Scritti scelti di Leonardo da Vinci*. Turin.
1954 *Delle acque*, in Leonardo. *Saggi e Ricerche*, pp. 257-89.
1974 *Bramante e Leonardo alla Corte di Lodovico il Moro*, in *Studi Bramanteschi*, pp. 9-26.

Brugnoli, M.V.
1974 "The Sforza Monument", in Reti, 1974[2], pp. 86-109.

Bruschi, A.
1978 "Pareri sul Tiburio del Duomo di Milano", in *Scritti rinascimentali di Architettura*, pp. 319-86.

Buonaccorso Ghiberti
Zibaldone (MS. B.R. 228, Biblioteca Nazionale, Florence).

Burroughs, C.
1985 Review of Prinz, 1980. *Journal of the Society of Architectural Historians*, XLIV, pp. 392-5.

Bury, J.B.
1984 "A Leonardo project realized in Portugal". *The Burlington Magazine*, CXXVI, n. 977, pp. 499-500.

Cadei, A.
1972-3 "Nota sul Bramante e l'Amedeo architetti del Duomo di Pavia". *Bollettino della Società Pavese di Storia Patria*, LXXXII-LXXXIII (1975), pp. 35-60.

Calvi, G.
1925 *I manoscritti di Leonardo da Vinci dal punto di vista cronologico, storico e bibliografico*. Bologna (reprint: Busto Arsizio, 1982).

Calvi, I.
1943 *L'architettura militare di Leonardo da Vinci*. Milan.

Campanus from Novara
1503 *Tetragonismus id est circuli quadratura*. Venice.

Canestrini, G.
1939 *Leonardo construttore di macchine e di veicoli*. Milan.

Cardano, G.
1550 *De subtilitate Libri XXI*. Nuremberg.

Carpiceci, A.C.
1978 *L'Architettura di Leonardo*. Florence.

Carusi, G.
See Arconati.

Cassi Ramelli, A. (ed.)
1964 *Luca Beltrami e il Duomo di Milano*. Milan.

Cellini, B.
1968 *Della Architettura*. Ed. B. Maier. Milan.

Cesariano, C.
See Vitruvius, 1969.

Chastel, A.
See Vasari, 1981-7.

Clagett, M.
1959 *The Science of Mechanics in the Middle Ages*. Madison, Wisconsin.

Clark, K.
1968 *The Drawings of Leonardo da Vinci in the Collection of Her Majesty the Queen*. Second Ed. revised with the assistance of C. Pedretti, 3 vols. London.
1976 *Leonardo and the Antique*, in *Leonardo's Legacy*.

Clayton, R.
1848 *The Parochial Churches of Sir Christopher Wren*. London.

Czarnowsky, C.
1949 "Engins de levage dans les combles d'églises en Alsace". *Cahiers techniques de l'art*, II, pp. 11-19.

Davies, P., and Hemsoll, D.
1983 "Renaissance Balusters and the Antique". *Architectural History*, XXVI, pp. 1-23.

De Jonge, K.
1987 *La travée alternée dans l'architecture de la Renaissance*. Doctoral dissertation, University of Louvain.

Dibner, B.
See Reti and Dibner.

Dimitrokallis, G.
1968 "Osservazioni sull'architettura di San Satiro a Milano". *Archivio Storico Lombardo*, XVC, pp. 127-40.

Drachmann, A.G.
Nota su le Gru antiche, in Singer, II, pp. 668-73.

DSB
1970-80 *Dictionary of Scientific Biography*. ed. C.C. Gillispie, 16 vols. New York.

Du Colombier, P.
1973 *Les chantiers des cathédrales*. Paris.

Falb, R. (ed.)
See Giuliano da Sangallo.

Favaro, G.
See Arconati.

Feldhaus, F.M.
1913 *Leonardo der Technicher und Erfinder*. Iena.

Fergusson, F.D.
1977 "Leonardo da Vinci and the Tiburio of Milan Cathedral". *Architectura*, VII, pp. 175-92.

Ferrari da Passano, C.
1973 "Storia della Veneranda Fabbrica del Duomo", in *Il Duomo di Milano*, II, pp. 1-96.

Ferrari da Passano, C. and Brivio, E.
1967 "Contributo allo studio del Triburio del Duomo di Milano". *Arte Lombarda*, XII, 1, pp. 3-36.

Fichten J.
1971 *The Construction of Gothic Cathedrals*. Chicago.

Filarete
See Averlino.

Firpo, L.
1963 *Leonardo architetto e urbanista*. Turin (reprint: 1973).

Francesco di Giorgio Martini
Florence MS. M. (Cod. Magliabechianus, II, I, 141, National Library, Florence), see Maltese, 1967, II, p. 293-569.
Turin MS. T (Cod. Saluzzianus 148, Biblioteca Reale, Turin), see Maltese, 1967, I, pp. 3-289.
Trattato I, see Maltese, 1967.
Trattato II, see Scaglia, 1985.
Codex Ashburnham 361 (Laurentian Library, Florence), see Marani, 1979.

Frommel, C.L.
1973 *Der römische Palastbau der Hochrenaissance*. 3 vols., Tübingen.
1984 "S. Pietro. Storia della sua costruzione", in *Raffaello architetto*, pp. 241-310.
1985 "Scale maggiori dei palazzi romani del Rinascimento", in *L'escalier dans l'architecture de la Renaissance*, pp. 135-43.

Galbiati, G.
1939 *Dizionario leonardesco. Repertorio generale delle voci e cose contenute nel Codice Atlantico*. Milan.

Galiani, B.
See Vitruvius, 1790.

Galluzzi, P. (ed.).
1974 *Leonardo letto e commentato*, Florence (see Garin, Heydenreich, Maccagni, Reti, Scaglia, Steinitz).

Garin, E.
1961 "Il problema delle fonti del pensiero di Leonardo", in *La cultura filosofica del Rinascimento*. Florence.
1967 *Ritratti di umanisti*. Florence.
1971 *La città in Leonardo* (Lettura Vinciana XII, 1971), see Galluzzi, pp. 309-25
See also Alberti, 1964.

Gaye, G.
1840 *Carteggio inedito d'artisti dei secoli XIV, XV e XVI*, 3 vols. Florence.

Ghiberti, B.
See Buonaccorso Ghiberti.

Giacomelli, R.
1936 *Gli scritti di Leonardo da Vinci sul volo*. Rome.

Gibbs-Smith, C.
1978 *The Inventions of Leonardo da Vinci*. Oxford.

Gille, B.
1964 *Les ingénieurs de la Renaissance*. Paris (English translation: Cambridge, Mass., 1966).
1978 *Histoire des techniques*. Paris.

Giordano, L.
1982 "L'Architettura", in *Santa Maria della Croce*, pp. 27-68.
1985 "San Lorenzo nella cultura del primo Rinascimento", in *La Basilica di S. Lorenzo*, pp. 117-43.

Giuliano da Sangallo
1902 *Il Taccuino Sense* [Cod. S.IV.8, Biblioteca Municipale, Siena]. Ed. R. Falb. Siena.

Gombrich, E.H.
1969 "The Form of Movement in Water and Air", in *Leonardo's Legacy* (reprint: Gombrich, E.H., *The Heritage of Apelles*. London, 1976).

Guillaume, J.
1968 "Léonard de Vinci, Dominique de Cortone et l'escalier du modèle en bois de Chambord". *Gazette des Beaux-Arts*, LXXI, pp. 93-108.
1969 "Chenonceau avant la construction de la galerie". *Gazette des Beaux-Arts*, LXX (Jan.), pp. 19-46.
1974 "Léonard de Vinci et l'architecture française. I. Le problème de Chambord. II. La Villa de Charles d'Amboise et le Château de Romorantin. Réflexion sur un livre de Carlo Pedretti". *Revue de l'Art*, no. 25, pp. 71-91 (also in *Bulletin de l'Association Léonard de Vinci*, XIV, Dec. 1975, pp. 29-39 [without illustrations]).
1983[1] *Comprendre Chambord*. Paris.
1983[2] Review of Prinz, 1980. *Bulletin Monumental*, CXLI, p. 219.
1985[1] "Le bâtiment et le parti décoratif", in *La galerie d'Ulysse à Fontainebleau*, pp. 7-64.
1985[2] "L'escalier dans l'architecture française: la première moitié du seizième siècle", in *L'escalier dans l'architecture de la Renaissance*, pp. 27-47.
1986 "La première Renaissance. 1495-1525", in *Le château en France*, pp. 179-90.

Hale, J.
1965 "The Early Development of the Bastion: An Italian Chronology c. 1450 to 1534", in *Europe in the Late Middle Ages*. London.

Hart, I.
1963 *The Mechanical Investigations of Leonardo da Vinci* (2nd. edition). Los Angeles, Cambridge, Mass., and London.

Hemsoll, D.
See Davies and Hemsoll.

Heydenreich, L.H.
1929 *Die Sakralbau-Studien Leonardo da Vinci's*. Engelsdorf-Leipzig (reprint: Munich, 1971).
1934 "Zur Genesis des St. Peter-Plan von Bramante", in *Forschungen und Forschritte*, pp. 365-7.
1937 "Intorno a un disegno di Leonardo da Vinci per l'antico altare maggiore della SS. Annunziata", in *Mitteilungen des Kunsthistoriscehen Institutes in Florenz*, V, pp. 436-7.
1949 *I disegni di Leonardo da Vinci e della sua Scuola conservati nella Galleria dell'Accademia di Venezia*, Florence.
1952 "Leonardo da Vinci, Architect of Francis I". *The Burlington Magazine*, XCIV, pp. 277-85.
1953 *Leonardo da Vinci*. Basel.
1954 *Leonardo da Vinci*. London.
1962 *Leonardo architetto* (Lettura Vinciana II, 15 aprile 1962), see Galluzzi, pp. 29-45.
1964 Review of Pedretti, 1962[1]. *Raccolta Vinciana*, XX, pp. 408-12.
1969 "Leonardo and Bramante: Genius in Architecture", in *Leonardo's Legacy*, pp. 125-48.
1974 "The Military Architecture", in Reti, 1974[2], pp. 136-65.
1981 *Studien zur Architektur der Renaissance*. Munich. See also Babinger and Heydenreich.

Hundt, M. Senior
1501 *Anthropolcgium, de hominis dignitate*. Leipzig.

Il Duomo di Milano
1973 , 2 vols. Milan (see Ferrari da Passano and Romanini).

Kecks, R.
See Prinz and Kecks.

Keele, K.
1983 *Leonardo da Vinci's Elements of the Science of Man*. London-New York.

Kemp, M.
1981 *Leonardc da Vinci. The Marvellous Works of Nature and Man*. London-Cambridge, Mass.
1982 "The Crisis of Received Wisdom in Leonardo's Late Thought", in Bellone and Rossi, pp. 27-39.
1986 "Analogy and Observation in the Codex Hammer", in *Studi Vinciani in memoria di Nando de Toni*, Brescia, pp. 103-34.

Klemm, F.
1954 *Technik, eine Geschicthe ihrer Probleme*. Friburg-Munich.

Koyré, A.
1966 "Léonard de Vinci 500 ans après", in *Études d'histoire de la pensée scientifique*. Paris, pp. 85-100.

La Basilica di S. Lorenzo
1985 Milan (see Giordano, 1985).

Laboratorio su Leonardo
1983 Milar. (see Marani, 1982[4]).

Lafond, J.
See *Le modèle à la Renaissance*.

La galerie d'Ulysse à Fontainebleau
1985 Paris (see Guillaume, 1985[1]).

Langs, S.
1968 "Leonardo's Architectural Designs and the Sforza Mausoleum". *Journal of the Warburg and Courtauld Institutes*, XXXI, pp. 218-33.

Laurens, P.
See *Le modèle à la Renaissance*.

Lazzaro, C.
1985 "Rustic Country Houses to Refined Farmhouses". *Journal of the Society of Architectural Historians*, XLIV, pp. 346-67.

Le château en France
1986 Paris (see Guillaume, 1986).

Le modèle à la Renaissance
1986 *Studies selected by C. Balavoine, J. Lafond and P. Laurens*. Paris.

"Léonard de Vinci. L'humaniste, l'artiste, l'inventeur", in Reti, 1974².

Léonard de Vinci par lui-même
1952 Texts chosen, translated and presented by A. Chastel. Paris.

Leonardo dopo Milano
1982 Catalogo della Mostra (Vinci 1982). Florence.

Leonardo e il leonardismo a Napoli e a Roma
1983 Catalogo della Mostra. Florence.

Leonardo e le vie d'acqua
1983 Catalogo della Mostra (Milan, 1983). Florence.

Leonardo letto e commentato
See Galluzzi.

Leonardo nella Scienza e nella Tecnica
1975 Atti del Simposio Internazionale di Storia della Scienza (Firenze-Vinci, 23-26 giugno 1969). Florence (see Vasoli).

Leonardo. Saggi e Ricerche
1954 Rome (see Brizio, Maltese, Marinoni).

Leonardo's Legacy
1976 An International Symposium (2-8 May 1966). Ed. C.D. O' Malley. Berkeley and Los Angeles (see Clark, Gombrich, Heydenreich).

L'escalier dans l'architecture de la Renaissance
1985 (Actes du colloque tenu à Tours en 1979). Paris (see Frommel, 1985; Guillaume, 1985², Pérouse de Montclos).

Leupold, J.
1724 *Theatrum Machinarum Generale*. Leipzig.

Lotz, W.
1940 "Michelozzos Umbau der SS. Annunziata in Florenz". *Mitteilungen des Kunsthistorischen Institutes in Florenz*, V, Heft 6, pp. 402-22.
1956 "Das Raumbild in der italienische Architekturzeichnung der Renaissance". *Mitteilungen des Kunsthistorischen Institutes in Florenz*, VII, Heft 3-4, pp. 193-226.

Maccagni, C.
1970 *Riconsiderando il problema delle fonti di Leonardo*. (Lettura Vinciana, X, 1970), see Galluzzi, pp. 275-307.

MacCurdy, E. (ed.).
1939 *The Notebooks of Leonardo da Vinci*, 2 vols. London.

Maier, B. (ed.)
1939 See Cellini.

Malaguzzi Valeri, F.
1913-17 *La corte di Ludovico il Moro*. 3 vols. Milan.

Maltese, C.
1954 "Il pensiero architettonico e urbanistico di Leonardo", in *Leonardo. Saggi e Ricerche*, pp. 331-58.
1967 *Francesco di Giorgio Martini. Trattati di architettura, ingegneria e arte militare*, 2 vols. Milan.
See also *Scritti rinascimentali di architettura*.

Marani, P.C.
1979 *Francesco di Giorgio Martini. Trattato di architettura* (Laurentian Library, Florence, MS. Ashb. 361). Florence.
1982¹ *Leonardo e l'architettura fortificata. Connessioni e sviluppi*, in Bellone and Rossi, pp. 115-39.
1982² "Leonardo e le colonne 'ad tronchonos': tracce di un programma iconologico per Ludovico il Moro". *Raccolta Vinciana*, XXI, pp. 103-20.
1982³ "Leonardo, Francesco di Giorgio e il tiburio del Duomo di Milano". *Arte Lombarda*, LXII, pp. 81-92.
1982⁴ Review to "Laboratorio su Leonardo". *Annali dell'Istituto e Museo di Storia della Scienza di Firenze*, VII, n. 1, pp. 126-31.
1984¹ *Disegni di fortificazioni da Leonardo a Michelangelo*. Catalogo della Mostra. Florence.
1984² *L'architettura fortificata negli studi di Leonardo da Vinci*. Florence (see Scalini).
1985 "Circuito dentato ortogonalmente" (MS. de Madrid 8937, f. 117 r.) *Leonardo, gli ingegneri e alcune macchine lombarde* (Lettura Vinciana XXV, 1985). Florence.

Marcolongo, R.
1939 *Indici per materie e alfabetico del Codice Atlantico di Leonardo da Vinci. Compilati da G. Semenza, rivenduti e pubblicati da Roberto Marcolongo*. Milan.

Mariano Taccola
See Taccola

Marinoni, A.
1944 *Gli appunti grammaticali e lessicali di Leonardo da Vinci*, 2 vols. Milan.
1954 *I manoscritti di Leonardo da Vinci e le loro edizioni*, in *Leonardo. Saggi e Ricerche*, pp. 231-74.
1981 *Leonardo da Vinci: l'automobile e la bicicletta*. Milan.
1982 *La matematica di Leonardo da Vinci. Una nuova immagine dell'artista-scienziato*. Milan.

Martelli, M.
1977 "Un disegno attribuito a Leonardo e una scoperta archeologica degli inizi del Cinquecento". *Prospettiva*, no. 10, pp. 58-61.

Martin-Demezil, J.
1981 "Chambord". *Congrès archéologique de France* CXXXIX (1986), *Blésois et Vendômois*, pp. 1-115.

Martini, Francesco di Giorgio
See Francesco di Giorgio Martini

Miller, N.
1976 "Musing on Maulne". *Art Bulletin*, LXVIII, pp. 196-214.

Möller, E.
1929 "Die Madonna mit den spielenden Kindern aus

der Werkstatt Leonardos". *Zeitschrift für bildende Kunst*, LXIII, pp. 217-27.

Mongeri, G.
1875 *Le rovine di Roma*, Milan.

Montag, U.
See Scaglia, Prager and Montag.

(Von) Moos, S.
1974 *Turm un Bollwerk*. Zurich.

Morgan, M.H.
See Vitruvius, 1914.

Morrogh, A.
1985 *Disegni di architetti fiorentini, 1540-1640*. Florence.

Murray, P.
1963 "Leonardo and Bramante. Leonardo's Approach to Anatomy and Architecture and its Effects on Bramante". *Architectural Review*, CXXXIV, pp. 346-51.

O'Malley, C.D. (ed.)
See *Leonardo's Legacy*.

Palladio, A.
1570 *I quattro libri dell'architettura*. Venice.

Papini, R.
1946 *Francesco di Giorgio architetto*, 2 vols. Florence.

Parsons, W.B.
1967 *Engineers and Engineering in the Renaissance*. Cambridge, Mass.-London (1st. ed.: 1939).

Pedretti, C.
1953 *Documenti e memorie riguardanti Leonardo da Vinci a Bologna e in Emilia*. Bologna.
1957 *Studi Vinciani. Documenti, analisi e inediti leonardeschi*. Geneva.
1960 "Il Neron da Sancto Andrea". *Raccolta Vinciana*, XVIII, pp. 65-96.
1962¹ *A Chronology of Leonardo da Vinci's Architectural Studies after 1500*. Geneva (see Heydenreich, 1964).
1962² "Ancora nel 'Neron da Sancto Andrea'". *Raccolta Vinciana*, XIX, pp. 273-5.
1962³ "Leonardo's plans for the enlargement of the city of Milan". *Raccolta Vinciana*, XIX, pp. 137-47.
1964 *Leonardo da Vinci on Painting. A Lost Book (Libro A)*. Berkeley and Los Angeles.
1970 "Leonardo da Vinci: Manuscripts and Drawings of the French Period, 1517-18". *Gazette des Beaux-Arts*, CXII (Nov.) pp. 285-318.
1972¹ "La Verruca". *Renaissance Quarterly*, XXV, n. 4, pp. 417-25.
1972² *Leonardo da Vinci. The Royal Palace at Romorantin*. Cambridge, Mass. (see Wasserman).
1975¹ *Disegni di Leonardo da Vinci e della sua Scuola alla Biblioteca Reale di Torino*. Florence.
1975² "Eccetera: perché la minestra si fredda" (Cod. Arundel, fol. 245r) (Lettura Vinciana XV, 1975). Florence.
1977 *The Literary Works of Leonardo da Vinci. Compiled and edited by J.P. Richter. A Commentary by C. Pedretti*, 2 vols. Oxford.

1978 *Leonardo architetto*. Milan (see Ackerman, 1981). French translation (*Léonard architecte*) by Marie-Anne Caizzi. Milan-Paris, 1983. English translation (*Leonardo Architect*) by S. Brill. New York-London, 1986.
1979 *The Codex Atlanticus of Leonardo da Vinci. A Catalogue of its Newly Restored Sheets*, 2 vols. Florence.
1983 "Le 'magne opere romane'", in *Leonardo e il leonardismo a Napoli e a Roma*. Naples-Rome, pp. 191-98. See also Clark, 1968.

Pérouse de Montclos, J.-M.
1985 "La vis de Saint-Gilles et l'escalier suspendu dans l'architecture française du XVIIᵉ siècle", in *L'escalier dans l'architecture de la Renaissance*, pp. 83-91.

Philo of Byzantium
See Prager, 1974.

Placzek, A.K.
See *Sebastiano Serlio*.

Pointing, K.P.
1979 *Leonardo's Textile Machinery*. Wiltshire.

Poncelet, J.V.
1945 *Traité de mécanique industrielle*. Paris.

Popham, A.E.
1946 *The Drawings of Leonardo da Vinci*. London.

Prager, F.D. (ed.)
1974 *Philo of Byzantium. Pneumatica*. Wiesbaden. See also Scaglia, Prager and Montag.

Prager, F.D. and Scaglia, G.
1970 *Brunelleschi. Studies of his Technology and Inventions*. Cambridge, Mass.-London.
1972 *Mariano Taccola and his Book 'De ingeneis'*. Cambridge, Mass.

Prinz, W.
1980 *Schloss Chambord und die Villa Rotonda in Vicenza: Studien zur Ikonologie*. Berlin (see Burroughs and Guillaume, 1983²).
1986 "Der Schwierige Weg zur Symmetrie in der französischen Schloßarchitektur der Renaissance", in *Symmetrie in Kunst. Natur und Wissenschaft*, Darmstadt, vol. I, pp. 291-305.

Prinz, W. and Kecks, R.
1985 *Das französische Schloss der Renaissance*. Berlin.

Puppi, L.
1980 "Prospetto di palazzo e ordine gigante". *Storia dell'Arte*, XXXVIII-XXXIX, pp. 267-75.

Raffaello architetto
1984 Eds. C.L. Frommel, S. Ray, M. Tafuri. Milan (see Frommel, 1984).

Ray, S.
See *Raffaello architetto*.

Reti, L.
1956-7 "Leonardo da Vinci nella storia della macchina a vapore", in *Rivista di Ingegneria*.
1963 "Francesco di Giorgio Martini on Engineering and its Plagiarists". *Technology and Culture*, IV, pp. 287-98.

1964 "Tracce dei progetti perduti di Filippo Brunelleschi nel Codice Atlantico", (Lettura Vinciana IV, 1964), in Galluzzi, pp. 89-130.
1974[1] "The Elements of Machines", in Reti, 1974[2], pp. 264-87.
1974[2] (ed.) *The Unknown Leonardo*. New York-Toronto (see Bedini, Brugnoli, Heydenreich, Reti, Zamattio).

Reti, L. and Dibner, B.
1969 *Leonardo da Vinci Technologist*. Norwalk Connecticut.

Richter, J.P.
1939 *The Literary Works of Leonardo da Vinci*, 2 vols. Oxford (2nd ed.).
See also Pedretti, 1977.

Romanini, A.M.
1973 "Architettura", in *Il Duomo di Milano*, I, pp. 97-232.

Rondelet, G.
1814 *Traité théorique et pratique de l'art de bâtir*. Paris.

Rosenfeld, M.N.
See *Sebastiano Serlio*.

Rossi, M.
1981 "I contributi del Filarete e dei Solari alla ricerca di una soluzione per il tiburio del Duomo di Milano". *Arte Lombarda*, LXI, pp. 15-23.

Rossi, P.
See Bellone and Rossi.

Saalman, H.
1980 *Filippo Brunelleschi. The Cupola di S. Maria del Fiore*. London.

Santa Maria della Croce a Crema
1982 Crema (see Giordano, 1982).

Santi, G.
1983 *Federigo da Montefeltro duca di Urbino Herausgegeben von dr. H. Holtzinger*. Stuttgart.

Scaglia, G.
1960-1 "Drawings of Brunelleschi's Mechanical Inventions for the Construction of the Cupola". *Marsias Studies in the History of Art*, X, pp. 45-67.
1971 *Mariano Taccola. De machinis. The Engineering Treatise of 1449*. [Codex Latinus Monacensis 18800]. Wiesbaden.
1981 *Alle origini degli studi tecnologici di Leonardo* (Lettura Vinciana XX, 1980). Florence.
1982 "Leonardo e Francesco di Giorgio a Milano nel 1490", in Bellone and Rossi, pp. 225-53.
1985 *Il "Vitruvio Magliabechiano" di Francesco di Giorgio Martini*. Florence.
See also Prager and Scaglia, 1970 and 1972.

Scaglia, G., Prager, F.D. and Montag, U.
1984 *Mariano Taccola. De ingeneis (Books I, II and Addenda)*. Wiesbaden.

Scalini, M.
1984 Review of Marani, 1984[2]. *Antichità viva*, XXIII, n. 3, pp. 51-2.

Scamozzi, V.
1615 *Dell'idea dell'Architettura Universale*. Venice.

Schofield, R.
1982 "Ludovico il Moro and Vigevano". *Arte Lombarda*, n. 62, pp. 93-140.

Scritti rinascimentali di architettura
1978 By A. Bruschi, C. Maltese, M. Tafuri and R. Bonelli. Milan (see Bruschi).

Scurati-Manzoni, P.
1968 "Lo sviluppo degli edifici rinascimentali a pianta centrale in Lombardia". *Archivio Storico Lombardo*, S. IV, VII, pp. 193-209.

Sebastiano Serlio on Domestic Architecture
1978 Ed. of Book VI (Columbia MS.) by A.K. Placzek, J.S. Ackerman and M.N. Rosenfeld. New York-Cambridge, Mass.

Semenza, G.
1908 "L'automobile di Leonardo". *Archeion: Archivio di Storia della Scienza*, IX, pp. 97-103.
1939 See Marcolongo.

Serlio, S.
See *Sebastiano Serlio*.

Serres, M.
1968 *Le système de Leibniz et ses modèles mathématiques*. Paris.

Singer, C. (ed.)
1954-1978 *A History of Technology*, 7 vols. Oxford.

Sohm, L.
1978 "The Staircases of the Venetian Scuole Grandi and Mauro Coducci". *Architectura*, VIII, pp. 125-49.

Solmi, E.
1904 "Documenti inediti sulla dimora di Leonardo da Vinci in Francia nel 1517 e 1518". *Archivio Storico lombardo*, XXXI, p. 389-410.
1908 "Le fonti dei manoscritti di Leonardo da Vinci", in *Giornale storico della letteratura italiana* (reprint: Solmi E., *Scritti Vinciani*, Florence, 1976).
1911 "Nuovi contributi alle fonti dei manoscritti di Leonardo da Vinci", in *Giornale storico della letteratura italiana* (reprint: Solmi E., *Scritti Vinciani*. Florence, 1976).
1912 "Leonardo da Vinci nella guerra di Luigi XII contro Venezia". *Nuovo Archivio Veneto*, XXIII, pp. 318-50.

Soufflot et son temps
1980 Catalogue of the exhibition (Lyons, 1980). Paris.

Steinitz, K.T.
1969 *Leonardo architetto teatrale e organizzatore di feste* (Lettura Vinciana IX, 1969), in Galluzzi, pp. 249-74.

Strobino, G.
1953 *Leonardo da Vinci e la meccanica tessile*. Milan.

(Von) Stromer, W.
1977 "Brunelleschis automatische Kran und die Mechanik der Nürberger Drahtmühle, Technologie-Transfer im 15. Jahrhundert". *Architectura*, VII, pp. 163-74.

Studi Bramanteschi
1974 Atti del Congresso Internazionale (1970). Rome (see Brizio, 1974).

Taccola
1971 *De machinis*, see Scaglia, 1971.
1972 *De ingeneis Books III-IV* (Palatinus MS. 766, Biblioteca Nazionale, Florence), see Prager and Scaglia, 1972.
1984 *De ingeneis. Books I and II on Engines and Addenda*, 2 vols. (Codex Latinus Monacensis 197, Bayerische Staatsbibliothek, Munich), see Scaglia, Prager and Montag.

Tafuri, M.
See *Scritti rinascimentali di architettura* and *Raffaello architetto*.

The Unknown Leonardo
See Reti, 1974².

Thiis, J.
1911 *Leonardo da Vinci. The Florentine Years*. London.

Truesdell, C.A.
1982 *Fundamental Mechanics in the Madrid Codices*, in Bellone and Rossi, pp. 309-19.

Usher, A.P.
1962 *A History of Mechanical Inventions*. Cambridge Mass. (Revised ed.).

Uccelli, A.
1940 *Leonardo da Vinci. I libri di meccanica nella ricostruzione ordinata di Arturo Uccelli*. Milan.
1952 *I libri del volo di Leonardo da Vinci nella ricostruzione critica di Arturo Uccelli*. Milan.

Valla, G.
1501 *De expetendis et fugiendis rebus*. Venice.

Valturius, R.
1482 *De re militari*. Verona.

Vasari, G.
1912-14 *The Lives of the Most Eminent Painters*, Newly translated by Gaston Du C. De Vere, 10 vols. London (reprint: New York, 1976).
1981-7 *Les vies des meilleurs peintres, sculpteurs et architectes*. Edited by A. Chastel, 10 vols. Paris.

Vasoli, C.
1975 "A proposito di Scienza e Tecnica nel Rinascimento",

in *Leonardo nella Scienza e nella Tecnica*, pp. 282-300.

Veranzio, F.
1615-6 *Machinae Novae*. Venice (Reprint: Münich, 1965 and Milan, 1968).

Vezzosi, A.
1984 *Toscana di Leonardo*. Florence.

Viollet-le-Duc, E.E.
1854-68 *Dictionnaire raisonné de l'architecture française du XI° au XVI° siècle*. 10 vols. Paris.

Vitruvius
1486 *De Architectura*. Rome.
1511 *De Architectura*. Venice.
1556 *I dieci libri dell'Architettura. Tradotti e commentati da Monsignor Barbaro*. Venice.
1790 *Dieci Libri di Architettura*. Ed. B. Galiani. Siena.
1914 *The Ten Books on Architecture*. Ed. M.H. Morgan. Cambridge, Mass.
1969 *De Architectura*. (Reprint of C. Cesariano's edition, Como, 1951). Munich.

Vliegenthart, J.M.
1972 "The Origins of Imperial Staircase". *Nederlands Kunst. Jaarb.*, XXIII, pp. 443-54.

Wasserman, J.
1976 Review of Pedretti, 1972². *The Burlington Magazine*, no. 878, p. 315.

Wittkower, R.
1949 *Architectural Principles in the Age of Humanism*. London.

Wurm, H.W.
1982 *Baldassarre Peruzzi Architekturzeichungen*. Tubingen.

Zammattio, C.
1974 "Mechanics of Water and Stone", in Reti, 1974², pp. 190-215.

Zoubov, V.P.
1960 "Vitruve et ses commentateurs du XVI° siècle", in *La science au seizième siècle*. Paris, pp. 67-90.

List of works in the exhibition*

Manuscripts

Leonardo da Vinci

Arundel Manuscript 263
1480-1518
240 × 145 mm, 283 ff.
The British Library, London
[open at f. 24 v, ill. p. 340]

Codex Hammer (formerly Codex Leicester)
1505-1510
299 × 225 mm, 36 ff. (18 separate sheets, all on exhibition)
The Armand Hammer Foundation, Los Angeles
[f. 34 v ill. p. 340]

Forster Manuscript I
1487-90 and 1505
145 × 115 mm, 55 ff.
Trustees of The Victoria and Albert Museum, London
[open at f. 49 r, ill. p. 341]

Forster Manuscript II
1495-7
105 × 80 mm, 160 ff.
Trustees of the Victoria and Albert Museum, London
[open at f. 123 v, ill. p. 341]

Forster Manuscript III
c. 1493
95 × 70 mm, 89 ff.
Trustees of the Victoria and Albert Museum, London
[open at f. 57 v, ill. p. 341]

Madrid Manuscript I (8937)
1493-1500
215 × 180 mm, 191 ff.

Biblioteca Nacional, Madrid
[open at f. 45 r, ill. on cover and Fig. 77]

Madrid Manuscript II (8936)
1503-5
215 × 180 mm, 157 ff.
Biblioteca Nacional, Madrid
[open at f. 157 r, Fig. 71]

Paris Manuscript B
1487-90
235 × 170 mm, 90 ff.
Bibliothèque de l'Institut de France, Paris

Other Renaissance Architect-Engineers

Anonymous
Additional Manuscript 34113.
Architectural and machine drawings
15th century
295 × 215 mm, paper, 261 ff.
The British Library, London
[open at f. 72 v, Fig. 129]

Anonymous
Palatino Manuscript 767
Architectural and machine drawings
15th century
268 × 183 mm, parchment, 133 ff.
Biblioteca Nazionale Centrale, Florence
[open at ff. 9 v-10 r, Pls VI B and D]

Anonymous
Palatino Manuscript 1077
Drawings of mills, machines and bridges
16th century
305 × 215 mm, paper, 208 ff.
Biblioteca Nazionale Centrale, Florence
[two sheets on exhibition: f. 63 r, ill. p. 342, and ff. 127 v-128 r]

*All measurements are given with height and width preceding depth.

339

Anonymous
Palatino Manuscript E.B.16.5.II
Drawings of machines and antique vases
16th century
445 × 285 mm, paper, 135 ff.
Biblioteca Nazionale Centrale, Florence
[f. 1 r (loose sheet), Pl. VI C; open at f. 53 r, ill. p. 343]

Buonaccorso Ghiberti
Zibaldone, Banco Rari 228
15th century
195 × 140 mm, paper, 229 ff.
Biblioteca Nazionale Centrale, Florence
[open at ff. 103 v–104 r, Figs 29 and 184]

Jacopo Mariano, called Taccola
Liber Tertius de Ingeniis ac edifitiis non usitatis
Palatino Manuscript 766
15th century
293 × 225 mm, paper, 48 ff.
Biblioteca Nazionale Centrale, Florence
[open at f. 10 r, ill. p. 343]

Francesco di Giorgio Martini
Saluzziano Manuscript 148
Treatise on architecture
15th century
385 × 265 mm, parchment, 100 ff.

Biblioteca Reale, Turin
[open at f. 50 r, ill. p. 343]

Giuliano da Sangallo
Taccuino Senese, S.IV.8.
15th century
120 × 260 mm, paper, 52 ff.
Biblioteca Comunale degli Intronati, Siena
[open at ff. 47 v–48 r, Fig. 30]

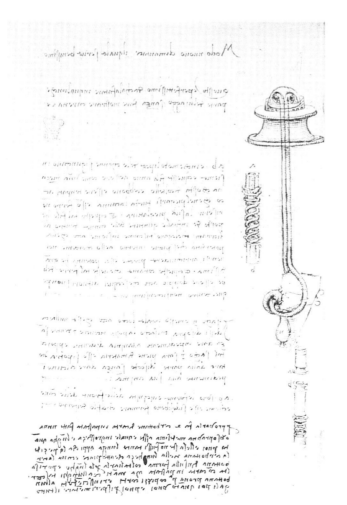

Arundel MS. 263, f. 24 v. Breathing mask.

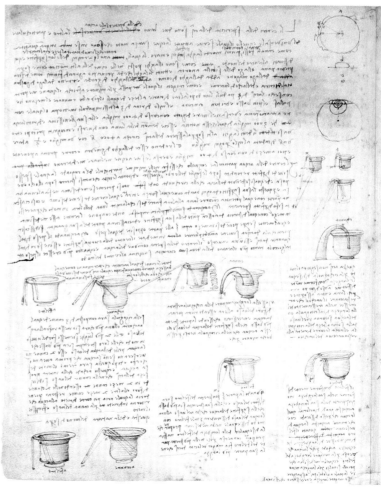

Codex Hammer, f. 34 v. Experiments with siphons.

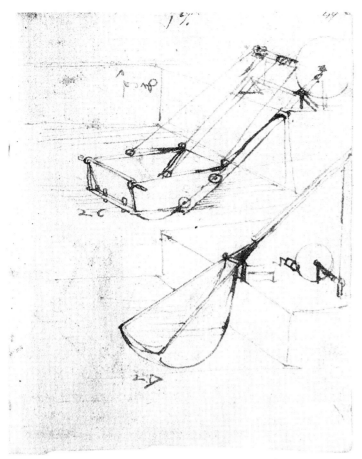

Forster MS. I, f. 49 r. Instruments for digging canals.

Forster MS. II, f. 123 v. Analysis of load capacity of ropes.

Forster MS. III, f. 57 v. Canal lock.

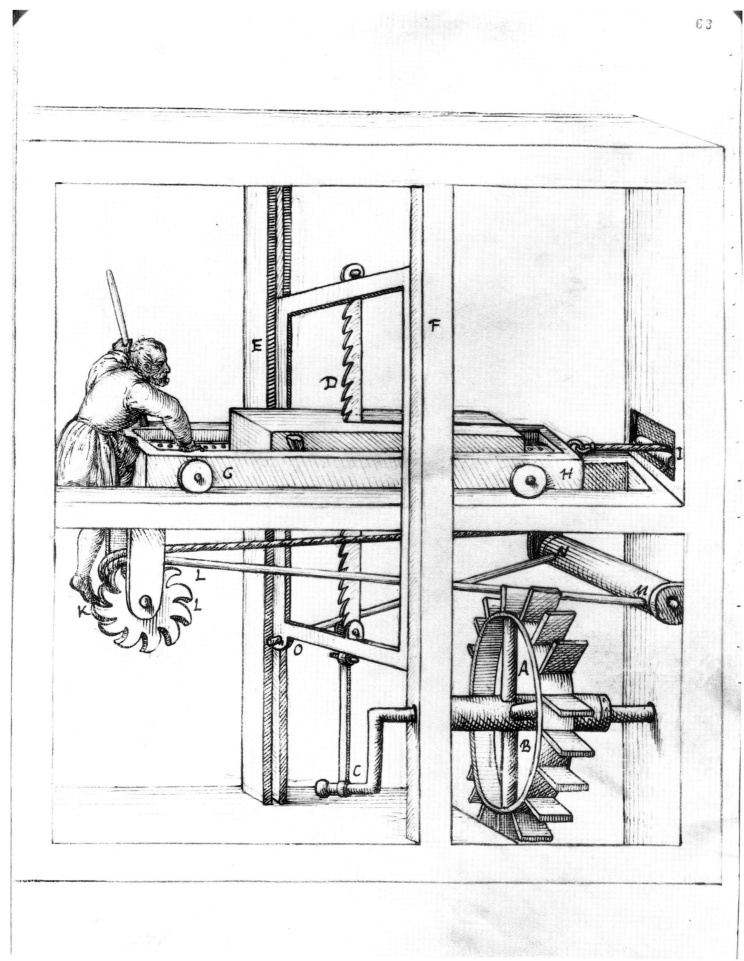

Anonymous. Palatino MS. 1077, f. 63 r. Hydraulic saw.

Anonymous. Palatino MS. E.B. 16.5.II, f. 53 r.
Double effect pump.

Jacopo Mariano, called Taccola. Palatino MS. 766, f. 10 r.
Horse-powered reversible hoist.

Francesco di Giorgio Martini. Saluzziano MS. 148,
f. 50 r. Reversible hoist.

Individual Sheets

Leonardo da Vinci

Map of the Arno from Florence to the West, showing a project for a navigable canal running through Pistoia and meeting the Arno at Vico Pisano
1503-4
Pen and brown ink over black chalk with washes, on white paper greyed by smudging and pricked for transfer
335 × 480 mm
Royal Library, Windsor Castle
RL 12279 [Fig. 92]
Lent by gracious permission of Her Majesty Queen Elizabeth II

Map of Imola
1502
Pen and ink, watercolour on paper
440 × 602 mm
Royal Library, Windsor Castle
RL 12284 [Fig. 85]
Lent by gracious permission of Her Majesty Queen Elizabeth II

Study of the foreleg and chest of a horse (recto); elevation of a palace (verso)
1517-19
Black chalk on paper
245 × 180 mm
Royal Library, Windsor Castle
RL 12292 r and RL 12292 v [Pl. XXIII]
Lent by gracious permission of Her Majesty Queen Elizabeth II

Sketch of a furnace for casting the horse of the Sforza monument
c. 1494
Red chalk over silver-point, pen and ink on paper
130 × 150 mm
Royal Library, Windsor Castle
RL 12348 [ill. p. 346]
Lent by gracious permission of Her Majesty Queen Elizabeth II

A masquerader seated on a horse (recto); geometrical and architectural sketches (verso)
c. 1507
Black chalk (recto); pen and ink (verso) on paper.
197 × 280 mm
Royal Library, Windsor Castle
RL 12585 r and RL 12585 v [ill. p. 346]
Lent by gracious permission of Her Majesty Queen Elizabeth II

A figure showing the anatomy of the veins, and plans and elevations of staircases (recto); an anatomical study, and plan of a staircase in a vestibule (verso)
1505-6
Pen and ink, sepia, red chalk (recto); pen and ink, sepia (verso) on paper
292 × 197 mm
Royal Library, Windsor Castle
RL 12592 r and RL 12592 v [Fig. 312]
Lent by gracious permission of Her Majesty Queen Elizabeth II

The courtyard of a foundry
c. 1487
Pen and ink on brownish paper
250 × 183 mm
Royal Library, Windsor Castle
RL 12647 [Fig. 64]
Lent by gracious permission of Her Majesty Queen Elizabeth II

Sketches of men with weapons and war machines
1483-5
Pen and dark ink, light wash on paper
200 × 278 mm
Royal Library, Windsor Castle
RL 12653 [ill. p. 347]
Lent by gracious permission of Her Majesty Queen Elizabeth II

Studies of lathes moved by a weight (recto); notes on geometry (verso)
1509-10
Pen and ink on paper
214 × 154 mm
Royal Library, Windsor Castle
RL 12667 r [ill. p. 347] and RL 12667 v
Lent by gracious permission of Her Majesty Queen Elizabeth II

Diagrams of a machine and tools for mixing mortar
c. 1486-7
Silver-point, pen and ink on light blue paper
224 × 168 mm
Royal Library, Windsor Castle
RL 12668 [ill. p. 347]
Lent by gracious permission of Her Majesty Queen Elizabeth II

Three studies of the left ankle and foot showing the movement of the ankle, and a rear view of a dissection of a shoulder (recto); and studies of the head, neck, thorax and shoulders of a man (verso)
c. 1510-14
Pen and ink on paper
545 × 375 mm (with mount)
Royal Library, Windsor Castle

RL 19001 r and v; K/P 136 r and v [recto ill. p. 348]
Lent by gracious permission of Her Majesty Queen
Elizabeth II

Drawings of the bones of the arm, pelvis and legs
(recto); two studies of an old man in profile (verso)
1509-10
Pen and ink on paper
545 × 375 mm (with mount)
Royal Library, Windsor Castle
RL 19004 r and v; K/P 138 r and v [recto ill. p. 348]
Lent by gracious permission of Her Majesty Queen
Elizabeth II

Schematic drawing of the cervical vertebrae, and
three diagrammatic drawings of umbilical blood ves-
sels (recto); schematic drawing of the brachial plexus
and of the junction of the skull with the spinal
column (verso)
c. 1506-9
Pen and ink on paper
545 × 375 mm (with mount)
Royal Library, Windsor Castle
RL 19021 r and v; K/P 62 r and v [verso ill. p. 348]
Lent by gracious permission of Her Majesty Queen
Elizabeth II

Studies of the diaphragm and intestines of a dog;
architectural details
1513
Pen and ink on blue paper
275 × 207 mm
Royal Library, Windsor Castle
RL 19077 v; K/P 168 v [ill. p. 349]
Lent by gracious permission of Her Majesty Queen
Elizabeth II

Drawings of ribs and diaphragm with notes (recto); a
detailed study of a bird's wing, and architectural
details (verso)
1513
Pen and brown ink (recto); red chalk, pen and ink
(verso) on coarse yellowish paper
275 × 201 mm
Royal Library, Windsor Castle
RL 19107 r and v; K/P 184 r and v [verso ill. p. 349]
Lent by gracious permission of Her Majesty Queen
Elizabeth II

Gold-beating machine (recto); mechanical studies
(verso)
1490-5
Pen and brown ink on paper
190 × 165 mm
Staatliche Graphische Sammlung, Munich
Nos. 2152 r [Pl. IV A] and 2152 v

Waterwheel (fragment)
c. 1480

Pen and brown ink on paper
65 × 55 mm
Staatliche Graphische Sammlung, Munich
No. 2152 A [Pl. IV B]

Inverted screw (fragment)
1482-5
Pen and ink on brown paper
45 × 140 mm
Staatliche Graphische Sammlung, Munich
No. 2152 B [Pl. IV C]

Architectural studies
1490
Pen and brown ink on paper
147 × 220 mm
Musée du Louvre, Paris
No. 2282 r [Fig. 200]

Etruscan tomb
1507
Pen and brown ink on paper
199 × 268 mm
Musée du Louvre, Paris
No. 2386 [Pl. XIX]

Church and studies of perspective (fragment de-
tached from CA, f. 44 r/13 r-a)
1517-18
Pen and ink on paper
290 × 95 mm
Universitätsbibliothek, Basle
Autogr. Slg. Geigy Hagenbach no. 2080 [ill. p. 349]

Drawings and notes on mechanics
1505-7
Pen and brown ink on paper
214 × 143 mm
The Governing Body, Christ Church, Oxford
No. 0035 [ill. p. 349]

Other Renaissance Architect-Engineers

Anonymous
Copies from Leonardo's drawings
16th century
Pen and ink on paper
430 × 385 mm
Gabinetto Disegni e Stampe, Uffizi, Florence
No. 4085 A [Pl. V]

Anonymous
Hydraulic saw
16th century
Pen and ink on paper
225 × 143 mm
Gabinetto Disegni e Stampe, Uffizi, Florence
No. 1867 A [ill. p. 350]

Gherardo Mechini
Drawing of the scaffolding surrounding the dome of
Santa Maria del Fiore
c. 1601
Pen and ink on paper
455 × 355 mm
Gabinetto Disegni e Stampe, Uffizi, Florence
No. 248 A [Fig. 26]

Antonio da Sangallo the Younger
Hoist
16th century
Pen and ink on paper
243 × 215 mm
Gabinetto Disegni e Stampe, Uffizi, Florence
No. 1483 A [ill. p. 350]

Battista da Sangallo, called Gobbo
Revolving crane
16th century
Pen and ink on paper
400 × 270 mm
Gabinetto Disegni e Stampe, Uffizi, Florence
No. 1665 A [ill. p. 350]

Windsor, RL 12348.

Windsor, RL 12585 v.

Windsor, RL 12653.

Windsor, RL 12667 r.

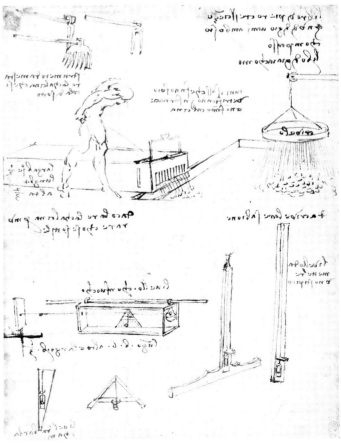

Windsor, RL 12668.

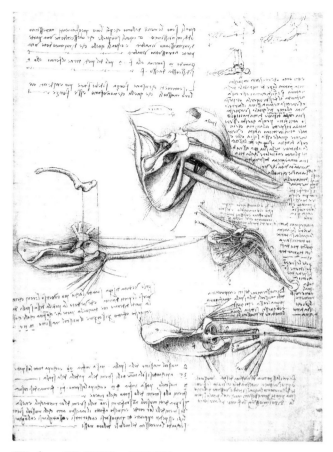

Windsor, RL 19001 r; K/P 136 r.

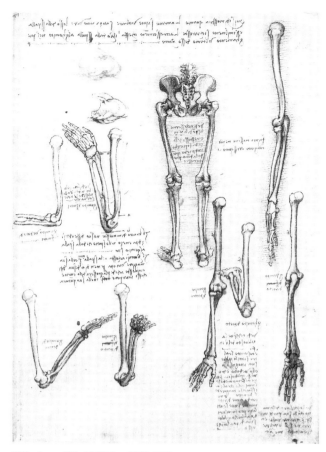

Windsor, RL 19004 r; K/P 138 r.

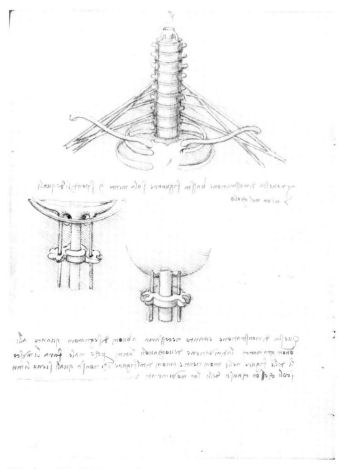

Windsor, RL 19021 v; K/P 62 v.

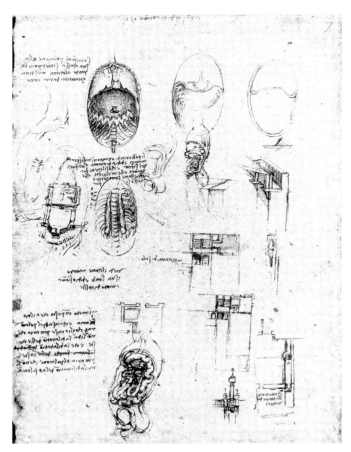

Windsor, RL 19077 v; K/P 168 v.

Windsor, RL 19107 v; K/P 184 v.

Universitätsbibliothek, Basle,
no. 2080.

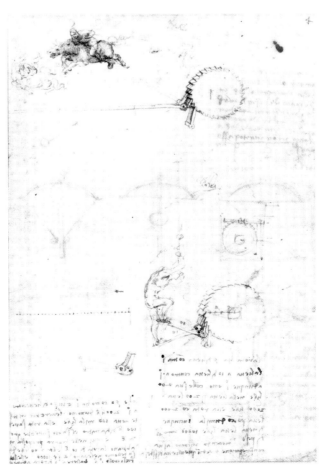

Christ Church, Oxford, no. 0035.

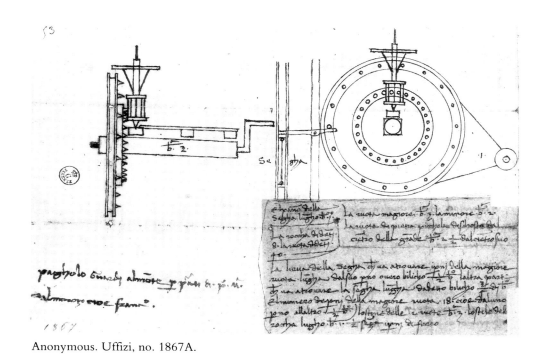

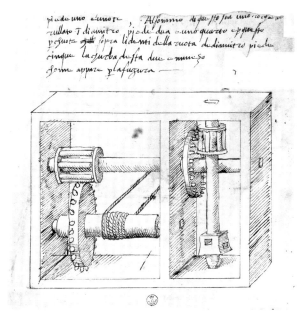

Anonymous. Uffizi, no. 1867A.

Antonio da Sangallo the Younger. Uffizi, no. 1483A.

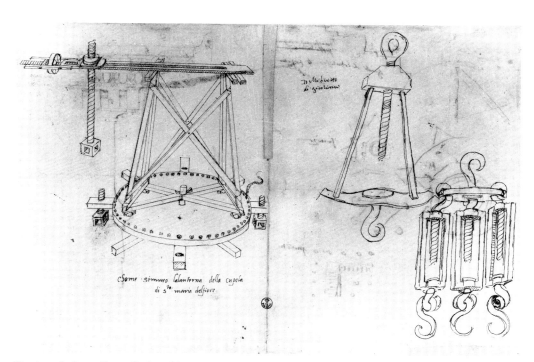

Battista da Sangallo, called Gobbo. Uffizi, no. 1665A.

Printed Work

Agostino Ramelli
Le diverse et artificiose machine
Paris 1588
Palatino 8.8.3.1
Folio
Biblioteca Nazionale Centrale, Florence
[open at pl. CXXXVI, Fig. 162]

Painting

Biagio d'Antonio (?)
Tobias and the Archangels
c. 1470
Oil on canvas
1550 × 1550 mm
Bartolini Salimbeni Collection, Florence
[Pls II and III (detail)]

Models

Revolving crane [ill. p. 353]
After CA, f. 965 r/349 r-a
Wood and metal
206 × 167 × 90.5 cm
Constructed by S.A.R.I. and Mariani, Florence, 1986
The Montreal Museum of Fine Arts

Reversible hoist [ill. p. 353]
After CA, f. 1083 v/391 v-b
Wood and metal
101 × 220 × 150 cm
Constructed by S.A.R.I. and Mariani, Florence, 1986.
The Montreal Museum of Fine Arts

Light hoist [ill. p. 354]
After Buonaccorso Ghiberti, *Zibaldone*, f. 35r
Wood and metal
60 × 70 × 70 cm
Constructed by the Dipartimento di Scienza delle Costruzioni, University of Florence
Museo Leonardiano, Vinci

Lantern rotary crane [ill. p. 354]
After CA, f. 808 v/295 v-b
Wood and metal
65 × 75 × 75 cm
Constructed by the Dipartimento di Scienza delle Costruzioni, University of Florence
University of Florence

Elevator and rotary crane [ill. p. 354]
After CA, f. 847 r/309 r-b
Wood and metal
83 × 65 × 65 cm

Constructed by the Dipartimento di Scienza delle Costruzioni, University of Florence
University of Florence

Screw-jack [ill. p. 354]
After Madrid MS. I, f. 26 r
Wood, metal and plexiglass
145 × 110 × 110 cm
Constructed by S.A.R.I. and Frullini, Florence, 1987
The Montreal Museum of Fine Arts

Spring motor [ill. p. 355]
After Madrid MS. I, f. 14 r
Wood and metal
125 × 174 × 71 cm
Constructed by S.A.R.I. and Frullini, Florence, 1987
The Montreal Museum of Fine Arts

Two-wheeled hoist [ill. p. 355]
After CA, f. 30 v/8 v-b.
Wood, metal and plexiglass
180 × 220 × 102 cm
Constructed by S.A.R.I. and Frullini, Florence, 1987
The Montreal Museum of Fine Arts

Inverted screw [ill. p. 355]
After Madrid, MS. I, f. 58 r
Wood, metal, plexiglass and paint
63 × 118 × 28 cm
Technical drawing by F. Marilli
Constructed by Muséo Techni, Montreal, 1987
The Montreal Museum of Fine Arts

Crankshaft [ill. p. 355]
After Madrid MS. I, f. 28 v
Wood and metal
106 × 229 × 96 cm
Technical drawing by A. Regoli
Constructed by Muséo Techni, Montreal, 1987
The Montreal Museum of Fine Arts

Alternating movement [ill. p. 356]
After Madrid MS. I., f. 17 r
Wood and metal
109 × 82 × 82 cm
Technical drawing by L. Martini
Constructed by Muséo Techni, Montreal, 1987
The Montreal Museum of Fine Arts

Ball-bearings [ill. p. 356]
After Madrid MS. I., f. 20 v
Wood, metal and plexiglass
31 × 58 (diameter) cm
Technical drawing by A. Regoli
Constructed by Muséo Techni, Montreal, 1987
The Montreal Museum of Fine Arts

Cam and hammer
After Madrid MS. I, f. 6 v

Wood and metal
121 × 83 × 120 cm
Technical drawing by A. Regoli
Constructed by Muséo Techni, Montreal, 1987
The Montreal Museum of Fine Arts

Helicoidal gear
After Madrid MS. I, f. 17 v
Wood and metal
125 × 157 × 99 cm
Technical drawing by L. Martini
Constructed by Muséo Techni, Montreal, 1987
The Montreal Museum of Fine Arts

Hoist with automatically-unlocking hook
After Madrid MS. I, f. 9 v
Wood and metal
170 × 160 × 140 cm; hook: 89 × 40 × 12 cm
Technical drawing by A. Regoli
Constructed by Muséo Techni, Montreal, 1987
The Montreal Museum of Fine Arts

Ball-bearing with conical pivot
After Madrid MS. I, f. 101 v
Wood and metal
77 × 47 × 47 cm
Technical drawing by L. Martini
Constructed by Muséo Techni, Montreal, 1987
The Montreal Museum of Fine Arts

Rectilinear alternate movement generated by a rotary movement
After Madrid MS. I, f. 28 r
Wood and metal
98 × 201 × 171 cm
Technical drawing by A. Regoli
Constructed by Muséo Techni, Montreal, 1987
The Montreal Museum of Fine Arts

Differential screw
After Madrid MS. I, f. 33 v
Wood and metal
70 × 50 × 12 cm
Technical drawing by L. Martini
Constructed by Muséo Techni, Montreal, 1987
The Montreal Museum of Fine Arts

Wheel and sprocket [ill. p. 356]
After CA, f. 1103 r/396 r-e
Wood and metal
75 × 75 × 104 cm
Constructed by G. Sacchi, Milano.
Museo Leonardiano, Vinci

Three-speed gear [ill. p. 356]
After CA, f. 77 v/27 v-a
Wood and metal

75 × 75 × 102 cm
Constructed by G. Sacchi, Milan
Museo Leonardiano, Vinci

Screw steering [ill. p. 356]
After Paris MS. B, f. 72 r
Wood and metal
85 × 75 × 87 cm
Constructed by G. Sacchi, Milan
Museo Leonardiano, Vinci

Rack and pinion [ill. p. 356]
After CA, f. 998 r/359 r-c
Wood and metal
96 × 75 × 80 cm
Constructed by G. Sacchi, Milan
Museo Leonardiano, Vinci

Water meter
After Paris MS. G, ff. 93 v and 95 r and Benvenuto di Lorenzo della Volpaia, MS. 5363, Biblioteca Marciana, Venice, f. 7 v
Wood, iron and copper
158 × 242 × 80 cm
Constructed by S.A.R.I., Frullini and Mariani, Florence, 1987
The Montreal Museum of Fine Arts

Centrally-planned church [Pl. XVI]
After Ashburnham MS., 2037, f. 5 v.
Wood
268 × 272 (diameter) cm
Drawing by K. De Jonge
Constructed by S.A.R.I., Florence, 1987
The Montreal Museum of Fine Arts

Monumental door
After CA, f. 757 v/279 v-a
Wood and metal
387 × 310 × 90 cm
Drawing by K. De Jonge
Constructed by S.A.R.I., Florence, 1987
The Montreal Museum of Fine Arts

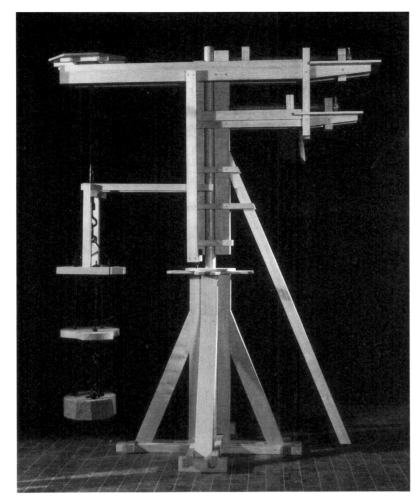

Revolving crane, after CA, f. 965 r/349 r–a.

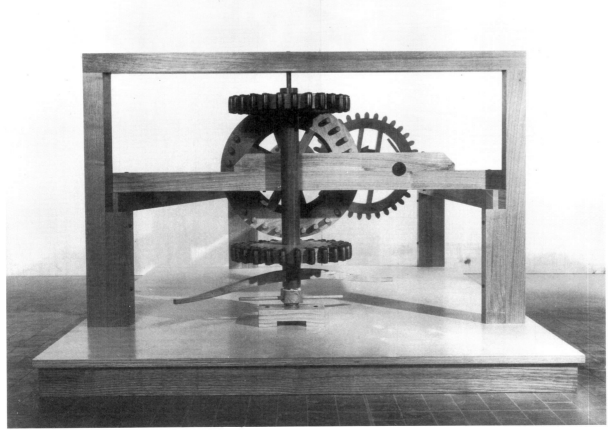

Reversible hoist, after CA, f. 1083 v/391 v–b.

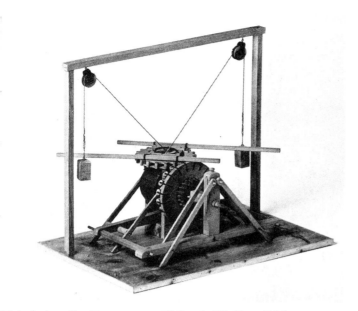

Light hoist, after Buonaccorso Ghiberti, *Zibaldone*, f. 35 r.

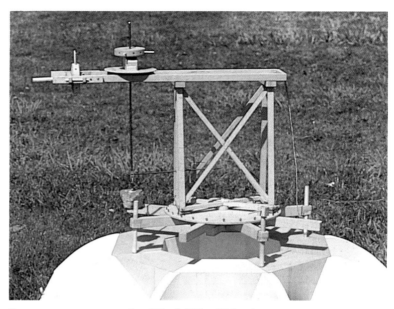

Lantern rotary crane, after CA, f. 808 v/295 v-b.

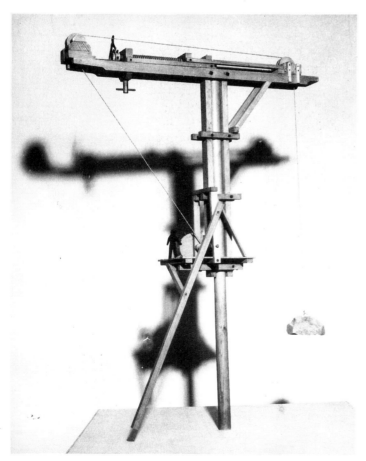

Elevator and rotary crane, after CA, f. 847 r/309 r-b.

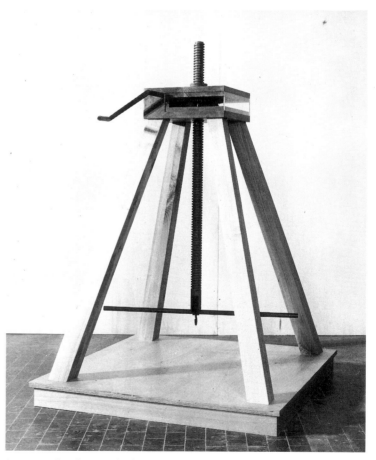

Screw-jack, after Madrid MS. I, f. 26 r.

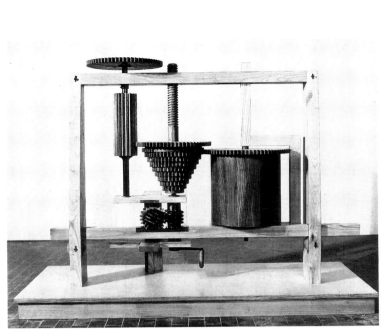

Spring motor, after Madrid MS. I, f. 14 r.

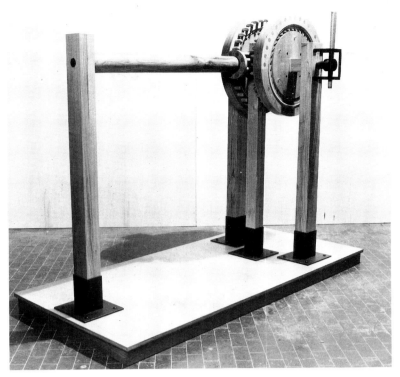

Two-wheeled hoist, after CA, f. 30 v/8 v–b.

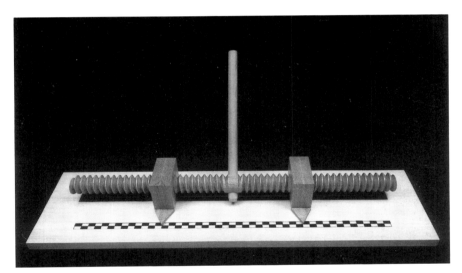

Inverted screw, after Madrid MS. I, f. 58 r.

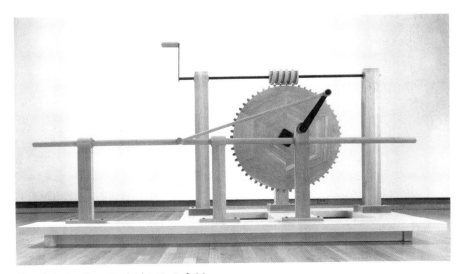

Crankshaft, after Madrid MS. I, f. 28 v.

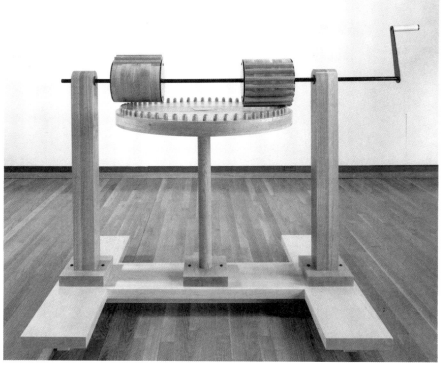

Alternating movement, after Madrid MS. I, f. 17 r.

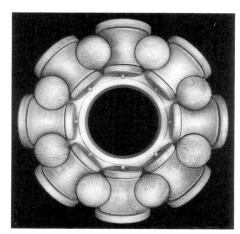

Ball-bearings, after Madrid MS. I, f. 20 v.

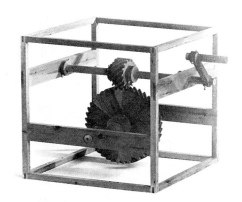

Wheel and sprocket, after
CA, f. 1103 r/396 r–e.

Three-speed gear,
after CA, f. 77 v/27 v–a.

Screw steering, after Paris MS. B, f. 72 r.

Rack and pinon, after CA, f. 998 r/359 r–c.

List of Lenders

Federal Republic of Germany
> MUNICH
> Staatliche Graphische Sammlung

France
> PARIS
> Bibliothèque de l'Institut de France
> Musée du Louvre

Italy
> FLORENCE
> Biblioteca Nazionale Centrale
> Collezione Bartolini Salimbeni
> Gabinetto Disegni e Stampe, Uffizi
> SIENA
> Biblioteca Comunale degli Intronati
> TURIN
> Biblioteca Reale
> VINCI
> Museo Leonardiano

Spain
> MADRID
> Biblioteca Nacional

Switzerland
> BASLE
> Universitätsbibliothek

United Kingdom
> LONDON
> British Library
> Victoria and Albert Museum
> OXFORD
> Christ Church, The Governing Body
> WINDSOR
> Royal Library

United States of America
> LOS ANGELES
> Armand Hammer Foundation

Photographic Credits

This catalogue is a publication of the Montreal Museum of Fine Arts,
General Communications Department, Publications Services

Coordination:
Francine Lavoie

In charge of translation and revision:
Judith Terry

Translation:
Murtha Baca (*Galluzzi*)
Jill Corner (*Marani, Di Pasquale*)
Martha Harrison (*Firpo*)
Susan Le Pan (*Guillaume*)
Judith Terry (*Marinoni*)

Graphic design:
Jean-Pierre Rosier

Photocomposition:
Fotocomposizione Leadercomp, Florence

Photo-engraving:
Fotolito Toscana, Florence

Paper:
Couché mat ivoiré, 150g/M²
Papeterie Job, Paris

Type:
Bembo

Printed in April 1987
by Industrie Grafiche G. Zeppegno e C., Turin
for Giunti Barbèra, Florence